Balthus

edited by Jean Clair

cover
Balthus, *Portrait de Pierre Colle*, 1936
Private collection

back cover
Balthus, *Le chat au miroir II*, 1986–89
Private collection

page 8
Balthus, *Portrait
d'André Derain*, 1936
Private collection

pages 10–11
Balthus, *Le chat
de la Méditerranée*, 1949
Private collection

page 12
Balthus, *La Montagne (L'été)*, 1937,
detail
New York, The Metropolitan Museum
of Art

© 2001 RCS Libri Spa
Ist edition Bompiani, September 2001

First published in the United States
of America by
Rizzoli International Publications, Inc.
300 Park Avenue South
New York, NY 10010

ISBN : 0-8478-2410-1
LC : 2001094169

I met Balthus in Rome on many occasions, during the sixties and seventies. In those days the circles in the capital that were interested in art had an important point of reference in the Academy of France and in Balthus, who was its director for sixteen years.

I already knew his paintings, but I was curious to meet him. I discovered a personality of the utmost elegance, a lover of art, a refined connoisseur of all the leading movements, with a predilection for fifteenth-century Italy.

He spoke a great deal, and perceptively, about others. On the other hand, he did not care to talk about himself and his works. I realize artists hold their own work in great esteem, but Balthus, either out of modesty or good manners, certainly did not show it.

And this restraint and reserve made his company and conversation all the more delightful, and this was particularly true on the last occasion we spent some time together, chatting candidly about his life in his Grand Châlet of Rossinière, above Montreux, when the weight of years was aggravated by ill health.

Palazzo Grassi—an institution which in addition to its investigations of the great civilizations of the past, exhibits the most challenging contemporary art—with this exhibition, the largest and most thorough ever devoted to Balthus, reveals one of the most fascinating, mysterious figures of twentieth-century painting.

Giovanni Agnelli

With the Balthus exhibition, Palazzo Grassi presents a major figure of twentieth-century art, in keeping with our mission from the very start to reflect the foremost movements and artists of the twentieth century.

The exhibition, exceptional in its scope and the quality of the selection of works, intends to perpetuate the identity of an artist who with extreme originality merged the grand tradition of art with the feelings and experiences of the twentieth century in that European dimension his fascinating personality exemplifies.

Palazzo Grassi would like to express its gratitude to all those who made the exhibition possible, in particular the museums, public and private institutions, and the anonymous individuals that generously contributed to the exhibition, by lending their works.

Cesare Annibaldi

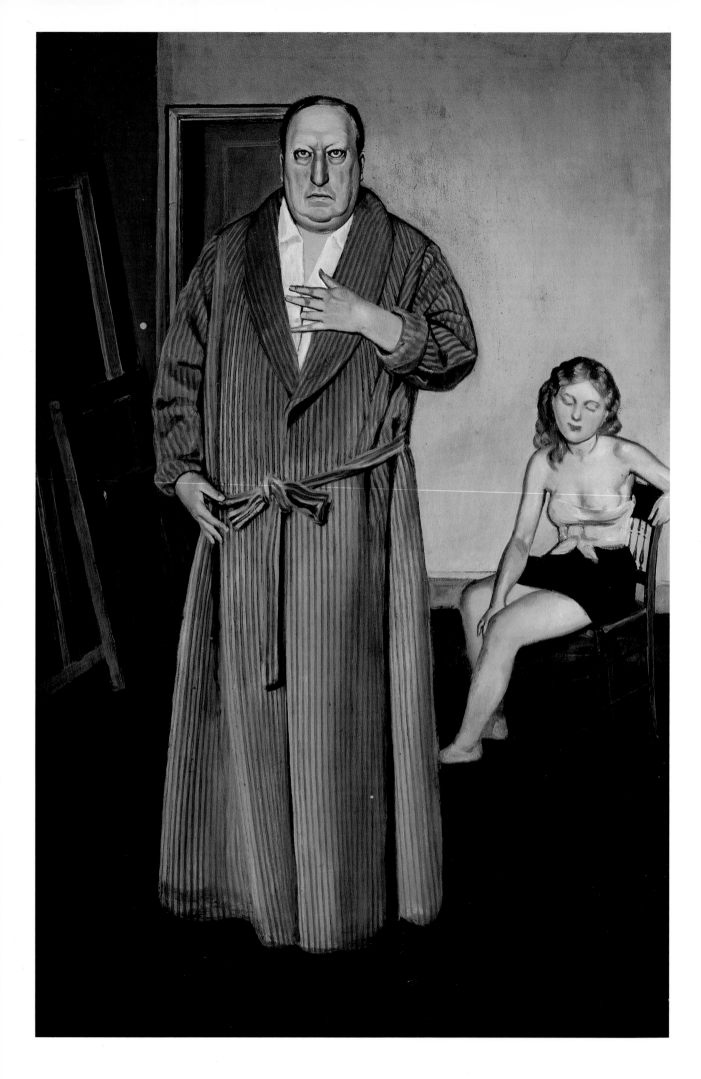

A tribute as significant as this exhibition implies the help, support, advice, backing, encouragement and collaboration of countless people. It would be impossible for me to mention them all. I trust they will forgive me.

Allow me nonetheless to recall a few of them. My gratitude above all goes to Giovanni Agnelli, who wished to give this retrospective tribute to a great painter recently passed away, an ardent friend of Italy and his personal friend, special prominence and solemnity. I am grateful also to Paolo Viti who, three years ago, decided to place this event on the program of Palazzo Grassi and set in motion the undertaking. My affectionate thanks for his unfailing friendship.

I further wish to thank Countess Setsuko Klossowska de Rola, who offered her support to the project, along with Stanislas and Thadée Klossowski de Rola. Thanks also to Balthus's friends, in particular the late Gaetana Matisse, who passed away a few months ago, and Alessandra Carnielli. Thanks to Arlène Bonnant, to Jean Leyris and to Emmanuel Roman. Thanks to Jean Leymarie, who succeeded Balthus at the Academy of France in Rome. Thanks to all the lenders and collectors, public and private, who were willing to generously entrust us with their masterpieces, or help us locate them, including Françoise Hersaint, Dorothea Elkon, Sabine Rewald, Alfred Pacquement, Jan and Marie-Anne Krugier, Myrtille Hugnet, Mess. Solanet and Francis Briest, Didier Imbert and many others to whom I apologize for not naming them.

This lengthy task would not have been possible without the constant efforts of Virginie Monnier and Odile Michel, as well as of Marina Rotondo for the publication of the impressive catalog.

I should like to personally dedicate this exhibition to the memory of Luigi Carluccio and the days we spent in Balthus's company, in Venice, in 1980.

Jean Clair

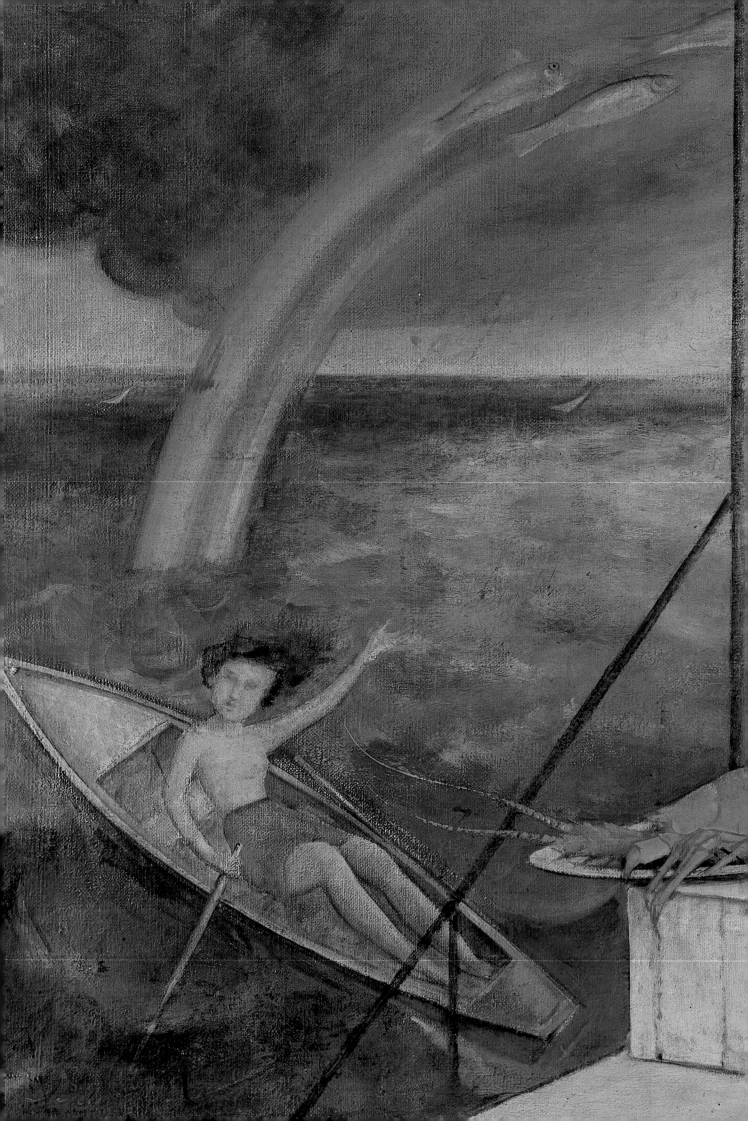

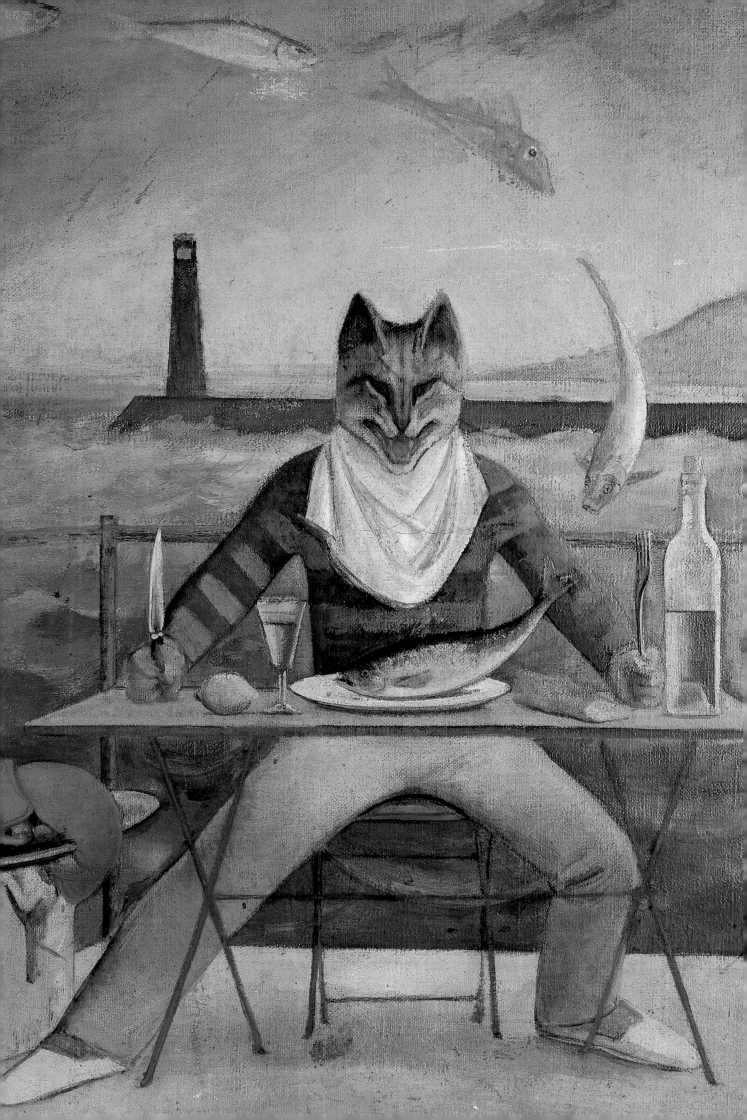

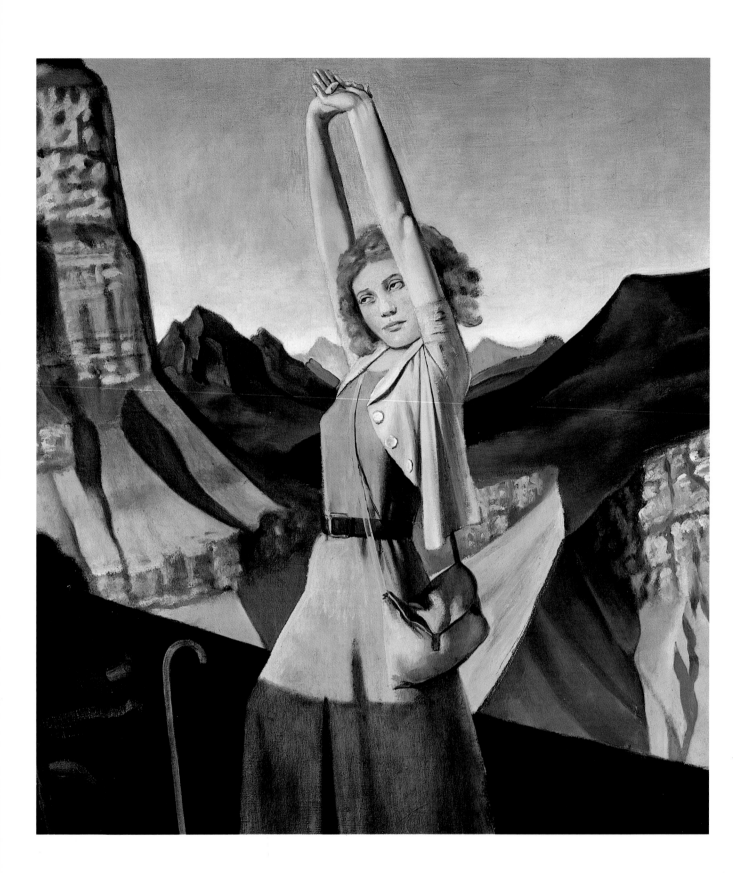

Aix-en-Provence, Musée Granet, private
 collection in deposit
Amiens, Musée de Picardie collection
Antibes, Musée Picasso
Bloomington, Indiana University Art
 Museum
Chicago, The Art Institute of Chicago,
 The Joseph Winterbotham Collection
Edinburgh, Scottish National Gallery of
 Modern Art
Comune di Gualtieri
Hartford, Wadsworth Atheneum, The Ella
 Gallup Sumner and Mary Catlin
 Sumner Collection Fund
Madrid, Thyssen-Bornemisza Museum
New York, The Metropolitan Musum of Art
New York, The Museum of Modern Art
Paris, Bibliothèque Nationale de France
Paris, Musée National d'Art Moderne,
 Centre Georges Pompidou
Paris, Musée Picasso
Philadelphia, Philadelphia Museum of Art
Poughkeepsie, The Frances Lehman Loeb
 Art Center, Vassar College, Katherine
 Sanford Deutsch collection
Troyes, Musée d'Art Moderne
Washington, Hirshhorn Museum and
 Sculpture Garden, Smithsonian
 Institution

Berlin, Ulla e Heiner Pietzsch collection
Caracas, Patricia Phelps de Cisneros
 collection
Geneva, Galerie Jan Krugier, Dietesheim
 & Cie
Los Angeles, Richard E. Sherwood Family
 collection
Lausanne, Alice Pauli collection
Mendrisio, Massimo Martino Fine Arts
New York, Charlotte and Duncan
 MacGuigan
New York, Carol Selle collection
New York, Matisse Foundation
New York, Sabine Rewald
New York, Sandro and Fiamma Manzo
New York, The Elkon Gallery Inc.
Paris, Blondeau & Associés SA
Paris, Laura Bossi collection
Rome, Giovanni Carandente collection
Upperville, Mrs Paul Mellon collection
Sandra Basch
Edmonde Charles-Roux Defferre
Maire, René and Rodney Chichignoud
Edwin C. Cohen
Roland Dumas
J.-M. Folon
Fondation Balthus
Richard Gere
Paola Ghiringhelli
Setsuko Klossowski de Rola
Stanislas Klossowski de Rola
Jan and Marie-Anne Krugier Poniatowski
 collection
Bruce McMurray and John Fowley
 collection, courtesy Salander O'Reilly
Magnum Photos
Beppe Modenese and Piero Pinto
Barrie and Emmanuel Roman

Exhibition *Catalog*

Curator
Jean Clair

Co-curator
Virginie Monnier

Coordination
Odile Michel

Installation
Gae Aulenti
with Francesca Fenaroli

Graphic design
Studio Cerri & Associati
with the collaboration of
Dario Zannier

Lighting consultant
Piero Castiglioni

Press office
Mario Spetia, *Fiat press office coordination*
Lucia Pigozzo

Organization coordinator
Pasquale Bonagura

*During the course of the exhibition the
following films are shown:*
Balthus the painter
directed by Mark Kidel
produced by Emma Crichton-Miller –
Rosetta Pictures, 1996;
Balthus de l'autre côté du miroir
directed by Damian Pettigrew
co-produced by Planète Cable and Baal
Films, 1996;
Balthus
directed by Xavier Lefevre
produced by JLR Productions and France 3,
2000

Editorial director
Mario Andreose

Chief editor
Elisabetta Sgarbi

Coordinating editor
Marina Rotondo

Editorial collaboration
Giovanna Vitali

Editing
Alessandra Fregolent

Graphic design
Sabina Brucoli

Translations
Jeremy Scott
Susan Wise
Stephen Wright
John Young

Technical staff
Eriberto Aricò
Sergio Daniotti
Carmen Garini
Valerio Gatti
Daniele Marchesi
Lorenzo Peni
Stefano Premoli
Roberto Serino
Enrico Vida

Contents

to Paolo Viti

The Exhibition at the Galerie Pierre

Balthus, of course, was never a surrealist. From very early on, his tastes, his inclinations swayed him toward the tradition of constructed, severe painting, able to engender stories, illustrate legends and resuscitate myths. Piero della Francesca, Masaccio, Poussin, David, Courbet were, in their respective centuries, his geniuses of choice. Such tastes scarcely predisposed him toward beauty welling straight out of an automatism of the subconscious, or dominated by the categories of the "marvelous" and the "convulsive" that André Breton was advocating at the time. The history of this filiation has already been written.

In the twenties, in the course of his journey through Italy, Balthus no doubt reinforced these tropisms by eyeing up the best of what young Italian painting, from *Valori Plastici* to *Novecento*, was producing, from Carrà to Casorati (fig. 1). He shared the frosty poetry, the fascination for mannequins and automatons, the magical realism and the taste for *bel mestiere*. This source of his modernity has also been explored. It complements the Germanic influence of the *Neue Sächlichkeit*, encountered in the Berlin of his youth in 1921, of which, though he always abjured it in his rejection of expressionism, he could not have been altogether ignorant. To these Mitteleuropean influences must be added the classical currents which were developing in Paris when he arrived. There were the Neo-humanists, around Christian Bérard—to whom he was, through his friendship with Cassandre, often very close—as well as Berman and Tchelitchew. There was also, a year after his first exhibition at the Galerie Pierre, the Salon des Forces Nouvelles, which opened in April 1935 at the Billiet-Vorms Gallery. It was an austere, earthy painting, turned toward the common people—peasants and workers. Just as the Italians had laid claim to the Italianness of Masaccio, and the Germans to the tradition of Dürer, some fifteen years later after the rest of Europe, the painters involved—Humblot, Rohner, Jannot, Tal Coat (fig. 3)—sought to celebrate it as a part of a "French tradition," which the famous exhibition at the Orangerie, "Painters of Reality," organized by Charles Sterling, had only just rediscovered[1]: Valentin and the French Caravagists, the Le Nain brothers, and above all Georges de la Tour (fig. 2). But just as in Italian painting, it was the rediscovery of Piero della Francesca that was celebrated (fig. 4). One theme in particular came up, in homage to *The Cheater* in the Louvre: the cardplayers (fig. 5). Balthus would take this theme up on a number of occasions in the course of his work, like a persistent recollection of his first Parisian discoveries (fig. 6). Yet, had Balthus been only that, he would not have become the artist we admire. Perhaps he would only have been the rather boring, nostalgic, old-fashioned, "museum-like" painter that his enemies allege him to be—but that he is obviously not. Something else thus came along to disrupt this excessively deliberate, overly learned construction.

Balthus, of course, was never a surrealist. His friendships, however, and the circles he was part of in Paris, as well as those who first wrote about his work, the gallery that first showed him—in apparent contradiction with what we have just recalled of his history—clearly show where his deepest affinities lie.

It was the Galerie Pierre, focal point of surrealism, that first opened its space to him; it was Antonin Artaud, Jacques Lacan and Georges Bataille whom he frequented; it was the intellectuals, artists, poets, philosophers, writers, historians, ethnologists and psychiatrists associated with the journal *Minotaure*, with whom he was in contact. And it was in the prestigious magazine founded by Skira and run by Tériade that his works would first be reproduced. There were ample grounds for confusion.

The strength of French genius is its inability to speak anything other than its language (this self-sufficiency is referred to, moreover, by an untranslatable word: chauvinism[2]). It is also its weakness. Every time France has moved, it has done so under the impetus of those who keep their eyes on the borders, on the lookout for fresh winds, astride different languages and civilizations; of those benevolent translators of various sensibilities, who have always been ferrymen between the Germanic world, the Mediterranean world and the Gallican peninsula. These informal customs officials, favorable to offering free access to thinkers and new tastes, have been Swiss like Rousseau and Germaine de Staël, Belgian like Maeterlinck or Henri Michaux, Francophile Italians like the de Chirico brothers, or Paris-enamored Austrians like Rilke and Stefan Zweig. Balthus Klossowski de Rola[3] belonged to that small élite, which, arriving in Paris, brought its cosmopolitanism along with it. The fantastic, the strangeness, the oddness one sees in his ear-

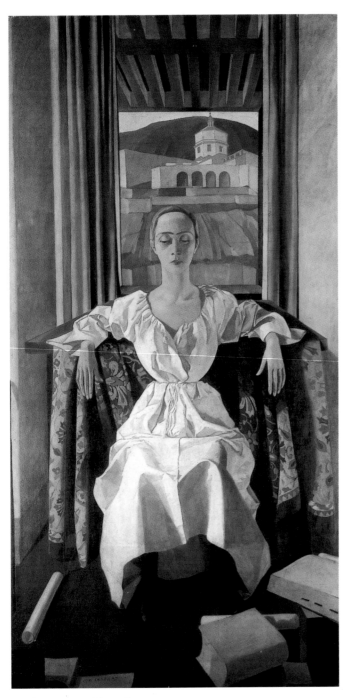

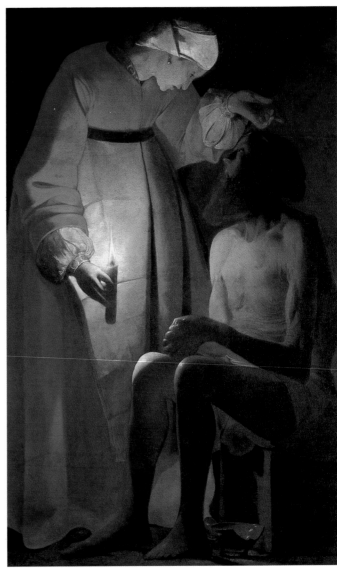

2. Georges de la Tour,
Job and His Wife, ca. 1650.
Epinal, Musée Départemental
des Vosges (full-page color
reproduction in *Minotaure*, 7,
June 1935, under the title
of *Le Prisonnier*)

1. Felice Casorati, *Silvana Cenni*,
1922, tempera on canvas.
Turin, private collection

3. Tal Coat, *Girl Lying down*.
Boulogne, Musée des Années trente

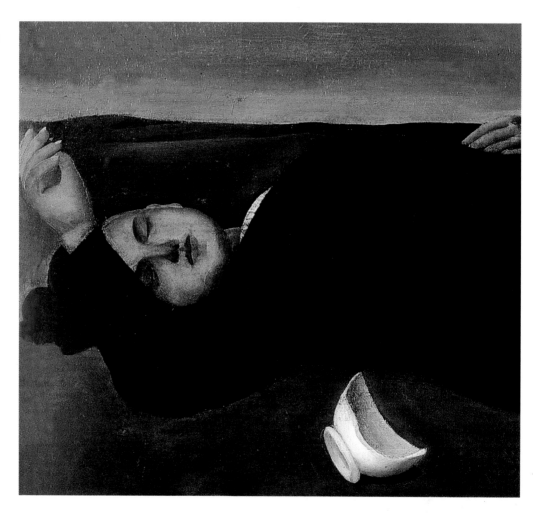

ly paintings was merely an echo of his own origins. As a child drifting between Paris, Germany, Switzerland and Italy, he was—far from Paris—the heir of a spiritual Lotharingia, irrigated by the Danube, the Tiber and the Rhine.

Romanticism for instance, the attraction for Novalis and Jean Paul,—which for Breton and his disciplines, who had scant knowledge of Goethe's language was a mere dandy's affectation—was for Balthus the natural milieu in which he had been immersed since his very first words. The sense of the subconscious, the fascination with women and the anxiety toward the "black continent," the terrible and bloody depths "of poor and beautiful human erotic power," everything that Jouve—initiated by his wife, Blanche Reverchon, of Swiss origin, and the friend and disciple of Freud—would sum up in his wonderful foreword to *Sueur de sang*,[4] Balthus possessed by birthright, whereas it was only much later, through unreliable, partial and often error-plagued translations that the Parisian surrealists were to become infatuated with the new theories of the science of the soul.

Balthus possessed all of that first hand—and from the hands of masters. Just as he possessed a sense of poetry that was unheard-of in such a young child—and that Rilke had been able to identify and make fruitful. And, through the teachings of his father and mother—both of whom were artists—a knowledge of painting that grown men could never rival. Let us recall too that the salon of Baladine Klossowska, initially on Rue Férou—where in 1925 Rilke was a daily guest—and later on Rue Malebranche (fig. 7), was a place where, in the course of evenings, where French, Italian, Spanish, German and English were spoken indifferently, the likes of Edmond Jaloux and Paul Valéry, Jean Cassou and Wilhelm Uhde, Jouve and Meier-Graefe, Jean Cocteau and Klaus Mann, Charles du Bos and André Gide, Ortega and the Maritains, Paulhan and the Princess Bibesco would meet up with one another. As Jean Cassou put it, this salon was, between the two wars, the place of "the last society of minds."[5] Such were the conditions in which Balthus, with his older brother Pierre Klossowski at his side—

4. Jean Lasne, *Homage to Piero della Francesca (Men),* 1937. Grenoble, Musée de Grenoble

5. Robert Humblot, *The Cardplayers,* 1935

6. Balthus, *The Cardplayers,* 1952, oil on canvas. Private collection

future and perfect translator of Hölderlin, Nietzsche, Kafka and Lou Salomé—was schooled, bringing with his spiritual training and polyglotism, order and confidence, culture and knowledge, even as the Parisian avant-garde was wallowing in approximations and all-the-more ostentatious manifestos. The misunderstanding was to prove tenacious.

"It was a time," as Jouve wrote, "of utter aesthetic anarchy and painting went all the way from cubist facility to surrealist facility. The severe impression given by his exactingly and deeply painted characters, brought together in strange scenes, struck virtually all who, experiencing the disorder of the moment, were hoping and praying for a renewed effort in structure."[6]

The Minotaure

Let's say that Balthus, in the early 1930s, was part of a certain spirit of the times, the quintessence of which had been distilled in *Minotaure*. Leafing through the journal, one is not surprised to sniff out a number of encounters. It was, after all, in June 1935, in issue 7, that the journal published a double-page reproduction of the drawings of *Wuthering Heights*, thanks to the friendship and admiration of Tériade.

The first, most singular and powerful trait—and one that Artaud was to emphasize in the emergence of this art, when he discovered it, as it had been exhibited the previous year on the Rue des Beaux-Arts at the Galerie Pierre—was indeed this singular violence bound up with sexuality. Jouve himself, in *Sueur de sang,* ten years before, in a commentary of the Freudian theory of sublimation, had referred to "this monster of Desire alternating with such an implacable tormentor."[7] This dark sexuality expressed itself freely in scenes of constraint or seduction experienced between an adult and an adolescent. It was, on the one hand, the nubile young girl, scarcely beyond childhood, who is awakened to life and the senses, who rejoices in the snacks which, every Thursday in the *Kinderstube*,[8] bring together groups of children sometimes beneath the gaze of a young governess, unknowing initiator of carnal sensations. She was, on the other hand, a person of authority, the *duenna*, the cruel stepmother, the wicked fairy, but at the same time the maker of angels, the witch, the fortune-teller or procuress.

In the same issue 7 of the journal, whose stated purpose was to express "nature's nocturnal side," and in which, apparently less than a year after the Galerie Pierre exhibition, the plates of *Wuthering Heights* had been reproduced, one discovered a selection of *curiosa* from Paul Eluard's personal collection. Amongst them were some very young girls in a state of nudity (fig. 8), along with texts from the poet which read as so many captions to the young girls painted by Balthus: "She awakens. She is alone on her bed. Has she no clock to stop her? Concentrated, she tilts her head, listens. The silence makes her laugh. The long fall of her black hair onto her pathetic body."[9]

And more scabrous play, even extending to rape, was often suggested in this first group of works from 1934—and sometimes even explicitly shown (fig. 9).

In at least one work, only a few years later, the act would be pushed to the extent of murder: in *La Victime*, the young woman is laying nude on a sheet, at the foot of which lies a dagger (fig.10). In the catalogue of the exhibition at the Centre Pompidou in 1983, I pointed out that the origin of this painting is perhaps to be found in Jouve's similarly entitled work, *La Victime*, published in 1935 in a collection called *La Scène capitale*—a book well worth rereading.[10]

It must be pointed out, however, that in the early thirties, a whole Sade-inspired current invaded literature and the arts. The first issue of *Minotaure* thus included a full-page reproduction of André Masson's *Massacres*, from 1932 and 1933, where virile figures are shown assaulting a woman and stabbing her to death (fig. 11). Here again, Jouve was the first to analyze their meaning: "The variety of these deadly couplings, their furor, sobriety and economy, where brutality is entirely transformed into a rite: that is what is immediately obvious; the calm which envelops the entire operation is also to be seen immediately afterward."[11] He concluded—no doubt with his new friend Balthus as much in his mind as Masson: "If art is capable of transcendence to the extent of the murder instinct, its power is truly extraordinary."[12]

Moreover, this violence fed on the news items of the day. Amongst these was the murder perpetrated by the two Papin sisters in 1933, which was to give Jacques Lacan the occasion for his first study of a "paranoiac crime," published in issue 3/4 of *Minotaure*, in December 1933—and would bring him fame. Jean Genét, in turn, drew inspiration from the same crime for his play *Les Bonnes*.

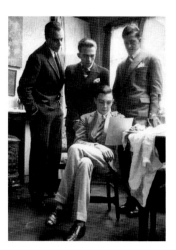

7. At the home of Baladine Klossowska, Rue Malebranche, in 1927. From left to right: Hubert Landeau, Pierre Klossowski, Yves Allégret. Sitting: Pierre Leyris

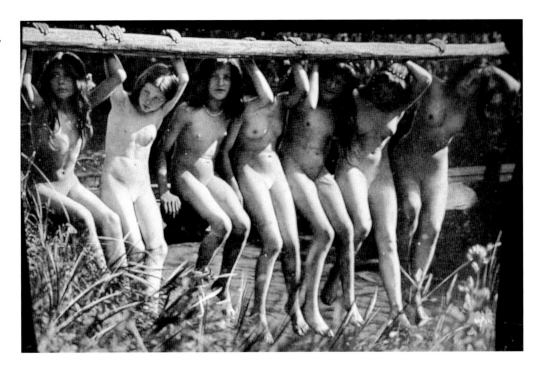

One of the journal's most faithful collaborators was Maurice Heine, biographer of the Marquis de Sade. He was to publish in the journal's pages a study on the origins of the English gothic novel: from *Gothic Tales,* and other tales of horror, to Lewis's *Tales of Terror*, Horace Walpole's *Tha Castle of Otranto*, and of course, Sade's *Histoire de Juliette*, supplemented with the vignettes and horrific engraving that had accompanied the stories in their day (figs. 12, 13).[13] The postures of the young girls—paralyzed with fright, thrown into the void—were occasionally taken up by Balthus (fig. 15). Did the 1933 work, *La Fenêtre*, according to Balthus himself, not in fact bear the eminently surrealist title *La Peur des fantômes*?

Tériade, in this same issue, went so far as to point out that one of the common traits of the painting of this period was "the passionate quest for movement in plastic expression. From pathetic expression to Dionysian expression, everything is movement, undulation, gyration, delirium of rhythms tangled in space in order to evoke time…"[14] The article was illustrated with paintings by Gaston-Louis Roux, Miro, Max Ernst (fig. 17)… and Balthus's *La Toilette de Cathy*.

Further on, Maurice Raynal would pause over the "sadistic" aspect of Lucas Cranach's work, and in particular on the imagery of Lucretia stabbed (fig. 18.[15]

But, far closer to Balthus, was it not indeed Pierre Klossowski, who, in that same year of 1933, devoted his very first essay to Sade, subsequently published in *la Revue française de Psychanalyse*?[16]

It is in the final issues of the journal, as if in echo—five years on—of Maurice Heine's essay on the English gothic novel, that one finds an article studying how this gloomy vein had been transposed for the cinema, and which reproduced and commented stills from those fantastical and crime films which were to become the icons of the new surrealist sensibility: Murnau's *Nosferatu,* Schoedsack's series *Frankenstein* (fig. 16), *Les Chasses du Comte Zaroff*, or even *King Kong*.[17]

At this time, however, and as the threats of extermination in Europe were becoming ever more unmistakable, a whole movement in painting began to assert itself; under the title "Cruel Art,"and accompanied by a preface by Jean Cassou, it was exhibited at the Billiet-Vorms Gallery from December 1937 to January 1938. Aside from André Masson and Picasso, the *Minotaures* and the *Massacres*, several other works, of a horrible and macabre cruelty, were also to be found—including Francis Gröber's *La Victime impatiente* and Suzanne Roger's *Les Empalées*.[18] Giacometti himself, working on the sadistic mechanics of *La Main prise* and *La Pointe à l'œil*, was very close to this current.

There is no doubt that compared to these extravagant images, Balthus's victims, as Albert Camus would say, seemed like "decent carcasses."[19] No blood, no screams, no convulsions. A "calm" comparable to that in Masson's *Massacres.*

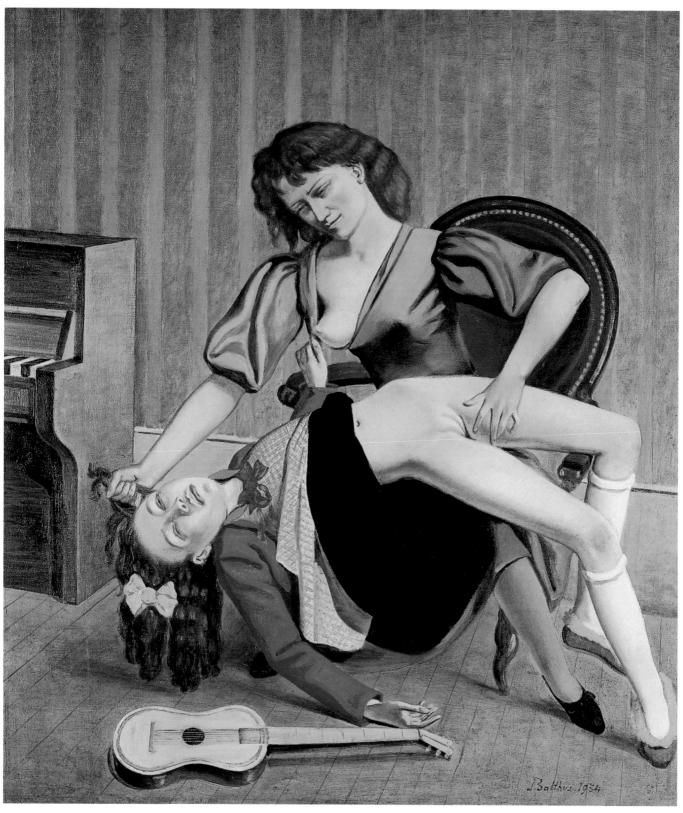

9. Balthus, *La Leçon de guitare*
[The Guitar Lesson], 1934,
oil on canvas.
Private collection

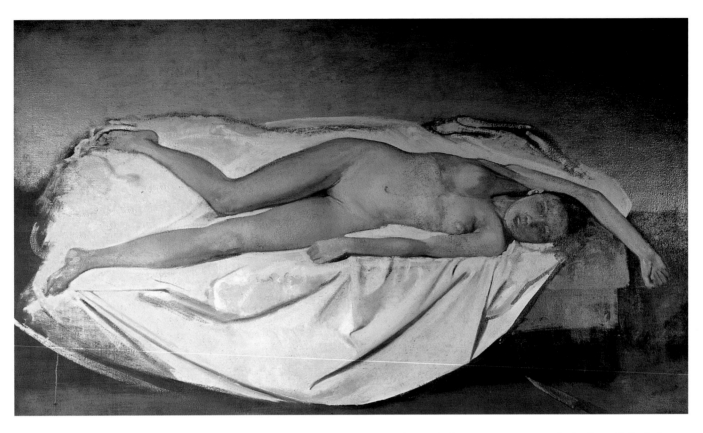

10. Balthus, *La Victime*
[The Victim], 1939–46,
oil on canvas.
Private collection

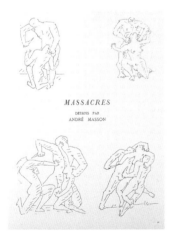

11. André Masson, *Massacres*,
reproduced in *Minotaure*, 1, 1933

But the fact is that a similar malaise ran through the representation of Bluebeard's little heroines—frightened, hypnotized, collapsed into a cataleptic state, or even murdered. They exude the smell of the crypt that Antonin Artaud had so perfectly detected in them: "I don't know why Balthus' painting smells as it does of the plague, storms and epidemics."[20] The characters are those of a great lady brooding, yet caught unawares in the most anecdotal sides of their lives. Ligeia, Morella, Eleonora, Berenice are shown in front of their washstands, Lady Macbeth doing her nails just moments before her bloody gulp...[21]

Four years after the exhibition at the Galerie Pierre, did Artaud himself not reveal his principles of a "theater of cruelty," which, healing evil with evil, turned theatrical representation into a magical act, capable, through its very violence, of responding to the cruelty of the world?[22] It was thus that he saw in Balthus his blood brother, his double, who, in the figures of Cathy washing herself, braiding her hair next to her stepmother; of Elsa Henriques untidy, her shirt open to the waist and hurled from the window; or in the nude of *Alice* with her blue eyes, like a monstrous chrysalis; in the twin sisters, having become almost presentable, like the disquieting heroines of Edgar Poe's stories: "Balthus has something more than painting to say, and that something, above and beyond his painting—which is so terribly strict, rigid, willful, faithful, exacting, scrupulous, meticulous and honest—smells of the grave, catastrophes, the obituary, the ancient ossuary, the coffin…"[23]

It was once again in issue 7 of *Minotaure* that one was to find Brassaï's admirable photographs intended to illustrate Young's *Les Nuits*. Three plates stand out from the rest, showing a geometer moth attracted by the light of a petrol lamp, the appearance of which Balthus was to resuscitate, one summer's night in Chassy (figs. 19 and 20).

But with Brassaï, it was also the whole urban fantastique, the magic of the diurnal and nocturnal everyday which surged forth. In issue 3/4 of *Minotaure*, which came out on 12 December 1933—that is, at the very time that Balthus was working on *La Rue*—Benjamin Péret published a text devoted to the magic of the automatons and androids, from Heron of Alexandria to Jaquet Droz.[24] The most recent photographs had been taken in the streets of Paris on the basis of the "automaton men" which one came across from time to time, not without feelings of strangeness and disquiet (figs. 22, 23). Balthus would recapture them in the frozen and jerky figures of his passers-by.[25] (fig. 21)

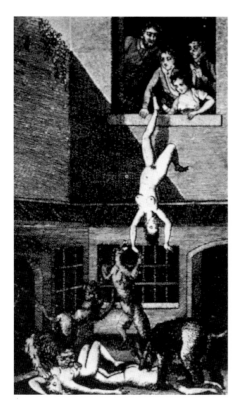

12, 13. Engravings for Sade's
Histoire de Juliette, 1707–1835

14. Frontispiece for Mme. De Méré's
*Les Capucins ou le Secret
du cabinet noir*, Bordeaux 1815

Also in that same issue 7, Breton had published *La Nuit du Tournesol*, a long poetical meditation, parallel to *Nadja*, on the magical, baleful, or beneficial appearances of the city, such as they perceived them in the signs offered up by the street as so many enigmas: the graffiti painted on the walls, with which Paris was so rich; shop signs like "Le Chien Qui Fume," "Le Bal des Innocents," "Grains et Issues," "Bois et Charbons," street names and place names like the Pont-au-Change, la Rue Gît-le-Coeur—and so why not Le Passage du Commerce?—statements with erotic insinuations, invitations to revelations of the flesh and the senses, the reading of which could announce misfortune or rapture.[26]

Balthus was assuredly the heir of this surrealist deciphering of the big city when, in *La Rue*, and later in *Le Passage du Commerce-Saint-André*—quite apart from the fascination with the passers-by—whom one is never sure if they are alive or inanimate—he would give all full resonance to the painted shop signs, to wall signs such as "REGISTRES," to the golden key, hanging nearby, similar to the golden key in fairy tales or yet again like the wand-like loaf of French bread tucked under the arm of the character (the painter himself), seen moving into the distance, like a magician, and who, armed indeed with a wand, manages to leave the enchanted circle (fig. 24).

The Temptation of the Masterpiece

But it was also in an issue of *Minotaure*—surprisingly enough, in a journal, which, devoted to surrealism, advocated automatism and the instinctual—that he would find a brilliant tribute to the masterpiece, signed by the inspired pen of Tériade: "It is urgent today, if only to reassure ourselves, to launch into that great work in which one risks the best of oneself, rather than continuing under the vague pretext of uncontrollable spontaneous expression or an overly facile self-abandonment, to deliver us from the fragments of works, and beginnings of worlds [...] Today, at the center of the irremediable debacle of all the personal little fauvisms, what are we waiting for? [...] The preoccupation with the masterpiece is the conscious responsibility of an artist with regard to a work, in order to carry it through to its perfection [...] For such artists to be worthwhile—in other words, genuinely creative—they first of all have to master their art—that is, possess it entirely, to the extent of freeing themselves from its preoccupation. The preoccupation with the masterpiece can then replace the useless preoccupation with painting."[27]

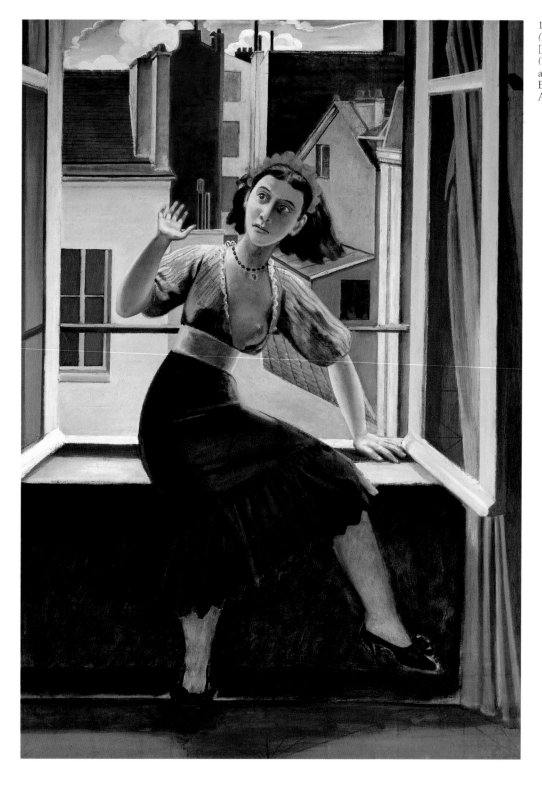

15. Balthus, *La Fenêtre*
(La Peur des fantômes)
[The Window
(The Fear of Ghosts)], 1933,
altered before 1962, oil on canvas.
Bloomington, Indiana University
Art Museum

16. "I caught sight of her collapsed body, thrown by the assassin onto her wedding coffin…" (from *Frankenstein or the Modern Prometheus* by Mary Shelley)

17. Max Ernst, *The key to song (the escape)*

18. Lucas Cranach, *Lucretia*, reproduced in *Minotaure*, 9, 1936

Balthus would soon make that his own painterly ethic. It can be heard resonating in all his proclamations on the need to silence the ego and to resort to know-how; on the vanity of personal expressions and on the need to rely on universal rules. In short, on the ambition of the masterpiece and the concern for its realization. It is this declaration of faith—so unusual in Skira's journal—that shows to what extent Balthus's two sources that we have sought to describe (return to tradition in the case of the Forces Nouvelles and Neo-Humanism, and rupture and revolution in André Breton's movement), could come together in one and the same ambition. And it was also no doubt on that note that the waters parted—the waters mixed with the surrealism in which he had immersed himself, and those of the slow and tranquil river on which he was henceforth to embark.

La Chambre

In a little known text devoted to his brother, Pierre Klossowski wrote: "I think of this large painting by Balthus, which for a while stood in the middle of this room, and I find nothing within myself except these words: the room—a painting by Balthus, with everything it suggests in terms of atmospheres, discussions, sympathy or antipathy, and so on. What is strange is that this painting represents none other than the room in which I live,[28] in which something bizarre can be seen to be happening, and which is not without analogy with a scene I described in a book that Balthus tried to illustrate; but he gave it up: indeed, he was in the midst of composing *La Chambre*."[29]

This book that Balthus gave up illustrating was very likely Pierre Klossowski's first novel, *Roberte ce soir*, which was published in 1953—that is, at the very time Balthus was indeed at work on *La Chambre*. The book was ultimately illustrated by Klossowski himself with five drawings, which were the beginnings of his parallel career as an artist, which he was to fully assume from the beginning of the seventies on.

One may wonder just what the relationship can be, in fact, between the imaginary *Chambre* that Balthus was painting at the time (fig. 27) and the actual room where his brother lived, in which he had set the action of his erotic and religious story. As a theologian, Pierre Klossowski, trained by the Jesuits, debated at length questions of substance, existence and essence, as well as the mirror and role play he had his characters play, to the extent indeed of playing on the notion of the *hôte*, a term which sometimes designates the character within who "receives," and sometimes he who gives, or is received, from without, in an ambiguity of words,

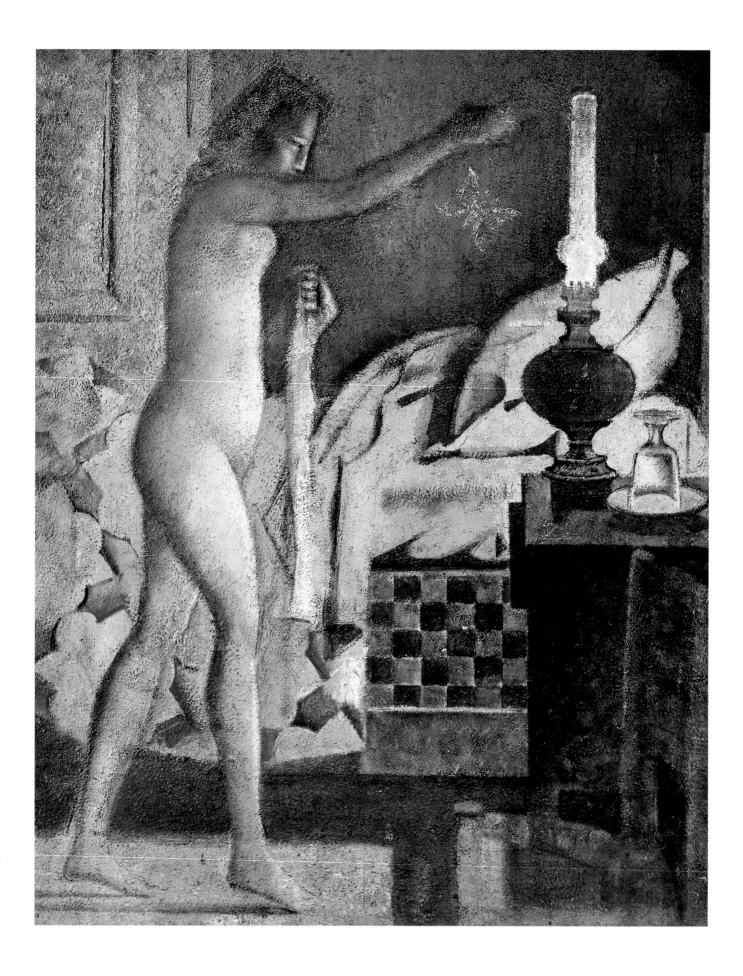

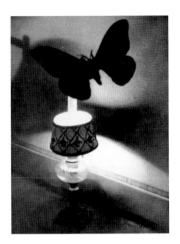

19. Balthus, *La Phalène* [The Moth], 1959, casein tempera on canvas. Paris, Musée national d'art moderne, Centre Georges Pompidou

20. Brassaï, photograph for Young's first *Night*, reproduced in *Minotaure*, 7, June 1935

where the body of the hostess becomes the stake offered to the visitors, the invitation extended to the guests, according to the laws of hospitality. The characters are Octave, the narrator's double, Antoine, his young nephew, and Roberte, Octave's wife. Octave hands his wife over to his guests in order to better possess her, by following beneath the diversity of her "possessions," the unique state, the essence, of her inaccessible nature.

The story opens with a photograph—or rather a photographic montage—taken in Ascona in the villa of a certain Madame de Watteville.[30] It is the snapshot of an " extraordinary scene" depicting Roberte whose "skirt has caught fire in the fireplace of the living room as she was rushing forward" and who throws herself into the arms of a guest "who tears her skirt off to put out the flame."[31] These visions of art, in the *tableaux-vivants* tradition, these Grand-Guignol scenes combining sadism and sarcasm, dreaminess and cruelty, these games of seduction and domination differ little from those which Balthus was painting at the time.

More interesting perhaps, in terms of fantasy, is the presence, in Pierre Klossowski's story, of two monstrous characters, who come to mingle with the living, one being the Colossus, and the other a little hunchbacked dwarf, who is both monstrous and libidinous (fig. 25). And he crops up once again in *La Chambre,* pulling the curtain to shed light on the exposed body of the young girl. "Is this dwarf character," writes Klossowski, "with a page's haircut, a dry and angular face, who with a lively gesture lifts the curtain of the high window, the elderly demon of childish vices, or simply the artist's soul, disguised as a chamber maid for the occasion? Is he the personification of his own gaze, so avid for visual treasures?"[32]

Pierre Klossowski finds the silhouette of this little monster, this dwarf and hunchback—whose origin I have elsewhere accounted for in the two brothers' common children's books[33]—in the little character crouching on the edge of the sidewalk in *Le Passage du Commerce*: "overwhelmed by the 'it will always be thus,' he watches the group of children to the left." Within this panorama of his own life Balthus is alleged to have unfolded on his large canvas—like an illustration of the Three Ages of life—Klossowski sees in the runt the picture of someone in the grips of depression (*cafard*). "Cafard," in the working-class French of the somber war and post-war years, was a feeling of sadness, melancholy and discouragement, which seized you at certain moments in life. "Avoir le cafard" was to have dark thoughts. But a *cafard* is also a hypocrite, a religious zealot, a bigot, someone two-faced who wears the mask of devotion. This play of mask and disguise also evokes a famous work, Kafka's *Metamorphosis*, where a human being turns into a repugnant insect (*cafard*).

An interpretation of this kind shows clearly to what extent Balthus's works always have to do with rites of passage: the passage from childhood to adolescence, and from adolescence to adulthood, as well as in the passageway, the Passage du Commerce, or in the room, another intimate place where tricks (*passes*) and commerce take place, and whose purpose is the human being's metamorphosis.

La Leçon de guitare [The Guitar Lesson] itself, in which Balthus later refused to see anything but youthful provocation, wonderfully incarnates that essential moment of initiation, at the same time shedding full light on the exorcising function of the simulacrum (do the bodies themselves, smooth and polished, not evoke the frozen statues of Roman *simulacra*?). Is the hieratism of this gynaeceum scene not every bit as gripping as the fresco in the so-called Villa of Mysteries? (fig. 26). But, more surreptitiously, they have to do with the rites which accompany the child's games of totemization prior to the age of majority: his propensity to identity with one animal or another, his attempts to cross the species' barrier, his monstrous unions with animals, and secret hierogamies with the cat, horse or lion; and perhaps too his powerlessness at not being able to avoid the fall into the most abject animality—that of the snake, the scorpion, the cockroach.

Every object in these rites of passage thus takes on symbolic dimensions. And the illustration Klossowski uses to shed light on the narrative of *Roberte ce soir* and Balthus's painting resemble each other inasmuch as both rely on the same accessories: on objects, that is, that are both common and religious—in the sense that it is religion which binds the real and the symbolic. They are, essentially, the washstand, the fireplace and the looking glass. These everyday, domestic and familiar implements of a certain *Häuslichkeit* take on a *mysterium tremendum et fascinans*. The looking glass is both the celestial and aquatic mirror, symbol of womanhood and the mother; the fireplace—infernal and terrestrial—is the symbol of virile violence. The

21. Balthus, *La Rue* [The Street],
1933, oil on canvas.
New York, The Museum of Modern
Art, bequest James Thrall Soby

22, 23. Automaton men, reproduced
in *Minotaure*, 3/4, December 1933

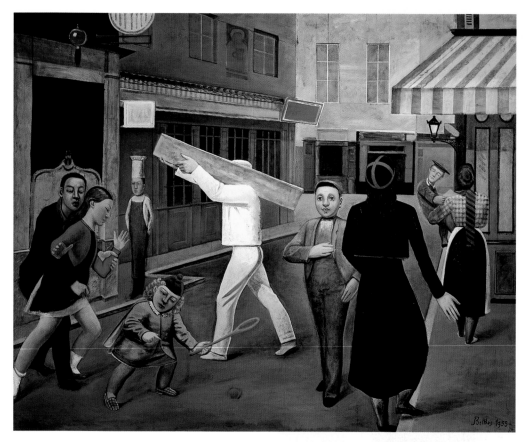

opposite page
24. Balthus, *Le Passage
du Commerce-Saint-André*
[The Passage du
Commerce-Saint-André], 1952–54,
oil on canvas, detail.
Private collection

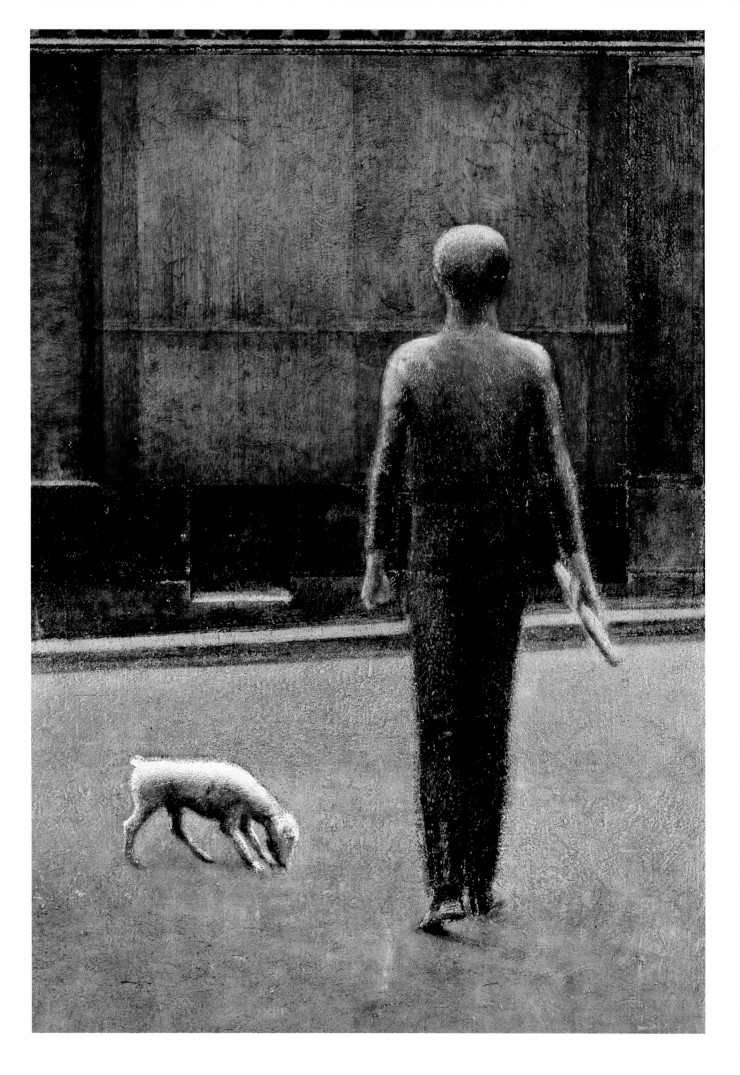

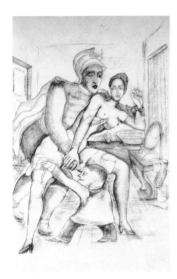

25. Pierre Klossowski, *Roberte,
the Colossus and the Dwarf*, 1953,
illustration for *Roberte ce soir*,
lead on paper.
Rome, Federico Fellini collection

26. Pompei, fresco
at the Villa of Mysteries

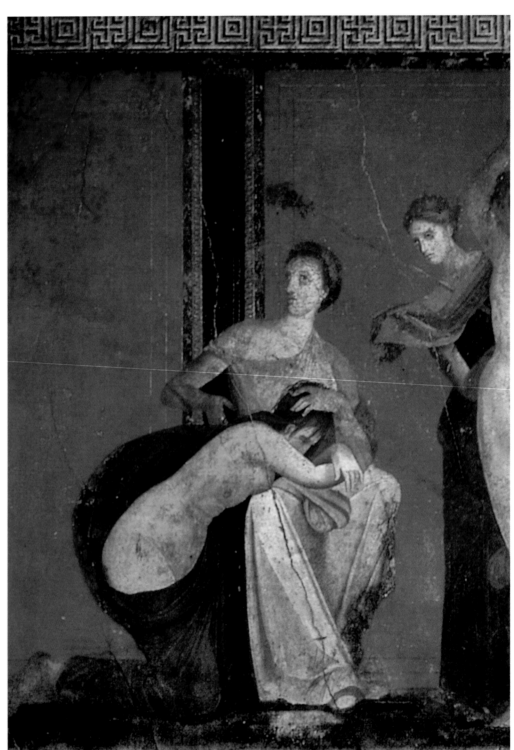

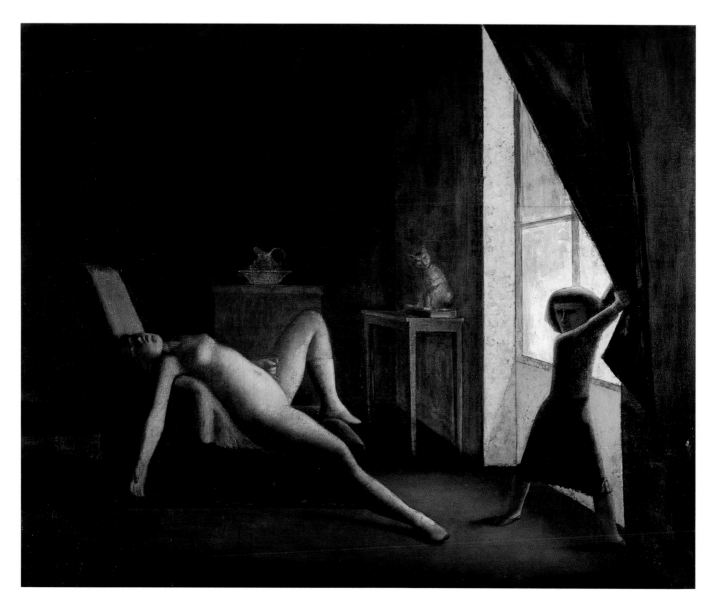

27. Balthus, *La Chambre*
[The Room], 1952–54, oil on canvas.
Private collection

gaping curtain, which parts and allows a triangle of light to penetrate right to center of the dusky hearth, opens at the same slant as the leg of the sleeping woman, revealing her *labra Veneris*. It is the burning orifice of an interior, a secret chamber, the disquieting vaginal mystery of an inner sanctum that the little monster lays bare before our desperate gaze.[34]

And the washstand is the alter, with the lustral water necessary for the ritual to come or for cleansing oneself once it has been completed. "Inside" and "outside," beneath the gaze of an immemorial cat, as old as the sacred animals of Bastet in Egypt, exchange their properties, just as the Cour du Commerce—"passageway" lined with closed or gaping doors and windows, is the outward reflection of *La Chambre,* whose interior is made up of darkness and dazzle, itself yet another passageway, another intimate realm, caught between the looking glass and the hearth.

Amongst the letters that Rilke sent the young Balthus every birthday, in one of the most beautiful he refers to "the crack"—the "secret and nocturnal slit" which leads to the eternal feast of the gods. "Always at midnight, a tiny slit opens between the day that is ending and the day that is just beginning […] The nimble person who managed to slip through would find himself outside of time, in a kingdom independent of all the changes we must undergo; it is there that is collected everything we have lost (Mitsou, for instance, the broken dolls of children, and so on and so on). It is there, my dear Balthus, that you have to slip away during the night of 28 February, to take possession of your party which is hidden there…"[35]

Only slightly off schedule, Balthus passed away on 18 February 2001,[36] ten days before the ninety-second birthday of his profane age and the twenty-third anniversary of his sacred age. He slipped away, forcing ever so slightly, into that fissure, which, once and for all, abolished the passage between inside and outside, between time and eternity, and at the bottom of which is found, spread out, all the treasures of childhood.

[1] The exhibition "Les Peintres de la Réalité," that opened in Paris in November 1934, for its intent to revive "national values," and its influence on young painters, must be compared to the "Mostra della pittura Italiana del Sei e Settecento," which took place in Florence, Palazzo Pitti, in 1922 (cf. F. Haskell, "The Redirection of Taste in Florence and Paris," in *The Ephemeral Museum*, Yale University Press, New Haven and London 2000, pp. 140–41.

[2] From the name of the soldier Chauvin, heroic member of Napoleon I's Old Guard in the armies of the Revolution and the Empire.

[3] However, only the eldest son, Pierre Klossowski, had the right to bear the countal title.

[4] Here are the opening lines: "We are now aware of thousands of worlds within the world of man, that all the work of man conspired to conceal; of the thousands of layers in the geology of this terrible being which emerges obstinately and perhaps marvelously (but without ever succeeding) from black clay and a bloody placenta…" ("Inconscient, spiritualité et catastrophe," in *Sueur de sang*, Paris 1955, p. 11).

[5] "He [Rilke] was seen in the company of the woman who was his first friend, Baladine Klossovska, named Merline in the publication of their correspondence. […] She lived on Rue Malebranche, in an apartment with an enormous studio, with her two boys, Pierre Klossovski, later known for his writing and drawing, and Balthus, the very first painting of whom— the bizarre *Cour du Commerce*—I saw immobilized in the stupor of an everyday and childish dream. We spent prestigious evenings in that studio, all of them charged with a cosmopolitan electricity, where Germans mixed with charming and mysterious Austrian girls, Spaniards, and of course Rilke, Groethuysen, Du Bos and Pierre Jean Jouve. But the latter avoided those gatherings where he was liable to come across unknown or unpleasant people. Gide, on the other hand, felt very much at ease in the house and turned up whenever he felt like it. […] Baladine was the most adorable woman in the world, cheerful, spontaneous, very naïve in her own way -inclined, that is, to savor the slightest pleasure which came up." (*Une Vie pour la liberté*, Laffont, Paris 1981, p. 83).

[6] P.J. Jouve, "Balthus," *La Nef*, Algiers, September 1944, pp. 139–40.

[7] *Op. cit.*, p. 11.

[8] Traditionally a day off, midweek, before the modernizations of "liberated" education.

[9] Paul Eluard, "Appliquée," *Minotaure*, n. 7, June 1935, pp. 15 ff.

[10] Blanche Reverchon-Jouve, explicitly making allusion to the theory of the primal scene in Freud's theory, is alleged to have said of Balthus: "He always paints as close as possible to the capital scene." Oral testimony of Philippe Roman to the author in 1984.

[11] P.J. Jouve, *André Masson*, Wolf, Rouen 1940. The text was taken up in P.J. Jouve, *André Masson*, Rencontre, Dumerchez, Paris 1994, p. 20.

[12] *Ibidem*, p. 23.

[13] M. Heine, "Promenadeà é travers le Roman noir,"*Minotaure*, 5, May 1935.

[14] E. Tériade, "Aspects actuels de l'expression plastique," *Minotaure*, 5, May 1934, pp. 33 ff.

[15] M. Raynal, "Réalité et mythologie des Cranach," *Minotaure*, 9, December 1936.

[16] "Eléments d'une étude psychanalytique sur le marquis de Sade," vol. VI, nn. 3–4. Taken up in part in *Sade mon prochain* in 1947.

[17] J.B. Brunius, "Dans l'ombre où les regards se nouent," *Minotaure*, 11, spring 1938, pp. 38 ff.

[18] See F. Moulignat, "L'Art cruel," *Cahiers du Musée national d'art moderne*, 9, 1982, pp. 51 ff.

[19] A. Camus, preface to *Balthus*, exhibition catalog, Pierre Matisse Gallery, New York 1949.

[20] It is interesting to note that three years after Jouve's text on "Inconscient, spiritualité et catastrophe," Artaud would use almost the same images of geological and biological turmoil.

[21] A. Artaud, "La jeune peinture française et la tradition," *El Nacional*, Mexico, June 1936.

[22] A. Artaud, *The Theater and its Double*, 1938.

[23] Antonin Artaud, *Sur Balthus*, 1947.

[24] B. Péret, "Au Paradis des fantômes," *Minotaure*, 3/4, December 1933, pp. 29 ff.

[25] Both the popular and scholarly sources of which have been analyzed (in Jean Clair, *Les Métamorphoses d'Eros*, Paris 1984), from Piero della Francesca to Masaccio in the silhouettes of *Strüwelpeter*.

[26] A. Breton, "La Nuit du tournesol," *Minotaure*, 7, June 1935, p. 48 ff.

[27] E. Tériade, "Réhabilitation du chef-d'œuvre," *Minotaure*, n. 6, winter 1935, p. 60.

[28] Pierre Klossowski lived at the time on Rue du Canivet, in an old seventeenth-century building, with high windows, in the shadow of the spires of Saint Sulpice.

[29] P. Klossowski, "Du *Tableau vivant* dans la peinture de Balthus," *Monde nouveau*, February-March 1957, p. 71.

[30] Antoinette de Watteville (or von Wattenwyll) descended from one of the oldest Swiss noble families, linked to the city of Bern. Balthus met her in 1924 and married her in 1937.

[31] P. Klossowski, *Roberte ce soir*, Minuit, Paris 1953, pp. 23–24.

[32] *Ibidem*, p. 78.

[33] This little hunchback, both familiar and disquieting, was taken straight out of a Germanic nursery rhyme, taken from the popular songs of *Des Knaben Wunderhorn*, "*Das bucklige Männlein*" (See "Le sommeil de cent ans," in *Balthus. Catalogue raisonné de l'œuvre* complet, Gallimard, Paris, 1999, pp. 32 ff.)

[34] Klossowski had used the following verses from *Médée* as an epigraph to one of the chapters of his story: "Allez, allez, Madame/ Etaler vos appas et vanter vos mépris/ l'infâme sorcier qui charme vos esprits…" [Go on, go on, Madam/ Display your charms and show off your scorn/ for the despicable sorcerer who enchants your spirits…].

[35] R.M. Rilke, letter to Balthus from Château de Berg-am-Irchel, undated (late February 1921), in *Rilke-Balthus. Lettres à un jeune peintre*, preface by M. de Launay, Somogy Archimbaud, Paris 1998, p. 32.

[36] See J. Clair, "The Funeral of Count Klossowski de Rola" in this catalog.

to Philippe Roman, in memoriam

1. Baladine Klossowska,
Balthus and His Cat,
water color, ca.1916.
Private collection

"For the sake of a line of poetry one must see many cities, people and things, one must be familiar with animals, one must feel how birds fly and know the movements with which little flowers open in the morning. One must be able to think back to ways through parts unknown, to unexpected encounters and to farewells that could long be foreseen, to childhood days as yet unexplained, to one's parents whom one could not but upset when they brought some new delight that one could not grasp (it was a joy for someone else…), to childhood illnesses that begin so strangely with such profound and heavy changes, to days spent in still and quiet rooms…"

Such were the thoughts of the young Malte Laurid Brigge when he came to Paris in 1904.[1] And such, no doubt, were the thoughts of the young Balthus when he in turn arrived in the capital in May 1924, filled with the teachings of the man who for five years had watched over the period of his apprenticeship. The work to be accomplished is the fruit of the childhood which one has successfully preserved within oneself. Two years previously, had not Balthus himself declared—he was fourteen at the time—"God knows how happy I would be, if I could remain a child forever"?

It is time to recognize that Balthus's painting, unique as it is in twentieth century art, albeit with a lineage that can be traced back to Courbet and David, owed much of its extraordinary development to the illuminating example of two of the greatest poets of the age.

Rilke was thus Balthus's spiritual father from 1920 to 1926. Upon his death, however, and in an unbroken line of continuity, Rilke was succeeded in this *sacra conversazione* by Pierre Jean Jouve. Meetings, coincidences and exchanges of letters proliferated between the painter and the two writers, and in so precise a fashion that we cannot but suppose that, moved by the mysterious magnetism of elective affinities, the aspirations of certain human beings, like those of metals or of plants, come together at points in space and time predetermined by an absolute necessity. Geneva, between Switzerland and France, Soglio in the Val Bregaglia, Beatenberg above Lake Thun, Muzot in the Valais were all places of this kind. And in the years between 1919 and 1926, certain dates lit up the points of a zodiac that was tracing out a destiny. On 29 December 1926 Rilke, the Bohemian poet who had guided the first steps of the young painter, was modestly to confide to the Baudelairean author of *Sueur de sang* his concern to be an inspiration for the works of his maturity. "I met Balthus," declared Jouve later, "at the time of the death of Rainer Maria Rilke, who had exercised a most noble influence upon him. Balthus was then a young man endowed with remarkable gravity, as if armed by experience which was not really his own."

Baudelaire and Courbet, Apollinaire and Picasso: such illustrious encounters have been noted before. But there are precious few examples—perhaps none at all—in a recent history which has tended to the chaotic, of a spiritual fraternity shared by three Europeans in the melting pot of a single output.

It all began on 11 June 1919. Rilke had been invited to Switzerland from Munich to give a lecture tour. He was offered hospitality by his friend Countess Dobrcenski-Wenkheim in her chalet at Nyon on Lake Geneva. After a brief stay Rilke moved to Geneva itself, where he set up residence—as always—in the Hôtel des Bergues, on the lakeshore, room 18. Before the cataclysm of 1914 laid low the four great Empires which supplied the aristocracy of Europe, this high place of neo-classical style was frequented by Grand Dukes of all the Russias, Kings of Prussia, Ludwig I and II of Bavaria, Princes of Naples or of Savoy.

There Rilke met again a young woman whose acquaintance he had made in Paris several years before, married to the painter and art historian Erich Klossowski de Rola. Her husband belonged to the minor Polish nobility and originally came from Silesia. The marriage had produced, she later wrote to the poet, "two ravishing sons," Pierre and Balthus Klossowski. According to custom, the elder son was the sole heir to the title. But Pierre Klossowski scorned the privilege, while his younger brother insisted on bearing the family arms despite the sarcasm of many that were close to him. Indeed, after 1962 he even refused to open any mail not addressed to Count de Rola. He provides an example which goes against the tendentious views of the Neo-Darwinian Frank Sulloway,[2] showing that the last-born can sometimes be more conservative than their elders. The Klossowskis had separated early in 1917. Erich Klossowski fled to France where he spent the rest of his life in a small colony of foreign artists set up in Sanary-sur-Mer.

2. Baladine Klossowska,
Self-portrait, 1917

3. Baladine Klossowska,
Rainer Maria Rilke, 1920

Rilke must have met again, on a number of occasions, the woman who signed her paintings—for she, too, was a painter—with the name of Baladine (fig. 1) and who was to engage in a copious correspondence with him using the name of Merline.[3] Their first significant rendezvous took place on 3 September 1920, again in the Hôtel des Bergues. Merline met Rilke at the station. He had planned to stay for a day only, but in the end remained for eight. Much later, Merline looked back on their week together: "Mes fils étaient mon école et mon plaisir—und ich war ihre Gespielin. Als dann Rilke dazu kam, waren wir alle vier wie glückliche Kinder."[4]

"All four of us like happy children...": Balthus was eleven years old when the author of the *Notebooks of Malte Laurid Brigge* entered into the life of the Klossowski family in the role of surrogate father as the lover of Merline, who was perhaps more childish than her two sons. At all events she described herself as their best comrade for games. A fortnight after this encounter, the elder of the two children once again awaited the arrival of a figure who had already become familiar: "Yesterday evening again, *around the time the train gets in*, Pierre was looking around and saying, 'It's like a party here.' It was all one big wait...."[5]

It is indeed astonishing that Rilke—normally so anxious to preserve his solitude—should have been so assiduous in his attendance upon his newly adopted family. He took steps for the children's education, find financial support, worry each week about their fate.

Above all—as is witnessed by his correspondence with his mother, in which the name of Balthus, still spelled Baltus, frequently appears[6]—he recognized the precocious talent of the young painter. He also wrote to him in person, not less than eight long letters between November 1920 and June 1926, a few weeks before his death.[7] In 1921 he arranged for Rotapfel to publish the first ink drawings of *Mitsou*, the story in pictures of a cat and a young child, honoring it with a splendid introduction. From then on until his death he showered concern, advice and gifts—later exchanged—with Balthus the child, the adolescent and finally the young man. They sent books to each other; one such was certainly Roberto Longhi's monograph on Piero della Francesca, the book that prompted the critical reappraisal of the Arezzo master. Reading it was part of Balthus's preparation for his famous trip to Italy in 1926. In return, the young painter gave the poet his little picture of *Narcissus*, copied from Poussin in the Louvre. Most significantly of all, one can detect in the early works, in 1928, the extremely direct, often literal influence of Rilke, who had died shortly before. The themes of the Luxembourg gardens, children playing with hoops, the fountain that stands still, the ball suspended in the air, the young confirmands: all these had been developed by the poet and were to be born again in the work of the young painter.

Indeed there are lines in the *Book of Images*,[8] written in Paris in 1903, such as:

> In white veils the young confirmands walk
> deep into the new greenery of the gardens.
> They have got through their childhood,
> and what comes next will never be the same.

which vividly recall Balthus's early pictures of girls walking to communion along the avenues of the Luxembourg (see Sabine Rewald's essay, page 52).

Other pictures from the same year recall works painted in 1901–02 by the other great friend of the Klossowski family, Pierre Bonnard, inspired by the Grand Lemps or by Parisian squares, peopled with children playing croquet, or with hoops or balls, and crossed once again by girls on their way to confirmation, so close in image and spirit to Rilke's poems (fig. 5). Balthus was undoubtedly familiar with these pictures, since he accompanied his mother on her visits to Bonnard at his house in Vernonnet, on the Seine near Giverny.

Other poems from the collection *New Poems*, such as *In einem fremden Park* [In a Foreign Park]—the Luxembourg gardens—or *Das Karussel*[10] [The Merry-Go-Round], which evokes the colorful fairground horses ridden by children dressed in white, read like descriptions of the small pictures to be painted later by the young Balthus:

> And so it goes on and hurries toward its end
> And spins and turns upon itself, aimlessly.
> A red, a green, a gray sent by,
> a little profile, barely begun.

4. Pierre Bonnard,
*The Family at the Park
(Le Grand Lemps)*, ca. 1901,
oil on canvas

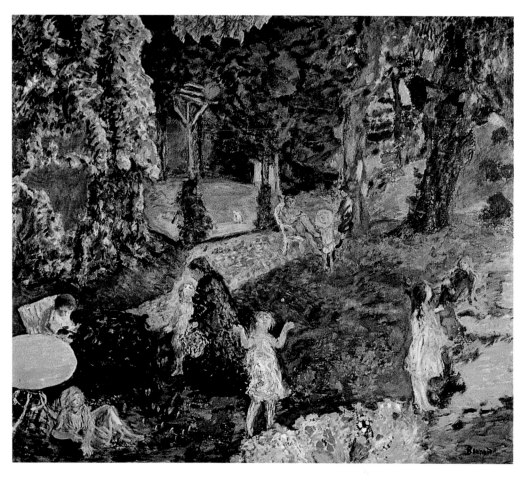

These snapshots taken beneath the greenery of the Luxembourg gardens, these gestures of child-hood frozen in time, shot through with an underlying, grieving awareness of how soon they will disappear, all appear again in the poem entitled *Vor dem Sommerregen*[9] [Before Summer Rain]:

Suddenly from all the green in the park
a something, one knows not what, has been taken;
one feels it come closer to the windows
and be silent. Imploring only and strongly
the plover calls from the bushes,
[…]
The faded wallpaper reflects
the uncertain light of afternoons
when one was frightened as a child.

Or again in the *Book of Images*, a poem such as *Kindheit* [Childhood] might be illustrated by a whole series of Balthus's paintings, including—almost like faithful transcriptions—*Le Bassin du Luxembourg sous la pluie* (fig. 6) and *L'Orage au Luxembourg* [Storm at the Luxembourg Gardens]. Dated 1928, these both seem to be recollections of the artist's mentor, who had just died.

The endless fear and time of school runs out
in waiting, […]
And to play so: ball and quoit and hoop,
in a garden that gently fades to pale,
and sometimes brushing against the grown-ups,
made blind and wild by running to catch,
but then in the evening quietly home, firmly collared,
with short stiff tread:
Oh understanding ever slipping away,
oh burden, oh dread.
And kneeling for hours and hours
with a little sailing boat by the great gray pond;

5. Balthus, *Enfants au Luxembourg* [Children in the Luxembourg Gardens], 1925, oil on canvas. Private collection

and forgetting it because many other, similar
and more beautiful sails cruise through the ripples,
and having to think of that small pale
face that appeared sinking out of the pond –:
Oh childhood, comparable images drifting away.
Where to? Where to?

Poetry, understood as the ability to capture the "Open," and the creative force of childhood, such as we find it in the *Notebooks of Malte Laurid Brigge*, in the *Sonnets to Orpheus* or in the *Duino Elegies*, were to be miraculously transposed in Balthus's early masterpieces of the thirties, the dreamy young girls, the glorious nudity of bodies still uncertain of themselves, the postures of clumsy abandon of children in the nursery, spending their time reading, daydreaming, "in waiting, all in vague dull things,"[11] during the seemingly endless recreation days. All this evokes the great latency of adolescence, the slow maturing of forms, the strange and bewildering rites of passage, the discovery of the flesh and its emotions, the games of masks and dressing up in the attic, with their terrors and delights—and remotely, perhaps, the still only confused awareness of death itself.

Balthus's greatest pictures—*Le Passage du Commerce, La Chambre* [The Room] or *Le Rêve* [The Dream]—convey something hieratical, with their cataleptic figures engaged in the celebration of a ritual whose meaning escapes us. How far, one wonders, were such effects dictated by Rilke's own particular sense of the sacred and the erotic, such as had been conveyed by his descriptions of the tapestries of the *Dame à la Licorne*? "But there is still a feast to come, though none be invited. Expectation has no part in it. Everything is there. Everything for always. The lion looks almost menacingly around: no one is allowed to come. We have never yet seen her weary; is she weary? Or has she just sat down because she is holding something heavy? One might think it a monstrance. But she bends her other arm toward the unicorn, and the animal, flattered, rears up and rises and rests in her lap. What she is holding is a mirror. Do you see: she is showing the unicorn its own image."[12]

One of the preferred meeting places was to be Beatenberg, above Lake Thun. Baladine went there for lengthy stays on several occasions, taking her two children. The village church provided the setting for Balthus's first public efforts: wall paintings on religious subjects—but taking the local country folk as models, warts and all. The parish priest was shocked, and the murals did not survive for long. Later, in 1937, Balthus was to make the Alpine landscape the privileged motif of *La Montagne* [The Mountain], the masterpiece of his youth. The painting continues to be something of an enigma, bringing together the characters in a drama, one of whom is recognizable as Antoinette de Watteville, Balthus's future wife, while the painter himself, a little silhouette on the hillside, turns his back on the scene and walks away.

It was from Beatenberg that on 18 August 1920 Merline wrote to Rilke: "You are something of a cult figure for people here. You're on the walls, they have all your books and you're much liked […] Lying in the grass, feeling as if I'd taken root in this rather damp and warm earth, I read your *Stundenbuch*. I read aloud and the more I read the more my voice began to tremble […] Also, I believe the mountain is a magic mountain. Shall I talk with the mountain, so that it brings you here by magic?" It was only late in August 1922, however, that Rilke joined his adoptive family in Beatenberg, the "magic mountain" of which he seemed to be the local deity. He returned there a year later, in August 1923, a decade before Balthus was to make the place the subject of his great painting.

Located at the heart of Switzerland, Beatenberg is like a magnetic pole of Europe, equidistant from Germany, Italy, Austria and France, from south and north, east and west, on the frontier between the wheat- and the olive-growing lands.

The atmosphere one breathed there was of that balanced cosmopolitanism which was perhaps to mark the essence of Balthus's art.

Thus, in the correspondence between Rilke and Baladine (including in the extract translated above), the text switches casually from French to German and back again, from the very first lines, without any notice being taken: "Kennen Sie mich denn René? Comment c'était? me demandez-vous. C'est moi, je crois, qui me suis penchée folle d'amour sur votre main en l'embrassant. Je n'ai presque plus de souvenir, je sais que quelques chose est hinausgetreten aus mir…"[13]

Indeed the home of Baladine Klossowska, to judge by the description given by Jean Cassou in

6. Balthus, *Le Bassin
du Luxembourg sous la pluie*
[Pond in the Luxembourg
Gardens], 1928, oil on canvas.
Private collection

his memoirs,[14] was to become a literary salon where French, Italian, Spanish and German were freely spoken, frequented by Rilke and Valéry, Verhaeren and Julius Meier-Graefe, Charles Du Bos and Wilhelm Uhde, Gide and Ortega y Gasset, the Maritains and the young Pierre Leyris... This was the highly cultured milieu in which Balthus grew up. It is impossible to understand the man without bearing in mind this European dimension, which was long to render his art incomprehensible to a French environment that had become too chauvinistic, too long turned in upon itself.

If we were briefly to summarize this cosmopolitan background, the first element would be his old Polish roots. On his mother's side, from his maternal grandfather who was a cantor at the synagogue in Breslau, Balthus preserved a Judaic sense of Scripture and the rule of the Law. In some of his more cruel and erotic drawings that sense occasionally brings him close to the work of his compatriot Bruno Schulz, who drew the perverse games of the *Livre idolâtre* and was also the author of the *Traité des Mannequins* (fig. 7 and 8). From the father's side, on the other hand, there came down the influence of Prussia and Pomerania: an impeccably Germanic culture which lacked neither the lowbrow basis of *Strüwwelpeter* and Wilhelm Bush's rascally boys, nor the more literary charms of the puppet theater of Heinrich von Kleist. The Middle-European influence, nourished by Rilke, goes some way toward explaining how the sharp and disturbing drawings for *Wuthering Heights* sometimes recall Alfred Kubin and in general a graphic style whose baroque sources can be traced back to Bohemia and Moravia (fig. 9). France came later—Paul Valéry and Gide, then the painters: Pierre Bonnard, the faithful friend, Derain, the revered master. Lastly there was Italy, the lessons of the Quattrocento in 1926 and Rome from 1962. In the midst of all, like a geographical and mental fulcrum, was Beatenberg, the spiritual Lotharingia to which he several times returned, in 1920; Geneva during the war; then finally Gruyère, the Pays d'Enhaut and the Grand Chalet at Rossinière.

On 24 July 1919, during his travels through Switzerland, Rilke arrived in Soglio, a remote mountain village in the Val Bregaglia, just across the frontier from Italy. The journey from Saint Moritz crosses the high plateau of the Silvaplana, along the shores of vast, still lakes, surrounded by glaciers and dazzling peaks, and over the Maloja pass. As one descends, awed by the stunning

7. Bruno Schulz, *Joseph Sitting at a Table: Self-portrait Wearing a Hat between Two Women*, before 1933, pencil on paper

perfection of the landscape, which seems to hesitate between the firs and larches of the north and the chestnuts and walnuts of the south, just as the architecture of the churches and palaces wavers between Italian baroque and German romanticism, one realizes that this was one of the essential places of Europe before the outbreak of the Great War and the collapse of those Empires whose ruling classes met at the Hôtel des Bergues.

A first meeting would surely be with Nietzsche, at Sils Maria, between the little house, now a museum dedicated to him, and the pinewood above the lake where he had his vision of Zarathustra. It is less well known, however, that ten years later the same locality provided the setting for a love affair of Marcel Proust, then aged twenty, who recorded his marveling recollections in one of the first and most attractive texts in *Les Plaisirs et les Jours*.[15] Continuing beyond the pass, one drops down into the Val Bregaglia, called the Bergelltal by the German-speaking Swiss. Thus, as in the name of Sils Maria, wrote the young Marcel, at the confines of two worlds, "the names are twice sweet, where the dreaming German sonorities die out amid the voluptuousness of the Italian syllables."[16] One then arrives in Stampa. To the left of the road, still just as it was, stands the thick-walled wooden chalet of the Giacomettis, the family of artists who grew up in the shadow of Hodler. The second of the three brothers, Alberto, was to become Balthus's closest friend in the fifties, when the latter was living in Chassy en Morvan. On the right there is the café which was run by the Varlin family, who gave Switzerland its best expressionist painter. Further down, one reaches the broad, desolate plateau where Giovanni Segantini painted the core of his output—the great triptych called the *Trittico della Natura* and the paintings in the cycle *Le cattive madri*—and where he died.

Soglio is reached by a little road that climbs steeply off to the right, often clinging dizzily to the mountainside. The village nestles high up on a terraced, south-facing site opposite the five rocky teeth of the Sciora peaks. The spot is an astonishing mix of gentleness and tragedy, tenderness and violence.

It was Rilke who introduced Soglio to the Klossowski family. Was it mere chance which led Jouve the same way in 1933, as reported in his autobiography? Or was it Rilke himself, in a correspondence which has remained unknown? What is certainly true is that a year later Jouve was staggered by the discovery of Balthus's painting when it was shown at the Galerie Pierre. Thence-

8. Bruno Schulz, *The Pensioner and the Boys*, illustration for *Le Sanatorium au croque-mort*, 1937, pencil on paper

forward he was to become, in company with Antonin Artaud, one of his most judicious and percipient critics. It was the beginning of a long, close friendship that was to last until they quarreled in the fifties. Jean Starobinski and Robert Kopp have unraveled the subtly binding ties that were woven between the works of poet and painter.[17] At the time of the exhibition at the Centre Pompidou in 1983, I myself established links which shed light on the figure of *La Victime* [The Victim], in both the work of Balthus and in the story of the same name by Jouve.

The poet was also for many years the owner of perhaps the most disturbing image ever painted by Balthus, *Alice*. The sitter for the picture was the wife of Pierre Leyris, Betty (one day a study will have to be written on how this cosmopolitan society was also a society of translators, guides across frontiers: Pierre Leyris, Pierre Klossowski, Jouve himself…). The picture of Alice could long be admired on the wall of the poet's room at 8, Rue de Tournon.[18] He dedicated an extraordinary piece to her. But all these things are beginning to become known, and we shall not go over them again.

What does remain a puzzle is Soglio, that hidden place, remote and inaccessible like the settings described in fairy tales, the remarkable location where, by turns, Rilke, Balthus and Jouve came to live and to draw on the core of their inspiration. From 1933 ontward, Jouve spent some of practically ever summer there. He made it the setting for one of the finest pieces of twentieth century French fiction, *Dans les années profondes*. His heroine, Hélène, is like a sensual emanation of the surrounding landscape in which she lives. A mannerist creature composed as much of the substance of the mountains, the forests and the light, as of flesh, down and mucus; Hélène is a mythical creature by her dual, mineral and organic nature, rock and hair, material and solar, close indeed to the tall female figures that Balthus was to paint in the forties, equally seductive in their own dual, angelic and diabolical nature.

Soglio is easily recognized as the model for the Sogno of Jouve's novel, just as the name Salis, common throughout the area, from the Casa Salis high up on the slopes to the Palazzo Salis down in the valley, became the fictional Sannis. In the meantime, however, Jouve had already confessed his fascination with the mother of Balthus and Pierre. The novel *Le Monde désert*, published in 1927, in other words "at the time of the death of Rainer Maria Rilke," to use his own words, and the year of his meeting with Balthus. Turning a page one suddenly comes across

9. Alfred Kubin, *Acrobatic Walz*, pen, ink and water color. Vienna, Graphische Sammlung Albertina

a female character called, like Balthus and Pierre Klossowski's mother, Baladine. "The whole person of Baladine is provoking. The way her big body moves makes it difficult to turn one's eyes from her. A female 'bird' would be a fairly accurate way of describing her. Long and shapely legs, a high instep, full hips and breasts linked by a supple waist […] a broad face, full of feline charm, gray eyes. Thin lips accentuated by deep red lipstick. As for her hair, provocative also, on the dark side, sensuous."[19] Looking at the surviving photographs of Baladine Klossowska, in particular the one of her with Rilke and the young Balthus, one may put the accuracy of Jouve's description to the test. The first part of the narrative takes place in the mountains of Bella Tola, rising to ten thousand feet, a vast pyramid commanding a view southtward over an extraordinary line-up of peaks, from the Matterhorn to the Monte Rosa, at the confluence of the French, German and Italian languages. The rest of the novel is set in the Valais, around Sierre, in other words not far from Muzot, the place where Rilke spent his last years, nor from the little cemetery at Rarogne where he lies buried.

[1] R.M. Rilke, *Die Aufzeichnungen des Malte Laurids Brigge*, in *Werke, Band III,1*, Insel Verlag, Frankfurt am Main 1966, translated by John Young.

[2] F.J. Sulloway, *Born to rebel. Birth Order, Family Dynamics and Creative Lives*, New York 1996 .

[3] D. Bassermann, edited by, *Rilke et Merline: Correspondance 1920–1926*, Max Niehans, Zürich 1954.

[4] [My sons were my school and my pleasure—and I was their playmate. When Rilke came to join us, we were all four of us like happy children]. Quoted by Dieter Bassermann, *op.cit.*, p. 38.

[5] Letter from Merline, 18 September 1920 .

[6] Letters of 16 and 20 October, 12–15, 27 and 30 November, 3 and 25 December 1920, 6 February 1921, etc.

[7] R.M. Rilke, *Lettres à un jeune peintre*, Archimbaud, Paris n.d.

[8] R.M. Rilke, *Die Konfirmanden*, from "Das Buch der Bilder, I. i," in *Werke, Band I, 1*, Insel Verlag, Wiesbaden 1966, translated by John Young.

[9] R.M. Rilke, *Vor dem Sommerregen*, from "Neue Gedichte (1907)," *ibidem*, translated by John Young.

[10] R.M. Rilke, *Kindheit*, from "Das Buch der Bilder," *ibidem*, translated by John Young.

[11] *Idem*.

[12] R.M.Rilke, *Die Aufzeichnungen des Malte Laurids Brigge*, cit., translated by John Young.

[13] Letter from Merline to Rilke, 2 September 1920: "Do you know me then, René? How was it? you ask me. It was I, I believe, who bent mad with love over your hand in kissing it. I have almost no memory any longer, I know that something has stepped out from within me…"

[14] J. Cassou, *Une Vie pour la liberté,* Laffont, Paris 1981, p. 83.

[15] M. Proust, "Présence réelle," in *Les Plaisirs et les Jours*, XXII, Paris 1896.

[16] *Idem,* p. 222.

[17] See the essay by Robert Kopp elsewhere in this catalog.

[18] See Robert Kopp, *op.cit.*

[19] P.J. Jouve, *Le Monde désert*, Mercure de France, Paris 1960, p. 40.

The Young Balthus

1. The young Balthus, ca. 1922

The story of Balthus's youth reads like a fairy tale: a fiercely precocious young boy (fig. 1) overcomes adversity—the upheavals of First World War, constant relocations, little schooling in a traditional sense, and a restless and unconventional childhood—to fulfill his great talent and becomes an artist. He was always conscious of his deep involvement with the world of childhood. In 1922, when only fourteen, he wrote to friends "God knows how happy I would be if I could remain a child forever."[1] In fact, the impressions, thoughts, and feelings from his own adolescence would always remain with him and would reappear throughout his lifetime of painting.

Balthus is a master at conveying the ambivalence that is part of adolescence. The children in his paintings are usually withdrawn, self-absorbed, and unsmiling. They while away their time in rooms closed to the outside world. Often they are pensive, sleeping or floating in daydreams. At times they assume poses of languid abandonment and at others the gangling postures so characteristic of the ambiguities of puberty. The rare presence of adults emphasizes the remoteness of the adolescents.

In his finest series of adolescent girls, the paintings of his young Parisian neighbor Thérèse Blanchard dating from 1936 to 1939, Balthus displayed intuitive understanding of the girl's psyche. Yet his complicity with the young sitter is mingled with erotic desire. So while his recognition of the model's defiance makes him a perceptive chronicler of her moodiness, his erotic desire for her adds tension to these works, which contributes to their unique character.

Balthus (Balthasar Klossowski) was born on February 29, 1908 in Paris. His father, Erich Klossowski (1875–1949; fig. 2), an erudite and cultured man, who held a doctorate in the fine arts, was a painter and art historian. His study on Honoré Daumier, published in 1907, is still valued today. His mother, Elisabeth Dorothea (née Spiro: 1886–1969; fig. 3), was a painter, later exhibiting her works under the name of Baladine. In 1903, the couple had left Breslau in Silesia, then part of Southeast Prussia, for Paris where they planned to be married.[2]

Like many Eastern Europeans, Balthus's forebears had been dislocated by the political and economic turmoil of the nineteenth century. Balthus's paternal grandfather, Leonard Klossowski, was a lawyer in Ragnit, East Prussia.[3] In 1830, the year of Poland's ill-fated War of Independence against Russian rule, the Klossowskis, an old Polish family entitled to the Rola coat of arms, left Warsaw. They took refuge in Southeast Prussia, where they joined the ranks of untitled Prussian nobility.[4] Balthus's maternal grandfather, Abraham Bear Spiro (fig. 4), was a cantor in Breslau, in Southeast Prussia.[5] In 1873 Abraham Bear Spiro and his family had moved from their native Kövelitz in Novgorod near Minsk to Breslau, where they acquired German citizenship.[6] Spiro was musical and composed a great deal of music for his services at the Old Storch Synagogue in Breslau. Two of his thirteen children became opera singers. Another son was the painter Eugen Spiro (1874–1972; fig. 5), the best friend and later brother-in-law of Erich Klossowski.

In Paris Balthus and his older brother Pierre (b. 1905), grew up in an artistic and intellectual family that lived in the Rue Boissonade in the 14th Arrondissement (fig. 6).[7] While his mother copied the works of Poussin in the Louvre, his father divided his time between painting and writing. The German art historian Julius Meier-Graefe (1867–1935) described his friend Klossowski: "Some time after 1900 he [Klossowski] arrived in Paris from Breslau. He conveyed greetings from Richard Muther, his Professor. 'So you are an art historian?' I asked him. 'Oh no, that was long ago'—perhaps he was just twenty-four-years-old. Questions about his profession made him uncomfortable. He moved quite a bit between Montmartre and Montparnasse, apparently always by himself. Light burned in his place until the morning hours. I discovered by chance his nighttime activities: he painted. His canvases of veiled daubs of color emitted a strange warmth. He complained 'At night the colors look one way, but the next morning they again look completely different.' I advised him to paint during the day, but he shrugged and thought it not worth his while since he was not doing it seriously anyway. He had already painted in Breslau while writing his doctoral dissertation. He spent his days in the Louvre studying Delacroix. We had long talks [...] he had never been seriously trained as a painter, never studied after the nude. I advised him to hire models. He had thought of it, but lacked the means and his studio was too small

2. Eugen Spiro, *Erich Klossowski*, ca. 1900, oil on canvas

3. Eugen Spiro, *Baladine Klossowska*, 1901, oil on canvas

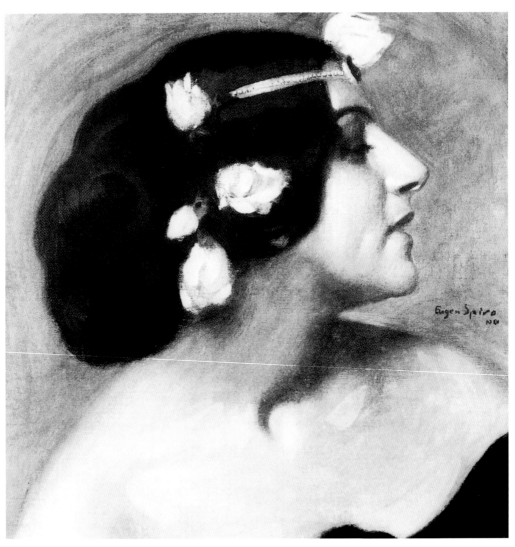

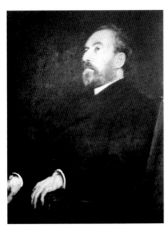

4. Anonymous, *Abraham Bear Spiro*, ca. 1890, oil on canvas

for these strangers anyway. He worked in spurts. For weeks he didn't touch a brush but only read from morning till night, he was a voracious reader, devoured the posthumous writings by Stendhal and Flaubert […] then one couldn't get him out of his studio, wouldn't even respond to knocks on the door, he was painting obsessively."[8]

A self-taught painter, Klossowski idolized Hans von Marées and Eugene Delacroix. In the German artists' encyclopedia Thieme-Becker Klossowski's figurative paintings of mythological and biblical subjects are described as "art-historical art."[9] Meier-Graefe praised his friend Klossowski for being the only German painter in the circle of Pierre Bonnard.[10] He also belonged to the group of German writers and artists who, like himself, had left Breslau. Among those who met at Le Dôme, the café in Montparnasse, were his friend Meier-Graefe, the German writer and art historian Wilhelm Uhde (1874–1947), and his brother-in-law Eugen Spiro. Uhde had been a friend in Breslau, where both studied with Richard Muther (1860–1909), the brilliant professor of art history and editor of *Die Kunst*, an important series of monographs on art to which Klossowski, Uhde, Meier-Graefe, and Rainer Maria Rilke had all contributed. Klossowski and Meier-Graefe wrote the catalogue raisonné (published in Munich in 1908) of the Cheramy Collection;[11] in 1922 they published *Orlando und Angelica*, a puppet play written by Meier-Graefe with illustrations by Klossowski which were inspired by the marionettes of Naples.[12]

The Parisian idyll was destroyed by First World War. When hostilities broke out, the Klossowskis, as German citizens, had to abandon Paris. They went to Berlin where Spiro had lived in 1904–06 when he was married to the actress Tilla Durieux.[13] A member of the Berlin Secession since 1909, Spiro soon became a prominent member of the Berlin art world, paint-

5. Eugen Spiro with Balthus, ca. 1909

6. Baladine Klossowska, Julius Meier-Graefe, Balthus (left foreground), and Pierre congratulating Erich Klossowski on his birthday. In the background is one of Klossowski's paintings, Paris, ca. 1911

ing portraits of the city's leading cultural personalities. The Klossowskis' move to Berlin initiated a ten-year period of privation, financial dependence on family and friends, and constant relocation. Meier-Graefe reports: "Klossowski fled to Berlin and was at his wits' end. He had supported his small family even before that time with great difficulty. From today's perspective it had been possible, because upkeep then was a song. However, it became embarrassing. Suddenly there was no room because strange models posed making a lot of noise and causing a sense of claustrophobia… Adieu Leda, adieu Daphnis, adieu Amazon. The end of an epoch. One would have to be a fool, under these circumstances to continue painting… What now? In cafes he met theater directors who sensed his talent for stage decoration. One entrusted him with several plays. The colors he had to keep at bay he now applied to the costumes and the sets. Huge success, applause at the opening of the curtain for the sets."[14]

During the war and postwar years, from 1916 until 1919, Klossowski became a successful stage and costume designer for Berlin's Lessing Theater and the Deutsches Künstler Theater, whose director, Victor Barnowski (1875–1952), was also from Breslau. In 1934, nearly twenty years later, Balthus would create his first stage designs for that same Barnowski, when the latter directed Shakespeare's *As You Like It* (Comme il vous plaira) at the Théâtre des Champs-Elysées in Paris.

Beginning in early 1917, Erich and Baladine Klossowski led separate lives in different cities. Baladine Klossowska moved with her two sons from Berlin first to Bern and then in November to Geneva.[15] Balthus and Pierre attended the Collège Calvin in Geneva from 1919 until 1921.[16] While they lived in Geneva from 1917 until 1921, their relatively stable life was captured in the forty ink drawings that illustrate *Mitsou*, the book in which the eleven-year-old Balthus evokes his adventures with a stray tomcat.[17] Balthus told his story in images that are remarkable for their draftsmanship; their innate sense of perspective, form and drama make captions superfluous. Albeit as austere as woodcuts, the images reveal a fine eye for detail. These works are reminiscent of those of Frans Masereel (1889–1972), a Belgian illustrator and engraver who lived in Geneva from 1916 to 1921. Baladine knew Masereel, and Balthus may have seen his woodcut illustrations for Pierre Jean Jouve's *Hôtel-Dieu*, a small book published in 1919. Balthus took some liberties with his surroundings; his illustrations give the impression that he lived as an only child with both parents in a large country house complete with servants and garden. In fact, he lived with his mother and brother Pierre in a furnished, two-room apartment at 11 Rue Pré-Jerôme in a modest neighborhood of Geneva.

In the autumn of 1920, during a visit to Baladine Klossowska, the German poet Rainer Maria Rilke (1875–1926) had been so enchanted by these drawings that he contributed a foreword in French and was instrumental in having them published by Rotapfel-Verlag, a Swiss-German firm, in 1921. At the request of Erich Klossowski, the cover of the little book *Mitsou* gave the artist's name as "Baltusz," as his son then spelled his nickname; thereafter, at Rilke's suggestion, he signed his work with this childhood name.[18] A critic later commented that "out of the childlike innocence of his picture book beckons something that is imponderable and strangely moving."[19] In a letter to Rilke in 1922, the publisher Kurt Wolff wrote that "the ability of the little boy to translate his feelings into graphic expression is astounding and almost frightening."[20]

Rilke had briefly met the Klossowskis twice in Paris before the war.[21] Then, in the summer of 1919, he spent some weeks in Switzerland where he visited Baladine Klossowska. A subsequent visit in August 1920 confirmed the friendship and love between the poet and Baladine Klossowska (their correspondence lasted until the poet's death in 1926; fig. 7). The sensuous and robust Baladine represented something of a departure for Rilke, who had been attracted to more ethereal women. Looking many years younger than her actual age, Baladine has been described as an extremely attractive woman.[22] This is how the French writer Pierre Jean Jouve, who met her in 1924 in Paris, described her in his novel *Le Monde désert* (1927).

"The whole person of Baladine is provoking. The way her big body moves makes it difficult to turn one's eyes from her. A female 'bird' would be a fairly accurate way of describing her. Long and shapely legs, a high instep, full hips and breasts linked by a supple waist […] a broad face, full of feline charm, gray eyes. Thin lips accentuated by deep red lipstick. As

7. Baladine Klossowska gave this photograph of herself to Rilke as a token of her friendship, Paris, ca. 1906

8. Baladine Klossowska with her older sisters Gina (upper left), Jenny, and nephew Fritz, Breslau, ca. 1901

9. Margrit Bay in her studio, 1930's

for her hair, provocative also, on the dark side, sensuous."[23] Her correspondence with Rilke reveals an ardent and passionate woman, capable of grand emotions. She hardly knew Rilke's work when they met, having not read his celebrated *The Notebooks of Malte Laurid Brigge* (1912). She worshipped more the man than the poet, writing to him: "I lie in my narrow bed, trembling with sweet longing for your young body, the beautiful one, I want to hold it, and look at it, and make love to it, for ever. I want to seek refuge in it, and sleep in it tenderly. Why should I not lead a double life, a different one… Do you reproach me for being so unconventional?"[24] Baladine wanted to leave her two sons in the care of her sister Gina Trebicky (née Spiro; fig. 8) in Berlin in order to live with Rilke.[25] But the poet thwarted this plan, out of his need for solitude, as well as out of concern for the two young boys, of whom he was very fond.[26] Baladine Klossowska transformed her Geneva apartment into a Rilkean shrine with an altar which was "always decorated."[27] She spent her days writing to the poet and reading his letters, daydreaming and sleeping. She refers to herself and her sons as "we three children,"[28] calling herself their "playmate."[29] Depending on her mood, Baladine seems to have been a flirtatious and seductive playmate or a preoccupied and distant mother. She led an erratic and unstructured life, always prey to her impulses and emotions. Her self-indulgence could also frighten her children, as revealed in the telling episode she recounts to Rilke: "I must tell you last night's touching story. When I go to bed I take morphine, because nights can be very painful, to say nothing of my nerves! Balthus, who runs after the girls, had not come home yet. At last he appears and, half asleep from the effect of the morphine, I tell him not to disturb me (for the last two nights he had been sleeping in my room). Frightened, Balthus was all in tears. 'Lottchen, oh Lottchen, why have you done such a thing—Oh Lottchen, why have you taken poison?' And he went on and on like that, poor dear. He switched on the light, looked for the bottle and found it empty. I thought he'd have a fit, and I had a great difficulty calming him down."[30] In its complete removal from ordinary conventions, Baladine's apartment seems to have anticipated that described by Jean Cocteau at the opening of his novel *Les Enfants terribles* (1929). The siblings Paul and Elisabeth, locked in a physically pure but mentally incestuous relationship, live in mental and physical disarray in a cluttered room in which most of the story unfolds. Their dream-like existence eerily echoes Baladine's unusual family life. We know that mood well, for Balthus recreated it many times in his later paintings of children in closed rooms.

By the end of 1922, Rilke's passion for Baladine Klossowska would cool. In letters to his friend Nanny Wunderly-Volkart, he sharply criticized Baladine's mental instability, her craze for amusement, her insensibility, and her naïve and stubborn behavior.[31] Rilke, however, continued to shape the lives of Baladine's two sons. As surrogate father and admired friend, Rilke encouraged Balthus's "unique talent," and recognized in the young boy a "great artist" and a few years later considered him "a genius."[32] His birthday letters to Balthus reveal confidence in, and admiration for the young boy. Balthus responded in kind by sending his works to Rilke, sometimes as gifts, sometimes to seek the poet's approval. In the fall of 1920, Balthus sent him his twelve illustrations for a Chinese novel. The poet replied: "My dear Balthus, one has nothing to fear, even if you are still so young, your artistic instincts seem profound enough to carry within them an unconscious judgement which told you, long before I do so, that these drawings, which you created spontaneously from your memories of this novel, have all the advantages of very happy inspiration."[33]

Rilke was a guardian angel to Baladine's little family, which, prey to the post-war disorders in Germany, often hovered on the brink of poverty. In the spring of 1921, financial difficulties obliged Baladine to leave Geneva. In April 1921 she moved with her sons to Berlin, where they remained, except for the summer months, until July 1923. First they lived in the apartment of her brother Eugen Spiro, who was away in Italy, and later with her sister Gina Trebicky and the latter's husband, in a cramped tiny apartment in Berlin Halensee. Baladine Klossowska wrote to Rilke that "it is all somewhat as in a nightmare or in a dream,"[34] and that her surroundings are "that black room in which I live."[35] She compared the court-yard outside her balcony to a "prison-yard."[36]

In letters to friends Rilke described their situation as "Russian pathos," because nothing could shield them from the nightmare of Berlin, a city troubled by political unrest, soar-

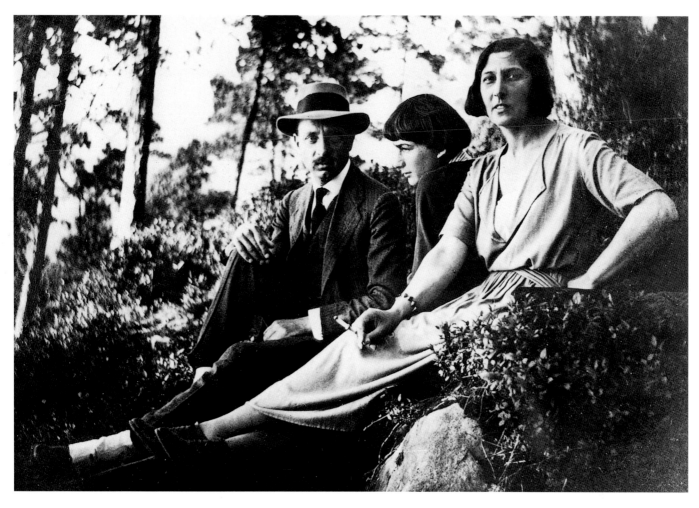

10. Baladine Klossowska,
Balthus, and Rainer Maria Rilke
in Beatenberg, summer 1922

ing inflation, labor strikes, and shortages of electricity, gas, and water. Rilke wrote to his friend Gudi Nölke: "Now Berlin is no place for children—if only they had a shaped and conventionally ordered existence—but Madame K(lossowska) is still too much of a child herself and is damaged by the present Berlin, which is so strange and repulsive... it is painful to watch these delightful and highly talented children live haphazardly, amid the alternate void and excesses of a disarrayed life."[37]

And to Countess Sizzo: "Now in these untamable surroundings (Berlin) there exist innumerable difficulties which prevent these French-educated children from having a sound future... Luckily, the language of little Balthazar (Balthusz) is drawing, which is international—but his letter from before Christmas simply reveals sorrow, sorrow and need, and already a part-childish and part-mature concern for the future."[38]

And to Nanny Wunderly-Volkart: "Klossowski, worn out by so many disappointments, only smokes and coughs—and Mouky's (Baladine's) pretty apartment looks beyond recognition, an encampment without any order, peace or organization. Without this blessed help of Georg (Winterthur)—which represents an enormous sum in Marks—there would be never ending misery."[39]

Rilke wrote to Balthus: "My God, if only the three of you would find yourselves again in circumstances that would enable you to do what you are capable of doing; if only one could give you some space, if one could liberate you from all this futile depression."[40]

The summer months of these years found Balthus in Beatenberg, a small quaint village above the Lake of Thun in Switzerland. Baladine and her two sons had discovered the scenic spot sometime around 1916.[41] From about 1922 on Balthus worked there as resident pupil and assistant to Margrit Bay (1888–1939), a sculptor (fig. 9) who formed part of a small and eccentric arts-and-craft group of anthroposophical orientation.[42] Bay had once belonged to the artistic and bohemian life of Munich. In Beatenberg she lived with her friend Dora Timm

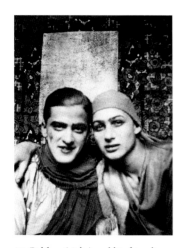

11. Balthus (right) and his friend
Jenö Salgo, in Beatenberg, ca. 1923

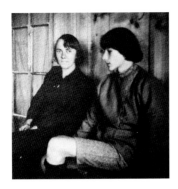

12. Dora Timm and Balthus in Beatenberg

13. Muzot, near Sierre (Valais)

14. Margrit Bay's anthroposophic sanctuary with altar piece and ceiling decoration by Balthus, Beatenberg, 1923–24

(1893–1982), a draftsman and wood engraver in an abandoned schoolhouse. Bay's father Hermann Bay had been the pastor of Beatenberg's Protestant church. With her brother Paul Bay, an architect, she had worked on the wood decorations of Rudolf Steiner's first Goetheanum (1913–20), a study center for the humanities built in a new kind of architecture in Dornach, Switzerland, which was later destroyed by fire.

Margrit Bay advised, supported, and encouraged Balthus for many years. He joined in the group's artistic activities and in their performances of German medieval plays (fig. 11). He converted Chinese plays into German ones and designed and sewed the costumes. His interest in Chinese art led him also to decorate a large cupboard with vignettes evoking Chinese ink paintings. As Dora Timm (fig. 12) remembered: "One summer day a boy fourteen or fifteen years old came into our studio, Balthus Klossowski, the son of a friend of Margrit's, the painter Baladine Klossowska, who was the friend of Rilke. Balthusz was a very intelligent little boy. He had just arrived from Berlin and it was simply amazing how precocious he was; he knew just about everything in literature and the visual arts. Margrit adopted him like her own son. He painted, drew, carved in wood, and showed great talent. He was a good friend. After our work was done, we devoted time to pleasure. On rainy days we produced plays. We mounted a play about St. George and one about Paradise. Our schoolroom then became stage and auditorium, friends and locals were a grateful audience. Margrit was a fine director and she also loved to act. We even tackled a play out-of-doors, but it was a money loser."[43]

Hikes into the nearby mountains would be remembered in 1937 in Balthus's *La Montagne* [The Mountain].[44] Rilke visited Balthus at Beatenberg in 1922, accompanied by Baladine (fig. 10). Rilke described this visit: "And everything in its surrounding somewhat old-fashioned, like the watering places and forests of my childhood; so that I have now the impression, after fourteen indescribable days, of having been confronted like a child in the richest and most particular ways. The child of so long ago, or rather, the one I should have become wanted to be, had I not too obtrusively been prevented from it… We have recuperated steadily under these influences, among which the presence and charm of little Baltusz must be counted."[45] In Beatenberg Balthus enchanted Rilke with his painted Chinese lanterns, and his knowledge of Chinese imperial and artistic dynasties. Together they read Okakura's *Book of Tea*. Later that summer, Balthus visited Rilke's home, Muzot, the medieval tower of a thirteenth-century castle, near Sierre in Switzerland (fig. 13). After Baladine Klossowska helped restore and decorate Muzot in 1921, Rilke invited her to spend the summer months there. While Rilke was away in the early autumn of 1922, Baladine and Balthus spent many hours painting and talking about art.

In the gentle landscape around Muzot, Rilke experienced a surge of creativity. The postcard Baladine had left behind at Muzot, with the reproduction of a drawing of *Orpheus Playing the Lira da Braccio* by the Venetian artist Cima da Conegliano (1459/60–1517/18), inspired Rilke in 1922 to compose the group of poems of *The Sonnets to Orpheus*. In 1912 at the castle of Duino, Rilke had already begun the cycle of poems that, once completed, would become the famous *Duino Elegies*. In Muzot, he also composed six more *Duino Elegies*, a series published in 1923. Written in a staccato style and approaching the indescribable, they are regarded as Rilke's masterpiece.

In the late autumn of 1922, shortly before his return to Berlin, the fourteen-year-old Balthus wrote from Beatenberg to Professor Jean Strohl (1886–1942), a zoologist and friend of Erich Klossowski: "I am now less afraid to return to Berlin since papa is now there. Perhaps I can visit the School of Fine Arts […] I would like to paint and to sculpt. I have sculpted here little figures in wood, then dressed them with costumes, because to be admitted to the school 'one must show what one is capable of doing.'"[46] Balthus's hope of winning admission to the State Academy of the Museum of Applied Arts in Berlin was never realized. Free from an academic routine, he immersed himself in pursuits at which he excelled. In the previous winter of 1921–22, he had designed maquettes for a Chinese play, which he offered without success to the Munich Staatstheater in January 1923.[47] Balthus spent the winter of 1922–23 mainly in the studio of his uncle Eugen Spiro in Küstriner Strasse in Berlin. He continued making figures, creating for his five-year-old cousin Peter Spiro a large Samurai with fierce black eyes in a face of wax, a figure he kept until his death. The Klossowskis

15. Margrit Bay, *Figurine of Balthus*, ca. 1917, plaster. Formerly Dora Timm collection, Minusio/Locarno

16. Erich Klossowski, *Still Life with Fruit*, ca. 1930, oil on canvas

17. Baladine Klossowska, *Balthus*, ca. 1924, oil on canvas. Private collection

found each other again in Berlin where they remained from November 1922 until July 1923. The little that is known of their last winter in Berlin comes from Rilke's letters to his friends cited above. Rilke tirelessly tried to alleviate their misery. In December 1922 he suggested, unsuccessfully as it turned out, to Baladine: "Could you not possibly write to the Bonnards—without telling Klo(ssowski)—and ask them if they might invite him down south to the Mediterranean? They might also enjoy it; if you could explain his worn-down physical condition and the sad, hopeless state of mind into which he has sunk, it might induce them to invite him, without even too much insistence on your part. The change of climate alone would already help him, I am convinced."[48] Baladine destroyed the letters she wrote to Rilke between December 1922 and May 1923 from Berlin, after they had been returned to her after his death. Whatever her letters may have revealed about her desperate life in the strike- and inflation-torn Berlin, she did not want it exposed in her published correspondence with the poet. Ironically, Baladine found her first recognition as a painter in Berlin. In February 1922, the Galerie Flechtheim included her works in an exhibition of women artists. One year later, the Kleine Galerie in Berlin mounted an exhibition of her oils, watercolors and drawings and gave her a two-year contract.[49] At that time she took Baladine as her artist's name, at the suggestion of Meier-Graefe.

After spending the summer of 1923 in Beatenberg, Baladine and Balthus remained there for the entire winter of 1923–24. Balthus stayed with Margrit Bay and Dora Timm in the schoolhouse. Baladine rented a room in a nearby chalet and complained to Rilke bitterly over the lack of heat, food and running water.[50] That winter Balthus painted his first large pictures: an altarpiece and ceiling decorations for a small room which served as Margrit Bay's anthroposophical sanctuary (fig. 14). This was an extraordinary undertaking for a fifteen-year-old boy. This room had an altar, various figures, some carved in wood, and a small plaster figurine by Bay of a very young Balthus in lotus position (fig. 15). (This sanctuary no longer exists: today a different local family lives in the schoolhouse). A faded photograph shows Balthus's worldly interpretation of a religious motif in a style reminiscent of the Swiss painter Ferdinand Hodler. Surrounded by a bare and rocky landscape, Mary holds her child, flanked by two athletic saints in white socks. Balthus also painted on the ceiling vignettes of houses and trees. Shortly after her arrival in Beatenberg late in December, Baladine described these works to Rilke enraptured: "He is a great artist. I was overwhelmed when he showed me his painting and the ceiling! I told myself, when I saw the four apostles this morning that I had in front of me someone who is chosen, a prodigy."[51] Baladine must have been referring to another project; during that winter Balthus also made cartoon sketches of four apostles for a church in the neighboring village of Dörstetten, which was never realized.

The Klossowskis' odyssey, which had lasted some ten years, was about to end. Erich Klossowski, after restlessly moving between Berlin, Zurich, Munich, and Diessen, on Lake Ammersee in Bavaria, finally setted in Sanary-sur-Mer, in the south of France, in 1927. He remained until his death in 1949 in Sanary, where he lived on and off with Hilde Stieler, a German journalist. He had met Stieler in April 1922, when she had made her debut in a play for which Klossowski had designed the decors at the Kammerspiele in Munich. During these last two decades of his life, Klossowski painted after nature, in a style characterized by well defined forms and bright colors (fig. 16). Meier-Graefe, who lived in nearby St. Syr-sur-Mer since 1930, continued to support his friend Klossowski until the writer's death in 1935.[52]

Balthus's older brother Pierre had returned to Paris in November 1923, having been invited there by André Gide, at Rilke's instigation. While Balthus and his brother Pierre were living in Berlin between 1921 and 1923, Rilke's alarm over their lack of schooling had grown. Prompted by Rilke, Erich Klossowski visited Paris in the spring of 1922 to arrange Pierre's admission to the Ecole Dramatique of the Théâtre du Vieux-Colombier. Rilke asked Gide, who was a friend of Jacques Copeau's, the theater's director, to assist Klossowski. Gide and Klossowski liked each other, and Gide promised his help. This plan was not realized, however, because Pierre could not get a visa.[53] In the meantime, Rilke had enlisted the support of Georg Winterthur, a cousin of his friend Nanny Wunderly-Volkart. Winterthur would contribute 250 Swiss francs each month for Pierre's tuition, starting in October 1922. As Pierre attended school only one year later in 1923, this sum of money helped the entire Klos-

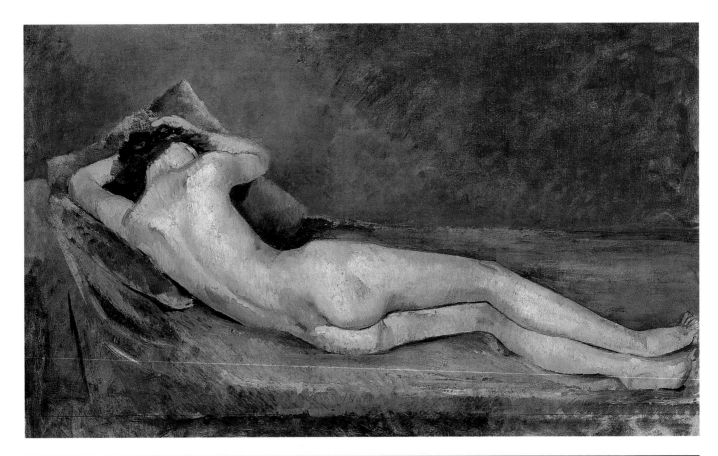

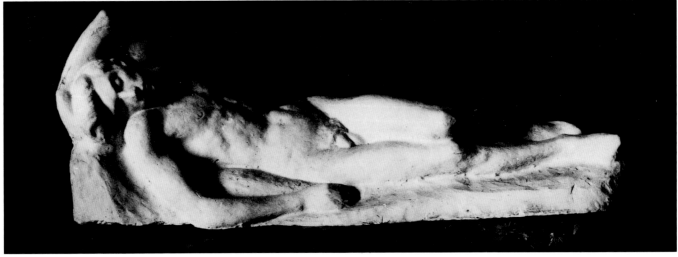

18. Balthus, *Nu allongé*
[Reclining Nude], ca. 1925–26,
oil on canvas.
Private collection

19. Margrit Bay, *Sleeping Adolescent*,
1923–24, plaster.
Formerly Dora Timm collection,
Minusio/Locarno

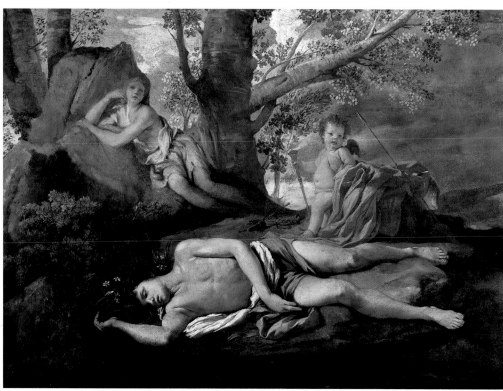

20. Balthus, *Nu debout*
[Reclining Nude], ca. 1925–26,
oil on wallpaper mounted
on cardboard.
Private collection

21. Nicolas Poussin,
Echo and Narcissus, ca. 1627,
oil on canvas.
Paris, Musée du Louvre

sowski family to survive their difficult winter of 1922–23 in Berlin. In November 1923, after a lengthy process of obtaining the necessary documents, Pierre Klossowski came to Paris and became Gide's secretary. He stayed first at Gide's Villa Montmorency, then at his country house in Cuverville, then at the apartment of a friend of Gide's across the Luxembourg Gardens, and with Yves Allégret, later a film director, who had become a friend.[54] Pierre did not attend the Vieux-Colombier but Lycée Janson de Sailly, where he met Pierre Leyris (who later became a friend of Balthus's).

Eager to join Pierre, Balthus wrote such a persuasive letter to Gide that the writer invited him as well,[55] and on March 7, 1924, Balthus returned to Paris for good. Baladine Klossowska followed, joining her sons on May 20, 1924. The three of them lived in various furnished apartments, until in March 1926, they moved into a studio in the Rue Malebranche, near the Panthéon. Baladine Klossowska had finally resumed a version of her former life in Paris before World War I. However, as in Geneva and in Berlin, Baladine and her two sons lived in an unconventional manner. The wife of Pierre Leyris, Betty, remembered: "Pierre was usually dressed in his bathrobe and scribbled while Baladine drew pictures of dead flowers."[56] Yves Allégret remembered: "Balthus told me at the time that he lived with his brother and his sister."[57] At that time she painted pictures of a pensive Balthus (fig. 17) and a reclining reading Pierre. In her studio Baladine Klossowska received poets and writers, such as Rilke, Pierre Jean Jouve and his wife Dr. Blanche Reverchon, the members of the Grand Jeu (Daumal, Gilbers-Lecomte, Miner), Klaus Mann, Wilhelm Uhde, Meier-Graefe, Jean Cassou, Adrienne Monnier and Sylvia Beach, Betty and Pierre Leyris, Friedrich Sieburg, among others. Sieburg, a writer and correspondant for the *Frankfurter Allgemeine Zeitung*, became a close friend. Jean Cocteau was a friend of Pierre Klossowski at the time. After visiting Baladine one day he was so enchanted by her that he briefly considered writing a play with the title *Les Mères folles*.[58] That was three years before the publication of his book *Les Enfants terribles* (1929).

The sixteen-year-old Balthus was absorbed by film and theater. Soon after his arrival he joined the team constructing the set for *Les Soirées de Paris*, a series of avant-garde programs produced by Count Étienne de Beaumont at the Théâtre de la Cigale in May and

22. Balthus, *Première communiante*
[First Communicant], 1925,
oil on canvas.
Private collection

June 1924. Pablo Picasso, André Derain, and Georges Braque had been commissioned to design sets and costumes for the various plays and ballets, the latter choreographed by Léonide Massine.[59] Yves Allégret, and his brother Marc, a close friend of Gide's, were among Balthus's fellow workers.

For his training as a painter, Balthus continued along the path of self-education, avoiding art schools or painting lessons. Instead, just as his father before him, he went every day to the Louvre and studied the old masters, a process he would continue in Italy in 1926. In 1924, however, Balthus frequently visited the informal sketching classes at the Grande Chaumière where in the evenings Pierre Bonnard and Maurice Vlaminck offered advice to any who sought it.[60] The twenty-minute long sketching classes, with live models, were open to anyone who bought an admission ticket. Balthus met there the English painter Tony Gross (b. 1909), and they became friends. Balthus told Gross that his aunt sold the admission tickets for these classes.

Bonnard had seen Balthus's work during a visit to Baladine Klossowska, and in October 1924 he, Maurice Denis, and Albert Marquet met with the young painter to look at a group of his recent pictures at the Galerie Druet.[61] The three older painters immediately recognizing the "fine artist in Balthus."[62] They suggested that he copy the works of Poussin, which he did in the autumn of 1925, setting his easel before *Echo and Narcissus*, ca. 1627 (fig. 21). He dedicated this painting, which is now lost, to Rilke, inscribing it "A René" on a rock; this was a response to Rilke's *Narcisse* (1925), a poem in French dedicated to the young Balthus.[63] The fey and handsomely elusive young Balthus clearly evoked in those who were most receptive to him the figure of Narcissus. Balthus's other mentor, the sculptress Margrit Bay, also must have had the figure of Narcissus in mind when she executed her sculpture of the *Sleeping Adolescent* (fig. 19) around 1923–24, for which Balthus posed. These works initiated the theme of narcissism whose symbols would be so prevalent in Balthus's œuvre. At the beginning of 1925, Rilke left Muzot for Paris where he remained from January until August. Among the circle of friends and admirers he saw during these months were the Comtesse Anna de Noailles, Paul Valéry, Paul Claudel, André Gide, Edmond Jaloux, Jouve, and the Princess Bassiono. He also made arrangements for Pierre and Balthus to have a "quiet year of work and study" in Paris starting in March 1925, by obtaining funds for that purpose from the wealthy Austrian industrialist Richard Weininger whom Rilke had met in Vienna in 1916. In January 1926, Rilke proudly reported: "I have the best news of our two protégés, the young K's. They really make progress (it would have been impossible without the help of W). The older passed again two exams with outstanding marks, while the little Balthus, by now quite grown-up, is what he was right from the beginning, a real artist of talent, perhaps of genius. It is really my good fortune that, during these years, and with the help of W., I could guide and support the lives of these two boys."[64] Two months later he wrote: "Rarely has money been better invested in life and in the future than the amount that W. donated for the purposes I suggested; the young K's have met in the meantime several of my Parisian friends with whom I did not want to bring them into contact last year because they appeared too young and their paths still too undecided. In the meantime, their young lives have accomplished more and more."[65]

Few of the works that Balthus painted during 1925 survive. *Reclining Nude* (fig. 18) and *Standing Nude* (fig. 20), both of ca. 1925, first present the theme of the adolescent nude that would be so prevalent in his late œuvre. Balthus shows the gracefully ethereal bodies chastely from the back. Yet these early works evince already the subtle ambiguity that remained so characteristic of Balthus. *Paysage provençal* [Provençal Landscape] depicts the region around Entrevaux-sur-Var, a medieval village in the south of France. Balthus had visited this spot during a bicycle tour through Provence in the summer of 1925 and was enchanted on finding the medieval village "occupied" by a movie crew in colorful Slavic costumes, shouting, yelling, and sitting in the only two cafés.[66] He also painted three pictures of little girls in their white communion dresses (fig. 22), a motif used by other artists including Chaim Soutine and Baladine Klossowska. These costumes made ordinary Parisian girls look like angels (one of Balthus's subject was the daugher of the neighborhood baker).[67] This mingling of reality with the otherworldly may have evoked for Balthus the angels of Piero della Francesca for which healthy, local peasant girls had posed.

23. Interior of Beatenberg Protestant church with Balthus's tempera wall paintings, 1927 (destroyed 1934)

Balthus had admired Piero's work since childhood. His father had a deep attachment to Piero whom he described as the Cézanne of his time.[68] Balthus realized his dream of visiting Arezzo, staying there from about July 20 until August 13, 1926. In Arezzo he studied *The Legend of the True Cross*, ca. 1453–54, Piero's fresco cycle in the church of San Francesco. *The Legend of the True Cross* forms part of the *Golden Legend* that was compiled in the thirteenth-century by Jacopo da Voragine (ca. 1230–1298). Piero chose sixteen episodes from this vast body of legendary events. The ten main episodes are distributed in six large compositions on the main walls. In his letters to Professor Strohl, who had sponsored his journey, Balthus speaks only of these ten episodes and it seems likely that Balthus's own six copies that he mentions in his letters are of these six compositions on the main walls. His letters to Professor Strohl and his wife reveal the young artist's extraordinary sophistication. After having been in Arezzo for about two weeks, Balthus wrote on August 2, 1926: "The wish to come here and to see Piero della Francesca has haunted me for the last five years. It is dangerous, however, to imagine something that exists far away: without knowing if one will ever see it. And is one not punished then for wanting to prepare one's own happiness? That is what I feared in coming to Arezzo. I had Arezzo erected already in my mind (and took walks there sometimes). When somebody mentioned its name I shuddered, as upon hearing the name of a beloved woman. But now, oh wonder, I have found what I have imagined and in what an adorable landscape. A little city on a hill, surrounded by walls, and there is the countryside. Such a well arranged countryside, just like a garden, with olive groves, vineyards like garlands and hills striped with fields… And some cypress trees, yes, just like toys, but I rather like this… dear Madame." And then he describes Piero's frescoes: "But how can I describe the 10 frescoes by Piero della Francesca? These frescoes are the most beautiful I have ever seen. So as to keep a memory of their colors, I have started making a few small copies of them. I'll send you a few if they are any good. While copying them, I admire them more every day. As they are the result of much thought, they are extremely well balanced, and the outcome of all this mathematical precision is beautiful painting expressed in clear, transparent colors, blended into unprecedented harmonies. It is great and pure; timeless. Its mystery makes one think of the 'Lady and the Unicorn,' and also of Valéry because it is mathematical, abstract, gracious and divine. However, all adjectives sound hollow. To describe these frescoes I can only paint them."[69]

Balthus worked in Arezzo on cardboard "to render better the effects of fresco painting." Of the six copies he mentioned, only four have survived.[70] However, even these four may not be his original copies, because he later made copies of the original copies. His copy of the two-episode composition known as *The Invention and Recognition of the True Cross* from *The Legend of the True Cross* is on cardboard and thus may be one of the original copies. Balthus's copy discloses an overriding interest in formal order, the quality he singled out in his praise of Piero to Strohl. Balthus also studied and copied Piero's *Resurrection* in Borgo Sansepolcro and he visited Assisi. Around August 13, 1926, he returned to Florence where he remained until mid-September. He had already visited Florence on his way to Arezzo in mid-July, reporting: "Yesterday I visited the monastery of San Marco and saw the frescoes by Fra Angelico, they are so pure and simple with the colors of flowers and butterflies. Especially one (fresco) had struck my attention: Christ spat upon by soldiers. He sits erect with bandaged eyes, like an idol, frightful. The saint and monk on either side in the foreground give the impression of seeing this scene again in their memory with an expression of remembrance on their faces that is indescribable… I stay at a friend's house, he is a young Swiss painter who has invited me; from the balcony overlooking the beautiful Piazza Santa Croce I watch for a long time at night the children play."[71]

During his second visit to Florence, from mid-August to mid-September 1926, Balthus copied the frescoes by Masolino and Masaccio in the Brancacci Chapel of Santa Maria del Carmine. Again he was captivated by the playing children: "And at night on the Piazza Santa Croce, trying to be as discreet as possible, I sketch the children, but it attracts their attention and I am quickly surrounded; then I'm enormously amused by little girls jumping over a rope. Moreover, they have a very special way of jumping, doing a sort of acrobatic pirouette at the moment they jump."[72] The unposed and droll postures of these children amused him, as they would do one year later when he painted a series of children in the Luxembourg Gardens.

24. Balthus, *Les Evangélistes Marc et Jean* [The Evangelists Mark and John], 1927 (destroyed 1934), tempera wall painting. Beatenberg, Protestant church

25. Balthus, *Les Evangélistes Luc et Matthieu* [The Evangelists Luke and Mathew], 1927 (destroyed 1934), tempera wall painting. Beatenberg, Protestant church

26. Balthus, *Le Bon Pasteur* [The Good Shephard], 1927 (destroyed 1934), tempera wall painting. Beatenberg, Protestant church

In the spring of 1927 Balthus applied the experience and inspiration he had gained from his Italian studies to wall paintings, executed in tempera on the east wall of the little Protestant church in Beatenberg. Upon his return from Italy in the fall of 1926, enlisting the help of Margrit Bay, he had offered to decorate the interiors of the parish churches of Beatenberg and Einingen, a nearby village. Dora Timm remembered Balthus telling her that he had learned from Maurice Denis the technique of fresco painting, and that he now "needed a church he could decorate."[73] Only the Beatenberg church, where Margrit Bay's father had earlier been the pastor, had accepted his offer. In the meantime, however, Balthus prepared cartoons for the decoration of the Einingen church. In an old faded photograph of the Einingen church interior, on either side of the entrance are tacked the cartoons of Balthus's planned decoration, a legendary episode of the founding of the tenth-century Einingen church, one of Switzerland's oldest. The scene of the angel bringing a message to the knight of Strättlingen combines elements of Piero and children's book illustrations. Balthus worked on his wall decorations for the Beatenberg church from April to the end of June 1927. As his subject Balthus chose the Good Shepherd flanked by the Evangelists— Luke and Mathew on one side, Mark and John on the other (fig. 23). According to Balthus's letters to Strohl, the peasants of Beatenberg watched his preparations in their church with great suspicion.[74] Balthus's four evangelists look rather wooden, both in the surviving cartoon sketches and in the wall paintings (figs. 24–25). The young Luke has an androgynous beauty; the aged Mathew shows similarities to Erich Klossowski. While Mark and John are Ossian-like bards in the cartoon sketches, their clipped beards in the final version give them the appearance of Roman senators. Balthus apparently studied the effects of light on small clay figures that he made for this purpose.[75] Although the cartoons for the four Evangelists had been approved at the parish meeting on December 2, 1926, Balthus's initial sketch for the center figure of the Good Shepherd was rejected.[76] Balthus had to make changes in his second sketch, and after more changes the parish approved his work only on June 10, 1927. Exasperatedly, Balthus wrote on May 20, 1927 that: "I am depressed. The parish council of Beatenberg has just refused my last sketch after two meetings that were so ludicrous I'll have to tell you about them. This sketch represents the central figure that I have just finished of the Good Shepherd. What caused all the commotion was that I had fitted his back with a basket and put a hat on his head. Now I will have to change everything and remove all the amusing and lively things from the picture. Oh, what a bore."[77] Four days later he wrote: "In any case, is a shepherd not already heavenly just by himself? At least mine was, and that his feet still touched the ground was only because the weight of the basket on his back prevented

27. Balthus, *Triple étude pour "Sarah effrayée par l'ange Raphaël"* [Triple Study for Sarah Frightened by the Angel Raphael], 1926, ink on paper

28. Balthus, *Jeune fille effrayée,* [Young Girl Frightened], 1928, ink on paper. Private collection

him from flying away. Moreover, it was this that the gentlemen from the parish council resented so deeply, because it did not appear reassuring to them. I am told that a more robust figure is needed, and consequently, I must try to make a different shepherd."[78]

Egon Grossniklaus (1913–96; fig. 32), a fourteen-year-old boy, posed for the main figure. Slim and graceful, he had a straw hat slung around his shoulders, wore classical leather sandals and ankle rings, and had a fruit basket strapped to his hip (fig. 26). This "popular" interpretation of biblical figures, in vivid coloring, was still remembered by the older residents of Beatenberg during my visit there in 1980. In 1979, after more than fifty years, the late Dora Timm wistfully remembered the Good Shepherd as "coquettish."[79] But a nephew of Egon, the model for the Good Shephard, seemed still irritated that Margrit Bay's anthroposophically inspired dark wood decorations should have been allowed "into that little Swiss church!"[80]

At Arezzo Balthus observed in Piero's art "an insistence on representing Scripture in terms of daily experience"[81] This influenced not only Balthus's treatment of sacred scenes but also his choice of subjects. For example, late in 1926 Balthus crossed the Lake of Thun on a stormy day. He saw a charming young peasant girl wearing a *Schwefelhuetli* (peasant hat) sitting beside a basket filled with apples. Thunder sounds, and a swell knocks over the basket. Balthus was enchanted, as he recounted the incident several months later to Jean Strohl, by how charming she was when "with instinctive fright, she turned to pick up the apples; surprised by the sound of thunder, she holds on to her hat about to be carried away by the wind… This incident gave me the idea for my painting, or, to be more precise, I saw it in front of me. There occurred at this moment, I don't know what, something moving, eternal and biblical…needless to tell you, that I hurried to pick up the apples. Anyway, in all this you probably do not see any relationship with Tobias until I tell you that, in my mind, this young woman became the frightened Sarah in front of the Angel who flies away."[82]

Balthus was planning a large painting of Tobias and the Archangel Raphael.[83] The incident on the boat inspired him to chose the episode when the Archangel Raphael took leave of Tobias and his family. Balthus continued in the same letter to Strohl: "I told you about it last winter when I thought of using this subject for Einingen. Meanwhile it has become more interesting because I want to use a peasant family (for example, friends from here), and a

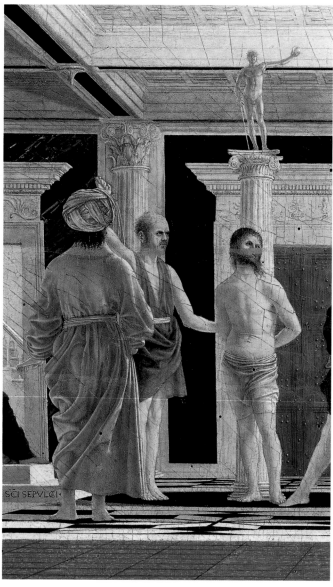

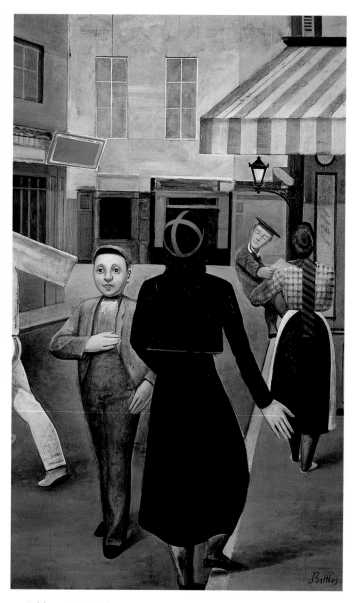

29. Piero della Francesca,
Flagellation, probably 1450s,
panel, detail.
Urbino, Palzzo Ducale,
Galleria Nazionale delle Marche

30. Balthus, *La Rue* [*The Street*],
1933, oil on canvas, detail.
New York, The Museum of Modern
Art, bequest James Thrall Soby

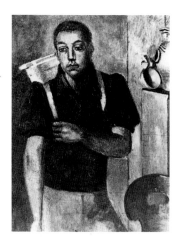

31. Balthus, *The Cow Herd*, ca. 1927, oil on canvas

32. Egon Grossniklaus (left) with his brother Paul, cousin Emil and a friend in Beatenberg, ca. 1924

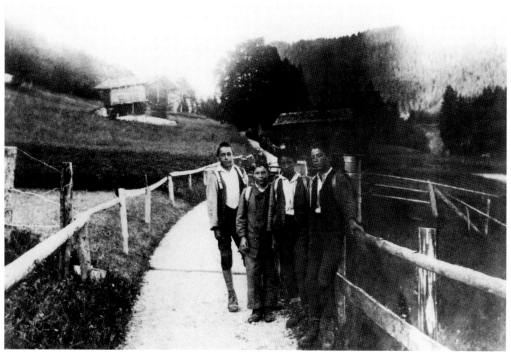

Raphael who wears a 'Kuhermützli' (peasant hat). It is rather risky, but perhaps it will be very amusing."[84] Only ink sketches survive of this painting (figs. 27–28), for which he made a small sketch in oil that has not survived. Few, no doubt, would have recognized a biblical theme in the finished work. This notion of transposing a biblical episode into a contemporary setting while concealing the identity of the figures, has a sly whimsicality. Several years later, after Balthus had assimilated some of the formalism characteristic of Piero, he applied it to secular subjects. These subjects appear, from time to time, cast in the mold of known subjects, religious and other, that are taken from earlier paintings: the frightened Sarah, for example, appears again as the bare-breasted model in *La fenêtre* [The Window] of 1933. The figure in white in Piero's *Flagellation*, ca. 1450s (fig. 29), reappears, in a reversal typical of Balthus, as the woman in black in *The Street*, 1933 (fig. 30). Poussin's sleeping youth of *Echo and Narcissus* ca. 1627 (fig. 21) is recast in the sleeping "wandervogel" in *L'Eté* [Summertime] of 1935 and in the foreground of *The Mountain*, 1937. The Louvre's mid-fifteenth-century *Pietà* of Villeneuve-lès-Avignons served probably as inspiration for *La Leçon the guitare* [The Guitar Lesson], 1934. The creation of this painting, ferocious yet of daring wit, coincided with the artist's bitter disappointment over the removal of his wall decorations in the Beatenberg church. The irreverence of these colorful wall paintings had finally led to their removal during the church's complete restoration in the autumn of 1934.[85] Balthus was furious over this decision by the Beatenberg parish council, and the many emotional letters he exchanged with Margrit Bay during the winter 1933–34 reveal the depth of his pain and anger.

From the Beatenberg period also date a group of drawings and paintings of Swiss motifs. Outstanding among these is an exquisite pencil portrait of Dora Timm of ca. 1927. Egon Grossniklaus (fig. 32) who had posed for the coquettish figure of the Good Shephard is also the model for the earthy *The Cow Herd*, ca. 1927 (fig. 31).[86] (Egon became the father of seven children and the representative for the Volkswagen car dealership in the small Swiss town Interlaken). Balthus had described Egon to his brother Pierre three years earlier: "I'll tell you about Egon whom our class is sketching with enthusiasm, knowing full well his youth will not last forever. Under his rough clothes I had already guessed the beauty of his body, but when he had shed them it was as if a precious stone had been hewn out of the surrounding lime. His perfectly harmonious body moves with exceptional grace. After holding him in my arms and sensing his shapely limbs with my body and arms, my pencil is more knowledgeable, for touch is as important as sight. I tell you that I hold him in my arms, but

it is as candidly as when I bite into a pear. Is this sinful? No, it is nothing but love for a perfect shape, love for God's masterpieces, the highest and purest of revelations. Oh, did I think I'd find Eros in peasant's garb?"[87]

Balthus's coquettish display of his sophistication to his older brother seems to be based in the shared homoerotic games or fantasies that are part of puberty. Balthus's appreciation of the beauty of Egon's body forecasts his own search for the perfection of form. At once aesthetic and erotic, it inspired his earliest surviving paintings of the standing and reclining model of ca. 1925 discussed above and his later paintings and drawings of adolescents. This longstanding quest had its roots in Balthus's unusual youth, and indeed his concerns and memories from boyhood would be present in his later art to an extraordinary extent.

[1] Balthus's letter to Professor Jean Strohl in Zurich, November 1922, private collection. All letters by Balthus to either Jean Strohl or Mrs. Strohl are in a private collection.

[2] In fact, they got married in London on October 1903, without the knowledge of their respective parents from whom they expected ill will toward their match. Cited from an unpublished letter by Baladine to Dieter Bassermann, February 1, 1954. Baladine Klossowska published her correspondence with Rilke, under the pseudonym of Merline, in two volumes. Only the letters of Rilke appear in *Lettres Françaises à Merline 1919-1922*, Paris 1950. Letters by both Rilke and Baladine appear in Dieter Bassermann, edited by, *Rilke et Merline: Correspondance 1920–1926*, Zürich 1954. Dieter Bassermann edited Rilke's and Baladine's letters extensively to create an underlying theme of the poet's last passion. Thus, entire letters or large passages from Baladine's letters were deleted, those which discussed matters of daily life. I was fortunate to come across the unedited, typewritten transcript of the entire correspondence, which will be referred to as U.C. (Unpublished Correspondence). It was in 1922 that Elisabeth Klossowska participated in an exhibition of women artists and adopted for that occasion, at the suggestion of Meier-Graefe, the name of Baladine. Rilke addressed her in his letters simply as "Mouky." All cited letters in this essay are either written in German or French, and all translations are mine.

[3] He was married to the former Lisbeth Doerk de Freval.

[4] The Klossowskis are registered in *Die Wappen des preussischen Adels: J. Siebmacher's grosses Wappenbuch*, part I, vol. 14 in the section entitled *Der blühende Adel des Königreiches Preussen: Edelleute*, p. 203, pl. 252, also in vol. 62, p. 145, pl. 176. The Klossowskis, together with over ninety-nine percent of all Polish nobility, hold no title. However, they bear the Rola coat of arms, as do seventy-two other Polish families. The name Rola derives from an old Polish family which dates back to the eleventh-century. It is an heraldic appellation, like a clan name in Scotland.

In his book dealing specifically with pretenders to non-existent Polish titles, Szymon Konarski, *O Heraldyce I "Heraldycznym" Snobismie* [Heraldry and Affected Heraldry], Paris 1967, cites the name Klossowski-Rola in the chapters "Pseudo-Comtes," p. 43 and "Pseudo-Princes," p. 39.

[5] He was married to the former Fanny Form. I am grateful for this information, and much else on the entire Spiro family to the late Lily Spiro, Eugen Spiro's widow, and to Balthus's cousin Peter Spiro, London.

[6] Abraham Bear Spiro's naturalization papers granting him, and his family, Prussian citizenship, were issued on December 3, 1873 in Breslau. Private collection, London.

[7] Conversation with Pierre Klossowski, July 11, 1980, Paris.

[8] J. Meier-Graefe, "Ein deutscher Maler: zur Klossowski Ausstellung bei Hartberg," 1930. Undated newspaper clipping.

[9] Thieme-Becker, *Allgemeines Lexikon der Bildenden Künste von der Antike bis zur Gegenwart,* edited by Hans Vollmer, Leipzig 1927, vol. 20, pp. 543–44.

[10] J. Meier-Graefe, "Klossowski," in *Entwicklungsgeschichte der modernen Kunst,* revised and enlarged edition, München 1927, vol. 3, pp. 541–42.

[11] J. Meier-Graefe, E. Klossowski, *La Collection Chéramy*, München 1908.

[12] J. Meier-Graefe, E. Klossowski, *Orlando und Angelica: Ein Puppenspiel*, Berlin 1912.

[13] Tilla Durieux's 1914 portrait by Pierre Auguste Renoir is in the Metropolitan Museum of Art, New York.

[14] J. Meier-Graefe, *op. cit.*, see note 6.

[15] Baladine lived with her two sons at Frohberg 3 in Bern, from March 10 until November 28, 1917. Erich Klossowski accompanied his family to Bern in 1917, where he remained with them for some weeks. Letter from the Stadtarchiv Bern, July 18, 1980 to the author.

According to Pierre Klossowski, during that brief time in Bern Balthus met a boy with the name of von Cotta. Cotta was a school friend of Robert de Watteville's. Balthus kept up with von Cotta, and one day met Robert de Watteville. In 1927 Balthus met Robert's sister Antoinette who, in 1937, would become his wife; see note 7.

[16] Transcript from the Lycée Calvin, Geneva, November 1979.

[17] *Mitsou, Quarante Images par Baltusz*, Erlenbach and Leipzig 1921, preface by Rainer Maria Rilke.

[18] Rilke's letter to Baladine, December 6, 1920, U.C.

[19] M. Osborn, "Misou, die Katze," *Literarische Umschau 4. Beilage zur Vossischen Zeitung*, Berlin, February 12, 1922, p. 1.

[20] Quoted in I. Schnack, *Rainer Maria Rilke. Chronik seines Lebens und seines Werkes*, Frankfurt am Main 1975, vol. 2, p. 766.

[21] Introduced by their common friend Ellen Kay before the war, Rilke and Kay one day visited Erich Klossowski and Baladine for lunch at their Paris apartment. Later, the Klossowskis visited Rilke at his apartment in the Rue Casette in Paris. See *Rainer Maria Rilke et Merline: Correspondance*, cit., p. 7.

[22] One of Balthus's German cousins who went ice-skating with Balthus and Pierre in Berlin in 1914, told me that Baladine looked twenty years younger than her age. According to family lore, Baladine was stopped at the border when she arrived with her two sons in Germany. She looked too young to be their mother. Inteview with Frances Maybaum, October 6, 1981, London. In 1925, the by then 39-year-old Baladine tells Rilke that she had introduced Balthus to her doctor, who thought Balthus was her lover. She writes: "What miraculous gifts God gave me—this face and young body—but I do suffer!" Baladine's letter to Rilke, December 19, 1925, U.C.

[23] P.J. Jauve, *Le Monde désert*, 3rd rev. ed., Paris 1960, p. 40.

[24] Baladine's letter to Rilke, March 27–28, 1921, U.C.

[25] Baladine's letter to Rilke, February 2, 1921, U.C.

[26] R.M. Rilke, *Briefe an Nanny Wunderly-Volkart*, edited by Niklaus Bigler and Rätus Luck, Frankfurt am Main 1977, vol. 2, letter of September 7, 1922, pp. 793–94.

[27] Baladine's letter to Rilke, March 11, 1921, U.C.

[28] Baladine's letter to Rilke, December 14, 1920, U.C.

[29] See *Rainer Maria Rilke et Merline: Correspondance*, cit., p. 38.

[30] Baladine's letter to Rilke, May 15, 1921, U.C.

[31] R.M. Rilke, *Briefe an Nanny Wunderly-Volkart*, cit., letter of October 20, 1922, pp. 799–800, letter of February 25, 1924, pp. 978–80.

[32] R.M. Rilke, *Die Briefe an Gräfin Sizzo 1921–1926*, Frankfurt am Main, 1950, letter of January 6, 1922, p. 11; Ingeborg Schnack, *op. cit.*, p. 1025.

[33] Rilke wrote eight letters to Balthus between November 1920 and June 1926. Balthus published these letters as "Rainer Maria Rilke - Lettres à un jeune peintre," *Fontaine*, 44 (summer 1945), pp. 526–37; this letter p. 528.

[34] See *Rainer Maria Rilke et Merline: Correspondance*, cit., p. 319.

[35] *Ibidem*, p. 371.

[36] Baladine's letter to Rilke, April 13/14, 1921, U.C.

[37] R.M. Rilke, *Die Briefe an Frau Gudi Nölke aus Rilkes Schweizer Jahren*, edited by Paul Obermüller, Wiesbaden 1953, pp. 103, 108.

[38] R.M. Rilke, *Die Briefe an Gräfin Sizzo*, cit., p. 11.

[39] R.M. Rilke, *Briefe an Nanny Wunderly-Volkart*, cit., vol. 2, letter of December 6, 1922, p. 821.

[40] "Rainer Maria Rilke - Lettres à un jeune peintre," cit., p. 531.

[41] Unpublished letter from Baladine to Dieter Bassermann of October 12, 1953, U.C.

[42] Balthus told Jean Strohl in his November 1922 letter from Beatenberg that he met Margrit Bay by pure accident one day in the street of Beateberg some five years ago. See note 1.

[43] I want to thank Adrian Gonzenbach who prepares a book on the arts-and craft group around Margrit Bay and Beatenberg for giving me access to this unpublished text by Dora Timm.

[44] During a delicious chance meeting with Balthus in the Pierre Baboza jewellery shop, in the Rue St. Honoré in Paris, on July 8, 1996, I told him of the Metropolitan Museum's recent purchase of his small *Summertime*, 1935, a study for *The Mountain*, 1937. When I asked him if *Summertime* was a transcription of Poussin's *Echo and Narcissus*—a variant of Balthus's lost copy—he did not reply. But he told me that both *Summertime* and *The Mountain* were based on a water color, now seemingly lost.

[45] R.M. Rilke, *Briefe an Nanny Wunderly-Volkart*, cit., vol. 2, letter of September 7, 1922, p. 782.

[46] Balthus's letter to Jean Strohl, November 1922, see note 1.

[47] Balthus's undated letter to the director of the Munich Staatstheater is on file in the Hauptarchiv, Munich Staatstheater (Pers. Dossier P 6142) and stamped as received on January 22, 1923.

[48] Rilke's letter to Baladine, December 11, 1922, U.C.

[49] Baladine's letter to Rilke, May 27, 1923 U.C.

[50] Baladine's letter to Rilke, November 21, 1923, U.C.

[51] *Rainer Maria Rilke et Merline: Correspondance*, cit., p. 469.

[52] Conversation with Annemarie Meier-Graefe-Broch, June 15, 1982, St. Syr-sur-Mer.

[53] R.M. Rilke, *Briefe an Frau Gudi Nölke*, cit., p. 121

[54] Rilke's letter to Baladine, December 23, 1923, U.C.

[55] Baladine's letter to Rilke, February 17, 1924, U.C.

[56] Conversation with Betty Leyris, June 14, 1980, Paris.

[57] Conversation with Yves Allégret, June 12, 1980, Paris.

[58] *Rainer Maria Rilke et Merline: Correspondance*, cit., p. 594.

[59] Part of the program was *Salade* by Darius Milhaud, *Mercure* by Eric Satie, the 15-act drama *Mouchoirs de Nuages* by Tristan Tzara and Shakespeare's *Romeo and Juliet* adopted by Jean Cocteau.

[60] Conversations with Tony Gross, November 5 and 8, 1981, London.

[61] *Rainer Maria Rilke et Merline: Correspondance*, cit., p. 521.

[62] *Ibidem*, p. 522.

[63] R.M. Rilke, *Sämtliche Werke*, Wiesbaden 1955–56, vol. 2, p. 7.

[64] I. Schnack, *op. cit.*, p. 1025.

[65] *Ibidem*, p. 1034.

[66] Balthus's letter to Jean Strohl and Madame Strohl, August 16, 1926.

[67] Conversation with Balthus, June 23, 1981, Spoleto.

[68] Balthus's undated letter to Jean Strohl and Madame. Strohl, mid-July 1926; also letter of August 16, 1926.

[69] Balthus's letter to Jean Strohl and Madame Strohl, August 2, 1926.

[70] See V. Monnier, J. Clair, *Balthus: Catalogue raisonné de l'œuvre complet*, Gallimard, Paris 1999: P 22, *La Légende de la Sainte Croix, Visite de la reine de Saba à Salomon*, 1926; P 23, *La Légende de la Sainte Crois, Bataille du Ponte Milvio*, 1926; P 24, *La Legende de la Sainte Croix, Invention et preuve de la vraie Croix*, 1926; P 25, *La Légende de la Sainte Croix, Exultation de la Croix*, 1926, pp. 105–07.

[71] Balthus's undated letter to Jean Strohl and Madame Strohl, mid-July 1926.

[72] Balthus's letter to Jean Strohl and Madame Strohl, August 2, 1926.

[73] Conversation with Dora Timm, Minusio/Locarno, December 22, 1979.

[74] Balthus's letter to Jean Strohl and Madame Strohl, April 23, 1927.

[75] Conversation with Dora Timm, Minusio/Locarno, November 30, 1979.

[76] Information taken from the Beatenberg church register, Beatenberg.

[77] Balthus's postcard to Madame Strohl, May 20, 1927.

[78] Balthus's postcard to Madame Strohl, May 24, 1927.

[79] D. Timm, *op. cit.*

[80] Emil Grossniklaus, July 1980, Beatenberg.

[81] F. Hartt, *History of Italian Renaissance Art: Painting, Sculpture, Architecture*, New York 1974, p. 236.

[82] Balthus's letter to Jean Strohl, July 8, 1927.

[83] Postcard to Jean Strohl, November 7, 1926.

[84] Balthus's letter to Jean Strohl, July 8, 1927.

[85] I read the transcripts of the parish meeting which were held between January 12, 1933 and September 17, 1934. It is curious that Balthus's wall decorations, their removal or their remaining in place, were never mentioned. However, the letters from Dr. Gräber, a journalist for *Neue Züricher Zeitung*, and from Margrit Bay, received on September 9 and 22, 1933, respectively, were discussed. The parish decided to ignore both letters. By the time the church's restoration was completed on December 30, 1934, Balthus's wall paintings had disappeared. They were either removed or covered over with white wash.

[86] Conversation with Balthus, February 22, 1983, Rossinière. Egon had worked as model for Margrit Bay from about 1922–23, since the age of nine. *The Cow Herd*, ca. 1927 is tentatively titled and dated "*Portrait de Richard* (avant 1929)" in V. Monnier, J. Clair, *Balthus. Catalogue raisonné de l'œvre complet*, cit., pp. 11, 101.

[87] Balthus's letter to his brother Pierre, February 23, 1924, U.C.

Wer spricht von siegen?
Überstehen ist alles.
Rainer Maria Rilke

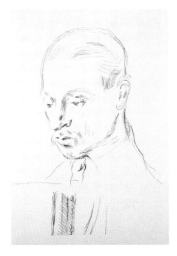

1. Baladine Klossowska,
Portrait of Rainer Maria Rilke,
pencil on paper, 1925

Baudelaire and Delacroix, Valéry and Degas, Apollinaire and Picasso, Paulhan and Braque—these are some of the pairs of writers and painters often linked together because of the correlations and echoes to be seen between their work, which might well be interpreted as extensions of each other. Another such pairing is that of Balthus and Jouve. The deep friendship between the two men was based on mutual esteem and admiration, personal affinities and shared concerns. Both exiles within their times, the two men rejected the fashions and false values of the avant-garde, had a deep sense of history, an aristocratic concept of art as spiritually nourished, and also shared profound respect for the tradition and profession of the artist and artisan. In effect, they were both aware that they were creating an œuvre that defied the times they lived in: "One must have the courage to think that throughout one's life one has been at work constructing a cathedral. Yes, such a belief requires courage!"[1] The phrase is from Jouve's "undated journal" *En miroir*, but it might well have been said by Balthus.

The relation between the two great artists merits detailed study.[2] Here I will restrict myself to discussing some previously-unpublished material, which enables us to glimpse the intensity and richness of the relationship between the two men—a relationship that first flourished under the influence of Rilke (fig. 1).

I. "I met Balthus around the time of the death of Rainer Maria Rilke, who had had such a powerful and noble influence upon him. At the time, Balthus was an unusually serious young man, who gave the impression of being endowed with his own experience of life that didn't really seem to belong to him. Painting was already his life, and a sort of fastidious disdain—together with an innate wisdom—made him reject all the current trends." These important observations come from the account Jouve wrote for the exhibition of twelve large new canvasses that Balthus held at the Galerie Georges Moos in Geneva, November 1943; the piece would then be reprinted in the September 1944 number of *La Nef*, published in Algiers (Jouve refused to publish in occupied France).[3]

In fact, Jouve had met Balthus, his brother Pierre and mother Baladine Klossowska in 1925. As is well known, the latter had been an intimate friend of Rilke's since 1919 (fig. 2) and would so remain until the poet's death at Valmont near Montreux on 26 December 1926.[4] After separating from her husband, Erich Klossowski, Baladine had moved to Switzerland with her two sons, living there from 1917 to 1921 (first for a few months in Bern, and then in Geneva). One wonders if during that period she ever met Jouve, who had fled to Switzerland in 1915. Part of the circle of Romain Rolland, he worked on various publications inspired by the pacifist ideas of Tolstoy—including *Les Tablettes*, whose illustrations were by the same Frans Masereel who would engrave the title-page for the *Danses des morts* and also provide twenty-five woodcuts for *Hôtel-Dieu, récits d'hôpital en 1915*, both collections published by Kundig of Geneva, respectively in 1917 and 1918.[5] Masereel himself was then living in Geneva; had been a friend of Baladine and Rilke for some time; and would soon become a friend of Jouve's. The artist's influence has quite rightly been identified in the forty pictures "Baltusz" created to recount the story of his cat *Mitsou*, which were published by Rotapfel-Verlag (Erlenbach-Zurich and Liepzig) in 1921 with a preface by Rilke.[6] There is no evidence that Jouve was familiar with this first work by the twelve-year-old boy, nor is there anything that shows he saw the "exhibition" which—during the period of Balthus's self-portrait in pencil and charcoal—Bonnard organized at the Galerie Druet in October 1924, the main purpose being to introduce Maurice Denis to the young painter's work.[7] However, I would argue that the two certainly met in 1925, when the ailing and fast-fading Rilke made his last visit to Paris (from 9 January to 18 August). The poet, in fact, was staying at the Hôtel Foyot in Rue de Tournon, near the house taken by Baladine in Rue Férou, where he was an almost daily visitor.

Rilke must have made a particularly profound impression on Jouve who was just recovering from a four-year period of profound crisis, during which he had totally abandoned his former life. His meeting with the psychiatrist (later psycho-analyst) Blanche Reverchon in Florence, April 1921, followed by a first visit to Salzburg (at the invitation of Stefan Zweig[8]) would mark the beginning of a *vita nuova* from which the past had—or was to be—erased. "Everything has to be changed, I felt. Everything has to be started over again. Everything

2. Rilke, Baladine and Balthus
at Beatenberg, 1922

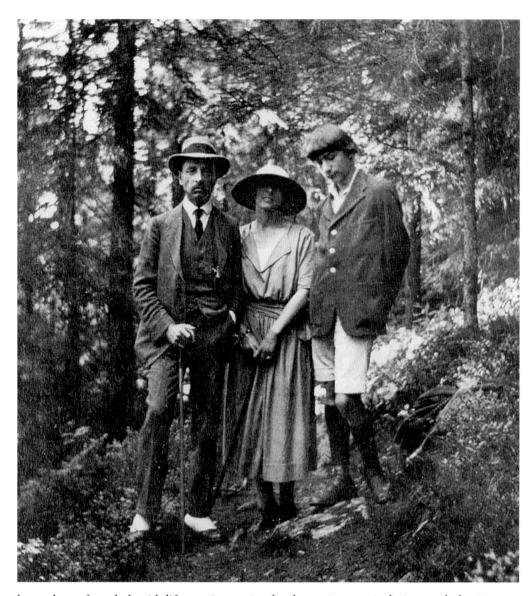

has to be re-founded, with life starting again, thanks to rigorous isolation, and obeying one main rule: the invention of one's own truth."[9] For Jouve, this truth meant "achieving a poetic language that stands solely as song [...]; finding within the act of poetry the religious aspect which is the sole response to the emptiness of time."[10] As some of the writings he had published since 1906 did not meet the requirements of his new aesthetics and ethics, Jouve rejected all his previous work *en bloc*—a total of some twenty books, comprising poetry, novels and drama. It is a rejection which calls to mind the admittedly less radical gesture by Rilke himself, who dismissed the works of his youth in the name of the very highest conception of what poetry should be—a conception that would also be shared by Jouve, whose death sentence on all his pre-1924 works was published in the postscript to the *Noces* of 1928.[11] This break was the most important of all those breaks and ruptures which punctuated the life of Jouve; and, undoubtedly, his gesture reveals both his need for solitude and his proud nature—two character traits he shared with Balthus. "I agree that, to a large extent, my exile was self-imposed. I am rather rude and untamed by nature, and almost always dissatisfied. Better exile than compromise, I said to myself. I have a tendency that only rarely suits the normal run of life: a tendency to sever the links."[12] Some thirty years later Balthus would be another one on the receiving end of Jouve's tendency to break-off relations; but is it not also true that the above comments from *En miroir* might well have been made by the painter himself?

The first expressions of Jouve's new poetics were published in 1925: a collection of poems

entitled *Les Mystérieuses Noces* and a novel entitled *Paulina 1880*. This was also the year of Gide's *Faux-Monnayeurs*, Cendrars's *Or*, Jean Prévost's *Plaisir des sports*, Breton's *Discours sur le peu de réalité* (published in the review *Commerce*) and Léon-Paul Frague's *Banalité*; cinemas were showing the *Rush of Gold* and the *Freudlose Gasse*; the Galerie Pierre was holding the first exhibition of Surrealist painting; Paris was organizing the International Exhibition of Decorative Arts, in Mannheim there was the Neue Sachlichkeit show, and Alban Berg's *Woyzeck* was being performed in Berlin. In short, one might well observe—and Jouve did—that this was a period of great aesthetic confusion, with a painful absence of clear points of reference.

When his novel was published in October 1925, Jouve sent a copy to Rilke, who had left Paris at the end of August in the company of Baladine. The letter of thanks would be written from Chateau de Muzot in the Valais, that medieval tower which Rilke and Baladine had discovered at the beginning of the summer of 1921 and which had then been converted and restored by Baladine.[1]

12 November 1925
Chateau de Muzot s/Sierre
(Valais) Switzerland

My dear Jouve,
You have thought of me in the friendliest fashion in sending me your book. I was very touched. I have just read it through for the first time, and I am already looking forward to reading it again.
It seems to me that, choosing the form you did, you took on a very difficult task, and have carried it off with full success. Assisted by your incomparable attention to detail, this form reveals itself capable of seizing the image and the absence, the overflowing and the invisible. Alongside this, there are the remarkable and rapid feelings of the narrator, who constantly presents us with these things, mixes them together and then, driven onward by the train of events, withdraws them. Whilst the reader is someone who learns, he is truly someone who knows, and who makes the prodigious best of his unavoidable and complete superiority... It is very striking; the eye seems to be looking through a sort of stereoscope that brings out all the plastic vitality of even the slightest moments of life. And, so closely associated with our own day and age, that instrument helps you to make "1880" all the more authentic. I wonder why this masterly technique is less convincing in the part of the book that is set in the convent? To tell you the truth, I admit I was less involved there, as the pace slackens in the last chapter... It is true that this part had to mark a period of repose and offer a full view of the settled and clarified substance of the story, the dense precipitate of so much agitation.
I congratulate and thank you.
Remembering the pleasent evening that I passed at your home, I would like to present my most faithful greetings to Madame and at the same time express all my friendship for you, my dear Jouve.
R.M. Rilke

[address] [postmark]
Monsieur Pierre Jean Jouve 12 November 1925
6, rue Boissonade
Paris 14e

Rilke's opinion of *Paulina* was of great importance to Jouve, who considered that the author of the *Sonnets to Orpheus* embodied "a conception of Poetry as priesthood, as an independent and ritual activity that must bring together all the powers of invention, all forms of love and a complete effort of modesty."[14] He shared this same lofty conception of poetry, the same contempt for contemporary "literary morals"[15] and also the same love for certain Swiss landscapes (the Valais and Engadine) which seemed to physically instil a sense of the sublime. Rilke was not the only one to appreciate the novel, which just missed winning the Prix Goncourt;[16] enthusiastic readers included Edmond Jaloux,[17] Henri de Régnier,[18] John Charpentier,[19] Jean Schlumberger[20] and, most importantly of all, Baladine Klossowska, who had been given the book by Rilke. The poet often advised her on reading matter, and had, for example, recommended Giraudoux's *Bella*, Duhamel's latest book and also the recent issues of *Commerce*. On 14 November 1925, he wrote to her from Muzot: "I have not read Berl's book [*Méditations sur un Amour défunt*], but I will have it sent to you by Morisse, along with another that Jouve was attentive enough to send me; it is called *Paulina 1880*, and seems to be to be quite remarkably written. There are very short quick chapters which are astonishingly plastic in their rendition, rather like images seen in a stereoscope. When reading it, you participate in it; the action is set in Italy, and all the reader's senses are involved, even the sense of smell. You will see."[21]

3. Letter from Baladine to Rilke about *Paulina 1880*, undated (late November 1925)

Baladine's reaction was immediate. In an undated letter,[22] which must have been sent shortly after the above from Rilke, she writes to Jouve offering to translate *Paulina 1880* into German:

> Thursday
> Monsieur.
> I don't think that you will remember me, but that is not important. In a recent letter my friend Rilke mentioned your book *Paulina 1880*, and then a few days later had it sent to me.
> I read it and was enraptured. I am continually re-reading it. It is almost too beautiful. I would like to translate it, if I have the courage. Is there already someone in Germany who is doing it? And would it be difficult to get the translation rights?
> Forgive me for asking these questions about something that is going so well; but it is very dear to me. I would be most grateful if you could give me some information on the matter.
> Please accept my best regards
> Baladine Klossowska
> 11, rue Malebranche, Ve

In spite of the go-ahead from the *Nouvelle Revue Française*, the project never came to anything; and *Paulina 1880* would only appear in German in 1964 (translated by Elisabeth Borchers). However, Jouve remained in contact with Baladine right up until her death in 1969. As evidence of this one might quote the short note she sent the poet to thank him for the copy of the new edition Gallimard published in 1963 of the *Poèmes de la folie de Hölderlin*, which he and Pierre Klossowski had translated together some thirty years earlier (printed on March 5):

> April 63
> Dear Pierre Jean Jouve,
> Your dedication in the poems of Hölderlin meant great deal to me. It gives me the opportunity to tell you that in reading it everything seems new. The French language is liberated, resurrected—proved innocent—by your genius!
> Baladine
>
> [address] [postmark]
> Monsieur Pierre Jean Jouve 6 April 1963
> 7, Rue Antoine Chantin
> Paris 14e

II. Shunning any forms of literary movement, from 1925 onward Pierre Jean Jouve engaged in a new and demanding series of works in which he aimed to grapple directly with the unconscious. "I had to cut back in order to get rid of my early associations [...] This was when I abandoned all those places where one puts oneself on show: publishers' offices, bookshops, theatres, newspaper offices. I read very little—or nothing at all—of what was being published. I was reading Pascal, the Romantics, the nineteenth-century, Dostoyevsky; I searched for nourishment in foreign poetry—in Dante, Shakespeare and Hölderlin"[23]—a list that includes a number of writers that were among Balthus's favorites as well. This was the period when Jouve produced *Beau regard* (1927, with illustrations by Sima), *Le Paradis perdu* (1929), *Sueur de sang* (1935) and—as we have seen—together with Pierre Klossowski translated *Poèmes de la Folie de Hölderlin* (1930, with a preface by Bernard Groethuysen). "I was searching for an order that was my own. Beyond the defined instinctive structures—that is, within and without them—one must be able to imagine the existence of an area of images which I called the poetic unconscious, the area that generates and holds together inspiration within the two main fundamental schemes of Eros and Death."[24] And this is the same sub-soil that would provide the inspiration for so much of Balthus's work.

Jouve's circle of friends during these years was restricted to a small group: Max Jacob, Léon-Paul Fargue, Jean Cassou, Gabriel Bounoure, Stefan Zweig, Hermann Hesse, Bernard Groethuysen and, undoubtedly, Baladine and her two sons. The artist would even pay Klossowska the tribute of using her christian name for the heroine of his novel *Le Monde désert*. Indeed, he took more than just her name: "Baladine Nikolaievna is the sort of relation that one sees in the afternoon or the evening. One skis or dances with her. An attractive woman. No-one knows her family name. A Russian from Moscow, married, I think, to a German, but there has never been a husband with her [...] Baladine's character and person are provocative. Once one notices certain movements that her large body makes, one can no longer take one's eyes off her. A fairly accurate description would be 'female bird'. She has long and very

attractive legs, high-arched feet and pronounced yet slim thighs and bosom [...] As for her hair, it too is provocative, slightly dark and sensual."[25] A mother figure and a *femme fatale* at one and the same time, Baladine is undoubtedly a character in a novel, but the writer created her by drawing on memories from various periods of his life (at least, that is what he claims in different passages in *En miroir*).

During the same period, Balthus was engaged in his apprenticeship, copying the works of Masaccio, Piero della Francesca and Poussin. He seems to have instinctively understood something that Roland Barthes would later express explicitly: "Being modern means knowing what has already been done." Whilst living most of the time in Paris, Balthus would make frequent long trips to Germany, Italy and Switzerland; he was at this time also painting his first portraits, his first nudes and his first Parisian street scenes. In the *La Nef* account already mentioned above, Jouve would write: "For him painting began in the quartier of Montagne Sainte-Geneviève and the Jardin du Luxembourg, a shrewd, sensitive and monumental district that had been nourished by the spirit of great men; the area of Meryon and Delacroix. For this young man full of curiosity, everything was to be re-learned from scratch. This is a feature of his work that becomes more pronounced as it progresses: he saw things as having to be done over—in the sense that some things that have been lost must be found again, others must be invented. Thus Balthus at the very start of his career as an artist was already rigorously independent of 'schools'; yet he was also an artist who knew the entire Louvre collection by heart, for whom the true school was the essential."[26]

The Jouve writing these notes is the man who has just taken refuge in Geneva, and recently published essays on Baudelaire, Delacroix, Meryon, Rimbaud and Courbet; a man who sees in Balthus a fellow spirit.[27] In effect, he was amazed that he had waited so long to write about him. After all, he could have done so a good ten years earlier, when—in April 1934—at Galerie Pierre Loeb in Paris Balthus had held an exhibition of the five large canvases that are here re-united for the first time: *La Rue* [The Street], *La Toilette de Cathy* [Cathy Dressing], *La Fenêtre* [The Window], *Alice* and *La Leçon de guitare* [The Guitar Lesson]. For Jouve, that had been the period of *Sueur de sang*, a novel preceded by the important text *Inconscient, spiritualité et catastrophe*, in which the unconscious (in the Freudian sense of the term) was championed as the main source of poetry. "Those poets who since Rimbaud have worked to free poetry of the rational know very well (even if they do not think they know) that it is in the unconscious—or, at least, in thought which is as open as possible to the influence of the unconscious—that they have found the old and new sources; they know that it is through the unconscious that they approach a goal that is new for this world [...] In its present phase of life, poetry is encountering multiple distillations that enable it to achieve the symbol—a symbol that is no longer controlled by the intellect, but one that surges forth on its own, formidable and real. It is like some sort of matter that releases the power inherent within itself."[28]

Once again, what Jouve says about poetry might well be applied to Balthus's paintings, the reason being that both painter and poet drew on the same source of inspiration. Others also drank at the same well—for example, the Surrealists, with whom neither Jouve nor Balthus felt any sort of bond—but without that essential concern over form. For Jouve and Balthus it was form itself that enabled the real to become symbolic.[29]

The two men saw each other regularly at this period; the relations between them had been getting closer ever since spring of 1932, when Balthus returned from his military service in Morocco. In 1933 Jouve had left the Rue Boissonade address for the Rue de Tournon, where Balthus was "one of the family," with the poet often visiting the painter's studio in Rue de Furstenberg. "He had by then found the place that corresponded to his formula of art, to everything he wanted to do and that he had already set about achieving with his characteristic determination [...] The strange little Rue de Furstenberg, with its provincial little square behind the seventeenth-century abbey of Saint-Germain-des-Prés, fed his spirit. Like all the other narrow streets in the area, it supplied him with amusing and unusual forms—just the sort of thing one might confuse with the stuff of dreams."[30]

Jouve did not review the exhibition Balthus held at the Galerie Pierre Loeb. It was Artaud (fig. 4) who mentioned the event in a piece published by the *Nouvelle Revue Française* in May 1934. "It seems that tired of describing wild beasts [*fauves*] and extracting embryos, paint-

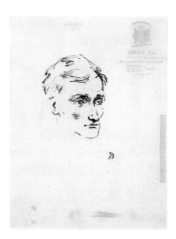

4. Balthus, *Portrait de Antonin Artaud* [Portrait of Antonin Artaud], 1935, India ink on paper. Private collection

ing wants to return to some sort of organic realism, which far from fleeing poetry, marvels and fairytales, uses the certain means at its disposal to render them even more successfully than before."[31] The first time Jouve publicly discussed the work of his friend was with regard to Artaud's *Cenci*, put on at the Folies-Wagram the following year, with sets and costumes by Balthus.[32]

However, even if he did not write about it, the exhibition at Galerie Pierre Loeb had a powerful effect upon Jouve; he could still remember it ten years later. "That was the period of total anarchy in aesthetics, and painting, which wandered from the ease of Cubism to the ease of Surrealism. The severe atmosphere generated by these exact and profoundly-rendered characters, painted together in these strange scenes, made an instant impression on all those who, aware of the disorders of the time, were calling for artistic work to show a new attention to structure."[33] Jouve saw Balthus occupying the same place in the painting of the mid-thirties as he himself had occupied in the literature of the mid-twenties. Discussing his return to Paris at the end of the Great War and his period of crisis from 1921 to 1924, Jouve writes in *En miroir*: "I found myself in Paris, in the middle of a bewildering confusion within the things of art: the disorder that followed that First World War overturned all perspective. Apollinaire's glory rested in part on his death, and was accompanied by a number of dubious imitations. And Dada introduced Rimbaud to the firmament of genius. This was the eve of Surrealism, and everyone was talking about Lautréamont. Cubist painting was settling in, and music was serving up a mix of muddles and somersaults."[34]

To Jouve's eye, Balthus was one of those rare painters—indeed, with the exception of Sima and Masson, the only painter—whose non-conformist aesthetics answered his own requirements of art. As a result he bought *Alice* (fig. 6), a painting he kept with him until his death and which features in the photographs he had taken of his apartment in Rue de Tournon (fig. 5). For Jouve, *Alice* was *the* painting. He describes his attitude admirably in a piece that appears in his collected *Proses*, published in 1960, which opens thus: "At that period in my life, there hung near my bed at the end of a wood-panelled bedroom, a large painting by a young master which tended to frighten those who came to visit me. Imagine a young woman with white eyes, dressed in a short blouse, who is combing her hair with a firm hand, whilst raising one of her legs onto a cheap chair and revealing her female sex for all to see. This strange companion was obviously the confederate of my night hours; by which I mean that she watched over my sleep and thus might slip her way into it. No, her over-heavy left breast, her almost masculine thighs, could not conjure up dark desire, the children of the past; which perhaps might have been the case if she had been more in tune with the two blue slippers she wore on bare feet. No, what seduced me here was the painting as such; it was so exact and precise, so intense in its embodiment of the carnal, that I considered 'Alice' as my companion."[35]

This is far from being the only text of Jouve's which describes a response to a Balthus painting; however, no other painting—not even *Portrait de Thérèse* (fig. 7), which Jouve bought in 1937 and hung over his desk—established such a feeling of intimacy.

Obviously, here I cannot cite here all of Jouve's writings mentioning a Balthus painting, but one of the most important to do so is *La Victime*, one of his *Histoires Sanglantes* (the title echoes that of a Balthus painting of around the same date). In effect, in the first editions *La Victime* is dedicated "A Balthus," a dedication that was dropped when the story was reprinted in *La Scène capitale* in 1961. The collection of piece in *Proses* could supply numerous other examples—such as, "Les Beaux Jours" refers to a painting of the same title and "Description" takes up the theme of *La Victime*.

III. So the close friendship between the poet and painter dated from the 1930s; then their relations were to be cruelly interrupted by the outbreak of a new war. In September 1939, Balthus was mobilized and sent to the front near Sarrebourg, where he was wounded. He returned to Paris in December before, in early 1940, going to spend some weeks convalescing with his in-laws in Switzerland. For their part, Blanche and Pierre Jean Jouve had spent part of the summer in Lucerne (at an international music festival organized by Toscanini), then the last three months of 1939 at Grasse before returning to Paris in January 1940. It was there that they would first learn of Balthus's distress.

5. *Alice* in Jouve's apartment
in Rue de Tournon

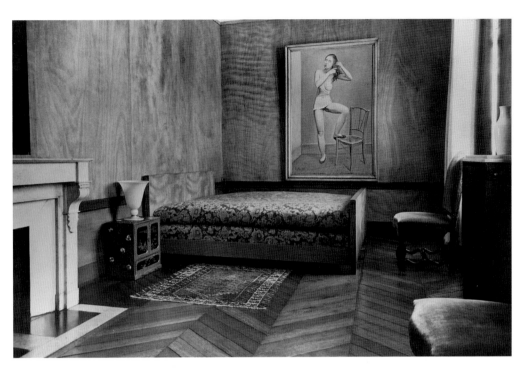

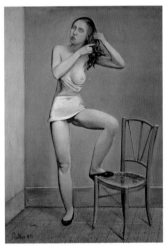

6. Balthus, *Alice dans le miroir* [Alice
in the Mirror], 1933, oil on canvas.
Paris, Muséee national d'art
moderne, Centre Georges
Pompidou

Sigriswil, Thursday 15 February
My dear Pierre,
When I periodically emerge from my gloom, I see myself hemmed in by an abyss of silence and cut off
from other people; each attempt to pass beyond this abyss has floundered in further discouragement.
To tell the truth, in my current state of dejection and deep despair, it was both impossible and hateful
to write news of myself. Since my return to civilian life I have collapsed inside, as if one of their bombs
had gone through all my floors, and I wear myself out in pointless attempts at rebuilding. I am ashamed
of myself. I thought I was more solid; but perhaps I had already used up too much of my strength in
order to live. How long ago seems that day last summer when we talked about our plans and projects
on the phone! I was, finally, on the threshold of a truly organized life; I was going to be able to work
in peace and quiet. Then I left for the war in a state of frenetic excitement. A month later I was back
in Paris, a total physical wreck. "Health is indispensable in war, and nothing can substitute for it." And
mine, I think, is buggered. What a pity you were still away from Paris; I missed you a lot in those two
weeks I spent there before we left for Switzerland.
We have settled in a charming village above Lake of Thun; a wonderfully romantic and gentle winter
landscape. However, as if by some sort of diabolic curse, everything that would normally be such a source
of pleasure has become a curse of sadness, plunging me into anguish and conjuring up bleak and somber
thoughts. At present, I have nothing but contempt for myself. If I am not required to rejoin the army,
I will still have to go on living somehow. I again feel a certain desire to work (even if, so far, I have been
totally incapable of doing so); but perhaps that is simply the result of my horror at how little I have
achieved so far. I haven't done anything yet. The problem of the artist who works with physical matter
has changed now once again. I wonder if he doesn't now occupy a position that is totally ridiculous. It
is the poet alone, I think, who must now hold the torch aloft. This is why I hope so much that you, the
greatest and purest of poets, will not cease to make your voice heard—a voice that is the last refuge of
light in this dark night, a glimmer of the dawn to come. It is now, more than ever, that one so profoundly
feels your usefulness.
In two days' time we are leaving this charming place that I have not been able to profit from. Undoubtedly,
I owe the fact that I am still alive at all to Antoinette, a miraculous and caring angel. We will stay in Bern
for a few days, then come back to Paris, where all sorts of annoyances will be awaiting me. I am eager
to see you again, my good and dear friends. I embrace you both.
Balthus

[in the margin]
My address in Bern:
c/o Colonel de Wattewille, Hallerstrasse 51, Bern

[address]
Monsieur Pierre Jean Jouve
8, Rue de Tournon
Paris 6e
France

[postmark]
Sigriswil
16 February 1940

Difficulty in settling down to work, dissatisfaction, the impossibility of rendering the cata-
strophe in words—these themes will recur in several letters from Balthus to Jouve. He calls

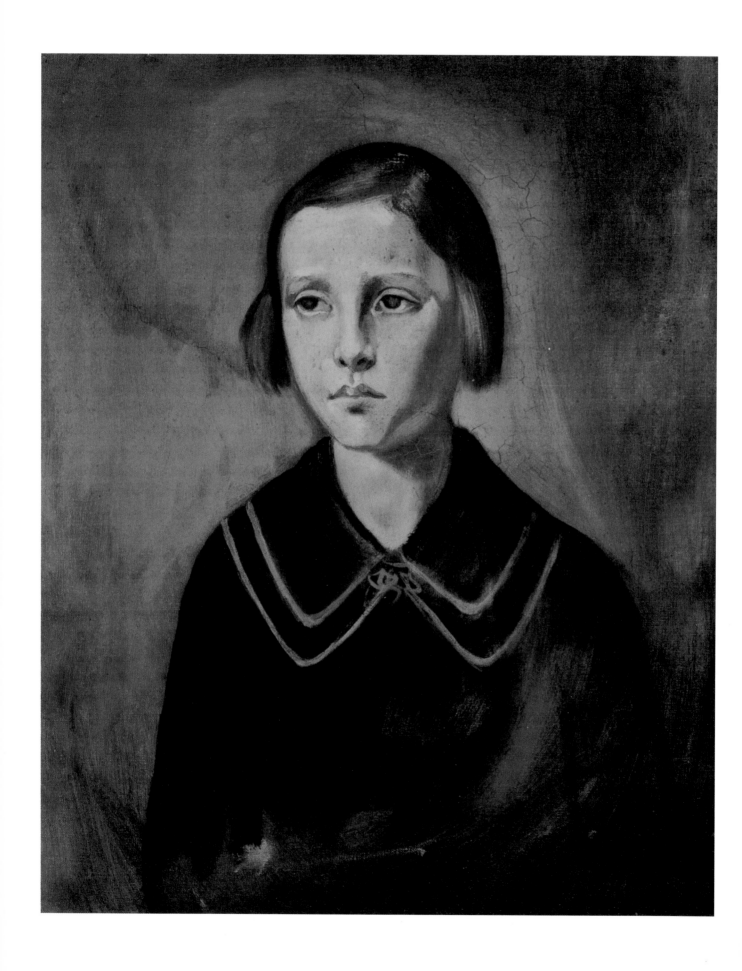

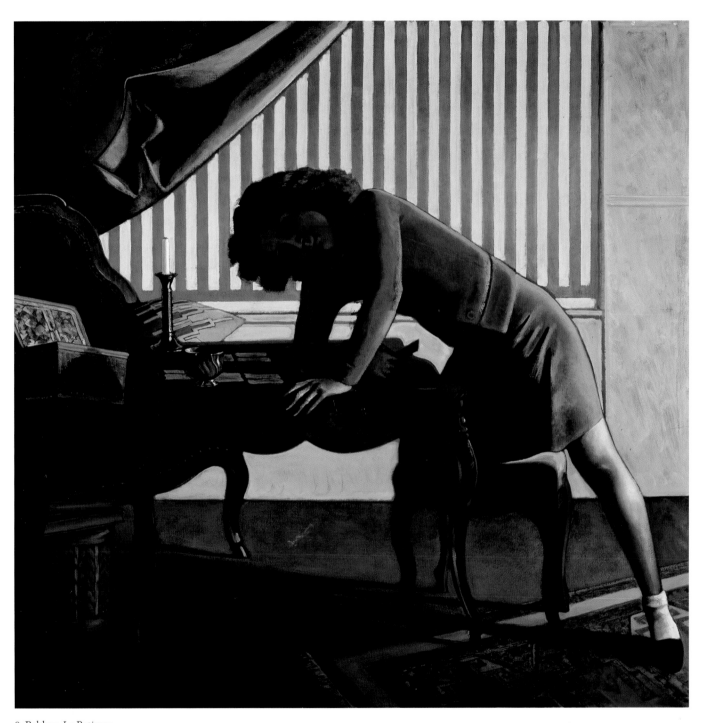

8. Balthus, *La Patience*
[The Game of Patience],
1943, oil on canvas.
Chicago, The Art Institute,
Joseph Winterbotham collection

opposite page
7. Balthus, *Portrait de Thérèse*
[Portrait of Thérèse],
1936, oil on canvas.
Private collection

on the poet, asking him to make his voice heard; and Jouve seems to respond—for example, in his "Poésie et catastrophe," the preface to Pierre Emmanuel's *La Colombe* (1943): "Within, yet in opposition to the catastrophe, the poet represents that which is most permanent and sacred in all political action. His ultimate seriousness is surpassed only by that of the man who fights and puts his life at risk. [...] The true poet, the poet of 'the essential,' draws on the forces of the soul and renders them in an eternal act, and thanks to that very act engages with his times, engages with events."[36]

Without making any direct reference to them, Balthus's own paintings are none the less a reflection upon those events. From their very first appearance, they were read in this way not only by Jouve but also by Jean Starobinski. "There is a deep link,—Jouve continues in "Poésie et Catastrophe,"—within the very character of the event between certain forms of trial and the inevitability of a poet's inspiration; then the poet must speak: he must, he must; because he is the only one who can do so in a raw material that is durable and perhaps eternal. The poet is the only one who can bring down both exterior and internalized censorship, the only one who can 'possess the body and soul of truth'; he is the only one whose task it is to revive the deep instincts of love in opposition to the seductive instincts of death."[37] And this duty of the poet that Jouve outlines in his preface to the collection by Pierre Emmanuel, is also one that he feels the painter can fulfil in his own way; this is the point he underlines in his piece in *La Nef* on the paintings Balthus had produced in exile.

Having returned to Paris, Balthus was demobilized. He left the capital on 11 June 1940, at the same times as the Jouves. While the latter went to Dieulefit, where they would remain until November, Balthus went to Champrovent. From there he would again take up his correspondence with his friend.

Champrovent, Tuesday

My dear Pierre,

I read with great emotion your letter, which arrived yesterday—that is to say, after a more bearable interval of time. All your other news arrived here with an irritating "disorder of time." Do not hold it against me, dear friend, that I am a bit late in writing to you—as you guessed, writing is still a little difficult for me—but I do not want to wait any more (by now silence has become terrible). Bewildered and full of anguish, I followed all your movements from here, desperate because I couldn't reach you, couldn't unite what little strength remains me with your own strength in order to help you bear the cataclysm. One had to wait for the mist to lift; and I felt a certain relief on learning that you are at Dieulefit, a place that you know and are fond of. Your journey must, I am sure, have been very similar to ours. After three days' travelling, we gave up the idea of joining you at Brioude and went to Lyons to rest for a few days; then we came here, and disgusted with the profession of the refuge, decided not to move, whatever happened. Anyway, we were soon encircled by the sound of battle; they were fighting just a few kilometers away; but our little corner has remained intact. In the end, the cannons fell silent; everything is over. Yenne was occupied for a few days. However, it is curious all the same to see these Angels of the Apocalypse close-to; we went down there once. All I saw were poor souls, very like those I had seen at the front. I was struck by the shy, modest and almost humble attitude of the men; as for the officers, they were more real than nature itself.

After the departure of this mob, life tried to get underway again. In an almost miraculous way, the ability to work has been restored to me in the midst of these horrors. I am holding onto it fast, in order to stop myself sinking; it is the life-raft that heaven has sent me. I fix my thoughts on the horizon bound by these two mountains, and the eternal rhythm of the life of the land presents me with an image of unchanging order that in some way reassures the spirit. For the moment I prefer to ignore everything—or else I would slip into that fatal step. We intend to stay, to pass the winter, here. As for Chemillieu, the house is ready to receive you. However, although I would love to have you here with us, I feel it is my duty to point out all the difficulties ["arisen" crossed out and replaced by] created by the new situation in the country. First of all, the bridge at Yenne is down; now there is a boat to ferry you across the Rhone. The intention is to build a walkway across the river—but when? Then there is the town itself; due to the interruption of communications, supplies are still scarce. Thirdly, and very importantly, private individuals are forbidden to use cars, which obviously is an enormous limitation for a place like Chemillieu (without a car, I fear you will feel very isolated up there). The position of Chemillieu compared to Yenne is a little like that of the Salishaus at Fex compared to Sils. It is very difficult for me to advise you, because I am caught between my enormous impatience to see you, my desire to have you near us, and my fear of recommending a place that, in the present conditions, suffers from all sorts of inconveniences. The house can certainly be heated in winter, but you would have to get in touch with Madame Maret to see if she is willing to rent it out in winter (the house has not been inhabited in winter for a number of years). There is no shortage of wood in the area, but one would have to buy a few small stoves—which we are going to do ourselves—given that fires in the fireplaces give off insufficient heat. I now regret that you didn't come directly to Chemillieu; when the German threat became concrete in the Ain you could have come to pass a few days at Champrovent, which was then the safest place in France. Thus you would have seen what the house was like. Finally, all the difficulties I have outlined to you are undoubtedly pretty much the same as those felt everywhere throughout the countryside at

9-11. Letter from Balthus to Jouve,
24 February 1941

present, and all of them would be counterbalanced by the fact that we could see each other, that we would be near each other—something which at the moment is of great importance to me. Ah, my dear friend, how painfully complicated all this is.

After a long period of anxiety, we have heard news of Pierre Leyris, who has miraculously escaped death; he has ended up in the Landes, after fighting his way across France. Soon he will be here with us (Betty has been here since April). I was terribly shaken by the news of Drougoul's death. It is almost impossible to bear the fact that we had to lose this that precious and rare being. It is that which makes it all so horrible. Now there is anguish about the memory of our last evening at Rue de Tournon, when he played Bach so admirably (each time he played, I was lost in contemplation of his face, which at certain passages in the music was suddenly illuminated, like a landscape when the sun breaks through the clouds. It was the divine reflection of the music—a marvelously cheering spectacle!). Ah, may God give us the strength to withstand our rage and disgust.

I embrace both of you, my dear friends, as does Antoinette. Let us hope for courage, courage—the trials and tribulations have only just begun.

Balthus

[address]
Monsieur Pierre Jean Jouve
"Beauvallon"
Dieulefit
Drôme

[postmark]
St. Jean de Chevelu
26 July 1940

Like Jouve, Balthus saw the defeat as a deep humiliation, a catastrophe to be opposed not by works that yielded to the temptation of facile symbolism or overt "commitment"—works such as those Jouve himself had produced during the First World War— but rather by works expressing deep and serious reflection upon events, by acts of creation that ensured the continuity of the true values—if not the very soul—of the nation. Thus *Le Cerisier* [The Cherry Tree] (fig. 13), painted at Champrovent in 1940, is in its own way a response to the disaster—as Jouve saw immediately: "The work was produced in April 1940—right after the disaster, after Balthus's introduction to war and exile—and it is a sort of reflection upon and inner protest against this state of affairs."[38] This first level of reading—which was later confirmed by Balthus himself[39]—was clearly not the only one possible. Apart from references

drawn from the history of painting, Jouve also caught the secret symbolism of fruit-picking, the physical mystery of a scene which "in broad daylight gives the impression of something belonging to the world of the fantastic."

In November 1940, the Jouves settled in Cannes. Having momentarily lost touch with them, Balthus sent a telegram from Champrovent to express his joy at having established contact again: "Profound joy at having found you again. Yes, confidence and prayer. Affectionately, Balthus."

In spite of the disaster, creative work had to continue. Through Pierre Emmanuel, Jouve sent Balthus a copy of *Nada*, a text that "reveals all the experiences and profound hope of this time of agony."[40] Balthus drew real comfort from the message of the work:

Champrovent, 24 February
My very dear Pierre,
I have just been through an odious period, struggling with the most terrible difficulties. I would have liked to write to you with a freer mind, but the line from Blanche (who, with her extraordinary intuition, could tell that I wasn't going to) has revealed the state of anxiety you are in to have some news of me. First of all, I want to thank you, dear friend, for the magnificent work that Noel Mathieu sent me. I have lived with it very closely throughout these abominable weeks, and you should know that it has been the greatest help to me. I will even tell you that often my eyes filled with tears—tears of the very highest kind. So, again I shake your hand and embrace you. I could talk to you about it much better than I could put it in writing. How I admire the art in this work, that marvelously light and simple art which is a re-creation of the language itself! Without knowing exactly why, I was reminded of the images of the twelfth century. I had ["above all" written over with "already"] been struck by the limpidity of the two admirable poems published in the two reviews you sent me, and whose authenticity makes them shine out amongst all that gross and boring stuff. A blessed source of fresh water in the desert of the present. As I have to send the manuscript back to Pierre Emmanuel, I was wondering if you could get Nada to make me a copy; if that were possible, I would be very happy.
We are going to Berne—to my father-in-law's—for a few days, and we will pass March there. We'll come back at Easter. The year hasn't started very well for me. Apart from the crushing worries about one's daily bread, there also seems to be a very serious threat to my work, because nowhere in the region seems to have paints, brushes or canvases. If I have to start practicing the art of restriction, I'll die. For some months now, I've been trying to do something working with tools that are more like brooms than paint brushes. My dear Pierre, when will we see each other again? It is terribly hard to be separated like this, when there is such a need for us to see each other. Write to me, I beg you, just a word, to Berne (c/o Colonel de Wattewille, Hallerstrasse 51).
I embrace both of you, with the deepest affection, as does Antoinette.
Balthus

[address]	[postmark]
Monsieur Pierre Jean Jouve	Chambéry
Hôtel Martinez	26 February
Cannes-sur-Mer	
Alpes-Maritimes	

Balthus therefore passed March and part of April in Bern, before returning to Champrovent for the rest of the year. He also tried to help the Jouves to get into Switzerland.

Bern, 3 April
My very dear friend,
On getting back from a few days in Zurich, I found the letter from Blanche and a line from Bardet asking me to help you find an apartment. The thought that we might soon see each other again fills me with almost feverish joy. By now you will have had my last letter, sent upon receipt of Nada's. Switzerland has its best face on at the moment. I think you will like it here. I myself am trying to find an outlet here for my painting (which does not appear to be easy; I am an illustrious unknown here) and if there were the slightest hope of doing so, I am sure I would return—particularly if you were there. Life in Savoie has become so expensive that the simple means at our disposal were no longer enough. Anyway, Antoinette will stay with her father a bit longer.
But the great difficulty is obtaining the entry permit. One must find someone with sufficient authority to intervene on your behalf, otherwise things could drag on for months. What a shame that Blanche no longer has any family in Switzerland, because "family reasons" is practically the only motivation for a permit that the Federal Police will consider. Perhaps you should write to Ramuz. Has Blanche already made the application? I am not going back to Champrovent until the end of the month. Write to me soon, and in detail, so that I can use the time I still have here to be of some use to you.
I embrace both of you
Balthus

[address]	[postmark]
Monsieur Pierre Jean Jouve	Bern
Hôtel Martinez	4 April 1941

12. Pierre Jean Jouve during
Second World War

Cannes
Alpes-Maritimes

Sender:
Balthus Klossowski de Rola
c/p de Watteville
Bern, Hallerstr. 51

The memories of the fall of France and their subsequent exodus abroad was to have a long-lasting effect on both the painter and the poet. How can one avoid thinking that the increasingly grave tone in their work was not due to the course of events. However, work was the only remedy in these bitter circumstances—as Balthus suggests in a letter to Jouve sent in June 1941.

Champrovent, tuesday evening
My dear Pierre,
Today it is exactly one year since we left Paris; a horrible nightmare, from which—against all expectations—we both have emerged safe and sound. I was thinking about you especially this evening. It is a year since we last saw each other! A year in which I have been severed from your good—and for me, so rich—friendship; such a separation is particularly painful in a period like this, and at times has been for me the equivalent of an amputation. I miss you terribly, my dear friend—how much I would have to talk to you about! Alas, we are reduced to letter-writing—a medium which, for my part, I am far from proficient in. You have sent me a sizeable œuvre, an admirable source of nourishment; but how can I myself make a present to you?
Having come back alone to Champrovent a month ago, I finally managed a period of concentration and work; I managed to get back to my previous ten hours a day—and I have shut myself off in a state of total isolation and ignorance of outside events, in order not to lose a moment of this precious state of grace. The fortress of the soul and spirit should have walls five meters thick. When I left Bern, Monsieur Hoo, whom I had met a number of times without realizing the connection, was working actively and with devotion to resolve the question of your permit—as were Ramuz and Mermod. Things seem to be going in the right direction. We assiduously searched out an apartment for you, but for the moment there is nothing habitable. Bern is "overrun" [English in the original] by the Diplomatic Corps. I also stopped off at Lausanne, where I saw Bardet and Saelsi, whose anxiety at not seeing Blanche I was able to calm a little. Where is he now? I am counting on your presence here a lot. I can't wait to see you again. Drop me a line.
I embrace both of you
Balthus

I tried to telephone you three weeks ago, but after having waited for an hour and a half to be put through, I finally gave up.

[address]
Monsieur Pierre Jean Jouve
Hotel Martine
Cannes s/mer
Alpes Maritimez

Sender
B. Klossowski de Rola
Chateau de Champrovent
Saint Jean de Chevelu
Savoie

[postmark]
Chambéry
13 June 1941

In July 1941, the Jouves finally arrived in Geneva, where they would remain until August 1945. These years of exile were a period of intense creative activity for the writer (fig. 12): he would produce numerous poems (*Porche à la Nuit des Saints*, *Gloire*, *Le Bois des Pauvres*), writings on music (*Le Don Juan de Mozart*), on literature (Baudelaire), history (Danton) and painting (Delacroix and Courbet). However, none of these texts were published in occupied France.
Together with Pierre and Pierrette Courthoin, he also ran the review *Lettres,* which was published in Geneva and included amongst its collaborators Marcel Raymond, Jean-Rodolphe de Salis[41] and Jean Starobinski.
It is this review which would publish appreciation of various Balthus works—from *La Rue* and *Le Cerisier* to *Montagne* and *Larchant* (the latter described as "a medieval tower in front of the forests of the Ile-de-France, with a strange air of awaiting the misfortune that will befall the nation").[42] However, it is another text for which the painter thanks the poet in the following letter:

13. Balthus, *Le Cerisier*
[The Cherry Tree], 1940,
oil on panel.
Mr. and Mrs. Henry Luce III

Wednesday 7 July
My dear Pierre,
Thank you for the admirable piece you have just sent me—both admirable and of an urgent necessity. It must be published right away. I have an idea on that subject.
It is possible that on Friday I will be coming to Geneva. Tomorrow I will be having a word with Moos, and will decide then. Whether I want to or not, I have to organize something for my work—for reasons more material that moral, given the great needs and worries that are looming on the horizon. Otherwise I would not be in the least interested in showing paintings here. The best that can happen is that it will make them want to find faults. If there are faults, that is—but then there always are.
I embrace both of you
Balthus

[address] [postmark]
Monsieur Pierre Jean Jouve Fribourg 7 July 1943
2, Rue du Cloître
Geneva

What was this "admirable piece"? One hesitates to identify it with the article that appears in *La Nef* in September 1944. However, that may well be the most probable solution. When one looks at Jouve's text closely, one sees that it is not really connected with the exhibition at the Galerie Moos, which is only mentioned toward the end of the piece. Above all, Jouve discusses the history of his connection with Balthus, the way in which he has followed his work stage by stage, his conception of painting, his place in the history of art and the multiple meanings of his paintings. "The peculiarity, almost the unreality, in the meaning of forms within the composition—this is the most pressing point one must make about his work. The objects have been imaginatively endowed with an unusual power and role [...] In Balthus's paintings there is a lot that is invisible; indeed, the more tyrannical the visible appears, the greater the presence within the picture of the invisible."[43]
In November 1943, the Galerie Moos exhibited twelve recent paintings. The catalog preface was written by Pierre Courthion. Along with Pierre Jean Jouve, another to review the exhibition was the young Jean Starobinski, who discussed "the grave and ancient splendor" of these paintings as a response "to the catastrophe and degradation" of the world around us.[44] Like Jouve, Starobinski would show particular interest in *La Patience* [The Game of Patience] (fig. 8), which shows a young girl bent over a table as she looks to the cards for a reading of the future. "Isn't it our future as well that "patience" will reveal? And the ray of light that cuts across the painting, doesn't it herald the dawn of hope that we have so long awaited?"[45] Jouve too saw the historic significance of the painting. Such a reading was not the only one possible—given that ambiguity was one of the cardinal points of Balthus's aesthetics—but it was one that immediately struck the public of the day. "*La Patience* produces light and victory, or at least the promise of a victory over present sorrows. The profound enigma of the painting—read at various levels—gradually becomes the clear expression of our long wait; it offers a secret yet clear echo of the march of our hope. The young girl gradually becomes the suffering nation to which the young girl herself belongs."[46]
This comment is a perfect illustration of how Jouve—and, no doubt, Balthus— saw the relation between artists and external events. One did not react to events, one internalized them; "the contraction of historic into personal time," Jouve would write in discussing Rimbaud. The expression might well be applied to Jouve himself[47]—and to Balthus .
However, if the hope embodied by "L'Homme du 18 juin" (De Gaulle) also inspired the artists and intellectuals who had taken refuge in Switzerland, the road ahead of Balthus himself was still a long one—and beset with immediate difficulties. This is clear from the "express" letter he sent to Jouve at the beginning of December 1943.

Wednesday
My dear Pierre,
I am very low at the moment: bad health, problems working, serious financial worries, feelings of exile—I feel crushed by all of this, which obviously makes it even more difficulty for me to write than usual. However, I wanted to write at length to talk about *Défence et Illustration*, the very great, very dear book that I could not prevent myself from avidly drinking down at one gulp. It made me so happy, but also so sad at the memory—and re-opening—all those wounds, drawing a cry of love and anguish from me: our France, oh, our France! There are so many things in the different parts of the book, so much extraordinary lucidity and precision in the critical judgements that you make. However I am incapable at the moment of formulating my thoughts clearly, so I will have to limit myself to voicing my admira-

tion—my profound gratitude and my complete agreement. I have a mass of ideas to share with you, but my enthusiasm ["always" crossed out] breaks against the blank sheet of paper: And to stop delaying, I will send you these few poor lines.
I embrace you and Blanche
Balthus

[address]
Monsieur Pierre Jean Jouve
2 Rue du Cloître
Geneva

[postmark]
Fribourg 9 December 43

Jouve returned to Paris in September 1945, followed by Balthus a shortly afterward. There would now be many more occasions to work together. In 1950, Balthus designed the sets and costumes for Jean Meyer's production of *Così fan tutte* at Aix-en-Provence.[48] Jouve, who had published his work on *Don Giovanni* in 1942, provided an important piece for the Festival program, which would be re-printed in *En miroir* in 1952. His analysis of the opera echoes that of Balthus, who "passed six months within *Così fan tutte* before imagining, and then painting, the sets." These sets focused on "the change of objects" within a closed universe; it was a "music-box set."[49] And in the future, people would study the importance of music, of questions of harmony and dissonance, in the works of both painter and poet.

The friendship between the two men clearly became less close after Balthus settled at Chassy. Each was absorbed in his own work—particularly Balthus, for whom the years in the Morvan were amongst the most productive of his career as an artist.[50] This absorption is clear in the last letter I include here.

Chassy 29 Nov 55
My dear friends, what a sad thing is my weakness with the pen; it ends up transforming my solitude into an inaccessible afterlife. How many vain attempts I have made to get in touch with you. How many letters I have started and then abandoned. Alas, it will always be the same. And you have no idea of the terrible weight of this involuntary silence, which is becoming ever more impossible to break. It is true that I am working like a madman, often more than twelve hours a day, and when I stop I am totally drained, in a state bordering on total imbecility. What is more, as I write, the thousands of things I have to say to you just seem to disappear. Well, I am leaving for Paris around the 15 December and will spend the winter there. My exhibition opens on 1 March. So, these few lines are nothing but a sign of life from a man who is more dead than alive. I am looking forward eagerly to seeing you again, and I embrace both of you with all my affection.
Balthus

[address]
Monsieur et Madame
Pierre Jean Jouve
7 Rue Antoine Chantin
Paris 14e

[postmark]
Blisme (Nièvre)
30 November 1955

Then one day there would be the falling-out described later by biographers. However, in spite of the estrangement, Jouve would still consider Balthus the artist par excellence, whose presence can be felt at the very heart of some of the most powerful poems in his *La Vierge de Paris*. And in the interviews he granted a journalist toward the end of his life, Balthus excluded Jouve from the general contempt he felt for the literature of his day: "His poetry was as pure as his personality was complex and difficult."[51] That Jouve's writings played a role in his life is beyond doubt, just as we know that, right up to his death, Jouve kept with him the two Balthus paintings he had bought before the war.

[1] P.J. Jouve, *En miroir*, quoted from *Œuvres*, Mercure de France, Paris 1987, vol. II, pp. 1079–80.
[2] Something that has not been missed by Jean Clair, a connoisseur of the work of both. In his numerous and penetrating studies of the painter he offers many stimulating insights and suggests various different approaches: see, in particular, "Les Métamorphoses d'Eros," in *Balthus*, exhibition catalog, Musée national d'art moderne, Centre Georges Pompidou, Paris 1983, pp. 256–79; "La Clef d'or. Le rite et le mythe dans l'œuvre de Balthus," in *Malinconia. Motifs saturniens dans l'art de l'entre-deux-guerres*, Gallimard, Paris 1996, pp. 203–20, and "Le Sommeil de cent ans" which opens V. Monnier, J. Clair, *Balthus. Catalogue raisonné de l'œuvre complet*, Gallimard, Paris 1999.
[3] It was reprinted in *Balthus*, 1983, cit. and in the small volume entitled *Sacrifices*, Fata Morgana, Cognac 1986. Another shorter piece, covering some of the same paintings, appeared (without Jouve's signature) in the first issue of the Geneva review *Lettres* (January 1943). The twelve paintings included *Le Cerisier*, *Paysage à Champrovent*, *Nature morte*, *La Patience* and *Le Salon* (see below).
[4] See D. Bassermann, edited by, *Rilke et Merline: Correspondance 1920–1926*, Niehans, Zürich 1954. Rilke had already met Erich and Baladine Klossowski through Ellen Key in 1906 or 1907, during their first period in Paris (1903–14), but

then would encounter Baladine again in Geneva in 1917—see E. Buddenberg, *Rainer Maria Rilke. Eine innere Biographie*, Metzler, Stuttgart 1957, pp. 345–52 *et passim* and W. Leppmann, *Rilke: Sein Leben, seine Welt, sein Werk*, Scherz, Bern and München 1981, pp. 277, 390 *et passim*.

[5] *Hôtel-Dieu* was distributed in France by the Librairie Ollendorff, named on the title page—together with the information: "Imported from Switzerland".

[6] See S. Rewald, *Balthus*, exhibition catalog, The Metropolitan Museum of Art, New York 1984, pp. 12–13. Jouve wrote three pieces about Masereel: in *La Nation* (9 December 1917), in *L'Aube* (1 November 1918) and in *L'Humanité* (6 November 1921), for the latter traveling to see Masereel's Paris exhibition of 1921. The last collaboration came in 1924: Masereel did a portrait of Jouve for the collection *Prière* (Stock) as well as the design of the cover.

[7] Letter from Merline to Rilke (27 October 1924): "I forgot to tell you that Bonnard was here a fortnight ago. He said some useful things about my paintings and was extraordinarily complimentary! I gave him a water color of mine that I was really pleased with, and will get something of his in exchange. What was really touching was the keen regard in which he holds the paintings and works of Baltusz. He was delighted with what he was doing, and the other day—Saturday— he had Baltusz go to Druet's so that he could show them to Maurice Denis. Baltusz has a nice account of all this. He says that it was a veritable exhibition at Druet's, with Bonnard saying all the time: 'Well, my fine Baltusz, here you are on exhibition at Druet's. I wonder what he is going to ask you!'." *Rilke et Merline: Correspondance*, cit., pp. 521–22.

[8] Jouve had been very close to Zweig since 1919 and dedicated to him his *Heures. Livre de la grâce*, published in January 1920 by Kundig in Geneva (with a woodcut by Masereel).

[9] *En miroir*, cit., vol. II, p. 1068.

[10] *Ibidem*, pp. 1068–69.

[11] See D. Leuwers, *Jouve avant Jouve ou la naissance d'un poète*, Klincksieck 1984.

[12] *En miroir*, cit., vol. II, p. 1164.

[13] I published this letter for the first time in 1972, in *Cahier de L'Herne* n.19, dedicated to Pierre Jean Jouve, pp. 116–17. It re-appeared in R.M. Rilke, *Œuvres* III, *Correspondance*, edited by Philippe Jaccottet, Seuil, Paris 1976, pp. 585–86.

[14] *Les Lettres*, 1952, special issue on Rilke, p. 235.

[15] *Ibidem*.

[16] After a fourth round of voting, the Prix would be awarded to Maurice Genevoix for *Raboliot*.

[17] *Les Nouvelles littéraires*, 26 December 1925.

[18] *Le Figaro*, 12 January 1926.

[19] *Mercure de France*, 1 March 1926.

[20] *La Nouvelle Revue Française*, 1 March 1926.

[21] *Rilke et Merline: Correspondance*, cit., pp. 545–46

[22] In the translation of the unpublished manuscripts the original punctuation has been maintained.

[23] *En miroir*, cit., vol II, p.1165

[24] *Ibidem*, p. 1076.

[25] *Le Monde désert*, Œuvres, vol. II, pp. 249–50.

[26] *Balthus*, 1983, cit., p. 57.

[27] The first edition of *Défense et Illustration* containing these texts was published at Neuchâtel by Ides et Calendes in 1943. he second edition (Charlot, Paris 1945) had this dedication: "To Balthus, a great painter who is sharing this exile." When, in 1957, Jouve reprinted some of these essays (Baudelaire, Delacroix, Meryon and Courbet) in the Editions du Seuil, volume *Tombeau de Baudelaire*, the dedication was omitted.

[28] P.J. Jouve, *Commentaires*, A la Baconnière, Neuchâtel 1950, pp. 32–33.

[29] See the chapter in *En miroir* entitled "L'Inconscient et la forme."

[30] Text from *La Nef*, in *Balthus*, 1983, cit, p. 57.

[31] A. Artaud, *Œuvres complètes*, Gallimard, Paris 1961, vol II, p. 248, which is also published in *Balthus*, 1983, cit.

[32] See S. Colle-Lorant, "Balthus, décorateur de théâtre," in *Balthus*, 1983, cit., pp. 314–27.

[33] *Balthus*, 1983, cit., p. 57.

[34] *Œuvres*, vol. II, p. 1068.

[35] *Ibidem*, p. 1223.

[36] This preface to the Pierre Emmanuel collection was then reprinted in *Commentaires*, cit., p. 77.

[37] *Ibidem*, p. 78.

[38] *Lettres*, January 1943, taken from in *Balthus*, 1983, cit., p. 55.

[39] *Balthus. Les méditations d'un promeneur solitaire de la peinture*, conversations with Françoise Jaunin, Bibliothèque des arts, Lausanne 1999, p. 44.

[40] Unpublished letter from Pierre Emmanuel to Pierre Jean Jouve, 15 November 1940.

[41] See his two accounts in "Les Années d'exil," in the *Cahier de L'Herne* dedicated to Pierre Jean Jouve (1972, pp. 172–80) and "Une Amitié," in *Balthus*, exhibition catalog, Lausanne 1993, pp. 61–69.

[42] *Lettres*, January 1943, taken from *Balthus*, 1983, cit., p. 55.

[43] *Ibidem*, p. 58.

[44] *Ibidem*, p. 69.

[45] *Ibidem*.

[46] *La Nef*, September 1944, *Ibidem*, p. 59.

[47] As is very well argued in Jean Starobinski's "Introduction à la poésie de l'événement", which also appeared in the first issue of *Lettres* and was then republished in *La Poésie et la guerre. Chroniques 1942-1944*, Minizoé, Geneva 1999.

[48] See S. Colle-Lorant, *op. cit.*, pp. 320 ff.

[49] *En miroir*, cit., pp. 196–97.

[50] See S. Rewald, "Balthus à Chassy," in *Balthus. Un atelier dans le Morvan, 1953-1961*, exhibition catalog, Dijon, Musée des Beaux-arts, 1999.

[51] *Balthus. Les méditations...*, cit., p. 121.

Così fan tutte by W.A. Mozart,
produced as part of the
Aix-en-Provence Festival, 1950.
Conductor: Hans Rosbaud
Director: Jean Meyer
Sets and costumes: Balthus
Principal characters: Suzanne Danco
(Fiordiligi), Emmy Loose (Despina),
Eugenia Zareska (Dorabella),
Leopold Simoneau (Ferrando),
Renato Capecchi (Guglielmo),
Marcello Cortis (Don Alfonso)

During the Christmas holidays 1947, the Comtess Jean Pastré, an imaginative and sure-eyed patron of the arts, invited Gabriel Dussurget, then Administrator of the Ballets des Champs-Elysées, to visit her home in Marseilles. An opera fan of great intelligence, the countess was a non-conformist, a sort of hippie *avant la lettre* with a rather striking physical appearance: "she looked like an unmade bed,"[1] Gabriel Dussurget liked to say. Attached, above all, to the delights of the intellect and the full expression of feelings, she was a woman of unfailing generosity, and during the war had opened her villa in Marseilles to numerous artists in difficulty who were fleeing from occupied France. These included Pablo Casals, Samson François and Edith Piaf; and each discovered Pastré's home to be "a fairytale palace that had something of the caravan about it."[2] The countess was also adored by the local people of Marseilles: "when she passed by, people practically genuflected!"[3] With the arrival of peacetime, she was soon aware of the dawning of a new age of tourism, and wanted to do something to contribute to the cultural standing of her city. Her idea was to set up a festival of music, and this was the project she outlined to Gabriel Dussurget. However, he was not particularly attracted by the large Mediterranean port, and reacted to her proposal without enthusiasm. At which point she suggested Aix-en-Provence; and after one visit to this museum town, they reached an agreement: the city of Consul Sextius and King René, with its seventeenth- and eighteenth-century additions, struck both of them as wonderful. However, they still had to find somewhere with good acoustics which could take a stage and an audience. That was when they discovered the courtyard of the Archbishop's Palace in the very heart of Aix.

Having completed the first stage in the project, they found that the second step forward was no less arduous. True, there was the total and unconditional support of the Comtess Jean Pastré; but where were they to find the financial backing necessary to set up such a Festival? At that time, all of France's casinos received tax exemptions for the organization of cultural events, and Roger Bigonnet, the director of the Aix-en-Provence Casino, fell in love with the idea of the Festival, asking Dussurget to draw up details of a program and budget. A short time afterward Dussurget suggested Mozart, to be performed by young musicians who were still not very well known; however, some time before the opening of the Festival Roger Bigonnet would say to him: "You know, I think we should do an opera, because the program as it stands is a bit thin."[4] And thus, thanks to the enthusiasm and daring of the backers, and to the hard work of the musicians involved, the Festival International de Musique d'Aix-en-Provence opened in July 1948 with a production of Mozart's *Così fan tutte*, conducted by Hans Rosbaud of the Munich Philarmonie.[5] The opera was directed by Marisa Morel, of the Milan Scala, who also sang the role of Despina, whilst the orchestra was made up of "les Cadets du conservatoire"—talented youngsters who had yet to complete their training—the chorus comprised members of the local Campra d'Aix, and the costumes and sets were designed by Georges Wakhévitch, who created a raised podium in the court of the Archbishop's Palace set against a carved backdrop of a fountain. The quality of the music made the production a triumph: "The first Festival went very well. A miracle! They even made some money!"[6] Gabriel Dussurget, the artistic director of the Festival, then had the idea of staging Mozart's *Don Giovanni* for the following season, because Roger Bigonnet wanted to "make a big splash." Together, they got in touch with the poster artist and theater decorator Adolphe Mouron, known as "Cassandre," who said: "I'd be happy to do the sets for *Don Giovanni*, if I can also do the theater."

Cassandre drew up plans and directed the construction work. Taking as his model the temporary open-air theaters of the Renaissance, he created a hall of around 1,700 seats in a covered structure of tubular scaffolding which could be dismantled and assembled every year. This lightweight structure was then faced with panels of wood, in a grain similar to that of the local stone, which served to integrate the theater as part of the Archbishop's Palace. The theater posed two problems for the designer: on the one hand, the stage was not very deep, and on the other, there was very little space between the floor and the ceiling. To resolve these difficulties, A.M. Cassandre designed sliding sets that rolled into the wings of the stage.

A.M. Cassandre's sets for the 1949 production of *Don Giovanni*—like Balthus's sets for the 1950 *Così fan tutte*—were made in Paris by Laverdet et Treiif. In their immense studios at the Porte des Lilas a whole team of set-painters worked on the panels. First the canvas was treated with a special paint/size, prepared on the spot; made up of crushed bone mixed with

1. Aix-en-Provence, the theatrical company of *Così fan tutte* posing on the stage. Balthus is sitting in the first row, third from the left

2. Balthus and Cassandre (in the foreground) during the rehearsals

pigment; heated, this had to be applied very quickly because it was rapid-drying. The sets were then sent on to Aix-en-Provence, where they were put in place and then retouched by the artist, using the same technique. One should point out that for almost one quarter of a century, the Aix-en-Provence Festival continued to use A.M. Cassandre's sets for its productions of Mozart's *Don Giovanni*, which seemed never to date, thanks to their stylized forms and classical design.

But who was Adolphe Mouron, known as Cassandre? A small, lively-witted man, he was of a very high-strung temperament, and was as demanding with himself as he was with his assistants. The poster artist Savignac, a friend and former pupil, describes him in these terms: "Cassandre was a man who worked himself into the ground trying to do everyone else's job. He couldn't stand it when someone did not push himself to the limit. People and things had to give of their best. He did; he expected other people to do the same. The incomplete, the unfulfilled, left him feeling ill. He was obsessed with perfection. He learned all there was too know about his various crafts, so that he would never have to accept it when someone said: 'what you ask is impossible...' And when he could produce the material proof that what he wanted was possible, he didn't do it with any sense of triumph. He was simply happy; because doing so was important for the job he had undertaken. Cassandre understood things quickly and completely: set designs, costumes (when he started to make them, very quickly he could have taught a thing or two to the very best seamstresses), direction, advertising, even the printing [...] He was that demanding. I'm sure that there have been few people who were as rigorous as he."[7]

Born in Kharkov in the Ukraine during the days of the last Tsar (1901), he fled revolution and war with the rest of his family in 1914, and after settling in Paris he had, at a very early age, to set about earning his living. He became a poster painter, a craft that is now dying out. Soon, the modern style of his graphics made a solid name for him in the field of advertising; and in 1924, his poster of *Le Bucheron*, which was put up all over Paris, established an unchallenged reputation. His simplified forms, use of close-ups and the expressive power and elegance of his draftsmanship made him known in Europe and the United States. In the flurry of the roaring Twenties and beyond, he produced such universally-recognized posters as the advertisements for *Intrans* (1925), *Le Chemin de fer du Nord* (1926), *Dubo-Dubon-Dubonnet* (1932), *La Normandie* (1935) and numerous others.

It was through the costumier Vera Karenska that A.M. Cassandre met Balthus in 1935. The previous year she had worked for both of them: for Balthus she had produced the costumes for *Les Cenci*, Antonin Artaud's adaptation based on texts by Shelley and Stendhal, which was put on at the Folies-Wagram in May 1934; for A.M. Cassandre, those for Giraudoux's

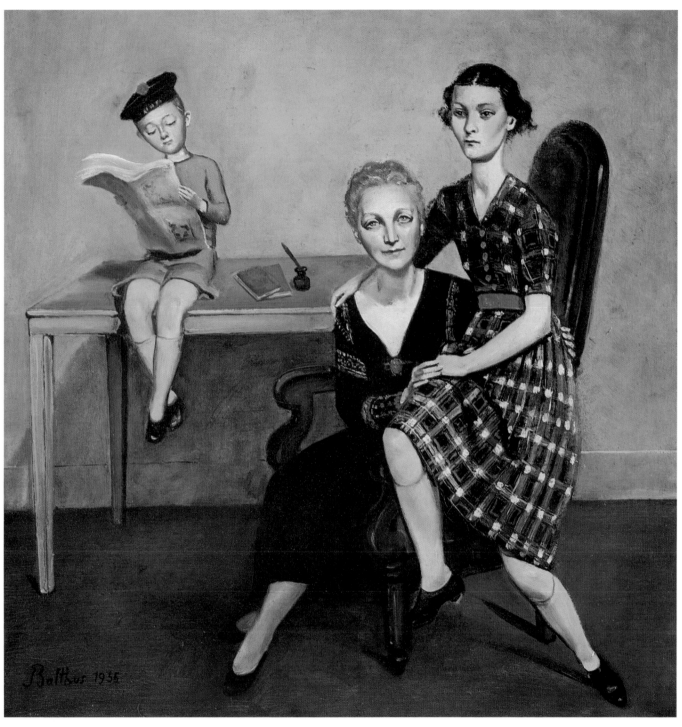

3. Balthus, *La Famille*
Mouron-Cassandre
[The Mouron-Cassandre Family],
1935, oil on canvas.
Private collection

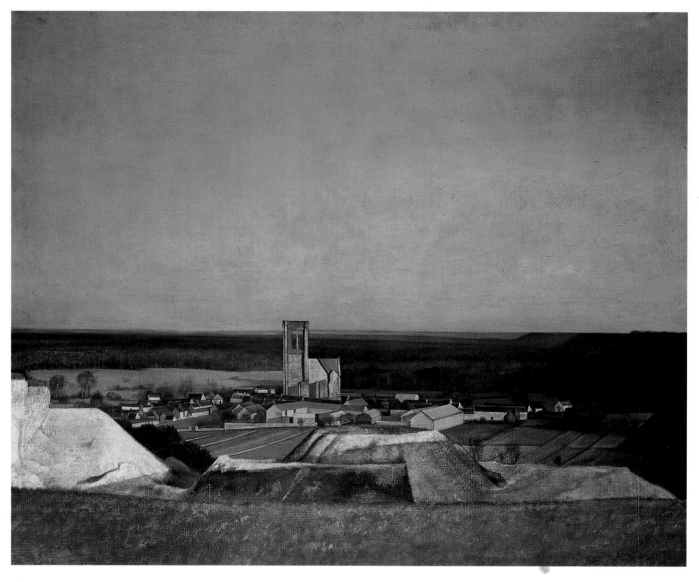

4. Balthus, *Larchant*,
1939, oil on canvas.
Private collection

Amphitryon 38, put on at the Théâtre de l'Athénée in October 1934 under the art direction of Louis Jouvet. The former piece was as much a cause of scandal and outcry, as the latter was an unqualified public success.

However, Balthus himself says that his first real meeting with A.M. Cassandre came in Bern,[8] when both men were there on holiday (for centuries, this Swiss city had been the fiefdom of the family of Balthus's future wife, Antoinette de Watteville). From the very first, a deep and sincere friendship arose between the two men, and was to last until A.M. Cassandre's death in 1968.

Cassandre was, in fact, a perfectly forthright person, who either loved or hated those around him. He had unlimited admiration for Balthus's art, which he defended against attacks of all sorts. When they met, the painter was a young man of just 27 years old, yet Cassandre immediately recognized the genius of a person whose fame would continue to grow while his own reputation would peak in the period between the two world wars and then go into a long decline (the irony is, that having once been totally forgotten, A.M. Cassandre is now considered one of the great "inventors" of the twentieth century).[9]

In the very early days of their acquaintance A.M. Cassandre commissioned Balthus to paint a family portrait, which would remain in his home until 1972. The work shows the artist's first wife Madeleine[10]—a widow twice-over and twelve years his senior—whom he had met in 1923 and married shortly after. Balthus depicts his characters in a moment of relaxation, dividing the composition into two parts. To the left is the very young Henri, wearing a sailor's

5. Carmen Baron's "Salon"
in a water color
by Raymond Mason, 1967

cap and studiously reading his newspaper while perched at the top of a table;[10] to the right, the composition is balanced by the group of female figures: Madeleine and her daughter Béatrice sitting on the same armchair. The mother, painted face forward, tenderly rests her hand on the young fifteen-year-old, who is long-limbed and has a rather stubborn look on her face (Balthus manages to capture here that expression which one sometimes sees in children who have grown up too quickly). The painting, therefore, shows Madeleine situated between these two silhouettes; and in later large-scale compositions, the artist would again use this tactic of stylistic incongruities.

A.M. Cassandre also bought another admirable painting, the 1939 landscape of *Larchant*. When did he buy it? Before or after the war? Whatever the answer, this is one of those classic masterpieces of painting that exalts the union of sky and earth. In the plain outside Nemours, the distant bell-tower of the medieval church rising above the village of Larchant is captured in a true moment of grace. Amidst these fields stand the grandiose traces of those heroic times when pilgrims came here on foot in the hope of a miraculous recovery from madness. This bell-tower, which symbolizes both madness and destruction, was for many years a source of inspiration for the painter A.M. Cassandre. In the sixties, as he was living in a small apartment, he had to part with it, and thus for three or four years I had the chance to live with this magnificent painting before my eyes. It cast its light in the Rue Varenne home of Carmen and François Baron, where it was hung in the salon A.M. Cassandre himself had designed, with walls done in saffron-yellow size over which had been added a fine layer of brushwork in orange. This was a miraculous background against which to hang paintings—especially the landscape of *Larchant*, given that the warmth of the color enhanced the blue of the sky in the picture.

A.M. Cassandre and Balthus shared a love of painting, an appreciation of craft and a passion for the music of Mozart—so it was natural that the former should, in 1949, suggest the latter to Gabriel Dussurget as a possible set designer for the Aix's new production of *Così fan tutte*. "Music plays a very important role in my life. I have a record collection that comprises numerous recordings of both contemporary and classical music; and I can assure you that Mozart is my favorite composer. For the sets of *Così fan tutte* I worked with the score

6. Balthus, *"Così fan tutte,"*
Etude pour le décor de l'acte I,
scène 1 ["Così fan tutte," Study
for the set of act I, scene 1], 1950,
water color on paper (cropped).
Private collection

7. William Hogarth, *A Reception*
at Sir Richard and Lady Child's,
1728–31, oil on canvas.
Philadelphia, Museum of Art,
John H. McFadden collection

for six months; in the end I knew every note," Balthus revealed to Janine Warnod in 1961.[11] And that opinion of Mozart would remain with the painter right up to the end of his life. "You know, one of my greatest masters was Mozart. Now, Mozart is full of humour; and humour does not exclude anything. It no more rules out gravity and profundity, than it does lightness and delicacy. All of it is there in Mozart. There is something Shakespearean about the range of his characters and the variety of atmospheres. Mozart is a world in itself. And that is what, in my own pretentious way, I aspire to," he told Françoise Jaunin in 1999.[12] As Balthus himself commented, what he found most seductive was the comedy of illusions within the opera (which, it is thought, was actually commissioned by the Austrian emperor Joseph II, and was first performed in Vienna on 26 January 1790; the first Parisian performance being on 28 January 1809).

The misogynist intrigue of the plot is designed to expose female inconstancy. A wager over their beloveds' virtue made between two lovers and a cynical philosopher leads to a double infidelity, with the adoption of disguises undermining established values and roles. In effect, the opera is a game of masks in which disguise is king and all identities are questioned. Who is who? Who is misleading whom?

Mozart and his librettist Da Ponte expose the fragility of love, whilst the music itself exalts love. However, as Pierre Jean Jouve puts it in the program notes for the third Aix-en-Provence Festival: "The marriage of pleasure and heartbreak is, from a musical point of view, an inebriating mix. Cruel truths are bathed in a wash of Music that blunts their sharpness. By rendering events implausible, Music gives truths the air of dream, makes them lie as dreams do." Totally immersed in the music of *Così fan tutte*, Balthus designed sets that translate this poetry of unreality by using visual illusions to underline the implausibility of the intrigue within the plot. This play on what is credible and believable sometimes leads him to multiply the scenes on stage, providing *trompe l'œil* "doubles" for the actual characters.

"In accordance with the original libretto, the action is set in Naples; and in the background is a smoking Mount Vesuvius. The backdrop that figures in numerous scenes conjures up the port with its lighthouse and sailboats. The first set (act I, scene 1) is the interior of an inn; and contrary to the Viennese tradition, Balthus's offers a large Roman-style room, with a terrace looking out over the Bay. The central bar of the café is flanked by two side rooms that also overlook the sea. To accentuate the unreality of the wager made by Don Alfonso, the painter also includes some *trompe l'œil* figures, who "mingle" with the singers on stage: to the left are two adolescents seen from the back, casually embracing each other as they look out of the window; in the center is the innkeeper himself, standing by his counter as he looks straight out into the room. The result is that the interior and exterior are closely interwoven, while real singers and painted figures all take part in the farce. In the next scene—as the lovers are supposed to depart for the wars—the same type of fiction is maintained by having a *trompe l'œil* horseman, saber in hand, roll across the stage as if fixed on a conveyor belt. These illusionistic effects in some ways herald the Pop Art of the sixties—particularly the work of the American painter Kienholz, who to achieve such effects would use veritable "ready-mades" in different types of environment.

The division of the interior sets into three different parts (tavern, boudoir, salon) suggests a triptych. In the above-mentioned first scene one should note that the style of the upper part of the bar draws on the paintings of the eighteenth-century English artist William Hogarth. The winged, circular face that hangs over it strangely recalls the way the table is rendered in the painting *A Reception at Sir Richard and Lady Child's*.

From act I, scene 3 onward, all Balthus's sets evoke the charm and insouciance of the eighteenth century. The architecture of Fiordiligi and Dorabella's boudoir suggests a late-eighteenth-century room in a chateau, decorated with garlands of flowers. It serves as the setting for that extravagant scene in which Guglielmo and Ferrando return disguised as Albanians.

Act I, scene 4 is when the two aspiring lovers, faking despair at the virtuous resistance of the ladies, pretend to have taken poison; it is set in a garden that has something of a landscaped English park, where—as in a painting by Fragonard—the wilds of nature have been domesticated. The ruins and the Classical temple reflect the taste of the day for a rediscovered Classical Antiquity. In this way, Balthus moves away from the usual German tradition for this

8. Balthus, *"Così fan tutte,"*
Etude pour le toile de fond de l'acte I,
scène 3 ["Così fan tutte,"
Study for backdrop of act I,
scene 3], 1950, water color
and pencil on canvas.
Private collection

scene, which involved a French-style garden complete with fountain and *rocailles*.

In act II, scene 2 the would-be seducers arrive in a boat, the prow of which is decorated with a stylized monumental Sphinx. This surprising apparition evokes the fairy-tale atmosphere that Watteau conjured up in his *Embarquement pour L'île de Cythère.*

These sets of boudoir, garden and boat create an atmosphere of poesie which suggests the ultimate success of the seduction. In the garden, Dorabella will yield to the pleas of Guglielmo; and in the next scene—set within the palace—Fiordiligi will weaken, touched by the amorous ardor of Ferrando. For this incident—act II, scene 3—Balthus divides the salon into three soberly decorated parts. To the side, draperies outline the doors, whilst over the balcony, allegorical *putti* observe the development of the action. The central part of the set is occupied by mirrors placed facing each other, to further underline the theme of the double which is so characteristic of this opera.

For the final scene, Balthus produced a set that seems quite straightforward: the Bay of Naples. At the beginning of the opera, the landscape was half-hidden, now it is revealed in its entirety. This outside setting for the scene again goes against tradition, because the libretto describes a richly decorated room as the backdrop for the parody marriage and the unexpected "return" of the lovers.

Balthus's name was unknown to the public at large; and when, at the first full rehearsal, the curtain went up on the act I, scene 1, the conductor Hans Rosbaud was dumbstruck. Horrified, he warned Gabriel Dussurget: "I will not conduct in front of sets like this." At which point, the director Jean Meyer added: "Neither will I. I won't direct." "Go!" replied Gabriel Dussurget, the festival's artistic director. "I am the director. I can do what I like." Jean Meyer walked out, and the baritone Marcello Cortis, a marvellous musician, offered his services: "Well, I'll be the director."[13]

The press were not much kinder about these sets by an unknown artist; though it is interesting to note that when they were used again—in Paris in 1963—they were greeted with unanimous enthusiasm (after, that is, Balthus had been appointed Director of the Villa Medici and had received a lot of press attention). The press reception of the sets at the original Aix production was varied. The reviewer from *Ecoutes* wrote (18 August 1950): "[...] The sets are unfortunately by Balthus. With the exception of the café and terrace giving on to the Bay of Naples, all the rest is rather heavy and grim. The interiors of the houses have the air of a rather

sad spa-resort boarding-house, whilst the park looks like a pupil's exercise in the design of tapestry..." Jean Hoyaux in the *Revue des Hommes et des Mondes* went even further: "[...] It is unfortunate that Balthus's sets do not reflect the wit of Mozart's work [...]. These dark purples and acid greens would go wonderfully with Chabrier, but here don't correspond to anything." And in *Témoinage Chrétien*, Antoine Goléa said: "[The sets] would have pride of place in a museum of horrors."

Fortunately not everyone was of the same opinion. In *La Revue de Paris*, Denise Bourdet liked "the sets, of a imagination and irony that is close to the exquisite touch of the score itself." Georges Auric was equally charmed: in *France-Soir* (13 August) he wrote of "the adorable, tender and moving sets by Balthus." In *Le Monde* (22 August) Yves Florenne came to the defence of the painter: "But doesn't M. A.M. Cassandre show his imaginative fancy in the choice of M. Balthus? The former was happily inspired to lend his theater and his stage machinery to the latter, who has created sets for *Così fan tutte* that are Baudelairean in their curious mixture and blend of the senses. In the filigree of the music one can hear the same soft, sharp and melting harmony of mauve, pink, almond and vanilla—which is almost as flavorsome to the palate as it is to the eye. These lines, colors and accords have something of the kaleidoscopic; at one and the same time they seem to be balls of colored glass and rather unique sorbets—the sort of sorbets one sees reflected *ad infinitum* in the mirrors of Café Florian in Venice."

This praise must have delighted Cassandre. Rather embittered by certain people's failure to understand the sets, he confessed his disappointment to his friend Lola Saalburg (21 July 1950). "I am happy that you can enjoy the benefit of this wonderful *Così*, which has cost Balthus and myself so much blood and tears. But the public must not know that. And wasn't our dear Mozart thrown into a pauper's grave? It's all the same. We live in an odd age, where the true artist has nothing left to see or to do. I am also happy that you saw *Don Giovanni*, which has 'aged' well, in spite of a 'regrettable' Donna Anna—to put it mildly (but I am not responsible for that, as you know). The others are better than last year. I don't know yet when I will leave here nor where I will go. Perhaps to the Morvan? After so much fuss and so many hurtful words, I want silence... Balthus is in the same situation as myself. What is more, his malaria knocks him flat, and means he hasn't even got the energy to get in a car."

However, with his feline gait, Balthus slipped away from Aix for Megève—but not alone! Like Mozart's own Don Giovanni, he took the charming Dorabella with him, whom he then abandoned to go back to Laurence Bataille. As always, Balthus would remain the master not victim of enchantments.

As for Gabriel Dussurget, he was preparing next year's season. But let's look a moment at his role in the creation of a Festival for which he was the driving-force up until 1972. He went round all the music festivals, traveling to Milan and Salzburg in search of young musicians, to discover new voices that were warm in timbre and rich in expression. "I went just about everywhere and looked for young singers. I had a conception that was a bit different from the traditional one. The traditional idea of opera was very beautiful, from the point of view of the music, but it was also a bit ridiculous. Donna Anna was always a fat lady; generally, Don Giovanni was an oldish man. Donna Anna was the same age as Zerlina. Don Giovanni would never have raped her if she was fat. So I set myself the aim of producing a Festival where there would be youth, promising new talent that was as yet unknown. It almost became a principle: I would only take them if they weren't known. I did the opposite of everyone else. If they had a name, I didn't hire them. If later on I took singers who had a name, that was because I couldn't find the right voice elsewhere."[14]

These young performers would also do works by composers who would show themselves to be great innovators. "I did a lot of Olivier Messiaen and Poulenc, all the young French composers. Monsieur Boulez had his debut in Aix, with *Le marteau sans maitre*; Maurice Jarre had his debut here as a 'serious' composer. I had everyone to play [...] Aix-en-Provence is the result of thirty years of leisure; I have gone through my life as if it were a stream which flows exactly where it wants to. I did what was a pleasure for me; I wasn't thinking of becoming someone."[15]

All those who have had anything to do with Gabriel Dussurget are grateful for his perspicacity in finding young artists who could work together and offer each other mutually en-

9. Balthus, *"Così fan tutte," Etude pour le toile de fond des actes I, scène 4, et II, scène 2, version dédinitive* ["Così fan tutte," Study for backdrop of acts I, scene 4, and II, scene 2, final version], 1950, water color and pencil on canvas. Private collection

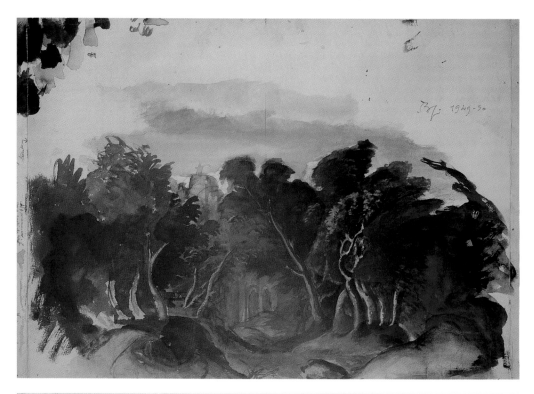

10. Jean-Honoré Fragonard, *A Party at Rambouillet (L'île d'amour)*, ca. 1775, oil on canvas. Lisbon, Fundação Calouste Gulbenkian-Museu

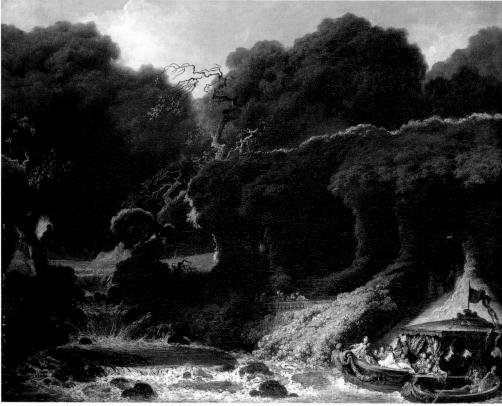

11. Balthus, *"Così fan tutte,"*
Etude pour l'acte II, scène 2
["Così fan tutte," Study for act II,
scene 2], 1950, water color
and pencil.
Private collection

12. Antoine Watteau,
Embarquement pour l'île
de Cythère, 1717, oil on canvas.
Paris, Musée du Louvre

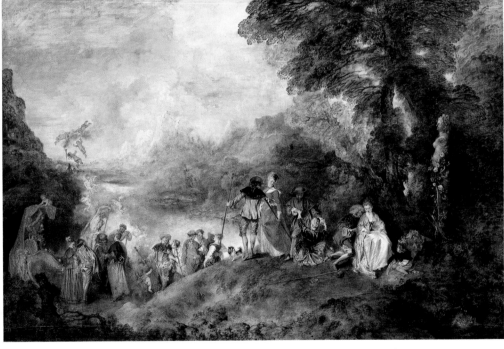

riching experience. Fresh out of the Madrid Conservatoire, Teresa Berganza was just twenty years old when she took the role of Dorabella in the Balthus-designed Aix production of 1961. She still remembers the advice and tips Marcello Cortis gave her on the ways to play her role.

And you might ask: What became of the Balthus sets? After putting on that production of *Così* in 1953, 1955, 1957, 1959 and 1961, the Festival sold off the sets to the Opéra Comique in Paris. They were then used for three performances in the Salle Favart in 1963, and thereafter all trace of them is lost.

That 1963 production saw Elisabeth Schwarzkopf in the role of Fiordiligi; and that Grande Dame of Mozart opera, imbued as she was in the Vienna tradition, rebelled violently against the suggestions put forward by Marcello Cortis's widow, who was director of the production. She also considered the whole production rather too provincial for her, a threat to her standing as an international singer. As a result, she made rather impetuous declarations to the press, and even expressed the wish to suspend performances; but in the end the program went ahead unchanged. However, the Balthus sets no longer had the same effect as previously; the press now talked about them as works of painting. For example, *Paris-Presse L'Intransigeant* (7 February 1963) commented on "Balthus's admirable sets, which were designed for the open-air but which sit so well in the Salle Favart."

The painter was not in Paris to enjoy his success. He was in Rome, where the pupils of the Villa Medici—and an even larger design project—awaited him.

A devotee of the infinitely beautiful, he might well have made Gabriel Dussurget's comment: "I prefer the faults of the young to those of the old." And in the same way, he seems always to have lived by the advice which Dussurget gave the young Teresa Berganza: "You must always believe in yourself. Don't listen to anyone. No-one but yourself. If you do something out of love, it will always be good."[16]

And in conclusion, let's hear more of what Balthus himself had to say about Mozart. "I would like my painting—just like Mozart's music—to have a structure that strikes the public as familiar and yet each time produces an uncanny effect. His works have everything: a passionate character that places them above lived experience, while at the same time they are very close to real life and real feelings. This paradox produces a shock so intense that it makes Mozart's work unique. He is the Shakespeare of music."[17]

[1] G. Dussurget, "Mémoire du siècle," *France Culture*, 8 September 1996.

[2] E.C. Roux, *Les premiers pas du Festival d'Aix-en-Provence*, France Musique "Les greniers de la mémoire," 11 June 2000.

[3] G. Dussurget, *op. cit.*

[4] *Ibidem.*

[5] Hans Rosbaud conducted *Così fan tutte* at Aix-en-Provence in 1948 (sets by G. Wakhévitch) and 1950, 1953, 1955 and 1957 (sets and costumes by Balthus).

[6] G. Dussurget, *op. cit.*

[7] R. Savignac, *Savignac affichiste*, Robert Laffont, Paris 1975, p. 99.

[8] Comment made by Balthus (January 2001).

[9] For more on the man and his work, see S. Lorant, *A.M. Cassandre, affichiste*, doctoral thesis presented at Paris University I in 1982, H. Mouron, *A.M. Cassandre, affiches, arts graphiques, théâtre*, Skira, Genève 1985, and *Idem*, *A.M. Cassandre*, Shirmer-Morel, 1991.

[10] Madeleine, daughter of the Paris industrialist Richard, who invented the taximeter, was the widow of the two Cauvet brothers, by whom she had had four children.

[11] J. Warnod, *Journal musical Français*, 6 July 1961.

[12] Balthus, *Les méditations d'un promeneur solitaire*, entretiens avec Françoise Jaunin, Bibliothèque des Arts, Lausanne 1999, p. 98.

[13] G. Dussurget, *op. cit.*

[14] *Ibidem.*

[15] *Ibidem.*

[16] *Gabriel Dussurget*, program by Ariane Adriani, "Musiques au coeur," France 2. Broadcast 13 October 1996 at 11.40pm.

[17] C. Carrillo de Albornoz, *Balthus*, Éditions Assouline, 2000, p. 20.

"The Landscape Is Very Chinese at The Moment…"
The Influence of Chinese Painting in Balthus's Landscapes

Three major genre types clearly predominate in Balthus's painting: the still life, the human figure and the landscape. While his paintings of the human figure are normally imbued with an atmosphere that is dream-like, erotic or anguished, and his still lifes are often sensual, allegorical or enigmatic, his landscapes depict a world immersed in absolute silence and deep calm; the feeling they generate most often is one of peace and well-being. Take his *Paysage de Monte Calvello* (1979), for example. The sky is slightly grey and misty—it is difficult to say what time of day it is—and the mountain, painted in pale and carefully-nuanced colors, is bathed in an even light; with no chiaroscuro or clearly perceptible volumes, it seems to have no material weight at all. And this airy lightness of the landscape makes it into something metaphysical—an atemporal image that calls to mind the Chinese "Mountain-Water" painting which Balthus loved so deeply.

It is no accident that one finds a certain Chinese atmosphere in the painter's landscapes. Attracted by China from his very childhood, Balthus has a profound knowledge of the culture of this land of dreams. He clearly feels very close to the Chinese concept of art, which he so often cites himself.

"What Matters Is the Universal…"
According to Balthus, true art should be a quest for the universal, not a manifestation of the individual. Great art, be it in the West or the East, always has this characteristic of the universal. He has said: "Art should be anonymous. The artist should not try to express himself, but to express what is universal. From this point of view, the conception behind the art of the Middle Ages or that of the Italian Primitives is the same as that behind Chinese art. Great western painting is that which expresses the same philosophy as great Oriental painting."[1] Given this starting-point, he shares entirely the Chinese conception of the relation between Man and Nature, which—to put it in simplified terms—sees Man as an infinitesimal part of the whole universe. Man has to forget himself to then totally harmonize with Nature. For an individual, artistic creation is not an end in itself but rather a means toward the universal; it is what art evokes that is important, not who it is created by. Striving to achieve this in his own art, Balthus scorns those of his contemporaries who are simply striving to invent their own personal sign and symbol, which—by definition—can only convey very limited meaning. "The painters of today paint to express their 'poisonality,' forgetting that what is important is the universal…"[2]

In Chinese thought, that invisible universality is seen as manifesting itself through visible appearances; essence and phenomena are inseparable. Indeed, at its highest level, painting must occupy the ground "between resemblance and non-resemblance"—that is, achieve a balance between substance and spirit, between the visible and the invisible. For Balthus, that achievement marks the highest accomplishment of painting. He has always emphasized the reality that lies beyond the visible. "Something else exists behind appearances, a reality that cannot be perceived directly by the eye, but which can be felt and perceived by the spirit. The Old Chinese Masters are excellent because they are able to capture this reality, and give it complete expression. As for me, all I aim to do is represent that which is behind appearances. Isn't that what painters like Fan Kuan[3] did? They didn't only paint what was in front of their eyes. Theirs is true art. What I am striving for and exploring is something that one cannot see, but something which is truly there behind the appearance of things."[4] Totally opposed to purely imitative representation, he stresses the identification between painter and subject matter. "Painting is not the simple representation of things, but an identification with them. When a Chinese painter paints a tree, he becomes a tree. He identifies with what he paints. In the West, this sense in art was lost after the Renaissance, when realist representation was introduced…"[5] And yet, the scenes depicted by Balthus are always strongly bound up with what is visible. According to him, a painter cannot invent anything of interest unless he looks at the outside world around him. Indeed, he claims, "painting occupies both the real and the imaginary at one and the same time. My figures, my landscapes or my still lifes fight to prevent fiction, which is their freedom, from disappearing into realism, which is their necessity."[6] Here the dualism in his painting links up with the eclecticism that is part of Chinese aesthetics.

This explains the importance that Balthus puts on craft, which in his eyes is essential if art is to last through time. Art is a means of attaining a spiritual goal; but it can only serve in that

1. Balthus, *Paysage de Monte Calvello* [Monte Calvello Landscape], 1979, casein tempera on canvas. Private collection

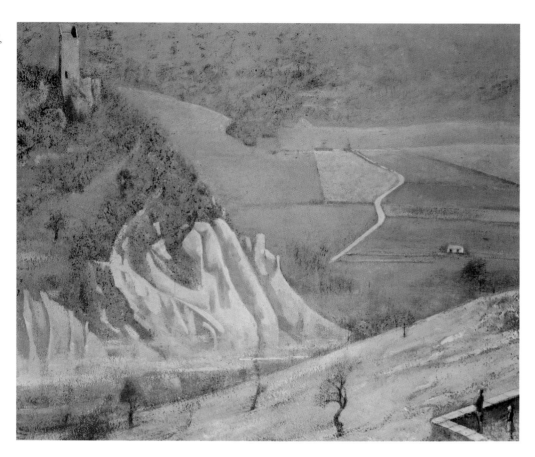

spiritual quest if it is bound by strictly aesthetic considerations. Balthus stresses that the very limits of painting should be respected. "Painting is a language, with its own specific range. If one tries to use it to express things that lie outside its domain, then it is inappropriate to the task."[7] Thus traditional craft and *métier* are the basis and premise for all new pathways of creation. Like the old Chinese painters, he has copied the Old Masters—in his case, Piero della Francesca, Poussin, Courbet, etc. Not concerned with achieving some personal style, the Chinese artists used the copy as a very important means for the apprentice to learn his craft; created or conventional forms serving as the bases from which to develop new forms of expression. Like that of the Chinese painter, Balthus's own respect for tradition is not a passive thing; it is a way of measuring oneself against the past in order to find one's own way forward. In an era when the definition of art is continually expanding, Balthus aims to reiterate the value of the solid craft of painting.

"To Make a Copy of a Fan Kuan … in Oils…"
Given these shared ideas, Balthus drew great inspiration in his own work from the "Mountain-Water" painting invented by Chinese literatis and considered the very peak of Chinese art. This is how he confirms the essential role of Chinese landscapes in the composition of one of his own paintings: "I have been told that *Le Gottéron* was bought by a Chinese-American. It is hardly surprising; that painting owes a lot to Chinese landscapes of the Song dynasty."[8] A great expert on the history of Chinese art, Balthus shows a marked preference for the landscapes of the Five Dynasties (907–960) and the Song dynasty (960–1279), the period of the landscapes by the literatis. In effect, the landscapes of this whole period have a power that is both metaphysical and real, as well as possessing an unequalled freshness of expression (later literati paintings would become more and more subjective and mannered as artists experimented with brush techniques). The art of this period may be compared to that of the Italian Quattrocento, which had been another important source of inspiration for Balthus. *Le Gottéron* (1943) depicts a Swiss mountain landscape, and in its composition there are striking similarities with Fan Kuan's famous landscape *Journey beyond the Rivers and the Moun-*

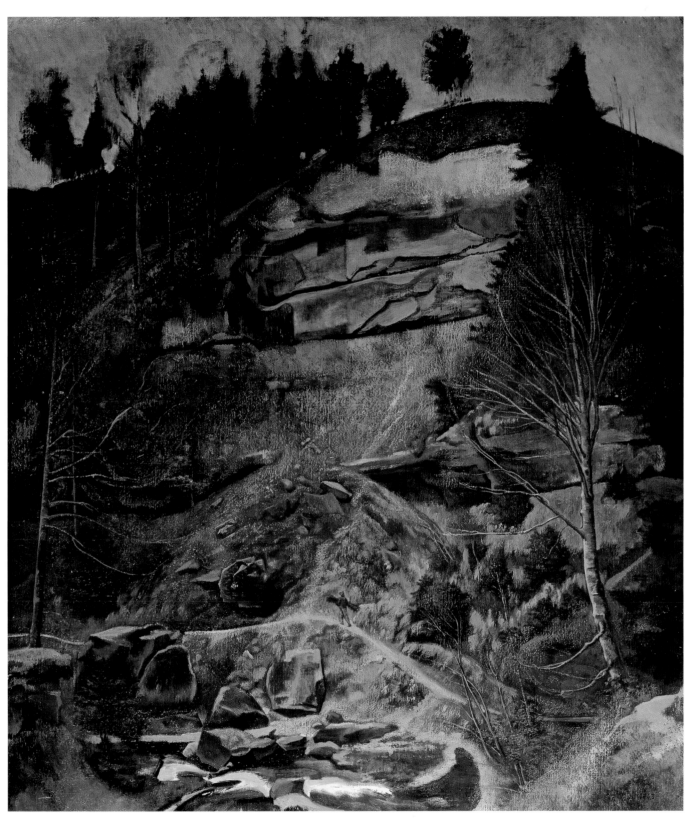

2. Balthus, *Le Gottéron*, 1943,
repainted after 1945, oil on canvas.
Tahiti, P.Y. Chichong collection

3. Fan Kuan (active 990–1030),
*Journey beyond the Rivers
and the Mountains.*
Taipei, Palace Museum

tains, one of the key works in the history of Chinese painting and a perfect example of literati-tradition landscapes. On various occasions Balthus had expressed his special admiration for this work, along with his desire to copy it using the medium of his own art: "I have a particular love for Fan Kuan. His landscape unfolds in a magnificent way. I would have liked to make a copy of this painting by Fan Kuan, but in oils of course."[9]

Like Fan Kuan's mountains, *Le Gottéron* as painted by Balthus has a magnificent and overwhelming presence; it subjects us to the power of nature. The entire vertical composition is occupied by a single summit. The spare forms, the sombre and subdued colors, create an image with a very austere atmosphere. The entire landscape has power of feeling; it is profoundly anthropomorphic, even if it does not imitate the form of the human body. The mountain opens up toward us, approaches us; it stands opposite us, like someone who wants us to share the emotions we can read in their face. In effect, one can see a similar vision of nature in the two painters. They do not limit themselves to appearances; their spirit penetrates to the very mystery of nature. The Chinese master wrote: "It is better to take nature as a teacher rather than a person; it would be even better to follow one's own heart."[10] So, for the Chinese literati-painters, landscape painting was more than the simple representation of the visible, it was the search for a higher reality; and that goal was to be achieved by communion between the outer world of nature and the inner world of the painter. This is how the basic terms of the aesthetics of landscape, like "sentiment-landscape" (*ging jing juo rong*) and "spirit-form" (*chen xing jiun bei*) first made their appearance in Chinese. Another literati-painter admired by Balthus,[11] Shi Tao, had this to say on the subject of the creation of landscape: "Now the Hills and the Rivers appoint me to speak for them; they are born in me, and I in them."[12]

Just as the Chinese painters caught the "wrinkles" of the mountains, so in *Le Gottéron* Balthus paid particular attention to the sheering and texture of the rocks. In his depiction of natural strata one can see both a stylization and a conceptualization of the phenomena, in the same way as the Chinese painters used conventional traits to represent different kinds of "wrinkle." However, this is not stylization as mannerism but as research into the rational, a striving for universal principles; the "wrinkles" have such intense internal power that they seem to be an expression of the very principles of the natural world itself. Just like the Chinese masters, Balthus paints landscape as it is seen by his heart. Having memorized immediate reality and then distanced himself from it, he works on his painting following a preconceived idea—and this leads to a landscape that has a sense of abstraction and simplicity, of an essential work created through economy of means. The result is that the painting has the air of the conceptual and a-temporal. However, *Le Gottéron* also contains the real and the living. Fan Kuan lived in the mountains for a long time in order to learn the true natural environment of the place; and Balthus himself had loved the mountains since his childhood, spending a large part of his time there. If Fan Kuan had to invent specific lines and strokes to capture the real substance and breadth of the mountains, Balthus for his part manages to avoid any artifice of technique that might undermine the force and power of the real; in its obsessional striving for the truth, his representation may even seem clumsy and maladroit at times. But here again, couldn't one say that he seems to comply with the Chinese dictum: "The full command of a rule comes down to the absence of rules"?[13]

"A Very High Horizon..."

Fan Kuan's *Journey beyond the Rivers and Mountains* reflects another important aspect of the aesthetics of Chinese landscape-painting: the sense of the infinite. In order to give their work a universal dimension, the literati-painters always represented the largest possible distances within the limited space of their pictures. The large, the distant and the infinite thus became goals toward which landscape-painting strove. When the great Song painter Guo Xi (1020–?) gave concrete expression to the three types of perspective, he did it in terms of the "Three Distances."[14] Distance evokes the very immensity of nature. The Chinese painter adopted a very free and subjective perspective, with multiple points of view; and as the moving eye roams over the landscape, it never runs up against a limited or enclosed space. A number of Balthus's landscapes also suggest the immensity of nature—for example, *La Montagne* (1935–37), *Paysage de Champrovent* (1942–45), *Paysage de Monte Calvello* (1979), etc. Often seen from a raised and distant point, these landscapes are compositions with no one fixed

94

5. Balthus, *Paysage d'Italie*
[Italian Landscape], 1951,
oil on canvas.
Private collection

point of view; they open up onto such vast spaces that they give the effect of infinity. In one of the painter's first landscapes—*Paysage Provençal* (1925)—the features of the landscape are stacked on top of one another, recalling those Chinese landscapes painted on vertically-hung scrolls. The composition is both a panorama and a vision. The point of view in *Le Paysage d'Italie* (1951) is an imaginary point in the middle of the sky, with the artist's eye capturing the landscape like a wide-angle lens, or sweeping across it in a tracking shot; in fact, one has to shift one's gaze in various different directions to seize each facet of the picture. This type of perspective also occurs in such other landscapes as *Le champ triangulaire* [The Triangular Field] (1955). In each, Balthus adopts a multiple point of view and thus invites the spectator's gaze to roam endlessly throughout the picture.

The series of landscapes of Monte Calvello which Balthus produced during the seventies (in drawings, water colors and oils) also recalls Chinese landscape painting for other reasons. Similar in composition, his dozens of charcoal and pencil drawings form a series of independent large-format works (70 x 100 cm) that depict Monte Calvello seen from a distance, on the other side of an abyss. Occupying the left side of the composition, the mountain seems to be rising from out of some morning or evening mist. A large part of the composition remains blank, thus evoking the idea of fog and suggesting a space that opens up toward the infinite and the indefinable. The atmosphere in these drawings might be described using the Chinese expression *kong ling* "empty and spiritual"—the highest accomplishment of painting, which so many Chinese artists and poets strove to achieve. According to Taoism, a philosophy of fundamental importance to understanding the work of the literati-painters, the universe originated in a Void. All creation comes from this Void; and it is in this Void that lies the universal Way, the Tao. Thanks to the Void, the breath of life can circulate and give birth to life itself. Hence the spiritual search for the Way must lie through the Void; and for the Chinese literati-painters, the greatest beauty is to be found in those things that are closest to nature, to simplicity and modesty—in other words, to the Void. They stress the empty space in a composition, "attaching the same importance to white as to black" and "being economical in their use of brush and ink." Balthus's particular interest in the painting of Ni Zan[15] is yet further proof of his deep understanding of the spirit behind the work of the literati-painters: "Of all the painters of Yuan, I admire Ni Zan the most. He paints with only a few, very freely scattered, brushstrokes. There is great economy of both ink and brushwork; but there are a great many, very profound, things behind all that. His paintings suggest and provoke reflection. One has to read what is behind them. There is a special taste in his paintings, a very high horizon that the others attain only

4. Balthus, *Paysage Provençal*
[Provençal Landscape],
1925, oil on canvas.
Troyes, Musée d'art moderne

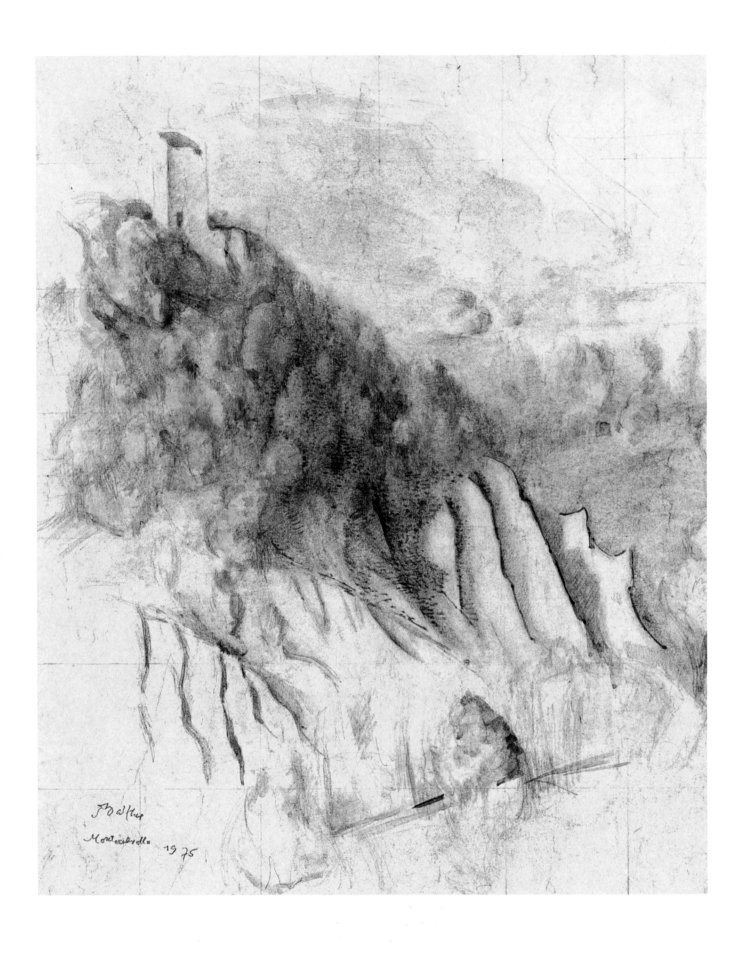

7. Balthus, *Paysage de Monte Calvello*
[Monte Calvello Landscape], 1978,
pencil and charcoal

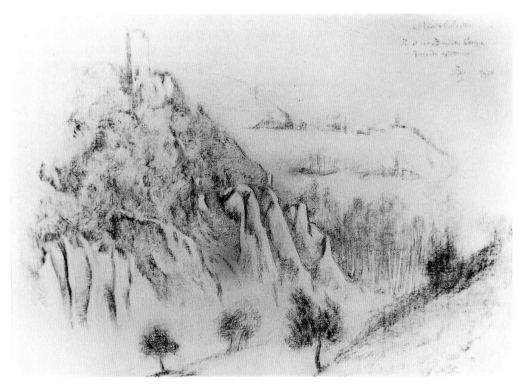

8. Balthus, *Paysage de Monte
Calvello* [Monte Calvello Landscape],
1978, pencil and water color.
Private collection

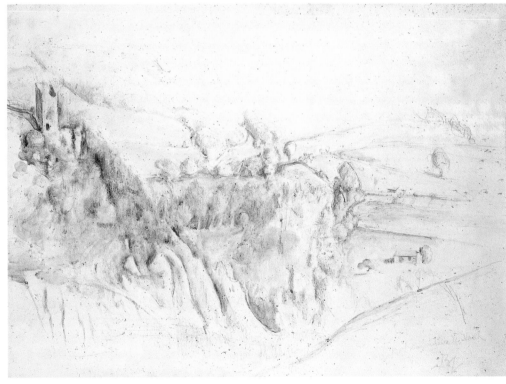

opposite page
6. Balthus, *Paysage de Monte Calvello*
[Monte Calvello Landscape], 1975,
pencil and water color
on elephant skin squared paper.
Private collection

9. Gao Kegong (1248–1310),
Mists on the Wooded Hills.
Taipei, Palace Museum

rarely."[16] Unlike other of Balthus's works, the drawings of Monte Calvello do not use the geometric composition that is part of the Western tradition; space here is organized through the complementary opposition of plenitude and void—as happens in Chinese painting. The composition is very close to that continually repeated by Chinese painters, with an isolated and distant mountain separated from the foreground by mist and clouds. Suspended in the void, Mont Calvello does not seem to be a fixed or set mass; it seems to float in the air. We cannot help but feel that, from one moment to the next, it will be swallowed up by the fog, that it will change appearance or disappear altogether. At one and the same time, these landscapes reflect solid reality and the illusion of a dream. There is something ephemeral, intangible and mysterious about them. Didn't Balthus himself say: "One cannot understand mountains without looking at Chinese painting"?[17]

"Understanding Mountains..."
In Chinese "Mountain-Water" painting it is almost always the mountain which forms the dominant part of the composition. Offering both physical and spiritual "elevation," the mountains were an ideal place in which to rediscover an original harmony with Nature and to reach Heaven itself (in fact, it was in the mountains that the Taoist immortals lived; and the character for *Xian*, "immortal" is formed of two components that mean "man" and "mountain"). This was the philosophical basis for that contemplation of the grandeur and beauty of the mountains that was so dear to Chinese artists and writers. The mountain was the ideal place in which each person could give free rein to their feelings.

Mountains are also the most constant feature in Balthus's landscapes; indeed, it was the mountains of Switzerland that stimulated his passion for the art of the Far East. He says: "When I was a child, my parents sent me to friends in Switzerland, in the mountains. I would often watch the mountains and the snow from my window. One day I came across a book on Chinese painting. I was amazed to see in it landscapes identical to those I had before my very eyes. That is what led to my passion for the art of the Far East."[18] And his home now is a mountain chalet at Rossinière, where mountains which are "exactly like the mountains in Chinese art"[19] continue to be an object of contemplation and affection. In a letter he wrote to his friend

10. Mi Fu (1051–1107), *Mountains and Pines in the Springtime Mist.* Taipei, Palace Museum

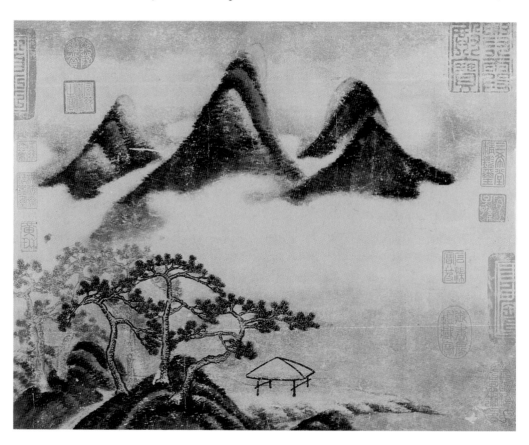

11. Ma Lin (active mid-thirteenth century), *In the Hills*. Beijing, Museum of the Forbidden City

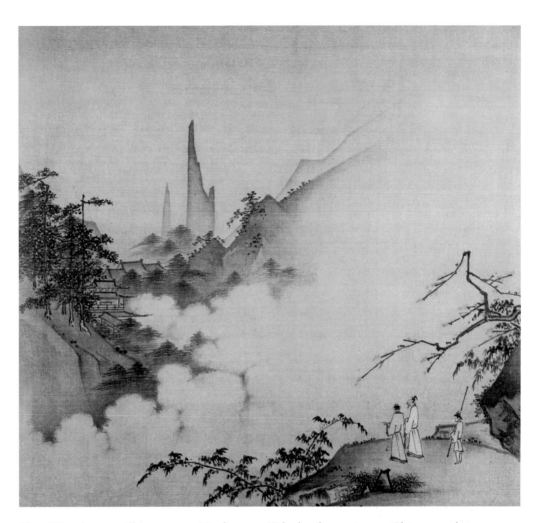

Xing Xiaosheng, a Chinese art critic, he says: "The landscape is very Chinese at the moment, with the fog covering and uncovering the mountains."[20] This shifting vision of distant mountains half-submerged in mist, which was so appreciated by Chinese painters, is, in effect, bound up with the Taoist idea that the soul of the cosmos lies hidden behind the unstable world of appearances, whose only worth is that it can serve to "translate" the being of the universe. For Balthus, Chinese landscapes represent this vision of the world, and are a sort of symbol of the landscape of the world beyond. It is a vision that evokes the idea of transformation and stimulates imagination; the real and the ideal, the visible and the invisible, all blend together. In a painting such as *In the Mountains* by the eighteenth-century Ma Lin, one sees two scholars contemplating or meditating as they look toward a mountain summit encircled with a nimbus of mist. Suspended in the distance, this world is unattainable, and yet it is also the locus of the true Way (the true Tao). The pure and idealized atmosphere in Balthus's own landscapes also inspires within us some sort of spiritual elevation; and when creating those paintings, hadn't he in mind the Chinese mountains which for him were "undoubtedly where some of the immortals live"?[21]

The parallels between the drawings of *Paysages de Monte Calvello* and Chinese paintings are made even stronger by the fact that the former are monochrome works. The different shades of black obtained in the drawings through rubbing in pencil or charcoal are related to those obtained in Chinese paintings by means of splashed or diluted ink, which achieve effects that serve as symbolic suggestions of tonal nuance rather than real renditions of volume. Monte Calvello appears to be of an unreal lightness; and the same effect is achieved in the watercolors of the same subject-matter. And while in other drawings Monte Calvello does appear more sharply, the clean strokes used there do not give a concrete imitative rendition of details; they tend to be stylized, to become calligraphic strokes that once more call to mind the painting of Ni Zan. The subtle mannerism of the fine lines and graceful forms creates draw-

13. Balthus, *La Bergerie* [The Sheep Farm], 1957–60, oil on canvas. Lausanne, private collection

ings whose elegance calls to mind the styles of Huang Gongwang[22] and Wang Hui,[23] both of whom Balthus admired.

In the painting of the *Paysage de Monte Calvello* which I mentioned at the opening to this essay, one can see—in the lower right-hand corner of the composition—two small figures seen from behind, two schematic silhouettes. Balthus said that initially he had not intended to paint in these two characters, but added them "thinking of Chinese painting."[24] Humankind is not effaced by Nature, even if it does not occupy the centre of the landscape. The mountains and man seem to exchange thoughts, in perfect harmony. Thus the atmosphere is restful; there is a feeling of peace that is both universal and eternal. One often finds this very modest human presence in Balthus's landscapes—for example, *La Bergerie*, *Le champ triangulaire*, etc. —in figures which seem to have set out on some quest, to be following their destiny. Look at the little figure ascending the path in *Le Gottéron*. Isn't he very similar to that in the painting *In Search of the "Way" within the Autumnal Mountains* by the great Chinese master Ju Ran[25]—a figure whose climb up the winding mountain path symbolizes the search for the universal Way, the Tao?

In effect, the oriental "feel" in Balthus's works does not arise from formal imitation but from an affinity of ideas and spirit. What is more, Balthus draws on the aesthetics of Chinese art in order to perpetuate and develop the great tradition of western painting. In an era when the rapid changes in modern society have led artists to feel they must question the past, Balthus had tried to restore a universal idea of art, a conception that is to be found in all traditional art—be it that of the Italian Quattrocento or that of Ancient China. Insisting upon the universal nature of artistic creation, he had developed an effective and eloquent form of expression that is linked with tradition. But it is no easy thing to take up the tradition developed by the Old Masters and make it the guarantor of a personal and contemporary means of expression—particularly when such an attempt flies in the face of fashion. The painter in this case needs talent and courage; and in this sense, Balthus's work is exemplary. While he may not be the only contemporary artist in the West who has taken an interest in the culture of the Far East, his immense knowledge and intuitive understanding of Chinese art— together with a vision that manages to blend together the art of East and West—make him unique. Taking two forms of art which appear to be so very different, he has managed to find a single underlying source, and the resulting encounter—or, rather, bond—between the two not only opens up new horizons for contemporary artists, but also teaches us all a new way of considering even the most distant cultures.

opposite page
12. Balthus, *Paysage de Monte Calvello* [Monte Calvello Landscape], 1994–98, oil on canvas. Setsuko Klossowska de Rola collection

[1] Balthus in conversation with the author, Rossinière 1991.

[2] Balthus, *Lettre de Balthus pour Beijing*, June 1995.

[3] Great artist of the Northern Song dynasty (active at the beginning of the eleventh century).

[4] Balthus in conversation with the author, Rossinière 1991.

[5] Balthus in conversation with the author, Rossinière 1991.

[6] Quoted by Jean-Marie Tasset in "Balthus, le peintre qui a la poésie pour sixième sens," *Le Figaro*, 17 August 1994.

[7] Balthus in conversation with the author, Rossinière 1991.

[8] Balthus in conversation with the author, Rossinière, October 1992.

[9] Balthus in conversation with the author, Rossinière, July 1992. Balthus expressed the same idea on another occasion: "I never tire of looking at the marvellous Fan Kuan landscape that you have so kindly had mounted for me. I hope to make a copy (to remain within the tradition)." Letter from Balthus to Xing Xiaosheng, 12 May 1992, quoted by Xing Xiaosheng in *Balthus*, Editions des Beaux-Arts du Peuple, Shanghai 1995, p. 1.

[10] Wang Zhaowen, edited by, *Historie de l'art chinois*, IV, Editions de l'Education, Jinan, p. 46.

[11] Balthus: "Shi Tao's treatise is so well-written. There is no theoretical work in the West that explains the fundamental problems of painting in such an effective way." Conversation with the author, Rossinière 1991.

[12] Shi Tao (1642–1707). French edition: *Les propos sur la peinture du monie Citrouille-Amère*, translation and commentary by Pierre Ryckmans, Hermann, Paris 1984, p. 16.

[13] Shi Tao, *op. cit.*, p. 71.

[14] "For the mountains there are three types of distance or perspective. When the spectator raises his eyes toward the summit from the foot of the mountain, that is *gao-yuan* "distance or perspective in height;" when, placed in front of the mountain, the spectator can enjoy an extended view of the mountains behind, that is *shen-yuan* "distance or perspective in depth;" when, from a nearby mountain, the spectator's gaze can shift horizontally toward distant mountains, that is *p'ing-yuan* "plane distance or perspective." Quoted by François Cheng in *Souffle-Esprit*, Seuil, Paris 1989, pp. 106–07.

[15] Ni Zan, 1306–74, great painter of the Yuan dynasty (1271–1368). He is known for his frugal landscapes, in which the few features and dashed strokes offer a very resonant evocation of the Void and the Infinite.

[16] Quoted by Xing Xiaosheng, *op.cit.*, p. 10.

[17] Balthus in conversation with the author, Rossinière 1991.

[18] *Ibidem.*

[19] *Ibidem.*

[20] Letter from Balthus to Xing Xiaosheng (7 April 1990).

[21] Balthus, *Lettre de Balthus pour Beijing*, June 1995.

[22] Huang Gongwang, 1269–1354, literati-painter of the Yuan dynasty.

[23] Wang Hui, 1632–1717, literati-painter of the Qing dynasty.

[24] Balthus in conversation with the author, Rossinière 1991.

[25] Ju Ran, great tenth-century artist, active between the Five Dynasties and the Northern Song dynasty.

Following the example of Federico Fellini,[1] one can still set off in discovery of Balthus at the Villa Medici today. From the exhibition gallery to the *bosco*, the place still bears the indelible mark left by the artist, who was Director of the Institute from 1961 to 1977, a crucial period in the history of the Académie de France in Rome. This was a time when there was not only fundamental restoration and refurbishment of the palace and gardens but also far-reaching changes in the institution itself. However, while there are an increasing number of publications dedicated to the life and work of Balthus, the two decades he spent at Villa Medici and his role as Director of the Académie de France in Rome are still largely unexplored—even though here in the palazzo on the Pincio in the sixties, we can see the painter at work as a restorer of a Cinquecento palace. This is clearly a very important aspect of his œuvre. Isn't it possible to recognize on the walls of the Villa itself those "colors turned to matter," those "colors resuscitated from the depths of time and held within the cracked surface of their appearance"[2] that can be found in the paintings of Balthus himself? Tracing the restoration work Balthus carried out at the Villa Medici—and seeing it within its historical context—involves one in charting the activities of a man who threw himself into his new role of site foreman with passion, the activities of a refined and innovative interior decorator as well as those of an inventive designer.

Balthus's Appointment
On 15 February 1961, Balthus was officially appointed Director of the Académie de France in Rome, replacing the composer Jacques Ibert.[3] His period of tenure was originally to be six years. In the event, his contract was renewed, and he would reign over the Villa and its award-winning *pensionnaires* for a total of sixteen years. The appointment initially stirred up a violent press campaign that involved the man responsible—André Malraux, Minister of Cultural Affairs and a close friend of Balthus[4]—and the Académie des Beaux-Arts, which had put forward the name of the landscape painter Yves Brayer, former winner of the Grand Prix de Rome, member of the Académie and Vice Chairman of the Salon d'Automne.[5] The Paris academy's main objection was that Balthus himself had never won the Prix de Rome, and that his appointment was an authoritarian gesture by the minister. In fact, it was the first time the Director of the Académie de France in Rome had been chosen by the Minister of Cultural Affairs rather than by the Paris Académie des Beaux-Arts. According to Balthus, Malraux's intention was clear. He wanted to revive the lustre and prestige of the Villa Medici through thorough restoration of both building and gardens. He also wanted Balthus to act as an ambassador of French culture in Italy, and —above all—nourished hopes that this centuries-old institution, which he saw as the victim of academic sterility,[6] might be radically reformed and rejuvenated. The Académie des Beaux-Arts regretfully had to accept the Minister's decision. Upon his appointment, Balthus was presented in Italy as one of the most famous names in contemporary French painting, yet also as an artist who was not part of any recognized school or movement. In 1961 Balthus's reputation also rested on his numerous set designs for theater and opera, with his services being sought after by such avant-garde playwrights and directors as Barnowski, Artaud, Barrault and Camus.[7] Scarcely known nowadays, his work as a set designer is fundamental to an understanding of the role Balthus played as restorer, architect and interior decorator at the Villa Medici in the sixties. The press took the opportunity offered by an exhibition of work by the Academy's *pensionnaires* (June 1961) to comment upon the sensational decision to appoint Balthus as director of the institution. Its verdict was unanimous: the appointment was a sign of renewal and revealed a clear determination to transform the Académie de France in Rome.

The Renovation and Decoration of the Villa Medici
Upon his arrival at the Villa Medici, Balthus found the building in a very poor state. The original palace was disfigured by the numerous rooms that had been added on and its decor was reminiscent of a Third Republic préfecture.[8] The restoration work, which began the very month of his arrival, involved the entire building, from the roof down to the foundations.[9] "The aim," Balthus wrote on 5 July 1961 to the Direction des Arts et des Lettres, "is to free the interior of the palace of all those unfortunate adjustments it has suffered over the last one hundred and fifty years, and through prudent restoration to recover its original style."

1. Rome, Villa Medici. The Joseph Room after the Second World War

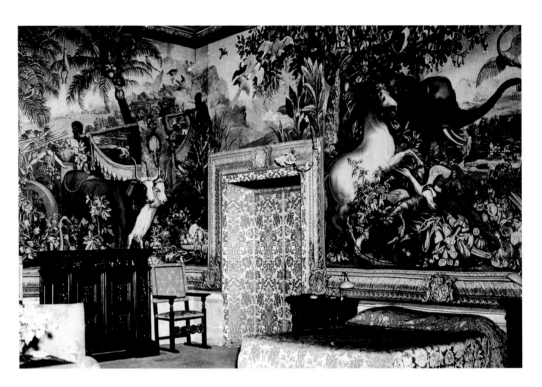

2. Rome, Villa Medici.
The Joseph Room after Balthus's restoration

On 10 August 1964 he outlined the second aim of this restoration work: "[...] The special work that I have had undertaken here since my arrival aims to restore the character of this illustrious building, at the same time as furnishing it with all the equipment and facilities that are necessary if it is to function in its present role."[10] These two priorities reveal the thinking behind the "restoration/refurbishment" of this Cinquecento villa. Balthus threw himself into the task whole-heartedly. He checked and participated in everything—from the design of the tiling to the layout of the stairs, from the purchase of furniture to the organization of the lighting. When discussing the restoration work at the villa in a March 1961 interview granted to E. Schlumberger, Balthus did not present himself as a painter or as the Director of the Académie de France in Rome, but rather as a site foreman.[11] He worked in close collaboration with two Italian companies: Arnolfo Crucianelli's team of specialist restorers and the Stracchi firm of house painters, who are still used in the various projects underway at the Villa. Balthus also involved the various *pensionnaires* of the Académie de France at the time. One of these, Jean-Loup Roubert (*pensionnaire* in architecture from 1963 to 1966),[12] mentions how Balthus used to go on his detailed morning inspections of the work accompanied by his entire "court." This included Roubert himself and other *pensionnaires* (for example, the sculptor André Barelier), representatives of the building firms and, if they happened to be present, the project architects (Guillaume Gillet, an architect with the Bâtiments Civils et des Palais Nationaux who was in charge of the Villa Medici site, and his Italian counterpart, Alessandro Villa).

The work began with the restoration of the façade of the *bosco* terrace and of the two rooms which had housed the museum of the Académie de France in Rome (a space where Balthus would install his own studio).[13] In March 1961 it was then extended to include the interior of the Villa, with work commencing on the Director's Apartments in the north-west section of the building, where the layout of the rooms was totally changed.[14] Work was completed in 1966, with the cleaning of the façades of the main building.

The Director's Apartments: an Original Balthus?

The Director's Apartments at the Académie de France are today the clearest witness to Balthus's work on the Villa. These are the best preserved of all the rooms and they functioned as a sort of "workshop" for the painter. The choices made here—and the techniques developed to implement them—would determine the course taken by the restoration of the entire building. They reveal not only Balthus's individual taste, but also the constant dialogue he maintained with the history of Italian art.

First tests carried out on the walls, which were covered with tapestries or coats of paint, revealed that in the Esther, Joseph and Genesis rooms[15] there were fresco-painted friezes on the upper parts of the walls; totally unknown beforehand, these dated from the middle of the sixteenth century. Thanks to the research of Pierre Arizzoli-Clémentel, we now know that at the time of Ferdinando de' Medici (1576–87), the man who originally had this opulent palazzo built, the walls beneath the frescoes in these three rooms were decorated with wall hangings in yellow and green or red and green taffeta.[16] The restoration of the frescoes and the refacing of the walls went hand in hand. Balthus, who was in favor of a simple restoration, chose to maintain the discreet fake marble dado that had been painted in the nineteenth century and at the same time to exploit what remained of the various layers of paint. The Joseph Room is a fine example of this approach. Underneath the various layers of paint, the restorers discovered an old layer of a luminous green, which went perfectly with the dominant shades in the Cinquecento fresco. Balthus decided to conserve and restore that layer (fig. 2). In completion of the restoration work, the cornices and moldings were varnished after being stripped; the stucco-work was repaired (with the missing parts replaced); the ceiling beams were stripped of the various layers of paint, then restored and repainted in an old wood finish; and the uneven nineteenth-century floors were redone with large square terracotta tiles which were hand-made to original period designs.[17] A photograph from the post-war period (fig. 1) shows what this room was like before its transformation: the entire wall surface was covered with eighteenth-century tapestries and oil paintings.[18] The contrast between that interior and what one has today reveals the full measure of the painter's daring in choosing to highlight the effect of the rediscovered frescoes by eschewing veneration of tradition for tradition's sake and instead deciding to reuse that layer of green which so fortuitously echoed the colors in the sixteenth-century frieze. However, as early as 1962 people started to look for historical echoes here in an attempt to explain—and, in some way, to justify—Balthus's decision. Over the years it has been argued that the green is a tribute to Piero della Francesca, or to the period when Ingres was Director of the Académie de France in Rome (some arguing that this particular layer of green paint dates from that time).[19] There can be no doubt that the art of these two masters, Piero della Francesca and Ingres, is fundamental to an understanding of Balthus's work. However, it is rather surprising to find them included in the restoration of a late-sixteenth-century interior.

The approach adopted in the Joseph Room was thereafter followed in the interior as a whole. The dominant color in the Genesis Room is ivory, the result of the discovery of an original sample; and in the Esther Room—which Balthus used as a drawing studio[20]—the dominant color is a bluish-green, which blends with the pastels of the frescoes (fig. 3). On the other hand, in the apartments' dining-room this matching and blending of tones was abandoned in favor of a play on the contrast between the pink walls and the sculpted frieze, the background of which was deliberately painted black to bring out the ornamental motifs (hedgehogs and suns that represent the Ricci family, and the fleurs-de-lys of the Farnese family; fig. 4).

Developed by trial and error, the technique used in painting the walls of the Villa Medici (often incorrectly described as *peinture à l'éponge*) followed samples that Balthus prepared for each room. Given that this technique has been the object of various mistaken interpretations, it is perhaps worth describing it in some detail.[21] By carefully scraping the walls to different depths, the various thicknesses of the layers of color were revealed. Then to obtain a more homogeneous surface, the shades in the old coats of paint were reworked by applying (with a brush) between three to six coats of different colors that were very close to those of the old layers. In the rooms with frescoes, Balthus obtained a sort of kaleidoscopic effect by exploiting these superimposed layers of color. He would then compare this palette with the range of colors in the frescoes in order to decide upon the dominant shade to use for the walls. These new layers of paint were applied in short intersecting brushstrokes varyingly spaced. These created a sort of grid which gradually got narrower and narrower, while the superimposed shades tended to blend into one another, creating the effect of a vibrant surface of color (figs. 5 and 6).

The final operation varied according to each room and to the final effect desired. In the Salon des Pensionnaires, the last coat was applied in horizontal strokes using a wide brush lightly dipped in the dominant color in order to achieve a sort of veiled effect. Given that the brush

3. Rome, Villa Medici.
The Esther Room

4. Rome, Villa Medici. Detail
of cornice in the Director's
dining-room

5, 6. Rome, Villa Medici. Details
of walls painted using the technique
developed by Balthus

opposite page
7. Rome, Villa Medici.
The Room of the Elements

8. Rome, Villa Medici.
The Director's Blue Salon
with the Knole sofa

9. Rome, Villa Medici. Detail
of the Turkish Room

was almost dry, the paint surface was very irregular (depending on the actual surface of the wall) and was clearly visible only in the lighter areas. In the Director's Blue Salon, archive research and oral traditions were blended together. The walls were finished with three layers, two ivory, one slate. In order to age the result obtained—which did not entirely satisfy Balthus—the artist tried rubbing the walls with the base of bottles, rotated backward and forward across the surface. He thus obtained not only the effect of a vibrant surface of color but also a rather brilliant patina (fig. 8). This was the solution he finally opted for, and then everyone—Balthus, his sons Thadée and Stanislas, and the workmen—all set to with bottles.[22]

The firms that worked with Balthus all agree that no precise deadline was ever fixed. The work was concluded only when Balthus was satisfied with the results obtained. The treatment of the walls was completed by the application of an invisible fixative (made with natural ingredients), which was dabbed on with a cloth. Hence no "sponge" was ever used in this famous "Balthus technique" and even cloths only made their appearance at the very last stage. They served a purely technical rather than decorative purpose. Perfected through trial and error and developed without any time constraints, this "Balthus technique", without Balthus is today the cause of rather difficult restoration problems.[23] However, it revealed at the time a totally innovative and original approach.

There are numerous connections between the atmosphere Balthus created at the Villa Medici and the atmosphere of his own paintings. To cite just two, one might mention the final version of *Les Trois sœurs* [The Three Sisters]in which one can see an echo of the Blue Salon, while the *Nu de profil* [Nude in Profile] evokes the walls created by Balthus in the Villa Medici. Here the profile of Michelina is bathed in warm Roman sunlight and seen against a subtly vibrant wall surface that combines the matt finish of fresco with the transparency of oil paint.[24] This latter picture was painted in 1973, in Balthus's *Atelier du Bosco* at the Villa Medici.

The Furniture

"A necessary complement to this work intended to safeguard and highlight the beauties of the Villa Medici," Balthus wrote to Gaëtan Picon in July 1961, "is the replacement of the

distressing present furniture with period pieces that are worthy of an old palace made rather demanding by the rediscovery of its nobility." His plan was ambitious: the vestibule of the Académie, refurbished and decorated with modern sculpture, was to lose "its sad air of a provincial museum." He also hoped to borrow Classical statuary from the Louvre storerooms for the niches in the loggia "in order to replace the dusty and tired plaster-casts that are rather mediocre in quality."[25] The portraits of former *pensionnaires* that then decorated the walls of the Villa were stored in the History of Art Room. In April 1961 the tapestries were sent to the Mobilier National in Paris for restoration.

From the beginning of the work right up until 1966 Balthus had a specific budget to spend on providing the Villa Medici with furniture.[26] He himself sought out pieces at antique dealers,[27] flea markets and public auctions. The *pensionnaires* were often dragged along to inspect the furniture themselves and had a say in what should be bought.[28] Most of the purchases were of rustic-style eighteenth-century Italian furniture. Balthus was not looking for sophisticated pieces nor was period congruency a prime concern. He was mainly interested in this furniture not as a collection of period pieces but as objects that had their own idecorative value or unusual shape and form. Certain pieces were restored at the Villa itself. When stripped they might then be left as they were or repainted so that they fitted in with the decor of the room for which they were intended.[29] Only on one occasion, in 1962, did Balthus call upon the services of a specialist, Henri Samuel, interior decorator to Baron Edmond de Rothschild, who worked for the famous firm of Alavoine which owed its international fame to the quality of its period-style decors.[30] Balthus had already worked with Henri Samuel on the refurbishment of his Chateau de Chassy in the Morvan.[31] However, document archives seem to suggest that Henri Samuel's collaboration on the Villa Medici project was limited. He supplied the collection of fabrics for the re-upholstering of the old furniture and of the modern settees and armchairs,[32] as well as designing the Knole settee in feather velvet for the Director's Salon.[33] The unusual form of this piece was inspired by a settee Balthus had seen in an English country house, a drawing of which he provided for Henri Samuel.[34]

And that brings us on to the role that Balthus himself played in the design of certain key pieces of furniture. His work in this field is even less well-known than his work as a set designer and interior designer. The Blue Salon contains two restored tables (eighteenth–nineteenth century), the tops of which were painted in an abstract composition of different patches of brown by Balthus himself.[35] A recently-discovered signature inscribed on one of these table tops (that of the lower table) proves the authenticity of these unusual abstract panels.[36]

The so-called "Balthus lamp" (fig. 10), whose elegant outline and subdued illumination is to be found in nearly all the rooms of the Villa, was a totally original Balthus design. It was created under his direction, in collaboration with the accountant Mario Tornesi and the ironsmith Umberto Troncarelli.[37] The approach adopted here was similar to that taken in developing the technique to be used in decorating the walls. Here again, Balthus exploited what he found already *in situ*, adapting it to modern needs. After several attempts, he eventually produced a unique lamp that drew its inspiration from two ancient forms of light-fitting that were already in the palace: one, an old candelabrum in solid iron, the other a remarkably-tall monumental nineteenth-century candlestick with a twisted base. For the main structure of his lamp, Balthus used rusty old water tubing, one end of which was fitted with light wood, in part hidden by the shade than added. This glimpse of wood gives the impression of a shaded candle, a subtle allusion to the models on which he based his design. The shades for the first lamps were made using parchment sewn with silk thread. The approach followed in designing the lighting for the spiral staircases—wall-fittings set within niches—was similar. This time the inspiration was an oil lamp that Balthus had noticed on the staircase of the northwest tower, on the same floor as the Turkish Room.

From this he took the idea of a slightly protruding piece of galvanized metal, which served to throw light down onto the stairs themselves. He adapted this model by replacing the wick with an electric bulb and also creating a sort of cover in sheet metal intended to make the electric light less blinding (fig. 11). This use of natural materials—sheet metal and tubing found on site, as well as wood and parchment—reflects a taste that is often to be found in the interiors of the sixties. It also echoes the use of recycled objects in the work of such contemporary artists as César, Janis Kounellis and the members of the Arte Povera group.

10. Rome, Villa Medici.
The "Balthus lamp"

11. Rome, Villa Medici.
The exhibition rooms at the time
of the Giacometti retrospective
(1970)

The Modernization of the Villa Medici

The last phase in the work involved the modernization of the building's facilities. A priority for both Balthus and Malraux was that the new Académie be well-equipped to perform its new functions. Thanks to the support of the Minister for Cultural Affairs (and substantial funding), the Director was able to fit Villa Medici with a new library,[38] a sound studio, a ceramic kiln, new presses for the engraving workshop, a screening room and a suite of seven exhibition rooms.[39] These latter were created on the ground and basement floors, where the entrance ramp and the so-called "Jeu de Paume" room were cleared.[40] Here, work again produced important discoveries. After the sixteenth-century frescoes, this time it was the Roman past of the villa that was unearthed, thus leading to further excavation work. The end result was the discovery of fragments of an ancient Roman villa and a water cistern.

The new exhibition rooms had about 232 meters of hanging rails around an area of some 680 square meters: "the whole thing comprising a series of varying volumes and surfaces, which created a pleasant space well-equipped for the hanging and lighting of works."[41] In order to maintain a certain sobriety and unity in the lay-out of these rooms, Balthus had all the walls done using the same technique of superimposed patinas in shades of ochre and brown. He had wanted a space that used only natural light, but this proved to be incompatible with the nature of the rooms themselves and with current trends in museum design (with its emphasis on enclosed spaces and artificial lighting).[42] The rooms were officially opened by André Malraux[43] on 10 November 1966, with an exhibition of work by the Académie's *pensionnaires* (there had been no such exhibition for the previous six years). Federico Fellini has this to say on the success of Balthus's new exhibition rooms:

"I remember when Balthus himself was trying to create a special *vibrato* effect in the decoration of the walls of the exhibition rooms in the Académie. The result was a 'color of time,' the creation of a space that was perfect to welcome the presence of Ingres, Courbet, Braques and Corot. Those paintings hung on those walls, in the exhibitions he organized at Villa Medici, finally had an active zone within which they could appear as they are (that is, as they were and always will be). There was none of the sumptuous fabric and molded plasterwork, the intrusive and wilful clutter to which, for more than a century, museum designers have doggedly resorted in order to imprison and madden those exclusive and delicate creatures, works of art. Identifying the space necessary for a painting or a work of sculpture is both a critical and creative act, comparable to the painting of a picture, the restoration of a monument and the successful understanding of ourselves and our inner rhythm. This was part of the lesson Balthus taught us [...]"[44]

The Gardens

The work on the gardens came at the end of Balthus's period as Director, from 1973–77. The main aim was to create a certain harmony between the gardens themselves and the newly-restored buildings—particularly the façade of the Villa and the *terrazza del bosco*. Three basic objectives were set: rearrangement of the statues in the gardens so that they would be seen in the best perspective; completion of the garden statuary with casts of the famous sculptures that had established the fame of the gardens at the time of Ferdinando de' Medici; reorganization of the *piazzale*. Once again a *pensionnaire*—this time the restorer and sculptor Michel Bourbon—was closely involved in the project.

Work began with the *piazzale*. Balthus had the magnolia removed and replanted the palm-trees from the other side of the *bosco* in order to reconstitute the original appearance of the garden as it can be gleaned from the sixteenth-, seventeenth- and eighteenth-century engravings that chart the transformations therein. A riot of luxuriant vegetation was replaced by a certain order (figs. 12 and 13). However, the reconstruction was necessarily simplified to a certain extent: for example, Balthus made no attempt to restore the flower-beds in the parterres to their original state.[45] On the other hand, assisted by Michel Bourbon, he did undertake the production of casts of the most famous of the Villa Medici sculptures, now in the Uffizi collection and the Boboli Gardens in Florence. Thus, in autumn 1974, the obelisk was restored to its place in the central perspective of the *piazzale*. This was the first cast produced by Michel Bourbon, working in collaboration with the mason Tommaso d'Ulizia. The procedure they used involved the adding of successive layers of resin and powdered granite around a core structure of iron.[46] Balthus completed this new arrangement of the *piazzale* with casts of the Dacian prisoners. Their location was carefully chosen so that there was a rhythmical alternation between them and the pine trees. Initially, he had cardboard models of the statues made so that he could test their visual effect in the garden.[47] He also had the Roman statue known as *The Roman Goddess* restored and placed in a more spectacular perspective, at the end of the avenue of orange trees. As contemporary engravings show, this *mise en scène* had already been adopted in the eighteenth century.

The last casts to be made were those of the *Niobides* (January–July 1976). These thirteen marble statues had been discovered in Rome in 1583 and that very year Ferdinando de' Medici had bought them for his Roman villa. From that time onward, they were considered as one of the main treasures in the cardinal's collection. The group of statues is inspired by the legend of Niobe that is recounted in Ovid's *Metamorphoses*[48] (the actual moment portrayed by the figures here is the slaughter of Niobe's children). In 1769 or 1775—sources vary—the statues were moved to Florence, where after restoration they were put on display in a specially-prepared room in the Uffizi.[49]

The *Niobides* represent Michel Bourbon's first attempts to reconstitute the material of sculpture using cements, resins and different types of lime; but while the technical part of the process was entirely his, the choice of the group and the arrangement of the ensemble was the result of collaboration between the young sculptor and the Director of the Académie de France. Exploiting the revealing detail in the base of the statues (made up of rocks that are intended as part of the composition as a whole), they decided to place the Niobides at ground level, in the natural setting of an open-air grotto. Initially, they had thought of recreating the

12. Rome, Villa Medici.
The Gardens: view of the *piazzale*
in the late nineteenth century

13. Rome, Villa Medici.
The Gardens: view
of the *piazzale* in 1997

14. Rome, Villa Medici.
The Gardens: the Square
of the *Niobides*

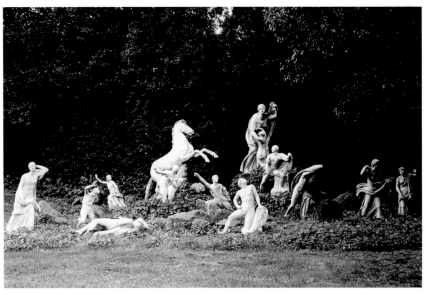

world of *The Dream of Polyphiles*, which recounts some sort of initiation ceremony. Significantly, they sought advice on this matter from both the archaeologist Geominy and the Florentine poet Piero Bigongiari.[50] However, in the end, the layout created by Balthus and Michel Bourbon is inspired above all by Ovid's *Metamorphoses* and by a 1638 engraving by François Perrier which shows the Medici *Niobides* arranged in the open air amidst rocks.[51] Together with the desire to recreate the spirit of the grotto with its luxuriant vegetation, was the wish to recapture the myth of Niobe. Therefore the casts were placed in a parterre of ivy and acanthus laid out in one of the squares of the garden (northern corner). The water system is designed to provide a mere trickle, the endless dripping of the water alluding to the distress of the mother Niobe at the same time as it evokes the atmosphere of a grotto; the oozing rock is here a metaphor for immense maternal grief (fig. 14).

The Restoration of the Villa Medici: Success and Criticism
The success of the restoration of the Villa Medici—in which Balthus made his presence felt not only as Director of the Académie de France but also as site foreman, designer and original restorer—meant that the finished work was immediately influential. There were soon echoes of it in both public and private restoration projects in Rome and elsewhere: for example, at Balthus's own *castello* at Monte Calvello in Umbria (bought and restored during the last years of his time as Director);[52] in the three rooms of the Roman palazzo that Principessa Pallavicini had restored around this time; and in the work that the French government started in 1969 at Palazzo Farnese and Villa Bonaparte (the seats of its embassies in Italy and in the Holy See).
Balthus had not approached his task in anything like an orthodox fashion; such restoration was clearly not his aim. The daring decisions made in the refurbishment of the Villa were probably more inspired by his personal taste and his work as a painter. For example, the monastic austerity of certain of the rooms does not correspond to what this late-sixteenth-century city residence must have been like in the days of Ferdinando de' Medici (when interior design was dominated by "different colors, rich fabrics, precious materials and the use of curios"[53]). However, in 1961 restoration work was not carried out with the historical rigor that is applied today. The international Venice Charter on restoration was not signed until 1964 and techniques of restoration have since evolved considerably (what is more, in France itself, the sixties was a period in which numerous painted interiors were destroyed forever). The opinion of specialists in this field only began to carry a certain weight in the eighties, when scientific and historical considerations began to outweigh the dictates of contemporary taste. Nevertheless, the work on the Villa Medici is a case apart, with Balthus carrying out the refurbishment and restoration in quite exceptional conditions. For example, he could draw on sizeable funding and, above all, his special relationship with the Minister of Cultural Affairs, André Malraux, meant that he enjoyed great independence. To illustrate the privileged position in which Balthus found himself, one might quote, as an example, this letter of 10 August 1964, from the Director of the Académie de France in Rome to M. Querrien, Maître des Requêtes au Conseil d'Etat and Directeur de l'Architecture:
"[...] We are now in the final stages of this restoration and, given the period left to me for its completion, there is no way an interruption can be contemplated. This is what I pointed out to the Minister, who is perfectly aware of the situation and, contrary to the reservations I find expressed in your letter, assured me that he will make sure that this restoration work can be finished without delay."[54]
What is more, when Balthus was Director, the Villa Medici had yet to be listed as a protected building under the care of an architect working for the Monuments Historiques (it was still the responsibility of an architect from the Bâtiments Civils et des Palais Nationaux, a former winner of the Prix de Rome who actually played a secondary role in the whole restoration operation).
Carried out over the period 1961–66 (and 1973–77, for the gardens), the restoration and refurbishment of the Villa Medici still strikes one as innovative and original. Those close to the artist speak of it more as part of his œuvre than as a simple project of restoration.[55] In the opinion of Jean Leymaire, his friend and successor at the Académie de France, Balthus's restoration of the Villa Medici "is one of his most perfect works, which exerted a significant

and positive influence on the man himself and on his art [...].” In fact, the Villa is a major —though often forgotten—record of the artistic research done by Balthus in the sixties and seventies. The painter celebrated the building in numerous pictures and the Villa as he left it can be seen to constitute a magnificent tribute to Italian art.

To return to the words of Jean Clair, Balthus’s Villa Medici may be compared to the artist’s “timeless paintings”; like them, it seems to suspend “the course of time [...] while still remaining part of our age.”[56]

[1] F. Fellini , “Balthus da Fellini,” in *Balthus*, exhibition catalog, New York, Galerie Pierre Matisse, 1977; this piece was republished in *Balthus*, exhibition catalog, Venice, Venice Biennale, 1980, p. 15. Introduced by Alain Cuny, Fellini met Balthus at the Villa Medici in 1962.

[2] “I colori divenuti materia,” “i colori ritrovati sotto la crosta del tempo, dietro una screpolatura di un intonaco.” F. Fellini, *op. cit.*, p. 18.

[3] Decree of 15 February 1961, published in the Journal Officiel de la République française (henceforward J.O.) on 17 July 1961. J. Ibert (1890–1962), prix de Rome in 1919, was the director of the Académie de France in Rome from 1936 to 1961.

[4] Andre Malraux had met Balthus during the forties, in Switzerland. When the painter returned to Paris after the war, the two met frequently, together with Paul Eluard, Albert Camus and Alberto Giacometti. On the friendship between Malraux and Balthus, see the conversation with J.-M. Drot of 12–08–1997. On Malraux himself, see J. Lacouture, *Malraux. Une vie dans le siècle*, Paris, 1973; S. Roger, *Malraux, premier dans le siècle*, Paris 1966; *Les affaires culturelles au temps d’André Malraux 1959-1969*, acts of a study seminar held in 1989, ed. Paris 1997; *A. Malraux: 1901-1976: bibliographie*, Mulhouse 1996.

[5] On Yves Brayer and the Académie de France in Rome, see Ch. Leribault, “Le musée perdu de la Villa Médicis (1933-?),” acts of the symposium *1797-1997, deux siècles d’historie de l’Académie de France à Rome. L’artiste, ses créations et les institutions*, Rome, Académie de France à Rome, 25–27 September 1997, to be published in 2002.

[6] Conversation with Count Balthazar Klossowski de Rola on 22–09–1997. See also C. Roy, *Balthus*, Paris 1996, p. 220–23 and C. Costantini, *L’enigma Balthus. Conversazioni con il pittore più affascinante del nostro tempo*, Roma 1996, pp. 73–74.

[7] On this subject see S. Colle-Lorant, “Balthus, le décorateur de théâtre,” in *Balthus*, Paris, Musée national d’art moderne, Centre Georges Pompidou, 5 November 1983 – 23 January 1984, pp. 316–18; F. Mèredieu, “Artaud, Balthus: Peinture et mise en scène,” in *Cahiers du Musée national d’art moderne*, 12, 1983, pp. 216–33; A. Bellony-Rewald, “Balthus ou le théâtre de la vie,” *Coloquiò Artes*, March 1984, pp. 36–41; C. Morando. “Balthus et le théâtre, avec l’étude spécifique des *Cenci* d’Artaud et de *L’Etat de siège* de Camus,” in *Balthus et les écrivains. L’œuvre de Balthus de 1924 à 1954 et les écrits de Antonin Artaud, Albert Camus et Georges Bataille*, Maîtrise dissertation, June 1993, Paris IV-Sorbonne, pp. 7–42.

[8] Conversation with Count B. Klossowski de Rola on 16–09–1997, 22–09–1997 and 10–01–1998; conversations with J. Leymarie of 31–08–1997 and 14–01–1997; conversation with J.-L. Roubert on 9–09–1997. See also the old photographs (dating from the nineteenth century up to the Second World War) that are part of the photographic library collection of the Académie de France in Rome. An inventory of the Director’s Apartments, drawn up on 3 May 1961, gives one an idea of the state and decoration of the rooms: see Archives of the Académie de France in Rome (henceforward AFR Archives), dossier 1961 (*correspondance -exposition*), letter n. 61070, from J. Mathieu to P. Bressol.

[9] A letter from J. Mathieu to J. Ibert bears witness to how quickly work got underway: see AFR Archives dossier 1961 (*correspondance -exposition*), letter dated 22 April 1961.

[10] See the detailed note of the work undertaken at the Villa Medici (dated 5 July 1961) that was sent to the Directeur des Arts et des Lettres, and the letter of 10 August 1964 sent to M. Querrien, Maître des Requetes au Conseil d’Etat and Directeur de l’Architecture. These letters are in the photographic library of the Académie de France in Rome, file “Moulages, restauration, fouilles, travaux,” section *Travaux-rapports Balthus 1972* (henceforward AFR Photographic library *Travaux-rapports Balthus 1972*).

[11] E. Schlumberger, “Les fresques retrouvées de la Villa Médicis: l’enquête commence” in *Connaissance des arts*, March 1962, p. 62. This is the only article on the restoration published while work was still in progress. In 1984, J. Leymarie offered a general account of these works in “Balthus at the Villa Medici. The Renaissance Roman Villa transformed with love by a modern master,” *House and Gardens*, The Magazine of Creative Living, January 1984, 156, n. 1, pp. 54–69.

[12] Conversation with J.-L. Roubert on 9–09–1997.

[13] See Ch. Leribault, *op. cit.*

[14] According to the accounts given by Balthus, his wife, J. Leymarie and the poet P. Bigongiari, the layout of the Director’s Apartments in Balthus’s day must have been as follows: private apartment on level six; the bedroom in the Room of the Elements (room 9); the Countess Klossowski de Rola, herself a painter, worked in the so-called Cupid Room (room 11), whilst the Room of the Muses (room 10) served as a salon. At level five, the Joseph Room and the Genesis Room (rooms 2 and 3) became guest-rooms, whilst the Esther Room (room 1) became Balthus’s drawing studio. The public and reception rooms were at level three. See B. Toulier, *La Villa Médicis, I. Documentation et description*, Roma 1989, plans of the Villa Medici, figs. 612, 572 and 545.

[15] See B. Toulier, *op. cit.*, fig. 572; rooms 1, 2 and 3 correspond to the Esther, Joseph and Genesis Rooms.

[16] See P. Arizzoli-Clémentel, “Le décor et les collections de la villa Médicis à l’époque du cardinal Ferdinand,” in *Villa Médicis. II. Etudes*, Roma 1991, p. 509.

[17] See the report written by Balthus himself and dated 5 July 1961, now in AFR Photographic library *Travaux- rapports Balthus 1972*.

[18] The furniture consisted of a red divan, pink chairs and a bed with a pink bedcover. See the inventory of the Director’s Apartments drawn up on 3 May 1961: AFR Archives, dossier 1961 (*correspondance -exposition*), letter n. 61070, from J. Mathieu to P. Bressol.

[19] E. Schlumberger, *op. cit.*, p. 64 and C. Costantini, *op. cit.*, p. 76.

[20] Balthus set up his studio in the rooms that had formerly housed the museum of the Villa Medici (under the *terrazza del bosco*); but he always used the Esther Room as his drawing studio.

[21] Comparison of the various unpublished accounts and reports on the different stages in the work (some drawn up by

Balthus himself, others by the contractors Crucianelli and Stracchi, by the mason Francesconi and the plumber Luigi Nardini) give one a clear, step-by-step, account of how the work progressed; they also make it possible to trace the gradual development of the "Balthus technique". I have limited myself here to giving a broad outline. These documents also give an account of Crucianelli's restoration of the frescoes. See AFR Archives, dossiers: *Travaux immobiliers-entretien 1960-1966, Travaux immobiliers-restauration 1961-1965*. Information therein was supplemented by interviews with the following: the count and countess Klossowski de Rola, Jean-Loup Roubert, Didier Reppelin, François Rouan, Tommaso d'Ulizia, Roberto and Stefano Stracchi and Luigi Filosini.

[22] See, in particular, the accounts given by Thadée and Stanislas Klossowski de Rola in the documentary on Balthus made by Damien Pettigrew and broadcast on the Planète channel (18 December 1996).

[23] Conversation (28–08–1997) with Didier Reppelin, Head Architect of the Monuments Historiques responsible for the Villa Medici.

[24] *Les Trois Soeurs*, oil on canvas, (1.31 x 1.75 m), dating from 1946 and now in a private collection; *Nu de Profil*, oil on canvas (2.25 x 2.0 m), dating from 1973–77 and now in a private collection.

[25] See AFR Photographic library *Travaux-rapports Balthus 1972*, report of 5 July 1961.

[26] AFR Archives, dossier 1961 (*correspondance -exposition*), letter from J. Mathieu to P. Bressol dated 15 April 1961; *Travaux immobiliers-restauration 1961-1965*; *Comptes 1966* (independent budget for the year 1966, period furniture).

[27] Some of the antique dealers most often mentioned in the documents include A. Nucita, A. Morandotto, V.L. Veneziani and P. Sciarra.

[28] According to the former *pensionnaires* André Barelier and Bruno Lebel, as interviewed in the documentary on Balthus made by Damien Pettigrew and broadcast on the Planète channel (18 December 1996).

[29] The work accounts of the Stracchi company bear witness to this work: AFR Archives, dossier *Comptes 1966*, independent budget for the year 1966, furniture and material. Document dated 14–11–1966.

[30] See B. Pons, *Grands décors français 1650-1800*, Dijon 1995, pp. 106, 133–34, 249, 293; S. Calloway, *L'époque et son style. La décoration intérieure au XX^e siècle*, Paris 1988, pp. 27, 39–40, 920.

[31] See the numerous accounts by J. Leymarie, as well as that given by J. Lord in "The Strange Case of the Count de Rola (Balthus)," in *Some Remarkable Men. Further Memoirs*, New York 1996, p. 168.

[32] See AFR Archives, dossier *Correspondance 1962*, letter from J. Mathieu to Balthus dated 17 September 1962 and that from H. Samuel to Balthus on 6 March 1962. The tone of the latter reveals how well the two knew each other.

[33] See B. Toulier, *op. cit.*, plan of Villa Medici at level six, fig. 545. Room 2 is the director's Blue Salon.

[34] This model was the eighteenth-century "Knole settee," at the Knole Park country house.

[35] See the inventory of antique objects and furniture at the Villa Medici drawn up by Pierre Arrizzoli-Clémentel and Chantal Coural in November 1980, p. 16 in AFR 80, 43 and AFR 80, 44.

[36] I would like to thank Bruno Racine, Director of the Académie de France in Rome, for pointing out this signature.

[37] See the interview with Mario Tornesi (17–09–1997).

[38] See AFR Photographic library *Travaux-rapports Balthus 1972*, report of 5 July 1961, and AFR Archives, dossier *Parma, 1961-1963*.

[39] See AFR Photographic library *Travaux-rapports Balthus 1972*, detailed note on the restoration and refurbishment work carried out at the Villa Medici, dated May 1966. For the refurbishment of the exhibition rooms, see AFR Archives, dossiers *Correspondance expédiée 1965-1968*, budget projection 1966; *Travaux immobiliers-restauration 1966-1968*.

[40] See Toulier, *op. cit.*, plan of the Villa Medici at level one, fig. 525, the exhibition rooms are rooms 5–6, 15–19 and E9.

[41] AFR Archives, dossier *Correspondance expédiée 1965-1968*, letter from Balthus to Gaëtan Picon (12–02–1966). See also the accounts given by the count and countess Klossowski de Rola, and those by Tommaso d'Ulizia and Mario Tornesi.

[42] See conversation with B. Klossowski de Rola (22–09–1997).

[43] On the exhibition of work by the *pensionnaires*, see the AFR Archives dossier *Correspondance expédiée 1965-1968*, especially the letters sent by Balthus on 12–12–1966: one to Gaëtan Picon, the other to the Secrétaire Perpétuel of the Institute.

[44] F. Fellini, *op. cit.* p. 18.

[45] On the work in the gardens of the villa, see AFR Archives, especially the dossiers *Travaux immobiliers, entretien, jardins, obélisque 1974; Entretien-jardins 1975; Travaux immobiliers 1975-1976*. This work on the gardens of the Villa Medici did not follow what are the present-day criteria applied by the Monuments Historiques. On the gardens at the time of Ferdinando di Medici, see S. D. Butters, "Ferdinand et le jardin du Pincio," in *Villa Médicis*, vol. II, pp. 351–410 and vol I for the reproductions of the engravings that show how the layout of the garden changed over the years.

[46] For more details of the procedure followed and further technical information, see the two conversations with T. d'Ulizia and the former *pensionnaire* (1972–1980) M. Bourbon (both 5–09–1997). See also M. Bourbon's articles " Le moulage aujourd'hui," in *La Sculpture de XIX^e siècle, une mémoire retrouvée. Les fonds de sculpture*, Paris 1986, pp. 60–68, and his "Le Matériau, techniques d'aujourd'hui, techniques d'avenir" in *Le Moulage*, acts of the international symposium held 10–12 April 1987, Paris 1988, pp. 15–25.

[47] Conversation with G. Brunel (10–09–1997).

[48] See Ovid *Metamorphoses*, book VI.

[49] On the history of the *Niobides* statues, the original format suggested by archaeologists and the fortunes of the works since their rediscovery, see E. Mandowsky, "Some notes on the early History of the Medicean *Niobides*," in *La Gazette des Beaux-Arts*, 1953, pp. 251–264; W.A. Geominy, *Die Florentiner Niobinden*, Bonn 1984; C. Pinatel, "Les Moulages des 'Niobides' florentins à Versailles," *La Revue du Louvre*, 3, June 1989, pp. 137–147.

[50] See the conversations with P. Bigongiari (20–02–1997 and 11–09–1997).

[51] According to the statement made by M. Boubon and quoted in C. Pinatel, *op. cit.*, p. 147, n. 69. F. Perrier, *Segmenta nobilium signorum et statuarum, quae temporis dentem individium evasere, urbis aeternae ruinis erepta*, Paris 1638, pl. 87.

[52] I would like to thank late Count Klossowski de Rola and his wife for allowing me to visit and photograph their villa at Monte Calvello.

[53] Here one should consult the reconstruction of the décor of the Villa at the time of Ferdinando de' Medici offered by P. Arizzoli-Clémentel on the basis of an inventory of the palace drawn up a year after Ferdinando left for Florence. See P. Arizzoli-Clémentel, *op. cit.*, pp. 506–30. He concludes "[...] one undoubtedly gets a more precise picture of the cardinal's life in a Rome dominated by classical antiquity—a taste which in this environment resulted in a varied use of color, fabrics, precious materials and curios."

[54] AFR Photographic library *Travaux-rapports Balthus 1972*. Also the comment by Balthus himself quoted in C. Constantini, *op. cit.,* p. 77: " Unfortunately, I didn't use to paint very much; but I was consoled by the results I obtained in the restoration of the villa. As I have already mentioned, I had an excellent team of workers [here he mentions the Crucianelli company]. Malraux himself followed the work with interest from Paris." In a conversation on 10–01–1998, Balthus confirmed to me this rather special situation: Malraux had given him *carte blanche* for the restoration of the Villa.
[55] "His complete restoration of the villa [...] is in itself one of his most perfect works and has had a significant and positive effect on both him and his art. The success is owing to the sureness of his artistic gifts, to his profound knowledge of Italy [...], to his infallible sensitivity [...]." J. Leymarie, *op. cit.,* 1984, p. 166.
[56] J. Clair, "Les Métamorphoses d'Eros," in *Balthus*, exhibition catalog, Musée national d'art moderne, Centre Georges Pompidou, Paris 1983, and *Balthus. Les Métamorphoses d'Eros*, Paris 1996, dustcover.

I keep a touching souvenir of the warm and generous way I have been received by the late lamented Count Balthasar Klossowski de Rola and his wife, that I whish to thank particularly. I would also like to take this opportunity to thank all those who have assisted me in my research. First of all, the staff of the Villa Medici—especially Bruno Racine, the Director, Michel Hochmann and Olivier Bonfait, successively Head of Art History at the Académie de France in Rome—and Balthus's friends. They all made an important contribution to this work, which also draws on unpublished material from the archives of the Académie de France in Rome, which was generously made available to me by Bruno Racine and the kind permission of Count Balthazar Klossowski de Rola. As a part of this research project, photographic documentation of the work at the Villa Medici was produced in summer 1997 by Stan Amand, a photographer who was also a pensionnaire at the Académie in that year. I would like to thank him for his invaluable collaboration. The complete account of this research will be included as part of acts of the symposium 1797-1997, deux siècles d'historie de L'Académie de France à Rome. L'artiste, ses créations et les institutions, Rome, Académie de France à Rome (25–27 September 1997), to be published in 2002.

Creation goes hand in hand with revelation, and the fullest measure of the former comes from a candid profusion of the latter, while common sense advises that the creator's personal life is paltry stuff compared to the great existence expected of his work. Having created it, moreover, the very best thing he can do by it is to die. And that is what Balthus did at last just yesterday, Sunday, February 18th, at three o'clock in the afternoon, aged 92. His reality was even greater than his identity, and he was bound to an involvement with it so passionate that the outcome far surpassed the personal. Greatness always begins that way. How far it can go, time, and death, always tell. Time for Balthus has at great length already contributed its revelatory largesse; and now death, too, provides a clear-cut perspective of distance. And so it is finally right to weigh the achievements of this superior creative past upon the exacting scales of posterity.

The pursuit of the masterpiece is the power that drives the creative determination. Determinism does the rest. It is remorseless, tireless, arbitrary, insidious. The boulder of Sisyphus is but a grain of sand by comparison. A piece of work, whether it concerns the uncertainty principle, an industrial building, a symphony or a painting is a demonstration of mastery only insofar as it elucidates the lifetime experience of the spectator, for it is in the visual judgment of any spectator, not in the image or utility of human life, that the redemptive power of creativity actually resides. And such judgment, needless to say, requires the severest and most prolonged self-discipline in search of the self beyond the appearance. A masterful human creation, in short, offers to all seriously perspicacious human beings a concept of life experience more profound and more "real" than everyday inferences can conceivably provide. It is only insofar as we are knowingly resolved to live more fully that we live at all. To stubbornly pursue a course toward hackneyed horizons saps vital energy and leads to banal nonentity. Thus, the pursuit and perception of the masterpiece must reach beyond the creation itself in order to disclose to the spectator the art of his own existence via the artist's transcendence of conscious talent and visionary commitment to the deliverance of spiritual revelation. But it is unfortunately easier to discuss masterpieces, their elusive effect and uncanny constitution than to recognize, to appreciate and, above all, to produce them.

The mystery of masterpiece is generated by the mystery of genius. Without the latter there would never be the former, but a fruitless determination to solve the latter is our only means of catching a glimpse of the illumination beyond the visible surface of the former. In other words, Piero's *Golden Legend*, Rembrandt's grandest self-portrait, Géricault's *Raft* or Cézanne's climactic *Bathers* reveal only impressive images to those unable to see that they are themselves the artist's primordial subject matter. This seemingly paradoxical happenstance is especially apposite when the artist may appear to have been preoccupied by scenes which suggest obsessive expression of a personal, emotive stimulus. Such might very well seem to be the case with Balthus, because countless presumptuous commentaries have been provoked by the frequent recurrence in his œuvre of the figures of nubile young girls posed so as to seem to rouse erotic fantasies. To impute such aesthetic, psychic activation to an artist as sensitive and intelligent as Balthus would appear as wonderful as endeavoring to interpret Cézanne's apples as symbols of his emotional determination to make of his "little sensation" a representation of his sensual dilemma. Balthus's girls and Cézanne's apples share a similar identity, being subjects concerned with the profoundest issues that confront humanity, being therefore also emblematic of the pursuits from which our species earns its nobility and redemption. Might art, indeed, redeem man, it could succeed only by showing him to himself as the very substance of art and thereby restoring him to primordial, innocent youth. Balthus's paintings abound in images evocative of such an eventuality.

From the beginning of his career, which was arduous and obscure, Balthus made an uncomprising issue of being "an artist of whom nothing is known." What needed to be known, after all, was seen—occasionally!—on the walls of galleries or in the palatial homes of a few wealthy connoisseurs. Balthuses were never inexpensive. The artist's determination to keep his back turned on the public—despite the execution of a few studied self-portraits never meant for sale—is deliberately illustrated in the two largest and most important paintings of his œuvre, *La Montagne* of 1937 and the *Passage du Commerce-Saint-André* of 1952–54, both clearly ventures toward the production of a masterpiece. The earlier work, accomplished, imposing, cryptic and tantalizing though it is, does not in the clairvoyance of hindsight ful-

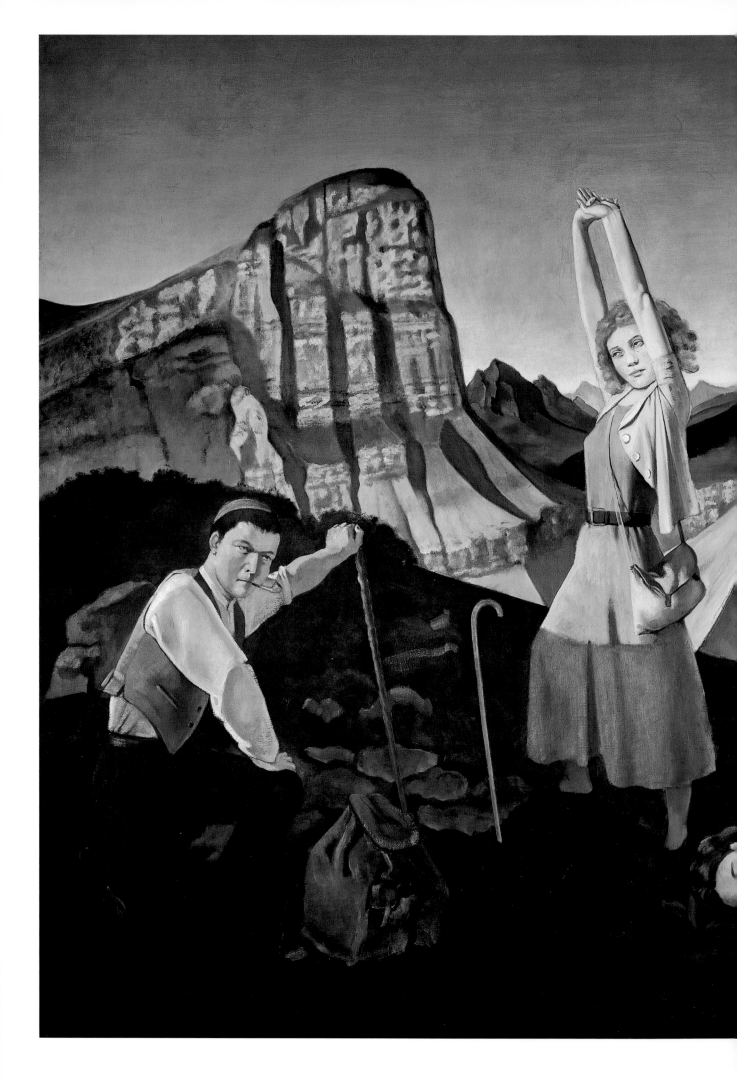

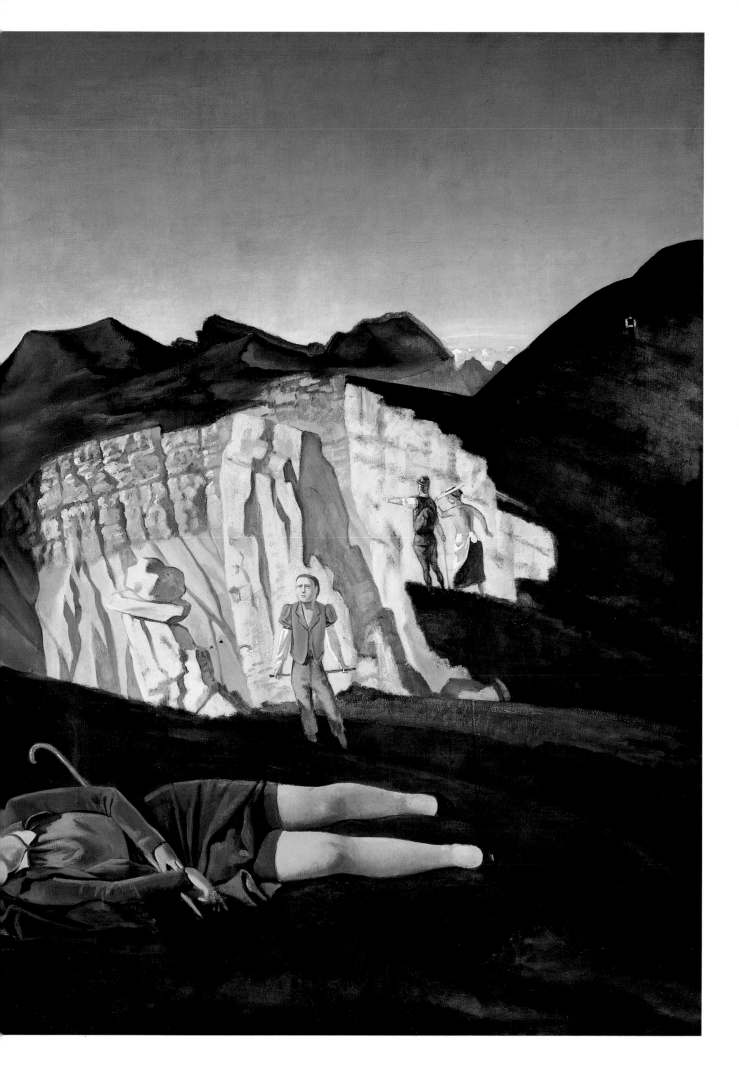

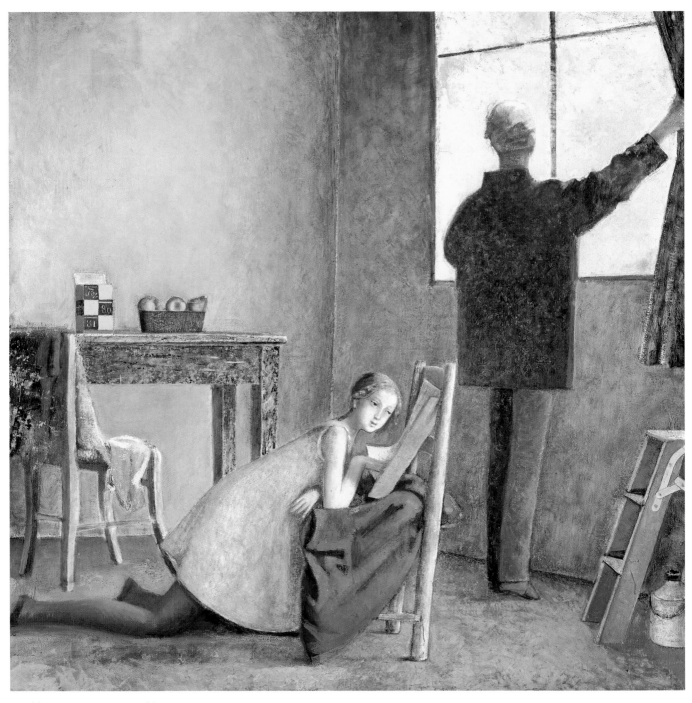

2. Balthus, *Le peintre et son modèle*
[The Painter and His Model],
1980–81, casein tempera on canvas.
Paris, Musée national d'art moderne,
Centre Georges Pompidou

fill its almost-too-felicitous potential. However, one seemingly-insignificant detail in the overwhelming mountain scenery draws arcane attention to itself for those who know how to see and recognize its significance: this is a male figure so tiny in comparison to the six others, three women and three men, that by its very diminutive size on a distant slope and its far, far removal from the rest, toward whom, moreover, he turns his back, emphasizing thus not only a seeming unawareness of their presence, indeed of their meaning and purpose, but also by his dogged hike toward the horizon a deliberate refusal to appear responsible for their very existence. This figure, of course, is the artist in person. He was not yet thirty when he executed this arresting, remarkable, enormous painting which today after forty-five years of obscurity commands the admiration and puzzlement of visitors to the Metropolitan Museum of Art in New York City.

Another decade and a half were destined to pass before Balthus in the fullness of his maturity would complete the indispensable masterpiece which from the beginning had been the *causa sine qua non* of his creative perseverance. Meanwhile, to be sure, he painted many admirable works, some of which might well have been deemed masterpieces if issuing from other hands, and these certainly are thrilling in concept and execution. But none were the great work which Balthus's *raison d'être* urgently required. This came to him as an urban, not rural, vision, the representation of a street scene close by his Parisian studio, peopled by eight figures, four women and four men, plus a small dog and the doll of a little girl. The scene is completely enclosed by buildings on three sides and the paved street below. No sky, no horizon. The contemplative world is purposefully limited to the artistic space and no other. It can hardly be by chance that the artist began his painting in the nearby studio but found himself unable to finish it until he was installed in a derelict *château* lost in the drab provinces of central France several miles from the nearest hamlet. Why such calculated solitude should have been vital to the ultimate fulfillment of the artist's unique and climactic masterpiece is not, after all, too puzzling. Though situated in a city, yet only human beings and one animal are present, not a single automobile or other intrusion of the industrial and depersonalized present, and indeed the painted site happened—not at all by chance—to have remained for more than a hundred and fifty years exactly as Balthus represented it, changeless and indelible. *Ars longa, vita brevis*. Like all great art, *Le Passage du Commerce-Saint-André* exists outside of the haphazard circumstances of human experience, outside of history's trivia and luck, outside, in short, of time. And yet it stands supreme in the measure of tradition, which is the accumulation of millenia. Yes, in order to come to terms with the grand challenge of civilization Balthus had no choice but to seek out the solitude immemorially conducive of phenomenal visions. A lonely man in the loneliest of centuries, he forged his fate entirely by himself, he conjured, created, delved deep, ever and ever into deepness and came up with reality. Certainly he went far, far down, below the limes of greatest resistance, summoning up images which we can glimpse only by standing on our heads, so to speak. Not figuratively, of course, but by putting vision in the place of seeing in order to discern ourselves and through our own eyes behold the spectacle of immanent life. Out of his mystery Balthus made and completed his masterpiece in the isolation of that ramshackle *château*, lacking in so-called "modern comfort" and five miles from the nearest telephone. I saw it there on the 5th of April, 1954, and the artist, dissatisfied as ever, declared he could do no more with it save, perhaps, a touch here or a touch there once it reached the residence of the Parisian collector whose private property it had long since become.

The descriptive, aesthetic, symbolic elements which make *Le Passage du Commerce-Saint-André* a masterpiece are so numerous, various and complex that their analyses would require by themselves a lengthy essay, and even this would be largely speculative. The resources of language are baffling, and, indeed, probably pointless when confronted by the requirements of adumbrating a visual experience which by definition defies verbal expression while at the same time challenging the egotistical impulse to see what reflects the superficiality of our vision. However, strenuous appreciation, all else failing, bids us to fathom as best we can the essential aspect of this painting, hopeful that the creative enigma may accordingly cede to interpretation. This aspect is the painting's central figure, though it is the dog, man's best friend, which occupies the actual center of the foreground. The crucial figure is unmistakably the artist, his back turned—once again!—to the spectator, walking away from—what?—

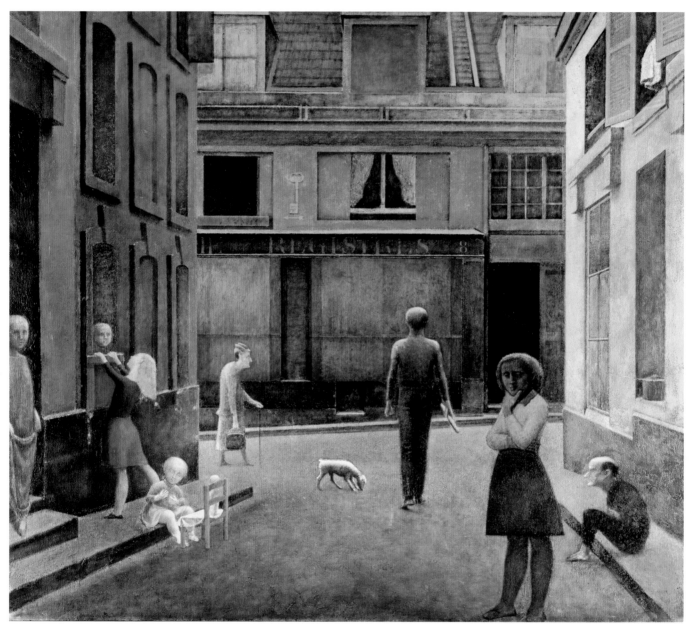

3. Balthus, *Le Passage
du Commerce-Saint-André*
[The Passage du Commerce-
Sanit-André], 1952–54,
oil on canvas.
Private collection

4. Balthus at Rossinière,
walking to his studio
in front of the Grand Chalet

the population of his creation, from its purpose and meaning, from his own artistic and personal act. His refusal to face the gaze of those for whom, after all, his work has been accomplished tells us yet again that it is our opportunity to perceive in our own experience the microcosm which he has placed mysteriously before us, and it seems therefore likely that he looks forward precisely to this perception as to an ultimate absolution. It is indispensable, too, to observe that as he makes his way toward an inexorable destination he bears with him in his *right* hand a loaf of bread, immemorial staff of life both figuratively and literally. And so the life of painting informs us of the labor of life to reveal its mystery by sacrificing its mortal condition. *Le Passage du Commerce-Saint-André* in time will accumulate more and more of the mysteries of masterpieces and genius. It will do so, indeed, by being the greatest work of the last great artist of an era which began seven centuries ago with Giotto and now has come to a decisive and deplorable conclusion amidst the sterile detritus admired and acquired by persons of good will who show nothing about the perils of looking at themselves in the image of creative truth and who flee from the ancient mysteries of mere reality made long ago anew.

Balthus did well to die when he did.

R.I.P.

1. Balthus at Chassy,
with the castle in the background
photographed by Loomis Dean

Balthus lived a very long life—even longer than Picasso's. But while of one we know almost everything—have practically a day-by-day account—that is far from being the case with Balthus. Obviously, Balthus was anything but ignored (numerous were the friends and admirers who made the journey to Villa Medici or to the Grand Chalet de Rossinière); however, he was a figure set apart. When he agreed to talk about his work, his total difference with the contemporary art world made his position all the more evident; perched as though on a solitary peak, he was in the natural position for someone whom Alain Cuny described as "a bird of the upper skies." At the end of his life, Picasso was alone, fiercely alone; the historic friends of his past had long since gone, yet had remained as presences, their names forever associated with that of the undisputed chief of modern painting. Balthus's independence means that he has left fewer traces; people generally know little about what a central character he was in the Parisian art world of the fifties, the period when I first made his acquaintance.

We met at the home of Carmen Baron in Rue de Varenne. Her first husband, Pierre Colle, a Parisian art dealer, had rapidly made a name for himself thanks to his sharp eye in choosing his artists. He put on Alberto Giacometti's first show, and then became the dealer for Derain and Balthus, before his premature death in 1948. The three daughters of that marriage—Marie-Pierre, Béatrice and Sylvia—are known to the history of art for *Les Trois soeurs*, which Balthus painted in 1960. Carmen was particularly gifted for friendship and she gathered around herself distinguished artists from all sides—I was the only unknown amongst them—and thus, without even thinking about it, created what was the last real artistic salon in Paris. The gatherings of Carmen Baron and her second husband François would bring together and among many others such figures as Balthus, Max Ernst, Man Ray, Giacometti (perhaps just for dinner), the great poster artist Cassandre, Francis Poulenc, Georges Auric, Jacques Prévert, Maurice Druon, Jeff Kessel, Jacques Lacan, Dora Maar, Marie-Laure de Noailles, the young—but already known—César and Christian Dior (who started out as an assistant in Pierre Colle's gallery).

In her large reception room, lined with admirable modern paintings, we enjoyed the pure pleasures of art and friendship. Whisky had already established itself as the necessary fuel of conversation, and everyone was smoking Gauloises, without having ever heard that those little wonders were dangerous and even fatal. In effect, if art brought us together—and politics sometimes separated us—the predominant note in the atmosphere was laughter and good humour. In this group of brilliant and witty men and women, the drollest of all was undoubtedly Balthus; his mordant pessimism was expressed with an irony and felicity of expression that soon had everyone in fits. He used to come up came to Paris from his retreat at the Chateau de Chassy in Morvan; and if he had to remain in town for a few days, he stayed at Carmen's, where he had his own room. He was the favourite of the household; indeed, if the truth be told, he was the darling child of the entire company, who considered him a rare, quintessential, artist. In those days, that environment of affection and friendship enabled him to flee public life; he disdained interviews with critics, and refused all photographers.

However, when trying to place Balthus in the context of his contemporaries, I automatically think of Alberto Giacometti, who was his best friend. They complemented each other wonderfully. Alongside Giacometti, with his massive head and his loud jerky delivery, Balthus held his own perfectly, with his rather haughty manner and his clear, drawling voice. Everything about him oozed certitude. He was no less a master, and he knew it. And this went together with a certain nonchalance in his appearance; his elegance of profile being matched by clothes just slightly worn but of perfect taste—all of which was in sharp contrast to the much more passionate nature of the sculptor. Alberto, never went much beyond the sports jacket that he would wear on all occasions, be it to work or for late night attire (in the latter case, adding a silk scarf); which he always bought from the famous "Old England" shop on Les Grand Boulevards, just as Claude Monet had done in his day.

Both of them were chain smokers. Alberto could get through four packets of Lucky Strike a day. He would take a drag every so often, but mainly I remember the cigarette between his fingers as he talked, or on the edge of his turntable as he worked. Balthus, on the other hand, always had a cigarette hanging from his lip, and to stop the smoke getting in his eyes tilted his head, like a bird; he'd look at one like that, with an eye half-closed, right up until his last day. Together, they always complained about the way their work was going. All their friends were familiar with Giacometti's "I just can't get it right," and Balthus's "I'm a failure;" but

2. Balthus, *Les Trois sœurs*
[The Three Sisters],
1964, oil on canvas.
Private collection

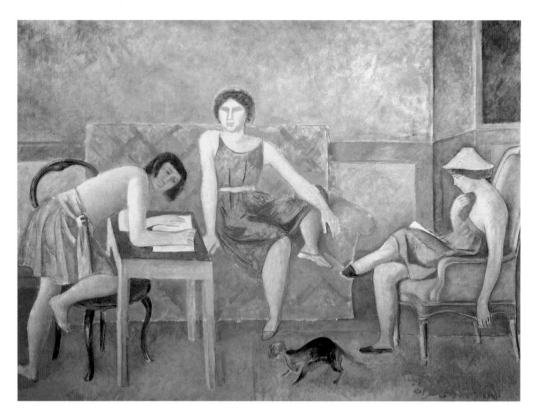

3. Carmen Baron

opposite page
4. Balthus, *Jeune fille aux bras
croisés* [Girl with Folded Arms],
1955, oil on canvas

when they were together, it was almost a competition to see who could say it most convincingly. They drank in the evening, but not with the contentment of modern-day artists; instead, they were consoling themselves for not having managed to achieve what they had hoped for during the course of the day. Obviously, neither of the two really thought of themselves as a failure. At one period I used to see a fine clay sculpture of a nude in Giacometti's studio that was gradually falling apart. Given its beauty, I protested several times, and each time Giacometti would always reply in an irritated tone that the statue was "neither done, nor worth doing." At which point, to please him, I later voiced some doubts about the piece. "Oh, yes?" he snapped. "What's wrong with it?"

If Giacometti was modest, it was when comparing his achievement to that of Ancient Egypt, and Balthus was thinking of himself in relation to Piero della Francesca, not their contemporaries. This litany of self reproaches revealed an important aspect of both men: they thought that art was greater, more important, than themselves. This wonderful faith, this thirst for the absolute in such successful artists has now disappeared. And that is something to be regretted, because it is this absence which makes contemporary art ring hollow.

I had known Alberto Giacometti for some years when I made the acquaintance of Balthus and his work. I was a passionate admirer of the former, and would bemoan my inability to follow him, to keep up with that concentrated gaze of his, which like a laser beam seemed to probe the objects before him with ever greater intensity. Despairing of that, I had let myself go by opening-up the modelling of some *haut-reliefs,* in which I placed my figures side by side, depicted in a simple frontal pose. From the very first, Balthus's paintings struck me as having enormous range. From one side of the canvas to the other, forms unfurled upon forms, the cheeks were well-rounded, the eyes wide open, the gestures monumental and ample. And one entered into this space thanks to the artifice of composition, to that sublime intellectual activity which I consider to be the *nec plus ultra* of art. These two artists were so different that one had to view them as two opposite poles; but that first day I recognized Balthus as the other pillar on which one could construct a new approach to the figure and to figurative art.

One should not forget that in the fifties Balthus and Giacometti were rather isolated in a Paris where abstraction reigned supreme. Alberto's rejection of formalist, surrealist art had led to him being marginalized. He was the first important sculptor to abandon the avant-garde for the tradition of busts and nude figures done after life. But it was precisely this survival of the

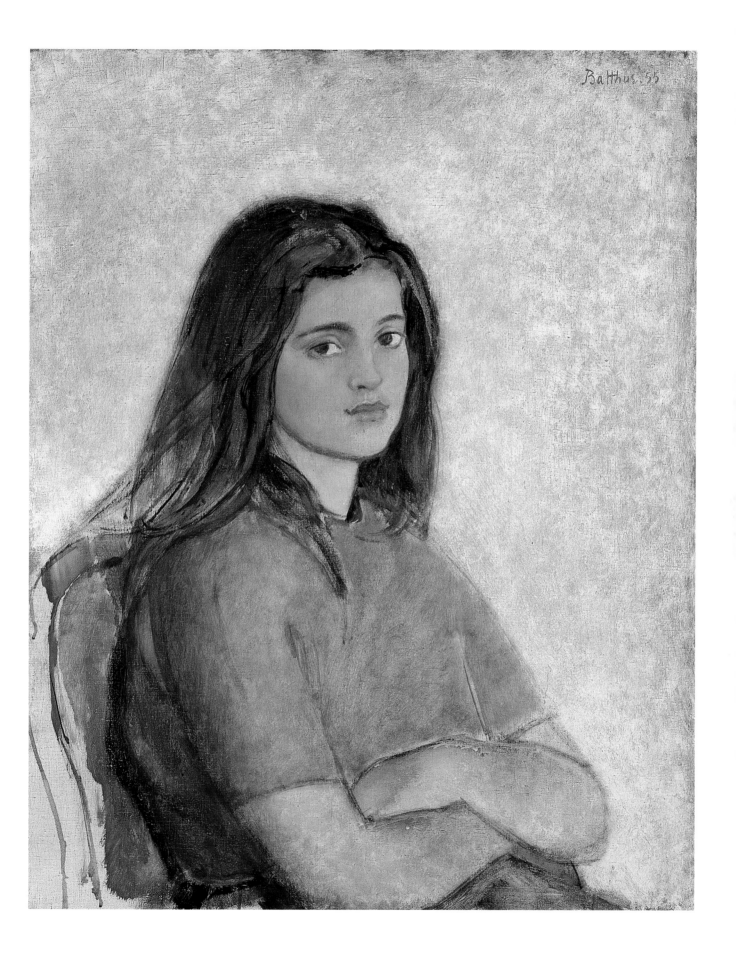

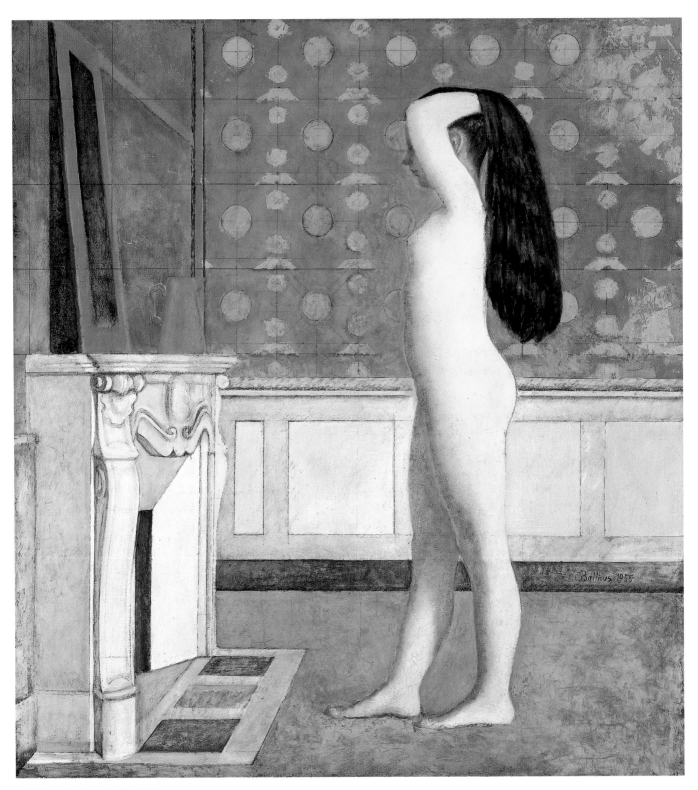

5. Balthus, *Nu devant le cheminée*
[Nude in front of a Mantel],
1955, oil on canvas.
New York, The Metropolitan
Museum of Art, The Robert Lehman
collection, 1975

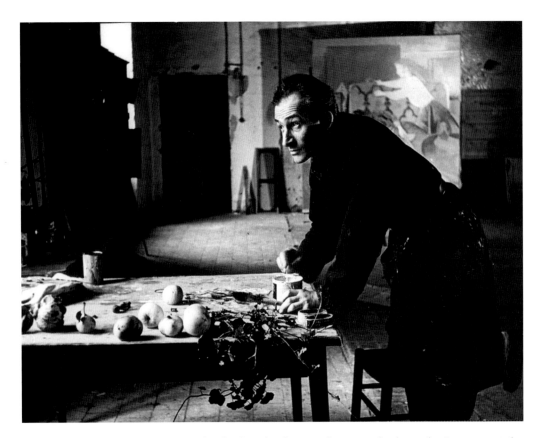

6. Balthus at work in his studio photographed by Loomis Dean

very essence of tradition—as embodied in the figure of man—which made Giacometti the sole artist truly "of his day" in a post-war world reeling from the memory of the concentration camps and the threat of nuclear destruction. Hence his glory. Balthus did not have to make this return, because he had never even dallied with formalism and abstraction. He was one of the rare artists of the twentieth century—perhaps the only one—who never strayed from his path; from his adolescence onward, he continued to investigate and return to the same themes and subjects. If certain of his works—such as *La Rue* [The Street]—were linked with Surrealism, it was the surrealists who said so, not he. The critics saw him as classical—not to say academic. In fact, Balthus accepted the challenge of rivalling and equalling the Old Masters, engaging in a solitary endeavor for permanency that ran contrary to the rather restive world of the avant-garde, which was in a perpetual state of change.

I am not an advocate of the idea that Balthus's works belong to the past. His paintings, which are very skilful from a technical point of view, were to my eyes a fine garment almost bursting at the seams with a content that was remarkably tough and daring. He worked at length on each of his canvasses, transforming them eventually into "loaded objects." The weight of meaning and significance within them goes well beyond questions of technique or presentation; and, of course, here I am not simply referring to the "erotic" pictures, because the landscapes, still lifes and portraits all have this same disturbing density and power. After the death of James Thrall Soby, a small number of major works from his remarkable collection were hung in the foyer of the MoMa in New York (a museum to which he had made an important contribution as curator). Amongst the first class Picassos, Mirós, etc., there was Balthus's radiant *La Rue*, whose remarkable ferocity seemed to dominate the other works. And there could be no doubt as to the painting's modernity.

From my very first—and memorable—encounter with Balthus's work, I recognized him as being what I consider most important in an artist—that is, a true "picture-maker," someone able to make a picture that is a significant whole. Such a result requires very elaborate and extensive work upon the composition of a painting—a labor that often reflects an explicit determination to produce a masterpiece. In effect, it can be seen in David more than Ingres, in Manet but not Monet, in the Seurat of *La Grande Jatte* but not Cézanne. And in Picasso it is always present. Whilst the first artist of each of these pairs was interested in synthesis,

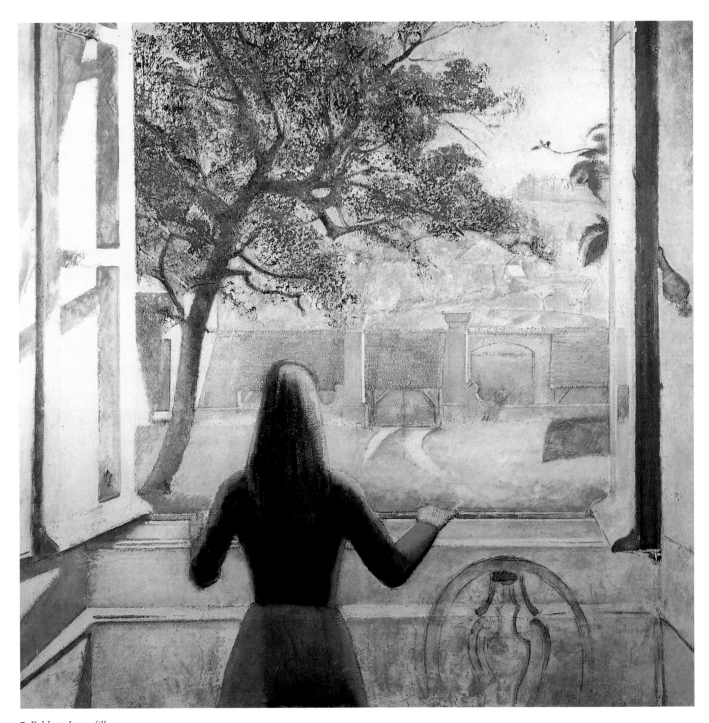

7. Balthus, *Jeune fille
à la fenêtre* [Girl at a Window],
1957, oil on canvas.
Private collection

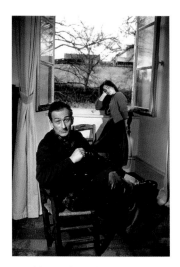

8. Balthus with Frédérique at the window photographed by Loomis Dean

the second was engaged in analysis. To the extent that one considers Alberto Giacometti as a painter, I find Balthus's significant whole much more interesting. The latter had such gifts for synthesis that I would consider him the most complete painter of the twentieth century after Picasso; indeed, Picasso himself recognized this, for he used to say that the two of them were the dual sides of the same coin (perhaps meaning that Balthus was an intimate painter, whilst he was an artist who addressed the world); what is more, in 1941 he had bought Balthus's *Les Enfants* [The Blanchard Children] from Pierre Colle—an unmistakable mark of esteem for the younger artist.

When I first knew Balthus I had temporarily turned my back on the work of Picasso, enthralled by the new path I saw in the work of Giacometti and Balthus himself. I was therefore surprised to hear the latter always speaking so highly of Picasso. I couldn't help but ask him why. "Ah! But I love Picasso because he is nothing but a painter," he said.[1] Their friendship was helped by the fact that they were almost neighbors; Picasso's studio in Rue des Grands-Augustins was just a stone's throw away from the very secret Cour de Rohan where Balthus lived and worked. The entrance to this courtyard, enclosed by sleepy red-brick facades in perfect *style Henri II*, is via the Passage du Commerce-Saint André, which is itself a perfect example of eighteenth-century architecture, with its simple buildings and large cobblestones. The place was also the subject of a painting that best illustrates Balthus's abilities and ambitions. His *Passage du Commerce-Saint-André* is an immense and well thought-out composition; it is his masterpiece (and was considered as such by the artist himself), one of those key works in French painting.

Composition is the art of organizing—or, better, reuniting—the various components of a scene to form a whole. One may consider it as being the architecture of painting; however, when the components are envisaged and organized in truly significant relation to each other—as happens in *Le Passage*—the artist achieves a sort of static music, a palpable suspension of time; there is a silence here where beauty reigns—so different to that one might perceive in other works of the period. And one should also underline another difference: as a man, Balthus was always inclined toward the aristocratic, was always associated with the very Gotha of European nobility; however, the astonishing thing is that his work is peopled by the humble. Be they enraptured adolescent girls or little old men bent double, his characters are always simple—if not necessarily innocent—beings. This proves that the life of a painter when he is at work is a secret thing, and fundamentally different from the life of the man himself. As Balthus often commented: "Paintings don't describe or reveal the painter."

While it may have been a concern for *grandeur* which led him to retire to the water-logged lands of the Morvan, it is also true that the Chateau de Chassy would meet Balthus's rigorous requirements as an artist. When I knew it, the fine building contained very little furniture—this was the most impoverished time in Balthus's life—and yet it was more than furnished by the presence of the artist, who in this period can be said to have been most truly himself. I will never forget the austerity of the place, the slight smell of damp walls, the windows thrown open onto the view and smell of the fields that led down into the valley. All Balthus's landscapes were painted from those windows, and now the mere sight on one of those admirable works can bring tears of loss to my eye as I recall the painter in his home. For me no paintings are as moving as those Balthus painted in this chateau deep in the heart of France; it is not only their beauty that takes your breath away, but also their tenderness—a tenderness that is unique in the art of the twentieth century. Chassy was where Balthus also completed the last great works of his Parisian period. I would enter his first-floor studio with the respect and intense agitation one might feel when visiting the site of a famous battle. This was where Balthus had emerged victorious from such giant pictures as *La Chambre* [The Room] and *Le Passage*. There were traces of those memorable months all over the walls, in easily recognizable fragments of painting.

Do people give full weight to his decision to leave Paris, to the fact that he turned his back on his pre-eminent place in the rich art circles of the day? And all to be able to paint! Balthus's integrity and dedication are revealed by this decision; in those days, time moved slowly in the isolated countryside and the artist was to be left entirely alone to confront his art.[2]

Chateau bought and decor settled, as if by enchantment a very beautiful young girl appeared—Balthus's niece by the marriage of his brother Pierre. After the completion of the large Parisian works—the satanic *La Chambre* and the grave *Le Passage*—the presence of Frédérique would lead to a new, and equally important, phase in Balthus's painting. Within the Virgilian set-

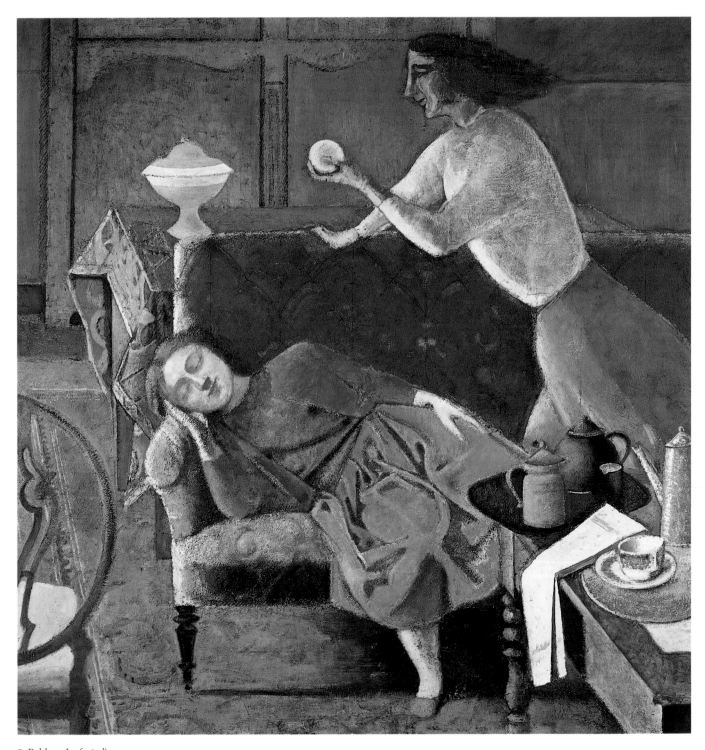

9. Balthus, *Le fruit d'or*
[The Golden Fruit], 1956,
oil on canvas.
Paris, private collection

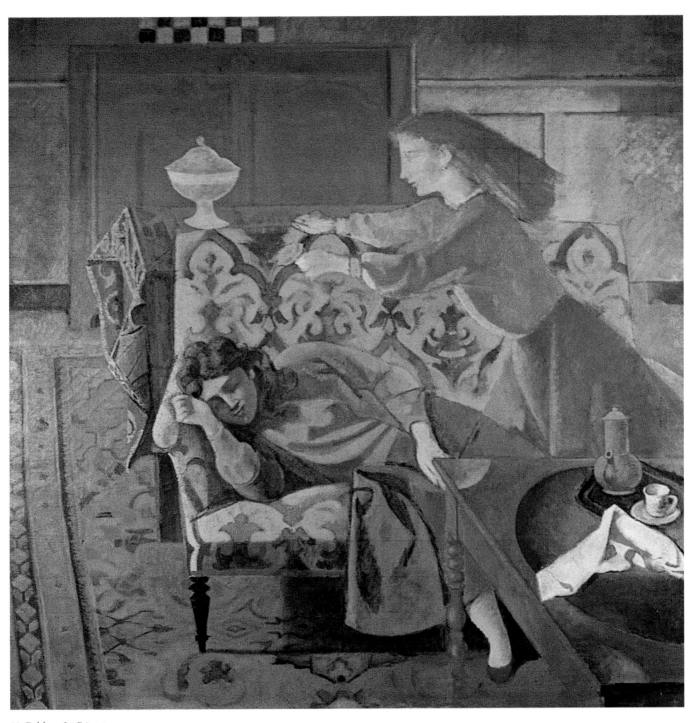

10. Balthus, *Le Rêve II*
[The Dream II], 1956–57,
oil on canvas.
Private collection

ting of reawakening nature, arrives all the grace of youth; and in the painting of this young girl at a window, ecstatically enthralled by the sun-lit landscape, I see the final unfolding of the message of the artist's much-beloved Piero della Francesca. The spring of the Quattrocento was now making itself felt through Balthus.

Some years later, when hanging his retrospective at the Musée des Arts Décoratifs in Paris, Balthus insisted on changing the rooms chosen so that he could exploit the natural light in those which gave onto Rue de Rivoli. After the changeover, there was no longer any space for the drawings and water colors. This collection of works on paper all belonged to Frédérique, for the simple reason that for years she had been saving the studies which Balthus discarded as he concentrated on the main task in hand: the painting. At the time I was running a small gallery in the Latin Quarter with my wife (it was named after her: Galerie Janine Ho). It had already established a certain reputation within artistic circles in Paris, and Frédérique, who had been our friend for many years, thought it would be a good idea for us to put on a show of the drawings and water colors to coincide with the exhibition at the Arts Décoratifs. Balthus agreed immediately, and as a sign of his good will agreed to come to our vernissage (having declined the invitation to that at the Museum).

One fine summer afternoon, our courtyard in Rue Monsieur-le-Prince was packed with the cream of the Paris art world. The works themselves were beautiful, and the well-lit space of our gallery showed them off to their best. As for price, Balthus decided the drawings should be sold in lots of seven at a fixed price of ten thousand francs. "Three good ones, and four bad," he commented dryly; when he wasn't working he rarely lost that sardonic sense of humour (his conversation revealed his rich range of interests—history, religion, the countries he had visited, different literatures—and yet his serious side never made him stand-offish: I remember the evening my Citroën broke down in Boulevard Montparnasse and we ended up passing the crowded terrace of La Coupole, with me at the wheel and Balthus behind, pushing).

At the time of the Rue Monsieur-le-Prince exhibition our gallery collection also contained some small Balthus paintings; though not entirely finished, these were nevertheless of fine quality—and yet the artist himself referred to them as "daubs."[3] This depreciation of his work revealed both an admirable modesty and a solid pride in his work—the result of which was an unflagging determination to do better, to go even further. Once, when we were in Rome, I told him that Pierre Matisse had been in touch with me, asking me to contact the courier I used there in order to organize the transport of *Les Joueurs de Cartes* [The Cardplayers] to New York. Balthus broke into giggles, and told me he had whitewashed it over that very morning. One could see all his pride as an artist, all his nobility as a painter, in this total lack of consideration of the finished work as an object of commerce.

In the later years of his life, Balthus protested with the very last of his energy against the increasing ignorance of the very techniques of painting. He certainly did not expect a young painter to have his expertise in the grinding of colors, in the application of glazes and scumbles, but he would always insist: "Given that you're painting, you might as well know the techniques that make painting exist." A statement that reveals how, right up to his very last days, Balthus believed in the timelessness of this art, this religion. "I am only a craftsman," he would say in a tone of reverence.

In remembering him, we should not refer to him as the last great painter, because the cycle of painting has not come to an end; painting continues. However, one can certainly describe him as one of the great painters, a great artist.

(*Text translated from French*)

[1] Many years later I was struck by just how perceptive that comment was—illuminating, for example, Picasso's relationships with women, which many have described as cruel. We have to accept that he was only a painter; the women in his life would come and go, but he continued to paint. There was one real passion—painting—and other passions came after that. When Picasso left to live in the South of France, Dora Maar stayed in Paris, where she remained a close friend of Balthus's. It was through her that I met Carmen Baron.

[2] He never even had a car; though one day he did show me an old Hotchkiss with flat tyres at the back of his grange—a hangover, he said, from the days when he thought of himself as some sort of Lemmy Caution.

[3] Pierre Matisse in New York, who had had Balthus under contract since 1938, shot across the Atlantic to see this "pirate" gallery that was exhibiting works on paper that he, the artist's recognized dealer, had never been able to get his hands on. When he was looking at these "daubs" in our back room, Matisse saw some of my work, and soon afterward I joined Balthus in his Madison Avenue gallery.

In the history of art, Balthus is on his own. Just as in his life. In famous places like Paris, Rome; or then become famous after he decided to live there, like Chassy in the Morvan, like Monte Calvello, or Rossinière right below Gstaad, where he dwelt in palaces, castles, or large châlets, as though he were the only person in the world. His earthly adventure was entirely special. Nothing like it can be compared to it, because the *petite bande* Balthus belonged to always had but one leading man: himself.

Alone, secluded, he drew and painted as though over that very long period of time his life spanned there were good things to eat, combined with ease and the wealth of grand designs, regal or imperial, that always naturally adjusted to be on his scale, that of the unique, great soloist to whom it was always granted to perform by himself: without an orchestra, without a conductor, without the theater with boxes and seats. When someone asked him about his life, he replied with a smile: "Balthus is a painter of whom nothing is known. And now let us have a look at the paintings."

But his love for the few friends he had was eloquent, exclusive, unfaltering, and so deep that his embraces now belong to History, with a capital H. In 1970 Diego, Alberto Giacometti's brother, was his guest at the Villa Medici, the premises of the Académie de France Balthus presided. At the Villa Medici he was to honor, with a large retrospective exhibition, his friend Alberto Giacometti, recently passed away.

When the day was over Diego, worn out from helping install drawings, paintings and sculptures, said goodnight to Balthus before retiring in one of the bedrooms down the hall. In wishing him goodnight Balthus clasped him in such an intense, lasting embrace that Diego had the impression that embrace was a farewell. He was so alarmed that, terrified at the idea of never waking up again, he didn't sleep a wink.

If you enter his world Balthus remains cloaked in his mysteries, but he pays attention to even the faintest rustlings that have to do with you and your work. From then on he doesn't leave you alone. He claims he misses you if, for a while, you don't call him on the phone. If it's you calling, he's always there.

"And now let us have a look at the paintings" he wrote in that cable he sent John Russel, who was arranging a major show for him at the Tate Gallery.

That is what we too shall endeavor to do, skipping from one year to another, when the scenes become more compelling, leaving aside birthdates and chronology, that is like a bad cold in art historians' heads.

You marvel at what he has already painted, but right before, or later on, leafing through a catalogue of one of his large shows you discover a picture or a drawing you had neglected to look at. Balthus cannot be defined. When he made up his mind to do portraits he always invented masterpieces: here is the one of André Derain's body, face, dressing-gown and the inside of his room; yet here is Miró, with his little girl. Two imperial frailties. In our day portraits of that quality don't exist. Just as we don't have his science of the amorous perfidy in portraying nubile girls, standing in the room, sitting in the armchair or lying on the couch, when they were not even more stretched out, with their eyes closed, as if the dream, in which the adventure of those adolescents was drawn out, shifted about between languor, delight, surprise, the revelation of that languid fever called rapture displaying to us a slumber even more lingering than the ones before, and that so lags on that you stay there with it, the slowest and most lasting possible, sinking into the adventure of that life that brings into being adolescents like the ones invented by Balthus, who had no other purpose, or aim in the world, than to make them recline on the verge of that rapture of awakening. And even if they are standing, or are just out of bed, or looking at themselves, undisturbed by their nakedness, in front of a mirror or, dressed, leaning on a windowsill: those girls belong to Balthus, unique and all alone in the world.

Now that they exist, painted on canvas, or reclining on large sheets of paper, we can talk to them, graze them or let our eyes linger: we can, and we do not often have such an opportunity, recognize them for what they are, because a great part of ourselves would like to be them. Leading actors without parents, without the alphabet, or grade A or B in the school where they certainly did set foot, because we might fancy that the world he painted has no other language. There they are, but on their own, they don't trust us, they don't humor us: and I don't figure that, were they asked to say something about their lives, they

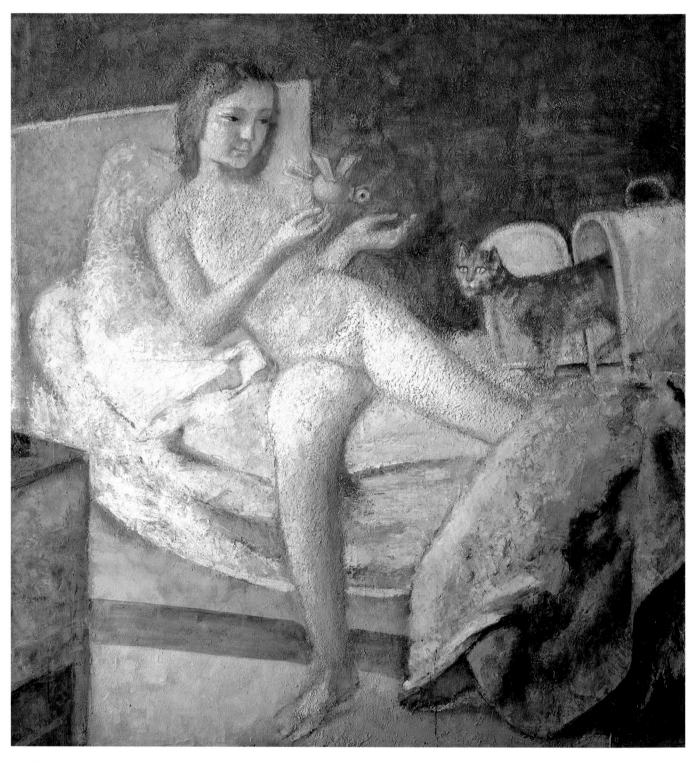

1. Balthus, *Le Lever*
[The Waking up], 1975–78,
oil on canvas.
Private collection

2. Balthus, *Nu au foulard*
[Nude with a Scarf], 1981–82,
oil on canvas.
London, private collection

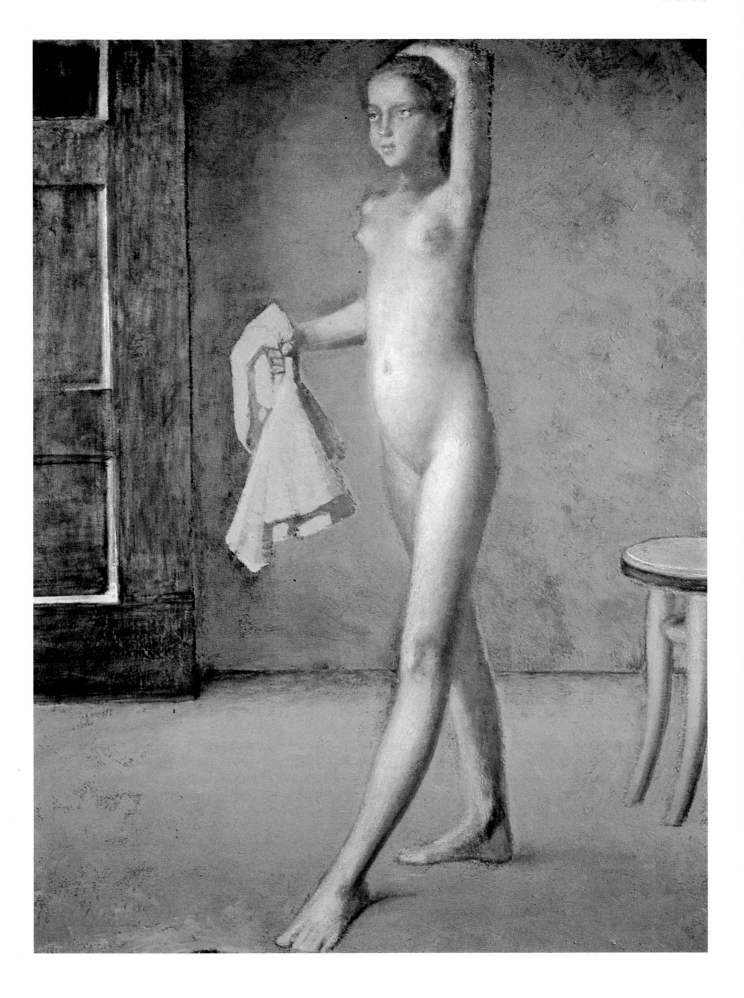

would have the time or the urge to utter a single word. Just like their father Balthus, they might reply with a smile, or with that other mysterious sound that is in the mind of someone about to go outdoors as if he had dreamed he'd been asleep in his own adolescent realm. Sometimes there is a kitten, a guitar, a pitiless light that overwhelms the room if a maid suddenly draws open the curtain to interrupt those feverish dreams, and the daylight reveals the presence of total nudity, or a vest baring that body to the crotch, the white panties, the short stockings, and the little slippers, they too just barely stirred from that huge torpor where they could conjure up what their life might be, entirely, we hope, without any of the usual unbearable women's domestic fuss.

But the quality in those paintings, peopled by figures in rooms, certainly does not make me forget the beauty, the intensity of the Italian and French landscapes with hills, fields, slopes, fruit trees, and all the classical landscape in which the agricultural countenance of central Italy is still present, and prevailing; and anyone who observes those landscapes knows he is looking at what he recalls having seen, glancing out the window of the train, or strolling in the countryside: and nothing can be more intense than that memory which now, precisely right now, and not five minutes ago, is right there under his very nose. The quality of what we are looking at matches the reality and the peace of that part of the old world we are still seeking so as to not forget it exists. It looms in those landscapes without a word, without a comment beyond the certainty that everything Balthus ever painted is without a single word of comment. Everyone looks at those paintings, and we look at them too, hoping no one will ask the slightest question. Those landscapes and those girls are in a separate world, they certainly grew up eating something, lighting a cigarette to while away time, like that creature called time whiles itself away in its own fashion and favorite ways.

I need a break. And to put a period at the end of that sentence. Not a question mark, because there is really nothing to ask, but not an exclamation mark either. "I shall come leaping the bridges" the poet Gabriele D'Annunzio wrote in a letter to a friend. Wouldn't someone else, at the end of that little poem "I shall come leaping the bridges," have added an exclamation mark, or suspension dots? I say stop and that's all. And if I were asked to, I could say it again, making another stop: so there is the full stop. And the pause for a break and to see if the time has come to go on with this little tale about the painter Balthus, or whether it would be better to keep quiet.

Together in his studio at the back of the Villa Medici in Rome, or at Rossinière, in Switzerland, in his eighteenth-century Grand Chalet, all built of toast-colored wood, that creaks even when you sit still. Rapture and slowness. Every once in a while the whistle of the little blue and white MOB train passing in the valley below the house on its way to Gstaad or back to Montreux: we had been alone and quiet for hours. But it was as though we had been talking about what we knew. That was the mood. Looking and not saying a word. Each in his own way. It's nearly night time, the only light is his lit cigarette, and his illuminating perfidy. "So did you ever write that interview I never gave you?"

"Of course I wrote it."

And he: "I was sure of it. You went upstairs to your favorite room, number 17, but you didn't sleep because you wanted to write the interview I never gave you."

I believe I never wrote a single word about his paintings after that month of June 1973: after inviting me to Rome to see the picture of *Les Joueurs de cartes*, he left me alone for over an hour when the Villa Medici butler told him the ambassador, from some other world perhaps, had arrived to see him.

I and the big painting of the *Cardplayers* in that no man's land where Balthus so willingly lives when he disappears to be alone, in that studio with its huge dusty windows overlooking the Roman *muro torto*, a few towels, a white enamel basin for rinsing his hands, a tumbledown couch, and lots of brushes stuck in big tin coffee or flour cans. Wooden ladders to climb a few steps if the canvas of the picture is tall; and dusk, the dusk that helps writers too. I do not know how to define a painter. I can tell what I am seeing, but I always would rather appeal to memory. He had worked on that picture for six or seven years. And there I was, for the first time, settled in front of the depiction of perfidy. Of a crime. Is there an interval between painting and perfidy? There, there was. Like when there is a quarrel in the family or between friends, we're hurt to death or we do not utter a word if our son

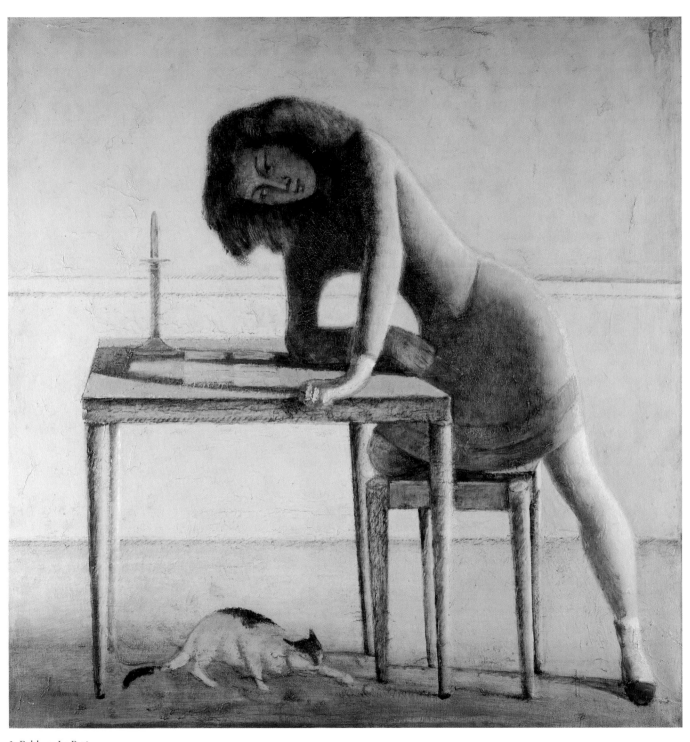

3. Balthus, *La Patience*
[The Game of Patience], 1954–55,
oil on canvas.
Private collection

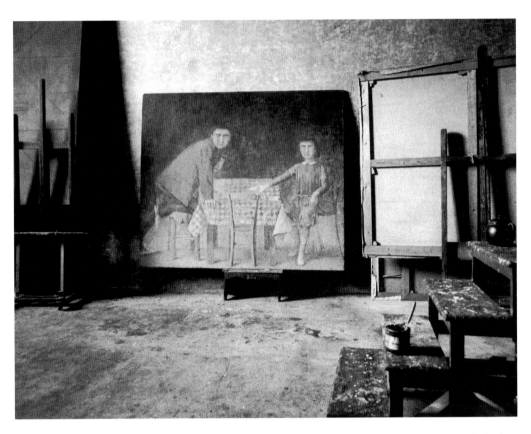

is mad at us because of a misunderstanding and, inevitably, we're about to have a clash that is going to leave serious wounds, but can also be side-tracked like in coronary by-passes: you can say you are over it, but the scars are still there when in the morning you are in the bathroom washing: right then you can see or touch the feeling of life and its imminent end, right there in front of the mirror. But the perfidy of those two children was utter perfidy, it was the everlastingness of that conflict, and the two of them were its absolute protagonists: their hatred was greater than any other disease. In fact the smart of remembering, the smart we keep on feeling for getting scorched, wouldn't go away because, from the very start, that painting, never seen before and thus without adjectives, was the portrait of the confession of perfidy descended on earth.

Dear Balthus, a diminutive of Balthasar, a nickname invented perhaps by his mother Baladine, Rainer Maria Rilke's friend, so:

Dear Balthus, you were the one to call me in Milan so I would come to Rome precisely to see the latest version of the picture of the *Cardplayers*. "You know," you told me on the phone, "it will be very difficult for you to see that picture again because it will be shipped away to a museum, far away…" And you left me all by myself in that huge studio to look at it. Did you or didn't you realize you were giving me a great gift when you left me there all by myself? I am not saying I would ever forget that Monte Calvello landscape, the one with the two little figures that are overlooking, from a terrace, rapture: because, in front of them, there is the *fata morgana* of that hillside that looks like it had just risen when Balthus made up his mind to paint it; nor could I ever forget one of those girls, lively or listless. But that painting of the *Cardplayers* was unforgettable because, were there an Olympiad, that picture would have surely won. It surpassed, in anxiety, all the other competitors. It won by detachment and by the quantity, not in the least muted, of wickedness exploded in that theater of cruelty on canvas that those two children's playroom was. Never shall I forget it. Because the disaster that is in that painting is everlasting. Called there in June of 1973 so that I would still be terrified by it, even now, around the year 2000.

Enough reminiscing. I'm quiet even now while I am writing, and I am writing because it is the one thing I know how to do. What in the world do you want to say? Great artists loved you because you always kept quiet. What in the world do you want to say, now that you're

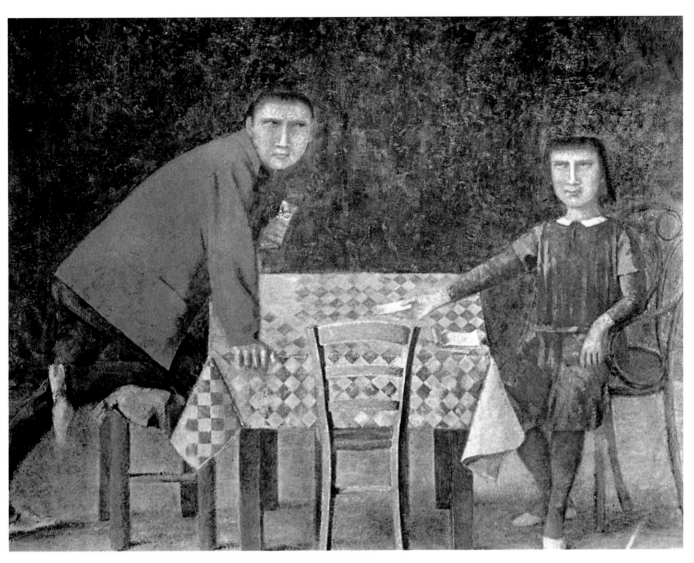

5. Balthus, *Les Joueurs de cartes*
[The Cardplayers], 1966–73,
casein, oil and tempera on canvas.
Rotterdam, Museum
Boymans-van Beuningen

by yourself? That you are looking at a fine painting? A fine discovery. And you happen to be looking at a painting precisely today? So just how does it affect you? All you can do is be there and, if you're able to, square it with the painting. Just what would you like to say to the picture? Tell the truth: better keep quiet, don't you think? Or else the marks, question marks, will start milling around in your empty head.

Why are those two kids staring at you? Because you, and all of us who are watching them, have disturbed them. That's it, full stop. People are not supposed to interfere while those two children are off in some part of the big house, concentrating on which card to play to continue the game, and there you come along—we onlookers come along—to watch what they are doing. Too bad, we are intruders who with our presence are bothering those two at their game. You haven't yet caught on that if someone looks at you a certain way, from a painting, you're supposed to ignore them, to look away but, above all, not try to understand? Now they have so grown up, so independently from what Balthus portrayed, they have a personality that will not put up with any sort of annoyance. And with you even less. And livid, they're telling you: why do you keep on watching us? Why don't you look somewhere else? Why don't you get out of this studio and go and look at the Villa Medici gardens?

Is there anything, around here, more beautiful and grandiose than this Villa Medici? There isn't. And then a tree, a flower or a plant wouldn't say a word to you, whereas the two of us are telling you: get out of here. And by the way, does Balthus know you took a picture of us? We bet he doesn't, says the girl, opening her mouth at last. Balthus despises photographs. You're the worst kind. You didn't just watch us, you even took photographs you weren't supposed to.

So there I was, without a protest, being ordered around by those two, the boy and the girl with their four wild eyes. But it was too late now. I had chanced there, and from now on I would be carrying on my back, or inside my gut, a sense of guilt, which in painting is something rare, if not unique. Because being berated by a picture is quite something. The enjoyment of looking at paintings is gone, it's up to me to remember whatever I want, to swear I've never seen a more attractive picture than the one I saw.

With that painting of the *Cardplayers* Balthus grabbed me by the neck, caught hold of the two infuriated players and my curiosity: I thought I could just go on my way, like when you leave a museum, but I've been trapped by what I've seen.

I'll take another break. I need another good pause and, if I can, I'll forget what I've seen. Often, in his paintings, Balthus, without uttering a single word, makes you realize you've been trapped by what you've seen.

The first time I "didn't" meet Balthus was in the early seventies. The painter Lorenzo Tornabuoni, who at the time was a mutual friend, arranged an appointment for me. I was to come for tea. When I arrived at the Villa Medici at five o'clock, Efisio, the concierge, called up to the "Contessa," saying there was a certain Signor Manzo here to see the "Count." The elevator took me slowly upstairs, where Benedetto—one of two faithful servants who, together with Luigi, looked after their illustrious hosts (and did so for more than sixteen years)—led me into a spacious drawing room and told me to wait. Before long Setsuko, Balthus's wife, arrived and asked me to sit down for tea. I was very tense and excited as I waited for my host to appear. But after a few polite comments on the mild Roman winter, I was told that Balthus was indisposed and would not come, although he had left a portfolio with drawings for me to look at. I chose a few and later regretted not having taken them all... I was unprepared and did not know what price I was supposed to pay. He had a reputation for being the most expensive painter in the world. At the time everyone was talking about *La Chambre* [The Room], the painting Agnelli had bought for no less than 100 million lire. It was Luigi Carluccio who had told "donna Marella" not to hesitate. I made my selection and after the tea I left, without having paid. Setsuko had said Balthus wanted to meet me and would invite me for tea the following week. He would tell me the price himself at that time. Thus began a friendship that was to last almost thirty years. I am sorry he will be not be able to read these remembrances and marvel at the things he did without realizing. Like the time when he summoned me urgently to Villa Medici for lunch. "The Director of an important French museum is coming for lunch. Can you make it? You'll amuse us with your Neapolitan ways," he told me over the telephone. The director was an elderly lady who was truly thrilled to be in the presence of the painter, whom she addressed as "master." He, in reply, told her brusquely, "Madame, call me Count or Balthus, for I am master of nothing..." The poor woman withered and not even my Neapolitan ways could manage to break the ice that had settled in.

When I recalled this episode to Balthus a few years ago at Rossinière, where I had gone to see him for one of his rare birthdays (since he was born in a leap year), the Count came down from the clouds and found it very amusing. Between puffs of his Dunhills, he laughed at his own meanness. During that same visit I introduced my wife Fiamma to him. I was tickled to see the look on his face when I told him she was a journalist. Twenty years earlier, when a friend of mine had asked me to arrange an interview for him, Balthus, mincing no words, had said, "Don't send me a journalist or I'll throw him out the window." And so our game continued, and he enjoyed it.

1. The front of Villa Medici in Rome

2. Balthus, *Japonaise à la table rouge*,
[Japanese Girl with a Red Table],
1967–76, casein tempera on canvas.
Private collection

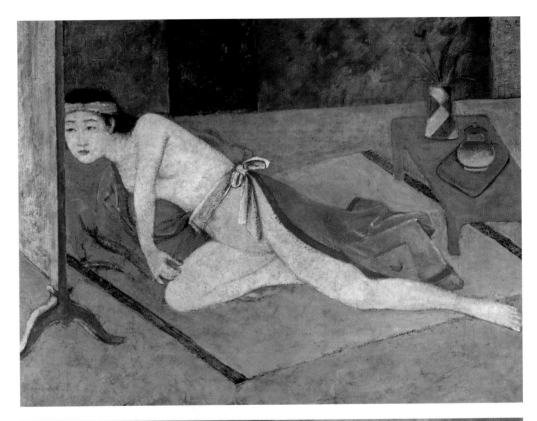

3. Balthus, *Japonaise au miroir noir*
[Japanese Girl with a Black Mirror],
1967–76, casein tempera on canvas.
Private collection

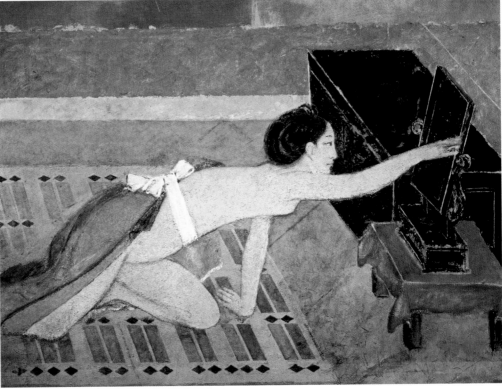

From me he was ready for anything, and accepted everything. He was a generous friend of a rare sort. He adored Memmo, his "alchemist," who from 1961 prepared all the canvases and pigments for his paintings. It was Memmo who, when his Giacometti sculpture was stolen from Villa Medici and they were reluctantly packing up to move to Switzerland, acted as a go-between with the Carabinieri to recover it. Years later, during one of our teas, he told me how that work had ended up at his house. "Alberto was a good friend of mine and gave me that gift because he had had a fight with his dealer Pierre Matisse, who when he had seen the piece in his studio had grimaced and said, 'so-so.' He called me immediately afterward and gave it to me."

Balthus had a soft spot for drama and the theater, and in Rome he immediately became friends with such film directors as Fellini and Zurlini, and actors such as Romolo Valli, Alberto Sordi and Nino Manfredi. Umberto Tirelli introduced him to many theater personalities and became a dear and faithful friend. It was Tirelli who gave Setsuko her signet ring, which she still wears on her little finger, while she had him make her kimonos. It was also Tirelli who gave their daughter Haroumi her Dalmatian, Fandor. When Umberto died, Balthus was very saddened. I remember his telephone call, full of affection and stories about our deceased friend. What he liked about me was the farceur side of my character, which reminded him of Naples. He had gone there for the first time when he was 17, as the guest of a professor friend of André Gide, who was a good friend of his father's. He went back to Naples in 1945, at the end of the war, and was very struck by what he saw. He found his old professor friend again, but the city had changed. He was impressed by the children, who seemed to have taken control of the situation. They were the same children one saw in the Nanni Loy film, *Le Quattro giornate*. First they had chased out the Germans, and then, to survive, they would get the American soldiers, the liberators, drunk, and then would steal all their belongings: shoes, watches, shirts, trousers. In Balthus's imagination, I always reminded him of one of these street urchins. When De Simone's *La Gatta Cenerentola* came to the Teatro Olimpico, we went together to see it. From that moment on, every time he found something amusing he would say, "C'est très Gatta Cenerentola," and he got angry if anyone ever dared express any reservations about that show. Every now and then he would say to me: "Bring this Simone to me." Once again he was attributing powers to me that I didn't possess, and indeed I never did manage to bring Roberto De Simone to him.

In 1974 he gave me drawings as gifts for the very first time, three or four, I think, to make up for a robbery that had taken place in my gallery. He had read in *Il Messaggero*, the Rome daily, that a Guttuso drawing had been stolen, and had rung me, asking me to come see him at once. "Sandrino mio, how could they possibly have robbed a Neapolitan...?": such was the greeting he gave me as he embraced me, more troubled by the fact that I could actually be robbed than by the monetary value of the losses. Our teas at Villa Medici became a regular custom and, speaking of Guttuso, who was also a friend of his, one afternoon, at the appointed tea-time, I found our hero in a rage because Valerio Zurlini had sent him a complementary copy of a book he had edited which contained an etching, a Guttuso portrait of Balthus... "But I don't look like that," he thundered. "Is it possible Renato hasn't understood a thing? I'll show you how portraits are done," and he walked away without even saying goodbye. A good while later he returned with two sketches he had done of Guttuso. They were on paper, and extraordinarily beautiful. He asked me which one I preferred, and then gave it to me as a gift with the dedication: "Our friend Renato. An attempt for Sandro."

When Guttuso came to the Gabbiano gallery for one of our crowded openings, he ran into Balthus. Seeing the drawing, he said to him: "Why on earth did you give that to Sandro?" Then he asked me: "How much does it cost? I want to buy it." I told me it wasn't for sale. Today the drawing hangs in Palazzo Grass, and remains for me an affectionate reminder of my friendship with these two deceased friends. Luigi Carluccio, when he became director of the Venice Biennale in 1980, asked me to talk to Balthus, in hopes of softening him and convincing him to have a show of his works. I left for Monte Calvello, where Balthus liked to spend a few months in summer, without much hope, but with my usual baggage of optimism and good will. This time our tea was served on a terrace looking out on the valley. I was asked to open a huge, white canvas umbrella, to shield us from the sun. My natural clumsiness, and the excitement at being assigned the role of "ambassador," ensured that I would break it. But this incident gave rise to the exhibition at the Scuola Grande di San Giovanni Evangelista during the 1980 Biennale.

In 1977, after sixteen years at the Villa Medici, Balthus left his position as director and moved

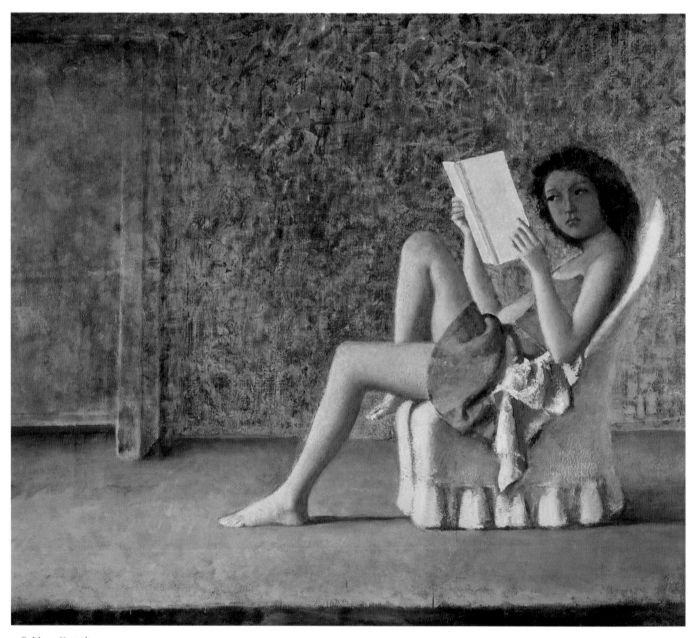

4. Balthus, *Katia lisant*
[Katia Reading], 1968–76,
casein tempera on canvas.
New York, private collection

5. Balthus, *Nu au repos*
[Nude at Rest], 1977,
oil on canvas.
Dolores Kohl collection

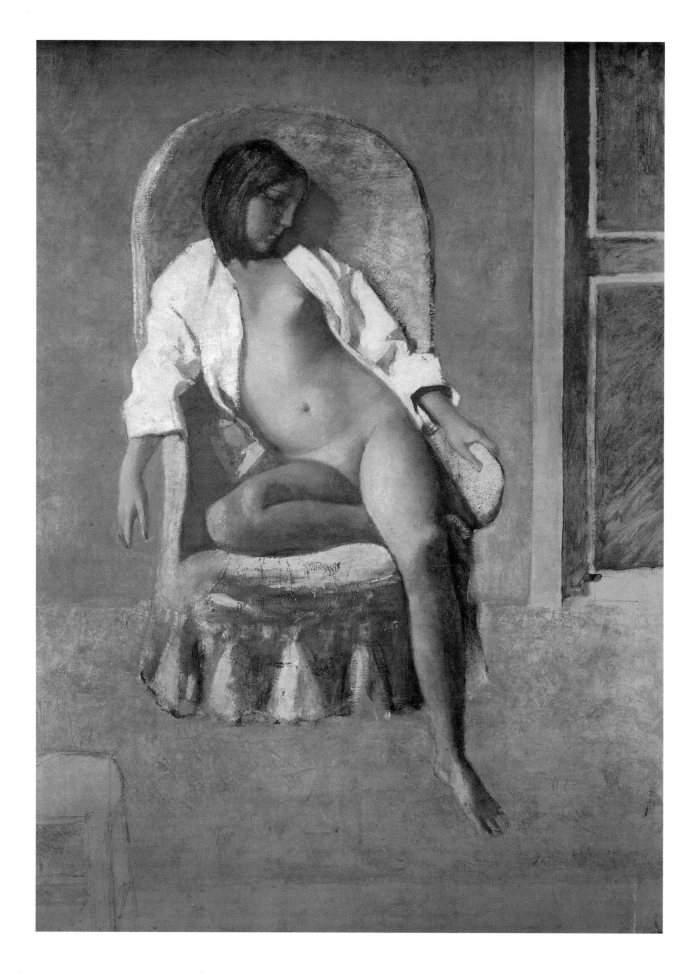

6. Balthus, *Portrait de Renato Guttuso* [Portrait of Renato Guttuso], 1975, pencil on paper. New York, private collection

7. Balthus in a taxi in Venice

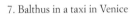

to Rossinière where he had bought a fifty-room chalet built in 1754. He had first gone there in 1970 to have tea with Setsuko. She immediately fell in love with the place. Walking through the rooms of the creaky, wooden old house, which had been turned into a hotel, had reminded her of her childhood in Japan. And it so happened that the owner wanted to get rid of the place, which was a bit of a burden to maintain. So the deal was made. Balthus called Pierre Matisse, his New York dealer, and had the money advanced to him in exchange for four paintings. The number was later increased to five, the fifth being to cover the interest accrued in the delay in delivering the works. Thus it was to Rossinière that I went to fetch him by car and drive him to Venice. We had a long journey ahead of us, full of surprises. I had an old Mercedes, which decided to break down along the road. We were fortunate enough to find a mechanic who could repair it at once, and we reached Venice in time to make our triumphant entrance by motorboat on the Grand Canal. Balthus had dislocated a foot and was wearing Swedish orthopedic clogs that made him look even taller than he was. He leaned painfully on a crutch, dressed in one of his grey kimonos with a red sash around the waist. Setsuko was there too, also wearing a kimono as always, with little Haroumi and one of her cats. It was pure theater. We formed a colorful but well-matched group. Perfect for Venice. When the time came to mount the exhibition, all hell broke loose. The cause was *Les Beaux Jours* [The Happy Days], on loan from the Hirshhorn Museum in Washington. The "Count" did not like the frame and said it must be removed. Alarmed, the painting's escort, son of one board of directors' members, wanted to call the museum, since he couldn't make the decision on his own. But time was running out and Balthus couldn't wait. Without further discussion, he told Memmo to remove "that horror." Meanwhile, to relieve the tension, something half tragic, half amusing—at least to me, who was watching everything as if I was at the movies—occurred. The doors to the church were closed as we were hanging the exhibition, and no one was allowed in. But all of a sudden some fury managed to slip in, yelling: "So who is this Balthus anyway, who won't let himself be seen... Who is he?" But the wretched woman was immediately greeted by our hero, who had transformed himself into a Samurai, using his crutch as his sword and screaming "Out! Out!" and chasing her all the way back down the stairs. We barely managed to save her from his wrath. His painful foot had miraculously healed, but only temporarily, for he continued to complain about it for the rest of his stay in Venice. I think he had great fun, however. He was fêted and coddled by all, and Carluccio was very grateful to me. He had got what he wanted, and deservedly so. That was when he introduced me to Jean Clair. We were in the Trattoria dell'Angelo, and he told me this young French critic was very intelligent and would go far. Eighteen years have passed since that dinner: Carluccio has passed away, Balthus too, and I have remained good friend with Jean Clair.

*Michela Terreri
with Slavica Perkovic
and Lewis Baltz*

Michelina

The artist had long white hair, through which he was always running his hands. When he was drawing, he always had a cigarette in his mouth; and if the drawing was a success, he would stand looking at it whilst the cigarette went out. He didn't even notice. If he took another cigarette, that meant the drawing wasn't satisfactory. And he had a very particular way of dressing: he always wore beautiful shirts and very brightly colored red and blue scarves. He wore checked shirts in shades of blue or green, beige trousers and *sabots*. I don't think I ever saw him in a pair of shoes...

At the start of a sitting, he almost never spoke or indicated what pose he wanted me to take. It was always me who chose; he would watch and then say: "Stay like that, there. That is a good position."

When he was drawing, he didn't say a word. He looked; and that was the really disconcerting thing. He abstracted me out totally; I was no longer a person, but an object to be drawn. I didn't exist any more; I was a vase. Every so often he would come up to me; but instead of saying: "No, raise the hand a little" or "Lower it," he would come up and move it himself. And if I said: "How should I hold my hand? Like this?", he replied: "No. Don't move." Those were his only words. He really did not talk at all when he was drawing. He was silent, moving only his hands, smoking, observing.

He would speak to me afterwards, when he would say: " You are tired; perhaps we should stop for a little." That was when he said to me: "Let's talk." He would tell me stories, stories he liked, or else he would tell me about things he had seen. Or he might say: "Look at how beautiful this painting is," showing me catalogs of the paintings he liked. Sometimes he would even speak to me in English, saying "Today we will do a little English conversation, that way you will learn it a bit better"—something that I never managed to do. He would also sing opera arias for me; I loved hearing him sing *Don Giovanni*, and asked him to sing the same piece over and over again.

I came back to the Villa, where I was to pose during the holiday period. We lived at the Académie, toward Porta Pinciana. My mother had an apartment there; and every afternoon the sitting would start around three o'clock, because the best light was from around three to five. So, I would leave the house myself or he would call: "Do you want to come and do some posing now?" Sometimes it was fine by me, sometimes a little less—because I had wanted to go out playing. Then he would say: "I have to finish this drawing," and I would say: "OK, I'll come." Some days I really wanted to go over there, to hear what he had to tell me,or because he had started a story the day before which I had really liked, and which he had still to finish. I wanted to go on posing to hear how it ended. I left home, went across the gardens— the avenue of orange trees—and I looked at the pebbles and the trees. Or I might go through the woods, because I liked that route. When I got to the Académie, I took the lift up.

There was a beautiful door. I don't know if it is still the same, but I remember it as light pink; and when you entered the studio there was beautiful light falling in through a window to your right. The sun lit up one part of the studio, whilst the other part remained entirely in shadow. There was a bed to one side, green divans, pink armchairs and a rather odd chair in dark green. It was there he usually told me to sit; or sometimes he would choose the armchair or the bed, depending a bit on which poses he wanted to draw.

The artist had two studios, one of which he used for drawing and one for painting. He almost never had me pose in front of a canvas; in all, I must have done that only two or three times during the whole of this period. Usually, he made preparatory drawings which he used in creating the painting. I spent most of my time in the studio where he did his drawing. There was no smell of paint, but rather a strong smell of flowers, of linden trees.

He never let anyone enter the other studio, the one where he did his painting; there was always a powerful smell of paint in there. It was a strange place, rather like an alchemist's workshop.

Whenever I went in there, the place always made me think of someone who is engaged in preparing something magical, something very special which no one must see, something that can only be viewed once it is finished. I don't know if he made up strange mixes of color and paint that no one else was supposed to know about.

It truly was his own private world. I was very powerfully aware of the fact that he did not want outsiders seeing how he started a painting, the work he did on the canvas. He was to-

tally different then. When he was drawing, he was much more relaxed; there were other people there; there was me, my sister. But when he began a painting he was always alone, as if he was ashamed of letting outsiders see it.

I never saw any of the artist's other models—apart from my sister, who I posed with; and I must say I was never very curious to know what they were like. Anyway, he never talked to me about them; perhaps from time to time, he might have said something, but not very often. When I saw the paintings and drawings, I always felt there was some similarity between me and all the other models—a detail, an expression. Sometimes, I seemed to find myself in paintings that he had created years before.

It was usually around five o'clock when we stopped; the butler would come through and tell us that tea was served, and so we would stop working and go through to have some tea. We went up to the next floor; the whole family was there, and each time the tea-drinking was like a veritable ritual. It was important for all of them, and there was a special way of taking afternoon tea: there were always little lemon tarts from the cakeshop near the Villa, which were delicious. Just before the sitting came to an end, I would be thinking to myself: "Soon there is going to be tea and those tarts I like so much." Sometimes there were other delicious cakes made by a German lady. I went there for the cakes.

The tea ceremony would last rather a long time, about an hour. Toward the end I would begin to get bored, thinking: "It's time for me to go now; I should be getting home."

The ceremony was very important to him because he had made numerous trips to Japan, which explained the pleasure he found in it. He would often get changed beforehand, putting on a kimono; it really was a very important moment in the day. His entire family was there, and there were very specific rituals to be performed. At first all that fascinated me; I would watch the way the tea was served, everything that was happening. But then I would begin to think that things were dragging on too long, and I preferred to leave.

When I started posing I was very young, so I had no idea who this artist was. I didn't realize how important he was. Everyone had said to me that he was very well known in the art world. I had never seen anything. I didn't know what that was; had never seen paintings before. I discovered a world that was unknown to me. Gradually, I got to know him a bit better. I should say that I posed for him several years, and thus was part of the family; we were together very often.

I began to understand that he was someone important, well known, from the fact that at teatime there were always other people who had come to see him: intellectuals, artists, always different people who wanted to talk to him. At first, all that bored me; but then I gradually became more interested in what they were saying.

I also met some of the very best set designers. I met Fellini, he took to see what a film shoot was like. It was truly wonderful.

Then there were the other artists, the other personalities who came: and it was always very interesting to watch the relations between them—what he said, how he spoke to them. Everyone was there listening to him, as if he had some special gift for fixing people's attention upon himself.

He taught me one thing: how to look at beautiful things, how to love painting, to stand in front of a picture, to see it a little through his eyes—thanks to what he said when we went to exhibitions or were looking at catalogs together.

I sat for him a number of years, in the period when I was passing from childhood to adolescence. At the time, I experienced all that differently; I would look at the drawings and see that change almost solely in physically terms. My outward appearance was changing. However, I did not really understand what that meant from a physical point of view. Now I can look at those drawings in a detached way, and sometimes I can't recognize myself. Perhaps because there are some highly sensual poses that are no longer part of myself. I think that they belong to a very special phase, a phase that one is living through at that age.

One of his characteristics was that he always used the same type of model, but I can't find any reason for that. I don't know why he always looked for the same type of women and young girls, who always had something in common.

What always strikes me as odd, is that there are people who look at those pictures, who look at me; and I often wonder what they think when they look at those drawings. The relation

between the painter and model is always very special; at least, the relationship between myself and this artist was very special. I think that the role of the model is fundamental. One feels a very strong bond, which is in some way a bond of dependence. The model always depends on the artist, whilst the artists only depends a little on the model. There is something unique about this which is difficult to describe. There is undoubtedly something that links us together; feelings are set up. He tries to find in you things that he can depict, aspects of you that are not simply physical. He tries to transcribe what you are; and so everything depends on the model, if she can reveal herself to the artist, who then draws what he wants to bring out.

When I go to an opening or an exhibition of work by this artist, sometimes people recognize me and see me as the model in the work. Some people are curious, others have a rather more morbid curiosity. They look at the drawings and they want to understand what is behind them; they ask questions, or look at me strangely.

Sometimes, I get the impression people are making fun of me; at other times, I am flattered to be recognized. However, I also realize that in a way I will be immortal, that in years to come I will still be there for those who look at me.

There are numerous people who see something scandalous in the paintings. I meet people who do not like this artist, who find him bizarre; consider his sensuality and eroticism odd. Each time, I think to myself that they are not seeing the picture the way I see it. For me, it shows someone managing to capture an important moment of passage—that from childhood to adulthood. What is left now? That is difficult to say. It annoys me to think about what others think about me. It also depends on the interest I feel in those who ask me questions; it is an experience that leaves its mark, which takes it out of you—because you are always thinking of what other people think about you. Above all, at that age. Now, I can be much more detached about the whole thing.

I was born in France and passed some years in Paris. We also travelled a lot because my father had come to work in Italy for his construction company. My mother joined him shortly afterward. My two sisters were born in Italy, whilst I was born in Paris—well, in a small town just outside Paris. It was a period when we travelled about—moved house—a lot. We spent some time in Paris, then some in Versailles; I don't remember much about my childhood in France, because I was eight-nine years old when we left. My mother tongue was French, so when we arrived in Italy I did not understand a word of Italian. I have very vague memories of my primary school; just as I have vague memories of the last house where I lived with my father, mother and one of my sisters—the oldest being in Italy for her studies. We lived in this very big house with a garden where we went bike-riding, where we could spend the entire day. It was a house with two floors, and my bedroom was upstairs; one could go through the garden up to bed, and that was fun. I also remember an aunt who used to come and visit us a lot; I was very fond of her. There was also a woman neighbor, who was a close friend of my mother's. This neighbor had a daughter who lived in Italy. When my father died, my mother did not want to stay in France, because she didn't have anything to do there. When speaking to this neighbor, she found out that her daughter had a scholarship at the Villa Medici, and that if she was interested she [my mother] could go and work at the Villa. They are things that I only remember vaguely; but my mother talked about them all the time. When we left for Italy we sold up everything; we did keep the house for a few years, but then we sold that off too. We took everything with us. I have a very vague memory of this move from Paris to Rome.

The first thing that struck me when we arrived at this place which seemed so big, so gigantic, was the immense garden, which was like a labyrinth when compared to the garden where I had played in France. At the beginning I used to spend my time dashing all over the garden; I would ride my bike up and down the paths, or else go off and play hide-and-seek. The Villa caretaker had a dog, a large and good-tempered German shepherd; you could say that dog was my first friend at Villa Medici. I spent most of my days running after him or playing with him. I would go into the alleys of the garden and hide, and a moment later he would come bounding up to find me. The Villa was imposing, and I felt so small in comparison to this enormous monument, this massive classical building that was a bit cold but which did have the warmth of the people living there. I can also remember the scents of the garden:

the avenue of orange-trees was full of smells, as were the hedges. At that time, the hedges were much bigger and the garden wasn't anything like it is today. It was a really fun place for a child who wanted to play hide-and-seek, because there were enormous hedges everywhere. That was how I passed my afternoons during the summer and Christmas holidays when we were at home. My sister and I had been sent to school in Florence when we first came to Italy; my mother put us in a boarding-school because she wanted us to have a good education. Later my sister returned home, because she was very attached to my mother, and I stayed in the boarding-school and only came back during the holiday periods. Then my sister met this artist who asked her to be his model. One day when I was back home, I asked her if I could go with her to a sitting, if I could see what the painter did.

At the beginning I was very curious, so I went to his studio. The door was open and there was an enormous room with a painted ceiling; there were armchairs, chairs and lots of sheets and crayons. My sister took up the pose the artist showed her and I sat in a corner to watch what happened. She didn't move and he went on looking at her and drawing without interruption. He always had a cigarette in his mouth, and smoked non-stop. When he was drawing, he never took his eyes off his model, never looked at anything else, so his cigarette would burn right down to the very stub. It would last about an hour. I had been intrigued and I wanted to do the same thing myself. He asked me if I wanted to try, and I said yes; I wanted to have this experience as well, to imitate my sister.

The first time it was a bit difficult, because I wanted to move about, to scratch.

When he said: " Stay like that" I understood that I couldn't move and that was a rather strange sensation: because it is when someone tells you to stay still that you suddenly want to move, to start walking about. It is at that moment that your arm or leg go to sleep, that you want to run your hand through your hair. So you start thinking about other things, letting your mind wander, dreaming up stories and inventing strange situations... Anything to enable you to stay as still as possible. What I remember of holding still like that is that you have any number of sensations: you are more intensely aware of colors, smells, everything that is around you.

The first time I was cold. At the beginning I thought it was going to be a bit boring, that I wasn't really going to like it. When he had finished, I saw the result and I must say I felt rather flattered; I thought he must be really good to manage to draw me so well, and that what he had drawn really was me, who had managed to stay still for all that time.

Whilst he drew, I watched him; sometimes he was a little frightening, sometimes less so. I thought he was physically imposing: he had long white hair that he often ran his hands through; he had very beautiful eyes with a penetrating gaze; he had very beautiful hands and a very special way of holding his pencil or cigarette.

After some time, when we knew each other better, he invited me to Tuscany with him and his family. We went in his car. The idea of seeing him in a totally different setting amused me; I wasn't seeing him behind his drawing-board but behind his steering-wheel, as someone who was driving—and yet even then he maintained something of his aristocratic bearing. It was strange to see him as any other normal person. So, we set off and then stopped at Orvieto and other small towns. He took me to see churches and—when we got to Florence—other monuments; he helped me to discover the most beautiful parts of that city.

What fascinated me about him was his intelligence, his culture. He answered all the questions I asked him. For me, it was like having a walking encyclopedia with me. It is something that has stayed with me in my relations with the other people I meet; I always try to discover what they know. He was an inexhaustible source of information. That was what most fascinated and attracted me.

I sat as a model for several years, and a very strong relationship grew up between us; we stayed in touch, even after I stopped posing for him. It was I who in the end stopped sitting for him, because I just didn't have the time any more. I had to study; I had grown up, had hundreds of other interests. I wanted to go out with my friends. At the beginning, he didn't want me to, because he had to finish certain drawings, certain paintings. At first, it was a bit difficult; and then he left and went to live in another city.

Martigny, 23 February

Well into the night, the drum rolls continued. The sound was muffled and repetitive; it would stop for long minutes at a time and then start up once again. Somewhere, someone is being buried, I repeated to myself confusedly; and cradled by the monotonous beat, I drifted off to sleep. At one o'clock in the morning, in the haziness of sleep, it could still be heard. I got up, and from the window, I saw several maskers bustling about at the crossroads beneath the stark light of the streetlamp: a white Pierrot, a witch with a large black cone-shaped hat, specters. It was carnival season in Valais.

It was a few days before his birthday, a month before the vernal equinox, when time still wavers between its beginning and its end, that Balthus chose to leave: at that moment when the dead, taking advantage of uncertainty, return for a few hours to mingle with the living. Exactly eighty years after Rilke's invitation to slip away through the fissure in time that opened on each of his 29 February birthdays, he slid out, ten days early, through that magical "crack" at the bottom of which, Rilke wrote, "is collected everything we have lost (Mitsou, for instance, the broken dolls of children and so on and so on." Celebrating the eternal meal of the gods in a carnival henceforth without end, he regained "possession of the party concealed there."

It was thus moving at cross-purposes from other humans that he came upon the shadows, playing on the momentary confusion of the two kingdoms. He loved mistaken identities, disguises, roles right to the very end. An old man of ninety-two, balding like an old sad-beaked bird? Or the disquieting seducer whose third-and-twenty birthday had just been celebrated a year before almost to the day?

There was also, in the hotel, shortly before midnight, a muffled and underground clap, which caused the walls to shudder for a few moments. I thought a boiler must have burst in the basement. But the next morning, I was told that there had been an earthquake, of four on the Richter scale, as happens in that part of the Alps.

Try as one may to not want to believe in occult powers, I could not prevent myself from thinking of what Artaud had said about his friend: "I don't know why Balthus's painting smells as it does of the plague, the storm, and epidemics," adding, a little further along: "it smells of the grave, catastrophes, the obituary, the ancient ossuary, the coffin…"

All great painting is born beyond the grave. Every work stems from a carnival. But naked, the flesh carved up, *carne levare*. In the studios, the practice of anatomy first involved studying the skeleton, before moving on to the naked body and then the clothed model. Seeing had to come first—seeing right to the bone. Only then could the flesh be put back on, and then clothes… Once the clothes were shed came the resurrection, the body *restituto ad integrum*. For each and every hair shall be counted, as Christianity assures us— in contradiction, in that regard, with so many other religions. And it is decidedly the religion of incarnation, of a glorious and obstinate carnality—both human and respectful of the whole and the parts, right to the very tip of the fingernails— that Balthus the painter chose as his own. Between Lent and Shrove Tuesday, affliction and comfort. A feast of the dead: that is what he offered in his very death itself. The need for art is born of the cult of the dead: of the need to fashion *imagines*, to keep them near oneself, after the models have passed on. In fact, one of the ingredients of the trade, on the shelf, amongst the flasks of colored pigments, was the mummy, extracted from the ancient Egyptians. The technical poverty of it conceals poorly the symbolic wealth of the gesture: it was from the cadaver that the embalmer's balm was taken, and which allowed the effigies' perennity. And it was because these ancient and naïve beliefs were forgotten—in the name of progress in art—that painting was doomed to nothingness.

Rossinière, 24 February

Slowly, the friends makes their way up to the village heights. First surprise: the Protestant church—larger than that of the small Catholic chapel, and thus better able to accommodate the crowd—has offered its space. Second surprise: four priests are to celebrate the mass. The priest and reverend from the village, but also the archbishop of Wroclaw, with an acolyte at his side. All that is missing is a rabbi, in memory of Abraham Spiro, cantor in Breslau, and Balthus's maternal grandfather, and the harmony would be complete. All of them are clad in sumptuous purple chasubles, and three of them are wearing miters. The august forms, basilical colors, heads crowned in geometric volumes all recall Balthus's taste for stereometric head-

gear crowning the contingent and occasionally uncouth facial features—the Pole's for instance, red and corpulent—with an ordered, elegant and necessary architecture. Innocent III, painted by Giotto in Assisi, comes to mind.

Wroclaw, pronounced in Polish, sounds like Breslau pronounced in German. Suddenly, all Balthus's origins—almost all—are brought to mind, betraying the play of the mask and the taste for costume. Costume is custom: behind the English affectations—the Brontë sisters, the Scottish romanticism, the "I am a descendent of Lord Byron," the Latin temptations, all the way from the journey to Italy in 1926 to *Signor Conte* of Rome forty years later—and finally from behind Balthus's Parisian attachments (literary salon on Rue Malebranche, around Gide and Valéry and small circles of dandies around Pierre Klossowski and Pierre Leyris) the central Europe that he had come from and never entirely left behind him, springs forth in all its coarseness. Between Prussia and Baltikum, Austrian Empire and Kingdom of Poland, torn, claimed, carved up, a faraway Silesia, land of margins and marches, emerges in the figure of the prelate whom Balthus had wanted to pronounce the last words. It is the confirmation of that unusual and spectacular Catholicism that Balthus had displayed recently—like the last, most difficult and most risky of his compositions.

Yet those sources, those quarrels never entirely dried up in his painting. They gave his work its toughness and cruelty, and gave him that singular accent, paying scant heed to Paris, and never entirely erased nor polished by the affected elegance with which Balthus would later speak English, Italian and French. Yet he spoke the latter with the Parisian working-class accent of the 1930s, in the style of Carette or Jules Berry, increasingly unusual as time went by, when the resistant and outdated cheek—like a tic, which, running through a man who has climbed to the summit of honors, suddenly betrays his humble origin—began to betray the nobiliary claims of the postwar period.

There again Artaud was dead on: "The most unusual pathology, the misfortune of bizarre fate, the acridity turning sour..." are the traits which aligne his work more with the demoniac drawings of Bruno Schulz, his compatriot, or with Heinrich Hoffmann's pathographies in *Der Strüwwelpeter*, than with the curly blond-haired angles of Piero, from whom, at the age of sixteen, having traveled to Tuscany, he had wanted to learn. If one has not seen the disquieting background of this painting, which continues to well up through the patiently and adroitly applied renderings and glazes, as one would like to erase the obscure origins in order to show nothing further of the world but its light and softness, one understands nothing of his Bohemian fascination for titles and distinction—in short, of everything that, once beyond the Mittel Europa, makes you agreeable to the polite society of the West. Nor of his taste for the Beautiful as an unquenchable nostalgia.

Quite naturally, in order to be understood by the cosmopolitan and multiconfessional assembly, the mass is given in Latin.

> Et introibo ad altarem Dei
> Ad Deum qui laetificat juventutem meam...

The words, the verses, unuttered for so long, came back spontaneously to the lips of some of those present, who took them up, first inaudibly—astonished to know them still—then in a clear voice. It was like a forgotten song from childhood, which comes back, fresh and ready after having so rarely served, which flows with ease, which one is surprised to still understand. It was the final *coup de théâtre* orchestrated by Balthus—man of the theater that he was; the final and posthumous act of faith of an artist faithful to painting as he had been faithful to his childhood, and which showed up the Church's efforts at modernization for what they are: a cosmetic to appear "young," a series of little betrayals. How can the Church believe in the *ecclesia*, when it trades in the universal *lingua franca* of Latin for an abandonment to the various vulgates?

Henri Cartier-Bresson, clever, whispers to me on several occasions: "I just don't believe it...," "I just don't believe it..." And then, suddenly, in a more thoughtful tone: "The politicians should give their speeches in Latin..."

The mass is sung. Monteverdi? One might have expected Mozart. But Monteverdi, deep down, leads to a more profound, more irremediable melancholy. And it is therein that the profane representation which Balthus was after yields to the holy ceremony.

At the elevation, the silence is deep—so deep, in that upland area buried in winter, in that white-walled church, that I can not recall having heard anything like it for many years. The shrill little sound of the choirboy's bell shatters it with pain. It had been years since I had seen choirboys. Red and white, their silhouette crossed the painting of this century, from Picasso to Soutine, and Bonnard to Balthus. It provided a happy note in a harmony of greens or grays. It was known, in studio jargon, as a *réveillon*. But they too, along with the priests and the angels, have perished—just as more or less everything has perished. And the black, the universal black of the uniform, has replaced color and brocade. This world is decidedly in mourning, forever bereaved of *réveillon*.

Leaving the service, it suddenly becomes cold. Snow begins to fall, veiling the late February sun. All the summits are twinkling, and the air takes the breath away. We shuffle along. Those present acknowledge one another. There are the faithful. The disciples. The longtime friends. And then there are the newcomers. The snobs. The socialites. And the models. The three sisters. And younger models, the beautiful adolescent from Rossinière, who had posed for the final paintings, as if Balthus—he who had never owed up to more than a quarter of his age—had had the privilege of giving the secret of eternal youthfulness. Those absent are also noted. It is pointed out by some that in other times, from Malraux to Mitterrand, from right to left, the great and the good would have made the effort to come and pay their last respects to he who had been the greatest living painter. But the greatest and best to be seen is of the stature of Victor Emmanuel de Savoie, whom Balthus had wanted to see return, not to the throne, but more modestly to within the confines of his homeland.

Absence of [...]. Highnesses, Eminencies and Excellencies chased away the modest phantoms of the past.

Several hours before he died, Balthus had been taken into his studio, on the other side of the road. He spent two hours alone, in private with his last paintings. Then he had begun to suffocate. He was, I believe, given morphine, to help him through. In the studio, now closed up, there was the marvelous landscape of Monte Calvello, to which he returned over a three or four-year period, with a very refined, almost Chinese-style horizon, a piling-up of abrupt planes, caught in a somber and reddish light. There was the large canvas of the girl with the mandolin, nude on a large four-poster bed, with Fandor, the dog, standing up on his hind legs, staring out the window at the encroaching night.

Carnival in Valais. I remember Balthus's rages against the denaturation of this happy valley—the valley of his childhood—in just a few short years. The *Quatrains valaisans* by Rilke speak of a world which is no longer here on earth. The chemical and food industries, the factories, the freeways have replaced the orchards and vineyards.

How is one to imagine that Crans-sur-Sierre, with its chair-lifts, snowboarding slopes, bars and nightclubs, belongs to the same planet as that where Sierre used to be, and where Rilke's tomb is to be found? I recall my own fury, when, last year, I tried to find the Muzot Tower, today invisible amongst concrete buildings.

Balthus's remains are taken to his grave, at the foot of a little chapel. The coffin is covered with the wool blanket with which he had protected himself from the cold of the studio, and his red and green uniform of the Knight of the Order of Saint Maurice. Once again, he loved decorations, uniforms, hats, etiquette—everything that makes a man into a silhouette, confers him a rank, which has to be achieved, and above all has to be maintained. The personality is the person. Right to the end, he would thus remain the little child from Prussia, fascinated by the shakos, the froggings, the sound of fifes and tabors, the numb gestures of adults marching between the houses with the jerky steps of automatons.

The emotions of the child that he had been—the rages, the turmoils, when the fine white skin was revealed beneath the cloth, when the lips parted, when sweat would bead in the fold of the groin, these early discoveries, so slow to come forth, so violent to experience, though without even noticing it, one forgets them so quickly once one becomes a "grown-up": it was the dazzling experience of these things that he sought endlessly to retain.

The coffin is held by his two sons, Stanislas and Thadée, their arms straight out. There is nothing so heavy in the world as a father held by his sons. It is hoisted up onto a cart, pulled by two horses. A young horsewoman, dressed in black, riding a pure-bred Arabian—also black and edgy, and constantly on the verge of throwing her—brings up the rear. The magnificent

animal seemed to have escaped straight from Kenitra, from the riding school in Morocco where the young Balthus had done his military service, with the Spahis. The girl, on the other hand, seems the counterpoint of the one in the 1941 painting, *L'écuyère blanche au cheval blanc* [White Horsewoman on a White Horse], that Balthus had painted perhaps in homage to Bonnard and his painting of the same title.

The Eminencies, the archbishop, the two priests and the reverend, gleaming and mitered, stick close to the carriage. A rabbi scurries along, unseen, behind them. The Excellencies, the Ambassadors have already left for Rome or elsewhere, without incense and without myrrh, nonetheless convinced they have experienced a great mystery. But the Highnesses, the Princes, mingling with the commoners and the dumbfounded villagers, valiantly keep up the pace beneath the snow which by then is falling heavily. The cortège thinned out along the way, and sometimes someone runs to catch up with the group. "It's like a Fellini film," Robert Kopp whispers to me.

Then, as we approach the grave site, like a sudden gravity around a black hole, the crowd comes together once again, to murmur the final prayers. On the slope, snowdrops and crocuses can be seen, melting the ice. Three young men begin playing horns—long elephant trunks whose sound resonates right to the depths of the valley. Their inarticulate wail—so muted, so low that it could no longer be heard—chanted the imperious sound of the drum of the day before, that was beaten henceforth, orphaned, in blue pants and red dolman, by King Nussknacker's guard.

ROLA KŁOSOWSKI

Catalog of Works
Virginie Monnier

Note

Titles
The titles given here are
those commonly used today.
Alternate titles are shown in
parentheses and the English
translation of the titles appears
in brackets.
Several early paintings were
exhibited under different titles,
cited following the relative
exhibition.
If need be, further indications
are offered in each individual notice.
Measurements
Measurements are in centimeters;
height before width.
Signatures
Signatures are not examined here.
On the subject, refer to *Balthus,
Catalogue raisonné de l'œuvre
complet* (Virginie Monnier, under
the scientific direction of Jean Clair,
Gallimard, Paris 1999).
Provenance
Auctions are listed under
that heading, even when the lot
considered did not have a purchaser.
Exhibitions
Exhibitions in galleries appear
under that heading, but the dealer's
name is included under
the provenance heading when
we are certain he/she sold the work
concerned.
Only monographic exhibitions
are cited here, along with a limited
number of other ones in which
works by Balthus were shown at the
same time as those by another artist,
but presented separately, both
as regards hanging and the
organization of the catalog
of the event.
For abbreviations used, see
the chronological list of exhibitions,
providing the complete references
to each catalog.
For the content of early exhibitions
without catalogs, see the above
mentioned *Balthus, Catalogue
raisonné de l'œuvre complet*
(Virginie Monnier, under the
scientific direction of Jean Clair,
Gallimard, Paris 1999), pp. 566–69.
Bibliography
For works quoted in an abbreviated
form, see the chronological
bibliography. The complete
references for the exhibition
catalogs are to be found
in the list of exhibitions.
References of articles and essays
cited in the notices are given
in the notes.
Balthus's letters from which several
extracts were drawn are in course
of publication (presented and
commented by Stanislas and Thadée
Klossowski de Rola, Buchet Chastel,
Paris).

The Early Years (1919–29)

This section begins with a small book titled *Mitsou*, published in 1921, whose forty drawings, executed two years earlier, are the first conserved works by Balthus.

The four copies of frescoes by Masaccio and Piero della Francesca, executed during a trip to Tuscany in 1926, are the only ones found hitherto. Determining in Balthus's initial training, they inspired the fresco design for the Einigen church and the ones for the Beatenberg temple, now destroyed, of which the study remains.

Concurrently, three paintings evoke Paris in the twenties and the experiments of the young, self-taught painter Balthus.

1. *Mitsou*

forty pictures by Baltusz
preface by Rainer Maria Rilke
Rotapfel Verlag, Erlenbach,
Zürich and Leipzig,
undated (1921)
the original India ink
drawings (1919) that belonged
to R.M. Rilke have not been
found
Paris, Bibliothèque nationale
de France

bibliography: a fac-simile
of the 1921 edition was printed
by the Éditions Séguier, Paris
1988; the forty drawings were
published in *Balthus,* exhibition
catalog, MNAM.CNACGP, Paris
1983, pp. 13–25; Clair,
Monnier 1999, nn. I 1512–1551;
Vircondelet 2000, pp. 62–65

In 1914, when the war broke out, Erich Klossowski, a German citizen, had to leave Paris with his wife, Elizabeth-Dorothea (née Spiro, her artist's name being Baladine) and their two sons, Pierre and Balthus. After a short stay in Zurich with Professor Jean Strohl,[1] the couple settled in Berlin where Erich Klossowski soon began making stage sets for Victor Barnowski, director of the Lessing Theater. In 1917, the couple separated and Baladine Klossowska moved to Switzerland with her two sons, first to Bern and then to Geneva, where in 1919 she met up with Rainer Maria Rilke whom she had known slightly in Paris and who was giving a lecture tour in Switzerland. The lengthy correspondence the poet kept up with Baladine (whom he calls Merline) until his death, in 1926, evidences the *amitié amoureuse* between them. But it also proves the interest the poet had in the two Klossowski boys, Pierre and Balthus. Thus, while recommending the elder to André Gide, he encouraged the younger one to draw and paint. He lent him a "Chinese novel," urging him to illustrate it, but above all took up his pen, solicited publishers and took the necessary steps to obtain the publication of a series of forty drawings the boy made in 1919. So *Mitsou* appeared in 1921. It is the story of a kitten, found at Nyon, brought by the boy to Geneva, and whose antics occasionally upset the smooth pace of everyday life. One day he disappeared, but his young master soon found him in the middle of the lawn and, ungrudging, cozily settled him on top of the stove. Alas, the day after Christmas he disappeared once again, while the child was asleep. The boy, holding a candle, looked for him everywhere, but in vain. The last picture shows him mournful, crushing with both hands the huge tears running down his cheeks. The way these images are treated somehow recalls woodcuts of the period, in the tradition of a Valloton and the *Revue Blanche*. Probably

more precisely, as Sabine Rewald[2] remarked, in the style of Frans Masereel, a friend of Baladine's, who lived in Geneva at the time and that very year had illustrated *Hôtel-Dieu* by Pierre Jean Jouve.
Mitsou is the story of a child and a cat, an animal that Balthus will make his emblem and that will be present throughout his work; but it is also, and above all, the astonishingly well-mastered expression of feelings and emotions, the evocation of an enchanted world, of a childhood from which, three years later, on the verge of adolescence, Balthus would feel he was forever outcast.[3] You can read *Mitsou* like one of those tales that charmed the years of his youth and those of his brother. But unlike the *Strüwwelpeter* (cf. cat. 21) and the terrifying punishments Dr. Hoffmann thought up, here we have nothing but gentleness and tenderness. A petted only child, on whom the life of the family is focused; one day his father, a painter, portrays a dignified Mitsou sitting on a tapestried stool; a while later, his mother is decorating the Christmas tree and the child, let into the room by the maid, gazes at it in wonderment, with Mitsou at his side. This is an exact opposite of Baladine's life at the time, separated from her husband and struggling with her two sons to make ends meet.
The imaginary friend of Balthus the book is dedicated to never existed, as the painter himself admitted. However, Mitsou has its real dedicatees, hidden behind an anagram: *A MON CHER/ ARSENE DAVITCHO,* turned around becomes indeed: *A MES/ ERICH DOROTHEA,* the child's parents.

[1] Cf. J. Leymarie, *Balthus,* exhibition catalog, Lausanne 1992, p. 36 and *infra*, n. 9.
[2] S. Rewald, *Balthus,* exhibition catalog, New York 1984, pp. 12–13.
[3] *Ibidem*, p. 11. "I wished I could remain a child forever," Balthus said at the time to one of his friends. That sentence, much-quoted, even by himself, and out of context, contributed to the legend surrounding him.

Preface

Qui connaît les chats? – Se peut-il, par exemple, que vous prétendiez les connaître? J'avoue que, pour moi, leur existence ne fut jamais qu'une hypothèse passablement risquée.

Les bêtes, n'est-ce pas, pour appartenir à notre monde, il faut qu'elles y entrent un peu. Il faut qu'elles consentent, tant soit peu, à notre façon de vivre, qu'elles la tolèrent; sinon, elles mesureront, soit hostiles, soit craintives, la distance qui les sépare de nous et ce sera là leur manière de rapports.

Voyez les chiens: leur rapprochement confidentiel et admiratif est tel que certains d'entre eux semblent avoir renoncé à leurs plus anciennes traditions canines, pour adorer nos habitudes et même nos erreurs. C'est bien cela qui les rend tragiques et sublimes. Leur décision de nous admettre les force d'habiter, pour ainsi dire, aux confins de leur nature qu'ils dépassent constamment de leur regard humanisé et de leur museau nostalgique.

Mais quelle est l'attitude des chats? – Les chats sont des chats, tout court, et leur monde est le monde des chats d'un bout à l'autre. Ils nous regardent, direz-vous? Mais a-t-on jamais su, si vraiment ils daignent loger un instant au fond de leur rétine notre futile image? Peut-être nous opposent-ils, en nous fixant, tout simplement un magique refus de leurs prunelles à jamais complètes? – Il est vrai que certains d'entre nous se laissent influencer par leurs caresses calines et électriques. Mais que ceux-là se souviennent de l'étrange et brusque distraction avec laquelle leur animal favori mit souvent fin à des épanchements qu'ils eussent cru réciproques. Eux aussi, ces privilégiés admis auprès des chats, ont été reniés et désavoués maintes fois et, tout en pressant encore contre leur poitrine la bête mystérieusement apathique, ils se sentaient arrêtés au seuil de ce monde qui est celui des chats et que ceux-ci habitent exclusivement, entourés de circonstances que nul de nous ne saurait deviner.

L'homme fut-il jamais leur contemporain? J'en doute. Et je vous assure que parfais, au crépuscule, le chat du voisin saute à travers mon corps, en m'ignorant, ou pour prouver aux choses ahuries que je n'existe point.

Ai-je tort, dites, de vous mêler à ces réflexions, tout en voulant vous conduire vers l'histoire que mon petit ami Baltusz va vous raconter? Il la dessine, c'est vrai, sans vous parler davantage, mais ses images suffiront largement à votre curiosité. Pourquoi les répéterais-je sous une autre forme? Je préfère y ajouter ce que lui ne dit pas encore. Résumons cependant l'histoire: Baltusz (je crois qu'il avait dix ans à cette époque) trouve un chat. Cela se passe au château de Nyon que, sans doute, vous connaissez. On lui permet d'emporter sa petite trouvaille tremblante, et le voilà en voyage avec elle. C'est le bateau, c'est l'arrivée à Genève, au Molard, c'est le tram. Il introduit son nouveau compagnon à la vie domestique, il l'apprivoise, il le gâte, il le chérit. "Mitsou" se prête, joyeusement, aux conditions qu'on lui propose, tout en rompant parfois la monotonie de la maison par quelque improvisation folâtre et ingénue. Trouvez-vous exagéré que son maître, en le promenant, l'attache à cette ficelle gênante? C'est qu'il se méfie de toutes les fantaisies qui traversent ce cœur de matou, aimant, mais inconnu et aventureux. Cependant, il a tort. Même le déménagement dangereux s'opère sans aucun accident, et la petite bête capricieuse s'adapte au milieu nouveau avec une docilité amusée. Puis, tout à coup, elle disparaît. La maison s'alarme; mais, Dieu soit loué, ce n'est pas sérieux cette fois: on retrouve Mitsou au milieu du gazon, et Baltusz, loin de réprimander son déserteur, l'installe sur les tuyaux du caiorifère bienfaisant. Vous goûterez comme moi, je suppose l'accalmie, la plénitude qui suit cette angoisse. Hélas! ce n'est qu'une trève. Noël parfois se montre par trop séduisant. On mange des gâteaux, un peu sans compter; on tombe malade. Et pour guérir, on s'endort. Mitsou, ennuyé de votre sommeil trop long, au lieu de vous éveiller, s'évade. Quel effarement! Heureusement, Baltusz se trouve assez rétabli pour se lancer à la recherche du fugitif. Il commence par ramper sous son lit: rien. Ne vous semble-t-il pas bien courageux, tout seul, à la cave, avec sa bougie qu'en signe de recherche il emporte ensuite partout, au jardin, dans la rue: rien! Regardez sa petite figure solitaire: Qui l'a abandonné? C'est un chat? – Se consolera-t-il avec le portrait de Mitsou que, dernièrement, son père ébauchait? Non; il y avait du pressentiment là-dedans; et la perte commence Dieu sait quand! C'est définitif, c'est fatal. Il rentre. Il pleure. Il vous montre ses larmes de ses deux mains:

Regardez-les bien.

Voilà l'histoire. L'artiste l'a mieux racontée que moi. Que me reste-t-il à dire encore? Peu.

Trouver une chose, c'est toujours amusant; un moment avant elle n'y était pas encore. Mais trouver un chat: c'est inouï! Car ce chat, convenez-en, n'entre pas tout à fait dans votre vie, comme ferait, par exemple, un jouet quelconque; tout en vous appartenant maintenant, il reste un peu en dehors, et cela fait toujours:

la vie + un chat,
ce qui donne, je vous assure, une somme énorme.

Perdre une chose, c'est bien triste. Il est à supposer qu'elle se trouve mal, qu'elle se casse quelque part, qu'elle finit dans la déchéance. Mais perdre un chat: Non! ce n'est pas permis. Jamais personne n'a perdu un chat. Peut-on perdre un chat, une chose vivante, un être vivant, une vie? Mais perdre une vie: c'est la mort! Eh bien, c'est la mort.

Trouver. Perdre. Est-ce que vous avez bien réfléchi à ce que c'est que la perte? Ce n'est pas tout simplement la négation de cet instant généreux qui vint combler une attente que vous-même ne soupçonniez pas. Car entre cet instant et la perte il y a toujours ce qu'on appelle – assez maladroitement, j'en conviens – la possession .

Or, la perte, toute cruelle qu'elle soit, ne peut rien contre la possession, elle la termine, si vous voulez; elle l'affirme; au fond ce n'est qu'une seconde acquisition, toute intérieure cette fois et autrement intense.

Vous l'avez senti d'ailleurs, Baltusz; ne voyant plus Mitsou, vous vous êtes mis à le voir davantage.

Vit-il encore? Il survit en vous, et sa gaieté de petit chat insouciant, après vous avoir amusé, vous oblige: vous avez du l'exprimer par les moyens de votre tristesse laborieuse.

Aussi, une année après, je vous ai trouvé grandi et consolé.

Pour ceux cependant q u i vous verront toujours éploré au bout de votre ouvrage, j'ai composé la première partie – un peu fantaisiste – de cette préface.

Pour pouvoir leur dire à la fin: "Tranquillisez-vous: Je suis. Baltusz existe. Notre monde est bien solide. Il n'y a pas de chats."

Au Château de Berg-am-lrchel,
en novembre 1920
Rainer Maria Rilke

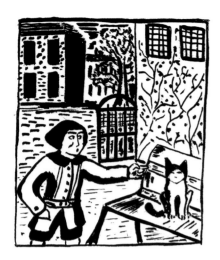

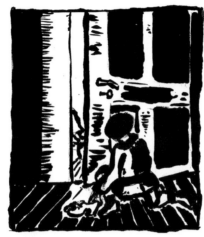

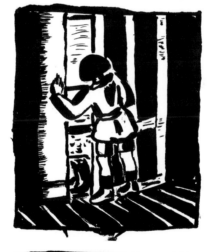

2. *Triple étude pour un autoportrait*, 1923 [Triple Study for a Self-portrait]
3. *Autoportrait*, 1924 [Self-portrait]

2.
pencil and charcoal
on yellowish paper
30 × 42 cm
New York, Sabine Rewald

exhibitions: Spoleto 1982, n. 2
bibliography: Carandente 1982,
n. 2; Clair, Monnier 1999,
n. D 351

3.
pencil and charcoal on paper
31 × 20.5 cm
handwritten inscription
by the artist's mother lower left:
"Baltus Selbstportrait"
Switzerland, private collection

exhibitions: Bevaix 1975, n. 8;
Andros 1990, n. 5; Rome 1990,
p. 34; Ornans 1992, n. 2;
Lausanne 1993; Rome 1996–97,
p. 169; Karuizawa 1997, p. 98;
Wroclaw 1998, n. 12; Zurich
1999, n. 19; Venice 2000, p. 38
bibliography: Faye 1998, p. 106;
Clair, Monnier 1999, n. D 352

There are very few Balthus self-portraits. In all,
four on canvas (one in the guise of Heathcliff
in *La Toilette de Cathy*) and four on paper,
one of which is lost. They range over slightly
less than thirty years (1923–49), and their being,
for the very first time, brought together
for an exhibition (cats. 41, 49, 64, 69, 84)
enables us to briefly dwell on the manner
in which the artist presents, or stages, himself.
In this one, the oldest, Balthus portrayed
himself in profile and full-face. The profile recalls
the engraved effigies of political figures during
the French Revolution and the Empire; besides,
the adolescent appears dressed in a high-collared
jacket, closed by a large button, typical of that
period. The short locks, drawn forward, are those
of a young pre-Romantic hero. We are reminded
of *René*, Chateaubriand's character, whose first
name Rilke borrowed to sign the letters he wrote
Balthus every year for his birthday.[1] But, whereas
those engraved portraits are usually inscribed
in an oval, this self-portrait is set in a circle,
slightly pencil-shaded, suggesting a medal.
The inscription "BALTHUS" we can make out
on the left edge confirms this assumption.
The full-face portrait on the same sheet might
have been drawn from a photograph (fig. 1),
while the hairstyle, the opposite in the next
drawing (cat. 3), might suggest the youth used
a mirror. Here, the play of light, particularly
on the hair, the shadows and planes of the face,
the careful drawing of the ear are evidence
of a far more painstaking drawing than
the previous one. The adolescent wants to appear
mature: the determined jaw, the firm line
of the lips are those of a young man who intends
taking control of his life. Indeed, this face is very
akin to that of the person who would portray
himself eight years later as *Roi des Chats* (cat. 49).

[1] R.M. Rilke, *Lettres à un jeune peintre, Balthus*,
Archimbaud, Paris undated (1994) and second edition,
undated (1995). Taken from "Lettres à un jeune
peintre," *Fontaine*, 44, Paris 1945.

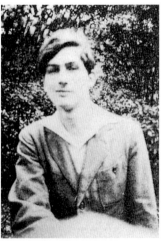

1. Balthus at Muzot, at Rainer Maria
Rilke's house, ca. 1923–24
(formerly Gomès archives)

2

3

4. *Premières communiantes au Luxembourg*, 1925
[First Communicants in the Luxembourg Gardens]

oil on canvas
56 × 54 cm
signed and dated lower left:
"Baltus 25" and lower right:
"Baltus"
private collection

provenance: gift of the artist
in 1930 to Anthony Gross
exhibitions: Madrid 1996
bibliography: Roy 1996, p. 48;
Clair, Monnier 1999, n. P 14

In the Spring of 1924, Baladine and Balthus
are in Paris, joining up with Pierre Klossowski
who had returned there a few months before.
They are greeted affectionately by old friends.
André Gide, who uses Pierre as his "secretary,"
Jean Paulhan, Jean Cassou, Jean Cocteau,
Albert Marquet, Maurice Denis and especially
Pierre Bonnard, with whom Baladine exchanges
drawings, and who shows interest in young
Balthus. We do not know which ones are
the "paintings and compositions" he examines
"with great interest," even having him take them
to Druet's, his dealer, to show them to Maurice
Denis. But the latter remarks: "You only lack
'know-how' material; you will succeed, but with
detours you could do without." And Baladine
adds "we agreed Baltusz should copy Poussin,"[1]
which he would begin doing a year later.[2]
Meanwhile, the adolescent spends his time
between the Académie Colarossi, at
Montparnasse, where he sits in on classes, and the
Luxembourg gardens, right by Rue Malebranche
where he is staying. This large park is located at
the intersection of three districts, Montparnasse,
Saint-Sulpice and the Latin Quarter; comings
and going are constant, and Balthus, with pencil
and notebook in hand, observes the passers-by on
the paths and the children playing on the lawns.
In May, the little communicants dressed like small
brides, stride about showing off their organdy
dresses. The subject was commonly treated during
the 1920's, practically a cliché. Aside from this
painting, Balthus himself left two portraits of
communicants and as for Merline, she painted one
the following year.[3] The way Balthus looks at them
here is full of mischief. Capturing, unbeknownst
to them, the attitudes of the different figures,
he subtly expresses their psychological or social
features. The two little girls are walking along
chatting, pretending to be nonchalant. The
dazzling white of their costume stands out against
a background of greenery treated like a tapestry.
Two boys are playing *pétanque*. The one in the
middle, a light-haired lad dressed in red, watches
them as he picks up his ball; the other, fist
on hip and foot flatteringly resting on the metal
hoops bordering the lawn, feigns indifference.
Humor, but also the strong rendering of details
enable Balthus to avoid mawkishess, frequent in
such representations. Thus he firmly emphasizes
the delicate "religious" pleating of the girls'
dresses and the two boys' muscle structure.

1. Balthus, *Enfants au Luxembourg*
[Children in the Luxembourg
Gardens], 1925, oil on canvas,
55 × 46 cm.
Private collection

On examining the series of views of the
Luxembourg by Balthus, you can tell he was
familiar with Bonnard's work. The way he plays
with the scale of the figures might arise from it:
by reducing some and turning others into giants,
he creates an unusual perspective and upsets
the viewer's perception. Thus, if the child
in the red suit were to stand up, he would be
three times the size of the three other characters.
There is another example of this in the *Enfants
au Luxembourg* (fig. 1): the boy pushing a hoop,
beyond the lawn, is excessively stretched
in height. With his light-colored clothes,
he barely stands out against the greenery;
you might mistake him for one of the statues
perched on a pedestal scattered throughout
the garden.

[1] *Rilke et Merline: Correspondance 1920–1926*,
Zürich 1954, pp. 521–22, October 27, 1924.
[2] *Ibidem*, p. 549, November 25, 1925.
[3] *Ibidem*, p. 587, June 16, 1926.

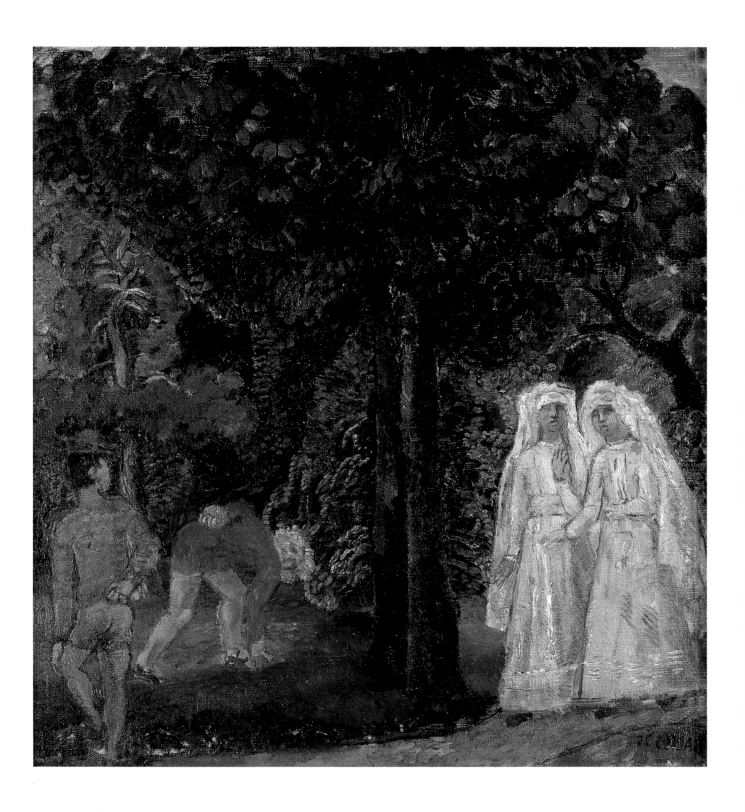

5. *Quatre études de jeune fille jouant au diabolo*, ca. 1925
[Four Studies of a Girl Playing with a Diabolo]

India ink on paper
21.5 × 16.5 cm
private collection

provenance: Stanislas
Klossowski de Rola
bibliography: Clair, Monnier
1999, nn. CC 1464/1–CC
1464/4

These four sheets, taken from a sketchbook,
are of the same period as the previous painting.
The scene is sketched in the Luxembourg garden.
A little girl is adeptly playing with a diabolo.
With a sweeping, precise gesture, she pulls
the sticks apart to stetch the string and launch
the spool, carefully watching its trajectory so
as to smoothly pick it up on the slackened string.
Swift, coordinated movements of arms and legs
will then be needed to give it a spinning speed
allowing to cast it as high as possible.
With a sharp pen, Balthus subtly rendered
the *tempo* of the successive stages of the game,
concurrently with the girl's suppleness, the grace
with which she swirls around in her cotton dress.
Psychological observation and humor are also
present in this series of sketches. On the second
sheet, the girl turns her head to the right looking
for her diabolo she has lost sight of; actually it had
flown too high, as shown by the arm stretched
upward and the hands shading the eyes of two
of the boys watching the game, and mischievously
commenting on the incident.

6. *Nu debout*, 1925-1926 [Standing Nude]
7. *Nu allongé*, 1925-1926 [Reclining Nude]

6.
oil on paper, printed with stencil
motifs, mounted on cardboard
55 × 25 cm
New York, Sabine Rewald

bibliography: Clair, Monnier
1999, n. P. 17

7.
oil on canvas
48 × 80 cm
private collection

provenance: gift of the artist
to M. and Mme Albert Vulliez
bibliography: catalog New York
1984, p. 15 fig. 9; Clair, Monnier
1999, n. P. 18

The two nudes illustrate another aspect
of Balthus's work during the years of his youth in
Paris. The model is a sixteen-year old girl, named
Simone Maubert, whom Baladine also painted[1]
and who posed at the Académie Colarossi that
Balthus attended from time to time. We find
her also in two small sketch-books[2] (figs. 1 and 2)
prior to the paintings shown here. She is the only
professional model yet to be found in Balthus's
work.
The *Nu debout* shows the girl from behind,
leaning against the partition of a room with
a parquet floor. It was painted in oil on a sheet
of paper with printed stencil motifs. An exception
in Balthus's work, that can perhaps be explained
by his wanting to suggest the wallpaper in the
room. The young girl's slender silhouette, the yet
childish curve of her cheek and her buttocks
blend with the big flowers of the background.
The *Nu allongé* is more austere. The young
model's body traps all the light, while the couch
she is reclining on stands out against a barely
worked background in a muted harmony
of dark red and dull blue.
The painting was a gift to the navy lieutenant
Albert Vulliez, when stationed at the Toulon base,
where Balthus painted the *Paysage Provençal*
that follows.

[1] Cf. Clair, Monnier 1999, p. 108.
[2] *Ibidem*, nn. CC 1462/1–1462/17.

1. Balthus, *Etude de nu*
[Study of Nude], 1924,
pencil on paper, 33 × 25.5 cm.
Private collection

2. Balthus, *Etude de Nu*, 1924–25,
pencil on paper, 22 × 27 cm.
Private collection

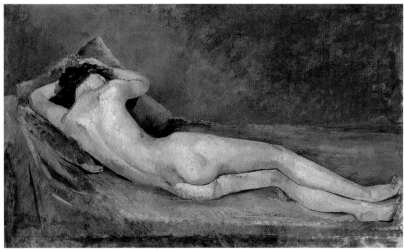

7

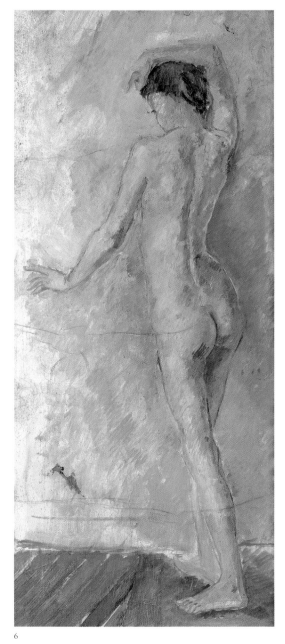

6

8. *Paysage provençal*, 1925
[Provençal Landscape]

oil on wood
77 × 51 cm
signed and dated lower left:
"Balthus 1925"; monogram
below: "B"
Troyes, Musée d'art moderne,
donation Pierre and Denise
Lévy

provenance: Martin sale,
Versailles, 7 juin 1961, n. 67bis;
Pierre Lévy
exhibitions: New York 1939,
n. 4
bibliography: Leymarie 1982,
p. 146 and 2nd edition 1990,
p. 151; catalog MNAM.CNACGP,
Paris 1983, p. 340, n. 5;
Roy 1996, p. 49; Clair, Monnier
1999, n. P. 9; Vircondelet 2000,
p. 48

In the spring of 1925 Balthus and his mother stayed in Toulon with the navy lieutenant Albert Vulliez and his young wife (née Marguerite Quersin), an excellent German scholar who advised Rilke when the poet, that same year, wrote his poems in French.[1]
Mother and son went back to Toulon for the next New Year's holidays, since at the time Baladine gave Marguerite a dedicated painting of Balthus reading in a corner of the living-room next to the Persian hound Albert Vulliez had brought back from a prior appointment.
The *Paysage provençal* is typical of the Toulon hinterland: you can recognize the hilltop village of Revest, protected by a Saracen tower, *restanques* planted with olive-trees; in the foreground, a *mas* with cracks in its ochre roughcast walls, and its little fenced garden; in the background, Mont Caume, done in large brushstrokes and whose sharp peaks, partly heightened in black, stand out against a cobalt blue sky flecked with heavy ceruse clouds.
The organization of the pictorial surface is what should hold our attention. We know that Balthus's circle showed him or gave him books on Italian painting;[2] we have yet to measure what he learned from it, but it cannot be denied. The *Paysage provençal* is an example of it, insofar as its construction is based on the "golden number" that has nurtured the imagination of artists and architects since antiquity, and, more precisely, on the "golden section," a theme dear to the Humanists and the painters of the Italian Renaissance.[3] Without going into detail, we should say the "golden number" is, in the decimal system, equal to 1.618,[4] and is used, in painting, to determine the dimensions of the painted panel: the biggest (L) being equal to the smallest (l) multiplied by 1.618. The canvas on which the *Paysage* is painted matches it with 5 cm to spare. The "golden section" that comes from it was used by painters to divide in an asymmetrical but harmonious way the surface of the picture.
The formula is the following: L – l, that will allow to enlarge the initial square l × l, but to determine the lines of composition as well. It is according to this "golden section," and, in this case, with great precision, that the *Paysage provençal* is composed (fig. 1). The line *de* that constitutes the upper limit of the initial square (l × l) is the visual axis around which the perspective is organized (so it is logical that the mas be seen "from above," whereas the village is "from below"). On each side of this axis, the two surfaces are structured according to the "golden section": given *ab* that, from the upper left edge, determines the vertical of the west rim of the tower; *jk*, from the lower right edge, the one on which the gable of the house and the little masonry construction backed up against the fence rest; and *fi* the bottom of the roof and the top of the pine trunk. Last, the focal point of the painting, *P*, materialized by a small dark bush, is placed on the geometric vertical axis of the picture, right above the line of perspective.
From this point, Balthus drew three concentric circles in which are respectively inscribed the mass of the village, the top of the tower and the end of the long sheepfold toward the middle of the canvas.

1. Balthus, *Paysage provençal*, construction sketch.
The height is equal to the width multiplied by the "golden number": L = l × 1.618.
The "golden section" equals L – l and coincides with the segments *ab*, *ce*, *fi* and *jk*.
The circles *R2*, *R4* and *R8* have the same radius; *R3* and *R5* as well.

It is in two other series of circles, having the same diameter, that the volumes of the landscape are organized. Generally speaking, they are materialized by the colored masses, dark greens, gray-greens and light ochres; this is especially apparent in the upper right corner. Just a word about the signature and the monogram. The latter is certainly contemporary to the execution of the painting, whereas the signature probably came later. The paintings of his youth are signed "Baltus." The "h" appeared after the young man was told of the existence of a Belgian painter named Baltus.[5] Existence mentioned by Rilke in a letter to Merline on September 25, 1925[6]: "Today's *Le Figaro* announces among its subscribers back in Paris a certain M. Baltus! I would be surprised if B., with his gift for encounters, weren't to run into this homonym sooner or later!".

[1] *Vergers* and the *Quatrains valaisans*. A copy of the book (N.R.F., 1926), adorned with an engraved portrait of Rilke, after a drawing by Baladine, was offered by the poet to the young couple. Its dedication reads: "To Madame and monsieur Albert Vulliez. To friends (from the first moment). To my first judges, to my only collaborators," and dated "Muzot, this 6 of July 1926."
[2] Rilke gave him for Christmas of 1923 a book by the German art historian W. Worringer and had H. Graber send him, in 1925, his monographic study on Piero della Francesca.
[3] One of the famous examples is the *Virgin of the Rocks* by Leonardo (Paris, Musée du Louvre).
[4] When I asked Balthus about it, on March 23, 2000, he gave me a very broad reply, but a moment later, gave me the mathematical formula of the golden number: $\frac{\sqrt{5}+1}{2}$
[5] Cf. Clair, Monnier 1999, p. 564.
[6] *Rilke et Merline: Correspondance 1920–1926*, Zürich 1954, p. 534

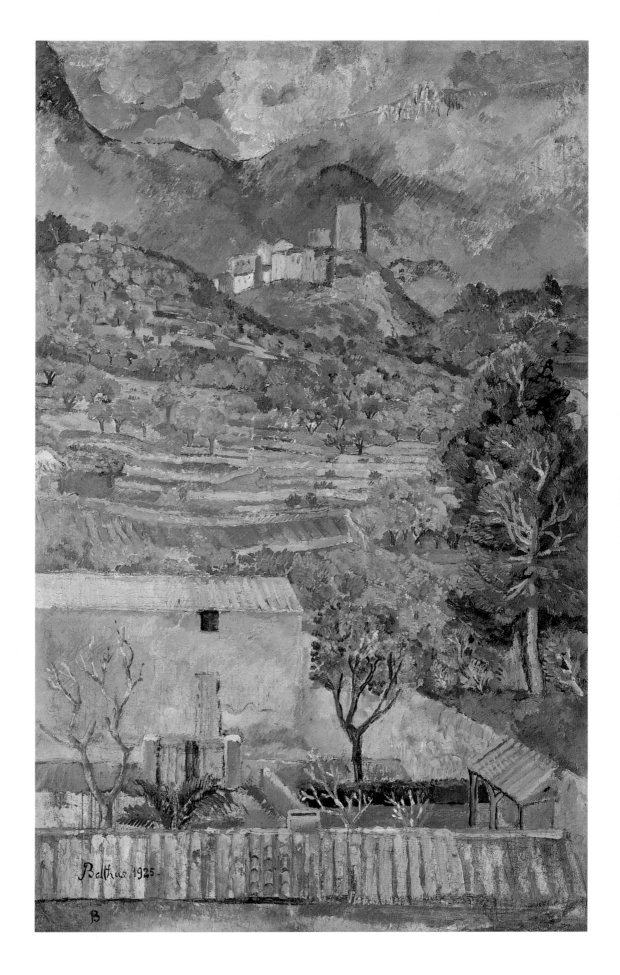

9. *Saint Pierre distribue les aumônes et la mort d'Ananias* (copie d'après Masaccio), 1926
[Saint Peter Distributing Alms and the Death of Ananias (copy after Masaccio)]

oil on cardboard mounted
on panel
59.5 × 54 cm
Paris, courtesy Blondeau
& Associés SA

provenance: gift of the artist
to André Derain;
private collection
exhibitions: Ornans 1992, n. 4;
Rome 1996–97, p. 53;
Karuizawa 1997, p. 32
bibliography: Roy 1996, p. 53;
Clair, Monnier 1999, n. P 26

Perhaps Bonnard was the one to urge his friend
Professor Jean Strohl, who taught literature
at the university of Zurich, to offer Balthus a kind
of "apprenticeship contract" so he could take a trip
to Tuscany and copy the old masters there.
A friend of Gide, who mentions him in his *Diary*[1]
with deep admiration, Strohl was also close to Rilke
and his patron, the great collector Werner Reinhart.
A collector himself, he owned works by Bonnard,
Vuillard, Kerr-Xavier Roussel and Derain.
He also had paintings by Baladine, Erich
Klossowski and the Swiss painter René Auberjonois
to whom they both were devoted.[2]
In July 1926, young Balthus set off for Italy.
We know, by a telegram from Rilke to Baladine
Klossowska, that he passed through Muzot July
8th, and by a letter from Baladine to Rilke
that he reached Florence before the 14th.[3] During
the fall, he stayed as every year at Beatenberg,
on the Lake of Thun.[4]
Despite what a letter Rilke[5] sent him seems
to suggest, it was his first visit to Italy. Florence,
where he first stopped over, dazzles him[6].
After visiting the Uffizi galleries, where he claimed
to be particularly impressed by the portraits of
Battista Sforza and Federico di Montefeltro by
Piero della Francesca, he undertook to copy the
frescoes by Masaccio and Masolino in Santa Maria
del Carmine. "Of the comparison between
Masaccio and Masolino at the Brancacci chapel,
he recalls—Germain Viatte writes—a Cézannian
Masaccio and of the Masaccio frescoes a far more
synthetic vision."
The copy shown here, and that Balthus had given
Derain, is the only one left of the series. It does
express that feeling. Balthus focuses his attention
on the group of figures, that he places in the middle
of his composition, whereas the fresco devotes
more space to the architecture and the landscape
(fig. 1). The copy is faithful, in an overall harmony
noticeably darker than the original; it is above all
the arrangement of the colored masses, rhythmed
by the deep creases of the clothes, that interests the
young man; in the endeavor to grasp the structure
of Masaccio's work, he simplifies certain details,
emphasizes others. We can feel here the influence
of Cézanne, whose works were well represented
in Swiss collections (Reinhart and Hahnloser)
and whose *exhibitions* increased by 1920.[7]

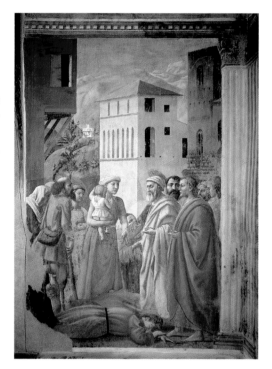

1. Masaccio, *Saint Peter
Distributing Alms and the Death
of Ananias*, fresco.
Florence, Santa Maria del Carmine,
Brancacci chapel

[1] In particular on May 6th and 10th, 1927. Cf. A. Gide,
Journal, Gallimard, La Pléiade, Paris 1951, pp. 835,
836, 839.
[2] We owe this information to Jan Krugier, the adoptive
son of Marguerite Bleuler, the niece and heir
of Jean Strohl who was childless.
[3] *Rilke et Merline: Correspondance 1920–1926*,
Zürich 1954, pp. 590 and 591.
[4] Letter from Baladine to Rilke, December 15, 1926,
op. cit., p. 600.
[5] Lettres à un jeune peintre, 26 June 1926, *op. cit.*,
p. 536, and 2nd edition, *op. cit.,* p. 29.
[6] On Balthus's stay in Tuscany, cf. G. Viatte, "Visite
à Balthus, à propos de son premier voyage en Italie,"
in *Hommage à Michel Laclotte. Etudes sur la peinture
du Moyen-Age et de la Renaissance*, Electa-Réunion
des Musées Nationaux, Milano-Paris 1994, pp. 648–51.
[7] Cf. *Cézanne*, exhibition catalog, Grand Palais, Paris
1995–96, pp. 577 ff. and 588.

10. *Résurrection (copie d'après Piero della Francesca)*, 1926
[Resurrection (copy after Piero della Francesca)]

oil on wood
29 × 31 cm
Jan et Marie-Anne
Krugier-Poniatowski collection

provenance: gift of the artist
to Professor Strohl;
Marguerite Bleuler
exhibitions: Bevaix 1975, n. 1
bibliography: catalog
New York 1984, p. 18, n. 13;
Fox Weber 1999, p. 114;
Clair, Monnier 1999, n. P 21

Jean Leymarie wrote that young Balthus had been raised by his father Erich Klossowski "to utterly worship Piero della Francesca, designated as the Cézanne of his time"[1]. Indeed, the "rediscovery" of the great fresco artist is owed to the book by L. Witting (Strasbourg 1898) and especially the essay R. Longhi published in *L'Arte* in 1913. Besides, in 1920 Hans Graber had published an important monographic study on Piero of which, on Rilke's urging, he sent a copy to young Balthus. That book had a decisive influence on the adolescent, who furthermore, when he met the historian in 1927, gave him one of the copies made in Arezzo.
The copy of Piero's *Resurrection* shown here expresses Balthus's intentness on grasping the deep meaning of the fresco—a sense of suspended time, telling rather than showing an event removed from any contingency—, and the way to render it: full-frontal view of the figure of Christ, accurately centered, standing out against a landscape without perspective; density of the bodies of the soldiers deep in sleep at the base of the tomb whose white marble cornice, in the lower third of the composition, defines with precision the boundary between two worlds, human and divine, of death and of life, a boundary the very event of the Resurrection shatters.
In his copy, Balthus retains the bare essentials: the miraculous apparition of the Resuscitated who, like a huge ghost, is nothing but light; and the complex organization of the curves and the colored triangles, that outlines the bodies of the four sleeping soldiers, as though thunderstruck by the apparition. In so doing, he discovered some details that the scholars had missed: that is, that the right leg of the soldier seated full-frontal is cut off from the knee down and that the legs of the one seen in profile had been evaded.

[1] *Balthus*, exhibition catalog, Lausanne 1992, p. 40.

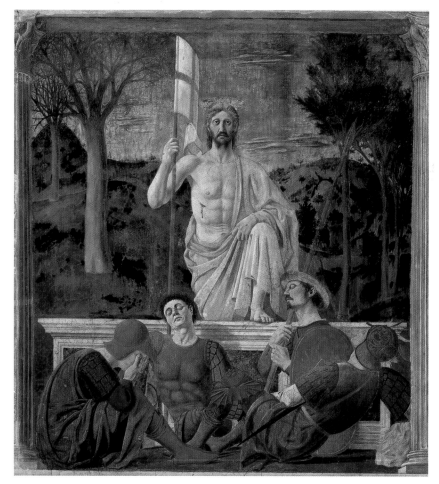

1. Piero della Francesca,
Resurrection, fresco.
Borgo Sansepolcro, Museo Civico

11. *La Légende de la Sainte Croix. Invention et preuve de la Vraie Croix*
(copie d'après Piero della Francesca), 1926
[The Legend of the True Cross. Invention and Proof of the True Cross
(copy after Piero della Francesca)]

oil on cardboard
45 × 67 cm
Aix-en-Provence,
Musée Granet, on loan
from private collection

provenance: gift of the artist
to Professor Strohl;
Marguerite Bleuler;
Galerie Krugier, Geneva
exhibitions: Bevaix 1975, n. 2;
Rome 1996–97, p. 55.
bibliography: catalog
MNAM.CNACGP, Paris 1983,
P. 341, n. 8; catalog New York
1984, p. 17 fig. 12; Roy 1996,
p. 51; Clair, Monnier 1999,
n. P 24.

The cycle of the Legend of the True Cross
Piero della Francesca painted in the basilica of
San Francesco of Arezzo contains seven frescoes.
Jean Leymarie wrote that Balthus had copied six.[1]
Up to now, four have been identified: *Visit
of the Queen of Sheba to Solomon*, *The Battle
of Constantine* (actually the *The Battle of Ponte
Milvio*), *The Invention and the Proof of the True
Cross* and *Heraclius Brings the True Cross Back
to Jerusalem*. The two first have not been found,
the two others are shown here. So, with those
of the Masaccio fresco and Piero's *Resurrection*,
all the known copies executed in Italy
are presented here.
However, Balthus certainly did not just make
oil copies, but quickly sketched a certain number
of other frescoes. For instance we can find the
Arezzo *Isaiah* in the figure of John the Evangelist
at Beatenberg (cf. cat. 14).
Piero's fresco, that is located on the left wall
of the choir of the basilica of San Francesco,
illustrates, on the same panel, two episodes
of the *Legend of the Cross*. On the left,
the exhumation of the crosses on Mount Calvary,
on the right, the miracle that allowed to identify
that of Christ. Balthus freely copied, you might
even say interpreted, the fresco in front of him.

Quite heedless of Piero's iconographic program,
he suppressed the view of the city and
the two figures who are on the far right (fig. 1).
He seems above all interested in studying
the arrangement of the figures. On the left,
they are standing, clearly separated from one
another, three full-front and three in profile.
They stand out against the green background
of the Golgotha. In the background, Jerusalem
that, in Piero, looks quite like a representation
of Arezzo, whereas in Balthus's copy, it is adorned
with Constantinople domes. The arms of the
two thieves' crosses clearly define the two spaces:
the sacred one of the place of execution
and the profane one of the city.
On the right, a compact group of kneeling
women, whose profiles and headdresses are
framed by the arches of the classical-style Temple.
In neglecting the right part of the scene and
especially the cross, held aloft by the young man,
that explains its meaning, Balthus seems to have
once again wanted to emphasize just the play
of circles and triangles that give the composition
its vigor and originality.

[1] J. Leymarie, *Balthus*, Skira, Genève 1982
(and 2nd edition 1990), p. 11.

1. Piero della Francesca,
*The Legend of the True Cross.
Invention and Proof
of the True Cross*, fresco.
Arezzo, basilica of San Francesco,
choir

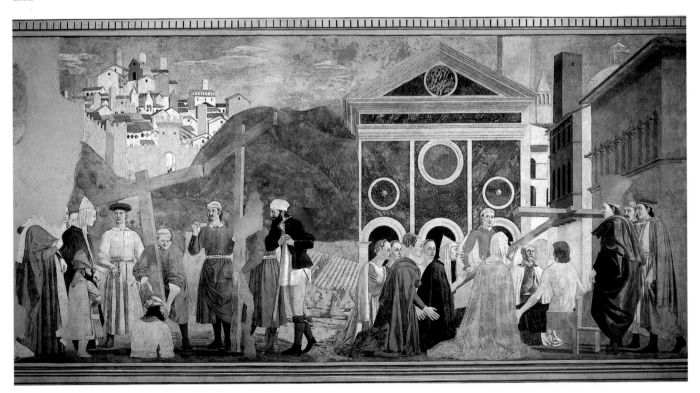

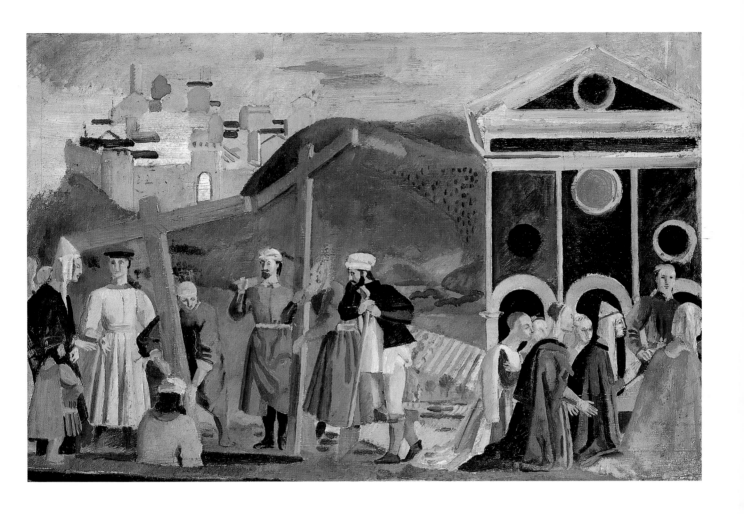

12. *La Légende de la Sainte Croix. Exaltation de la Croix.*
Héraclius rapporte la Croix à Jérusalem (copie d'après Piero della Francesca), 1926
[Legend of the True Cross. Adoration of the Cross. Heraclius Brings the Cross Back to Jerusalem (copy after Piero della Francesca)]

oil on cardboard
50 × 34 cm
signed and dated on the reverse,
in pencil: "Balthus Arezzo
1 28-29?"
Switzerland, private collection

provenance: Beatenberg,
private collection
exhibitions: Andros 1990, n. 7;
Rome 1990, p. 45.
bibliography: catalog Lausanne
1993, p. 40; Roy 1996, p. 51;
Clair, Monnier 1999,
n. P 25.

Like the preceding work, above which it is placed, this fresco of Piero's combines in a single panel two episodes of the *Legend of the Cross*, *The Arrival of Heraclius in Jerusalem* and *Adoration of the True Cross*. And like the other one, it opposes a group of six standing figures, forming a freize, to another, more close-set one, of kneeling faithful, overlooked by a standing man, in profile, with an Assyrian beard and a tall Oriental headdress. The ramparts and towers of Jerusalem, the arrangement of the worshippers of the Cross gives depth to the pictorial space, whereas on the left, Heraclius and his companions move laterally, in a space devoid of perpsective. Balthus was only interested in that second group that, besides, he did not entirely reproduce. Indeed, he left out the figure—quite damaged— of Heraclius, as well as the large cross he holds aloft, demonstrating once again his disregard for the original iconography.

In Piero, the high-priest Heraclius, wearing a miter, and his acolyte, are dressed in large draped cloaks. The oblique play of the creases of the fabrics enables the fresco artist to suggest the dynamism of the figures, in opposition with the static postures of the other three on the left, particularly the one he dressed in a white tunic and a large cone-shaped bonnet that seems to be weighing him down.
The tension introduced by that opposition is what interested Balthus. In his copy, the cloaks become mere colored masses, enlivened by dark brushstrokes stressing the movement. Likewise, he strongly modelled the shadows of the creases of the white tunic to emphasize its sculptural appearance. We should also mention that he replaced the missing or damaged parts of the bonnets of the two figures on the left, always heedful of the arrangement in triangles that he admired in Piero.

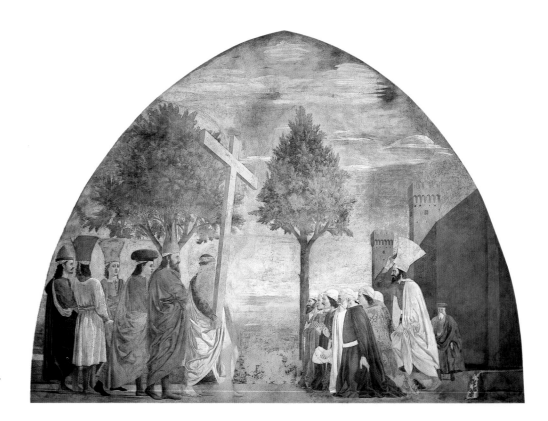

1. Piero della Francesca,
Legend of the Cross. Adoration of the True Cross. Heraclius Brings the Cross back to Jerusalem, fresco.
Arezzo, basilica of San Francesco, choir

13. *Message de l'ange au chevalier de Strättligen*, 1926–27
[The Angel's Message to the Knight of Strättligen]

tempera on two sheets
of brown paper
mounted on canvas
155 × 148 cm
signed and dated lower left:
"Bal/thus 1922"
(not visible on the photograph
because posterior to the shot)
Bern, private collection

exhibitions: Spoleto 1982, n. 1;
Andros 1990, n. 1; Rome 1990,
p. 33; Lausanne 1993;
Zurich 1999 (not included
in the catalog)
bibliography: catalog
MNAM.CNACGP, Paris 1983,
p. 340, n. 2; catalog Lausanne
1993, p. 39; Roy 1996, p. 50;
Clair, Monnier 1999, n. D 378

After spending the summer of 1926 in Tuscany, Balthus settled in Beatenberg, on the Lake of Thun, for the fall. He had been there often since 1917, usually staying with Margrit Bay, a woman sculptor for whom he worked as an assistant and for whom he had painted, three years earlier, a large picture representing *The Madonna and Child Surrounded by Saint John the Baptist and Saint Luke*. Margrit Bay, in fact, was an anthroposopher and had installed a private oratory in the house where she lived.
We can suppose she urged the youth to benefit by his recent experience in Italy; whatever may be the case, he then planned three large religious compositions. The first was a painting drawn from the Old Testament and representing various episodes of the story of *Tobia and the Angel.* Balthus met with difficulties in arranging the different scenes and gave up the project.[2] The second composition was a mural, whose project is presented here. Balthus designed it toward the end of 1926 and, although his mother announced its imminent execution to Rainer Maria Rilke (December 15, 1926[3]), it was finally refused by the sponsors.
The work was meant for the little church of Einigen, one of the most ancient in Switzerland (tenth century) on the south bank of the Lake of Thun. According to Giovanni Carandente,[4] it relates the legend of the founding of the church. The Strättligen family, whose fortress, located on the hill bearing the same name, looms over the area, won fame in Carolingian times in the person of Rudolph I, king of trans-Jura Burgundy in 889. Taking advantage of the conflicts dividing Charlemagne's descendants and the deposition of his grandson Charles III the Fat, emperor of the West, king of Italy and Germany, Rudolf of Strättligen fashioned for himself this kingdom that included the region of Geneva, the Valais, the Chablais and the Bugey. He had rivals—

among whom a certain Arnulf, a relative of the emperor—, and appears to have justified this takeover of the territory as being owed to divine will. The founding of the church would have been in compensation.
The painting represents the first episode of the legend: while he is asleep and yet a mere knight, an angel appears to Rudolf to inform him of his mission. The brave, leaning against his courser, is wearing armor and a Roman-style tunic. He is holding in the crook of his arm a helmet directly drawn from the one of the legionaries in Piero della Francesca's *Resurrection* (cat. 10, fig. 1) which Balthus had copied a few weeks earlier. A messenger angel, with a Greek profile, wearing boots as he is, his right hand raised, extends to him in his right hand a sword—for dubbing?—on an alpine scene background.
The large dimensions of this drawing, made on a double sheet, lead us to assume the painting was to be more or less the same size, meant for a pillar or a side aisle of the church. The limited range of colors, gray, pink, ochre and blue, in layers, the dark-outlined forms recall the Italian pre-Renaissance, whereas the freize-like composition and the horse (reversed) come directly from Piero's *Battle of Ponte Milvio*, whose copy by Balthus (now lost) is mentioned in one of his sketch-books.[5]
The datation given by the artist at the request of the present owner is recent and, as Baladine's letter proves, inaccurate.

[1] Cf. Clair, Monnier 1999, n. P 6 and S. Rewald, "Balthus's magic Mountain," *Burlington Magazine*, September 1997, pp. 622–28.
[2] Interview of September 28, 1994.
[3] *Rilke et Merline: Correspondance 1920–1926*, Zürich 1954, p. 600.
[4] *Balthus, disegni e acquarelli*, exhibition catalog, Spoleto 1982, p. 23.
[5] Clair, Monnier 1999, p. 402, n. CC 1465/5.

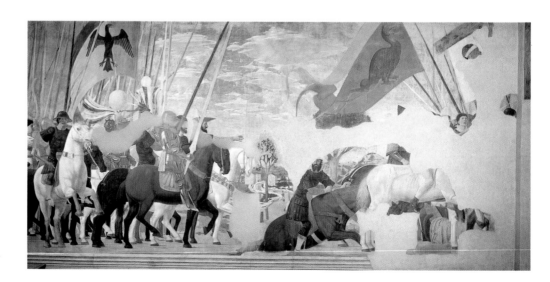

1. Piero della Francesca,
The Legend of the True Cross.
The Battle of Ponte Milvio,
fresco, detail.
Arezzo, basilica of San Francesco,
choir

14. *Les Evangélistes Matthieu et Luc*, 1926–27
[The Evangelists Matthew and Luke]

gouache on paper mounted
on cardboard
147 × 99.5 cm
private collection

provenance: sale Laurin,
Guilloux, Buffetaud,Tailleur,
Paris, 25 May 1976, n. 37;
sale Binoche et Godeau, Paris,
6 December 1985, n. 76bis;
sale Ader, Picard, Tajan,
9 April 1987, n. 33;
Pierre and Marianne Nahon,
galerie Beaubourg, Paris; sale
Loudmer, Paris, 13 June 1994,
n. 91; sale Christie's, London,
29 November 1994, n. 147
exhibitions: Bevaix 1975, n. 42;
Andros 1990, n. 6; Rome 1990,
p. 39
bibliography: Clair, Monnier
1999, n. D 379.

It is probably thanks to Margrit Bay, who
was a minister's daughter, that Balthus had
the opportunity, in 1926, to decorate the inside
of the Protestant temple of Beatenberg.
This is the second "church" painting Baladine
mentions in the above-mentioned letter.
The ambitious project consisted of three groups
of figures, topped by Bible inscriptions, placed
on each side of the large windows of one
of the temple walls (cf. p. 54, figs. 24, 25).
It was fully completed, but the frescoes were
probably not to the parishers' liking, since they
were whitewashed over a few years later (1934).
In the middle you could see the Good Shepherd
carrying a lamb on his shoulders and with a ewe
on each side, standing upon a rock from which
gushed four springs. Wearing a short tunic
and a sheepskin, he was leaning on his crook
and pointing his forefinger to the sky. A small
basket of fruit lay on his hips, a large Bern-style
straw hat hung on his back.
The Evangelists, identified by their attributes,
were arranged in two groups: Matthew and Luke
on one side, Mark and John on the other.
The drawing shown here is a study for the first
two. Its dimensions are quite close to those
of the fresco.
The two Evangelists have the severe countenance,
long hair and beard attributed to patriarchs.
They are dressed in long pleated and belted tunics

taken directly from the frescoes of the cycle
of the *Legend of the Cross* in Arezzo.
But, to imagine his Evangelists, Balthus probably
remembered the prophets of the same basilica.
He gives Matthew the full-face posture, the
parchment scroll and the colors of the clothes
(reversed) of Piero's *Jeremiah*. For Luke's clothes,
he chooses a harmony of ochres, yellow and red,
green and white drawn from the *Isaiah* of Arezzo
(fig. 1). The position of this same *Isaiah* appears
to have directly inspired that of the Evangelist
John of the temple of Beatenberg (fig. 2).
As for the round-cheeked angel, oddly given
a single wing, who guides Luke's hand,
in the fresco he will be given a second arm
(here embrionic) pointing upward. The passage
of the study on paper to the mural entailed
the suppression of a certain number of details
and the updating of the figures.
The two saints, rejuvenated, have short hair
and a trimmed beard; the *putto* is turned
into a lad in whose straight hair the wind plays;
as for the conventional ox, it now looks like a cow
with curved horns and a damp muzzle. Naiveté?
Desacralization? A definite determination,
anyway, in the very young artist Balthus is to place
in his time and in the rural décor around him
the holy figures he is depicting.
That is probably what shocked the brethren
and led to the disappearance of the frescoes.

1. Piero della Francesca,
The Prophet Isaiah, fresco.
Arezzo, basilica of San Francesco,
choir

2. Balthus, *Study for the frescoes
of the temple of Beatenberg.
The Evangelists Mark and John.*
Location unknown

15. *Nu à la veste rose*, 1927
[Nude with Pink Jacket]

oil on canvas
98.5 × 77.5 cm
signed and dated lower left:
"Baltus 27"
private collection

provenance: Ernst
Rinderspacher; sale Sotheby's,
London, 30 November 1988;
private collection, Switzerland;
sale Loudmer, Paris, 22
November 1993, n. 66
bibliography: Roy 1996, p. 45;
Clair, Monnier 1999, n. P 31

Balthus, in a letter written in Zurich on September
12, 1928 to his father (private collection),
proudly announces he sold his *Nu assis sur
le lit* [Nude Seated on a Bed] for the amount
of 300 francs, to the Swiss painter on glass
Ernst Rinderspacher. He appears highly
satisfied by the price he obtained for it,
but also by the quality of the purchaser who,
professionally, must have appreciated
the endeavors of the young self-taught painter.
Portrayals of nudes, more or less dressed in
gorgeous fabrics, are countless in nineteenth-
century painting. From Ingres to Manet,
from the *odalisques* to *Olympia*, the handling
of the subject varies considerably, the means used
are manifold. But in every case, the point was
to express, by the rendering of light, the delicacy
of a woman's skin and the sumptuousness
of the fabrics that set her off.
That is exactly what we have here. Proof being,
on the one hand, the model's relatively ordinary
posture and, on the other, the preparatory study
to the painting, unearthed by Sabine Rewald (fig. 1).
The young woman's face and body, violently lit
(notice the shadow cast, very rare in Balthus,
on the wood of the bed), are treated in sand tones
with blueish shades. Touches of pure white,
on the brow, the nose, the shoulders, the tip
of the knees, the heel, aim at rendering the glow
of her skin, contrasting with the model's moody
expression and lifeless gaze. The backgrounds,
wall, bedstead, bedside table, are treated
in blue-gray and purplish brown monochrome,
lit here and there by the complementary ochre
yellow tone. Against these backgrounds
the gorgeousness of the pink satin vest
and the dull white of the sheet, marked by deep
black creases, stand out, echoing Balthus's
studies in Arezzo.
Like a virtuose, Balthus trims the garment
with a satin ribbon, whose blue, identical
to the velvet counterpane, differs by its
shimmering.

1. Balthus, *Etude pour
"Nu à la veste rose"*
[Study for "Nude
with Pink Jacket"], 1927,
oil on cardboard, 25.4 × 19 cm.
J.M. Simpson collection

16. *Portrait d'Hedwig Müller*, 1928
[Portrait of Hedwig Müller]

oil on canvas
81 × 65.7 cm
signed lower left: "Baltus"
signed, inscribed,
dated and signed on the reverse:
"Le Dr. Hedwig Müller
peint à Zurich en 1924 Balthus"
private collection

provenance: Hedwig Müller;
son Dr. Jean Dunant, Zurich;
his step children; sale Sotheby's,
London, 2 July 1980, n. 232;
sale Habsburg Felman SA.,
Geneva, hotel NogaHilton, 24
November 1987; sale Christie's,
New York, 1st May 1996, n. 172
bibliography: catalog
MNAM.CNACGP, Paris 1983,
p. 342, n. 16; Leymarie 1990,
p. 123; Clair, Monnier 1999,
n. P 41.

In the above-mentioned letter, young Balthus tells his father about the seven months he had just spent in Zurich and the pictures he painted there: a small nude, a few still lifes, but, above all, he proudly claims, "I had the daring to do some portraits." An important step for him, even more so since they are commissions and he clearly sees therein the proof of the acknowledgement of the craft he is slowly acquiring.
The portrait shown here, compared to the photographs of Hedwig Müller and the evidence about her we have been able to gather, is physically and psychologically accurate. It gives a sense of self-mastery and balance, that Balthus appears to have sought also to render by the chromatic harmony. The brief description he gives of it to his father is as follows: "Miss Hedwig Müller…—beige dress, sitting in an armchair upholstered in toile de Jouy, dark background— the entire canvas in a gray and blond tone."
Hedwig Müller was a doctor; for a long time she was the companion of Kurt Tuchovsky, a poet and essayist *engagé*, who committed suicide in 1935 after his writings were destroyed by the Nazis. His sister Gertrud, whom Balthus had probably known in Paris where she attended avant-garde circles, was also portrayed by him.[1]
The Müllers, like the Thomanns who hosted and also supported Balthus by buying some paintings and commissioning two portraits,[2] owned a linen weaving mill that did not survive the crash of '29. They are not related to the collectors of the same name whose collection is now in the museum of Soleure.

[1] Clair, Monnier 1999, n. P 42.
[2] *Ibidem*, n. P 43 and P 44.

17. *Orage au Luxembourg*, 1928
[Storm in the Luxembourg Gardens]

oil on canvas
46 × 55 cm
signed and dated lower right:
"Baltus 28"
Switzerland, private collection

exhibitions: Ornans 1992, n. 5;
Lausanne 1993; Rome 1996–97,
p. 59; Karuizawa 1997, p. 35
bibliography: Roy 1996, p. 43;
Klossowski 1996, n. 4;
Clair, Monnier 1999, n. P 38

On his return to Paris in the fall of 1928, Balthus resumes, and even completes, the series of little scenes he had begun three years before in the Luxembourg gardens. Again here are the children playing ball or badminton, the sulking little girls and the teasing boys wandering in the lanes like in the earlier pictures.

Three of these works are noteworthy as precursors of the experimentation with perspective found in the urban landscapes of 1929–30: *Orage au Luxembourg*; *Luxembourg à la colonne* (fig. 2) and *Bassin au Luxembourg* (fig. 3). In Orage au Luxembourg appears the same "flattened" perspective that Balthus used later in *Les Quais* (cat. 18) and *La Place de l'Odéon* (cat. 18, fig. 2). The device allows him to bring forward the distant backdrop of the twin towers of the church of Saint-Sulpice which shape the composition.

Laterally, Balthus "compresses" the landscape and considerably reduces the distance that, in reality, separates the column (on the left) from the front body of the palace (on the right). The latter, in Balthus's vision, has lost a good third of its width, and, although it kept its pediment, tall chimneys and three large windows, it lost a storey. As for the column, it is excessively stretched out in height, even greatly exceeding the tops of the trees. The human eye cannot see it

thus unless you are sitting at its base. This distortion can also be found in the *Luxembourg à la colonne* (figs. 1 and 2). In the *O rage*, the lateral reduction of space is obtained by combining two different points of view, located at several meters one from another, along the pool. It becomes clear if you consider the position of the basin out of which the fountain rises: to align it, as Balthus does, on the right edge of the building, you must be placed at the left end of the pool. But from that point of view the column is out of sight. Vice versa, if you place yourself so as to see it above the corner of the pool, the palace and the fountain shift out of your field of vision. Balthus accentuated this distorsion even more in the *Bassin du Luxembourg*, painted the same year (fig. 3). The lateral compression is less great, and the building returns to its actual height. On the other hand, the pool has lost half of its surface. You nearly have to lie down in the sand, where Balthus placed the little boy launching his sailboat, to recreate the optical distortion: the size of the child, huge compared to his double in the *Orage*, the narrowness of the pool and the steep slope of the bank, whose truncated pyramid-shaped structure refers to the roof of the theater of the Odéon in the background.

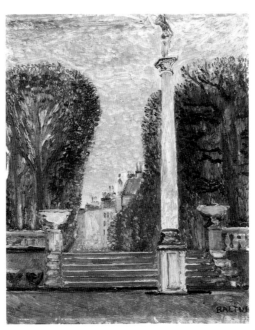

1. The Luxembourg Gardens in 1999

2. Balthus, *Luxembourg à la colonne* [At the Column in the Luxembourg Gardens], 1928, oil on cardboard, 46 × 38 cm. Private collection

3. Balthus, *Le Bassin du Luxembourg* [Pond in the Luxembourg Gardens], 1928, oil on canvas, 45.6 × 37.9 cm. Private collection

18. *Les quais (la berge près du Pont-Neuf)*, 1929
[The Quais (The Embankment near Pont-Neuf)]

oil on canvas
73 × 59.8 cm
signed and dated lower left:
"Balthus 29"
dedicated lower right:
"A Pierre Matisse, Balthus"
private collection

provenance: gift of the artist
to Pierre Matisse
exhibitions: New York 1939,
n. 3; New York 1949, n. 5;
New York 1956, n. 2; New York
1962, n. 1; Cambridge 1964,
n. 2; Chicago 1964, n. 2;
London, Tate Gallery 1968,
n. 2; Detroit 1969, n. 2;
Marseilles 1973, n. 1;
Paris, MNAM.CNACGP 1984, n. 4;
New York 1984, n. 1; Kyoto
1984, n. 1, Lausanne 1993
bibliography: Leymarie, 1982,
p. 123 and 2nd ed. 1990, p. 121;
Klossowski, 1983, pl. 3; catalog
MNAM.CNACGP, Paris 1983,
pl. p. 123 and p. 341, n. 13;
Roy 1996, p. 57; Klossowski
1996, n. 5; Fox Weber 1999,
p. 133; Clair, Monnier 1999,
n. P. 50

In December 1926, the gallery Bernheim-Jeune
of Paris presented an important ensemble
of drawings by Seurat. We do not know whether
Balthus, who was still in Beatenberg on the 15th,
but went with his mother to Toulon for Christmas
(cf. cats. 7 and 8), saw this show. However there
is no doubt but that Seurat's work influenced
him considerably when, a year later, he began
the series of paintings depicting the banks
of the Seine. A small study for *La Berge de l'île
Saint-Louis* [The Embankment on Ile Saint-Louis]
(Clair, Monnier 1999, n. D 404), especially,
looks directly inspired by Seurat's *Tree-trunk*
(fig. 1) that was in the exhibition, but that could
also be seen in the Musée du Luxembourg
to which Camille Pissarro had bequeathed
it in 1904.[1]
It is, of course, in spirit rather than in technique
that *Les Quais*, like *Le Pont-Neuf* (fig. 3), are very
akin to the *Dimanche à la Grande Jatte* by Seurat.
Balthus remains true to the chromatic harmony
typical of the paintings of the 1920's, and the dull
tones on which he plays are far from the pure
colors of neo-Impressionism. The way he lays the
colors on the canvas, in thin superimposed layers,
heightened here and there with impastos,
frequently white or black, is very far from
Pointillism as well.
On the other hand, in *Les Quais*, like in Seurat's
famous painting, perspective is suggested by the
diagonal that, opposing shadow and light, crosses
the lower part of the painting. "Like in a stage
set," Robert L. Herbert writes,[2] who also adds,
still referring to *La Grande Jatte*: "Most of
the figures are seen in profile, full-front or from
the back, which flattens them and emphasizes
their distance, structural as well as psychological,
from their neighbors."
That comment could equally be inscribed
under the first version of *La Rue* (cf. cat. 19),
contemporary of *Les Quais*, or under *La Place
de l'Odéon* (fig. 2), executed the year before,
that combines the "compressed" perspective
system of the *Orage au Luxembourg* (cat. 17)
with figures *à la* Seurat.
On the other hand, typical Balthus is the student
wearing a cap who, leaning on the parapet, like
at a theater balcony, is observing the matron,
her cat and the snack she placed by her feet on
a bright-colored dishcloth. Although placed
in the background, the figure, like in some scenes
in the Luxembourg garden (cf. cat. 4), ignores
scale. But it introduces, as in those scenes,
a discreet, slightly humorous psychological bond
between the people. Is he wondering whether
he might get the pathetic cat she has a firm grip
on to escape, or if he might spirit away her bottle
of wine, arousing, for sure, the wrath of the
concierge and the hilarity of the passers-by?

[1] *Seurat*, exhibition catalog, Paris, Grand-Palais,
9 April–12 August 1991, p. 65, n. 10.
[2] *Ibidem*, p. 207.

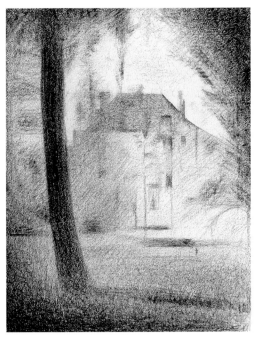

1. Georges Seurat, *The Tree-trunk*,
1879–81, Comté pencil
and charcoal, 31.3 × 24.2 cm.
Paris, Musée du Louvre,
Département des Arts graphiques,
collection Musée d'Orsay
(gift Camille Pissarro, 1904)
R.F. 29.549

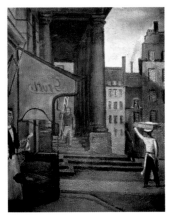

2. Balthus, *La Place de l'Odéon*,
1928, oil on canvas, 100 × 88 cm.
Private collection

3. Balthus, *Le Pont-Neuf*, 1928,
oil on canvas, 73 × 79 cm.
Private collection

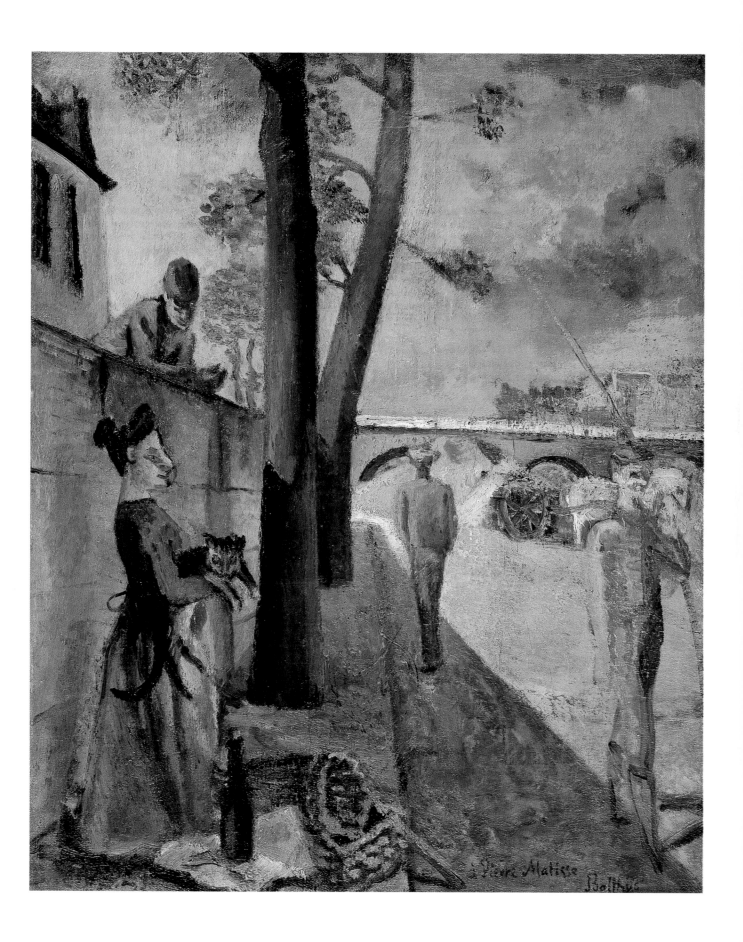

19. *Etude pour "La Rue," 1929*
[Study for "The Street"]

pencil and India ink on paper
17.4 × 21.8 cm
New York, The Museum
of Modern Art, gift of James
Thrall Soby

exhibitions: New York 1963,
n. 1; London,Tate Gallery 1968,
n. 61; Detroit 1969, n. 14;
New York, MoMA *et alia*
1966–67, n. 19; Spoleto 1982,
n. 3; Paris, MNAM.CNACGP
1983–84, n. 1
bibliography: catalog New York
1984, p. 58 fig. 93; Roy 1996,
p. 69;
Clair, Monnier 1999, n. D 414

The cycle of cityscapes Balthus painted in the late twenties ends with *La Rue* (fig. 1), a key work that is both a synthesis of his investigations and an opening onto the future: he would do its second version in 1933 (cat. 43) and especially *Le Passage du Commerce Saint-André* (cat. 92), that in 1954 marked the end of his Paris life. The first version of *La Rue* was purchased by Pierre Matisse (cf. cat. 56), when he discovered Balthus's work at the Galerie Pierre during the summer of 1934. Its whereabouts today are, alas, unknown. The second verison, like the present drawing, were bought by Balthus's first American collector, James Thrall Soby, who left them both to the Museum of Modern Art of New York. Jean Clair[1] referred to "that peculiar, magic time of the thirties in Paris, that in-between, not war but spiritual in-between, when the first lights of Surrealism had gone out and those of Existentialism did not yet exist." The Rue Bourbon-le-Château, that is shown here, is exactly in the heart of the old Saint-Germain-des-Prés district, two steps away from the Galerie Pierre, the Café de Flore, the Rue des Grands-Augustins where Picasso was soon to move to, and one where the followers of the two movements would run into each other. Near also to the Rue de l'Ancienne Comédie, the one where

the Comédiens-français had settled in 1689. A coincidence, of course, but what struck his contemporaries was indeed the theatrical aspect, the sense of suspended time. In a gilded pasteboard set with sharp angles and an overdone perspective, a young man comes toward us, his hand over his heart, his eyes wide. Perhaps he comes from Masaccio,[2] the sketch does not allow us to decide; no more than to say whether the mason carrying a board that you can barely discern on his left is a reminiscence of Piero's *Legend of the Cross* Balthus had seen at Arezzo.[3] On the other hand, the housewife moving away and whom the young man passes without seeing her, an accurate, geometrically composed silhouette, might well come from Seurat's *La Grande Jatte*. Actually, these two silhouettes already appeared in *Le Pont-Neuf* of 1928 (cf. cat. 18, fig. 3); just as the bearded bourgeois wearing a bowler who is moving forward in profile in the left part of the picture was already in *La Place de l'Odéon* (in the background, cf. cat. 18, fig. 2).

[1] J. Clair, "Le Paris de Balthus," *Beaux-Arts*, 7, November 1983, pp. 38–41.
[2] J. Clair, "Les Métamorphoses d'Eros," in *Balthus*, exhibition catalog, Paris 1983, p. 260, compares him to the Theophilus in the Brancacci chapel in Florence.
[3] J. Russel, "Mais l'Alice de Tenniell…," *ibidem*, p. 283.

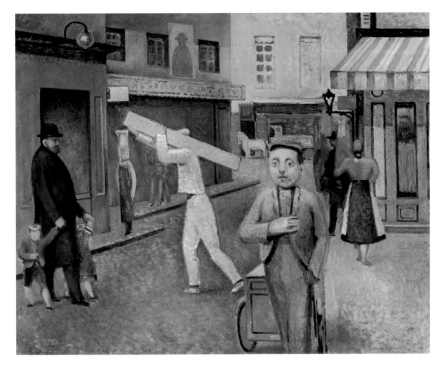

1. Balthus, *La Rue* [The Street],
1929, oil on canvas, 130 × 162 cm.
Location unknown

After performing his military service in Morocco, recalled by *La Caserne*, Balthus returned to Paris where he devoted himself to preparing his first Parisian exhibition, at the Galerie Pierre.

Six of the seven paintings, *Alice*, *La Toilette de Cathy*, *La Rue*, *La Fenêtre*, *La Leçon de guitare* and the *Portrait de jeune fille en costume d'amazone* (the last one not being identified), that were shown in April 1934 are reunited here once again, and for the very first time. That exhibition, although it did not cause the uproar the young painter sought, drew onto Balthus the attention of the art world and is considered today one of the outstanding events of the pre-war Parisian art scene.

Several portraits of his friends, Pierre and Betty Leyris, Antonin Artaud, Miró, or Lelia Caetani, of his dealers, Pierre Colle and Pierre Matisse, offer a less familiar aspect of Balthus's temperament, the portraitist's intentness on expressing, by various formal means, his sitters' intimate personality. Four others, portraying the children Hubert and Thérèse Blanchard, blend the austerity of a rigorous layout with the affectionate attention he devoted to them.

That was also the period when he made the illustrations for Emily Brontë's novel *Wuthering Heights*. Those fourteen India ink drawings, in which Balthus gave Heathcliff and Cathy his own features and those of his future wife Antoinette de Watteville, form a stunning ensemble, by its coherency and dramatic intensity, within his graphic work.

The magnificent landscape of *Larchant* concludes this chapter. Painted in 1939, it is laden, just as it was for Pierre Jean Jouve to whom it inspired several poems, with a great symbolic value, just before the outbreak of the war.

20. *Portrait de jeune fille en costume d'amazone*, 1932 (altered in 1982)
[Portrait of a Girl in a Riding Habit]

oil on canvas
72 × 52 cm
inscribed, signed and dated
on the reverse, on two lines:
"There was a time, I need
not name,/ Since it will never
forgotten be,/ When all our
feelings were the same,/
As still my soul hath been
to thee."
"Bébé. à Berne en Juillet 1932/
(Repeint cinquante ans plus
tard/ Pour Stash Noel 1991/
Balthus"
Stanislas Klossowski de Rola

provenance: the artist
exhibitions: Tokyo 1993–94,
n. 1; Hong Kong 1995, n. 1;
Beijing 1995, n. 1; Taipei 1995,
n. 1; Madrid 1996; Rome
1996–97, p. 61; Karuizawa 1997,
p. 39; Zurich 1999, n. 4.
bibliography: Klossowski 1983,
n. 20; catalog MNAM.CNACGP,
Paris 1983, p. 342, n. 19; catalog
New York 1984, p. 24 fig. 26;
Leymarie 1990, p. 124; Roy
1996, p. 41; Klossowski 1996,
nn.25-26; Fox Weber 1999,
p.140; Clair, Monnier 1999,
n. P 62

The *Jeune fille en costume d'amazone*, whose
portrait Balthus painted in 1932, appears to us
today with the features of a child. He considerably
retouched it about twenty years ago, but
an old photograph allows us to restore its first
appearance (fig. 1). At the time Antoinette
de Watteville was twenty years old, and this
is the second of the eight portraits he was
to paint of her (of which fig. 2 and cats. 54
and 61). Balthus would also give her face to Cathy,
the heroine of *Wuthering Heights* by Emily
Brontë, whose illustrations he was working
on at the time (cf. cats. 22–37). He had met
Antoinette's brothers fifteen years before,
in Bern, and met the young girl in 1924
when she was twelve.
He had been in love with her since 1930, having
with her a rather intermittent correspondence[1]
that reflects the girl's sentimental vacillations,
but also an intimacy, a complicity made up
of childhood memories and shared books.
Byron's verses[2] Balthus copied on the reverse
of the canvas express these perfectly.
The alterations the portrait underwent bear
mainly on the features of the face: the curve
of the cheek, the rounded eyes and ridge
of the nose give it a childish look. The height
of the head was reduced, the hairstyle and the
opening of the jacket changed. The juxtaposition
of transparent photographs reveal that, to alter
the silhouette, Balthus merely lengthened the tails
of the jacket a little and moved the hands down
a bit. To restore the overall balance,
he emphasized the creases of the skirt
and widened the right arm of the armchair.
The silhouette stands out against a deep red
background whose color reflection tones the face,
the hands and the skirt.
Balthus brought this portrait back to Paris,
after his summer stay in Bern in 1932,
and he mentions it five or six times in his letters
to Antoinette. These mentions, compared to one
another, allow us to claim it was one of the two
portraits, not identified until now, that figured
in the 1934 exhibition at the galerie Pierre.

[1] Private collection.
[2] Byron, 1808; cf. *The Complete Poetical Work*,
J.J. McGann, Clarendon Press, 1980, vol. I, n. 118.

1. Balthus, *Portrait de jeune fille
en costume d'amazone*, 1932,
first state

2. Balthus, *Jeune fille assise
(Antoinette)* [Girl Seated
(Antoinette)], 1930,
oil on canvas, 91.5 × 72.5 cm.
Location unknown

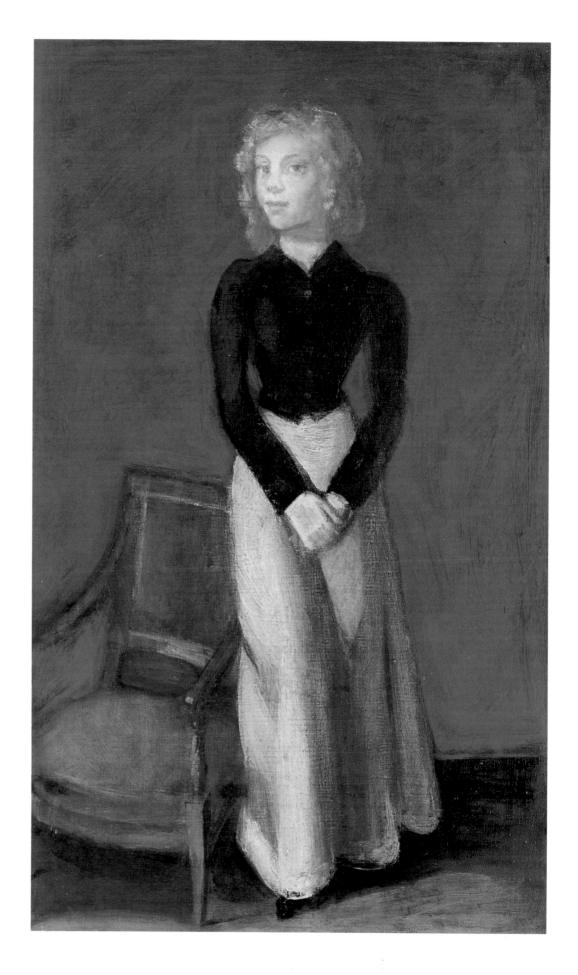

21. *Der Strüwwelpeter*, 1932
[Shock-headed Peter]

India ink on paper
recto-verso
21.5 × 7.5 cm
private collection

provenance: private collection

Already in 1956, Pierre Klossowski, Balthus's
older brother, pointed out the importance
of nineteenth-century picture books as "initial
elements of Balthus's original vision."[1] He quoted
Tenniel's illustrations for Lewis Carroll's *Alice*,
images d'Épinal (eighteenth- nineteenth-century
popular prints) and Heinrich Hoffmann's
Strüwwelpeter. Jean Clair sought out traces
of that children's literature in the work of Balthus,
and appraised its significance.[2] "They are—he
wrote in particular—those catalysts that stimulate
and speed up the rebirths, the resonances,
the echoes the painter implements."
And elsewhere: "Under the familiarity of the loans
from the history of forms, we can see another tale
shining through, that belongs neither to a place
nor to a time, except primitive ones, before
the awareness of a place or a time even existed."[3]
Now, if references to *Strüwwelpeter* can be
spotted in a certain number of paintings (see cat.
83), if accurate reminiscences of it can be found
in the *croquetons* of the post-war years and even
in a drawing done for his daughter Harumi
around 1976 (cf. cat. 200), the drawing shown
here, unearthed a few months ago, is the only one
known representing Shock-headed Peter himself.
It was monogrammed and dated with a ball-point
pen, that is, after the Second World War:
"Bs 1922," altered "1932." We shall not dwell
on that "slip" and shall retain the second date,
since the drawing is stylistically very close
to the ones Balthus was working on at the time,
the illustrations for *Wuthering Heights* by Emily
Brontë (see cats. 22–37). This means that,
at the age of 24 and creating the major works
that Pierre Loeb was to show two years later,
La Rue (cat. 43), *Alice* (cat. 40), *La Leçon
de guitare* (cat. 44), he was nonetheless still living
at the same time in the magic, frightening world
of his childhood. A fascinating superimposition
of "different layers of meanings that gradually
let themselves be seen," Jean Clair wrote,
and that the existence of this drawing irrefutably
proves.

[1] P. Klossowski, "Balthus beyond Realism," *Art News*,
New York, vol. 55, 8, pp. 26–31. Translated in French
in *Monde Nouveau*, Paris, February–March 1957,
pp. 78–80. Reprinted in *Balthus*, exhibition catalog,
Paris 1983, pp. 80–85.
[2] J. Clair, "Les Métamorphoses d'Eros," *ibidem*,
pp. 256–79.
[3] J. Clair, "Eros et Cronos. Le rite et le mythe dans
l'œuvre de Balthus," *La Revue de l'art*, 63, Paris 1983,
pp. 83 ff.

1. *Der Strüwwelpeter*,
illustration by Heinrich Hoffmann
for his book of the same name.
Frankfurt, 1844

22–37. *Illustrations pour* Les Hauts De Hurlevent *d'Emily Brontë*, 1932–1935
[Illustrations for *Wuthering Heights* by Emily Brontë]

The 14 drawings shown here are the ones selected by Balthus, out of about fifty more or less advanced studies, to illustrate Emily Brontë's book.
They all relate to the first part of the novel, that ends with Cathy's death (ch. 15).
In a conversation with C. Costantini,[1] as well as in the postface of the 1993 New York edition, Balthus said he had not been able to illustrate the following episodes, whose atmosphere is very different, yet still preserve a stylistic unity, and this despite having worked on it for over a year. The only drawing known today that refers to the second part, and that we cannot connect with a specific episode,[2] indeed shows that.
The project for an illustrated edition was not carried out at the time. The fourteen drawings the artist had selected appeared together for the first time in the exhibition catalogue of the Musée d'Art Moderne de Paris in 1983, then in that of the Metropolitan Museum of Art of New York (1984). A fifteenth drawing[3] was added to them in the two illustrated editions of the novel (Séguier, Paris 1989 and The Limited Editions Club, New York 1993). Mme. Jacqueline Matisse-Monnier confirmed to us that when her father, Pierre Matisse, had purchased the set, Balthus considered it to be complete and ready for publication, and there was no question of a fifteenth. The artist was unable to clear up this point.
Some of these drawings have autograph captions in English. They prove the artist, whom we know had a perfect mastery of the language, worked on the original text of the novel.
However, at the time the drawings were made, there was a French translation (Payot, Paris 1929, translation F. Delebecque). We refer to it here, for the French titles and pagination. Pierre Leyris, in whose home the artist was living in 1932–33 (see cat. 39), did another one that appeared much later (Pauvert, Paris 1972). For the English titles of cats. 23, 27, 32, 34, 36, 37, we refer to the 1965 edition, Penguin Books Ltd, Hammonsworth, Middlesex.
It is not possible to date the drawings with accuracy. We know from the artist that the series was not completed at the time of his exhibition in 1934 at the Galerie Pierre. A year later, eight of them satisfied him enough to allow them to appear in *Minotaure*, the review founded by Albert Skira (see cat. 85). It would seem he had completed the last one at the end of that same year and would exhibit the group in London at the end of February 1936.
An examination of the paper and the dimensions, however, show that cats. 22, 23 and 25 come from a same notebook, and cats. 27, 28, 31, 32 and 33 from a second one; so they were probably done at the same time.
The technique adopted is India ink, without color heightening; it perfectly expresses the intensity, the near state of hallucinated violence in which Balthus worked. "I want,—he then wrote[4]— to put in them many things, tenderness, childish longing, dreams, love, death, cruelty, crime, violence, cries of hatred, howls and tears!"

We know that at the time he was very much in love with Antoinette de Watteville, whose family was worried about her plighting her troth to an unknown young painter without means. *Wuthering Heights*, an unequalledlove story by the dramatic intensity it is steeped in throughout, had certainly made a deep impression on the romantic, sensitive youth he was, and he somehow embodied the couple he formed with Antoinette in the heroes of the novel, by giving Heathcliff and Catherine their own countenances. The research Balthus made for *Wuthering Heights* represented a major step in his training, echoing throughout his entire work.
We shall examine here the illustrations that are significant in that regard.

[1] C. Costantini, *L'Enigma Balthus*, Gremese Editore, Roma and Denoël, Paris 1996, p. 49.
[2] Clair, Monnier 1999, n. I 1593.
[3] Repr. in Clair, Monnier 1999, n. I 1583.
[4] Letter to Antoinette, 8 November 1934 (private collection).

22. *"Tirez-lui les cheveux en passant"* (ch. 3, p. 38)
["Pull his hair when you go by"]

India ink on paper
38.5 × 31cm
inscribed below the drawing:
"Pull his hair when you go by"
private collection

provenance: Pierre Matisse,
purchased from the artist;
Mme Alexina Duchamp
exhibitions: New York 1939,
n. 5; New York 1956; New York
1963, n. 17; Chicago 1964,
n. 25; New York, MoMA *et alia*
1966–67, n. 10; London, Tate
Gallery 1968, n. 62 (not repr.);
Detroit 1969, n. 29; Spoleto,
1982, n. 4; Paris, MNAM.CNACGP
1983–84, p. 27, n. 1; New York
1984, n. 52; Andros 1990, n. 8;
Rome 1990, p. 52; Bern 1994,
n. 4
bibliography: *Minotaure,* 7, 1935,
p. 60; catalog New York 1984,
p. 40 fig. 63; librairie Séguier,
Paris 1989; The Limited
Editions Club, New York 1993;
Roy 1996, p. 10; Clair, Monnier
1999, n. I 1552

23. *"Parce que Cathy lui enseignait ce qu'elle apprenait"* (ch. 6, p. 74)
["Because Cathy taught him what she learnt"]

India ink on paper
38.8 × 31 cm
inscribed below the drawing:
"I have got the time on with
writing for twenty minutes"
private collection

provenance: Pierre Matisse,
purchased from the artist;
Mme Alexina Duchamp
exhibitions: New York 1939,
n. 6; New York 1956; New York
1963, n. 12; Chicago 1964,
n. 26; New York, MoMA *et alia*
1966–67, n. 2; London, Tate
Gallery 1968, n. 62 (not repr.);
Detroit 1969, n. 27; Spoleto
1982, n. 5; Paris, MNAM.CNACGP
1983–84, p. 27, n. 2; New York
1984, n. 53; Andros 1990, n. 9;
Rome 1990, p. 53; Bern 1994,
n. 5
bibliography: *Minotaure,* 7, 1935,
p. 60; Leymarie,1982, p. 26
and 2nd ed. 1990, p. 26; catalog
New York 1984, p. 86 fig. 104;
librairie Séguier, Paris 1989;
The Limited Editions Club,
New York 1993; Koharu,
Takashina, Motoe 1994, p. 100;
Roy 1996, p. 10; Faye 1998,
p. 120; Fox Weber 1999, p. 382;
Clair, Monnier 1999, n. I 1553

The first illustration of the novel is about the
vexations inflicted on Heathcliff by the Earnshaw
family who had taken him in. The next five,
the rapport that develops between him and
Catherine, the young lady of the household:
"[Heathcliff] bore his degradation pretty well
at first, because Cathy taught him what
she learnt, and worked or played with him
in the fields. They both promised fair to grow up
as rude as savages [...]." We said above that
Balthus had given his features to Heathcliff and
Antoinette's to Cathy.
And we can assume that, when drawing that
scene, he recollected an episode of his childhood
in Switzerland: "Oh! Bébé,—he wrote to
Antoinette in December 1933—remember
our studious winter evenings, when even

our homework (over which we bent, breathless
from having run in the snow)had something
fairylike about it (such a mysterious radiance
was in all things) and we were already so full
of expectation!"[1] We have not heard of any
preparatory studies for this illustration, whose
composition, nearly pyramidal, is formed by a
skillful play of triangles and rectangles, probably
a reminiscence of Piero, for whose investigations
in that scope he still recently professed boundless
admiration. We shall come back later to this
drawing that was borrowed, with a few variants,
for the painting titled *Les Enfants Blanchard* (cat.
53) and, in part, in *Le Salon* (cat. 101 fig. 5) and
Trois personnages dans un intérieur (cat. 59, fig. 1).

[1] 21 december 1933. Private collection.

24. *"Mais c'était un de leurs grands amusements de se sauver dans la lande"* (ch. 6, p. 74)
["But it was one of their chief amusements to run away to the moors"]

India ink on ochre paper
36 × 29.4 cm
inscribed below the drawing:
"But it was one of their chief
amusements to run away
to the moors"
private collection

provenance: Pierre Matisse,
purchased from the artist;
Mme Alexina Duchamp
exhibitions: New, York, 1939,
n. 7; New York 1956; New
York,1963, n. 10; Chicago 1964,
n. 27; New York, MoMA *et alia*
1966–67, n. 7; London, Tate
Gallery 1968, n. 62 (not repr.);
Detroit 1969, n. 22; Spoleto
1982, n. 6; Paris, MNAM.CNACGP
1983–84, p. 28, n. 3; New York
1984, n. 54; Andros 1990,
n. 10; Rome 1990, p. 54;
Bern 1994, n. 6
bibliography: librairie Séguier,
Paris 1989; The Limited
Editions Club, New York, 1993;
Roy 1996, p. 10; Clair, Monnier
1999, n. I 1554

It was one of their chief amusements to run away to the moors and remain there all day.

25. *"Cathy et moi nous étions échappés par la buanderie pour nous promener à notre fantaisie"*
(ch. 6, p. 75)
["Cathy and I escaped from the wash house to have a ramble of liberty"]

India ink on paper
38.7 × 31 cm
inscribed below the drawing:
"Cathy and I escaped from
the wash house to have a ramble
of liberty"
private collection

provenance: Pierre Matisse,
purchased from the artist;
Mme Alexina Duchamp
exhibitions: New York 1939,
n. 9; New York 1956; New York
1963, n. 11; Chicago 1964,
n. 29; New York, MoMA *et alia*
1966–67, n. 5; London, Tate
Gallery 1968, n. 62 (not repr.);
Detroit 1969, n. 26; Spoleto
1982, n. 7; Paris, MNAM.CNACGP
1983–84, p. 29, n. 4; New York
1984, n. 55; Andros 1990,
n. 11; Rome 1990, p. 55;
Bern 1994, n. 7
bibliography: Minotaure, 7, 1935,
p. 60; librairie Séguier, Paris
1989; The Limited Editions
Club, New York 1993;
Roy 1996, p. 10; Clair,
Monnier 1999, n. I 1558

The recent discovery of a splendid study
for this episode of the novel (cf. cat. 26) indicates
that Balthus thought about it a great deal before
completing the illustration presented here.
Notice, first of all, that Heathcliff is dressed in
tight-fitting pants in the fashion of the eighteenth
century (as in the first version of the next
drawing), a style that Balthus will very quickly
replace by a modern outfit: a suit and jacket.
That way he updated the novel while putting it
at a certain distance.

In the study, Cathy is shown climbing out
the window, helped by Heathcliff who
is boosting her up.
In the final illustration, the obstacle is already
cleared and the girl is about to jump out. We can
discover an altered reminiscence of her position,
her left leg taut, her right bent against her thigh,
arm raised, in the *Studies* for *La Semaine
des quatre jeudis* (cats. 80 and 81), that are
contemporary of the *Nu au chat* of the National
Gallery of Melbourne (cats. 76, 77 fig. 1).

Cathy and I escaped from the wash-house to have a ramble of liberty —

26. *"Cathy et moi nous étions échappés par la buanderie pour nous promener
à notre fantaisie"* (ch. 6, p. 75)
["Cathy and I escaped from the wash house to have a ramble of liberty"]

India ink on paper
24 × 26 cm
signed and dated below, right:
"Balthus 1932"
London, Edwin C. Cohen

provenance: Jacques
and Madeleine Matarasso; sale
Briest, Paris 27 October 2000,
n. 50

27. *"Nous avons couru depuis le sommet des Hauts"* (ch. 6, p. 76)
["We ran from the top of the Heights"]

India ink on paper
39.8 × 31 cm
private collection

provenance: Pierre Matisse,
purchased from the artist;
Mme Alexina Duchamp
expositions: New York 1939,
n. 8; New York 1956; New York
1963, n. 14; Chicago 1964,
n. 28; New York, MoMA *et alia*
1966–67, n. 13; London, Tate
Gallery 1968, n. 62 (not repr.);
Detroit 1969, n. 20; Spoleto
1982, n. 14; Paris,
MNAM.CNACGP 1983–84, p. 30,
n. 5; New York 1984, n. 56;
Andros 1990, n. 13; Rome 1990,
p. 57; Bern 1994, n. 8
bibliography: *Minotaure,* 7, 1935,
p. 61; librairie Séguier, Paris
1989; The Limited Editions
Club, New York 1993;
Roy 1996, p. 12;
Clair, Monnier 1999, n. I 1560

28. *"Le démon l'avait saisie par la cheville"* (ch. 6, p. 78)
["The devil had seized her ankle..."]

India ink on paper
39.8 × 31cm
inscribed below the drawing:
"The devil had seized her
ankle..."
private collection

provenance: Pierre Matisse,
purchased from the artist;
Mme Alexina Duchamp
exhibitions: New York, 1939,
n. 10; New York 1956; New
York 1963, n. 16; Chicago 1964,
n. 30; New York, MoMA *et alia*
1966–67, n. 11; London, Tate
Gallery, 1968, n. 62 (not repr.);
Detroit 1969, n. 21;
Spoleto, 1982, n. 8; Paris,
MNAM.CNACGP 1983–84, p. 30,
n. 6; New York 1984, n. 57;
Andros 1990, n. 12; Rome 1990,
p. 56; Bern 1994, n. 9
bibliography: *Minotaure,* 7, 1935,
p. 60; librairie Séguier, Paris
1989; The Limited Editions
Club, New York 1993;
Roy 1996, p. 12;
Clair, Monnier 1999, n. I 1562

29. *"Je voyais qu'ils étaient remplis d'une admiration stupide"* (ch. 6, p. 81)
["I saw they were full of stupid admiration"]

India ink on paper
35.4 × 31 cm
inscribed below the drawing:
"I saw they were full of stupid
admiration"
private collection

provenance: Pierre Matisse,
purchased from the artist;
Mme Alexina Duchamp
exhibitions: New York 1939,
n. 11; New York 1956;
New York 1963, n. 20; Chicago
1964, n. 31; New York, MoMA
et alia 1966–67, n. 6;
London, Tate Gallery 1968,
n. 62 (not repr.); Detroit 1969,
n. 17; Spoleto 1982, n. 9; Paris,
MNAM.CNACGP 1983–84, p. 31,
n. 7; New York 1984, n. 58;
Andros 1990, n. 14; Rome 1990,
p. 58; Bern 1994, n. 10
bibliography: librairie Séguier,
Paris 1989; The Limited
Editions Club, New York 1993;
Clair, Monnier 1999, n. I 1564

30. *"Tu n'avais qu'à ne pas me toucher"* (ch. 7, p. 86)
["You needn't have touched me"]

India ink and pencil on paper
mounted on paper
(transverse tear)
39.4 × 30.9 cm
inscribed below the drawing:
"You needn't have touched me"
private collection

provenance: Pierre Matisse,
purchased from the artist;
Mme Alexina Duchamp
exhibitions: New York 1939,
n. 13; New York 1956;
New York 1963, n. 21;
Chicago 1964, n. 33;
New York, MoMA
et alia,1966–67, n. 15; London,
Tate Gallery 1968, n. 62
(not repr.); Detroit 1969, n. 16;
Spoleto 1982, n. 10; Paris,
MNAM.CNACGP 1983–84, p. 32,
n. 8; New York 1984,
n. 59; Andros 1990, n. 15; Rome
1990, p. 59; Bern 1994, n. 11
bibliography: *Minotaure* , n. 7,
1935, p. 61; librairie Séguier,
Paris 1989; The Limited
Editions Club, New York 1993;
Roy 1996, p. 12;
Clair, Monnier 1999, n. I 1565

It is in the seventh chapter that initiates the tragedy that is to separate Cathy and Heathcliff forever. In most of the following scenes, Balthus expressed the intensity of emotions that overwhelm the heroes by stretching their bodies along diagonals or obliques that appear to cut across the composition. But it is equally from then on that appears, in the illustrations, the figure of Nelly, the governess with her tight bun, systematically shown in profile, tight-lipped when she is but a witness of the scene.
A recollection perhaps of the matron with her cat in *Quais* (cat. 18), we see her again five times in the series of pictures painted in Paris between 1946 and 1952, in particular in the *Jeune fille* (cat. 73) and in *La Toilette de Georgette*

(cat. 83).[1] John Russel mentioned on the subject etchings by Hogarth, especially the wealthy old maid in *Morning*.[2] A relevant comparison if we recall the painted version of *Columbus Breaking the Egg* he gave of it around 1953.
The old woman personifies, as Russel says, "the others," elders, censors, guardians, the third age of life, somehow, in Balthus's own personal mythology, and which we shall go into later.

[1] As well as in *Jeune fille à sa toilette*, 1948 (cat. 75), *Jeune fille au miroir*, 1948 (cat. 74 fig. 1), *La Concièrge*, 1952 (Clair, Monnier 1999, n. P 216).
[2] J. Russel, in *Balthus*, exhibition catalog, London, Tate Gallery 1968. Trans. in French in *Balthus*, exhibition catalog, Paris 1983, pp. 280–97.

You need n't have touched me.

31. *"Alors, pourquoi as-tu cette robe de soie?"* (ch. 8, p. 107)
["Why have you that silk frock on, then?"]

India ink and pencil
39.8 × 31 cm
inscribed below the drawing:
"Why have you that silk frock
on, then?"
private collection

provenance: Pierre Matisse,
purchased from the artist;
Mme Alexina Duchamp
exhibitions: New York 1939,
n. 14; New York 1949, n. 2;
New York 1956; New York
1963, n. 18; Chicago 1964,
n. 34; New York, MoMA *et alia*
1966–67, n. 14; London, Tate
Gallery 1968, n. 62 (not repr.);
Detroit 1969, n. 28; Spoleto
1982, n. 11; Paris,
MNAM.CNACGP 1983–84, p. 33,
n. 10; New York 1984, n. 60;
Andros 1990, n. 16; Rome 1990,
p. 60; Bern 1994, n. 12
bibliography: *Minotaure,* 7, 1935,
p. 61; catalog New York 1984,
p. 64 fig. 96; librairie Séguier,
Paris 1989; The Limited
Editions Club, New York 1993;
Kisaragi, Takashina, Motoe
1994, p. 110; Roy 1996, p.12;
Fox Weber 1999, p. 293;
Clair, Monnier 1999, n. I 1570

This drawing shows Cathy Earnshaw who,
in the absence of her brother, is readying herself,
with the help of the servant Nelly, to receive
her suitor Edgar Linton. Heathcliff also supposes
he can take advantage of Hindley's absence
to spend the afternoon with the girl. Bursting
into the room, he asks her if she plans to go out,
and on hearing her evasive replies, expresses
his surprise at seeing her thus dressed on a rainy
day: "Why have you that silk frock on, then?"
His dark, emaciated face, his disheveled hair,
his tense attitude betray his anxiety, his suspicions.
Nelly, her face reproachful, hostile, witnesses the
young people's quarrel. It is the arrival of Edgar,
his rival, that makes Heathcliff grasp the situation.
During the summer of 1932, Antoinette
de Watteville was engaged to a Belgian diplomat,
and Balthus bitterly read the letters she sent him
reproving him for being jealous. In a long letter

dated 18 January 1934, he refers to his dashed life
and the immensity of his love, before commenting
on three of his recent paintings. Among them,
La Toilette de Cathy (cat. 41) that resumes,
considerably changing its meaning, the episode
illustrated here, with respect to which he gives
his interpretation of Emily Brontë's text:
"[…] The moment when two human beings,
who actually are but one and are complementary
to one another, come to the crossroads of their
respective fates and will, like two stars whose
trajectories meet but once every thousand years,
resume the course that will part them to follow
the circle that the universal, implacable rhythm
imposes on them."
By thus transposing in the fiction of the novel
the reflections and feelings that torment him,
Balthus strives to exorcise them and to bear
their intolerable weight.

Why have you that silk frock on, then?

32. *"D'un mouvement instinctif, il l'arrêta au vol"* (ch. 9, p. 116)
["By a natural impulse he arrested his descent"]

India ink on paper
39.8 × 31 cm
private collection

provenance: Pierre Matisse,
purchased from the artist;
Mme Alexina Duchamp
exhibitions: New York 1939,
n. 16; New York 1956;
New York 1963, n. 19;
Chicago 1964, n. 36; New York,
MoMA *et alia* 1966–67, n. 3;
London, Tate Gallery 1968,
n. 62 (not repr.); Detroit 1969,
n. 19; Spoleto 1982, n. 12;
Paris, MNAM.CNACGP 1983–84,
p. 27, n. 11; New York 1984,
n. 61; Andros 1990, n. 17; Rome
1990, p. 61; Bern 1994, n. 13
bibliography: librairie Séguier,
Paris 1989; The Limited
Editions Club, New York 1993;
Roy 1996, p. 12;
Clair, Monnier 1999, n. I 1574

33. *"Nelly, ne faites-vous jamais de rêves singuliers?"* (ch. 9, p. 122)
["Nelly, do you sometimes dream queer dreams?"]

India ink and pencil
39.8 × 31 cm
inscribed below the drawing:
"Nelly, do you sometimes
dream queer dreams?"
private collection

provenance: Pierre Matisse,
purchased from the artist;
Mme Alexina Duchamp
exhibitions: New York 1939,
n. 15; New York 1956;
New York 1963, n. 22;
Chicago 1964,n. 35; New York,
MoMA *et alia* 1966–67, n. 8;
London, Tate Gallery 1968,
n. 62 (not repr.); Detroit,1969,
n. 23; Spoleto 1982, n. 13; Paris,
MNAM.CNACGP 1983–84, p. 35,
n. 12; New York 1984, n. 62;
Andros 1990, n. 18; Rome 1990,
p. 62; Bern 1994, n. 15
bibliography: *Minotaure,* 7,
1935, p. 61; librairie Séguier,
Paris 1989; The Limited
Editions Club, New York 1993;
Roy 1996, p. 12;
Clair, Monnier 1999, n. I1575

The scene to which Balthus explicitly refers by
the manuscript note he wrote below the drawing and
below the only study of it (very resembling[1]) we
know, is the cornerstone upon which Emily Brontë's
novel is built. Cathy, unaware of Heathcliff's presence
in the room, and after having told Nelly a dream that
haunts her (chased from heaven, she sobs for joy in
finding she is back on the Heights), confesses her
love for the youth: "[…] I love him; and that, not
because he's handsome, Nelly, but because he's more
myself than I am. Whatever our souls are made of,
his and mine are the same […]." A love that will
never be fulfilled ("It would degrade me to marry
Heathcliff, now") and will drive her to her death.
It is worthwhile pointing out the liberties Balthus
took with the text, all the more so that this is
the only episode where he does so. Emily Brontë
carefully indicated Cathy's comings and goings,
finally sitting down on the bench beside Nelly
to tell her her secret. Nowhere is it written

that she is lying on the floor.
Cathy's peculiar position, particularly that of her
legs, is not without recalling Poussin's *Narcissus*
(fig. 1), that Balthus had copied at the Louvre in
1925[2] and whose image, the complex symbolism of
the double, of love and death, is also to be found
in *La Montagne* [The Mountain] of 1937 and,
reversed, in *La Victime* of 1939–46 (cat 63).
Poussin, in his painting, drew his inspiration from
the wish Ovid lends to the nymph Echo, rejected
by Narcissus and turned into a rock. He refers
ambiguously to Cathy's avowal: "May he himself
fall in love with another as we have done with him!
May he too be unable to gain his loved one".[3]

[1] See Clair, Monnier 1999, n. I 1576.
[2] That copy, now lost, had been sent to Rilke in 1926.
The latter, in return, composed for Balthus the poem
Narcisse.
[3] Ovid, *Metamorphoses*, III, vv. 406–7.

1. Nicolas Poussin,
Echo and Narcissus, also known
as *The Death of Narcissus*, ca. 1627,
oil on canvas, 74 × 100 cm.
Paris, Musée du Louvre, Inv. 7297

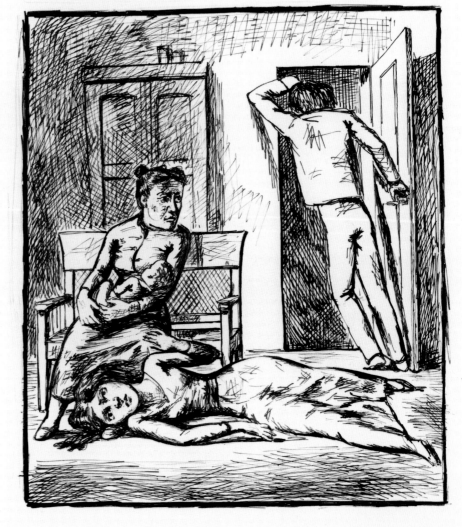

Nelly, do you sometimes dream queer dreams?

34. *"Non, non, Isabelle, vous ne vous sauverez pas"* (ch. 10, p. 160)
["No, no, Isabella, you sha'n't run off"]
35. *"Je vous refuserai à l'avenir l'accès de cette maison"* (ch. 11, p. 174)
"There you've done with coming here"

34.
India ink on paper
31.5 × 26.5 cm
private collection

provenance: Pierre Matisse,
purchased from the artist;
Mme Alexina Duchamp
exhibitions: New York 1939,
n. 17; New York 1956;
New York 1963, n. 13;
Chicago 1964, n. 37;
New York, MoMA *et alia*
1966–67, n. 9; London, Tate
Gallery 1968, n. 62 (not repr.);
Detroit 1969, n. 18; Spoleto
1982, n. 15; Paris,
MNAM.CNACGP 1983–84, p. 35,
n. 13; New York 1984, n. 63;
Andros 1990, n. 19; Rome 1990,
p.63; Bern 1994, n. 14
bibliography: librairie Séguier,
Paris 1989; The Limited
Editions Club, New York 1993;
Clair, Monnier 1999, n. I 1577

35.
India ink on ochre paper
35 × 26.9 cm
inscribed below the drawing:
"There you've done
with coming here"
private collection

provenance: Pierre Matisse,
purchased from the artist;
Mme Alexina Duchamp
exhibitions: New York 1939,
n. 12; New York 1956;
New York 1963, n. 9; Chicago
1964, n. 32; New York, MoMA
et alia,1966–67, n. 12; London,
Tate Gallery 1968, n. 62
(not repr.); Detroit 1969, n. 24;
Spoleto 1982, n. 16; Paris,
MNAM.CNACGP 1983–84, p. 36,
n. 14; New York 1984,
n. 64; Andros 1990, n. 20;
Rome 1990, p. 64; Bern 1994,
n. 16
bibliography: librairie Séguier,
Paris 1989; The Limited
Editions Club, New York 1993;
Clair, Monnier 1999, n. I 1580

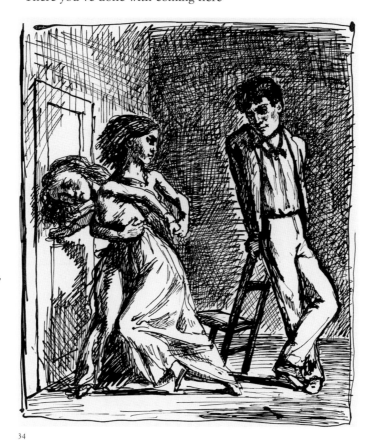

34

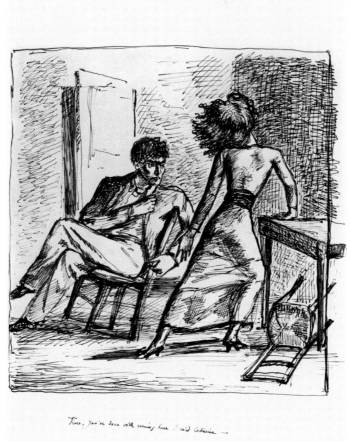

35

36. *"Les bras de Cathy s'étaient relachés et sa tête pendait sur son épaule"* (ch. 15, p. 244)
["Catherine's arms had fallen relaxed, and her head hung down"]

India ink on paper
29.4 × 26.2 cm
private collection

provenance: Pierre Matisse,
purchased from the artist;
Mme Alexina Duchamp
exhibitions: New York 1939,
n. 18; New York 1956;
New York 1963, n. 15; Chicago
1964, n. 38; New York, MoMA
et alia 1966–67, n. 4; London,
Tate Gallery 1968, n. 62
(not repr.); Detroit 1969, n. 25;
Spoleto 1982, n. 17; Paris,
MNAM.CNACGP 1983–84, p. 38,
n. 16; New York 1984, n. 65;
Andros 1990, n. 21; Rome 1990,
p. 65; Bern 1994, n. 17
bibliography: librairie Séguier,
Paris 1989; The Limited
Editions Club, New York 1993;
Clair, Monnier 1999, n. I 1592

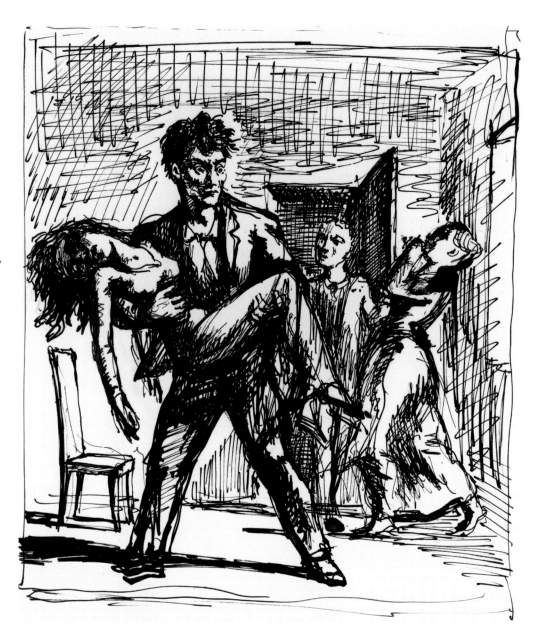

37. *"Je la suppliai de se retirer (de la fenêtre) et, à la fin, j'essayai de l'y contraindre"*
(ch. 12, p. 191)
[I entreated, and finally attempted to force her to retire (from the open window)]

India ink on paper
signed and dated "1932"
lower right
33 × 25 cm
London, Edwin C. Cohen

provenance: Jacques
and Madeleine Matarasso;
sale Briest, Paris,
27 October 2000, n. 51

Ultimately Balthus would not keep for publication any of his illustrations for the twelfth chapter of the novel, relating Cathy's illness. However, we have four studies for one of the episodes "Oh! Nelly, the room is haunted! I'm afraid of being alone!"[1] The present drawing is the only one, up to now, illustrating the second part of the same scene, in which Cathy wishes she "were a girl again… among the heather on those hills…," and insists that her servant open the window so she can get a glimpse of her childhood home. The fact the two women's postures recall a like one in an illustration of chapter 10: "No, no, Isabella, you sha'n't run off" (cat. 34), may explain why Balthus gave up the idea of representing this scene.

[1] Cf. Clair, Monnier 1999, nn. I 1583–I 1586.

38. *La Caserne*, 1933
[The Barracks]

oil on canvas
81 × 100 cm
Signed and dated lower right:
"Balthus 1933"
private collection

provenance: Arthur Jeffress Esq.;
Hugh C. Wheeler, New York;
sale Sotheby's, New York, 13
November 1985, n. 78
exhibitions: New York 1984,
n. 4; Rome, 1996–97, p. 63
bibliography: Roy 1996,
pp. 66–67; Clair, Monnier 1999,
n. P 75

In October 1930, Balthus was drafted into
the fourth Régiment de tirailleurs marocains
(Moroccan infantry) and went to Morocco
for fifteen months to perform his military service.
He spent the first nine months at Kenitra,
on the Atlantic coast and then, in August 1931,
was transferred to Headquarters at Fez.
He seems to have found the boredom of garrison
life hard to bear and been rather insensitive
to the charm of Morocco: "It is truly very beautiful,
very romantic, maybe slightly too picturesque, but
after all I don't care much for exoticism," he wrote
for instance[1]. He did very little drawing and did not
paint. Of his stay in Kénitra, all that remains
is a water color portrait of his buddy Despériez
(fig. 1) and a few preparatory sketches for a
painting representing *La Chambrée* [The Barrack-
room], that was never executed.
On the other hand, he liked Fez; his secretarial
tasks did not keep him very busy and he enjoyed
observing his surroundings. Thus he very
humorously described a dinner at the Pacha's.[2]
Ironic, a touch condescendant, he kept Muslim
civilization at arm's length. Even the old city
of Fez, whose architecture was a match
for Granada, and *fondouks* the most picturesque
in North Africa, hardly seems to interest him:
he does not care for exoticism.
La Caserne was painted after Balthus came back
to Paris, after a few India ink studies (fig. 2).
It rather reflects his attitude. He seeks to render
southern light, all the shades of whites, turned
ochre by the desert winds, the bright reds and
deep blues of uniforms, but without any reference
to nineteenth-century Orientalism. The conserved
studies render the violence of the scene he wants
to represent: the fright of the horse with its bent
hocks, about to rear and whinny, the hammering
hooves, the dust and the men shouting.
Balthus recreates the scene with his imagination.
He replaces the dust-filled yard with a bright,
rigid space, the cold light and long shadows
of one of Giorgio de Chirico's *Piazzas*. He also
borrows from him the blue-green sky brightening
toward the west and the stiffness of the figures
that look like dummies or puppets; as the
horseman trying to control the horse about
to rear. The scene bathes in a dreamlike silence,
we no longer hear the horse snorting nor the dull
thud of the hooves on the ground; it seems
the horseman's cry—the trainer's great loud
"Ooh!"—will never be uttered.
The secondary figures are no less uncanny;
the groom holding out the halter looks like he is
performing a dance step, the Moroccan leaning
against the tree hardly has a regulation attitude;
the rider in the background is riding a wooden
horse, with an elongated neck, with neither bit nor
halter, very unlike the one figuring in the study.
Balthus remembers his stay in Arezzo as well:
the horseman viewed from the back, on the right,
could come straight out of one of Piero's frescoes;
his massive silhouette is topped by a red chechia

1. Balthus. *Portrait de Despériez*
[Portrait of Despériez], 1931,
watercolor and pencil on paper,
24 × 35 cm.
Private collection

2. Balthus, *Etude pour "La Caserne"*
[Study for "The Barracks"], 1931,
India ink on paper.
26.5 × 35 cm.
Private collection

recalling the tall headdress of Heraclius's
companion (cat. 12, fig. 1) and his large burnouse
is the same deep blue-green as the patriarchs's
cloaks. Likewise, in the background to the left,
the rows of sycomores in front of the turretted
tower remind us of Renaissance landscapes.
The scene, being theatrical, calls for an audience.
Ourselves, certainly, and in the painting, the
Moroccan soldier leaning against the adobe wall
on the right; but also the light-skinned European
with chestnut-brown hair standing on the left.
His back is turned, we cannot identify him;
his tall silhouette serves as a repoussoir, introduces
a distance between us and the action taking place,
as though the painter himself wished to emphasize
the fact that he is standing back from the depicted
scene.

[1] Letter to Antoinette de Watteville, 29 December 1930.
Private collection.
[2] *Idem*, 24 June 1931.

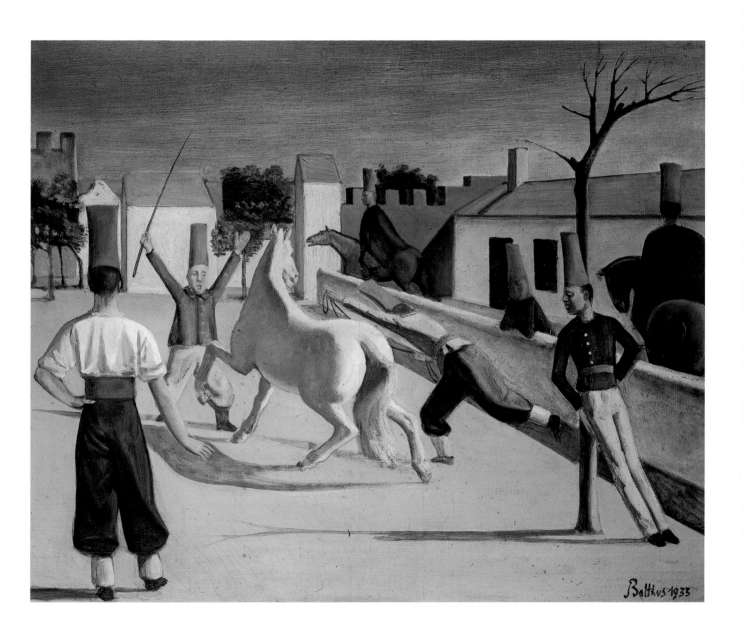

39. *Pierre et Betty Leyris*, 1932–33
[Pierre and Betty Leyris]

oil on canvas
70 × 50 cm
Berlin, Ulla and Heiner
Pietzsch collection

provenance: Pierre and Betty
Leyris; Gertrude Stein Gallery,
New York; sale Sotheby's,
New York, 11 November 1987,
n. 67
bibliography: catalog New York
1984, p. 25 fig. 28; Leymarie
1990, p. 124; Clair, Monnier
1999, n. P 67

During the summer of 1932 Balthus spent his time
in Bern copying some of the paintings of the cycle
of *Swiss Peasant Costumes* by Joseph Reinhardt
(1794–95). He has said that work had been very
worthwhile, and Sabine Rewald observed that
the face of Christen Heumann (Fribourg canton)
could be seen in *La Montagne* dated 1937.[1]
In the years 1932–36, Balthus did a series
of double portraits (*André Derain, Roger et son
fils, Joan Miró et sa fille Dolorès*, cat. 55) or with
several figures (*La Famille Mouron-Cassandre*,
cat. 50, fig. 1), the idea for which might have been
suggested to him by those of the Bern master.
The *Portrait de Pierre et Betty Leyris* is the oldest
of the series. It was painted during the winter
of 1932–33 when the young man was staying
at the young couple's. Pierre Leyris (1907–2001),
who had been a school-mate of Pierre
Klossowski's at the lycée Janson-de-Sailly
in 1924–25, was dedicated to literature and would
become known as a translator of the great
English-language authors; Betty is a skilled
draughtswoman whom Balthus admired.
They posed for Balthus several times;[2] Betty
would be the model for *Alice* (cat. 40) as well.
Two of their portraits remind us of Cézanne.
Pierre's (fig. 2) is a direct reference to the left part
of the *Cardplayers*, bequeathed to the Louvre
in 1908 and now at the Musée d'Orsay (fig. 4);
Betty's, expressionless, dressed in a blouse with a
ruff (fig. 3), recalls the *Portrait of Madame Cézanne*
at the Museum of Fine Arts of Houston. They
are shown here absorbed, the one in his thoughts,
the other in her game. Pierre Leyris' rather soft
face with almond-shaped eyes and peculiar profile
contrasts singularly with his wife's, wearing make-
up and a bright blouse, intense, as concentrated
as he seems dreamy. However, secret bonds unite
the couple (fig. 1). Let us draw a median line: it
cuts between Betty's two hands before reaching
the tips of Pierre's right-hand fingers and his
red sock that echoes the young woman's blouse.
The horizontal axis, instead, goes through the lips
of the young husband to reach his wife's pubis.
Bilboquet was a very popular game between the
two world wars, but its representation in this
portrait is not anecdotic in the least. Indeed,
if we compare the drawing of it to Pierre's head,
we see that the curve outlined by the string
accurately follows that of his skull, from his
jawline to his hairline; the ball occupies the space
of his forehead, between it and the arch of his
eyebrows, and the drawing of the stick coincides
with the points of his collar and chin before
reaching his mouth. So the object, laden with
a secret meaning, becomes a bond between the
Leyris couple. In this perspective, we can compare
it to Giacometti's *Pointe à l'œil* (fig. 8) or his *Boule
suspendue*, one of his *Objets mobiles et muets*,
that he published in 1931 (figs. 5–7). We should
mention that it was exactly that sculpture
that inspired Dali's thoughts on the "symbol-
producing object" that appeared in the same issue
of *Le Surréalisme au service de la Révolution*.[3]

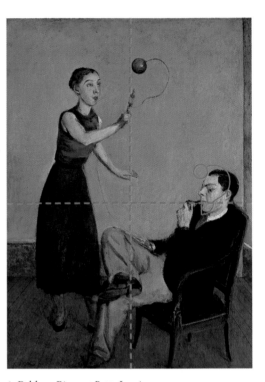

1. Balthus, *Pierre et Betty Leyris*,
composition sketch

[1] *Balthus*, exhibition catalog, New York 1984, pp. 22–23.
[2] Clair, Monnier 1999, n. P 68, p. 70.
[3] N. 3, December 1931.

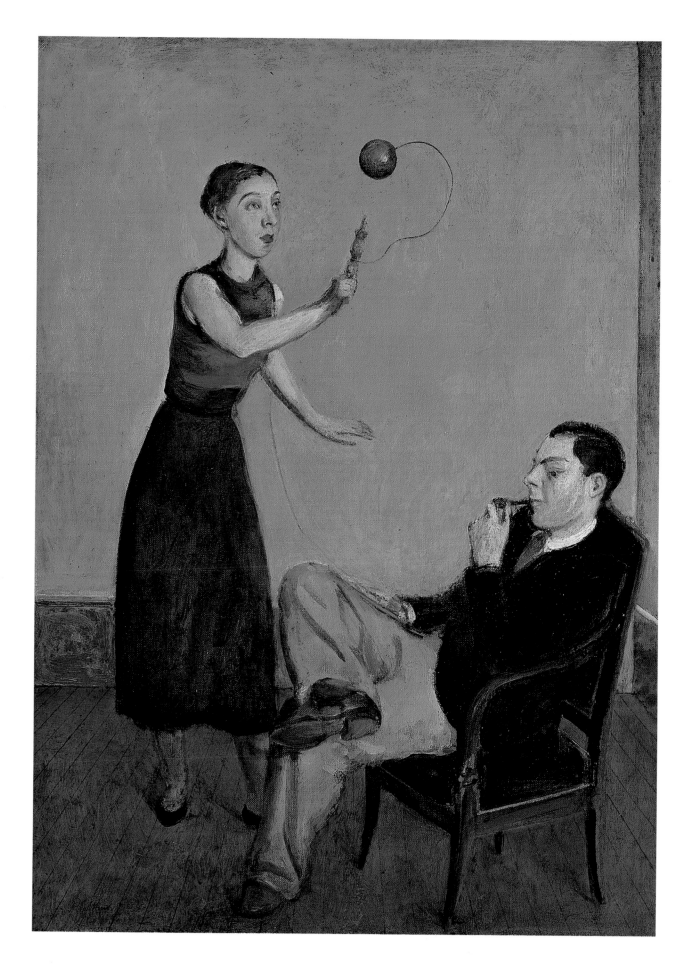

2. Balthus, *Portrait de Pierre Leyris*
[Portrait of Pierre Leyris],
1932–33, oil on canvas.
New York, Gertrude Stein Gallery

3. Balthus, *Portrait de Betty Leyris*,
[Portrait of Betty Leyris], 1932–33,
oil on canvas, 80.6 × 65 cm.
Private collection, New York

4. Paul Cézanne, *The Cardplayers*,
1893–96, oil on canvas, 47 × 56 cm.
Paris, Musée d'Orsay, bequest
of count Isaac de Camondo
(R.F. 1969). V 558; N.R. 714

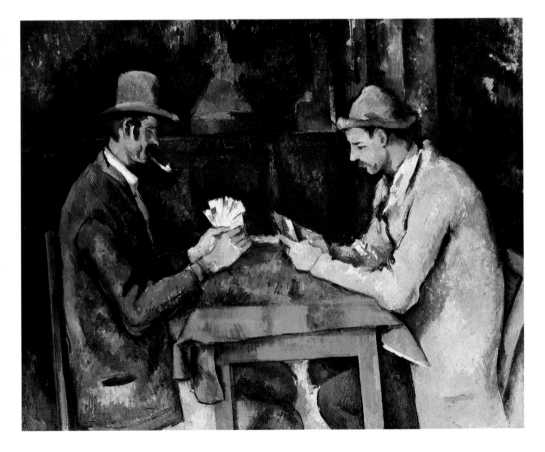

5–7. Alberto Giacometti,
Boule suspendue, illustrations
for "Objets mobiles et muets,"
*Le Surréalisme au service de la
Révolution*, n. 3, December 1931

5

6

8. Alberto Giacometti,
Pointe à l'œil. 1931–32, drawing,
9 × 11.6 cm. Fondation Alberto
Giacometti, Zurich, Kunsthaus
(GS 125)

7

8

40. *Alice (Alice dans le miroir)*, 1933
[Alice (Alice in the Mirror)]

oil on canvas
162 × 112 cm
signed and dated lower left:
"Balthus 1933"
(subsequent to its restoration)
Paris, Musée national
d'art moderne,
Centre Georges Pompidou

provenance: Pierre Jean Jouve;
private collection, England;
Marlborough Fine Arts,
London; 1985, private
collection, United States
exhibitions: Paris 1934; Paris,
MNAM.CNACGP 1983–84, n. 9;
Karuizawa 1997, p. 41
bibliography: Leymarie 1982,
p. 139 and 2nd ed., 1990,
p. 143; Klossowski 1983, pl. 8;
catalog MNAM.CNACGP, Paris
1983, p. 65, pl. p. 131 and
p. 343 n. 21; catalog New York
1984, p. 28 fig. 35; Clair 1984,
p. 97 fig. 72; Roy 1996, p. 79;
Klossowski 1996, n. 10;
Fox Weber 1999, pl. 8;
Clair, Monnier 1999, n. P 71

The art historian William Uhde, a great collector
of Cubist painting and of Cézanne, was
a long-standing friend of Erich Klossowski's.
In December 1933, he took Pierre Loeb to young
Balthus's studio. Galerie Pierre, that opened in
1924, had already presented a year later the first,
memorable exhibition of Joan Miró (who was
shown there eight times in ten years) and the first
event of the Surrealist group in the plastic arts.
It also showed, over the next ten years, works
by Lurçat, Bérard, Picasso, Tchelichew, Matisse,
Giacometti, Arp, Calder, Ernst and Hélion.[1]
On December 18, 1933, Balthus wrote his father[2]
that Pierre Loeb had come "to see him five times
in the space of a week, each time bringing people
with him, finally claiming that my painting
was the most important thing he had seen
in the past ten years." As for Loeb, he has told
about his amazement on discovering Balthus's
large canvases.[3]
The exhibition he gave him (1934) is now
considered a significant event in art history.[4]
There were five large paintings and two portraits
(one of which, identified by us, is that of
Antoinette (see cat. 20): *Alice, La Toilette de Cathy*
(cat. 41)*, La fenêtre* (cat. 42)*, La Rue* (cat. 43)
and, in a small room separated by a curtain,
La Leçon de guitare (cat. 44).
At the time, the exhibition was noticed
but by a small circle of collectors, dealers
and writers, among whom Pierre Jean Jouve
and Antonin Artaud, who wrote a good article in
the *N.R.F.*[5] Yet Balthus had won the provocative
success he sought: "Innocent students are side
by side with the Freud of painting," Gaston
Poulain titled, among others, in *Comœdia*.[6]
At the time he protested, but weakly. Thus,
in a letter to his benefactress Margrit Bay[7]
or another one to Antoinette de Watteville,
on the subject of *Alice*: "As for the nude…
I don't believe it is obscene and I think the grave,
severe atmosphere it is steeped in is such that
even a young girl can look at it without blushing.
(The mirror is the viewer.)"[8] Nonetheless, a small

preparatory sketch,[9] where the model is nude,
shows that Balthus had placed the young woman's
pubis precisely at the center of the composition.
In all likelihood, the title of this painting refers
to Lewis Carroll's *Alice in the Looking-Glass*,
since we know the model is Betty Leyris
(see cat. 39). Sabine Rewald has pointed out
the contrast between the powerful sensuality
of the young woman's muscular body and her
strange absent gaze, as though misted over. As for
Artaud, he suggested "the notion of trompe l'œil
that is not in the canvas, but in the canvas plus
the décor in which you put it." Pierre Jean Jouve,
who bought the painting in 1935, wrote
he had been attracted to this "piece of painting,
so exactly accurate, having such an intense
carnality, that I considered "Alice" as being my
companion." And he describes the hallucinations
the painting aroused in him, after he had already
owned it for over twenty years.[10] He also devoted
a poem to it: "À Balthus."[11]

[1] See *L'aventure de Pierre Loeb, la galerie Pierre
1924-1964*, exhibition catalog, Musée d'art moderne
de la Ville de Paris, Paris 1979.
[2] Private collection.
[3] *Voyages à travers la peinture*, Bordas, Paris 1946.
[4] See Ch. Derouet, "Les réalismes en France, rupture
ou rature," in *Les Réalismes, 1919-1939*, exhibition
catalog, Musée national d'art moderne, Centre
Georges Pompidou, Paris 1980, pp. 196–206.
[5] *Nouvelle Revue Française*, 248, May 1934.
[6] 16 April 1934, p. 3.
[7] Quoted by Sabine Rewald, in her fundamental article
on that show: "Balthus lessons," *Art in America, 9*,
September 1997, pp. 88–96 and 121. That article
repeats, completing it, the catalog of the Metropolitan
Museum of Art, 1984, out of print.
[8] 18 January 1934. Private collection.
[9] Repr. in Sabine Rewald, *art. cit.*, p. 93.
Location unknown.
[10] *Proses*, Mercure de France, Paris 1960, pp. 45–49.
Repr. in *Balthus*, exhibition catalog, Paris 1983,
pp. 64–65.
[11] *La Vierge de Paris*, Egloff, Paris 1945, p. 173,
repr. in the same catalog, p. 48.

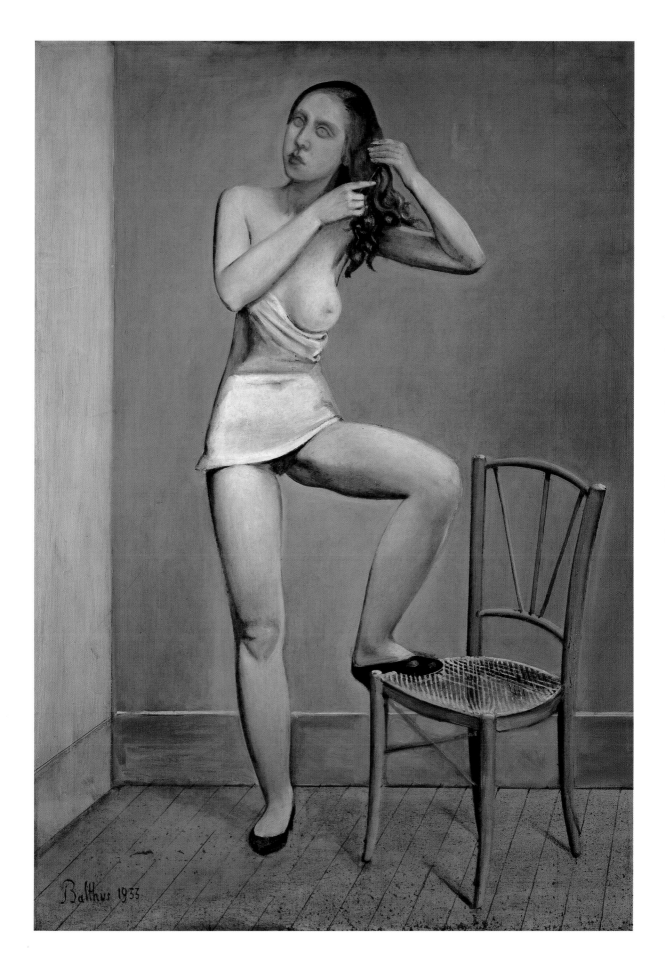

41. *La Toilette de Cathy*, 1933
[Cathy Dressing]

oil on canvas
165 × 150 cm
signed and dated lower left:
"Balthus 1933"
Paris, Musée national
d'art moderne,
Centre Georges Pompidou
(purchased in 1977)

provenance: Galerie Pierre,
Paris; 1937, Pierre Matisse
Gallery, New York;
James Thrall Soby; 1943–77,
Pierre Matisse Gallery,
New York
exhibitions: Paris 1934; New
York 1938, n. 2; New York
1949, n. 7; New York 1962, n. 3;
New York, MoMA *et alia*
1966–67, n. 1; London, Tate
Gallery 1968, n. 5; Detroit 1969,
n. 4; Paris, MNAM.CNACGP
1983–84, n. 6; New York 1984,
n. 5; Tokyo 1993–94, n. 2;
Hong Kong 1995, n. 2;
Beijing 1995, n. 2;
Taipei 1995, n. 2
bibliography: Leymarie 1982,
p. 139 and 2nd ed., 1990,
p. 143; Klossowski 1983, pl. 9;
catalog MNAM.CNACGP, Paris
1983, pl. p. 125 and p. 343
n. 20; catalog New York 1984,
p. 29 fig.36 and p. 33 fig. 47;
Clair 1984, p. 96 fig.70;
Kisaragi, Takashina, Motoe
1994, pl. 3; Xing 1995, pl. 3;
catalog Madrid 1996, p. 38;
Roy 1996, p. 13; Klossowski
1996, n. 11; Clair, Monnier
1999, n. P 74

Sabine Rewald holds[1] that *La Toilette de Cathy*
depicted an episode from *Wuthering Heights*,
presented in the exhibition under the title
"Why have you that silk frock on, then?"
(cat. 31). In fact, as Artaud had felt in the
comment on the 1934 exhibition that he gave
the *N.R.F.*, it is more like a kind of daydream,
a vision, consecutive to that scene.
In the letter of which we quoted an extract above,
Balthus insists that the painting is not an
illustration of the novel, and adds: "Cathy
is nude because she is symbolic; besides,
the group she forms with the maid is treated
like a vision, like a memory recalled by Heathcliff,
who in fact is sitting in the room alone.
It is already a past event."
If we compare the drawing and the painting,
we can indeed see the relationship between
Heathcliff and Cathy is profoundly altered.
The young girl—a sphinx, Artaud claims—now
nude, gazing at the ceiling, appears lost in a
dream, in a world of wealth and sexuality. Balthus
portrayed himself in the guise of Heathcliff, his
face gray and hostile, his fist clenched, seeming
to be mulling over some idea of revenge. Stylishly
dressed in the fashion of the thirties, he is a far cry
from the untidy youth, entirely intent on Cathy,
the drawing showed. The scene of jealousy
has turned into a conflict over which looms
the shadow of a tragedy.
"Cathy is nude because she is symbolic"
Balthus wrote, but not content with baring her,
he markedly changed her morphology.
The abdomen seems longer, the head smaller,
the left hand forefinger is separated from
the other fingers (a unique example in Balthus's
work).
The silhouette recalls the medieval canon
of female beauty, like the *Venus in a Landscape*
by Cranach that can be seen in the Louvre.

[1] *Balthus*, exhibition catalog, New York 1984, n. 5, p. 64.

1. Lucas Cranach the Elder,
Venus in a Landscape, 1529,
oil on panel, 38 × 25 cm.
Paris, Musée du Louvre, Inv. 1180

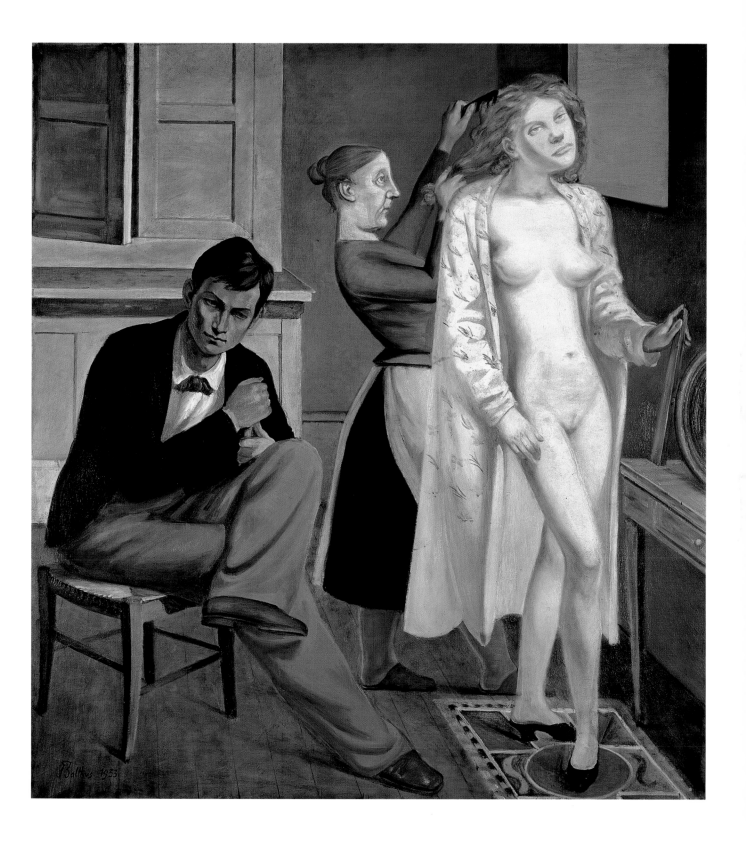

42. *La Fenêtre ("La Peur des fantômes")*, 1933 (altered before 1962)
[The Window ("The Fear of Ghosts")]

oil on canvas
162.2 × 114.3 cm
Bloomington, Indiana
University Art Museum

provenance: 1947, Pierre Matisse
Gallery, New York; 1970,
Donald Morris Gallery Inc.,
Detroit
exhibitions: Paris 1934;
New York 1949, n. 6; New York
1962, n. 2; Cambridge 1964,
n. 4; Chicago 1964, n. 4, Detroit
1969, n. 3; Paris, MNAM.CNACGP
1983–84, n. 7; New York 1984,
n. 6; Madrid 1996
bibliography: Leymarie 1982,
p. 129 and 2nd ed. 1990, p. 130;
catalog MNAM.CNACGP, Paris
1893, pl. p. 127 (2nd version)
and p. 343 n. 22 (1st version);
catalog New York 1984, p. 28
pl. 34; Kisaragi, Takashina,
Motoe 1994, pl. 2; Xing 1995,
pl. 4; Roy 1996, p. 98;
Fox Weber 1999, pl. 6;
Clair, Monnier 1999, n. P 72

Visitors who saw this picture at the Galerie Pierre,
in 1934, must have had a very different impression
from ours today. As we can see in an old
photograph (fig. 1), the painting was entirely
reworked at a date and in circumstances unknown
to us.[1]
The model, Elsa Henriquez, was a shy young girl
of Latin American birth; a photograph of her,
published by Sabine Rewald,[2] reveals that she did
not have the American Indian, vaguely negroid,
features Balthus had lent her. On the other hand,
it is true that he set up a scenario to induce
in her the impression of terror we can read on her
face: when she knocked on the door to the studio,
Balthus, wearing an old army uniform, rushed at
her, holding a dagger and, with a ferocious mien,
pretended to want to tear off her blouse.[3] That is
why, in the painting's first version, she looks about
to let herself fall out the window, risking her life.
The alterations Balthus made change the
interpretation of the picture. Her face now calm
and quite true to life, Elsa appears to be politely
rejecting the advances she may have urged by
baring her left breast. To counter the libertine
character of the scene and the sitter's inexpressive
countenance, Balthus reworked several elements
of the composition. The skirt was partially
repainted, as well as the wall below the window,
now treated with wide brushstrokes; heavy clouds
shift behind the rooftops as though forewarning
a storm. Yet these alterations do not recreate
the dramatic mood of the painting's first version,
nor the physical expression of terror Balthus
had sought to provoke on the young girl's face.
That may well be why, at the time
of the publication of the *Catalogue raisonné*
of his work, he requested to have added
the sub-title *The Fear of Ghosts*.

[1] Purchased by Pierre Matisse in 1947, the painting
never left the United States, a country where Balthus
never went. Pierre Matisse exhibited it 1949, without
reproducing it in his catalog; it appears in its present
state in the catalog of the 1962 exhibition. Balthus was
not able to provide an indication on the subject.
The detailed description of the repaints visible
to the naked eye, communicated by Mrs. Kathleen
A. Foster in 1994, appears in Clair, Monnier 1999,
p. 122.
[2] S. Rewald, "Balthus lessons," *Art in America, 9*,
September 1997, p. 91.
[3] *Ibidem.* Verbally confirmed by Balthus.

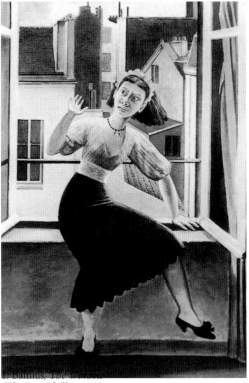

1. Balthus, *The Window*
(The Fear of Ghosts),
first version

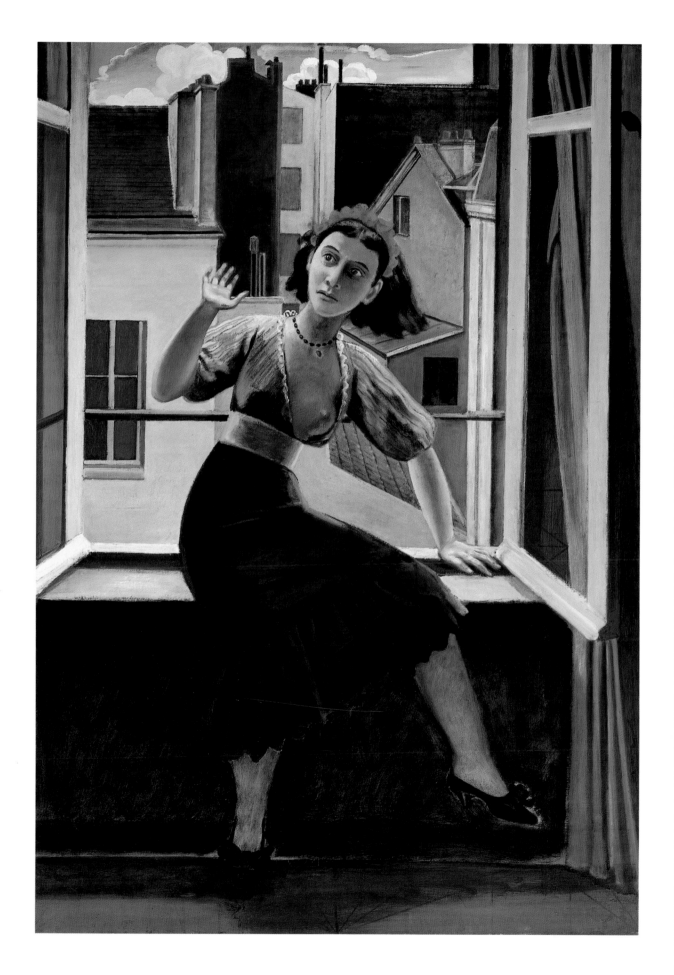

43. *La Rue*, 1933
[The Street]

oil on canvas
195 × 240 cm
signed and dated lower right:
"Balthus 1933"
New York, Museum of Modern
Art, bequest James Thrall Soby

provenance: 1937, Pierre Matisse
Gallery, New York, purchased
from the artist; James Thrall
Soby
exhibitions: Paris 1934;
New York 1938, n. 1;
Paris 1956; New York 1956,
n. 3; Paris 1966, n. 1; Knokke-
le-Zoute 1966, n. 1; London,
Tate Gallery 1968, n. 4; Venice
1980; Paris, MNAM.CNACGP
1983–84, n. 8; New York 1984,
n. 3; Lausanne 1993
bibliography: Leymarie 1978,
pl. 1 and 2nd ed. 1990, pl. 1;
Leymarie 1982, pl. p. 17
and p. 124 and 2nd ed. 1990
pl. p. 17 and p.122; Klossowski
1983, pls. 5–7; catalog
MNAM.CNACGP, Paris 1983,
pl. p. 129, pp. 260, 261, 283
and p. 343 n. 23; Clair 1984,
pp. 16–17 fig. 1 and p. 26
fig. 13; Davenport 1989 fig. 1;
Kisaragi, Takashina, Motoe
1994, pl. 1; Xing 1995, pl. 5;
catalog Madrid 1996, p. 33;
Roy 1996, p. 70; Clair 1996,
p. 8; Klossowski 1996, nn. 7–9;
Costantini 1996; Fox Weber
1999, pl. 4;
Clair, Monnier 1999, n. P 73;
Vircondelet 2000, p. 51

According to all the persons who went to
Balthus's studio in 1933, *La Rue*—an elaborated
version of the 1929 canvas—was the most
impressive painting. But, oddly enough,
at the time it did not occur to any one of them
to decipher it. Julius Meier-Graefe, and he is
not the only one, even thought it looked comical.
Even Artaud barely mentions it in his review
of the exhibition at the Galerie Pierre, and only
devotes half a line to it in his article of 1936:
"a street where dream automats pass by."
Gaétan Picon endeavored to prove, in 1966,
how it differed from Surrealism, but without
analazing its iconography nor its sources:
"Between Surrealist painting and that of Balthus,
the opposition has to do with the intent, even
the place. The former take over the space where
the dream conveys what has been seen to hold it
at its mercy, to immolate it; while it is to preserve
the privileged forms of life and the very order
of their coexistence that Balthus opens the space
of his painting."[1]
We must wait until the eighties to find attempts
to interpret *La Rue*. Sabine Rewald interviewed,
in 1981, Stanley William Hayter who had
collaborated in the preparation of the canvas.[2]
According to him, the iconography was drawn
from Lewis Carroll, the young girl on the left
being Alice aggressed by Tweedledum, whose twin
Tweedledee is moving toward us in the center;
the mason carrying a board was the carpenter
in the tale, without his companion the walrus.
Guy Davenport[3] sees in it a reversed transposition
of Botticelli's *Primavera* or, in the group formed
by the little boy and the two women, an allegory
of the three Christian virtues, Hope, Faith
and Charity.
More likely are the formal analyses and the
influence of the Quattrocento, pointed out
by Jean Leymarie,[4] John Russel[5] who suggests
comparing the carpenter to one of Piero's
frescoes in Arezzo (fig. 1), and Jean Clair[6] who,
in particular, sees in the face of Masaccio's
Theophilus the source of the boy (fig. 2) and,
in Piero, in the reversed face of one of the
hand-maidens of the queen of Sheba (fig. 3),
that of the litle girl on the left.
These two last authors have furthermore noticed
the influence of the Quattrocento in the theatrical
representation of the city, but a complementary
and convincing source has been pointed out by
Jean Clair. It is an illustration by Heinrich
Hoffmann for one of his tales, *König Nussknacker
und der arme Reinhold*, 1851 (fig. 4).
That comparison is a key, insofar as it refers
to the closed world of the children's room,
the original paradise where time is suspended,
and that is ruled by secret laws, belonging to ritual
or magic. Likewise, Pierre Klossowski wondered
about a hidden order, a *capital scene* of which
we would find here scattered fragments.[7]
The little Balthus has written about *La Rue*
corroborates these various elements. We know
he felt it to be his first important painting
and claimed he had succeeded in expressing
in it exactly what he wanted to say.[8]
In an unpublished letter to Antoinette

2. Masaccio, *History of Theophilus.
Theophilus and the Courtesan*,
fresco, detail.
Florence, curch of Santa Maria
del Carmine, Brancacci chapel

1. Piero della Francesca,
The Erection of the Cross,
fresco, detail.
Arezzo, basilica of San Francesco,
choir

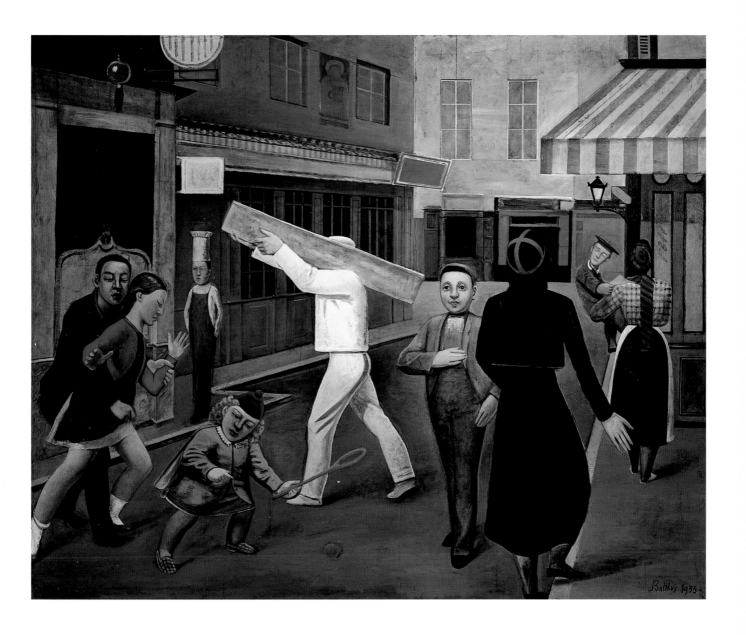

(18 January 1934), he commented on the photograph of it he is sending: "There is not much to say about *La Rue*: it is somehow the manifesto of a plastic attitude. If you like, it is the exteriorization of various primitive or primordial feelings: most of the actors of the scene are children. Looking at the picture that is not in the least comical, but over which looms a dreadful mystery, don't think about Meier-Graefe's review that you will have fortunately forgotten and that missed the essential point. The erotic group in the left corner (the photograph, as though out of modesty, is very dark in that spot: the boy trying to rape the little girl) is not at all obscene—just think of the idiotic little girl who shouted "Salut Katzli!" in front of some cats' pathetic mating."

He expressed himself another time about that group, when J. Thrall Soby, who wanted to exhibit the painting at the MoMA, asked him to alter it (fig. 6). Balthus then wrote him (in English): "I succeeded only in the last few days to change the objectionnable gesture of the boy—a rather difficult affair, the whole painting having been built up mathematically. As I told P.[ierre] M.[atisse] I accepted to reconsider the matter as I do not think—and never thought—that the real interest if any was residing there. It was rather done in a mood of youthful desire to provoke..."[9]

That letter leads us to examine the construction of the painting: "mathematical," Balthus writes, and—in fact—infinitely more complex than the 1929 version (see cat. 19, fig. 1). On the regular squaring of the canvas, he set out a series of isosceles and complementary triangles, constructed and arranged according to the geometric development of the "golden section" (see cat. 8 and fig. 5). It is inside these triangles, the angles of which must be equal to 36° or multiples of it, that the figures are framed. We give three examples, but the model can be developed, in particular around the central figure of the carpenter. The hand Soby asked Balthus to displace was at the point of one of these triangles (fig. 6).

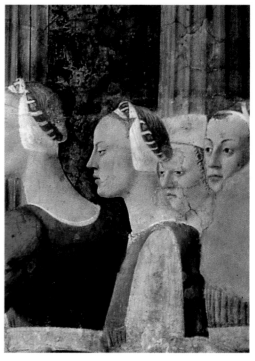

3. Piero della Francesca,
*Visit of the Queen of Sheba
to Solomon*, fresco, detail.
Arezzo, basilica of San Francesco,
choir

So what is the "dreadful mystery" looming over the painting? It is assuredly connected with childhood, but might it have something to do with Euclid's π? *La Rue*, to go back to Balthus's own words, is the "manifesto of a plastic attitude;" indeed, it is constructed in keeping with the *divina proportione*.

[1] Preface to *Balthus*, exhibition catalog, Paris, Arts décoratifs 1966. Reprinted in *Balthus*, exhibition catalog, Paris 1983, pp. 98–103.
[2] S. Rewald, "Balthus lessons," *Art in America, 9*, September 1997, p. 91.
[3] G. Davenport, *A Balthus notebook*, The Ecco Press, New York 1989, pp. 43–44.
[4] J. Leymarie, in *Balthus*, Skira, Genève 1982; 2nd ed. 1990, p. 16.
[5] J. Russel, preface to *Balthus*, exhibition catalog, London, Tate Gallery 1968; reprinted in *Balthus*, exhibition catalog, Paris 1983, pp. 283–84.
[6] J. Clair, "Les Métamorphoses d'Eros," in *Balthus*, exhibition catalog, Paris 1983, pp. 256 and ff.
[7] *Du tableau vivant dans la peinture de Balthus*, 1956, reprinted in *Balthus*, exhibition catalog, Paris 1983, pp. 80–85.
[8] Letter to M. Bay, June 1933, quoted by S. Rewald, *art. cit*.
[9] Soby papers, MoMA archives, New York, quoted by S. Rewald, *art. cit*.

4. Heinrich Hoffmann,
*König Nussknacker
und der arme Reinhold*, 1851

5. Balthus, *La Rue*, composition
sketch based on the "golden
triangle" whose top angle is 36°
and two lower angles each 72°.
The obtuse angle of the
"complementary golden triangle"
is 108° and the two angles
at the base each 3°

6. Balthus, *La Rue*,
first state

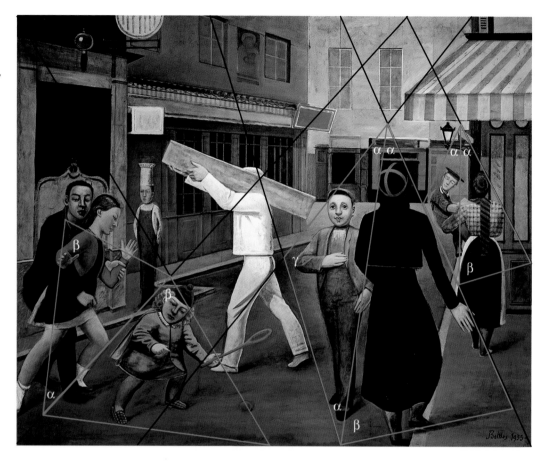

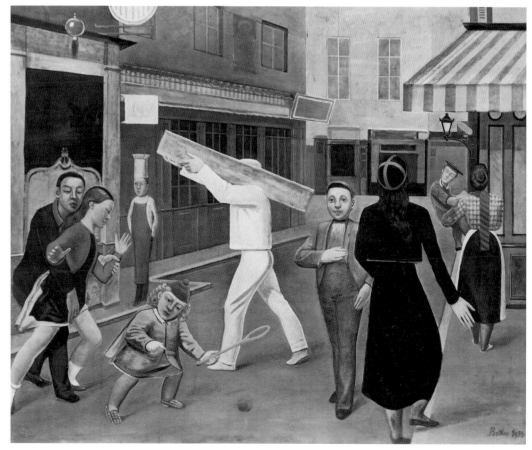

44. *La Leçon de guitare*, 1934 [The Guitar Lesson]
45. *Etude pour "La Leçon de guitare,"* 1934 [Study for "The Guitar Lesson"]

44.
oil on canvas
161 × 138.5 cm
signed and dated lower right:
"Balthus 1934"
private collection

provenance: James Thrall Soby;
1945, Pierre Matisse Gallery;
private collection; 1978,
the Museum of Modern Art,
New York; 1982, Pierre Matisse
Gallery, New York; Mike
Nichols; private collection,
California; 1985, Galerie
Beyeler, Basle; 1985, private
collection; 1985: Thomas
Ammann Fine Arts AG., Zurich;
1985, private collection
exhibitions: Paris 1934;
New York 1977, n. 1
bibliography: Leymarie 1982,
p. 139 and 2nd ed. 1990, p. 143;
catalog MNAM.CNACGP, Paris
1983, p. 343 n. 24; catalog
New York 1984, p. 30 fig. 37;
Clair 1984, p. 56 fig. 43; Roy
1996, p. 77; Clair 1996, p. 70;
Fox Weber 1999, pl. 5;
Clair, Monnier 1999, n. P 79

45.
India ink on paper
20.6 × 30.8 cm
Richard Gere

provenance: B.C. Holland;
John Rewald; sale Christie's,
New York, 11 May 1994,
n. 461
bibliography: catalog
New York 1984, p. 31, fig.41;
Clair, Monnier 1999, n. D 446

La Leçon de guitare is a legendary picture,
and it is an tremendous privilege to be able
to present it here. After exhibiting it at the Galerie
Pierre in 1934—but in a small separate room,
partly closed by a curtain—, for over forty years
Balthus forbade its being shown or reproduced,
apprehending, he said, its misinterpretation
by the public.
Given to the Museum of Modern Art of New York
by Pierre Matisse, in memory of his wife
Patricia Kane, it was withdrawn four years later,
at the request of an outraged trustee. The most
provocative of Balthus's paintings changed hands
eleven times, a record, and over all those years
rare were those allowed to see it.
La Leçon de guitare has given rise to few
commentaries, but the little that has been said
makes its interpretation disturbing. The position
of the two figures seems inspired by the *Pietà
de Villeneuve-lès-Avignon*, a masterpiece of French
fifteenth-century painting conserved at the Musée
du Louvre (fig. 1). Sabine Rewald has suggested,[1]
yet without pressing her point, that Balthus might
have thus taken his revenge on the Beatenberg
parishers who had decided, at the time he had
begun this painting, to destroy the murals
he had painted in their temple in 1927
(cf. the essay by Sabine Rewald). In the same
article, she reproduced a painting by Eugen Spiro
representing a strict schoolteacher under the
features of his sister, Baladine Klossowska,
and suggested a Freudian interpretation
of *La Leçon de guitare*. The teacher would actually
be Baladine offering her son an Oedipian sexual
experience through transposed persons.
A less extravagant elucidation than it might
appear, she adds, if you know Balthus was very
close to Pierre Jean Jouve and his wife, Blanche
Reverchon, a psychoanalyst of repute, and that
they had both collaborated in the translation
of Freud's *Three Essays on the Theory of Sexuality*.
Sabine Rewald also pointed out that the green-
and-pink striped wallpaper in *La Leçon de guitare*
is identical to the one in Eugen Spiro's painting.
More recently, in a questionable biography,

1. Enguerrand Quarton,
Pietà de Villeneuve-lès-Avignon,
ca. 1455, panel, 163 × 218 cm.
Paris, Musée du Louvre

2. Balthus, *Etude pour
"La leçon de guitare,"* 1934,
pencil on paper, 19.5 × 30 cm.
Private collection

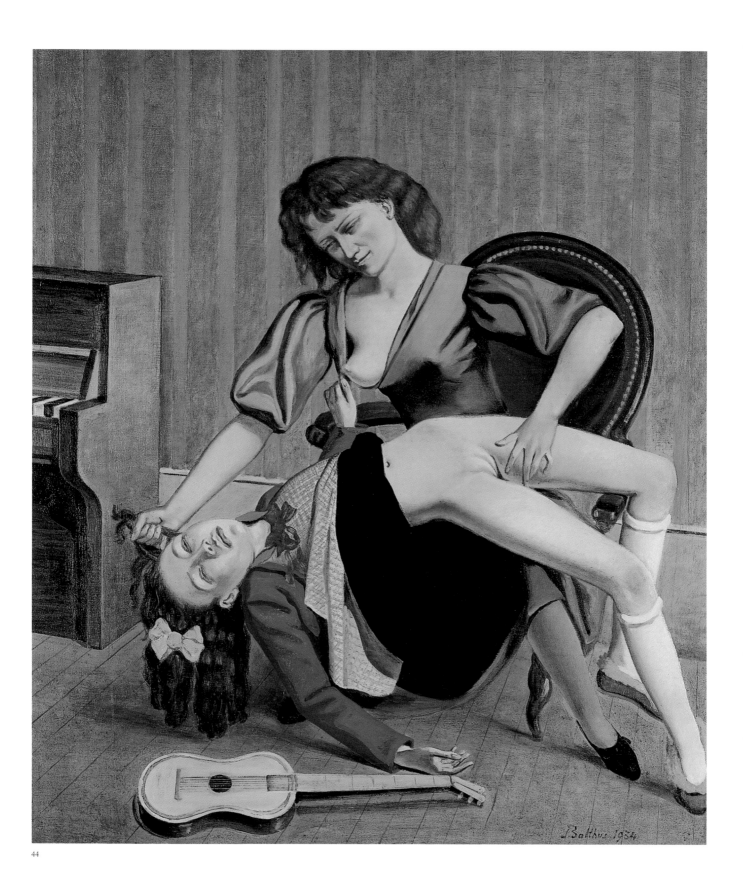

Nicholas Fox Weber claimed it to be
a self-portrait of Balthus. An unconvincing
interpretation, based on the painter's presumed
sadism, and that neither the preparatory drawings
known today (cf. cat. 45 and fig. 2),
nor a letter, still unpublished, from Balthus
to Antoinette de Watteville, justify in the least.
"I am preparing a new canvas. A rather ferocious
one. Do I dare tell you about it? If I cannot talk
to you about it—It's an erotic scene. But you have
to understand, it is not in the least quirky, none
of the usual little naughtiness you show around
under cover with winks and nudges. No, I want
to proclaim in broad daylight, with sincerity
and feeling, all the throbbing tragedy of a drama
of the flesh, proclaim vociferously,
the deep-rooted laws of instinct. Thus to return
to the passionate content of an art. Down with
hypocrites! The picture represents a guitar lesson
(by the way Robi has seen the drawing), a young
woman has given a little girl a guitar lesson, after
which she continues playing the guitar on the little

girl's body. After vibrating the chords of the
instrument she vibrates a body—('as Lesbos chose
me among all those on earth/ to sing the secret
of its budding virgins'). So you see I am exposing
myself to be properly insulted."[2]
Several weeks later, he brought up the subject
again: "I finally found a little girl, the child
of a concierge in a poor part of town. She came
to pose three times accompanied by her mother.
She was terribly cross-eyed but undressed with
a child's marvellous lack of modesty, while her
mother, a wretched woman from Luxembourg,
an atrocious victim of life, sat knitting in a corner.
So there was no corruption of a minor."
Behind the caustic tone, Balthus's legendary
"ferociousness," appears the sadistic character
of the scene however, the consenting child's pain,
with her arched body and contorted face. Her lips
swollen, her hand outstretched toward the adult's
raised nipple. The latter's cruel expression,
the violence with which she pulls the child's hair
and the accuracy of her fondling add to
the arousal the painting causes. Balthus depicts
the scene with the simplicity, the feigned naiveté
of an illustration for a children's book, as Sabine
Rewald correctly remarks. It is precisely that
distance that makes *La Leçon de guitare* a unique
painting in erotic art. We are as far removed
from Victorian naughtiness as from
the sadomasochist etchings confined to portfolios
for the secret delight of prurient collectors.
"Down with hypocrites!" was Balthus's cry.
With this painting, the only authentically erotic
one he felt he ever painted, he immediately
renewed the genre and shifted the emphasis
of the controversy.
The unexpected details he inserted in the picture
contribute to its deciphering: the child's peasant
slippers, the identical black and white piano keys,
the disproportion of the guitar. Did a music lesson
really take place? The guitar is a child's toy,
ridiculously small compared to the bodies,
the piano keys do not relate to an existing
instrument, no score could be performed
on it. The lesson is not musical…
A drawing of 1949 goes back on the theme
(fig. 3). It is a reinterpretation of the painting
but the iconography is actually very different.
The music instruments have vanished,
and by replacing the female teacher by a man,
Balthus eliminates the work's disturbing intensity.
Of course, we are still dealing with an erotic
scene, a man playing upon a little girl's body,
but the violence and the cruelty are expressed
by several new, ambiguous details: like the fact
that the man is gripping between his teeth
the cloth around the child's waist, bearing
all its weight, or that the scene takes place
in front of an open window, its curtain blown
about by the wind.

3. Balthus, *Etude pour
"La leçon de guitare,"* 1949,
India ink on paper, 29 × 19 cm.
Private collection

[1] S. Rewald, "Balthus Lessons," *Art in America, 9,*
September 1997, pp. 88–94 and 120–121.
[2] 1st December 1933. Private collection.

45

46. *Portrait d'Antonin Artaud*, 1935 [Portrait of Antonin Artaud]
47. *Portrait d'Antonin Artaud*, 1935 [Portrait of Antonin Artaud]

46.
India ink (on the verso
of a headed sheet of the café
Le Dôme)
24 × 20.5 cm.
monogrammed lower right: "B"
private collection

provenance: the artist
exhibitions: New York 1949,
n. 1; New York 1963, n. 27;
Spoleto 1982, n. 28; Paris,
MNAM.CNACGP 1983–84, n. 71;
Kyoto 1984, n. 35; Andros 1990,
n. 23; Rome 1990, p. 75;
Bern 1994, n. 20
bibliography: Leymarie 1978
and 2nd ed.; bound 1990;
Leymarie 1982, p. 14 and
2nd ed. 1990, p.14, catalog
MNAM.CNACGP, Paris 1983,
p. 45; catalog New York 1984,
p.32, fig. 45; Costantini 1996;
Clair, Monnier 1999, n. D 456

47.
pencil on paper
drawing: 15 × 11.5 cm;
sheet: 30.8 × 20 cm
monogrammed and dated
lower left: "B 1935"
inscribed and dedicated
lower center: "Antonin Artaud
Pour Tristan Tzara"
Paris, Bibliothèque Nationale

provenance: Tristan Tzara; sale
Loudmer, Paris, 4 mars 1989,
n. 54
bibliography: Clair, Monnier
1999, n. 458

Antonin Artaud had published in the *N.R.F.*[1]
a very laudatory review of the 1934 exhibition
at the Galerie Pierre. The following fall, he waxed
enthusiastic over the forest sets Balthus had
painted at Victor Barnowski's[2] request for
Shakespeare's comedy *As You Like it*, and this
despite the play's failure.[3] The two men became
friends and we know Artaud visited Balthus
several times at his studio in the Rue
de Furstemberg.[4]
Artaud had been developing, since 1932,
the concept of the *Theater of Cruelty*, whose
principles he applied in *Les Cenci* (see cats.
161–171). It was quite naturally that he thought
of Balthus for creating the sets and costumes.[5]
If their fascination for Far-Eastern cultures
brought Artaud and Balthus together, they
particularly shared a parallel course in the search
for a new expressivity. An intuitive feeling ran
between them, that can be seen again in Artaud's
comments on Balthus's painting. Pierre Jean Jouve
felt it when he wrote, after seeing *Les Cenci*:
"This is what Antonin Artaud and Balthus
understand and know. When Artaud created
the theory of a 'Theater of Cruelty,' he sought
how the rather devastated sensibility
of present-day man could once again experience
those principles of duration, of tension
and of transposition, in an intoxicating,
implacable event."[6]
By comparing a notebook of Artaud's[7] containing
sketches for *Les Cenci* and the designs, we can't
but be struck by the affinity of thinking between
the two men. That affinity was completed
by such a great physical likeness that they could
be mistaken for one another.
The two portraits presented here show us Artaud's
handsome face, before the physical deterioration
caused by his illness. The first was done
at the Dôme, the Montparnasse café attended
by all the artists of the time.
The second was given to Tristan Tzara,
probably after Artaud's death and at a time
when Balthus did several sketches of him.[8]

[1] N. 248, May 1934.
[2] Barnowski had left Berlin in 1933. He was famous
for having staged plays by Ibsen, Shaw, Wedekind
and Strindberg. Erich Klossowski had created sets
for him at the Lessingtheater in 1916.
[3] It was in competition with the one Jacques Copeau
staged at the same time at l'Atelier. Barnowski was
also denigrated by an anti-semitic campaign.
[4] See section "Balthus and His Circle."
[5] On the collaboration between Artaud and Balthus,
see F. de Mèredieu, "Peinture et mise en scène, Artaud
Balthus," *Cahiers du MNAM*, 1983, n. 12, pp. 217–23.
[6] "Les Cenci d'Antonin Artaud," *N.R.F.*, n. 261, June
1935, repeated in *Balthus*, exhibition catalog, Paris 1983,
pp. 50–53.
[7] Bequest Paule Thévenin, Paris, Musée national
d'art moderne, Centre Georges Pompidou, cabinet
de dessins.
[8] In 1952. See Clair, Monnier 1999, nn. D 688–692.

46

47

48. *Lelia Caetani (Jeune femme dans un parc)*, 1935
[Lelia Caetani (Young Woman in a Park)]

oil on canvas
116 × 88 cm
private collection

provenance: Marguerite Chapin
Caetani, princess Bassiano,
purchased from the artist;
sale Sotheby's, New York,
18 November 1986, n.47;
sale Christie's, New York,
8 May 1991, n. 30
exhibitions: probably New York
1938, n. 5; Tokyo 1993–94, n. 3;
Hong Kong 1995, n. 3; Beijing
1995, n. 3; Taipei 1995, n. 3;
Madrid, 1996
bibliography: catalog New York
1984, p. 36 fig. 55; Klossowski
1996, n. 14;
Clair, Monnier 1999, n. P 82

This painting was probably shown by Pierre
Matisse in New York in 1938, under the title
Jeune femme dans un parc. It portrays Lelia
Caetani, of whom there is another portrait
not recovered), undoubtedly smaller since
estimated three times less, figuring in the same
exhibition as n. 6.
So we do not know which is referred to in
the passage in a letter from Balthus to Antoinette
de Watteville: "It is a real painting, you know,
not very big perhaps, but nonetheless quite
important because very new in conception,
and then very accomplished."[1] It shows the young
woman, "a beanpole, much taller than I am, rather
lacking in grace, but whose face is not without
style and quite Italian sixteenth-century,"
in a garden of the Champs-Elysées, near the
Caetani's house. A slick décor and one that might
be said to be miniaturized. The lamppost,
the park chairs are the size of toys whereas Lelia's
head is level with the tops of the bare winter trees
and the winged genii on the top of the tiny dome
of restaurant Le Doyen in the background.
The Caetani family, whence pope Bonifacio VIII
(1294–1303) came, owned a palace in Rome
on Via delle Botteghe Oscure. Lelia's mother,
Marguerite Chapin Caetani, princess Bassiano,
who was of American birth and entertained
the cosmopolitan intelligentsia, backed a literary
magazine to which she gave that name and where
appeared Artaud, Bataille, Camus, Thomas Mann,
Moravia, Italo Calvino, Pier Paolo Pasolini,
and so on.
The Caetani family also owned the castle
of Sermoneta, south-west of Rome, where
Balthus in 1951 painted the *Paysage d'Italie*
[Italian Landscape (cf. p. 95, pl. 5)],
that belonged to Albert Camus
and then to Jacques Lacan.

[1] 9 February 1935. Private collection.

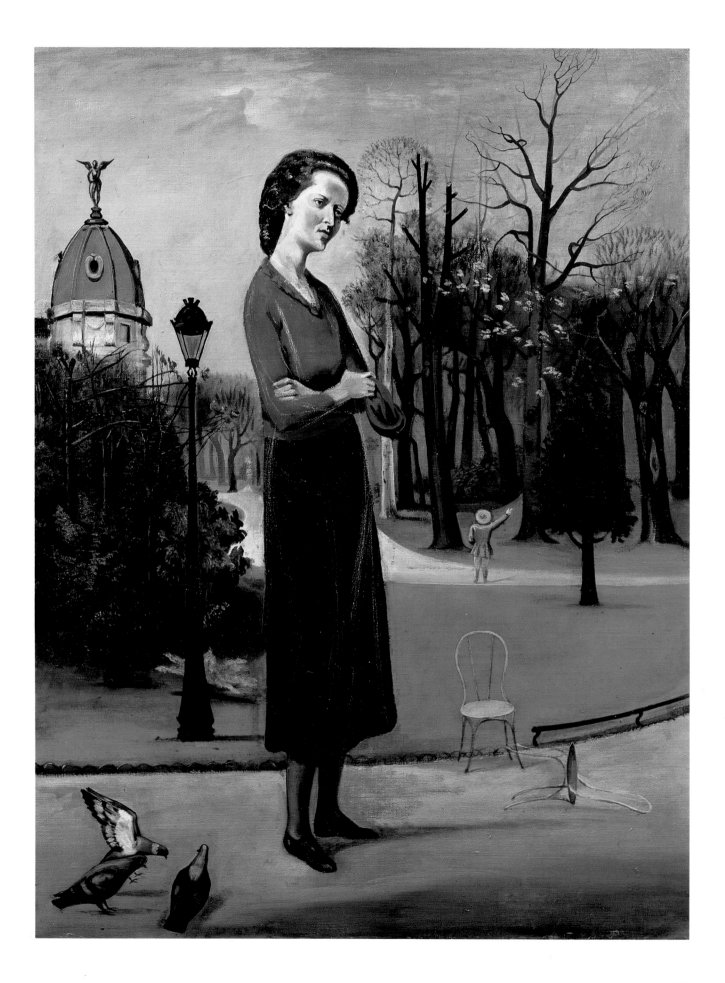

49. *Le Roi des chats*, 1935
[The King of Cats]

oil on canvas (restored)
71 × 48 cm
Inscribed lower right:
"A PORTRAIT OF/ H.M./ THE KING
OF CATS/ PAINTED BY/ HIMSELF/
MCMXXXV"
Switzerland, private collection

provenance: private collection,
Great Britain (gift of the artist);
sale Sotheby's, London, 26
June1984, n. 45; sale Sotheby's,
New York, 10 May 1988, n. 44;
private collection
exhibitions: New York 1984,
n. 9; Rome 1996–97, p. 67
bibliography: Leymarie 1990,
p. 124; catalog Musée cantonal
des Beaux-Arts, Lausanne 1993,
p. 32; Kisaragi, Takashina,
Motoe 1994, pl. 5; Roy 1996,
p. 29; Costantini 1996;
Clair, Monnier 1999, n. P 84

This self-portrait was painted two years after
La Toilette de Cathy (cat. 41) in which Balthus has
portrayed himself but, he said, "very transposed."
Since then, he had gone through a difficult period:
his nerves had been strained in preparing his
exhibition at Pierre Loeb's, and in 1934 he was
torn between alternate phases of exaltation and
despair complicated by Antoinette's sentimental
vacillations. Around the middle of 1935 the pace
of his life seemed assuaged. He received several
commissions for portraits that insured his living,
the costumes he designed for Antonin Artaud's
Les Cenci had made his name known; *Vogue*
printed an article about them, while *Minotaure*
published eight of his illustrations for *Wuthering
Heights*. Yet those who met him at the time do
not fail to describe him as moody and living
in an extremely romantic atmosphere:
"He has now become as haughty as Delacroix,"
his mother wrote to Erich Klossowski.[1]
Le Roi des chats can thus be read as the image
he wants to give of himself. The long, dandy's
silhouette stands out against the bare wall
of an empty room. The black of the jacket snaps
in the silence. The gaze is drowned in shadow,
the cheek hollow, but the brow carved by light;
it is indeed the portrait of the romantic genius,
consumed by an inner fire, and the world
he carries within.
Tight-lipped, the painter is walled in his solitude
and his one companion is a cat, an enigmatic,
disturbing animal, free to come and go
as in his attachments. This is the first appearance
in his work of the emblematic feline to which
his name is linked.
Against the stool, upon which lies an
animal-tamer's long whip, Balthus set a canvas
that looks like marble, engraved like a classical
stele:

"A PORTRAIT OF/ H.M./ THE KING OF CATS/
PAINTED BY/ HIMSELF/ MCMXXXV."

We are in the presence of a Byronian aristocrat,
a sovereign even, ruling over a secret kingdom
of which he alone has the keys, and about which,
no more than about his painting, he does not have
to give an explanation.

[1] 16 August 1935. Private collection.

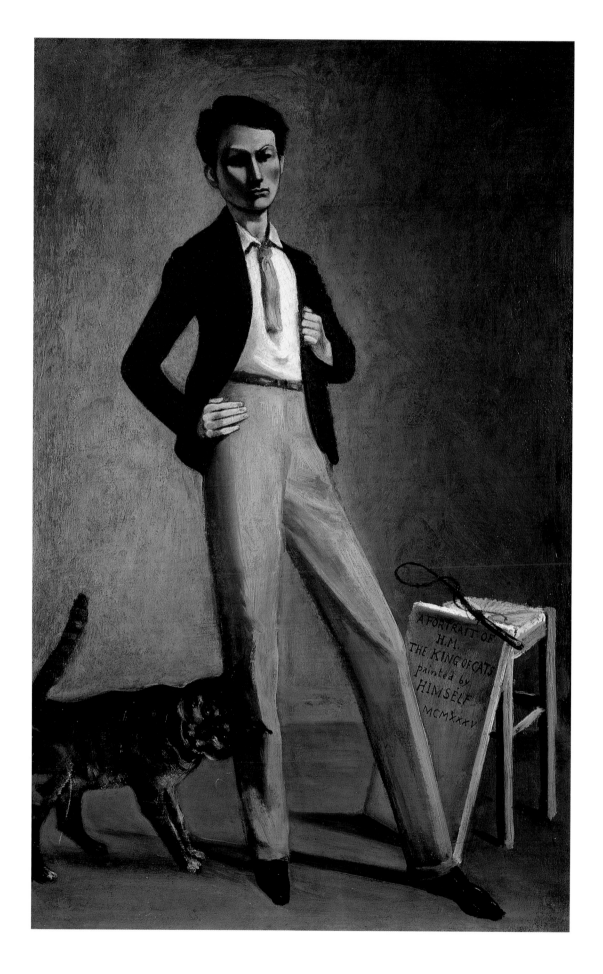

50. *Etude pour "La famille Mouron-Cassandre,"* 1935
[Study for "The Mouron-Cassandre Family"]

pencil on paper
33.7 × 24.3 cm
monogrammed lower right: "B"
New York, Carol Selle collection

provenance: Mr and Mrs
Richard Selle
exhibitions: Chicago 1980,
n. 6
bibliography: Clair,
Monnier 1999, n. D 454

1. Balthus, *La famille
Mouron-Cassandre*
[The Mouron-Cassandre Family],
1935, oil on canvas, 82 × 72 cm.
Private collection

Cassandre[1] and Balthus met in the spring of 1935, at Varia Karinska's, who had just finished making the costumes for *Les Cenci* (cats. 161–171). The graphic artist, famous for the typographical alphabets and especially for the posters he had created,[2] in the past two years had become interested in the theater. Louis Jouvet commissioned him, in 1933, for the sets of *Amphytrion 38* by Giraudoux, and Serge Lifar the ones for the ballet *Aubade* in 1934. According to his son, Henri Mouron,[3] the discovery of Balthus's painting was a revelation for Cassandre who, besides, was fascinated by the young painter. He immediately commissioned the portrait (fig. 1) of which this drawing is the study, and from then on was to devote a great deal of his time to easel painting.[4]
In 1949, Cassandre designed the outdoor theater of the Festival of Aix-en-Provence, for which he made the sets and costumes of Mozart's *Don Giovanni*. It was on his suggestion that Balthus was called, the following year, to create those of *Così fan tutte* (see cats. 172–185). Madame Mouron posed several times in Balthus's studio between September and December 1935. She was 46 years old at the time. When she had married Cassandre, in 1924, she had been twice widowed and had four children. She is portrayed here with one of the daughters of her first marriage, Beatrice Cauvet, and young Henri, aged ten, born of her marriage with Cassandre. Mother and daughter look alike: the same small

mouth, the same strong cheekbones, the same pointed chin. In the drawing, they both are staring at us, whereas in the painting the daughter is looking into space. Madame Mouron has put her fingers on her daughter's hand and that affectionate gesture is significant since, in the painting, those hands will be placed on the horizontal axis of the representation. Young Henri does not appear in the drawing. He takes up the entire left side of the painting. Quietly seated on the table, he seems to be waiting for his mother to examine his homework and, ostensibly indifferent to his surroundings, he is absorbed in reading an illustrated magazine. It is not known why he is wearing a sailer's hat. That headdress connects him with the child being carried by his nurse that we can see in the background of *La Rue* (cf. cat. 43), a child who is reading a picture book, too.

[1] Adolphe Jean-Marie Mouron, dubbed Cassandre, born in Kiev in 1901, died in Paris in 1968.
[2] The alphabets *Bifur, Acier* and *Peignot* in 1929; the posters for *Dubo…Dubon…Dubonnet* (1932) and *Nicolas* in 1935.
[3] See H. Mouron, *Cassandre*, Schirmer-Mosel, Paris, München 1991.
[4] The paintings of that period were destroyed. Among the ones he did after the war, we have a portrait of Marie-Laure de Noailles and landscapes of Bugey, treated by Balthus as well. Furthermore, Cassandre owned the magnificent *Larchant* Balthus painted in 1939.

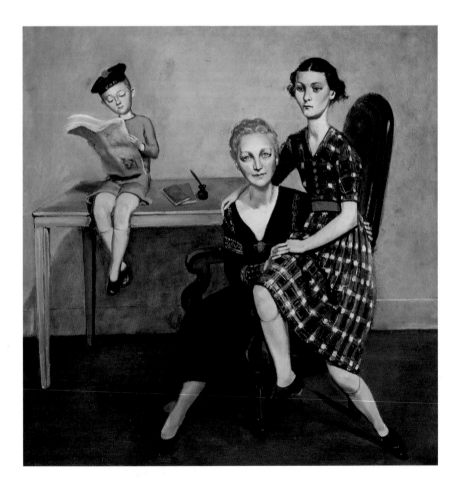

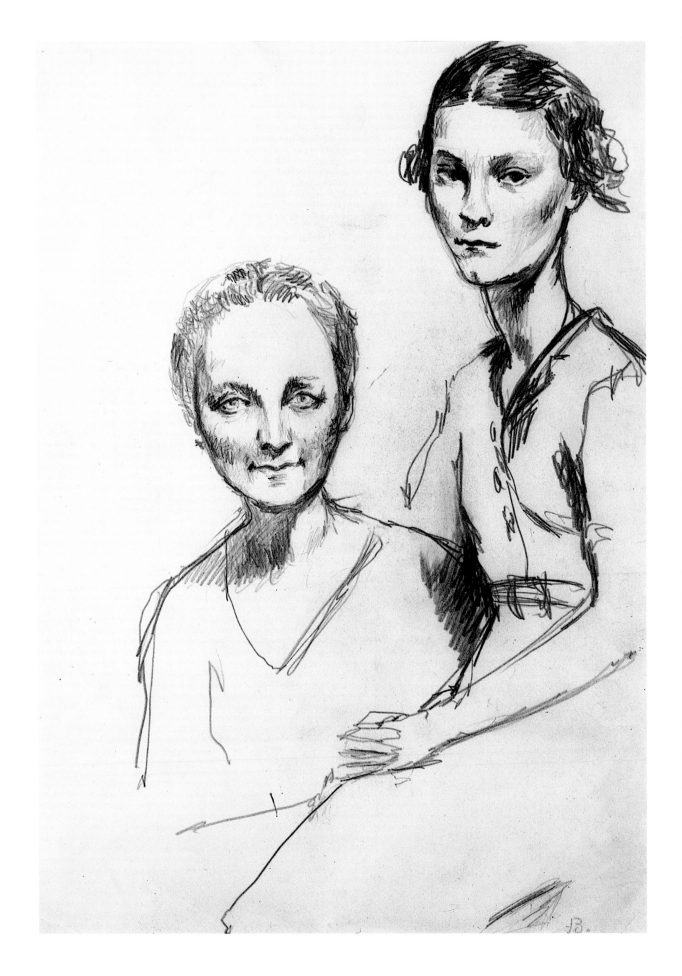

51. *Portrait de Pierre Colle*, 1936
[Portrait of Pierre Colle]

oil on canvas
55 × 46 cm
signed and dated lower right:
"Balthus 1936"
private collection

provenance: purchased
from the artist by Pierre Colle
exhibitions: Karuizawa 1997,
p. 49
bibliography: catalog
MNAM.CNACGP, Paris 1983,
p. 345 n. 34; Leymarie 1990,
p. 125; Clair, Monnier 1999,
n. P 89

"In a portrait by Balthus—Antonin Artaud wrote
the same year this one was painted[1]—there is
the very principle that relates it to ancient Chinese
calligraphy and certain Primitive paintings.
Through his portrait by Balthus, the person is
united with his historical model. And none
of this is obtained by adding on, but by what
we might call stripping bare. The head is held
aloft outside oftime, in a luminous atmosphere,
in an exhibition to the light that immediately gives
his raison d'être and the key to his fate."
As soon as he arrived in Paris, in 1928, Pierre
Colle (1909–48), thanks to Max Jacob, met
Picasso, Cocteau, Derain. At one time associated
with the future fashion designer Christian Dior
(1931 to 1935), he later opened his own gallery,
29, Rue Cambacérès, where he showed Picasso,
Braque, Matisse, Derain, Dufy, Modigliani,
Soutine, as well as Bérard, Lurçat, Max Jacob,
Jean Hugo, Chirico… He exhibited Dalí, too
(1931 to 1937), Giacometti (1932), Miró, Calder,
and organized in 1933 a group show "You must
visit the Surrealist exhibition." In 1939, the year
of his marriage with Carmen Corcuera y de Mier,
he presented with Maurice Renou, the friend
of the Impressionists, an exhibition on Mexico,
organized by André Breton. You could see there
in particular pre-Columbian and folk art pieces
and, for the first time in Paris, works by Frida
Kahlo de Rivera. After the war, the gallery
Renou et Colle showed paintings by Hélion
and photographs by Brassaï.
Pierre Colled died in 1948, while he was setting
up the *Balthus* exhibition, whose works he had
been selling for a long time. His widow, remarried
to François Baron, gathered in her home the most
miscellaneous personalities of the artistic world,
such as Sauguet, Auric, Poulenc, Kochno,
Max Ernst, Man Ray, Masson, Balthus, Cassandre,
Kessel, Druon, César, Mason or Schauer.[2]
Pierre and Carmen's daughters were the models
for the *Trois Sœurs* (see cats. 101 and 102).

[1] A. Artaud, "La jeune peinture française et la tradition,"
El Nacional, Mexico, 17 June 1936.
[2] See *Carmen Baron, Instants d'une vie*, recollections
assembled and introduced by Lina Lachgar, Du Saule,
Paris 1995.

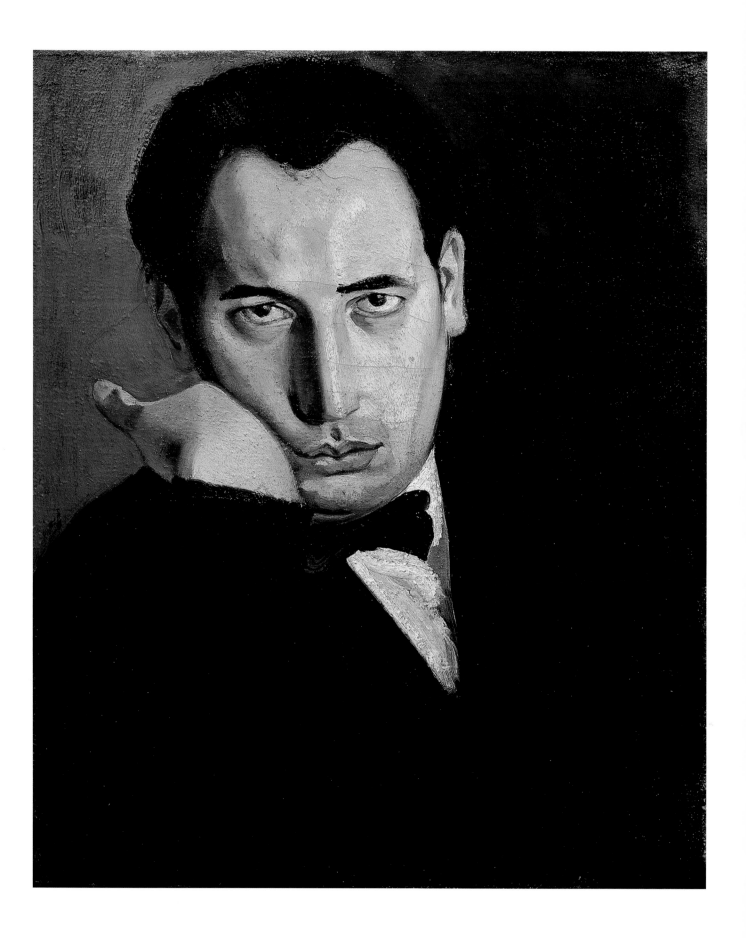

52. *Frère et sœur*, 1936
[Brother and Sister]

oil on cardboard
92 × 65 cm
signed lower left: "Balthus"
Washington, Hirshhorn
Museum and Sculpture Garden,
Smithsonian Institution, bequest
Joseph H. Hirshhorn

provenance: Galerie Pierre,
Paris; sale Parke Bernett,
New York, 17 January 1945,
n.139; private collection;
Albert Loeb Gallery, New York;
1963, Joseph H. Hirshhorn
exhibitions: probably New York
1938, n. 7; Cambridge 1964,
n. 3; Chicago 1964, n. 3.
bibliography: Clair,
Monnier 1999, n. P 94.

In 1936, Balthus had the idea of a large painting
whose subject was a drowning scene near the
Pont-Neuf, that he had witnessed. There are two
traces of it: the first is a colored-pencil drawing,
probably done on the scene, from a small
sketch-book[1]: it is very soiled, but you can see,
on the right, two policemen, with kepi and cape,
and a man in a bowler hat accompanied by a small
child; on the left you glimpse the arches
of the bridge, while on the bank, a half-a-dozen
figures press around the barely sketched body.
The second one, in India ink (fig. 1), is far more
advanced, since the composition is set up around
clearly defined axes, diagonals and converging
lines. The arches of the bridge are recentered
and the figures, less numerous, arranged in three
groups. The one on the left shows a boy trying
to reach the central group while an older child
holds him back.
The work arisen from this drawing no longer
exists. Pierre Leyris (see cat. 39) could remember
it,[2] without being able to specify whether
it had ever been completed or not. The present
painting is on cardboard and a normal format
("30 paysage") available on the market.
So we must exclude that it might be a fragment
of the large composition Leyris had seen.
Yet it certainly proceeds from the drawing
reproduced here.

[1] See Clair, Monnier 1999, nn. CC 1466bis/ 1.
[2] Conversation with Jean Clair, 1998.

1. Balthus, *Sur les quais*
[On the Banks] 1936,
India ink on paper, 27 × 36 cm.
Private collection

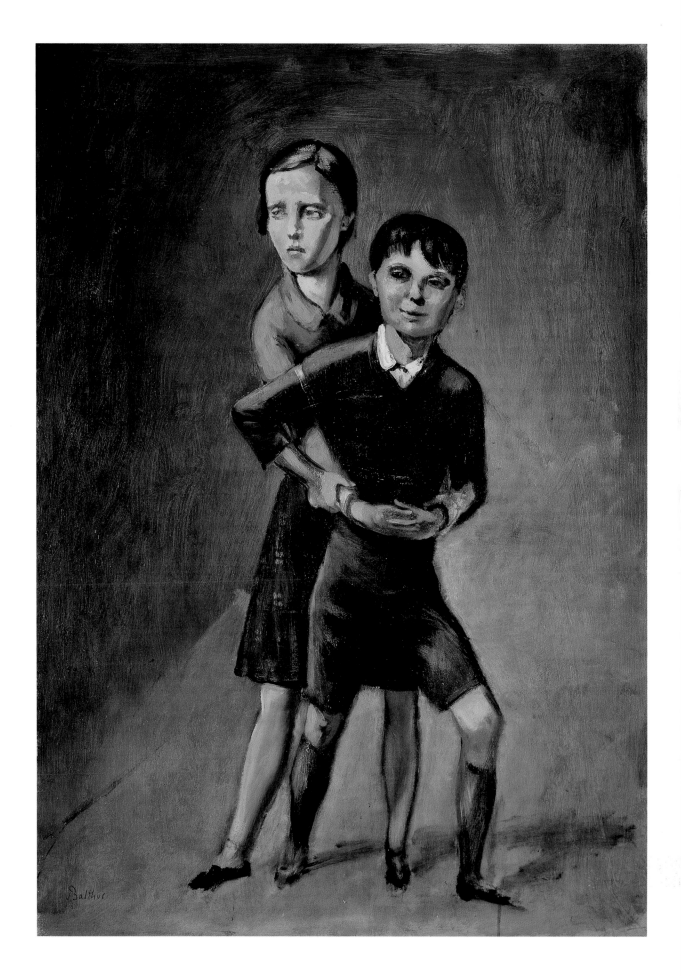

53. *Les Enfants Blanchard*, 1937
[The Blanchard Children]

oil on canvas
125 × 130 cm
signed and dated on verso
upper right: "Balthus 1937"
inscribed on verso upper left:
"Les Enfants-Hubert
et Thérèse Blanchard"
Paris, Musée Picasso

provenance: Pierre Colle;
Pablo Picasso
exhibitions: Paris 1946, n. 5;
New York 1949, n. 8; New York
1956, n. 6; Paris, MNAM.CNACGP
1983–84, n. 12; New York 1984,
n. 16; Kyoto 1984, n. 4; Ornans
1992, n. 12; Lausanne 1993;
Hong Kong 1995, n. 4
(not shown); Beijing 1995, n. 4;
Taipei 1995, n. 4 (not shown);
Madrid 1996; Karuizawa 1997,
p. 53
bibliography: Leymarie 1978,
pl. 4 and 2nd ed. 1990, pl. 4;
Leymarie 1982, pl. 27 and
p. 129 and 2nd ed. 1990, p. 130;
Klossowski 1983, pl. 16; catalog
MNAM.CNACGP, Paris 1983,
pl. p. 134 and p. 346 n. 43;
catalog New York 1984, p. 38
fig. 59; Davenport 1989, fig. 5;
Kisaragi, Takashina, Motoe
1994, pl. 9; Xing 1995, pl. 8;
Roy 1996, p. 11; Klossowski
1996, n. 21; Fox Webe 1999,
pl. 10; Clair, Monnier 1999,
n. P 100

This painting is famous for having been purchased by Picasso in 1941. It was given to the Louvre with his entire personal collection in 1973 and that is how Balthus happens to have been the only livingpainter in that museum, whose collections do not cover the twentieth century. Since 1985, the canvas is on deposit at the Musée Picasso of Paris.[1]
The painting goes back to a theme Balthus had worked on in 1932 for the second illustration of *Wuthering Heights* (cat. 23). But unlike *La Toilette de Cathy*, that went back on the seventh (cats. 31 and 41), here there is no explicit reference to Emily Brontë's novel. Quite the opposite, Balthus seems to want to disconnect the two by writing, which he rarely did, a title on the verso of the work: "Les enfants, Hubert Thérèse Blanchard.""
The young Blanchards, who had posed the year before for *Frère et sœur* (cat. 52), were his neighbors in the cour de Rohan and would be his models until 1939.[2] They both died during the war. In the 1937 canvas, Balthus increased by a third the space in which Heathcliff and Cathy had been framed. The pyramidal composition of 1932 now rests on strong orthogonal lines: the section of wall on the right, and the table, henceforth seen frontally, and entirely shown. To re-establish the balance of the composition, he placed the girl in front of the piece of furniture whereas previously she was kneeling between its legs. The chair has been shifted, the position of each child is less hunched up. Hubert has his elbows on the top of the table and no longer on the back of the chair, he is staring straight ahead.
Two preparatory drawings for the painting[3] show how Balthus gradually altered the children's positions. By lowering the boy's pelvis, he reduced the angle created by his thigh and his right calf, while by elongating Thérèse's left leg, he opened

the angle created by her thigh and trunk. So she was forced to straighten her torso and was thus in a remarkably uncomfortable position, one for which children, however, do have a knack. Thérèse is wearing the short plaid skirt she already had on in *Frère et soeur* and a tube-like felt cardigan that hides the tip of the shoulder. As for the boy, he is wearing the belted school-boys' smock of the time. They have thrown their satchels over by the wall, under the table, and are immersed, she in a book and he in his daydreams. In the illustration for *Wuthering Heights*, the areas of shadow and light are indicated by a play of more or less thick hatching that defines the particular space in which the youngsters move about. The same is to be found in *Les Enfants Blanchard*, precisely delimited, to the right, by the brown-colored partition. "From the floor to the ceiling,— Jean Clair commented[4]—the space is theirs, and with it the possession of time." The time of a suspended movement, of a precariously balanced position, that was striking in the portrait of the Leyris couple (cat. 39) and that we see again in the one of Miró and his daughter (cat. 55) and, in an emblematic way, in the last picture of the series, *Thérèse sur une banquette* (cat. 60).

[1] On the purchase of the painting and the relationship between Picasso and Balthus, see H. Seckel-Klein, *Picasso collectionneur*, Réunion des Musées Nationaux, Paris 1998.
[2] See cats 58–60 and Clair, Monnier 1999, nn. P 95, P 101, P 112, P 118 to P 120, P 122.
[3] These two drawings are dated 1938 and have sometimes been believed to have been made after the painting. Balthus confirmed to us that they were indeed preparatory sketches and that the date, added later, was inexact. Cf. Clair, Monnier 1999, nn. D 463, D 464.
[4] J. Clair, "Le Sommeil de cent ans," in Clair, Monnier 1999, p. 38.

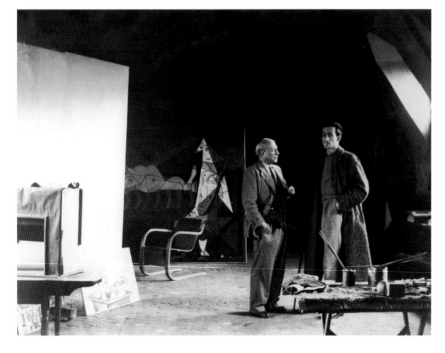

1. Picasso and Balthus photographed by Cecil Beaton in the studio Rue des Grands-Augustins in front of *L'Aubade*, November 1944.
Paris, Musée Picasso, Ph 355

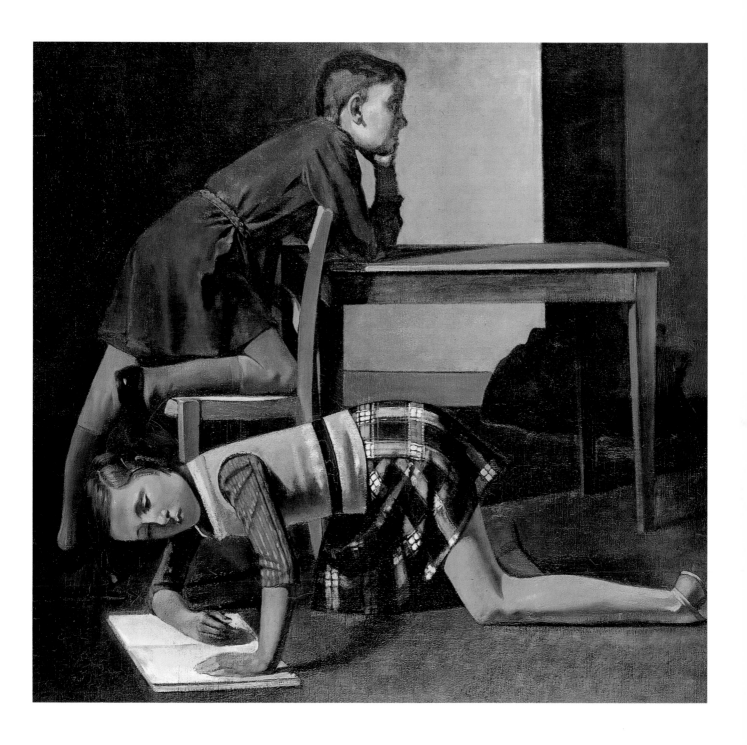

54. *Femme à la ceinture bleue*, 1937
[Woman with a Blue Belt]

oil on wood
91.5 × 68.5 cm
signed and dated lower right:
"Balthus 1937"
Amiens, Musée
de Picardie collection

provenance: Pierre Colle; 1937,
Pierre Matisse Gallery,
New York
exhibitions: New York 1949,
n. 11; Cambridge 1964, n. 5;
Chicago 1964, n. 6
bibliography: Leymarie 1982,
p. 127 and 2nd ed. 1990, p. 126;
catalog MNAM.CNACGP, Paris
1983, p. 347 n. 44; Roy 1996,
p. 112; Clair, Monnier 1999,
n. P 106

This portrait of Antoinette was painted the year she married Balthus. So it is exactly concurrent with the wonderful *Jupe blanche* (fig. 1), too fragile to be removed. The flowing elegance of the young woman, whose body follows the diagonal of the painting, contrasts here with the massiveness of a pyramidal composition. The meticulousness with which he treated, in the one, the embroidered slippers, the trimming on the curtain and the fabric of her outfit, contrasts, in the other, with the wide brushstrokes of the full woolen dress. The gentleness of the face in the one with the sullenness of the other. The portrait focuses on a line that follows the part in the hair, the rim of the nose and divides the chest in two. The *Jeune fille en vert et rouge* (fig. 2) is composed in the same fashion, differing only in that the frontality is perfect, it being the light that divides the canvas by illuminating in a contrasted way the left half of the face and the scarlet of the two-part sweater. In both cases, a heavy cape lying on the right shoulder emphasizes the ridge of the triangle.
The *Jeune fille en vert et rouge* looks younger than the *Femme à la ceinture bleue*. Yet, the painting was done seven years later, time enough for a war and two children. Balthus turned the slightly moody young woman of 1937 into a sort of Pythia, the priestess of an uncanny, cruel rite whose mute violence might suggest the years of the Occupation.[1]

[1] The knife stuck in the loaf of bread did not figure in a first version of the painting, published in *Cahiers d'art*, 1945–46, vols. XX–XXI, p. 207.

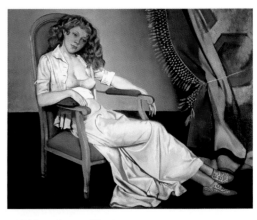

1. Balthus, *La jupe blanche*
[The White Skirt], 1937,
oil on canvas, 130 × 162 cm.
Private collection

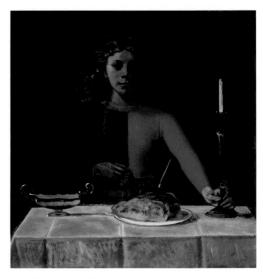

2. Balthus, *Jeune fille en vert
et rouge (Jeune fille au chandelier)*
[Girl in Green and Red
(Girl with Candlestick)],
1944–45, oil on paper mounted
on canvas, 37 × 44.5 cm.
Location unknown

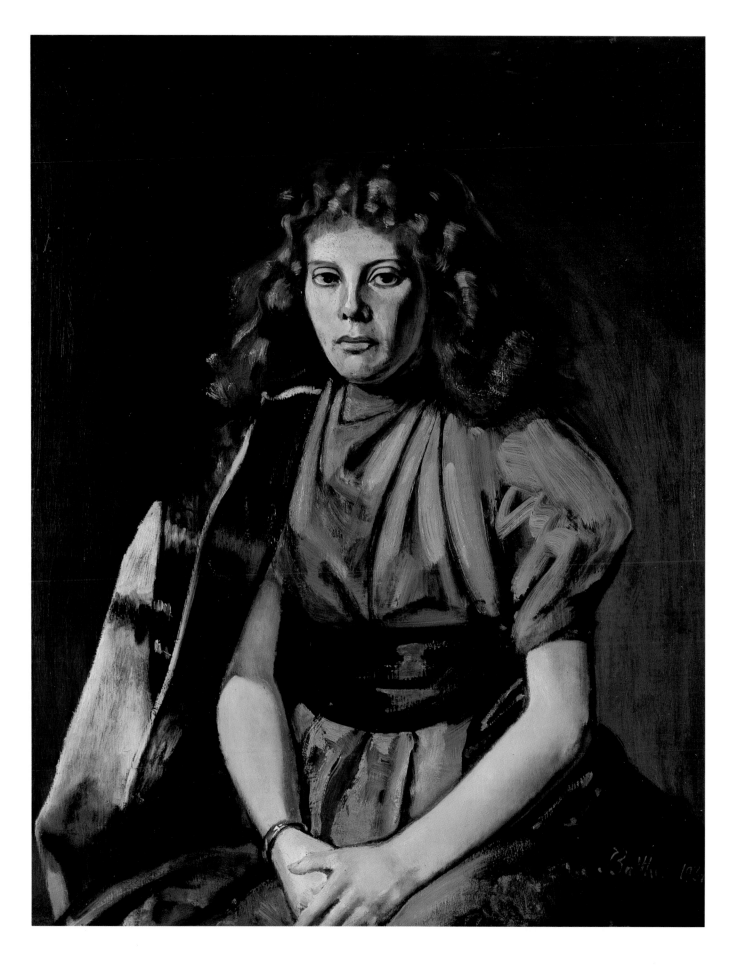

55. *Joan Miró et sa fille Dolorès*, 1937–38
[Joan Miró and His Daughter Dolorès]

oil on canvas
13.2 × 88.9 cm
signed and dated lower left:
"Balthus1938"
signed and dated on reverse:
"octobre 1937-janvier 1938"
New York, The Museum
of Modern Art, Abby Aldrich
Rockefeller Fund

provenance: Galerie Pierre,
Paris; 1938, Pierre Matisse
Gallery, New York; 1938,
Museum of Modern Art,
New York, Mrs. John D.
Rockefeller Junior
exhibitions: New York 1938,
n. 15; New York 1949, n. 15;
New York 1956, n. 9; Paris,
Arts Décoratifs 1966, n. 6;
Knokke-le-Zoute 1966, n. 6;
London, Tate Gallery 1968,
 n. 10; Detroit 1969, n. 6; Paris,
MNAM.CNACGP 1983–84, n. 18;
New York 1984, n. 12; Kyoto
1984, n. 5; Lausanne 1993;
Madrid, 1996
bibliography: Leymarie 1978,
pl. 3 and 2nd ed. 1990, pl. 3;
Leymarie 1982, pl. p. 23
and p. 126 and 2nd ed. 1990,
pl. p. 23 and p.126; Klossowski,
1983, pl. 21; catalog
MNAM.CNACGP, Paris 1983,
pl. p. 143, p. 348 n. 50; catalog
New York 1984, p. 37 fig. 57;
Davenport 1989, fig. 2; Kisaragi,
Takashina, Motoe 1994, pl. 10;
Xing 1995, pl. 12; Roy 1996,
p. 103; Klossowski 1996, n. 27;
Costantini 1996; Fox Weber,
1999, p. 351; Clair, Monnier
1999, n. P 111

The *Portrait de Joan Miró et de sa fille Dolorès*
was commissioned by Pierre Loeb on the occasion
of the Catalan painter's 45th birthday, since the
year before a refugee in France. Between October
1937 and January 1938, Miró and his daughter
posed over forty times in the studio of the Cour
de Rohan. Balthus expected the child to stay
seated on her father's thigh, yet without being able
to firmly rest her feet on the ground. A posture
perhaps derived from the portrait of Betty Meyer
and her young sister that he had copied at Bern
a few years earlier (fig. 1). Dolorès was unruly
and could not hold the uncomfortable pose
that was demanded of her; she was terrified
of Balthus who threatened to put her in a cloth
sack, and she has told[1] that, finally giving in,
he slightly altered the pose and drove some nails
in the floor on which she could wedge her toes.
Instead Miró is said to have found the sittings
relaxing, even occasionally dozing off.
Balthus and Miró, although total opposites,
admired each other enormously and got along
well. Balthus expressed amazement at Miró's
capacity to be silent for hours on end, without
his silence ever being oppressive. He also
remembered his wondering, childish gaze.
At the same time, the portrait does justice to the
Catalan's reserved temperament, a kind of earthy
solidity that had struck John Russel, suggesting
to him a formal kinship with the Italian *Madonna
and child* pictures, insofar as the painters had
simple, very real women pose, and with children
slightly too old for the part.
The likeness between father and daughter leaps
to the eye, but equally striking is the tacit
understanding, the restrained tenderness between
them. Their hands express it with delicacy, Miró's
pressing against him the little girl on the verge
of sliding, and Dolorès', resting trustingly on her
father's wrist. The child's left thumb is oddly
separated from her forefinger, Miró's right hand
is, according to Fox Weber, arthritic and even
bestial. Instead of speculating on Balthus's
supposed intentions or eventual lack of skill,
it is advisable to examine the photographs
to see that these are merely the transcription
of a morphological peculiarity.
A ray of light emphasizes the division
of the canvas in two contrasting areas, creating
a vibration bringing the entire painted surface
to life. It seems to approximately follow
a horizontal line, but on closer examination
you can observe the subtle shifting upward
of the left segment, like a tiny movement
of life behind Miró's transfixed silhouette.

[1] N. Fox Weber, *Balthus*, Alfred A. Knopf Inc.,
New York 1999, pp. 353 ff.

1. Joseph Reinhardt, *Canton of Zug:
Bette Meyer and Her Young Sister*,
1794, oil on canvas, 70 × 50 cm.
Bern, Historisches Museum

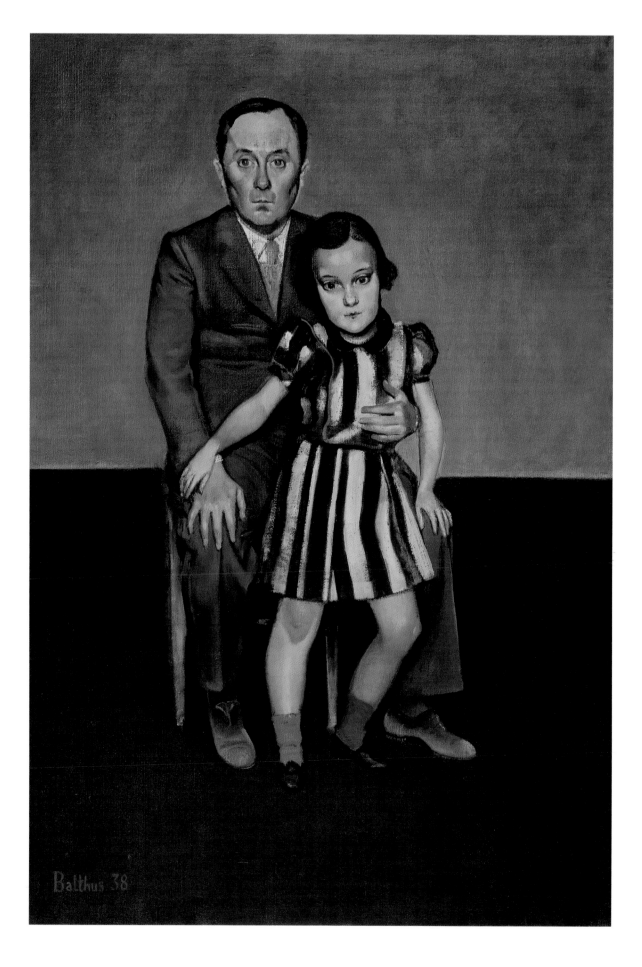

56. *Portrait de Pierre Matisse*, 1938
[Portrait of Pierre Matisse]

oil on canvas
128.8 × 86.7 cm
signed and dated lower left:
"Balthus 1938"
private collection

provenance: gift of the artist
to Pierre Matisse; given as lost
from 1982 to 1990
bibliography: Leymarie 1982,
p. 127 and 2nd ed. 1990, p. 126;
catalog MNAM.CNACGP,
Paris 1983, p. 347 n. 49
(support incorrect);
Clair, Monnier 1999, n. P114.

Pierre Matisse (1900–89), the son of the painter
Henri Matisse, moved to New York in 1924.
After having mounted for the Valentine Gallery
several exhibitions of "French Moderns"
(Matisse, Vlaminck, Bonnard, Segonzac,
Marchand, Utrillo, Laurencin, Denis, Dufy,
Marquet, Roussel, Vuillard, etc.) that were
presented in various American museums, he
opened his own gallery in 1931. Miro is the first
artist with whom he signed a contract (1933),
Calder the second (1934) and Balthus,
whom he showed in 1938, the third.
He had met him at the Galerie Pierre in 1934,
but after the closing of the exhibition, of which
he saw but a few paintings left in the gallery
(in particular, *La Rue* that he bought in 1937
with *La Toilette de Cathy* (cats. 41 and 43)
and sold to James Thrall Soby).
An authentic ambassador of French painting
in the United States, Pierre Matisse equally
exhibited, during the thirties, Pascin, Maillol,
Masson, Rouault, Lurçat, Chirico, Léger, Tanguy
and Derain; in addition he presented four
exhibitions of primitive art.
He remained Balthus's dealer up to his death.
No preparatory sketches are known of this
portrait, painted in the course of the many visits
Pierre Matisse made to Balthus in the summer
of 1937. The oval of the face stands out against
the dark background of the canvas, entirely
painted in various shades of gray, with which
the scarlet spot of the sock contrasts vividly,
a chromatic "device" imagined for the *Portrait
de Pierre et Betty Leyris* (cat. 39) and that Balthus
would use many times (see cats. 74, 116, etc.).

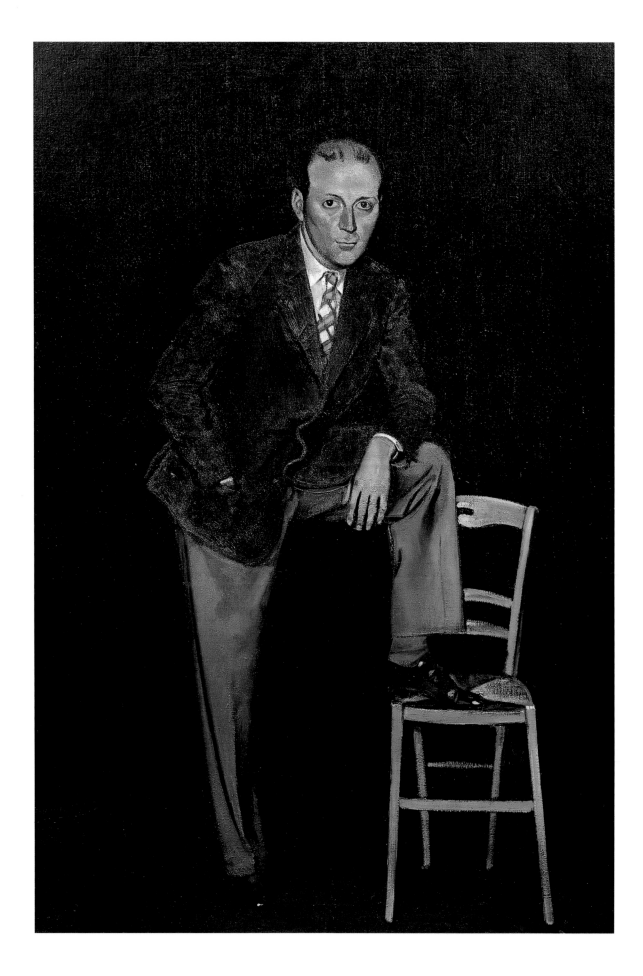

57. *Portrait d'enfant (copie d'après Géricault). Etude de tête d'enfant. Etude de tête*, 1938
[Portrait of a Child (copy after Géricault). Study of Child's Head. Study of Head]

pencil on paper
17.4 × 25 cm
signed and dated lower right:
"Balthus 1938"
private collection

provenance: Dr. Hans Naef,
purchased from the artist
exhibitions: Bern 1994, n. 22;
Madrid 1996; Rome 1996–97,
p. 171
bibliography: Clair, Monnier
1999, n. D475

We already mentioned (cat. 33) the copy of the
Narcissus by Poussin that Balthus made in 1925.
It is now nowhere to be found, nor do we have
a photograph or a sketch allowing to visualize
the spirit in which Balthus worked. Just a word
of Baladine's to Rilke gives us somewhat an idea[1]:
"I went to the Louvre today to see that fine copy
by Baltusz; he is beginning to have an audience.
His copy resembles Géricault painting, Pierre who
arrived later on said the same thing right away."
That indication is valuable because it shows
the importance, for the young copyist,
of the painter of the *Raft of the Meduse*.
We know about the friendship between
Erich Klossowski and Julius Meier-Graefe;
they both had catalogued the Cheramy collection
that included paintings by the master,
and the latter was also the author of a study
titled *Delacroix und Géricault*[2] that Balthus
may have read.
In 1928, Balthus was to copy one of the studies
for the canteen woman group of the *Raft
of the Meduse* (fig. 2). He could only have known
the drawing in reproduction,[3] but on the other
hand he may have been familiar with the *Portrait
of a Child* he copied here. Indeed the painting
had been shown in Paris in 1924 at the exhibition
of the P. Boucher collection and, if he copied it
but much later, we can assume he had
a photograph of it.
Hans Naef, who had bought this drawing directly
from Balthus and kept it up to his death, devoted
a number of articles and books to the work
of Ingres, and in particular a study in five volumes
on the portraits drawn by the master.[4]

[1] Letter of 19 November 1925, in *Rilke et Merline:
Correspondance 1920–1926*, Zürich 1954, p. 549.
[2] Munich undated (around 1914).
[3] The drawing was in London at the time, but had been
reproduced in the monograph by Clément (1879)
and the catalog of the J.P.H. collection in 1911.
[4] *Die Bildniszeichnungen von J.-A.D. Ingres*, Bentcli
Verlag, Bern 1977–80, 5 vols.

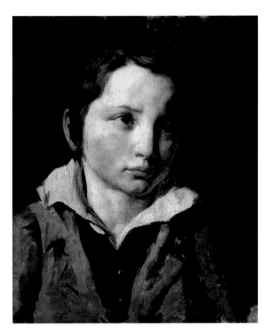

1. Théodore Géricault,
Portrait of a Child, oil on canvas,
46.5 × 38 cm.
Le Mans, Musée du Tessé,
formerly P. Boucher collection

2. Balthus, *Etude pour "Le Radeau
de la Méduse" (copy d'après
un dessin de Géricault)*
[Study for "The Raft of the
Meduse" (copy after a drawing
by Géricault)], 1928, pencil
and India ink on gray paper,
20.8 × 26.8 cm.
Cambridge, Mass., The Fogg Art
Museum, Harvard University

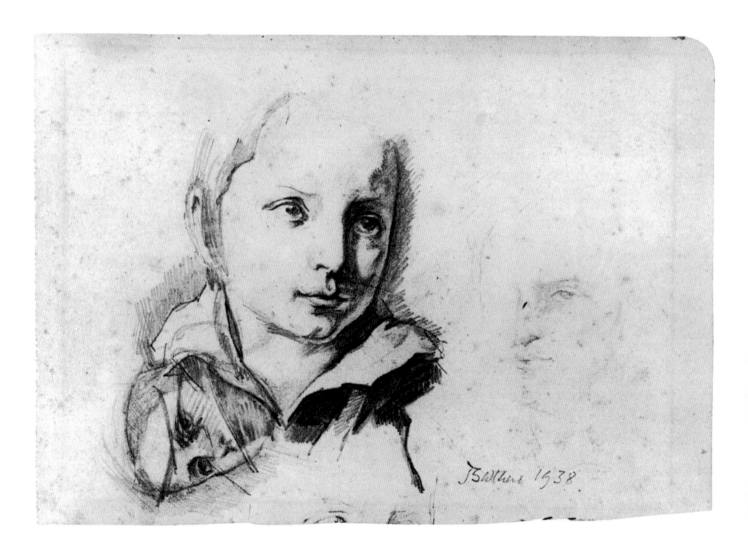

58. *Thérèse*, 1938

oil on wood
103 × 83 cm
signed and dated lower left:
"Balthus 1938"
Metropolitan Museum of Art,
New York, bequest
Mr and Mrs Allan D. Emil
in honor of William
S. Lieberman

provenance: purchased in 1958
in London by Mr and
Mrs Emil
exhibitions: New York 1938,
n. 15 (under the title *Fillette
au gilet rouge*); Paris, Arts
décoratifs 1966, n. 7;
Knokke-le-Zoute 1966, n. 7;
London, Tate Gallery 1968,
n. 11; Detroit 1969, n. 7;
Marseilles 1973, n. 6; Paris,
MNAM.CNACGP 1983–84, n. 19;
New York 1984, n. 18;
Lausanne 1993; Tokyo 1993–94,
n. 5; Madrid 1996; Rome
1996–97, p. 73; New York 2001
bibliography: Leymarie 1982,
p. 130 and 2nd ed. 1990, p. 130;
Klossowski 1983, pl. 14; catalog
MNAM.CNACGP, Paris 1983,
pl. p. 145 and p. 348 n. 53;
Kisaragi, Takashina, Motoe
1994, pl. 13; Xing 1995, pl. 14;
Klossowski 1996, n. 18;
Clair, Monnier 1999, n. P 113

Thérèse Blanchard was Balthus's most important
model between 1936 and 1939. He portrayed
her eleven times, of which three with her brother
(cats. 52, 53 and Clair, Monnier 1999, n. P 122)
and eight by herself or with her cat.
Serious most of the time (fig. 3), here the little girl
looks rather sulky, as though tired of the long
poses. She is charmingly dressed in a close-fitting
little jacket and a woolen skirt that shows
her thighs. She is barefoot and bare-legged,
her left leg crossed high on the right. But what
might be immodest in her position is offset
by the adolescent's natural distinction. Her frailty,
the delicacy of her bone structure and the elegant
way she holds her hands immediately rule out any
sense of provocation. Her hands, very carefully
drawn (fig. 2), already look like a woman's, as
though expressing her maturity, the self-possession
with which Thérèse enters puberty, the transition
from childhood to femininity.
We shall see her again in a painting of the same
year (fig. 1), dreamy, her eyes closed, on the studio
bench-seat, indifferent to her surroundings,
to her cat lapping milk in a saucer. Aware of her
seduction, her legs spread, immodestly showing
her crotch, her childish panties and the lace-
trimmed cotton slip she is wearing, she is
concentrating entirely on herself, repulsing
the viewer's gaze. Weary, with that weariness that
sometimes comes over children in puberty, she
seems, at the same time, to deny the exhibitionism
of her position. A pose that may not have been
natural to her, but imposed by the painter, and
that might stem from a *photomontage* by Man Ray,
published in 1935 in an issue of the *Minotaure*
review in which the same year seven of Balthus's
illustrations for *Wuthering Heights* appeared.[1]

[1] Cf. S. Rewald, "Balthus's Thérèses," *The Metropolitan
Museum Journal*, 33, 1998, pp. 305–14.

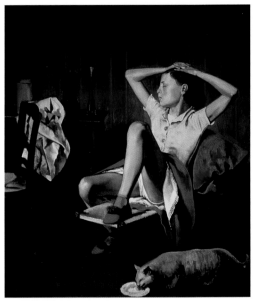

1. Balthus, *Thérèse rêvant*
[Thérèse Dreaming], 1938,
oil on canvas, 150.5 × 130.2 cm.
New York, The Metropolitan
Museum of Art, The Jack
& Natasha Gelman collection

2. Balthus, *Etudes de main
(pour "Thérèse") et de jambes
(pour "La Jupe blanche")*
[Study of Hand (for "Thérèse")
and Legs (for "The White Skirt")],
ca. 1937, 26 × 17 cm.
Private collection

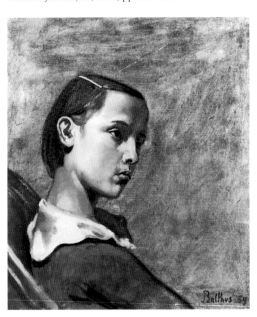

3. Balthus, *Portrait de Thérèse*
[Portrait of Thérèse], 1939,
oil on canvas, 55 × 46 cm.
Kochi Shinkin Bank

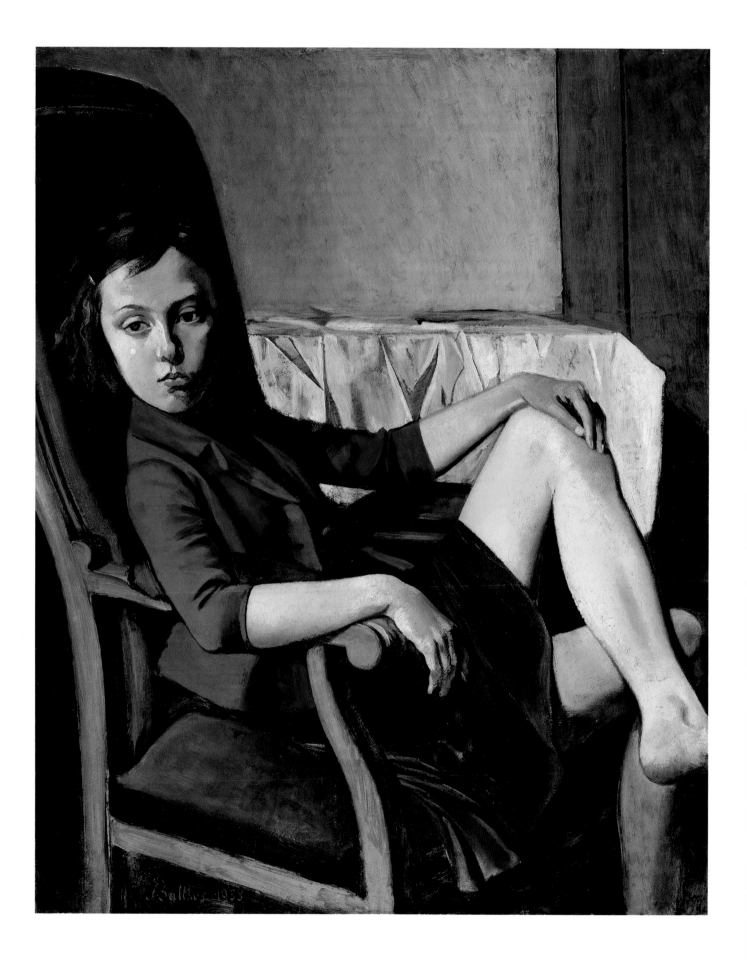

59. *Etude pour "Trois personnages dans un intérieur,"* 1939
[Study for "Three Figures in an Interior"]
60. Thérèse sur une banquette, 1939
[Thérèse on a Bench-seat]

59.
pencil on paper
34.5 × 24.5 cm
monogrammed lower right:
"Bs"
private collection

provenance: from the artist
exhibitions: Spoleto 1982, n. 34;
Andros 1990, n. 22; Rome 1990,
p. 79; Clair, Monnier 1999,
n. D 476

60.
oil on canvas
71 × 91.5 cm
signed and dated lower left:
"Balthus 1939"
Los Angeles, Richard
E. Sherwood family collection

provenance: 1964, Los Angeles,
Mr. et Mrs. Richard
E. Sherwood
exhibitions: Chicago 1964, n. 10
bibliography: Leymarie 1982,
p. 130 and 2nd ed. 1990, p. 131;
catalog MNAM.CNACGP, Paris
1983, p. 349 n. 56; Clair,
Monnier 1999, n. P 121

The last painting for which the Blanchard children posed, at the beginning of 1939, is titled *Trois personnages dans un intérieur* (cf. Clair, Monnier 1999, n. P 122). It is a peaceful scene, but where each person seems apart from the others.
Hubert is looking out the window, veiled in light; he is resting one hand on the back of a chair upon which he has put his knee, and the other on the window catch; he seems taken up with the street scene. Thérèse, half-reclining on a bench seat, is playing with her dog. She is holding in her right hand a yarn at the end of which there is a ball the pet is trying to catch. We discern, in an armchair, the silhouette of their mother reading a newspaper. On the table there are two round jars with goldfish swimming around.
At first, Balthus had placed the two children rather close to each other. We can glimpse, in the lower left corner of the drawing, Thérèse's head and arm, and two sheets from a sketch-book show the manner in which Balthus gradually built the scene. Thérèse's posture has not changed; instead, as he moved her away from her brother, Balthus altered the latter's position. His left arm, at first bent (fig. 1), stretched downward and his head leaned forward (fig. 2).
However, in putting a certain distance between the children and by placing them in two different spaces, Balthus did not create an affective separation between them, quite the opposite. We observe, indeed, in the painting, that if Thérèse's silhouette were straightened up, it would coincide nearly exactly with her brother's. The formal structure expresses here the complementarity between the two children, the close bond between them, if only in the diffused, shared boredom of an interminable winter afternoon.
In the same way that *Frère et sœur* (cat. 52) showed the two children removed from the initial scene that explained their attitude, Thérèse on a bench seat was painted a second time detached from any context. We no longer understand what her occupation is, since the ball of yarn and the dog have disappeared. Only the thin piece of yarn connects us with the reality of her game. A highly subjective reality, temporarily erased as the pet is erased, "in a precarious balance that will be maintained but a few moments… Balthus painted [here] one of the most emblematic pictures of that singular state, close to childish grace, that comes just before the graceless, heavy and awkward age of the adolescent."[1]
The plaid skirt, the red sweater, the socks and the large white collar that stand out on the moiré brown background belong to an extremely spare chromatic harmony, distributed according to an accurate triangulation, inspired perhaps by the great neo-classical compositions of French painting.

[1] J. Clair, "Le Sommeil de cent ans," in Clair, Monnier 1999, p. 38.

59

1. Balthus, *Etude pour "Trois personnages dans un intérieur,"* 1939,
pencil and India ink on paper,
36 × 24.5 cm.
Private collection

2. Balthus, *Etude pour "Trois personnages dans un intérieur,"* 1939,
pencil and India ink on paper,
36 × 24.5 cm.
Private collection

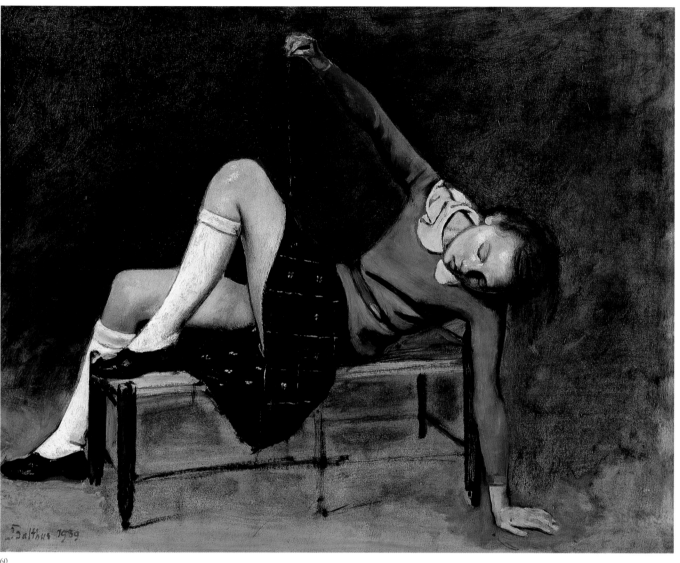

60

61. *Le chapeau bernois*, 1939
[The Bernese Hat]

oil on canvas
91.7 × 72.7 cm
signed and dated lower left:
"Balthus"
Hartford, Wadsworth
Atheneum, collection
Ella Gallup Sumner
and Mary Catlin Sumner

provenance: Pierre Matisse
Gallery, New York
exhibitions: New York 1949,
n. 17; New York 1956, n. 11;
Cambridge 1964, n. 11;
Chicago 1964, n. 9; London,
Tate Gallery 1968, n. 13;
Marseilles 1973, n. 8; Berkley
1980; Hartford 1981
bibliography: Leymarie 1982,
p.127 and 2nd ed. 1990, p. 127;
catalog MNAM.CNACGP, Paris
1983, p. 349 n. 59; catalog
Lausanne 1993, p. 66;
Clair, Monnier 1999, n. P 116

Antoinette posed for this painting wearing
the traditional large flat hat of the Bernese peasant
womenfolk, that Balthus had already used in two
still lifes of 1928 where the necessary tools for
farmwork were assembled: sickle, basket, milk
can, basket for grapes.[1] There is another portrait
of a woman wearing that hat, the one
of Dora Timm, who lived at Beatenberg
at Margrit Bay's (fig. 1).
In that portrait, as in Antoinette's, the hat is used
to enhance the oval of the face. Of Dora Timm
that is all we can see, with just a glimpse of her
hair pulled back; Antoinette's hair, instead, falls
on her shoulders, but a ribbon, tightly tied under
her chin, frames her cheeks. She is wearing a dark
jacket, with short tails, buttoned all the way up,
recalling her portrait of 1932 (cat. 20).
The shadow that divides her face along the ridge
of her nose roughly follows the diagonal
of the painting, in keeping with a familiar
composition scheme of Balthus's. The form
of the hat, the pale-colored straw it is made of,
brighten this austere portrait.

[1] See Clair, Monnier 1999, nn. P 45 and P 46.

1. Balthus, *Portrait de Dora Timm*
[Portrait of Dora Timm], 1925–26,
pencil on paper, 28 × 28cm.
Private collection

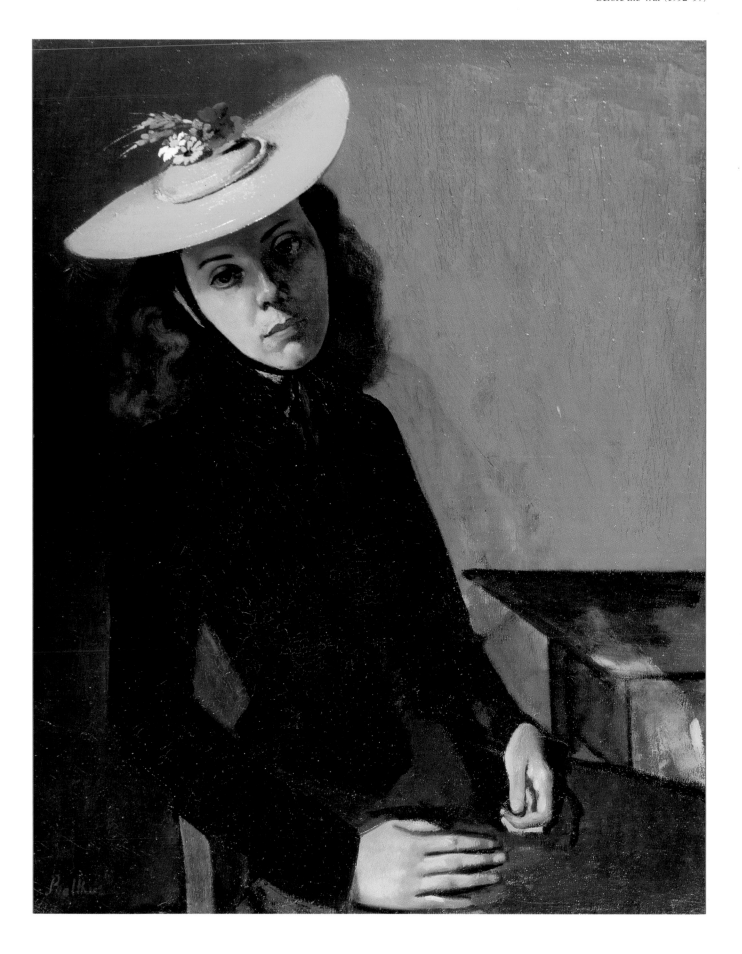

62. *Larchant*, 1939

oil on canvas
130 × 162 cm
Mendrisio, private collection
courtesy Massimo Martino
Fine Arts

provenance: Adolphe (Dola)
Mouron, known as A.M.
Cassandre; sale Galerie Motte,
Geneva, 25 May 1963;
Galleria Galatea, Turin;
private collection, Turin;
Società Assicuratrice Industriale,
Turin
exhibitions: Paris 1946, n. 6;
probably, Paris 1948; New York
1956, n. 12; Paris, Arts
décoratifs 1966, n. 8;
Knokke-le-Zoute 1966, n. 8;
London, Tate Gallery 1968,
n. 14; Venice 1980; Paris,
MNAM.CNACGP 1983–84, n. 21;
New York 1984, n. 21; Kyoto
1984, n. 6;
Rome 1996–97, p. 75.
bibliography: Leymarie 1978,
pl. 8 and 2nd ed. 1990, pl. 8;
Leymarie 1982, pl. p. 35
and p. 146 and 2nd ed. 1990,
pl. p. 34 and p. 151; Klossowski
1983, pl. 24; catalog
MNAM.CNACGP, Paris 1983,
pl. p. 149, p. 93 and p. 349
n. 57; catalog Musée cantonal
des Beaux-Arts, Lausanne 1993,
p. 78; Kisaragi, Takashina,
Motoe 1994, pl. 12; Xing 1995,
pl. 15; Roy 1996, p. 134;
Klossowski 1996, n. 32;
Clair, Monnier 1999, n. P. 123

The church of Saint-Mathurin in Larchant,
built at the same time as Notre-Dame in Paris
and belonging to the same chapter, was, up to
the late sixteenth century, the site of an important
pilgrimage for the healing of the insane
and the possessed. Burnt down by the Protestants,
ransacked, it was then abandoned and left to fall
in ruins. A restoration campaign was undertaken
in 1939 that would last twenty-five years.
It may have been Pierre Jean Jouve who first
acquainted Balthus with Larchant. In a poem,
published in 1938,[1] he had made the basilica
the symbol of his revolt and anguish over
the gathering clouds of war. He was to recall
the church in two poems written during his exile
in Switzerland, *Mémoire de Larchant*, published
in 1942,[2] and *Elancé de Larchant*.[3]
In his essay on *Balthus et Jouve*,[4] Robert Kopp,
using unpublished documents, throws light
on the closeness between the two men at the time
Larchant was being painted. The site appears
to have become for the two of them a shared,
meaningful "haven of memory."

> Ta ruine, église de Larchant
> Se jette à l'infini comme le miel
> Entre l'immense plaine aussi nue que la mer
> Et les vallées les côtes amoureuses
> Des bleuâtres toisons,
> D'ici poussant ce cri Réconciliation!
> L'écho est le cri de l'angoisse sous mon cœur:
> Le ciel écoute les barbares: bruissement
> Lointain du fer et plaies en mouvement.

[1] P.J. Jouve, "Ta ruine, église de Larchant," in *Kyrie*,
Gallimard, Paris p. 334.
[2] P.J. Jouve, in *Vers majeurs*, Egloff, Fribourg 1942
and in *Poésies*, Mercure de France, Paris 1965, p. 108;
repr. in *Balthus*, exhibition catalog, Paris 1983, p. 49.
[3] Published in 1945 in *La Vierge de Paris*, Egloff,
Paris p. 135; repr. in *Balthus*, exhibition catalog,
Paris 1983, p. 148.
[4] Cf. *supra*.

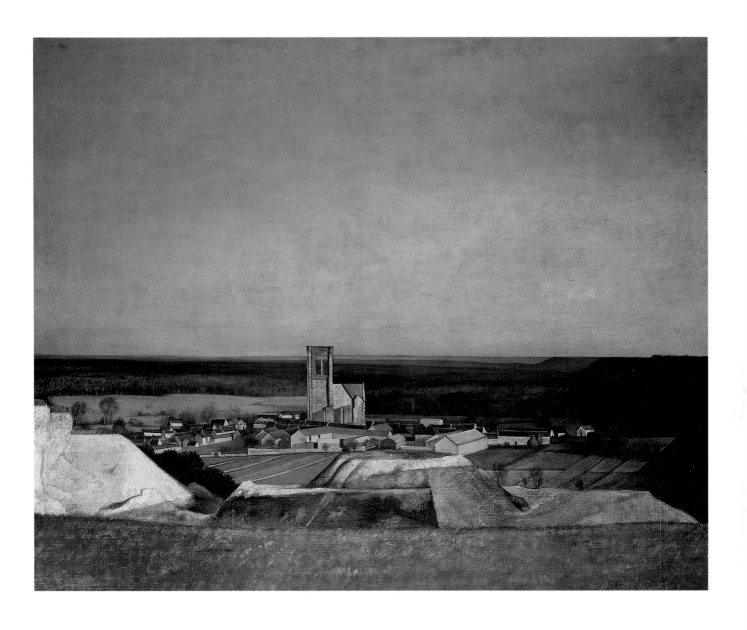

Balthus spent the years 1940–1946 in Savoie and then in Switzerland. The paintings of that period reflect his anguish over the cataclysm that overwhelmed the western world (*La Victime*) and the thoughtful, austere withdrawal following it.

After returning to Paris, Balthus investigated several themes, *Nus dans des intérieurs* or *Parties de cartes*, which he would regularly come back to during the next decade.

Several portraits—including those of Claude Hersaint and of Laurence Bataille exhibited for the first time—are of the same kind as the earlier ones. Three *Autoportraits* form, along with those presented in the previous sections, the totality of those extant.

The period ends with two major paintings, *Le Passage du Commerce-Saint-André* and *La Chambre*, that can be held to represent the aesthetic summing up of the first half of Balthus's œuvre.

63. *La Victime*, 1939–46
[The Victim]

oil on canvas
133 × 220 cm
private collection

provenance: Galerie Renou
et Colle, Paris
exhibitions: Paris 1946, n. 27
(under the title *La Victime I*,
dated 1939–46); Paris,
Arts décoratifs 1966, n. 3;
Knokke-le-Zoute 1966, n. 3;
Paris, MNAM.CNACGP, 1983–84,
n. 22; New York 1984, n. 20;
Ornans 1992, n. 13; Lausanne
1993; Madrid 1996
bibliography: Leymarie 1982,
p. 139 and 2nd ed. 1990, p. 143;
Klossowski 1983, pl. 23; catalog
MNAM.CNACGP, Paris 1983,
pl. p. 151 and p. 346 n. 38;
catalog New York 1984, p. 31
pl. 43; Clair 1984, p. 89 pl. 67;
Roy 1996, p. 83; Klossowski
1996, n. 28; Fox Weber 1999,
p. 312; Clair, Monnier 1999,
n. P 157

When Henriette Gomès showed this painting,
in 1946, before it was placed in the collection
where it still is, she titled it *La Victime I*, dating
it 1939–46.[1] *La Victime II*, known today
as *Nu couché* (fig. 2), was dated 1945.
When it was shown a second time, twenty years
later, *La Victime* [I], it was ascribed to 1937,
a date that has been repeated since then,
for no good reason. On the other hand, there
is a sommary sketch of it in a sketchbook where
all that remains is four studies for *Trois
personnages dans un intérieur* (cf. cat. 58,
figs. 1, 2) and three for *Larchant* (cf. cat. 62),
two works assuredly executed in 1939.
So we have chosen here to retain the dates given
in the 1946 catalog, on the assumption that,
the exceptional size of the canvas not permitting
him to remove it to Champrovent and then
to Switzerland, the painting had been begun in
Paris in 1939 and finished after the war ended.
La Victime II alias *Nu couché*, far smaller and
whose connection with *La Victime* [I] is more
of a formal nature than in depth, would have
been painted in the course of the year 1945.
La Victime belongs to a group of works painted
between 1937 and 1945, characterized by the
violence and ambiguity of a diffused sense of
impending danger, all the more anguishing since
it plays at once on the past and the future.
Thus, the *Nature morte* of 1937 (fig. 3) displays
the spectacle of a snack interrupted even before it
began. On a plain wooden table are placed a glass
and a full carafe of water, in a basket a brown
bread, a slice of which is placed on the clean
plate, and a ham with a big butcher's knife stuck
in it. The neck of an empty crystal bottle has
been broken by a hammer blow. A blue silk
garment has been left on the back of a chair.
Stillness and silence permeate the representation
of an event without our understanding its cause
nor what is to come out of it.
In 1940, Balthus painted two matching pictures;
they are the same format (30 points: 92 × 73 cm)
used in one case vertically and the other
horizontally, featuring the same silverware bowl
and the same glass of cider.
L'Enfant gourmand (fig. 1), an obese, clumsy
baby, may succeed in grabbing the bowl but will

probably in the meantime break the glass sitting
on the corner of the mantel-shelf. Was the glass
not broke? It is there again in *Le Goûter*
[The Afternoon Snack], where the threat comes
from a knife driven through the rustic loaf
of bread. A threat that eliminates any possible
reference to a sacred scene revealed by the heavy
curtain drawn by the young girl, or to a
eucharistic meal laid out on a lace tablecloth
similar to an altarcloth.
The third painting of the group has already been
described (cat. 54, fig. 2). Here we shall only
point out the iconographic alteration performed
on it, just before Henriette Gomès exhibited it,
late 1946 (cf. cat. 54, note 1). The bread loaf,
quite a bit larger than in the first version,
now has a knife stuck in it, introducing in the
scene an unexpected temporality and aggressivity:
if the young girl stuck the knife in the loaf before
seizing the candlestick, it was not without
a reason; once again here we have the feeling time
is suspended, laden with a threatening future.
In *La Victime*, the knife is in the foreground,
pointed at the girl's heart, but there are no signs
of blood or a wound. It is not the cause of the
state of catalepsy the young girl is in. Her face
is tumefied, her body blued, she may have been
the victim of a rape, like the eponymous heroin of
the novel by Pierre Jean Jouve (1935), dedicated
to Balthus. Midway between life and death,
we notice that her position recalls, in reverse,
that of Poussin's *Narcissus* (cf. cat. 33, fig. 1). But
we also wonder about the meaning of the string
with a lead weight hanging from her left foot.
Outstretched on the winding-sheet shaped like
a mandorla, her eyes rolled back, *La Victime*
is an enigma. "It is the Bluebeard aspect
of this painting," Albert Camus wrote.[2]
"Balthus is too fond of limits to not leave room
for crime where sometimes the most fearsome
knowledge is accomplished."

[1] See exhibition catalog, repr. in Clair, Monnier 1999,
p. 567.
[2] A. Camus, "Nageur patient...," preface to *Balthus*,
exhibition catalog, New York 1949; French trans.
in *Balthus*, exhibition catalog, Marseilles 1973
and Paris 1983, pp. 76–77.

1. Balthus, *L'Enfant gourmand*
[The Greedy Child], 1940,
oil on canvas, 92 × 73 cm.
Private collection

2. Balthus, *Nu couché*
[Reclining Nude], 1945,
oil on canvas, 44.5 × 59.7 cm.
Private collection

3. Balthus, *Nature morte* [Still Life],
1937, oil on panel, 81 × 99 cm.
Hartford, Connecticut, Wadsworth
Atheneum, collection Ella Gallup
and Mary Catlin Sumner

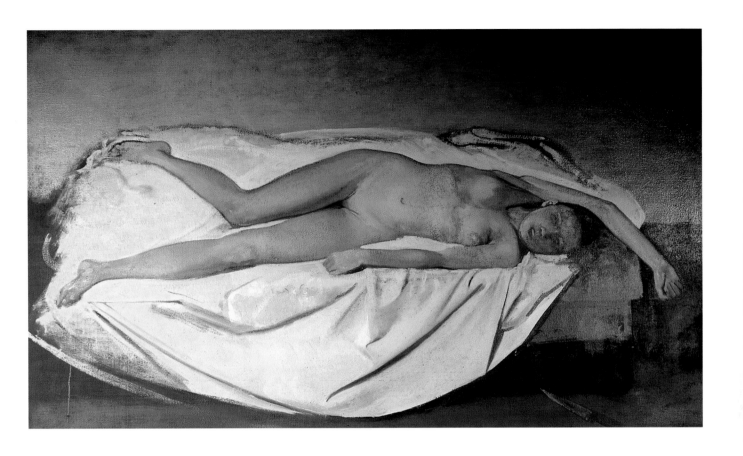

64. *Autoportrait*, 1940
[Self-portrait]

oil on canvas
44 × 32 cm
monogrammed
lower left: "B"
dated upper right:
"Juillet 1940"
private collection

provenance: Antoinette
de Watteville; Stanislas
Klossowski de Rola
exhibitions: Lausanne 1993;
Tokyo 1993, n. 6; Hong Kong
1995, n. 6; Beijing 1995, n. 6;
Taipei 1995, n. 6; Madrid 1996;
Rome 1996–97, p. 79;
Karuizawa 1997, p. 55.
bibliography: Kisaragi,
Takashina, Motoe 1994, pl. 15;
Roy 1996, p. 14; Klossowski
1996, n. 1, 30-31; Clair, Monnier
1999, n. P 124

When the war broke out, in September 1939,
Balthus was drafted and sent to Alsace.
He returned to civilian life three months later for
reasons of health and in the early summer of 1940
settled in the farm of Champrovent, in the hamlet
of Vernatel, near Aix-les-Bains. He had already
been there with Pierre and Betty Leyris and
painted *La Falaise* and the two versions of *Sous-
bois*. In Savoie, he was back with Antoinette, who
had spent the early days of the war in Switzerland.
The hall of the castle-farm of Champrovent was
the background for the *Salon*, whereas the village
of Vernatel and the landscapes of Bugey can be
found in several works of the time (cat. 65).
Balthus and Antoinette stayed at Champrovent
until early 1942.
The 1942 *Autoportrait* is exactly concurrent
with the *Cérisier* (fig. 3). John Russel compared
that summer scene to a detail of Poussin's *Autumn*
(fig. 2), suggesting considering it not strictly
speaking a loan, but the use of an old model
as a stimulating element for a new impetus[1].
Balthus was irritated by that kind of comparison,
but it must be observed that there is a likeness
on the formal level that tends, in both cases, to
elevate the subject to an intemporal plenitude.
The small *Autoportrait* of the summer of 1940
is striking by its austerity. His face severe,
his brow creased, the artist is seated in profile, his
head slightly turned toward the mirror he is using
to see himself. He holds a brush in his left hand
(the right in reality) and a rag in the other.
The canvas he is working on is not even sketched
out. The extreme thinness of the background layer
of paint is such that from a distance it completely
fades away and only the effigy is left. The white
of the shirt collar, placed on the diagonal, dazzles
between the grayish-green of the jacket
and the subtle flesh tones.
Balthus was merely 32 years old when he painted
this portrait; but his lined face, shaded

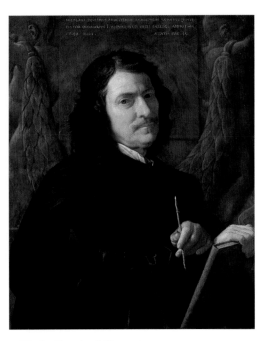

1. Nicolas Poussin, *Self-portrait*,
1649, oil on canvas, 78.3 × 64.5 cm.
Berlin, Staatliche Museen,
Gemäldegalerie

by a stubble of a beard, the bitterness of the lines
of his mouth make him appear older. It is
the countenance of a man whom life, the war,
suffering has marked. We have the feeling
he is no longer staging himself, as he had done
in *Le Roi des chats* (cat. 49), or suggesting
a definition of himself as he would in the 1949
Autoportrait (cat. 84), but expressing an essential
dimension of his being. The classicism of the pose,
the sobriety of the composition and the pictorial
means used recall a pictorial tradition that belongs
to the great seventeenth-century French
portraitists. We are certainly not dealing
with a copy, nor even a loan from such and such
a master, but with a likeness of composition,
a spiritual kinship that allows to place this portrait
in a lineage and to mention the name of Poussin,
from whom, even very recently, Balthus drew
his inspiration for his *Songe d'une nuit d'été*
[Mid-Summer Night's Dream].[2]

[1] J. Russel, preface to *Balthus*, exhibition catalog,
London, Tate Gallery 1968, reprinted in *Balthus*,
exhibition catalog, Paris 1983, pp. 280–97.
[2] To celebrate the millenium, the National Gallery of
London invited 24 living artists to create a work freely
inspired by a painting from its collection. Balthus chose
the *Sleeping Nymph Surprised by Two Satyrs* of 1626–27.
See *Encounters*, exhibition catalog, London, National
Gallery, June–September 2000.

2. Nicolas Poussin, *Autumn*,
1660–64, oil on canvas,
118 × 160 cm, detail.
Paris, Musée du Louvre, Inv. 7305

3. Balthus, *Le Cerisier* [The Cherry
Tree], 1940, oil on panel, 92 × 72.9 cm.
Mr. and Mrs. Henry Luce III

65. *Paysage de Champrovent*, 1941–43 (touched up 1945)
[Landscape at Champrovent]

oil on canvas
96 × 130 cm
signed and dated lower right:
"Balthus/Champrovent
1941–45"
private collection
provenance: private collection
exhibitions: Geneva 1943,
n. 5 (dated 1941-43, not
reproduced); Paris 1946, n. 14
(dated 1941-45); Venice 1980;
Paris, MNAM.CNACGP 1983–84,
n. 27; New York 1984, n. 25;
Kyoto 1984, n. 9; Lausanne
1993
bibliography: Leymarie 1978,
pl. 10 and 2nd ed. 1990, pl. 10;
Leymarie 1982, pl. p. 38 and p.
146 and 2nd ed. 1990, pl. p. 38
and p. 151; Klossowski 1983,
pl. 28/29; catalog
MNAM.CNACGP, Paris 1983,
pl. p. 159 and p. 353
n. 77; Xing 1995, pl. 20;
Roy 1996, p. 129; Klossowski
1996, nn. 38–39; Clair,
Monnier 1999, n. P 135

This landscape was exhibited in 1943 at the
gallery Moos in Geneva that presented Balthus's
first one-man show in Switzerland. It featured
twelve paintings: two portraits, one *Dormeuse*,
two still-lifes, four landscapes. Pierre Courthion,
who wrote the catalog preface, was immediately
aware of their importance in Balthus's work:
"One of the painter's secrets is not in just making
us touch with our eyes—like a Courbet—
the things he wanted to represent, but moreover,
in order to communicate with us on a deeper
level, painting the things beneath things.
Thus we recognize in the 'Paysage de
Champrovent'—the skeleton under the flesh—,
the artist's underground landscape."
Likewise, the *Paysage aux bœufs* (fig. 1), that
extends it on the right and in which again appears
a big dead tree, has a weightiness and a gravity
that Jean Starobinski pointed out on reviewing
the exhibition: "The landscapes, the figures,
the gestures we observe in these paintings,
we know that their secret, necessary effects
helped the painter to oppose the catastrophe
and degradation all around him."[1]
Of course, on seeing these works, we are
reminded of Courbet, of his Comté landscapes,
huge and highly composed, not so unlike those
of the Bugey, and his views of the shores of lake
Geneva, painted during his exile in the Vaud
where he died. Certainly Balthus thought
of him when he painted, in 1940, the *Paysage*
representing the lake of Bourget[2] and copied,
the same year, the *Wounded Man* of the Louvre
and the *Man with Pipe* of the Musée Fabre
in Montpellier, of which he must have owned
reproductions.[3]

[1] J. Starobinski, "Des peintures de Balthus à la galerie
Moos," *Le Curieux*, 13 November 1943. Repr. in
Balthus, exhibition catalog, Paris 1983, pp. 68–69.
[2] Cf. Clair Monnier 1999, n. P 127. Balthus gave that
painting to the vicomtesse de Noailles in 1951. It hung
at the bottom of the grand stairway of her residence
on the Place des Etats-Unis in Paris. Cf. Ph. Julian,
"Une des maisons-clés pour l'histoire du goût
au XXᵉ siècle," *Connaissance des Arts*, 152,
October 1964, p. 70.
[3] Cf. Clair Monnier 1999, n. D 479.

1. Balthus, *Paysage aux bœufs
(le Vernatel)* [Landscape
with Oxen (the Vernatel)],
1941–42, oil on canvas,
72 × 100 cm.
Private collection

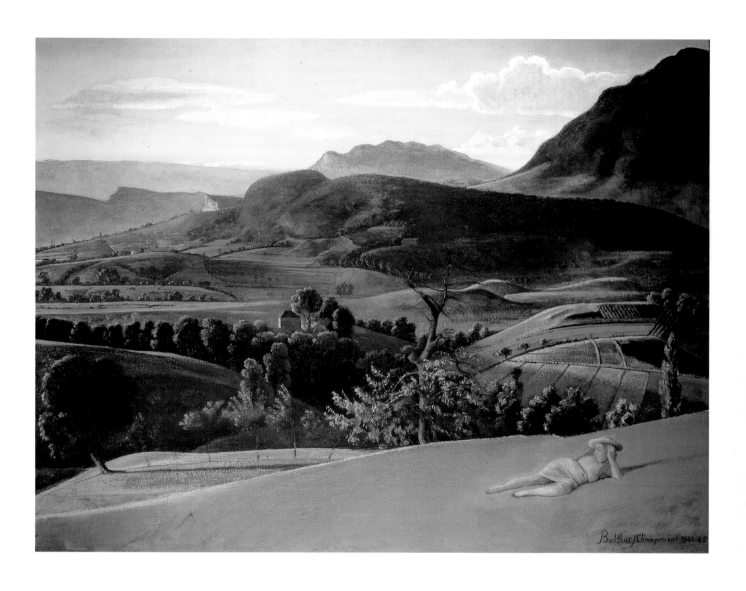

66. *Portrait d'Antoinette*, 1942 [Portrait of Antoinette]
67. *Jeune fille au pull-over vert et rouge*, 1942 [Girl with Green and Red Pullover]
68. *Portrait d'Antoinette*, 1943 [Portrait of Antoinette]

66.
pencil on paper
26 × 20 cm
monogrammed lower right:
"Bs"
dated lower left: "Dans
la nuit du samedi au dimanche
13 mars 1942"
dedicated lower right:
"Pour Stasz Noël 1988"
private collection

provenance: the artist
exhibitions: Andros 1990, n. 29;
Rome 1990, p. 83; Lausanne
1993; Tokyo 1993–94, n. 33;
Madrid 1996; Rome 1996–97,
p. 166, New York 2000, n. 1
bibliography: Clair,
Monnier 1999, n. 489

67.
pastel on paper
32.5 × 27.9 cm
dated, signed and inscribed
on the reverse on the panel:
"1942/Balthus/Berisville"
Stanislas Klossowski de Rola

provenance: Antoinette
de Watteville
exhibitions: Lausanne 1993;
Tokyo 1993, n. 32; Rome
1996–97, p. 131; Karuizawa
1997, p. 96; Zurich 1999,
n. 20; New York 2000, n. 2
bibliography: Klossowski 1996,
n. 44; Clair, Monnier 1999,
n. P 133

68.
pencil on paper
82.5 × 75 cm
Stanislas and Thadée
Klossowski de Rola

provenance: Antoinette
de Watteville
exhibitions: Bevaix 1975, n. 16;
Spoleto 1982, n. 38; Paris,
MNAM.CNACGP 1983–84, n. 76;
Kyoto 1984, n. 38; Andros 1990,
n. 31; Rome 1990, p. 84;
Lausanne 1993; Tokyo 1993–94,
n. 34; Bern 1994, n. 26; Madrid
1996; Rome 1996–97, p.165;
Karuizawa 1997, p. 96; Zurich
1999, n. 21; New York 2000,
n. 3
bibliography: catalog New York
1984, p. 80 fig. 102; Roy 1996,
p. 110; Clair, Monnier 1999,
n. D 490

The likeness between the first two portraits leads
us to presume they were executed within
an interval of a few days, during one of Balthus's
and his wife's stays at Beatenberg, next to which
lies the village of Bérisville, whose name figures
on the reverse of the second, after the signature.
Antoinette is shown in three-quarters, once facing
left and once right, and we have a hint, on the
drawing, of the neck of the sweater she is wearing
in the pastel (see also *Jeune fille en vert et rouge*,
cat. 54, fig. 2). In the first her head is a bit
inclined and her gaze dreamy, as we shall see
in the half-length portrait of 1943, in the second,
she holds her head erect and looks at the painter.
Balthus rarely used pastels, three or four are
documented, but this is the only one known
to date.
The third portrait shows Antoinette, slightly
languid, seated at an angle in a large armchair.
She has one hand on the belt of her dress,
the other on a cushion. She seems absorbed
in a secret daydream; as a matter of fact,
she told us,[1] she was pregnant with her second
son at the time of the execution of this portrait
she was especially fond of.

[1] During a visit to her in May 1993.

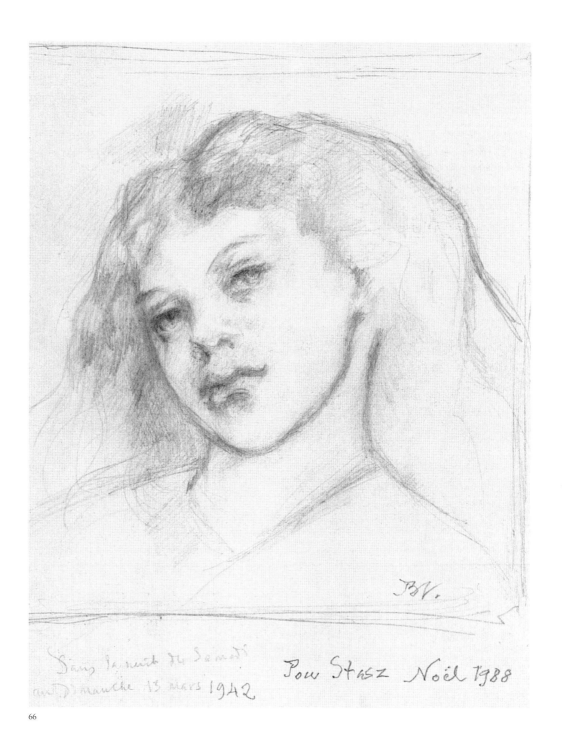

66

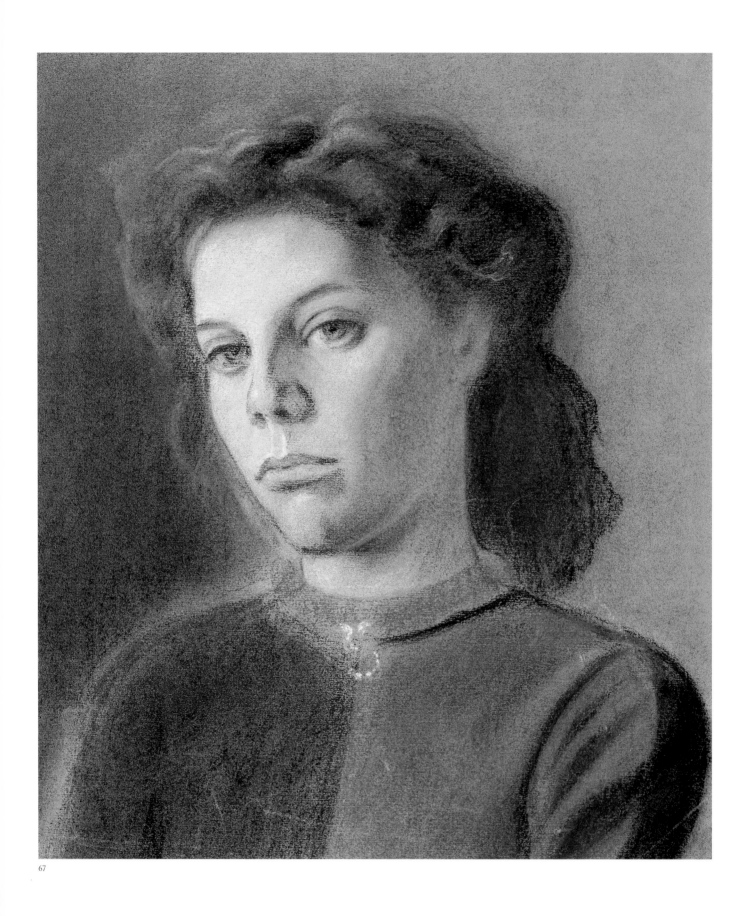

67

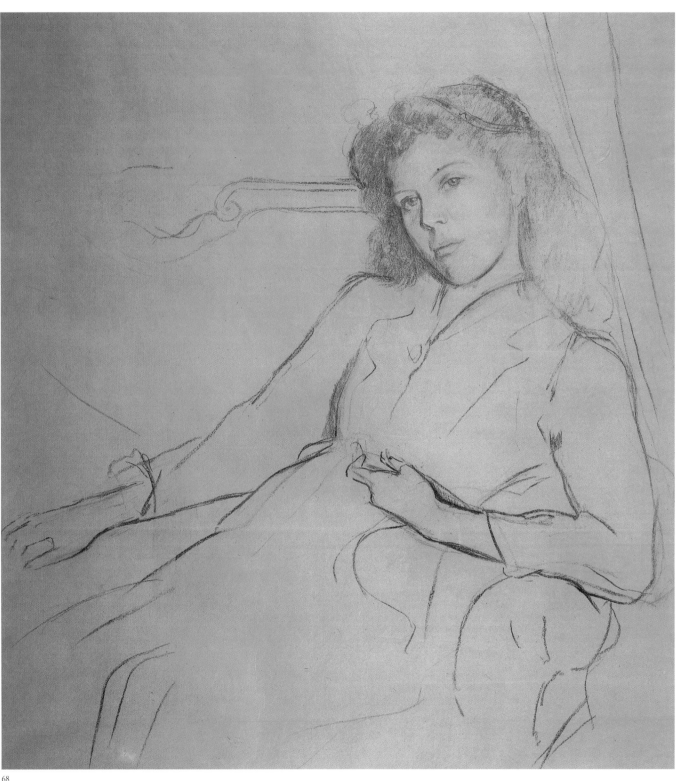

68

69. *Autoportrait*, 1943
[Self-portrait]

charcoal on paper
63 × 45.7 cm
monogrammed and dated
lower left: "Bs 43"
private collection

provenance: Pierre Matisse,
New York
exhibitions: Detroit 1969, n. 30;
Marseilles 1973, n. 52; New
York 1977, n. 17; Spoleto 1982,
n. 36; Paris, MNAM.CNACGP
1983–84, no.78; New York 1984
(not numbered, repr. back
cover); Kyoto 1984, n. 40;
Andros 1990, n. 28; Rome 1990,
p. 82; Lausanne 1993; Tokyo
1993–94, n. 35; Bern 1994,
n. 25; Madrid 1996; Zurich
1999, n. 22
bibliography: Leymarie 1978
p. 6 and 2nd ed. 1990, p. 6;
Leymarie 1982, p. 8
and 2nd ed. 1990, p. 8;
Xing 1995; Roy 1996, p. 18;
Fox Weber 1999, p. 421;
Clair, Monnier 1999, n. D 491

This *Autoportrait* is extremely similar to another
one, drawn the year before and today lost
(cf. Clair, Monnier 1999, n. D 486). They both
are concurrent with the portraits of Antoinette
presented above. Balthus appears in three-
quarters, half-length, and his face, lit from
the right, is serene, quite different from
the painted *Autoportrait* of 1940 (cat. 64).
The brow is smooth, the lips stretched in a hint
of a smile, the composition is airy, the charcoal
line stumped on the hair. We have the impression
of a moment of quietude, of respite in the midst
of a difficult existence and period.

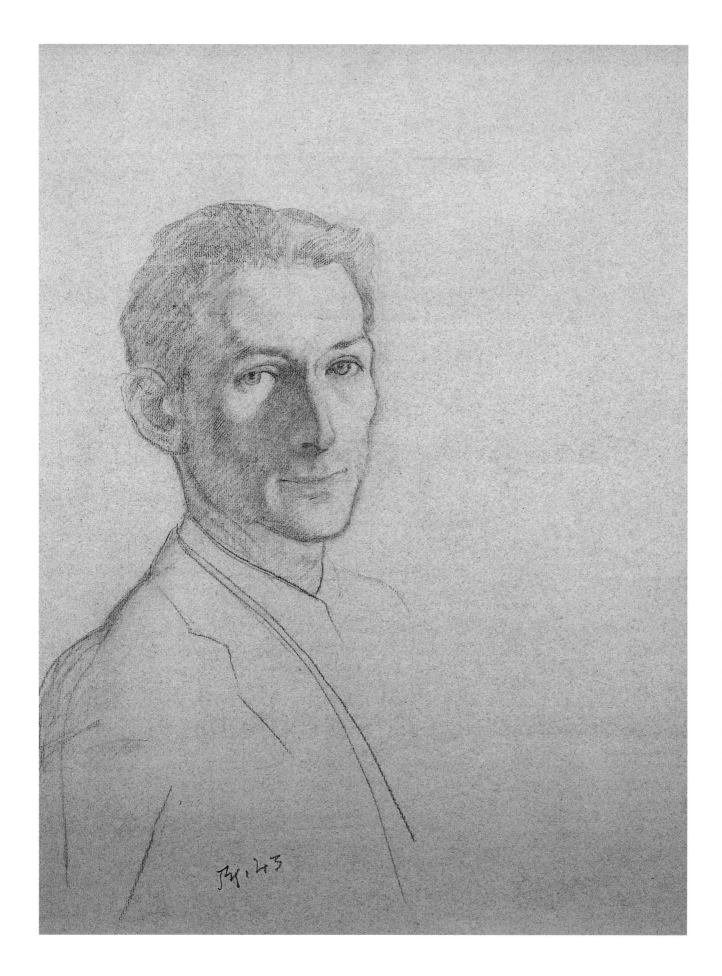

70. *La Patience*, 1943 (altered between 1946 and 1948)
[The Game of Patience]

oil on canvas
161.3 × 165.1 cm
signed and dated lower left:
"Balthus 43"
Chicago, The Art Institute, the
Joseph Winterbotham collection

provenance: Pierre Matisse
Gallery, New York, purchased
from the artist in 1948
exhibitions: Geneva 1943, n. 11;
Paris 1946, n. 17; New York
1949, n. 20; New York 1956,
n. 15; New York 1962, n. 6;
Cambridge 1964, n. 12;
Chicago 1964, n. 12; London,
Tate Gallery 1968, n. 20;
Chicago 1980, n. 3; Paris,
MNAM.CNACGP 1983–84, n. 28;
New York 1984, n. 27
bibliography: Leymarie 1982,
p. 131 and 2nd ed. 1990, p. 132;
Klossowski 1983, pl. 31; catalog
MNAM.CNACGP, Paris 1983,
pl. p. 161 and p. 351 n. 66;
catalog Lausanne 1993, p. 47;
Kisaragi, Takashina, Motoe
1994, pl. 21; Roy 1996, p. 20;
Klossowski 1996, n. 41;
catalog Dijon 1999,
p. 78; Clair, Monnier 1999,
n. P 14

For the first time, with this painting, the card
game theme appears in Balthus's work, either
solitaire, as here, or with two players (cf. cat. 89),
a subject he was to treat eight times, over a span
of thirty years.

This first representation offers a peaceful scene
placed in a space closed to the left by a heavy
curtain and a large wing chair. The player, a girl,
standing, her two hands resting on the marquetry
table, rests her knee on a velvet-upholstered stool.
The composition is balanced, the body forming
a complementary angle to that of the curtain,
and stands out against a striped wall covering
that, at first, went all the way to the right edge
of the canvas.[1] A tapestried pillow, a painted box,
a pewter bowl, a rug complete the elegant setting.
The lighting of the scene is what confers on it a
disquieting connotation: the young girl's face is in
the shadow, as well as the cards she is leaning over,
and we wonder about the meaning of the snuffed
candle placed in front of her. The presence
of the curtain then becomes ambiguous: is it
merely part of the decoration, masking a hallway,
a stairway? Or a curtain that suddenly drawn
unveils the secret game the girl is indulging in?
One of the preparatory sketches for the painting
(fig. 1) shows the work performed on arranging
the curves of the furniture: the back of the chair,
that later would disappear, the legs of the chairs
and table with the cut-out edge. Between the table
legs we glimpse a sketchy outline of a cat chasing
a ball. Card game, ball game: that combination
will return in a second *Patience*, refined and much

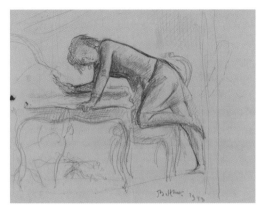

1. Balthus, *Etude pour "La Patience"*
[Study for "The Game of Patience"],
1943, pencil on paper, 25.2 × 31 cm.
Stanislas Klossowski de Rola
collection

smaller, painted at Chassy ten years later (fig. 3).
La Patience of 1943 is also interesting because
of its formal likenesses with the various *Parties
de cartes* to come. Thus, for instance, in a
preparatory study (fig. 2) for the one of 1948–50
(cat. 89), there is again a like organization of space
and a recollection, in the player on the right,
of the one we see here.

[1] There is a photograph of it, published in *Cahiers d'art*,
1945–46, vols. XX–XXI, p. 205.

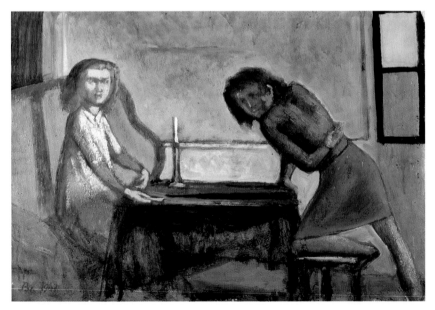

2. Balthus, *Etude pour "La Partie
de cartes"* [Study for "The Card
Game"], 1947, oil on cardboard,
44 × 63 cm. Location unknown

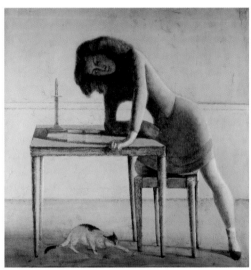

3. Balthus, *La Patience*, 1954–55,
oil on canvas, 90 × 88 cm.
Private collection

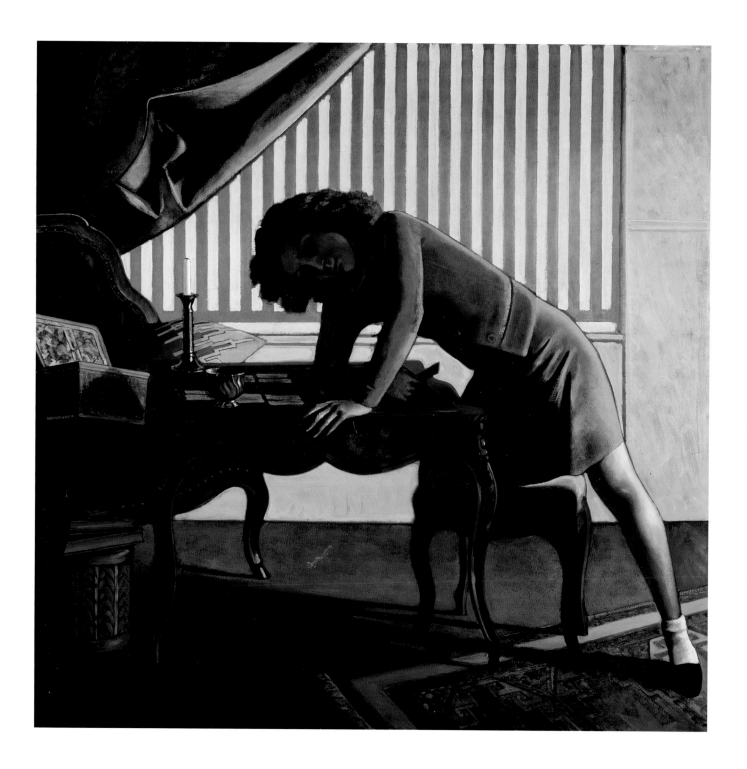

71. *Etude pour "Les Beaux jours,"* 1944 [Study for "The Happy Days"]
72. *Les Beaux jours,* 1944–46 [The Happy Days]

71.
oil on paper mounted
on canvas (remounted)
37 × 44.5 cm
monogrammed and dated
lower left: "B 44"
private collection

provenance: Galerie Henriette
Gomès, Paris
exhibitions: Ornans 1992, n. 17
bibliography: catalog
MNAM.CNACGP, Paris 1983,
p. 352 n. 73; Leymarie 1990,
p. 132; Roy 1996, p. 88;
Clair, Monnier 1999, n. P 150

72.
oil on canvas
148 × 200 cm
Washington, Hirshhorn
Museum and Sculpture Garden,
Smithsonian Institution,
gift of the Foundation
Joseph H. Hirshhorn

provenance: Pierre Matisse
Gallery, New York; 1959,
Joseph Hirshhorn
exhibitions: Paris 1946, n. 25;
New York 1949, n. 19;
New York 1956, n. 16; Paris,
Arts décoratifs 1966, n. 13;
Knokke-le-Zoute 1966, n. 13;
London, Tate Gallery 1968,
n. 23; Venice 1980; Paris,
MNAM.CNACGP 1983–84, n. 30;
New York 1984, n. 28; Kyoto
1984, n. 10; Lausanne 1993
bibliography: Leymarie 1978,
pl. 14 and 2nd ed. 1990, pl. 15;
Leymarie 1982, pl. p. 48
and p. 132 and 2nd ed. 1990,
pl. p. 45 and p. 132; Klossowski
1983, pl. 32; catalog
MNAM.CNACGP, Paris 1983,
p. 67, pl. p. 164, pp. 272, 276
and p. 352 n. 71; Clair 1984,
p. 50 fig. 36, p. 53 fig. 40
and p. 63 fig. 48; Davenport
1989, fig. 7; Kisaragi, Takashina,
Motoe 1994, pl. 23; Xing 1995,
pl. 23; Roy 1996, p. 89; Clair
1996, p. 77; Klossowski 1996,
n. 47; Costantini 1996;
Fox Weber 1999, pl. 4;
Clair, Monnier 1999, n. P 155;
Vircondelet 2000, p. 14

The study for *Les Beaux jours* presented here
is probably the first of the two (fig. 1) Balthus
made, since the model's pose differs quite
a bit from what it will become in the final version
of the painting.
It is all the more interesting, since it illustrates
the slow evolution of certain ideas, certain images,
in Balthus's thinking. Thus, the backward-
reclining position, one leg bent, of the young girl
will reappear in a whole series of paintings in the
years 1948–49 (cats. 76–77, fig. 1 and cats. 80–81,
fig. 1), achieving its final expression in the
masterful 1952–54 *La Chambre* (cat. 93).
Likewise the handmirror, appearing here
for the first time, will return in the second version
of the *Trois sœurs* (1955, cat. 102), still again in
La Chambre turque of 1963–66 (cats 127–128,
fig. 1) and, associated with the cat as in the second
study for *Les Beaux jours* (fig. 1), in the three
versions of the *Chat au miroir* of the years
1977–94 (cats. 156, 158, 159).
Jörg Zutter discovered that *Les Beaux jours*
had been the first painting by Balthus ever shown
in a museum. Indeed, he had included it
in an exhibition titled "Ecole de Paris," presented
at the Kunsthalle of Bern in 1946, of which
he had been the promoter, in collaboration
with the French Embassy[1].
The young girl coyly preening in her mirror,
lit by the light from the window in front of which
are placed a table and a white enamel basin, seems
oblivious of her companion. Yet her half-bared
breast, her widely parted legs are an unequivocal
appeal to which the desire of the man, bent over
the blazing fire, responds. Balthus always denied
his torso was bare, but the shirt he is wearing
seems his very flesh, warmed by the flames
as much as by the young girl. We are aroused
on observing the smooth-faced child-woman,
not knowing whether she will refuse or let herself
be taken by the man and love-play. It is that
uncertainty, that ambiguity that underlies the
eroticism of the scene.
A stanza of a poem by Paul Eluard, dedicated
to Balthus and published in 1947, might well be
inspired by this painting, that had been shown
the previous November at the galerie Beaux-Arts:

> La flamme naine perd sa fleur dans son miroir
> Et ce rire est la fin du rire pour toujours
> Et cette source est la première et la dernière.[2]

[1] J. Zutter, *Balthus*, exhibition catalog, Lausanne 1993,
p. 27. The picture was under n. 28.
[2] P. Eluard, "A Balthus," poem appearing in *Les Cahiers
du Sud*, Marseilles 1947. Reprinted in *Voir*, Ed. des Trois
collines, Genève 1948.

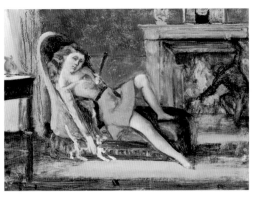

1. Balthus, *Etude pour "Les Beaux
jours,"* 1944, oil, 80 × 100 cm.
Location unknown

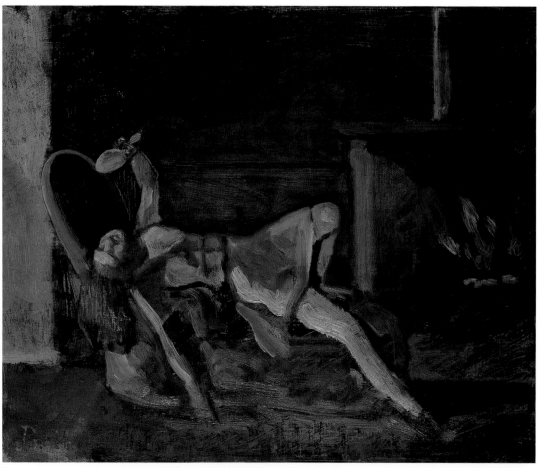

71

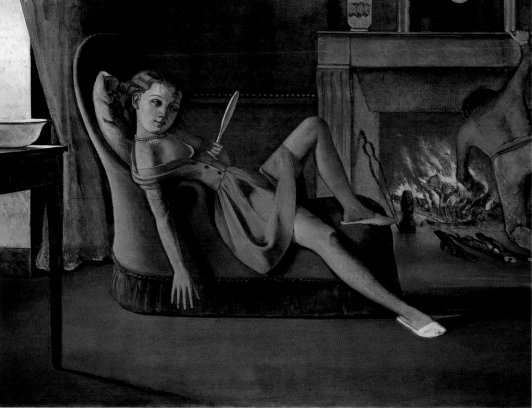

72

73. *Jeune fille*, 1946
[Girl]

oil on cardboard
40.7 × 33 cm
monogrammed and dated
lower right: "B 1946"
Mendrisio, private collection
courtesy Massimo Martino
Fine Arts

provenance: Marguerite Caetani,
duchess of Sermoneta,
purchased from the artist;
private collection, Baltimore,
USA; sale Christie's, London,
30 March 1981, n. 73;
Galleria Il Gabbiano, Rome
exhibitions: Paris 1946
bibliography: Leymarie 1982,
p. 132 and 2nd ed. 1990, p. 134;
catalog MNAM.CNACGP, Paris
1983, p. 352 n. 76; Clair,
Monnier 1999, n. P 159

This painting, that appears among the negatives
of the 1946 exhibition, is not illustrated
in the catalog, but may have replaced the *Portrait*
that was under n. 26 and has not been identified.
Here we have the first appearance, in a painting,
of the old woman, a duegna or concierge,
an avatar of the Nelly of *Wuthering Heights*
(cf. cat. 30), whom we find on various occasions
(cat. 83) in that period. She is withdrawn,
in the semi-darkness, all the light being focused
on the young girl. The latter is seated at an angle
in front of her dressing-table; she has already
arranged her hair and, having slipped down
the top of her long nightgown, is probably about
to dress. Luminous and tranquil, she is the
embodiment of youth in contrast with the old
woman's rheumatism-bound posture.
There is a variant of this picture, probably painted
the year after. The pose of the model is identical,
but the young woman has a more developed body,
heavier breasts; she is sitting in a bed holding
onto the sheets so the atmosphere of the painting
becomes entirely different.

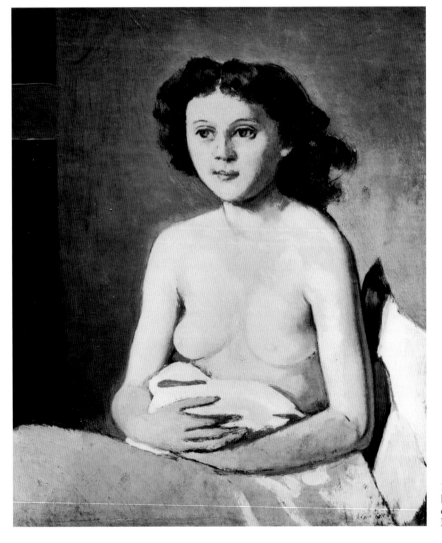

1. Balthus, *Buste de jeune fille*
[Bust of a Girl], 1947,
oil on canvas, 40.5 × 37cm.
Location unknown

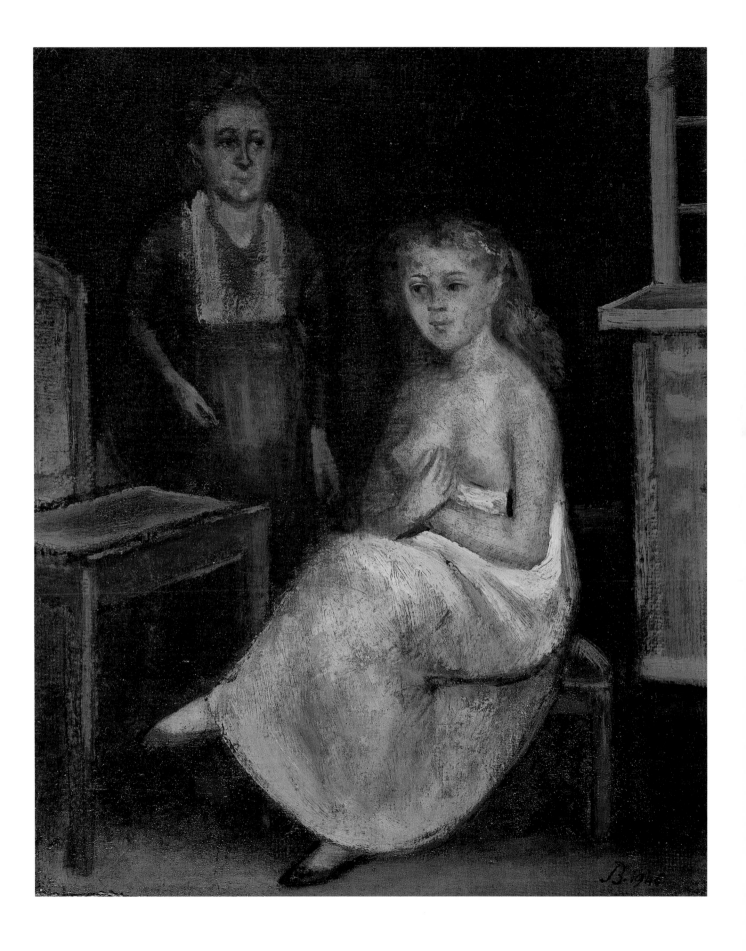

74. *La Chambre*, 1947–48 [The Room]
75. *Jeune fille à sa toilette*, 1948 [Girl at Her Toilet]

74.
oil on canvas
189.9 × 160 cm
signed and dated lower left:
"Balthus 1947–48"
Washington, Hirshhorn
Museum and Sculpture Garden,
Smithsonian Institution,
gift of the Joseph
H. Hirshhorn Foundation

provenance: Pierre Matisse
Gallery, New York, purchased
from the artist; 1959,
Joseph Hirshhorn
exhibitions: New York 1949,
n. 21; New York 1956, n. 17;
Cambridge 1964, n. 13;
Chicago 1964, n. 13; Paris,
Arts décoratifs 1966, n. 14;
Knokke-le-Zoute 1966, n. 14;
London, Tate Gallery 1968,
n. 26; Madrid 1996
bibliography: Leymarie 1982,
p. 140 and 2nd ed. 1990, p. 144;
catalog MNAM.CNACGP, Paris
1983, p. 355 n. 90; Clair 1984,
p. 95 pl. 71; Roy 1996, p. 191;
Fox Weber 1999, p. 417;
Clair, Monnier 1999, n. P 169

75.
oil on canvas
55.9 × 46.4 cm
monogrammed and dated
upper left: "B 1948"
Geneva, Galerie
Krugier-Ditesheim

provenance: Claude Hersaint,
Meudon, purchased
from the artist; Richard
L. Feigen, Chicago; Gallery
Jan Krugier, Geneva; Gallery
Claude Bernard, Paris; 1977,
private collection, France;
Thomas Gibson; James
Kirkman, London; sale
Christie's, London, 23 June
1997, n. 47
exhibitions: New York 1949,
n. 23; New York 1956, n. 18;
Cambridge 1964, n. 14; Chicago
1964, n. 14; London, Annely
Juda 1968; London, Tate
Gallery 1968, n. 27
(photograph reversed)
bibliography: Leymarie 1982,
p. 140 and 2nd ed. 1990, p. 144;
catalog MNAM.CNACGP, Paris
1983, p. 355 n. 87; Roy 1996,
p. 73; Clair, Monnier 1999,
n. P 170

In the morning light, a young girl is preparing to wash. The room she lives in is typical of humble lodgings, like the thousands in Paris up until the sixties. One room, with a fireplace topped by a mirror, and a stove used also for heating water brought in from the landing. Light bathes her body that stands out against the ochre walls, with their sumptuous emerald green casing. She has put on (red) socks because it is cold; her little companion, crouching by a chair, is leafing through an album while drinking a bowl of milk. She is turned, admiringly, toward the young girl standing very erect before us, one arm flung aside as though to offer us the beauty of her body, the radiance of her glowing youth. There are two variants of this picture, painted in 1948. In *Jeune fille à sa toilette*, we recognize the young girl's posture, but the framing is quite different, her body, cut off at mid-thigh, takes up the entire height of the canvas. We have the impression the young girl is striding toward us, triumphant, about to come out of the frame. No longer static and offered, as she was in *La Chambre*, but caught in motion, firmly grasping the back of a chair she is about to move. A bathing cap hides her hair, giving her sensuous face a determined expression, nearly boyish, arousing with respect to her barely pubescent body. The child figuring in *La Chambre* is replaced by a wrinkled old woman, seen in profile. She is in the middle distance and we will see her again, identical, in *La Toilette de Georgette* (cat. 83). She appears to be airing the bedsheets, an image of the adult age, domestic order and the familiarity with everyday gestures,

contrasting with the bather's fiery spirit. In the second variant, titled *Jeune fille au miroir* (fig. 1), the light, reflected and as if multiplied by the bright mirror, seems to come from the young girl's very body. This composition is also related to *La Chambre*, from which it also borrows the immaculate cloth flung over her shoulder. The girl seems absorbed in the contemplation of her reflection, while the chilly old woman, with her crocheted shawl around her shoulders, her worn hands on the back of the chair, looks like she is patiently waiting for time to resume its suspended course, and for the nude beauty to emerge from its self-contemplation to finish dressing.

La Chambre inspired Pierre Jean Jouve to write this poem:

> Un grand spectre est dressé dans
> la lumière close/ Femme nue à la rose; et tenant
> la chemise/ Froide à l'épaule et la main élargie/
> Loin du centre comme un signal de majesté/
> Que saisit-elle en ces prunelles agrandies?/
> Et l'enfant d'une cheminée de fausse éponge/
> La regarde avec chair et tristesse et envie/
> Sur des meubles poudreux; le temps parfume/
> encore/ D'odeurs suaves ou serrées, la rêverie/
> Se fait longue à partir d'un point d'orgue
> pileux./
> La mort est-elle là? La vie est-elle songe/
> Aucun espace ne répond parmi les cieux.[1]

[1] P.J. Jouve, "Un tableau de Balthus," in *Génie* II, GLM, Paris 1948 and *Œuvres,* I, Mercure de France, Paris 1987, p. 1163.

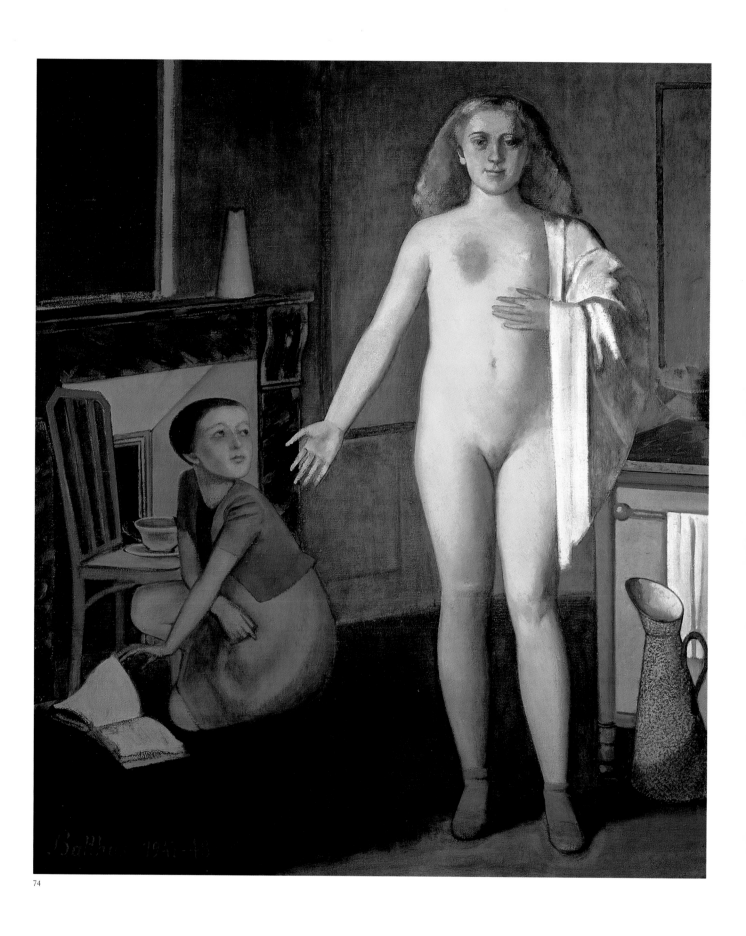

74

1. Balthus, *Jeune fille au miroir*
[Girl at the Mirror], 1948,
oil on cardboard, 100 × 80 cm.
Private collection

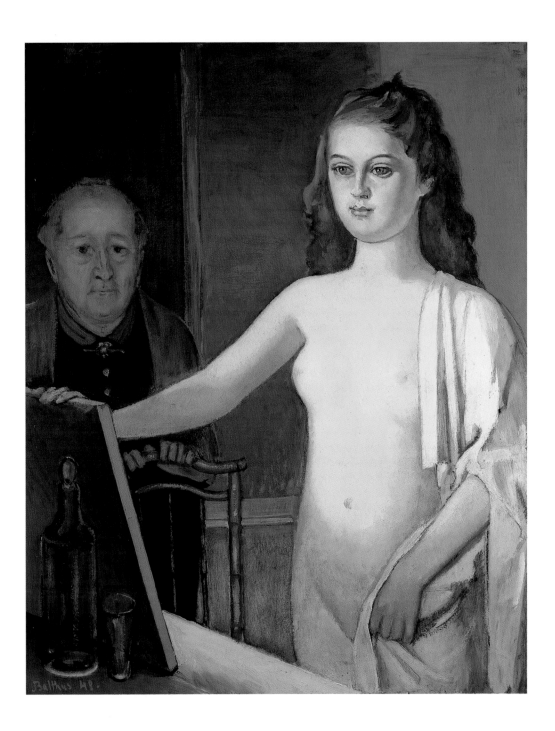

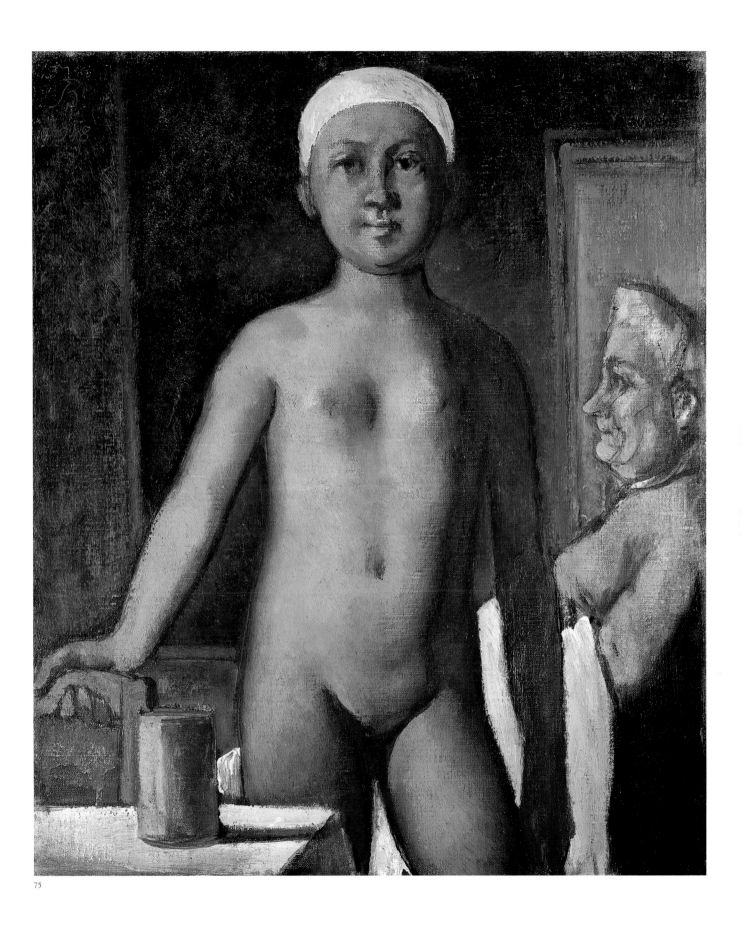

75

76. *Etude pour "Nu au chat,"* 1948 [Study for "Nude with a Cat"]

77. *Etude pour "Nu au chat,"* 1948 [Study for "Nude with a Cat"]

76.
India ink on paper
29 × 44 cm
monogrammed lower left: "Bs"
New York, Sabine Rewald

provenance: John Rewald
exhibitions: Spoleto 1982, n. 43,
Paris, MNAM.CNACGP 1983–84,
n. 86
bibliography: catalog New York
1984, p. 116 pl. 116; Faye 1998,
p. 118; Clair, Monnier 1999,
n. D 643

77.
India ink on paper
30 × 45.1 cm
New York, The Museum
of Modern Art, gift
John S. Newberry

exhibitions: London,
Tate Gallery 1968, n. 71;
Detroit 1969, n. 33;
Spoleto 1982, n. 41; Paris,
MNAM.CNACGP 1983–84, n. 35;
Madrid 1996 (not repr.)
bibliography: catalog New York
1984, p. 114 pl. 115;
Clair, Monnier 1999, n. D 644

Half of the pictures Balthus painted between
1948 and 1950 represent female nudes seen in the
intimacy of a room. The *Toilettes*, of which two
are shown here (cats. 75, 83) form a first
ensemble. A second group, of equal importance,
consists of seven canvases around two major
works, the *Nu au chat* (or *Nu à la bassine*, fig. 1)
and *La Semaine des quatre jeudis* (cat. 81).
If the different *Toilettes* can be seen as variations
on a same theme, the oils of the second series
seem instead to be variants allowing Balthus
to explore the expressive possibilities of different
formal propositions.
The repair work the Melbourne National Gallery
is involved in prevented the presence of the *Nu
au chat*, but the two studies shown here provide
a fair illustration of that research.
The model's thrown-back torso and raised left
arm recall the first study for *Les Beaux jours* (cat.
71). In the first drawing we recognize the low
armchair and the chest of the *Nu au chat* and in
the second the high-backed armchair that will
figure in *La Semaine des quatre jeudis*. The leg
movement will be reversed from one composition
to the other: we will find the project of the first
drawing in the second composition and vice

versa, that of the second drawing in the
Nu au chat.
The left part of the Museum of Modern Art
of New York drawing (the Girl in the armchair)
is composed around the play of curves
and counter-curves designed by the model's arm,
breast, chest and bent leg. There exist several
variants in which the arched body, the swelling
of the neck and bosom remind us of some
odalisques in Ingres' *Turkish Bath*. A comparable
lasciviousness permeates the harem scene and
the *Nu au chat*, but the originality and strength
of Balthus's composition comes from the context
in which he places his model. As early as the first
drawings and throughout the different studies,
he builds an austere décor consisting of a few
pieces of coarse wooden furniture, whose
verticals are multiplied by the light frame
of a high, curtainless window.
In front of it, he drew a small male figure,
that we get a glimpse of, crouching, in the second
drawing figuring here. He will appear again,
kneeling, in one of the studies painted for
La Semaine des quatre jeudis (cf. cat. 81, fig. 1)
and then, standing, feminized but as stiff
as a dummy, in the *Nu au chat*.

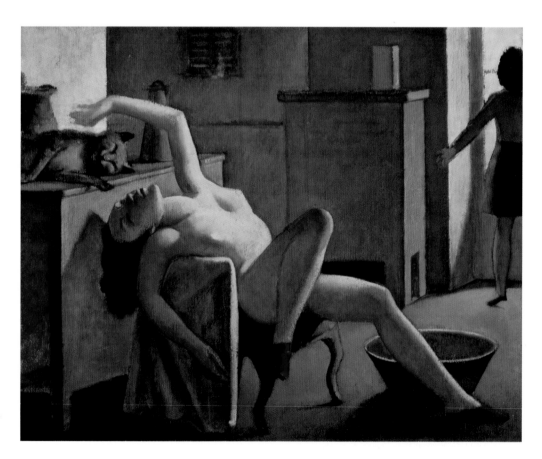

1. Balthus, *Nu au chat.*
(Nu à la bassine) [Nude with
a Cat (Nude with a Basin)],
1948–50, oil on canvas, 65 × 80 cm.
Melbourne, National Gallery
of Victoria, Felton bequest in 1952

76

77

78. *Les Poissons rouges* (1948) [The Goldfish]
79. *Le Poisson rouge* (1948) [The Goldfish]

78.
oil on canvas
62.2 × 55.9 cm
private collection

provenance: Pierre Matisse
Gallery, New York, purchased
from the artist in 1950;
Louis McLane, Los Angeles;
the Reverend James McLane,
Los Angeles; 1973,
Pierre Matisse, New York
exhibitions: New York 1949,
n. 22; New York 1956, n. 19;
Marseilles 1973, n. 14; Kyoto
1984, n. 12; Ornans 1992, n. 19;
Tokyo 1993, n. 10;
Karuizawa 1997, p. 61
bibliography: Leymarie 1982,
p. 132 and 2nd ed. 1990, p. 133;
catalog MNAM.CNACGP,
Paris 1983, p. 354 n. 85;
Roy 1996, p. 35;
Clair, Monnier 1999, n. P 175

79.
oil on canvas
82 × 84 cm
private collection

provenance: Pierre Matisse
Gallery, New York;
Olivier B. Jennings
exhibitions: Chicago, 1964,
n. 15 (dated 1948); Paris,
Arts décoratifs, 1966, n. 12
(dated 1942); Knokke-le-Zoute,
1966, n. 12; Madrid, 1996
bibliography: Leymarie 1982,
p. 132 and 2nd ed. 1990, p. 133;
catalog MNAM.CNACGP,
Paris 1983, p. 268 and p. 354
n. 86; Clair, 1984, p. 41, fig. 24;
Roy, 1996, p. 34; Clair,
Monnier 1999, n. P 174

A young mother and her child are watching
some goldfish swim around in a fish-bowl placed
on the table. On the chair, in the foreground,
an "alley cat" is looking at us, familiar, slightly
sardonic. Thus described, the scene sounds
commonplace and probably drawn from everyday
life: there is indeed a drawing (fig. 2) figuring
the same child, sitting on a chair and watched
over by an old woman, maybe a concierge,
in whose lodge there is a fish-bowl and a cat.
A more common sight, in other words, was not
to be found in the old districts of post-war Paris.
Observed by Balthus, the scene takes on
a fantastic dimension. In cat. 79, the old woman
has disappeared, leaving the child at the mercy of
an accident. But the chair the child was sitting on
has also been conjured away, and with it, the
child's body. Its big round, bald head, stuck on an
embrionic neck, looks like turned wood,
reminding us of a huge piece in a chess game,
set on the edge of the table. For some unknown
reason it is holding in its little hand a large
snuffed candle. The cat, with "its wicked human
smile," in Yves Bonnefoy's words,[1] is making
a face like those in the cartoons of that period,
and looks about to fall upon the fish.
 In the nocturnal tones Balthus has chosen, the
only spot of color is the fish. The light emanates
from the bowl, it is their reflection that blushes
the face of the child and its mother, probably
a young employee, but whose profile, pointed
skull and plastered-down hair recall the Tuscan
ladies who posed for Piero della Francesca (fig. 1).

[1] Y. Bonnefoy, "L'invention de Balthus," *L'Improbable*,
Mercure de France, Paris 1959, pp. 49–74; 2nd ed. 1980,
pp. 39–56; reprinted in *Balthus*, exhibition catalog,
Paris 1983, pp. 86–93.

1. Piero della Francesca,
The Legend of the Holy Cross.
Encounter between Solomon
and the Queen of Sheba,
fresco, detail.
Arezzo, basilica of San Francesco,
choir

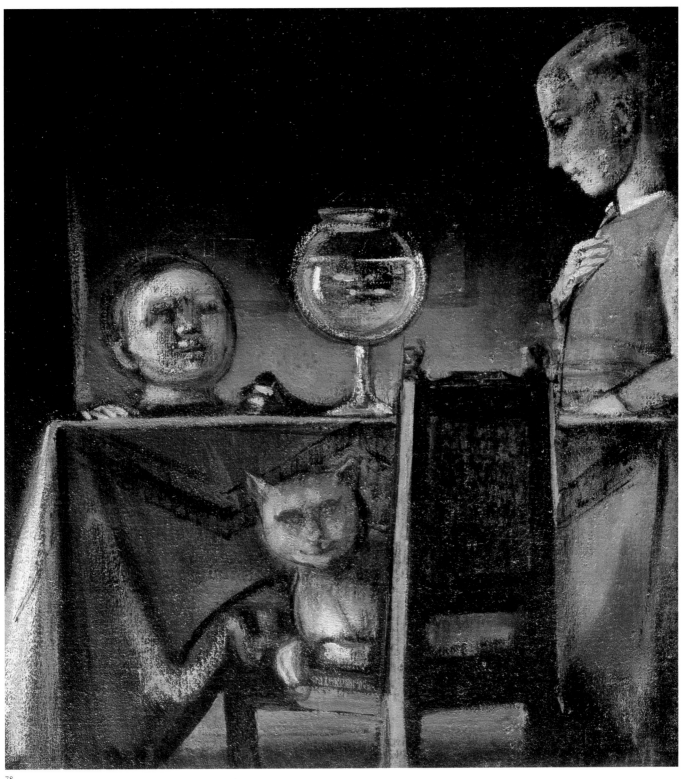

78

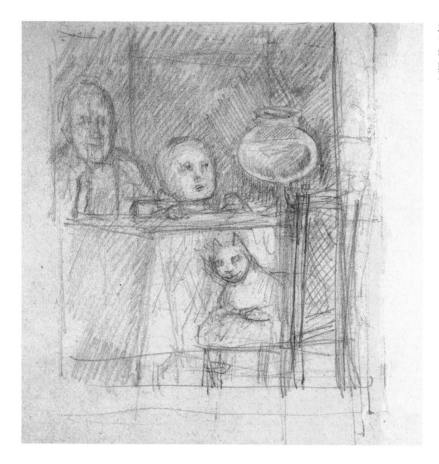

2. Balthus, *Etude pour
"Le Poisson rouge"* [Study
for "The Goldfish"], 1948,
pencil on paper, 22.7 × 21.5 cm.
Location unknown

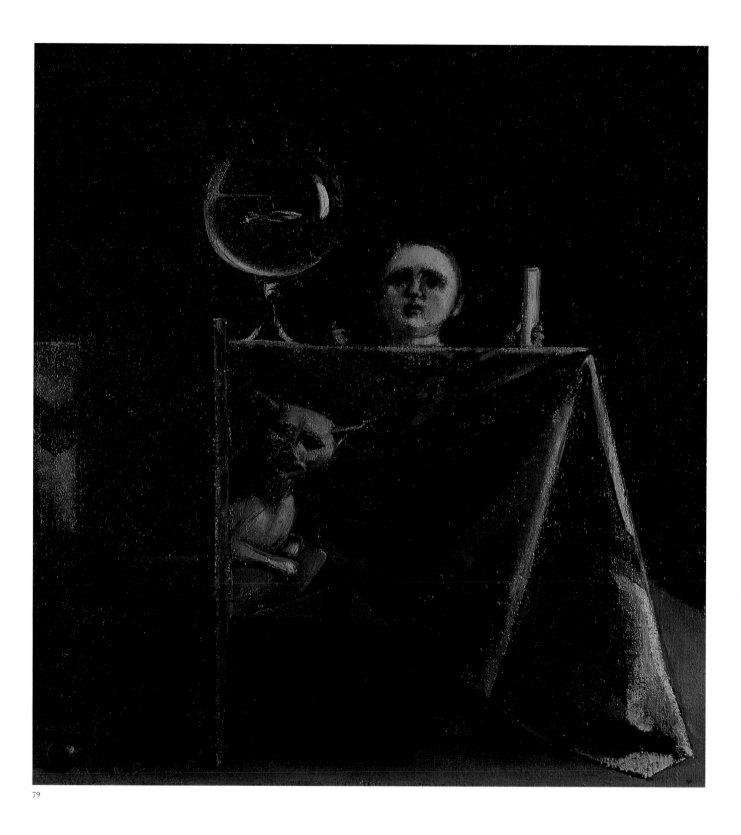

79

80. *Etude pour "La Semaine des quatre jeudis,"* 1948
[Study for "The Week with Four Thursdays"]
81. *La Semaine des quatre jeudis*, 1949 [The Week of Four Thursdays]

80.
oil on cardboard
71 × 77 cm
monogrammed and dated
lower left: "Bs 48"
private collection

provenance: private collection
bibliography: catalog
MNAM.CNACGP, Paris 1983,
p. 356 n. 95; Leymarie 1990,
p. 146; Clair, Monnier, 1999,
n. P 179

81.
oil on canvas
97 × 83.8 cm
signed and dated lower right:
"Balthus 1949"
Poughkeepsie, The Frances
Lehman Loeb Art Center,
Vassar College,
Katherine Sanford Deutsch
collection

provenance: 1952: Pierre Matisse
Gallery, New York,
purchased from the artist;
Mr. and Mrs. Deutsch
exhibitions: New York, 1949,
n. 26; New York, 1956, n. 22;
New York, 1984, n. 30
bibliography: Leymarie 1982,
p. 133 and 2nd ed. 1990,
p. 134 and p. 146; catalog
MNAM.CNACGP, Paris 1983,
p. 356 n. 96; Roy 1996, p. 87;
Fox Weber 1999, p. 418;
Clair, Monnier 1999, n. P 182

The title of these pictures refers to the fact that
when they were painted school-children's holiday
was on Thursday. So the popular expression
"it's the week with four Thursdays" suggests
a wonderful week of near-holiday and childhood
freedom.
Two very young girls are shown here, idle,
in the bright morning light. One of them seems
absorbed in what she sees in the street. She is
standing, in front of the window through which
the gables and zinc rooftops of the buildings
across the street are outlined. She is dressed,
the movement of her raised shoulder and right
arm seem to suggest she is about to open the
window, and get away, at least in her thoughts,
from the closed world of the room she is in.
Instead her companion feels comfortable there.
Still in her dressing gown, she is leaning back
in an armchair, with her eyes closed, ignoring
the toilet table and the mirror we glimpse on
the right. With one hand, she is patting the head
of a cat with a faunlike facies, arched on the back
of the chair. The young girl is deep in
a voluptuous daydream, in which, by the gesture
of her left arm, she seems to associate the feline.

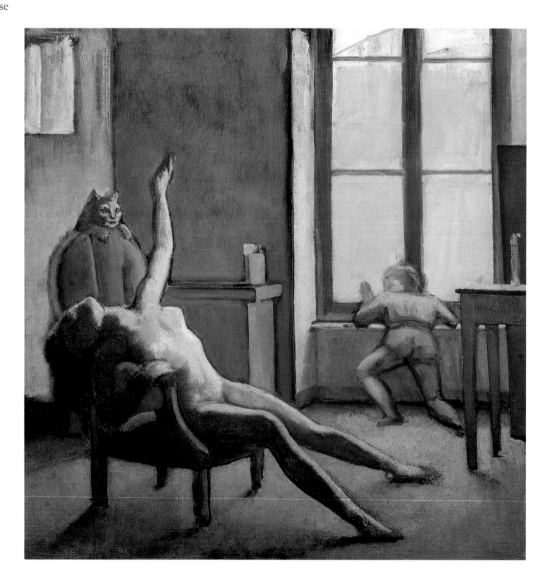

1. Balthus. *Etude pour
La Semaine des quatre jeudis,*
1948, oil, 57 × 58 cm.
Private collection


War and Afterwar (1940–53)


80


303


In one of the preparatory studies for the painting, she was naked and the curves of her body focused vision on the triangle formed by her closed thighs (fig. 1). The unusual position of the small boy half-kneeling in front of the window emphasized the scene's impression of diffuse lasciviousness. The *Etude* and the last version presented here are without it. By dressing the young girl in a thick terry-cloth robe, by placing her body along a strict oblique highlighted by a brown line (a highlighting that also stresses the edges of the furniture), Balthus favors formal composition over a subjective interpretation of the scene. We already said that *La Semaine des quatre jeudis* was the last picture of a series of seven. Comparing it to the others, we notice a tendency to simplify, lines as well as the color scale. A simplification that will lead to the formal bareness of *La Chambre* of 1952–54 (cat. 93). In some aspects, *La Semaine des quatre jeudis* might seem clumsily executed; like the shapeless torso of the young girl at the neckline of her dressing gown, the rash way her head is connected with her neck or the unlikely position of the cat, that we cannot see how it is able to stay on top of the chair. A merely apparent clumsiness, that is perfectly controlled. That feigned naiveté, contrasting with the sensuality of the subject, is what makes the scene so arousing.

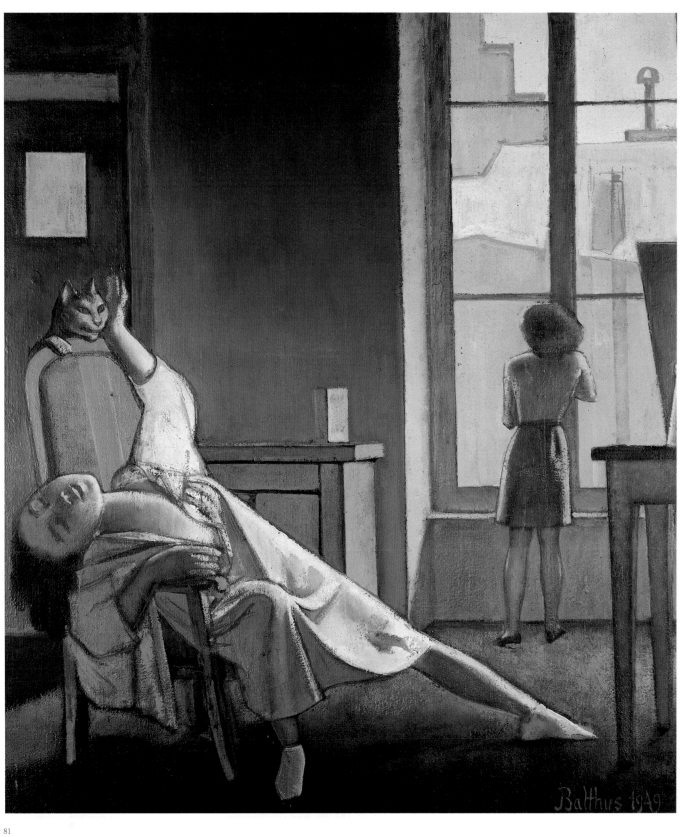

81

82. *Etude de nu dans un intérieur*, 1949
[Study of Nude in an Interior]

charcoal on paper
37.9 × 54 cm
monogrammed lower left:
"Bs 49"

New York, The Museum
of Modern Art,
John S. Newberry collection
exhibitions: Spoleto 1982, n. 40;
Paris, MNAM.CNACGP 1983–84,
n. 37; Kyoto 1984, n. 41;
Bern 1994, n. 34; Madrid 1996
(not repr.)
bibliography: Xing 1995;
Clair, Monnier 1999, n. D 648

This drawing is dated 1949. So it was executed
at the time when Balthus was completing
La Semaine des quatre jeudis (cat. 81) and still
working on the *Nu au chat* (cats. 76–77, fig. 1).
The model's position results from the paintings
of that series.
On carefully examining the drawing, we notice
that three, even four, different sketches are
overlayed in it. The girl's left leg, first bent,
gradually straightens out, and the head, first erect,
falls back in two stages, causing the consecutive
shifting of the right arm. The posture finally
chosen—the most visible one here—is identical
in the *Nu sur une chaise longue* of 1950 (fig. 1).
There is also an accessory there, the high white
socks glimpsed in the drawing. Notice as well
that the upholstered méridienne is replaced
by an uncomfortable chaise-longue made
of chestnut boards.
The main difference between the composition
of the painting and that of the drawing lies
in the fact that Balthus reduced the design
to the *Nu*, whose body, outstretched along the
diagonal, occupies most of the painted surface.
All the right-side part, the window masked
by a heavy curtain that a child draws back,
disappears, and the depth of the field is reduced
by the suppression of the tall armoire on the left.
The buffet on which a basin and a pitcher were set
is replaced by a chest, of which we only see half,
topped by an opaline or faïence jar.
Notwithstanding, this drawing is essential
to understand the process whereby Balthus's
paintings were conceived and connected.
Indeed, he kept in mind the idea of the drawing,
its overall composition, the placing of the two
figures and the various elements of the décor.
He will return to them when conceiving
La Chambre of 1952–54 (cat. 93). The only
alteration will be the position of the *Nu*.

1. Balthus, *Nu sur une chaise longue*
[Nude on a chaise longue],
1950, oil on canvas.
Private collection.

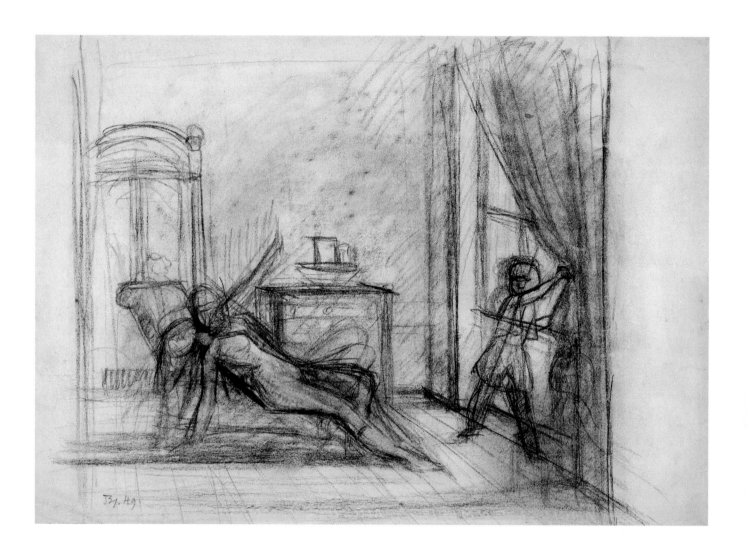

83. *La Toilette de Georgette*, 1948–1949
[Georgette at Her Toilet]

oil on canvas
96.5 × 92 cm
signed and dated lower left:
"Balthus 1948–1949"
Elkon Gallery Inc.

provenance: Pierre Matisse
Gallery, New York, purchased
from the artist; 1949, Louis
McLane, Los Angeles; 1956,
The Reverend James Mc.Lane,
Los Angeles; 1966, Mrs Mary
McLane, Los Angeles; 1968,
Pierre Matisse Gallery,
New York; 1971–72, Galerie
Claude Bernard, Paris;
private collection, USA
exhibitions: New York 1949,
n. 24; New York 1956, n. 20;
Cambridge 1964, n. 15;
Chicago 1964, n. 16; Paris,
Arts décoratifs 1966, n. 15;
Knokke-le-Zoute 1966, n. 15;
London, Tate Gallery 1968,
n. 28; Detroit 1969, n. 9;
Tokyo 1994, n. 11; Madrid
1996; Rome 1996–97, p. 85;
New York 1998, n. 13
bibliography: Leymarie 1982,
p. 140 and 2nd ed. 1990, p. 144;
catalog MNAM.CNACGP, Paris
1983, p. 355 n. 88; catalog
Metropolitan, 1984, p. 40 pl. 64;
Roy 1996, p. 73; Klossowski
1996, n. 49; Clair, Monnier
1999, n. P 186

Serge Fauchereau has compared the works
of the Polish writer and draughtsman Bruno
Schultz (1893–1942) to some of Balthus's
paintings, not to look for sources—unlikely, since
we do not know whether the two men knew each
other—but to analyze the kinship of their work
and check if one could help understand the other.[1]
La Toilette de Georgette, among others, drew
his attention. He noticed the complacency with
which the very young girl, like Schulz's women,
contemplates her image in the mirror. Naked,
still practically a child, she is wearing a high white
sock, matching the stockings of Schulz's
courtesans, an important accessory in classical
erotic vocabulary, for the echoes it arouses
in the male imagination.
Serge Fauchereau equally points out the function
assigned, in the same register, to hair. In Balthus,
it is either combed by the girl herself, or entrusted
to a servant, like in the *Toilette de Cathy* (cat. 41).
This leads him to envisage the role
of the old woman in the present painting. She
is undoubtedly an avatar of Nelly in *Wuthering
Heights*, but Fauchereau disagrees with the widely
accepted notion that she is an embodiment
of the adult age. Instead he sees in her a kind
of double of the young girl, suggesting
a complicity between the two figures, comparable
to the one between Cathy and Nelly.
The old woman, he writes, is holding a carpet
beater, that might be interpreted as the instrument
either of a punishment, or else of a spanking

the adolescent[2] might receive with a certain
pleasure, or else sado-masochistic practices
as shown in some of Schulz's images.
But we can also see the enigmatic item the old
woman is holding under her arm as a huge curling
iron she might be taking away after having
combed the adolescent's curls. A suggestion that
corroborates what was written above about the
erotic role of hair. At the same time, the curling
iron oddly looks like a monstrous pair of scissors,
with its implied mutilating connotation. We are
aware of the importance, in Balthus's imagination,
of Heinrich Hoffmann's tales. We mentioned it
in connection with the *Strüwwelpeter* (cat. 21)
and *La Rue* (cat. 43), and we shall have occasion
to come back to it (cat. 200). One of the tales
is called "The story of Konrad who sucked his
thumb" (fig. 1). The illustration of the final
episode deserves being told here: one day a
skeletal, nightmare figure rushes at the little boy
and, equipped with shears, cuts off both his
thumbs, grinning sardonically. That image,
unconsciously castrating, haunted the nights of
generations of children. We cannot exclude that
Balthus may have transposed here its recollection.

[1] S. Fauchereau, "Balthus devant Schulz, Klossowki,
Jouve et quelques autres," *Cahiers du Musée national
d'art moderne*, n. 12, 1983, pp. 225–43.
[2] There are many examples of such an episode in racy
Victorian literature. Sabine Rewald published one
in her article "Balthus Lessons," *Art in America*, n. 9,
September 1997, pp. 89–94.

1. Illustration for "The story
of Konrad who sucked his thumb,"
from Heinrich Hoffmann's
Der Strüwwelpeter, 1844

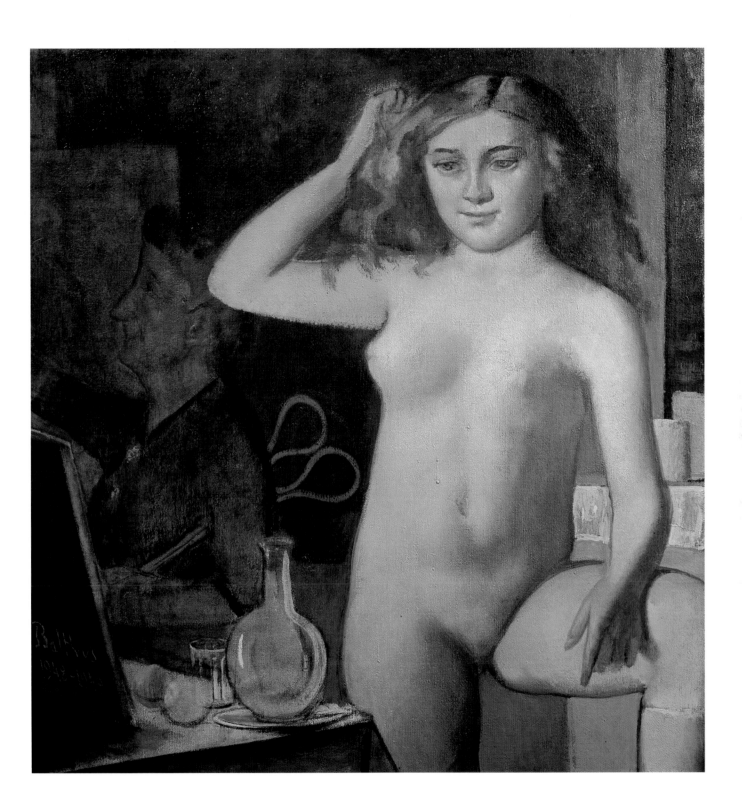

84. *Autoportrait* (1949)
[Self-portrait]

oil on canvas
116.8 × 81.2 cm
Geneva, private collection

provenance: 1962, Pierre Berès
(purchased from the artist);
sale Loudmer, Paris, 17 June
1990 n. 45; sale Sotheby's,
London, 30 November 1993,
n. 24
exhibitions: London, Tate
Gallery 1968, n. 31; Marseilles
1973, n. 19; Ornans 1992, n. 21;
Zurich 1999, n. 9
bibliography: Leymarie 1982,
p. 128 and 2nd ed. 1990, p. 128;
catalog MNAM.CNACGP, Paris
1983, p. 97 and p. 357 n. 98;
Roy 1996, p. 17; Clair,
Monnier 1999, n. P 198

This *Autoportrait* is the last one Balthus painted.
He presents himself in the everyday reality
of his life, in his activity as a painter. He has
his arm on a crate, in which, since he is wearing
a glove, he may have put a painting. He is dressed
in a coarse cotton smock, stained with white.
The craftsmanship aspect of his work is what
he wants to emphasize. He has said over and over
that he placed *métier*, technical know-how,
over everything else. An exercice of the art
of painting acquired through experience,
and based on the empirical handling of coatings,
pigments and binders.
The 1948 *Autoportrait* is the most austere
of the four he did of himself. The background
is practically black. The emaciated face is stern,
the nose like a sabre blade, and the thin lips
remind us of the head of a bird of prey.
The texture of the painted canvas shows through
the thin pictorial material shaping the smock,
thus suggesting the roughness of a monk's frock.
When Balthus posed for Irving Penn, dressed
in this same tunic, he belted it with a rope
with a complicated knot, a sort of reference
to the one Franciscan monks wear. For the
photographer, he sat at an angle in the big studio
armchair, relaxed, his eyes merry, a lit cigarette
at his lip.
A stubble of a beard, graying temples situate
him in a live, tactile present. On the canvas,
he is close-shaven, and his hair, brushed back,
leaves his brow entirely bare. Balthus gives himself
an ascetic appearance, and it is nearly a monacal
image that he offers of himself here.

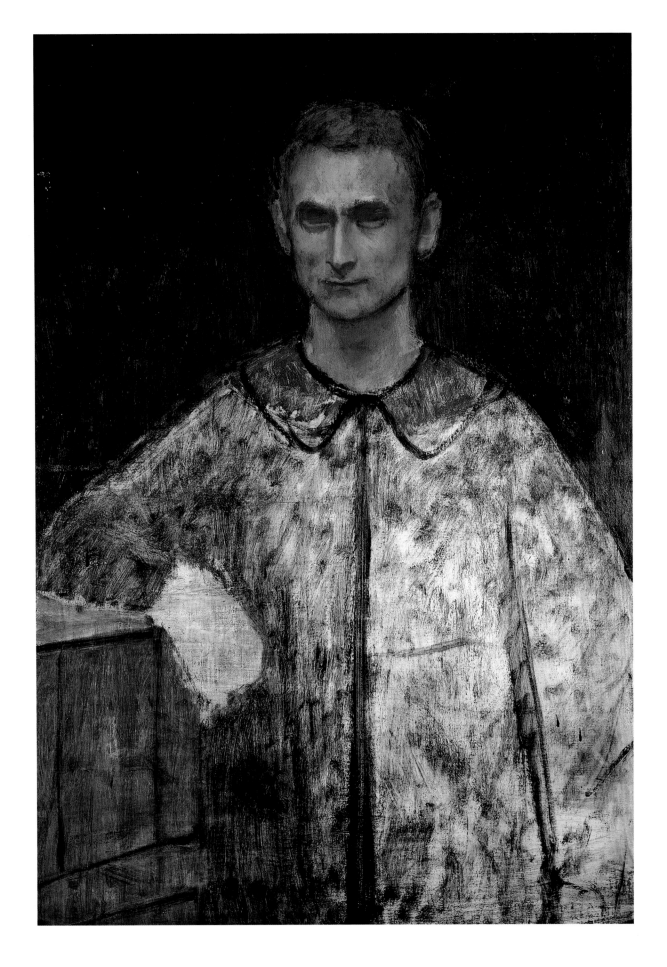

85. *Portrait de Rosabianca Skira*, 1949
[Portrait of Rosabianca Skira]

oil on canvas
60 × 48.5 cm
private collection

provenance: Albert Skira,
Geneva (purchased from
the artist)
exhibitions: Marseilles 1973,
n. 18; Lausanne 1993
bibliography: Leymarie 1982,
p. 128 and 2nd ed. 1990, p. 127;
catalog MNAM.CNACGP, Paris
1983, p. 357, n. 99; Roy 1996,
p. 114; Clair, Monnier 1999,
n. P 197

Rosabianca Skira (1916–99) was the daughter
of the art historian Lionello Venturi and the wife
of the artbook publisher Albert Skira (1904–73).
After his death she ran the Editions Skira
up to 1996.
Albert Skira's career started off with a
masterstroke: 25 years old, unknown and without
a fortune, he got Picassso to sign a contract with
him for the illustration of Ovid's *Métamorphoses*
(30 etched plates, published in 1931). The year
after, Matisse illustrated for him his *Poésies* by
Mallarmé and, in 1934, Dalí drew the illustrations
for Lautréamont's *Chants de Maldoror*.
Concurrently, Albert Skira started up a review,
Minotaure (1933–39, 13 issues), whose innovatory
conception—the interaction and reversibility
of image and text—enabled Surrealism to assert
itself. We have seen that in n. 7 he published eight
of Balthus's illustrations for *Wuthering Heights*.
After the war, his monthly, *Labyrinthe* (1944–46,
23 issues) allowed French artists to express their
faith in the future. During the same period, he
conceived, with André Malraux, la *Psychologie
de l'art* (1947–49).
Albert Skira published also several series of art
books: *Trésors de la peinture française* (1934),
*Grands siècles de la peinture, Peinture-couleur-
histoire* (18 vol.), *Le Goût de notre temps* (30 vol.).
In the sixties, he had the idea for *Art-idées-
Histoire* (10 vol.) in which the illustration was
subordinated to the presentation of a reflection,
and *Les sentiers de la création* (1969), to question
artists and writers about the early steps of their
production. Thus the greatest of them were
published by Skira in the course of a forty-years'
career.
Balthus became acquainted with the Skira couple
in Geneva in 1946; at the time he was living
at Cologny, in villa Diodati, famous for having
accommodated Byron. It was on the occasion
of a dinner arranged by Albert Skira that he met
André Malraux; the future Minister of Culture
of General de Gaulle was to call upon him,
fifteen years later, to run the Académie de France
in Rome.
The portrait of Rosabianca was painted in Paris
in 1949. The gray and reddish-brown tones,
the scarcely rendered background are reminiscent
of Italian frescoes of the Renaissance and enhance
the young woman's aquiline profile and
almond-shaped eyes. A brown stripe frames
the canvas; it suggests the frame of a window
upon which Rosabianca is resting her forearm,
in the tradition of old portraits.

1. Balthus, *Portrait d'Albert Skira*
[Portrait of Albert Skira], 1952,
pencil on paper, 21 × 27 cm.
Saint Louis Art Museum,
gift Robert Elkon

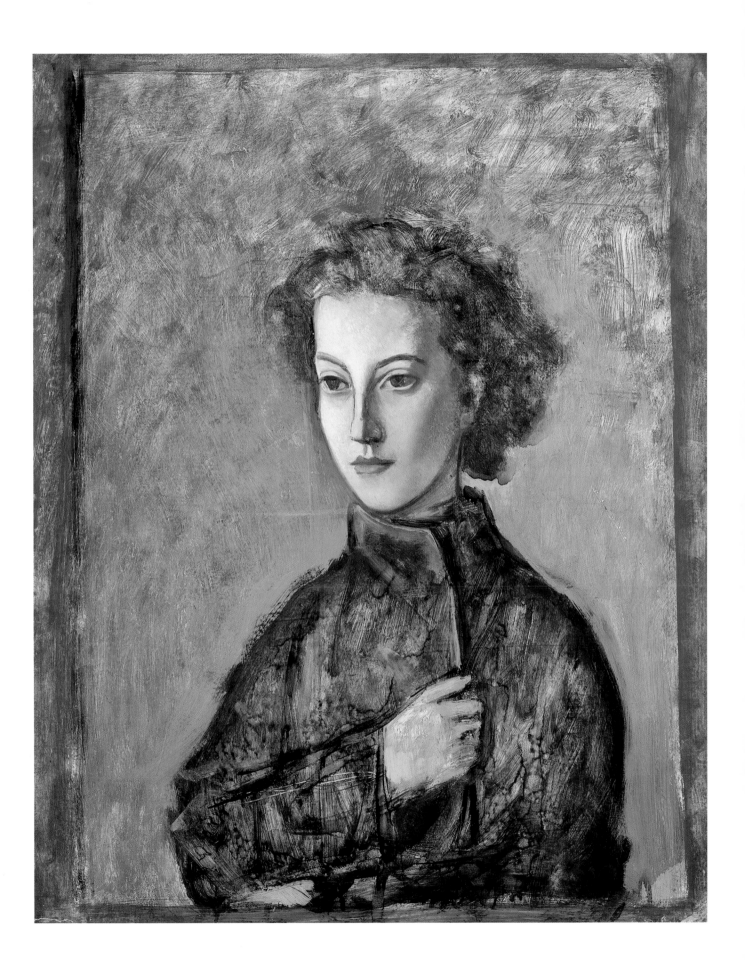

86. *Portrait de Laurence Bataille* (1949)
Portrait of Laurence Bataille

oil on cardboard
63 × 44.5 cm.
private collection

provenance: from the artist
bibliography: catalog
MNAM.CNACGP, Paris 1983,
p. 358 n. 110; Leymarie 1990,
p. 128; Roy 1996, p. 108;
Clair, Monnier 1999, n. P. 199

Balthus met Laurence Bataille when he returned to France in 1947. The young girl, who was 17 at the time, lived with him until 1951. She belonged to a family that had been very prominent on the intellectual scene since the thirties. Her father, Georges Bataille, was close to Pierre Klossowski, Balthus's older brother. Her mother, Sylvia, an actress who played in particular in films by Jean Renoir (*Le Crime de M. Lange, La Partie de Campagne*) and Marcel Carné (*Les Portes de la Nuit)*, was connected with the *Groupe d'Octobre* and Jacques Prévert. A friend of Picasso, Sylvia was also André Masson's sister-in-law. Her second husband was the psychoanalyst Jacques Lacan, who was a collector himself.[1] Françoise Gilot, Picasso's companion, recently told about the first meeting between Balthus and the young girl, during a dinner in the port of Golfe-Juan.[2] While the vicomtesse de Noailles was reminiscing about the great old days of Surrealism, the adolescent, tired of the conversation or maybe of the way Balthus was staring at her, climbed into a little boat and went off rowing in the port. A demonstration of independence that would have delighted Balthus and the recollection of which we can see in the painting-signboard titled *Le Chat de la Méditerranée* (cat. 87). The first of the three portraits that we know was painted the same year; the one shown here, and that is exhibited for the first time, two years later. In both cases, the dark mass of luxuriant hair brings out the perfection of the young girl's features, the line of the jaw, the arch of the eyebrows, the line of the nose, and especially the huge pale eyes, so light they are nearly liquid, that we might describe as dreamy if the firm outline of the mouth did not contradict that impression. The red of the scarf, standing out against the monochrome of browns of the ground of the canvas and the clothes painted in swift brushstrokes, and that is placed exactly along the diagonal of the composition, is there to recall graphically the young girl's strong personality. After a brief acting career,[3] she devoted herself to medicine, then, as of 1969, to Lacanian psychoanalysis. Like other members of her family, she was very committed politically as well. If she had been too young to actually join the Resistance, she became personally involved in the struggle Parisian intellectuals were conducting for the independence of Algeria. That is how she was arrested in 1960, at the same time as her cousin Diego Masson, "accused," Simone de Beauvoir tells, "of possession of arms and having conveyed in her car an important member of the F.L.N."[4]

[1] By Balthus, he owned one of the versions of *Le Gottéron* of 1943 (Clair, Monnier 1999, no. P 142) and the *Paysage d'Italie* of 1951 (*idem*, n. P 209)
[2] *Françoise Gilot, The Early Years 1940-1955*, exhibition catalog, Elkon Gallery, New York 1998.
[3] In 1953, with Alain Cuny and Sylvia Monfort, she played the leading role in *L'Ile des Chèvres* by Ugo Betti, for which Balthus designed the sets.
[4] S. de Beauvoir, *La Force des choses*, Gallimard, Paris 1963, p. 530.

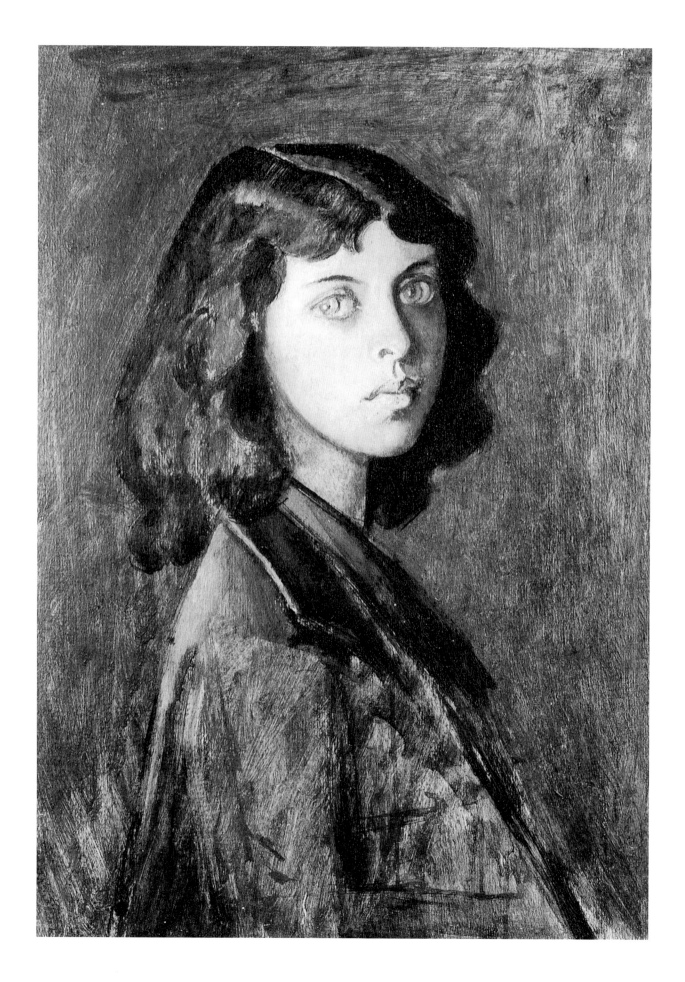

87. *Le Chat de la Méditerranée*, 1949
[The Cat of La Méditerranée]

oil on canvas
127 × 185 cm
signed and dated lower left:
"Balthus 1949"
private collection

provenance: restaurant
La Méditerranée, Paris;
J. Subrenat, Paris; Thomas
Ammann Fine Art A.G., Zurich
exhibitions: Paris, Arts
décoratifs 1966, n. 16;
Knokke-le-Zoute 1966, n. 16;
London, Tate Gallery 1968,
n. 30; Marseilles 1973, n. 16;
Bevaix 1975, n. 35; Venice 1980;
Lausanne 1993; Madrid 1996;
Rome 1996–97, p. 89.
bibliographie: Leymarie 1978,
pl. 15 and 2nd ed. 1990, pl. 16;
Leymarie 1982, pl. p. 51
and p. 133 and 2nd ed. 1990,
pl. p. 49 and p. 134; Klossowski
1983, pl. 35; catalog
MNAM.CNACGP 1983, p. 357
n. 104; catalog New York 1984,
p. 47 fig. 78; Clair 1984, p. 61
fig. 44; Kisaragi, Takashina,
Motoe 1994, pl. 26; Xing 1995,
pl. 24; Roy 1996, p. 33;
Klossowski 1996, n. 246;
Fox Weber 1999, p. 419;
Clair, Monnier 1999, n. P 193;
Vircondelet 2000, p. 84–85.

This painting was executed on the instigation of the vicomtesse de Noailles, whose portrait Balthus had painted in 1936, for the fish restaurant La Méditerranée, Place de l'Odéon in Paris, frequented by writers and artists. Meant to be a sort of sign, it hung inside the restaurant, facing the entrance. It was supposed to point out the freshness of the fish it offers, and that a rainbow casts directly from the sea onto the plate of the ogre-cat, about to devour it; the picture also emphasizes the excellency of the restaurateur, who has just prepared the huge lobster displayed in the foreground. The table the cat is sitting at is located on the jetty of a small harbor whose lighthouse we can see in the background. On the left side of the composition, separated in two by a metal post, appears a young girl who is moving away in a little boat and waving good-by.
The memory of a luncheon in the harbor of Golfe-Juan was Balthus's inspiration for this unexpected iconography, a lunch described by Françoise Gilot and on which occasion Balthus met Laurence Bataille (cf. cat. 86). As a result *Le Chat de la Méditerranée* is all the more ambiguous. Who is hiding behind the features of this cynical, imperious feline, what prey is he lying in wait for, like a crook in a movie? Is it fish, or might it be the young mermaid-girl toward whom the lobster shoots its antennae?

1. Balthus, *La Langouste*
(étude pour "Le Chat
de la Méditerranée")
[The Lobster, study for
"The Cat of La Méditerranée"],
1949, oil on plywood,
64.5 × 81cm.
Caen, Musée des Beaux-Arts

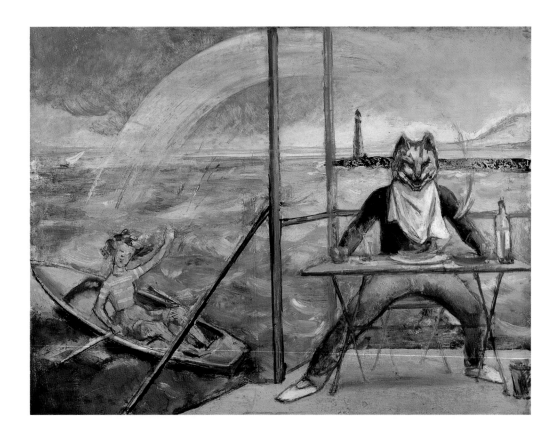

2. Balthus, *Etude pour*
"Le Chat de la Méditerranée"
[Study for "The Cat
of La Méditerranée"],
oil on cardboard, 46 × 61cm.
Private collection

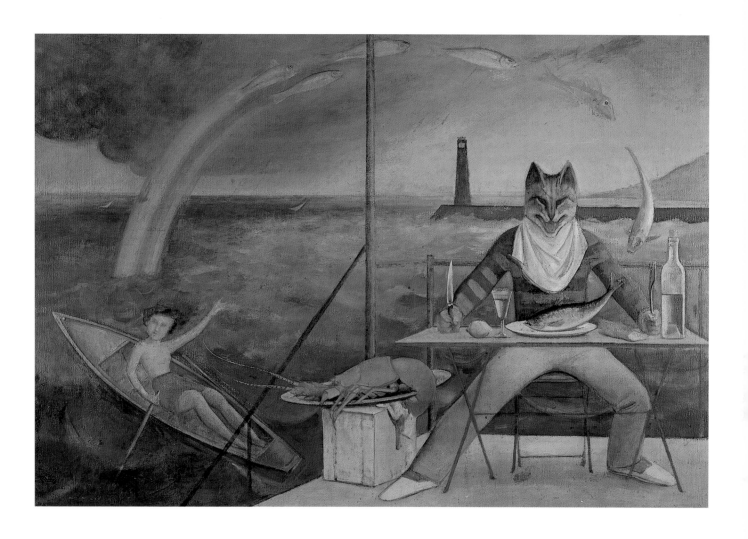

88. *Portrait d'Alberto Giacometti* (1950)
[Portrait of Alberto Giacometti]

pencil on squared paper
21 × 16.5 cm
monogrammed lower left: "Bs"
inscribed lower right: "Alberto"
Switzerland, private collection

provenance: from the artist
exhibitions: Ornans 1992, n. 26;
Lausanne 1993; Bern 1994,
n. 36; Karuizawa 1997, p. 81;
Zurich 1999, n. 23; Venice 2000,
p. 40
bibliography: Roy 1996, p. 92;
Faye 1998, p. 105;
Clair, Monnier 1999, n. D 671

Alberto Giacometti belonged to the delegation
of Surrealist artists who went to visit Balthus
in his studio in the rue de Furstemberg in 1933.
It was the following year that the two men became
friends, a friendship based on mutual respect
and fed by interminable conversations, lasting
until the sculptor's death in 1965. They were also
linked by their common devotion to Antonin
Artaud and Georges Bataille, their common
irritation toward André Breton and their reserved
position regarding Surrealism.
Jean Leymarie has described the story-like
circumstances of their second meeting.[1] They both
happened to be in Bern, planning to go to visit
Paul Klee. Quite by chance they met in front
of the famed bear pit, a conversation sprung up
so they forgot all about the purpose of their trip.
Another testimony was that of Jean Starobinski
who met them several times during the war
n Albert Skira's offices in Geneva.[2] The latter
had launched a new monthly, *Labyrinthe*, that
succeeded *Minotaure*, and their collaboration
with the review drew them together in Place
du Molard. Starobinski recalls Balthus ardently
commenting on paintings by Conrad Witz,
the fifteenth-century master well-represented
in the Musée d'art et d'histoire of Geneva,
while Giacometti would endlessly go on about
Jacques Callot's etchings.
Balthus used to say he loved Giacometti like
a brother, in his studio he had pinned up a
"tutelary" snapshot of Alberto, and paid tribute
to him on the occasion of the exhibition
Claude Bernard organized in 1975.[3]

[1] J. Leymarie, "Balthus/Giacometti," in *Balthus
et Giacometti*, exhibition catalog, Karuizawa 1997,
pp. 15–16.
[2] J. Starobinski, "Balthus et Giacometti à la place
du Molard (Genève 1945)," *ibidem*, pp. 12–13.
[3] *Alberto Giacometti. Dessins*, Paris, Galerie Claude
Bernard, 18 December 1975–31 January 1976.
Repr. in *Balthus*, exhibition catalog, Paris 1983,
p. 390 and in *Balthus et Giacometti*, cit., p. 82.

1. Alberto Giacometti in his studio
in 1954, photographed by Denise
Colomb, sister of Pierre Loeb

89. *La Partie de cartes*, 1948–50
[The Game of Cards]

oil on canvas
139.7 × 193.7 cm
signed and dated lower left:
"Balthus 1948–1950"
Madrid, Thyssen Bornemisza
Museum

provenance: Pierre Matisse
Gallery, New York, purchased
from the artist in 1950;
Hanover Gallery, London; 1968,
private collection, Great Britain;
Thomas Ammann Fine Art SA,
Zurich
exhibitions: New York 1956,
n. 21; London, Tate Gallery
1968, n. 29; Zurich 1982, n. 3;
Paris, MNAM.CNACGP 1983–84,
n. 31; New York 1984, n. 29;
Kyoto 1984; Madrid 1996
bibliography: Leymarie 1982,
p. 133 and 2nd ed. 1990, p. 134;
Klossowski 1983, pl. 38; catalog
MNAM.CNACGP 1983, pl. p. 167
and p. 358 n. 105; Clair 1984,
p. 80 pl. 60; Roy 1996, p. 19;
Klossowski 1996, n. 52;
Fox Weber 1999, p. 421;
Clair, Monnier 1999, n. P 200

This painting differs from its preparatory study
(reproduced above, cat. 70, fig. 2) mainly owing
to the fact that Balthus replaced the player
on the right, a girl, with a lusty youth. The play
of his muscles is apparent under his tight-fitting
clothes, making the harmless game more
aggressive, contrasting his budding virility
with the feminine delicacy of his opponent.
His posture, leaning forward, his hand behind
his back, the oblique created by his shoulders
and the way he holds his head are borrowed,
in reverse, from a cliché of seventeenth-century
painting: Caravaggio's *Cheater*, a lost work,
but that inspired, among others, Valentin
and Georges de La Tour.
Les Joueurs de cartes of 1952 (fig. 1) repeat,
reversing it, the *Partie de cartes* presented here.
They are an even more precise reference to
Caravaggio-style painters: we can find the exact
position of La Tour's *Cheater* of the Louvre
(fig. 2), and, as in Valentin, a third figure is
introduced: an old woman, in the middle distance,
silently attending the game. Now the young girl
is wearing a full dress and a bonnet, more akin,
it is true, to Giotto or to Piero than to the
fabulous turbans of Caravaggio's fortune-tellers,
but quite as spectacular. The player with
the prognathous facies has a gnome's body.
His sardonic expression interjects in the scene
a violence that was suggested in the works
by Caravaggio's followers but here is openly
displayed.
The final version of the *Joueurs de cartes* (fig. 3)
was painted in Rome between 1966 and 1973.
It differs considerably from the preceding ones
and we only bring it up here from the point of
view of the figures' expressions. Indeed their sly
eyes, their countenances are stamped with a nearly
unbearable wickedness. In their flattened skulls,
the perpendicular lines of the eyebrows and noses,
nothing human remains. Jean Clair found its
source in the drawings by Villard de Honnecourt
for his "Art de portraiture" and the comparison
he suggests is irrefutable.[1]

[1] J. Clair, "Les Métamorphoses d'Eros," in *Balthus*,
exhibition catalog, Paris 1983, p. 268 and 2nd
ed. Réunion des musées nationaux, Paris 1996, p. 46.

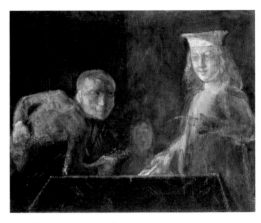

1. Balthus, *Les Joueurs de cartes*
[The Cardplayers], 1952,
oil on canvas, 64 × 81 cm.
Private collection

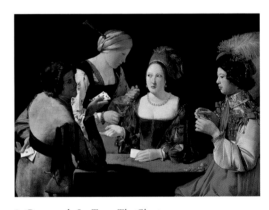

2. Georges de La Tour, *The Cheater,*
detail, ca. 1635 (?), oil on canvas,
107 × 146 cm.
Paris, Musée du Louvre

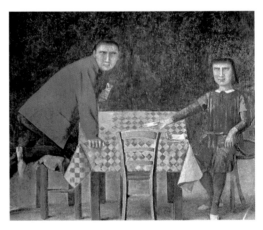

3. Balthus, *Les Joueurs de cartes,*
1966–73, casein, oil and tempera
on canvas, 190 × 225 cm.
Rotterdam, Museum
Boymans-van Beuningen

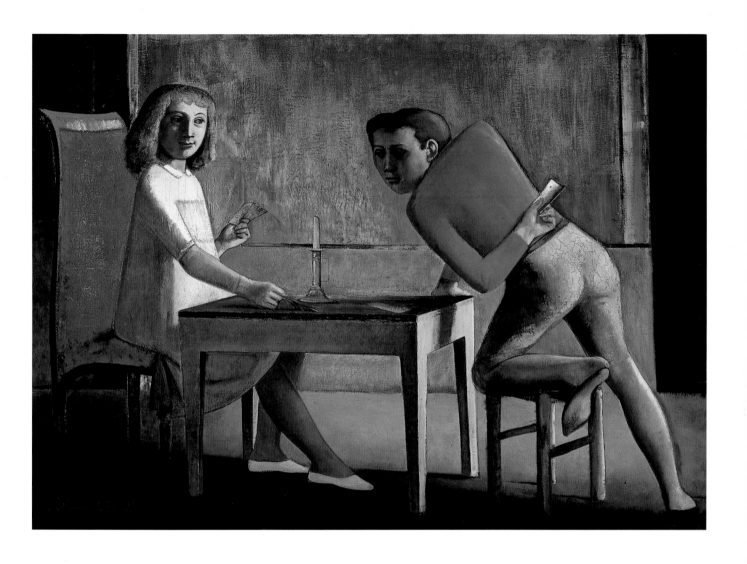

90. *Nu*, 1951
[Nude]

charcoal on paper
32 × 22 cm
Washington, Hirshhorn
Museum and Sculpture Garden,
Smithsonian Institution
gift Joseph H. Hirshhorn

provenance: Joseph
H. Hirshhorn
exhibitions: New York *et alia*,
1966–67, n. 23
bibliography: Clair,
Monnier 1999, n. D 677

This drawing, that exists in two dated variants,
can be linked up with a painting that recently
reappeared on the art market (fig. 1).
We recognize the same model, with her slender
silhouette and delicate bone structure. The young
girl, her shirt revealing her thighs and torso,
is shown asleep, her head resting on a pillow.
She is tranquil, apparently unaware of her beauty:
nothing indecent or provocative in her pose.
Balthus used the trace of the charcoal on the
coarse-grained paper to render the velvety texture
of her skin, contrasting with the immaculate white
starched shirt. Yet the drawing is not devoid
of sensuality; the sleeping girl's thighs are parted,
we get a glimpse of her pubes under her hand
and she appears to be having a voluptuous
dream on the soft pillow, suggested by three light
pencil lines.
In the *Nu aux bras levés*, she has awakened
and is stretching in the warm, russet light,
her body frontal and head in profile. She is
wearing thin, tight panties and, on her right foot,
a light canvas shoe. The counterpane cast
to the foot of the bed, the pleasure the young girl
seems to feel offering her body to the sun, evoke
the end of a nap, on a fine late summer afternoon.

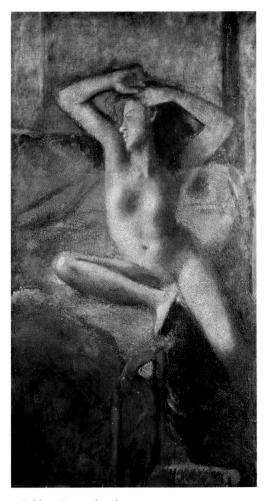

1. Balthus. *Nu aux bras levés*
[Nude with Raised Arms], 1951,
oil on canvas, 150.5 × 82 cm.
Private collection

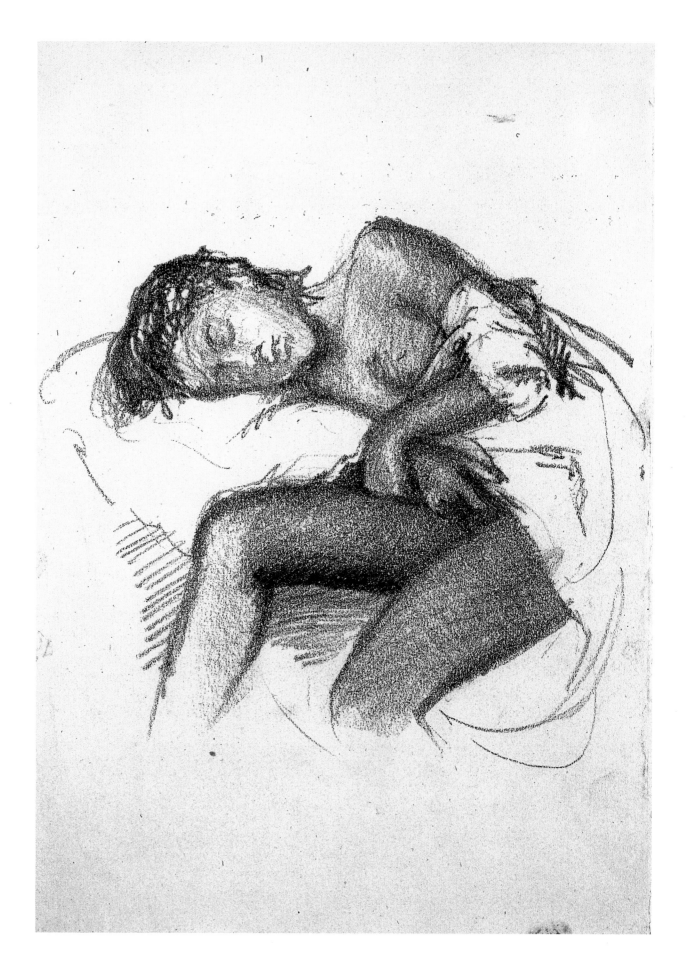

91. *Portrait de Claude Hersaint*, 1951
[Portrait of Claude Hersaint]

oil on cardboard
92 × 73 cm
monogrammed and dated
to the left on the edge
of the table: "Bs 1951"
private collection

provenance: purchased
from the artist
bibliography: Clair, Monnier
1999, n. P 178 (mistakenly
believed to have been
painted in 1948)

Claude Hersaint (São Paulo 1904–Montana 1993)
was the son of a doctor whose family, originating
from Sarreguemines in the Moselle, settled
in Brazil in the early nineteenth century. Still
a youth, he returned to France and finished his
schooling at the lycée Janson-de-Sailly, where
he was Bazaine's condisciple. In 1921, while
preparing his baccalaureat in philosophy,
he visited Max Ernst's first Parisian exhibition,
organized by the bookstore Au Sans Pareil.
He purchased his first painting there, a *Cage*.
After graduating from the École des Sciences
Politiques and the Faculty of Law, he made
his career in banking and finance. He gradually
formed a remarkable collection around
Max Ernst, Miró, Dalí and Picasso, extended,
after the war, to Magritte, Masson, Dubuffet,
Wols, Fautrier, Tapiès and Millarès... Possessed
with a exceptional intellectual and spiritual rigor,
he never parted with the works that he had all
acquired out of a deep passion.
He was close to Jean Hugo, to Jacques and Raïssa
Maritain, but also to Jean Paulhan, Roland
Penrose and especially Marie-Laure de Noailles,
who introduced him to Balthus, of whom he
owned a number of paintings.
He was his discreet sponsor when, with Charles
de Noailles, he offered him financial backing,
when Balthus moved to Chassy. Later, with
Henriette Gomès, Pierre Matisse and Alix de
Rothschild, he set up a contract that, in exchange
for pictures, freed Balthus from material worries.
The preparatory studies for the *Portrait de Claude
Hersaint* seem to express some hesitation on
behalf of Balthus as to how to render the complex
personality of this secretive man. Several drawings
show him full-length, in a suit, wearing a long
overcoat and holding a cane. In others, dated
1948, he is shown half-length, right or left three
quarters. Balthus ended up by portraying
him in profile, seated in an armchair, his right
hand at his chin.
Claude Hersaint posed wearing his coat
in the poorly heated studio in the cour de Rohan.[1]
We know nothing about the two men's long
conversations, nor do we know why Balthus,
in the painting, replaced the garment with a thick,
black wool monk's robe with a hood.
He did not say either why he placed an apple
on the table beside the armchair. When
Claude Hersaint questioned him about the
presence of that fruit, Balthus merely replied:
"You'll see, one day you will take a bite out of it!"
Placing Claude Hersaint with his back to the
window, Balthus left his face in the shadow; this
is a unique example in his entire work, making all
the more precious the presence in this exhibition
of this painting that has never before been shown.

[1] Cf. Clair, Monnier 1999, n. D 608.

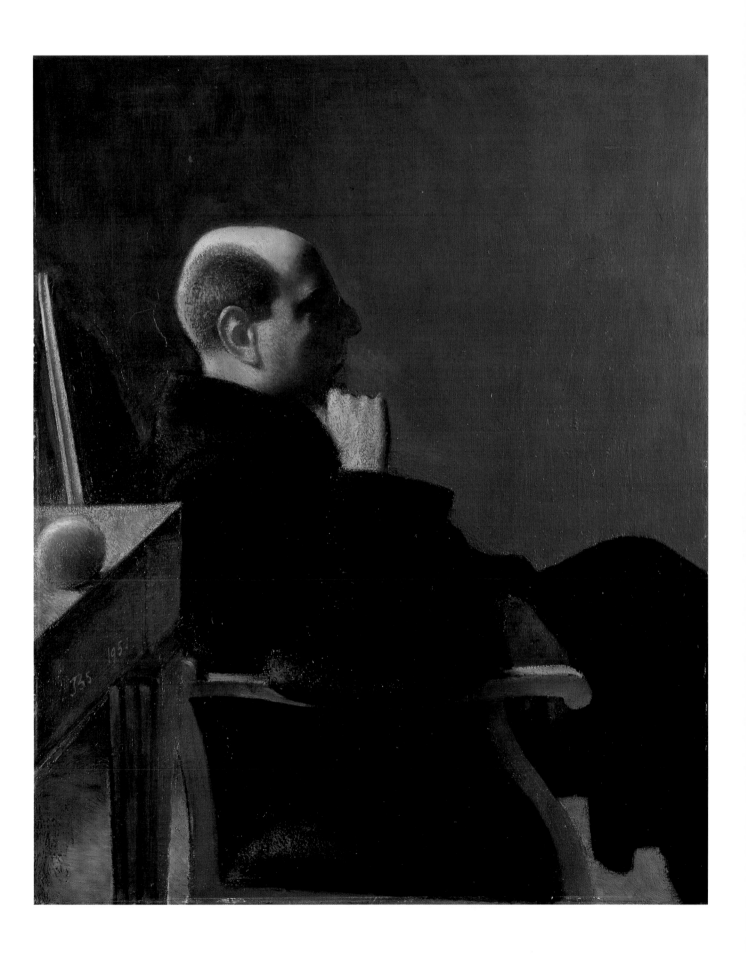

92. *Le Passage du Commerce-Saint-André*, 1952–54
[The Passage du Commerce-Saint-André]

oil on canvas
294 × 330 cm
possibly dated on the reverse,
on stretcher: "52-54"
private collection

provenance: from the artist
exhibitions: Paris 1956;
New York 1956, n. 24;
Venice 1980; Paris,
MNAM.CNACGP 1983–84, n. 34;
New York 1984, n. 33;
Kyoto 1984, n. 14;
Lausanne 1993
bibliography: Leymarie 1978,
pl. 19 and 2nd ed. 1990, pl. 20;
Leymarie 1982 pl. p. 59
and p. 124, and 2nd ed. 1990,
pl. p. 55 and p. 122; Klossowski
1983, pl. 42–43; catalog
MNAM.CNACGP 1983, pl. p. 171,
p. 292 and p. 361 n. 129;
Clair 1984, cover, p. 79 pl. 59
and p. 101 pl. 6; Davenport,
1989, pl. 4; Kisaragi, Takashina,
Motoe 1994, pl. 29; Xing 1995,
pl. 30; Roy 1996, p. 71;
Klossowski 1996, nn. 56–57;
catalog Dijon 1999, p. 28;
Fox Weber 1999, p. 28;
Clair, Monnier 1999, n. P 220

The cour de Rohan, where Balthus's studio was by late 1935, gives onto this passage connecting the boulevard Saint-Germain with the rue Saint-André-des-Arts. The district, one of the oldest in Paris, since the walls raised by Philippe-Auguste in the very early thirteenth century circumscribed it, had been rebuilt in the seventeenth century, becoming, with the creation of the Comédie Française (1689) and the opening of the famous café Procope, one of the meccas of literary and theatrical life. A century later, the effervescence had not died down. The great actors of the Revolution, Marat, Danton, Camille Desmoulins, Billaud-Varennes, would get together at the Procope, that had a second entrance in the Passage du Commerce. Danton lived there, at n. 20; n. 8, that we can see in the picture, housed the printing shop where Marat published, in 1793, his newspaper, *L'Ami du Peuple*. The guillotine was experimented on at n. 9... The development of Paris during the nineteenth century and Haussmann's urban renovations restored to the district a provincial calm that it still enjoyed during the fifties. Pierre Klossowski devoted the last two paragraphs of a text significantly titled "Du tableau vivant dans la peinture de Balthus"[1] to the Passage du Commerce-Saint-André. "Two voices seem to alternate and echo one another; 'so it was' and 'so it will be forever'— like an evocation of things past and the perpetual return of that evocation in the pace of self-resigned everyday life," he wrote in particular. The *Passage du Commerce-Saint-André* indeed produces that sense of a suspended life, of a sort of spell cast over the figures, of "the painting in the painting" we had already experienced in front of *La Rue* (cat. 43). Two studies in paint show how Balthus gradually composed the picture; first the empty stage (fig. 2) with the blind façades, in lighter, gray and blue, tones, rather moonlike, and transfixed in a dead silence. Then a figure (fig. 1), the thoughtful little girl,

her hand on her chin, seen half-length, wearing a short cape that will later be removed.[2] Last, after some hesitations evidenced in the preparatory drawings, the others: the two children on the left whose heads, round like buoys, focus vision on the old hunchbacked woman, who is matched by the gnome seated on the sidewalk, on the right; the little girl playing with her doll, settled in the gutter, reminding us of the child with the shuttlecock in *La Rue*. At center, a man is moving away, with a loaf of bread in his hand; instead, in a preparatory drawing, he was coming toward us carrying a milk-churn (fig. 3). That was also the case with the central figures in *La Rue* and, to tell the truth, it does not matter whether he is going or coming: "It is from him—Pierre Klossowski writes—that proceeds the sense of uncertainty in the painting: at the center of the magic circle formed by 'so it was' and 'so it will be forever,' he himself is at once under the spell and yet free from it… The man who is walking and yet in his walking is immobile, is holding the very promise of breaking the hopeless circle, and breaking out of it: the loaf of golden bread, in which we might recognize something like an emblematic intention on behalf of Balthus."

[1] First published in English under the title "Balthus beyond realism," *Art News*, New York, vol. 55, n. 8, pp. 26–31, then in French in *Monde nouveau*, Paris, February–March 1957, nn. 108–109, pp. 70–80. Reprinted in *Balthus*, exhibition catalog, Paris 1983, pp. 80–85.
[2] Two models posed for this figure: one Parisian and anonymous, whose features return in the final version ; the other, as several drawings indicate (cf. Monnier, Clair 1999, nn. D 715–D 718), was Colette, the mason's daughter at Chassy. Balthus has confirmed to us that the work, begun in Paris, had been then removed to the Morvan. But he did not recall having brought it back to Paris to finish it, to "give it its light" as André Gomès reported. The collector who purchased the painting after having followed its elaboration was unable to provide details on the subject.

1. Balthus, *Etude pour "Le Passage du Commerce-Saint-André,"* 1951, oil on cardboard, 92 × 72.5 cm. Location unknown

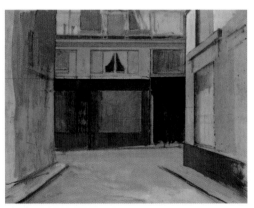

2. Balthus, *Etude pour "Le Passage du Commerce-Saint-André"* [Study for the "Passage du Commerce-Saint-André"], 1950, oil on cardboard, 71 × 90 cm. Private collection

3. Balthus, *Etude pour "Le Passage du Commerce-Saint-André,"* 1950, charcoal on paper, 37 × 54 cm. Private collection

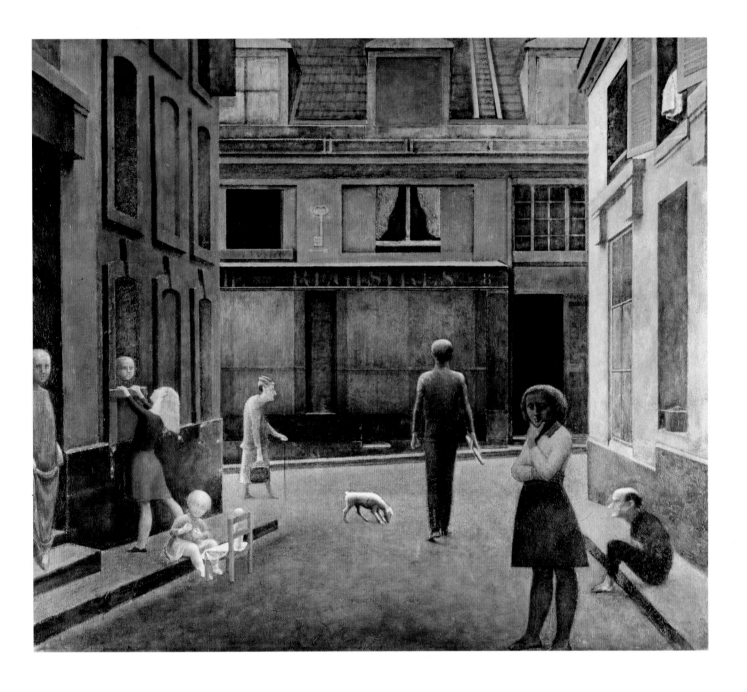

93. *La Chambre*, 1952–54
[The Room]

oil on canvas
270.5 × 335 cm
private collection

provenance: collection
of the artist; Galerie Frezer
exhibitions: Paris 1956;
New York 1956, n. 25;
New York 1957, n. 4; Paris,
Arts décoratifs 1966, n. 19;
Knokke-le-Zoute 1966, n. 19;
London, Tate Gallery 1968,
n. 34; Venice 1980; New York
1984, n. 32; Kyoto 1984, n. 15;
Rome 1990, p. 109
bibliography: Leymarie 1978,
pl. 18 and 2nd ed. 1990, pl. 19;
Leymarie 1982 pl. p. 55
and p. 141 and 2nd ed. 1990,
pl. p. 53 and p. 145; Klossowski
1983, pls. 40–41; catalog
MNAM.CNACGP, Paris 1983,
pl. p. 175 and p. 361 n. 128;
Clair 1984, p. 69 fig. 57; catalog
Lausanne 1993, p. 79; Kisaragi,
Takashina, Motoe 1994, pl. 25;
Xing 1995, pl. 29; Roy 1996,
p. 85; Klossowski 1996,
nn. 54–55; catalog Dijon 1999,
p. 28; Fox Weber 1999, pl. 1;
Clair, Monnier 1999, n. P 221;
Vircondelet 2000, pp. 78–79

"The light of day is cast upon the victim, offered and thrown back on a chaise longue; is this an orgasm following a rape? Or else nothing happened at all. The painting seems to be situated on the verge where 'nothing happened' and 'the irrevocable' are poised. The determined gesture of the figure pulling back the curtain is like an endless reiteration of the flagrante delicto of which the cat on the table is the only witness: that cat (belonging to the same species as the skirted dwarf) observes with some amazement the illuminating gesture of its accomplice, what consequences will the latter draw from what he is showing, other than a magnificent painting?"
Pierre Klossowski thus comments *La Chambre*, in an essay titled *Du tableau vivant dans la peinture deBalthus*.[1] And on the subject we should point out that the canvas being 2.70 m high, the figures depicted are life-size. In the same text, Pierre Klossowski tells that Balthus attempted to illustrate a book he was then writing, but then gave it up precisely because he was busy painting *La Chambre*. And he adds that, uncannily, the painted scene does have a connection with one of the scenes in the book. This story is probably *Roberte ce soir*, published in 1953, of which Jean Clair analyzes above the cross-connections it has with the painting.[2] Jean Clair insists, in particular, on the presence of a fantasy the two brothers share: that of the "little hunchbacked dwarf, monstrous and libidinous," avatar of the Colossus or of the "ageing demon of childish vices," a character whose origins Jean Clair found in a Germanic nursery rhyme, *Das bucklige Männlein*, repeated ad nauseam in turn-of-the-century *Kinderstuben*.[3]
La Chambre was painted in Paris between 1952 and 1954, at the same time as the *Passage du Commerce-Saint-André* (cat. 92); those two masterful works concluded Balthus's Parisian period.[4] As a matter of fact he would have liked the two pictures to be in the same collection, an offer that the purchaser of the *Passage du Commerce* declined, owing to the size of the paintings. They have not been reunited since over a quarter of a century, and we wish to pay tribute here to their respective owners' generosity.
Up to now, investigations to locate the sources, either literary or pictorial, of *La Chambre*, have failed. At a later period Balthus himself, with his incisive humor, contributed to confuse the issue.[5] The severe, bare atmosphere of the room, the association of the Empire green of the curtain and the antique red of the plinth at the base of the blank walls bring to mind great neo-classical French painting. We are reminded of a certain David,[6] of some portraits by Gros, of Eric Rohmer's way of rendering, in motion pictures inspired by those paintings, the strange, dramatic mood of a period convulsed by wars and the arising of a new sensibility.
La Marquise d'O. (1976), is the literal transposition of a short story by Heinrich von Kleist (1777–1811), that is set in Northern Italy during the Empire wars. It is the dramatic tale of a young widow, raped by a Russian officer during the seizing of the fortress her father commanded and while she was in a swoon, and consequently confined by her family.
A pre-Romantic tragedy taking place in a violent atmosphere and steeped in a mystery that will finally be resolved by the remorseful officer asking for her hand. In the tale, Kleist contrasts the misleading reality of appearances with an ideal reality embodied in the individual confronting society.
The same elements can be found, transposed, in *La Chambre*: sexual violence (nobody has ever had any doubt but that the young girl had been raped) embodied by the cat with its satanical facies, opposed to the purity and innocence represented by the jug of water and the basin (that furthermore have the transparency of glass); mystery, unveiled by the dwarf who, by pulling the curtain, casts light on the scene; death (or at least the trance the young girl in catalepsy is in, her stiffened right arm recalling that of a Christ taken off the cross in Medieval painting). The only drawing prior to the painting that we know of (cat. 82) does not have that dramatic connotation; the well-lit room has a parquet floor, it is a child instead of a gnome who pulls the curtain that falls in soft folds, the water jug is in plain faience and, above all, there is no cat. The young girl may be merely absorbed in a voluptuous dream. In the painting, her face and her hands are reddened. Not by flowing blood, but by the blush that surfaces beneath the skin, from the warmth given by pleasure. According to Balthus, his intention was not to express eroticism.
It is the spectator who, behaving like a voyeur, reads the various iconographic elements of the picture in that sense. Such an interpretation arises here from the presence of the cat and its connection with the dwarf. And also, and this time concretely, from the high white socks the young girl is wearing, of which we have already pointed out the meaning and the role with regards to *La Toilette de Georgette* (cat. 83).

[1] Published in *Monde Nouveau*, 108–109, Paris, February–March 1957, pp. 70–80; reprinted in *Balthus*, exhibition catalog, Paris 1983, pp. 80–85.
[2] Cf. *supra*.
[3] J. Clair, "Le sommeil de cent ans," in Clair, Monnier 1999, pp. 32 ff.
[4] On the subject, see the article by Jean Clair, "Le Paris de Balthus," *Beaux-Arts*, 7, November 1983, pp. 38–41.
[5] Several years ago, looking at a reproduction of *La Chambre*, Balthus claimed he was suddenly struck by the likeness of the gnome on the right with the *Bonaparte au pont d'Arcole* in the famous painting by Gros. He immediately drew the consequences, ruling that his work should henceforth bear the sub-title: *Bonaparte découvrant les plaines fertiles de la vallée du Pô* [Bonaparte Discovering the Fertile Plains of the Po Valley]. And with the gravity of humorists, imposed it on the occasion of the publication of the monograph Claude Roy had written on him (Gallimard, Paris 1996, p. 85).
[6] The back of the armchair of *La Chambre* oddly, ironically recalls the meridienne in *Madame Récamier*.

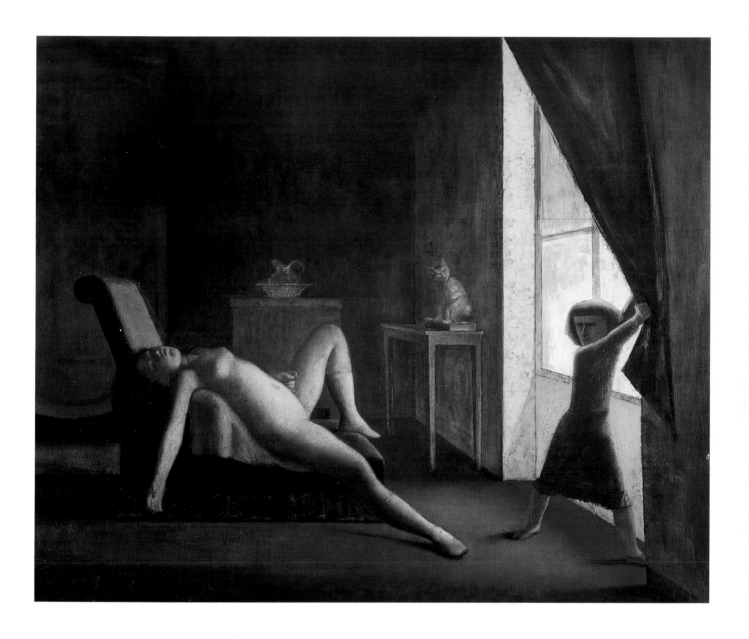

Chassy (1953–61)

Balthus's move to the château de Chassy in the Morvan coincided with a renewal of his inspiration and his palette.

A number of Paysages depict the castle's immediate surroundings, while the *Portraits* and the *Nus* become diversified.

Balthus painted there a series of still lifes as well, of which the *Fruits sur le rebord d'une fenêtre* (shown for the first time) is the loveliest.

The theme of the *Rêve*, day or night dream, appeared in his work, just as he began the first variations on the theme of the *Trois Sœurs*.

94. *Paysage du Morvan et études d'arbres*, 1954 [Morvan Landscape and Studies of Trees]
95. *Quatre études de paysages dans le Morvan*, 1954–55 [Four Studies of Morvan Landscapes]

94.
India ink and water color wash
on ochre paper
30.5 × 23.4 cm
monogrammed and dated lower
left: "B 1954"
Poitiers, private collection

provenance: Henriette Gomès,
from the artist; André Gomès;
sale Briest, Paris, 18 June 1997,
n. 145
exhibitions: Dijon 1999, n. 6
bibliography: Clair, Monnier
1999, n. D 776

95.
water color on blue paper
48.7 × 55 cm
(reverse of cat. 96)
private collection

exhibitions: Spoleto 1982,
n. 58 b; Paris, MNAM.CNACGP
1983–84, n. 40; Kyoto 1984,
n. 42; Dijon 1999, n. 26
bibliography: Roy 1996, p. 135;
Clair, Monnier 1999, n. D 823

In 1953, Balthus left Paris to settle in the Morvan.
The castle of Chassy that he moved into,
an old possession of the de Choiseul family,
is a seventeenth-century edifice, part-castle
part-farmhouse, like many in the area: a main
building flanked with four towers opening
onto a courtyard, the latter being preceded
by a farmyard surrounded by farm buildings
(cats. 100, 122).
Most of the landscapes Balthus painted there
were taken from his studio, set up on the first
floor cats. 113, 114, 115), or from one of the
windows on the second (cats. 107, 110). Only
two canvases[1] and a dozen drawings were
executed in the surrounding countryside (fig. 1).
The two sheets shown here belong to that group.
The first depicts a hut, backed up against a wood
and built on a hillock, of which there are many
like it in the Morvan. The grays, greens, ochres or
browns, quickly jotted down, create a harmony
that is typical of Balthus's landscapes. In the lower
part of the sheet, an India ink wash, concentration
is on the play of shadows and light on the foliage
rather than on the design of the branches, which
is unusual for Balthus.
The second sheet is divided in four parts. Upper
left, two tree studies, a few bushes forming a
wood or hedge are lightly watercolored. Below,
you can glimpse one of the pointed castle towers,
seen from the north. The upper right composition
shows us hilltops and sappy plants that stand out
vividly against the blueish ground of the paper.
Notice the humorous representation of the yoked

1. Balthus, *La Vallée de l'Yonne*
[The Yonne Valley], 1954,
water color and pencil on paper,
22.5 × 29.5 cm.
Private collection

oxen led by two peasants, a unique little scene
in Balthus's work, most of his landscapes being
empty, since his interest in agriculture was scarse.
Last, the lower right holds a surprise for us.
It had past unnoticed up to now[2] that this is not
a depiction of the Burgundy countryside, but
the outlet of the Trouville harbor, drawn from
a painting by Bonnard conserved in the Musée
national d'art moderne in Paris (fig. 2).

[1] Clair, Monnier 1999, nn. P 249bis, P 303.
[2] Jean Clair kindly informed us of this discovery.

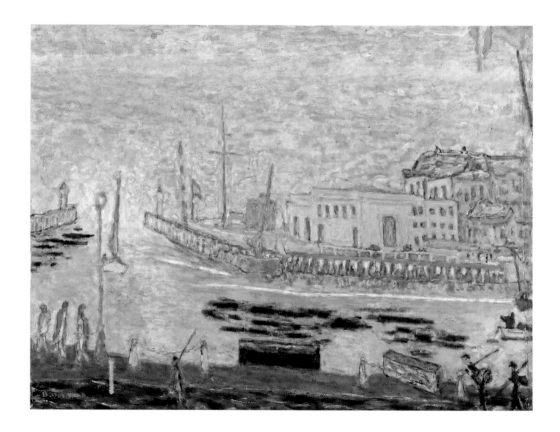

2. Pierre Bonnard,
Trouville, la sortie du port
[Trouville, The Harbor Outlet],
1938–45, oil on canvas.
Paris, Musée national
d'art moderne, Centre
Georges Pompidou

94

95

96. *Etude pour "Le Rêve* I*,"* 1954 [Study for "The Dream I"]
97. *Esquisse pour "Etude pour Le Rêve* I*,"* 1954
[Sketch for "Study for The Dream I"]

96.
water color and pencil
on blue paper
48.7 × 37.4 cm
(recto of cat. 95)
private collection

exhibitions: Spoleto 1982,
n. 58a; Paris, MNAM.CNACGP
1983–84, n. 40; Kyoto 1984,
n. 45; Dijon 1999, n. 26
bibliography: Clair, Monnier,
1999, n. D 805

97.
pencil on paper
53.5 × 40 cm
(reverse of cat. 98)
J.-M. Folon

exhibition: Kyoto, 1984, n. 83
bibliography: Clair,
Monnier 1999, n. D784

A young girl, whose body has fallen over on
the side, is asleep on a couch, under the window
framed with light curtains. The faded blue and
brown monochromes emphasize the play of curves
and shadows, suggest a dimmed light and create
an impression of quietude confirmed by the
balance of the composition. So this watercolor
can be considered an independent work, yet
it is interesting to compare it to a series of studies,
draughted or painted, that perhaps it inspired
and whose outcome was to be *Le Rêve* I.
One of these studies (fig. 1) resembles our water
color: it features a comparable arrangement
of curves and blue-yellow dominant.
Another one (fig. 2) should be linked up with
the sketch shown here under cat. 97. Two figures
are depicted; the first, a vague silhouette, is
leaning over the second who is lying on its back.
The curves of the bodies match but we cannot
grasp the meaning of the scene. It is the painted
sketch that provides a hint since the sleeping
figure shown before appears in it.
One study leading to another, we thus come to
the large canvas titled *Le Rêve* I (fig. 3), the first
of a series (cf. cat. 109 figs. 1 and 2 and cat 119)
that occupies a special place in Balthus's work
because of the dreamlike dimension it adds to it.
Balthus often drew or painted young girls asleep,
saying they were "dreamers;" but for the first time
he represents in these paintings at once the sleeper
and the object of her dream. There are other
examples in the history of painting, one of the
oldest being the famous *Nightmare* by Johann
Heinrich Füssli[1] the Surrealists would refer to.
Balthus has as little to do with the one as with the
others, since the dreams he stages are dreams of
happiness, as free of anxiety as of psychoanalytical
connotations. Furthermore, and this is perhaps his
most original contribution to the genre, he places
the conjured-up figure amidst the reassuring,
familiar context of everyday reality: the selfsame

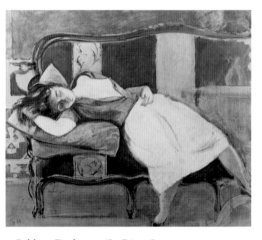

1. Balthus, *Etude pour "Le Rêve* I*,"*
oil on canvas, 80 × 92 cm.
Private collection

light illuminates the dreamer and the "fairy"
bent over her. The poppy she is offering her
comes from the bouquet placed on the pedestal
table; she is dressed like everybody else and
with her left hand has a very human gesture
to tell us to keep still.
Nonetheless, it is indeed an angel who has come
to awaken the young girl. A barefoot angel, with
a slightly stiff body and a sexless air, a straight
profile and curly hair. Her weightless body forms
a contrast with the very real one, drawn all in
curves, of the bare-breasted sleeper, whose weight
we can perceive on the couch.
The different studies show how, borrowing from
one or the other, Balthus gradually elaborated
and rendered, by contrasting them, the difference
of nature between the two figures.

[1] 1790–91, Frankfurt, Goethemuseum.

2. Balthus, *Etude pour "Le Rêve* I*,"*
oil on canvas, 45.5 × 56 cm.
Private collection

3. Balthus, *Le Rêve* I *[The Dream 1],*
1955, oil on canvas, 130 × 163 cm.
Private collection

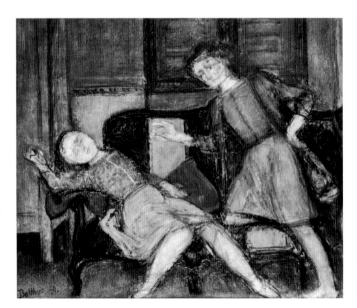

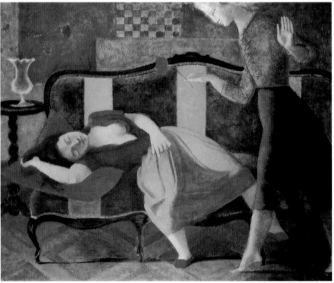

96

97

98. *Etude pour "Nu devant la cheminée,"* 1954
[Study for "Nude in front of a Mantel"]

pencil on paper squared
by the artist
53.5 × 40 cm
(recto of cat. 97)
signed and dated lower right:
"Balthus 1954"
J.-M. Folon

exhibitions: Kyoto 1984, n. 44
bibliography: Clair,
Monnier 1999, n. D 795

There are a dozen studies, partial or overall, for the *Nu devant la cheminée* of 1955 (fig. 1). This one, the most similar to the painting, is probably the last. In fact it was squared to be transferred onto canvas.
The young girl is standing, nude, alone, in a bright, empty room. She is seen in profile, her left foot placed forward of the right, in the manner of Egyptian statues. Her marmoreal body has their same compactness and, owing to the way it is framed, seems huge. With one hand, she is lifting up her long hair, her left arm nearly entirely masking her face. The other one, that figures on the sketched study, does not appear in the canvas, creating a puzzling sense of irreality. We might suggest an explanation: we can discern in the drawing three slanting lines starting respectively from the lower left angle of the composition, from the base of the mantel and the corner of the marble slab extending the hearth. Those three lines converge on the young girl's side, at a point that is at once the center of gravity of her body and the focus point of the composition. The arm, that was at the same level, was discarded to prevent the viewer's eye from wandering.
In the years right after the war, young girls at their mirror were often assisted by an old woman, their accomplice or their double according to some historians. Here, the mirror is the double. Against the overmantel that (in the painting) reflects the blue wall, is placed a framed mirror, whose surface is black, scantily lit, in the lower part, by a vague ghost. What is its meaning? What is the idea, the symbol, it is hiding? We cannot tell.

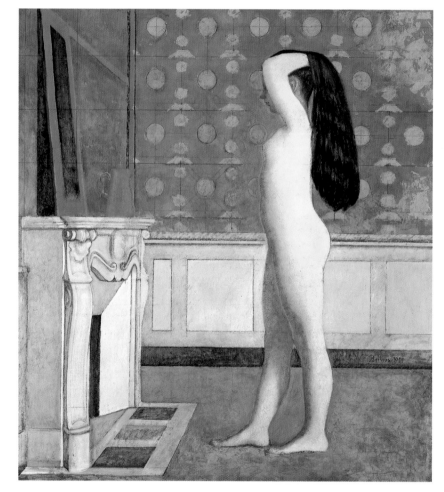

1. Balthus, *Nu devant la cheminée* [Nude in front of a Mantel], 1955, oil on canvas, 190 × 164 cm. New York, The Metropolitan Museum of Art, The Robert Lehman collection

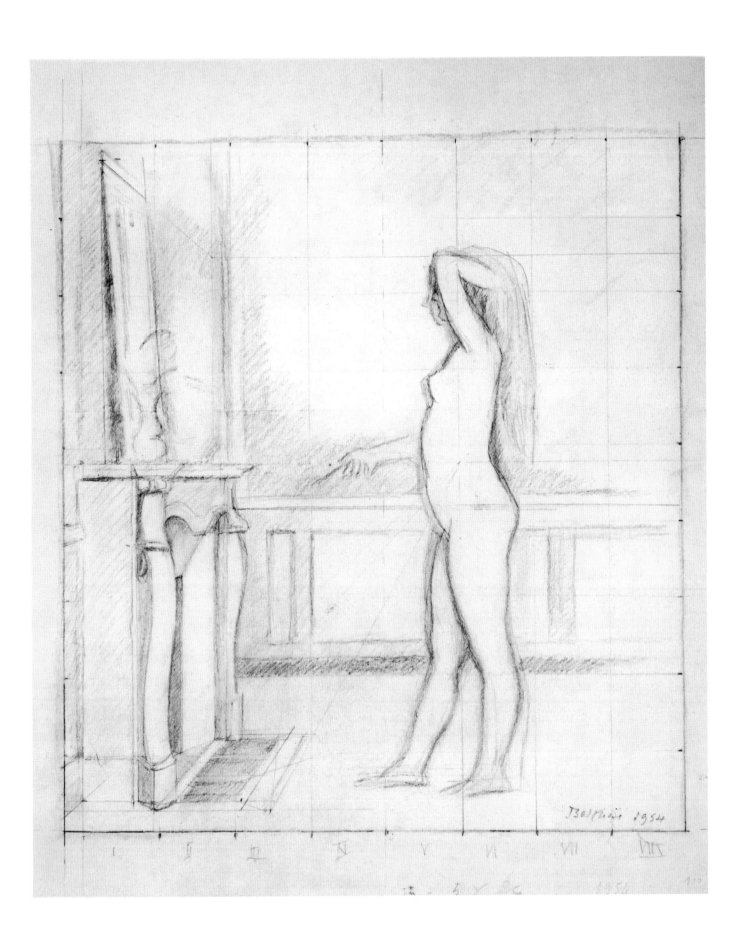

99. *Colette de profil*, 1954
[Colette in Profile]

oil on canvas
92.5 × 73.5 cm
signed and dated on reverse:
"Balthus 54"
private collection

provenance: Maurice Rheims;
Jan Krugier Gallery, New York;
Lee A. Ault,
New York; sale Sotheby's,
New York, 12 May 1993, n. 281.
exhibitions: Paris 1956;
New York 1957, n. 1; Paris,
Arts décoratifs 1966, n. 20;
Knokke-le-Zoute 1966, n. 20;
London, Tate Gallery 1968,
n. 37; Tokyo 1993–94, n. 14;
Hong Kong 1995, n. 10; Beijing
1995, n. 10; Taipei 1995, n. 10;
Madrid 1996; Rome 1996–97,
p. 93; Zurich 1999, n. 12;
Dijon 1999, n. 21
bibliography: Leymarie 1978,
pl. 21 and 2nd ed. 1990, pl. 22;
Leymarie 1982, pl. p. 63
and p. 128 and 2nd ed. 1990,
pl. p. 59 and p. 128; catalog
MANAM.CNACGP, Paris 1983,
p. 362 n. 133; Kisaragi,
Takashina, Motoe 1994, pl. 30;
Xing 1995, pl. 31; Roy 1996,
p. 161; Jaunin 1999, p. 125;
Clair, Monnier 1999, n. P 224

The portrait of *Colette de profil* is the first major
work painted at Chassy. Considering the dates
of the sketchbooks referable to it,[1] Balthus worked
for a year on this picture that represents the
daughter of the mason working on the restoration
of the castle.
The painting is immediately striking for the
luminous vibration it diffuses. As if, on leaving
the city for the country, Balthus had at the same
time perceived what he was seeing with a fresh
eye, consequently altering his way of painting.
The image of Colette does not look as though
it had been drawn on the canvas, but seems
to arise, to spring from the canvas itself
or from the golden wall she stands out against.
The child is still and silent; she is resting her
hands, already those of a woman, on the table
and, by her gesture appears to be seeking,
out of sheer will-power, to control their febrility.
There is a tension between those alive, nervous
hands, and the flat face, with its absent gaze,
and whose outlines are dissolved in the light.

An uncanny gaze, owing to her strangely globular
right eye, that has caused Colette's face to be
compared to that of a sphinx or to a mask.
That face "is not defined by light, but in itself
is light and glow, an immaterial matter."[2]
Fabian Rodari is the author of a long poetic
meditation on this portrait of Colette.[3] He writes:
"Her gaze does not seize the world around her,
but instead is generous, welcoming; not a mirror
in which the world disappears, but an attentive
openness letting itself be permeated, absorbing.
Henceforth the absence the child wraps herself
in enables her to understand, to contain in herself
the irruption, painful and promising, of life
that all of a sudden tears her from her immediate
cares, letting her glimpse an unknown world,
rich with silences and alarms."

[1] Clair, Monnier 1999, nn. CC 1480/5 ff.
[2] C. Roy, *Balthus*, Gallimard, Paris 1996, p. 160.
[3] F. Rodari, "Balthus l'énigmatique," *Revue
de Belles-Lettres*, 3–4, April 1973, Paris, pp. 111–24.

1. Balthus, *Etude pour
"Colette de profil"*
[Study for "Colette in Profile"],
(1953–54), pencil on squared
paper, 18.5 × 28 cm.
Private collection

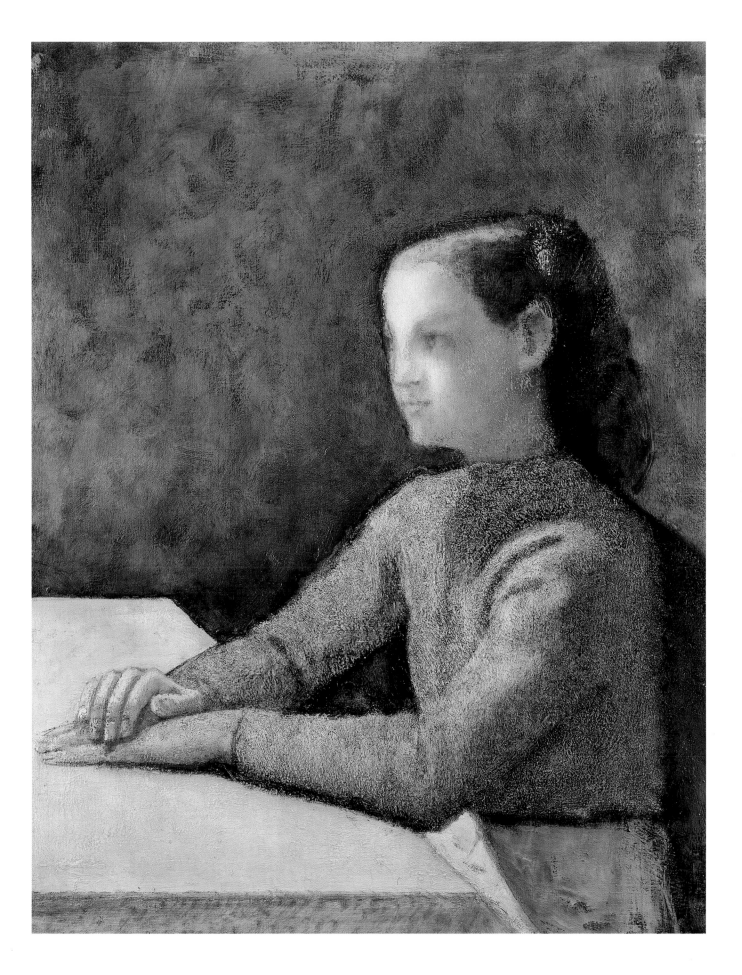

100. *Paysage de Chassy (la cour de la ferme)*, 1954
[Landscape at Chassy (The Courtyard of the Farm)]

oil on canvas
100 × 81 cm.
private collection

provenance: Pierre Matisse
Gallery, New York; 1981–88,
Gallerie Claude Bernard, Paris
exhibitions: New York 1977,
n. 3; Madrid 1996; Dijon 1999,
n. 2
bibliography: Leymarie 1982,
p. 147 (cliché reversed)
and 2nd ed. 1990, p.153;
catalog MNAM.CNACGP, Paris
1983, p. 362 n. 131; Roy 1996,
p. 116, Clair, Monnier 1999,
n. P 236

We have before us the second of the seven views
Balthus would give of the Chassy farmyard,
another one of which, as bright as this one
is muted, features in the exhibition (cat. 122).
The canvas is vertical and the composition seems
to unfold, in a continuous flow, from bottom
to top. The lower part, where we see in the
foreground the castle courtyard with its tall bare
tree, and in the middle distance, the adjoining
farmyard, is laid out according to a precise
squaring. The edges of the walls, the pillars
of the first gate, the wooden posts supporting
the roof of the sheds delineate the verticals; the
low wall and the rooflines design the horizontals.
Beyond the faint line of the tiles along the ridge
of the roof that divides the painted surface in two,
a landscape of hills with soft undulations unfolds,
rising to the leaden sky. The silvery spots of
the small slate roofs are the only touches of light
in this wintery, practically monochrome painting.
Thus the two worlds of this painting closed upon
itself are distinctly differentiated: rigid diagonals
for the domestic space, curves of hills and hedges
for the countryside. The clawing branches
of the tree, spreading like a net over the right side
of the painting, form the plastic link between
the two systems; the masonry porch with its posts

subtly underlined in blue-gray and its rounded
top represents the symbolic transition from
one to the other.
Balthus spoke many times about his fascination
for Chinese landscape paintings, telling how,
very young, in front of the mountains of the massif
of Beatenberg he had had the revelation that there
was no difference between what he had before
his eyes, the landscapes of the Song period
and those of the Siennese painters. A sentence
that was frequently repeated without its meaning
ever really having been elucidated.
On the occasion of a recent conversation
with him,[1] he went into it at greater length.
The likeness does not stem from the physical
structure of the landscapes, nor from the
intellectualization whereby somebody renders
them, but has to do with the fact that here or
there, certain elements can disappear and
reappear depending on the light or the focusing
of the painter's eye. Therefore, you must give
an overall vision of the landscape, "look from
a distance to grasp the lines of force and the
appearance of a landscape and from close up
to seize its substance,"[2] and as Xing Xiaosheng
writes, "seize the essentials of things by the most
economical means."
From Chinese painting, Balthus borrows
its near-monochromy and its perspective in height
theorized by the Songs' painter, Guo Xi.[3]
As in *Le Gottéron* of 1943 (fig. 1) which the
present picture resembles in many respects,
Balthus gives the smallest detail the same value as
to the largest: the tinest bit of roof here "weighs"
as much as an entire section of a wall, the slightest
bush as much as the big tree in the foreground.
Likewise in *Le Gottéron*, the minute woodcutter
matched the large black larch and the white foam
of the stream with the schist cliff.
We pointed out the binary composition
of the *Paysage de Chassy*, the opposition
and the complementarity of the two "worlds"
shown therein. Here as well, Balthus is inspired
by Chinese culture, by the *yin* and the *yang*.
We shall find again another interpretation
of it in the *Paysage de Monte Calvello* (cat. 122).

[1] 23 March 2000.
[2] Fan Kuan, quoted by Xing Xiaozhou, *Balthus
et l'Extrême-orient*, 3rd cycle doctoral thesis,
Université de Paris I Panthéon-Sorbonne, June 1997,
pp. 130 ff.
[3] *Haut message [des forêts] et des sources*,
quoted by Xing Xiaozhou.

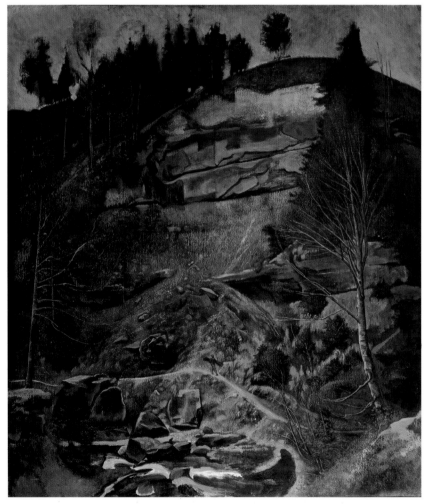

1. Balthus, *Le Gottéron*, 1943,
oil on canvas, 115 × 99.5 cm.
Tahiti, P.Y. Chichong collection

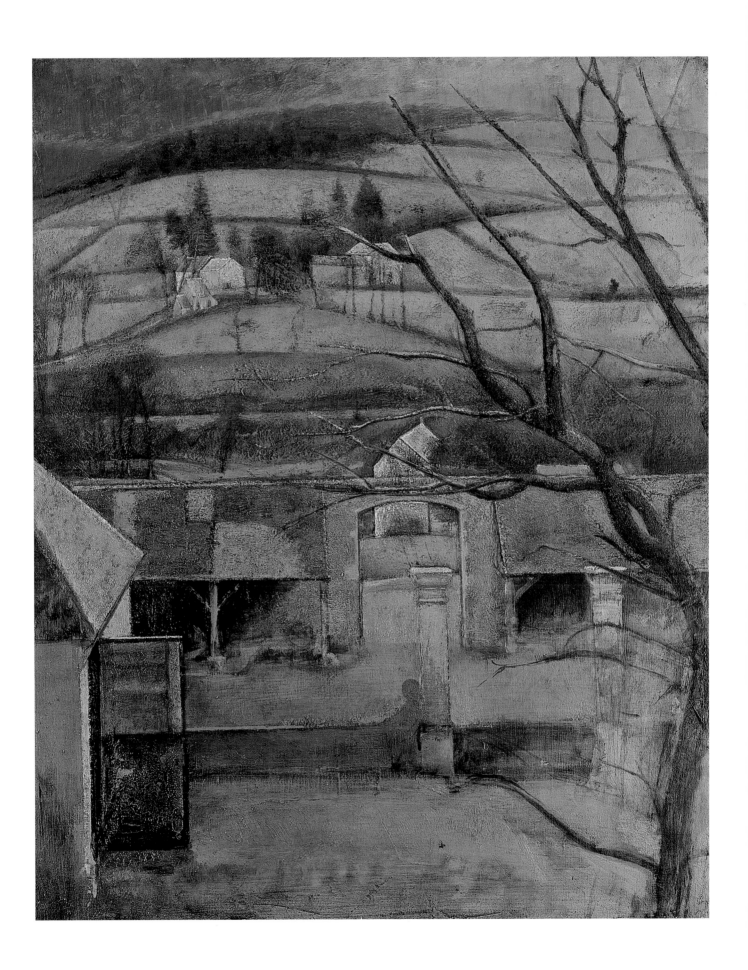

101. *Les Trois sœurs (Sylvia, Marie-Pierre et Béatrice Colle)*, 1954–55
[The Three Sisters (Sylvia, Marie-Pierre and Béatrice Colle)]
102. *Les Trois sœurs*, 1955 [The Three Sisters]

101.
oil on canvas
60 × 120 cm
private collection

provenance: gallery Henriette
Gomès, Paris; Alain Lalonde,
Paris; private collection,
New York
exhibitions: Paris 1956;
Paris, Arts décoratifs 1966,
n. 21; Knokke-le-Zoute 1966,
n. 21; London, Tate
Gallery 1968, n. 43; Paris,
MANAM.CNACGP 1983–84,
n. 47; New York 1984, n. 34;
Lausanne 1993; Tokyo
1993–94, n. 16; Madrid 1996
bibliography: catalog
MANAM.CNACGP, Paris 1983,
pl. p. 187 and p. 363 n. 142;
Clair 1984, p. 64 pl. 51;
Leymarie 1990, p. 135; Kisaragi,
Takashina, Motoe 1994, pl. 32;
Xing 1995, pl. 38 (repr.
reversed); Roy 1996, p. 197;
catalog Dijon 1999, p. 68;
Fox Weber 1999, pl. 12;
Clair, Monnier 1999, n. P 234;
Colle, Lorant, Saalburg 2000
p. 25

102.
oil on canvas
130 × 196 cm
signed and dated lower right:
"Balthus 55"
Caracas, Patricia Phelps
de Cisneros collection

provenance: Claude Hersent,
Paris; Hélène Anavi,
Villeneuve-sur-Lot; Thomas
Ammann Fine Art A.G., Zurich
exhibitions: Zurich 1982, n. 2
bibliography: catalog
MANAM.CNACGP, Paris 1983,
p. 367 n. 165 (incorrect
dimensions and localization);
Roy 1996, p. 198; Clair, Monnier
1999, n. P 252; Colle, Lorant,
Saalburg 2000, p. 33

In 1952, Balthus wished to resume possession
of an important painting, *La Jupe blanche* (cat. 54
fig. 1), that he had formerly sold to Pierre Colle
(cat. 51). The latter's widow, Carmen, remarried
to François Baron, asked him, in exchange,
to do the portrait of her three daughters,
Marie-Pierre, Béatrice and Sylvia.
Marie-Pierre, the eldest, was the first to pose, in
the studio of the cour de Rohan, and a few pencil
studies were kept.[1] Then, during the summer of
1954, Balthus spent some time in the large family
home, at Biarritz, where the three sisters were
together for the holidays. He did other studies,
still on paper, from which, once back at Chassy,
he painted three partial studies for the large
picture: Sylvia by herself, Marie-Pierre and Sylvia,
Marie-Pierre and Béatrice (figs. 1, 2, 4).
The triple portrait of the three sisters (cat. 101)
was finished the following year. It is similar
to the painted studies that he recomposed
in a frieze on a canvas twice as wide as it is high.
We can recognize here the furniture of the
music-room of the villa *Le Chapelet* at Biarritz.
The sisters are dressed in summer outfits that,
incidentally, came from Christian Dior, Carmen
Baron being his collaborator. They are wearing
Basque espadrilles matching their clothes, purple
for Sylvia, orangey red for Marie-Pierre, light
yellow for Béatrice. The oldest is enthroned
on the couch, the second taking a bite of fruit,
the youngest reading, seated in an armchair.
The canvas is rigorously divided in three vertical
bands defined by two lines that go respectively
along Marie-Pierre's nose and the tip of Sylvia's
foot, the couch cushion and Béatrice's knee.
Lengthwise, Marie-Pierre's extended arm
and the base of the couch draw the horizontals.
Jean Leymarie enjoyed recalling, on the subject
of this composition, the large fresco of the *Three
Virtues* by Ambrogio Lorenzetti at the Palazzo
Publico of Siena[2] (fig. 3). Closer to us, and within
Balthus's own work, we can link it up with the
first study for *Le Salon* of 1943 (fig. 5) in which
he had placed three young girls, only two
of which would be retained for the later
versions of the said *Salon*.[3] He used the same
three-part division, and the decorative structure,
in particular replacing the door figuring
on the left in the *Salon* by the curtain against
which Sylvia's silhouette stands out.
Chance had it that Balthus was led to paint several
versions of the *Trois sœurs* as well. Indeed,

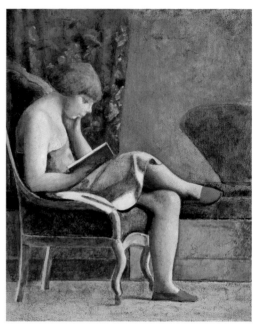

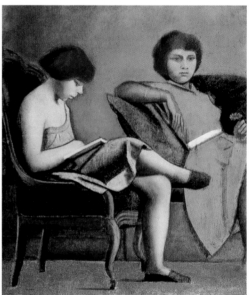

1. Balthus, *Etude pour
"Les Trois sœurs" (Sylvia Colle)*
[Study for "The Three Sisters"
(Sylvia Colle)], 1954,
oil on canvas, 101.5 × 83.2 cm.
Saint Louis Art Museum

2. Balthus, *Etude pour
"Les Trois sœurs"
(Sylvia et Marie-Pierre Colle)*
[Study for "The Three Sisters"
(Sylvia and Marie-Pierre Colle)],
1954, oil on canvas, 98.4 × 80 cm.
Private collection

3. Ambrogio Lorenzetti,
*The Three Virtues. Allegory
of Good Government*, 1338,
fresco, detail.
Siena, Palazzo Pubblico

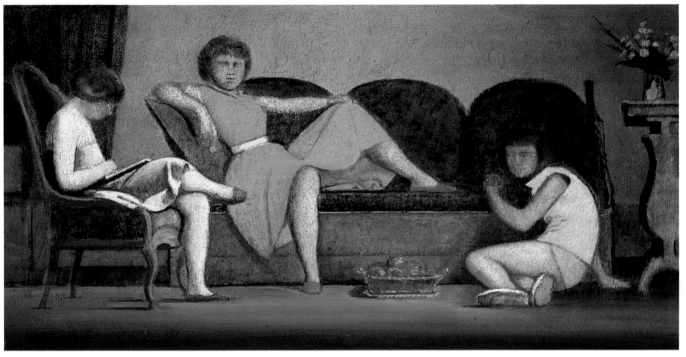

101

the contract binding him to a group of sponsors since he had moved to Chassy (cf. cat. 91) stipulated that each one of them could choose several paintings each year. That is how the first version of the *Trois soeurs* became the property of Henriette Gomès, while the second (cat. 102) entered in Claude Hersaint's collection.

That one, with more compact proportions, adopts approximately the iconography of the first and, in a soft, more luminous harmony, like contrasts of chromatic values, yet arranged differently. The décor is still the Biarritz music-room. This second version would be followed by three others, executed at the Villa Medici in the sixties. Their décor is different; a couch and a carpet with a geometric pattern contrast with the flected wall in one (fig. 6), a ghost of a cat is going through the other (fig. 7). This last version is painted in a light texture that enhances the geometrization of the composition. Marie-Pierre is still enthroned in the middle but, as in the fourth version, her two sisters have switched positions.

Now Béatrice is reading, too, her knee resting on a chair, her elbows on a table, in a position that remotely recalls that of Hubert in the *Enfants Blanchard* (cat. 53).

Thus, around the *Trois sœurs* is formed a cycle of ten paintings in all (the eight above-mentioned ones plus two studies of Sylvia and of Marie-Pierre executed in Rome[4]) and of a dozen drawings that, by its scope, is the most important one to be found in Balthus's work. Each piece stands on its own, but, replaced in the ensemble, also evidences the evolution of Balthus's style at a crucial moment of his career.

[1] Cf. Clair, Monnier 1999, nn. D 738 ff. and Colle, Lorant, Saalburg 2000.
[2] In Colle, Lorant, Saalburg 2000, p. 15.
[3] Cf. Clair, Monnier 1999, nn. P 132, P 137 and P 138.
[4] Cf. Clair, Monnier 1999, nn. P 318 and P 319 and Colle, Lorant, Saalburg 2000, pp. 69, 108.

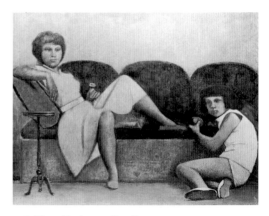

4. Balthus, *Etude pour "Les Trois sœurs" (Marie-Pierre et Béatrice Colle)* [Study for "The Three Sisters" (Marie-Pierre and Béatrice Colle)], 1954, oil on canvas, 90 × 117 cm. Location unknown

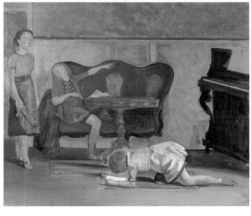

5. Balthus, *Etude pour "Le Salon"* [Study for "The Salon"], 1941, oil on canvas, 65 × 81 cm. Private collection

6. Balthus, *Les Trois sœurs*, 1963–64, oil on canvas, 127 × 170 cm. Private collection

7. Balthus, *Les Trois sœurs*, 1964, oil on canvas, 131 × 175 cm. Private collection

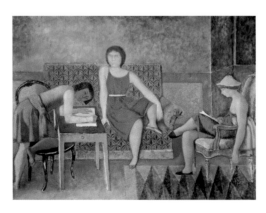

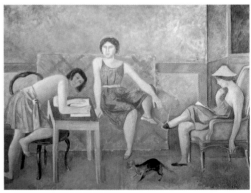

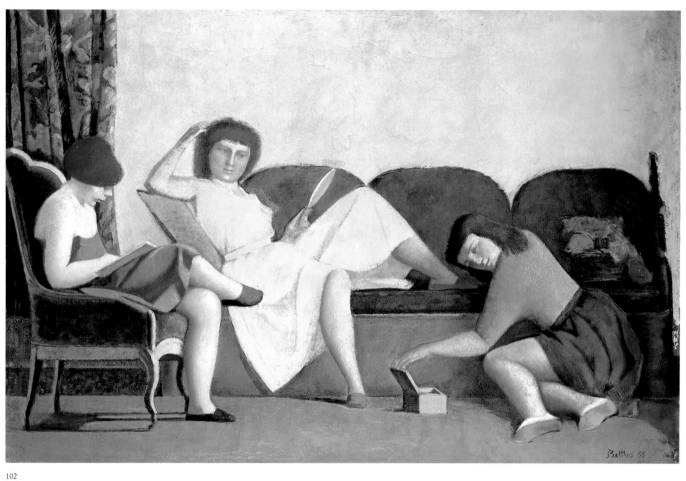

102

103. *Etude pour "Le Lever,"* 1955 [Study for "The Waking up"]
104. *Le Lever*, 1955 [The Waking up]

103.
pencil on paper
103 × 68.5 cm
private collection

provenance: Galerie Henriette
Gomès, Paris, purchased from
the artist; André Gomès; sale
Briest, Paris, 17 June 1997, n. 19
exhibitions: Paris, Gomès 1966;
Paris, Gomès 1983–84; Andros
1990, n. 55; Rome 1990, p. 123;
Lausanne 1993; Bern 1994,
n. 38
bibliography: Xing 1995;
Roy 1996, p. 188; Clair,
Monnier 1999, n. 845

104.
oil on canvas
162 × 130 cm
Edinburgh, Scottish National
Gallery of Modern Art

provenance: baroness
Alix de Rothschild; private
collection; Andrée Stassart
exhibitions: Paris 1956; Paris,
Arts décoratifs 1966, n. 26;
Knokke-le-Zoute 1966, n. 26;
London, Tate Gallery 1968,
n. 40; Dijon 1999, n. 31
bibliography: Leymarie 1982
p. 142 and 2nd ed. 1990, p. 147;
catalog MNAM.CNACGP, Paris
1983, p. 295, p. 366 n. 160;
Clair 1984, p. 90 pl. 68; Roy
1996, p. 188; Fox Weber 1999,
p. 478; Clair, Monnier 1999,
n. P 260

In the preface to the catalog of the exhibition
he curated in 1968,[1] John Russel pointed out
that *Le Lever* had been inspired by Caravaggio's
Amore Vincitore (fig. 3). The parallel was all the
more discerning since at the time Russel probably
had not seen the painted *Etude* (fig. 1),
preparatory to the work, that was not published
until 1982.[2] The *Etude* is the exact graphic
transposition of Caravaggio's painting.
The position of the head is identical, the body,
in both cases, without its left arm, has not yet
assumed the Ingres-like roundness it will have
n the final version of the *Lever*; the curtain
occupying the upper left angle follows the outline
of the wing of *Amore*, and the pillow we glimpse
beneath the girl's raised arm that of the arrows
the adolescent is holding; there are equally
the deep, vertical creases of the sheet falling
to the ground and then obliquely rising under
the figure's right thigh.
Etude pour "Le Lever" effects the transition
between the first painted version and the one
at the Edinburgh Museum. Balthus works
exclusively on the figure. With an unhesitating
line, he rounds the curves of the body, throws
the head back, then models the breasts, extends
the left leg and imagines the second arm, thus
entirely transforming the subject. He has not yet
begun topay attention to the layout.
The bedsprings, the blanket and the sheet
will be dealt with in a separate drawing without
the model (fig. 2). Over the bed, he sketches
several black obliques that form two triangles.
They are not legible and can only be understood
by comparing this study to the painting (they lead
to the beige curtain hanging behind the bed).
That triangulation, that combines with the curve
drawn by the edge of the sheet and the satin
ribbon trimming the blanket, resumes a recurrent
composition scheme in Western painting,

1. Balthus, *Etude pour "Le Lever,"*
1955, oil on canvas, 33 × 24 cm.
Private collection

originating in the late Gothic period.[3]
The work is centered on the left fold of the groin.
An arousing focus point—and shifted with respect
to Caravaggio's model—, contributing
to the sensuality of the painting. We are not
in the presence of a portrait, nor of a naughty
scene but of a sort of "manifesto" with an intense
sexual connotation. The ambiguousness
Caravaggio had given his picture, by the realism
of the young boy's face and body, is transposed
here. It is expressed by this sexless body, with its
mishapen face, yet whose femininity is expressed
by the emphasized curves of the body
and the luxuriant black hair falling to her waist.
Balthus makes it stand out against the beige
curtain, but concentrates the light on it, wrapping
it in bluish grays and purplish browns.

[1] London, Tate Gallery, 1968, preface reproduced in
Balthus, exhibition catalog, Paris 1983, pp. 280–97.
[2] J. Leymarie, *Balthus*, Skira, Genève 1982, p. 142.
[3] Medieval Virgins and Pietàs, but also several Descents
from the Cross and Entombments in particular
the one by Caravaggio.

2. Balthus, *Etude pour "Le Lever,"*
1955, pencil and water color
on paper, 54.7 × 43.2 cm.
Private collection

3. Caravaggio, *Amore Vincitore*,
1602, oil on canvas, 156 × 113 cm.
Berlin, Gemäldegalerie, Staatliche
Museen Preussicher Kulturbesitz

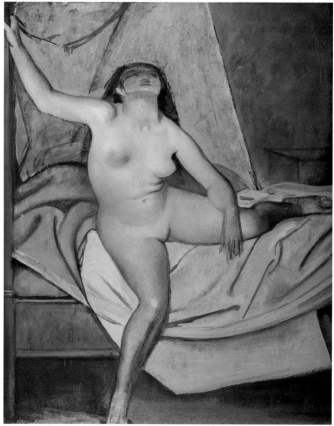

104

103

105. *Jeune fille à la chemise blanche*, 1955
[Girl with a White Shirt]

oil on canvas
116 × 89.9 cm
private collection

provenance: private collection,
Paris; baroness Alix de
Rothschild; Pierre Matisse
Gallery, New York
exhibitions: Paris 1956;
New York 1956, n. 30; Paris,
Arts décoratifs 1966, n. 24;
Knokke-le-Zoute 1966, n. 24;
London, Tate Gallery 1968,
n. 39; Marseilles 1973, n. 26;
New York 1977, n. 4;
New York 1984, n. 36;
Kyoto 1984, n. 18; Lausanne
1993; Tokyo 1993–94, n. 18;
Madrid 1996; Dijon 1999, n. 30
bibliography: Leymarie 1978,
pl. 22 and 2nd ed. 1990, pl. 23;
Leymarie 1982, pl. p. 64
and p. 142 and 2nd ed. 1990,
pl. p. 58 and p. 147; Klossowski
1983, pl. 44; catalog
MNAM.CNACGP, Paris 1983,
p. 365 n. 155; Kisaragi,
Takashina, Motoe 1994, pl. 31;
Xing 1995, pl. 34; Roy 1996,
p. 172; Klossowski 1996, n. 59;
Fox Weber 1999, p. 470;
Clair, Monnier 1999, n. P 258

Frédérique Tison, who is portrayed here,
came to stay with Balthus at Chassy in 1954.
She was sixteen at the time, and was to share
his life for about eight years; during that period,
she was his principal model. She had known
Balthus for several years, since her mother, when
she became a widow, had married, after the war,
Pierre Klossowski, Balthus's older brother.
Frédérique is seen here three-quarters, an angle
Balthus often adopted, and that appears in a series
of studies drawn in 1954[1] and in two other
portraits of 1955 (figs. 1 and 2). On the whole,
the pose is traditional and has been compared to
portraits by Corot, in particular by John Russel.[2]
Nonetheless the painting differs from them
by its monumental character.
Frédérique is very erect, her head in the axis
of her spine, her gaze in the distance.
That hieratic pose is emphasized by a certain
number of elements.
The composition is centered on a vertical
that runs along the ridge of the nose, the tip
of the chin and down to the sternum;
and that vertical is multiplied by the mass
of dark hair framing the face.
The right shoulder, where the hair falls, like in
Egyptian statuary, is lit by a crescent of light that
touches also half of the face but leaves the body
in the shadow. The arms, that stand out against
the white of the shirt, are hampered by a tail
of the clothing, knotted under the breasts.
The horizontal drawn by the knot graphically
supports the composition, contributing to the
nearly mineral density of the garment, that seems
like a base on which the bust has been raised
aloft.
The overall chromatic harmony enhances that
impression, the vert-gris of the background
reappearing in the face, the creases of the shirt,
and the hollow of the knees.
"A pure and noble presence," Yves Bonnefoy
wrote,[3] "as evident as stone, whose gaze no longer
questions, where childhood and maturity
are reconciled in the repose of an Egypt,
as far removed from furtive gestures
as from the rigors of antique geometry."

[1] Cf. Clair, Monnier 1999, nn. D 750 ff.
[2] J. Russel, preface to *Balthus*, exhibition catalog,
London, Tate Gallery 1968.
[3] Y. Bonnefoy, "L'Invention de Balthus,"in *L'Improbable*,
Mercure de France, Paris 1959, pp. 49–74 and 2nd
ed. 1980, pp. 39–56.

1. Balthus, *Jeune fille aux bras
croisés* [Girl with Folded Arms],
1955, oil on canvas, 81 × 65 cm.
Location unknown

2. Balthus, *Portrait de Frédérique*
[Portrait of Frédérique], 1955,
oil on canvas, 49.5 × 41 cm.
Location unknown

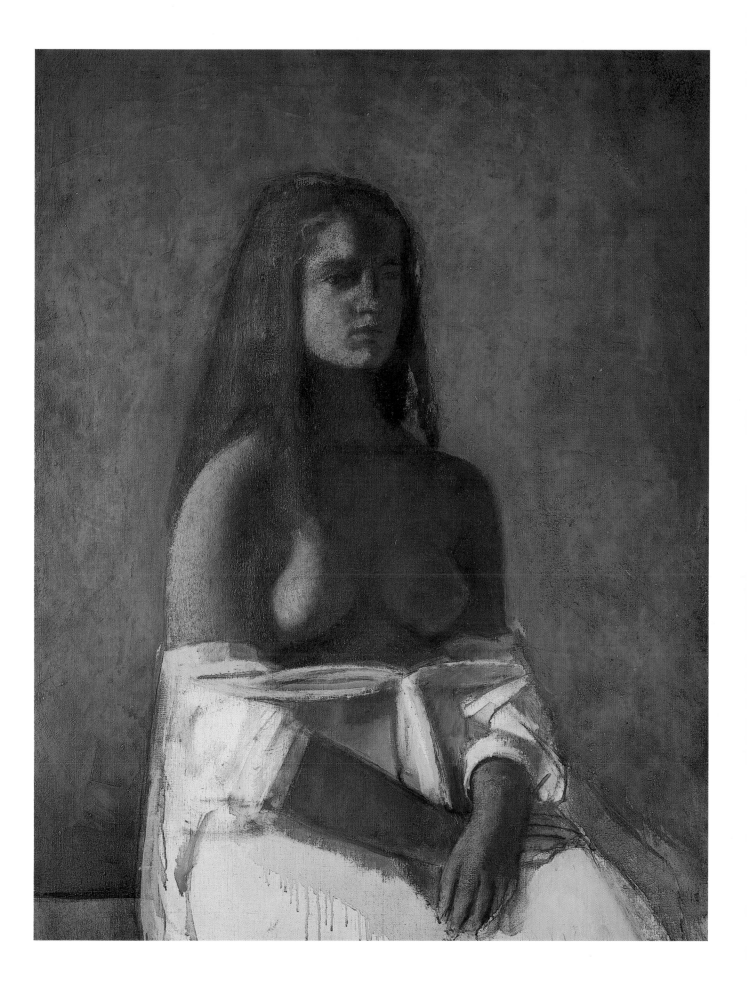

106. *Jeune fille assoupie*, 1955
[Girl Dozing]

oil on canvas
116 × 89 cm
signed and dated lower right:
"Balthus 55"
Philadelphia Museum of Art

provenance: Pierre Matisse
Gallery, New York, purchased
from the artist; Mr and Mrs
Albert M. Greenfield
exhibitions: New York 1957,
n. 9; Paris, Arts décoratifs 1966,
n. 22; Knokke-le-Zoute 1966,
n. 21; Madrid 1996
bibliography: Leymarie 1982,
p. 134 and 2nd ed. 1990, p. 138;
Klossowski 1983, pl. 48;
catalog MNAM.CNACGP, Paris
1983, p. 365 n. 153; Klossowski
1996, n. 64; Clair, Monnier
1999, n. P 262

Once again Frédérique posed here, this time in
the formal drawing-room of the castle of Chassy.
The painting, that looks unfinished, has the
lightness of a sketch, to which color gives its relief.
We recognize the chromatic harmony of *Rêve I*
(cat. 96, fig. 3), the striped chair, the green
and pink clothes blended with an intense orange.
Her head and the curve of her back are inscribed
in a perfect quarter-circle, while her hanging arm
recalls the vertical of the mantel post.

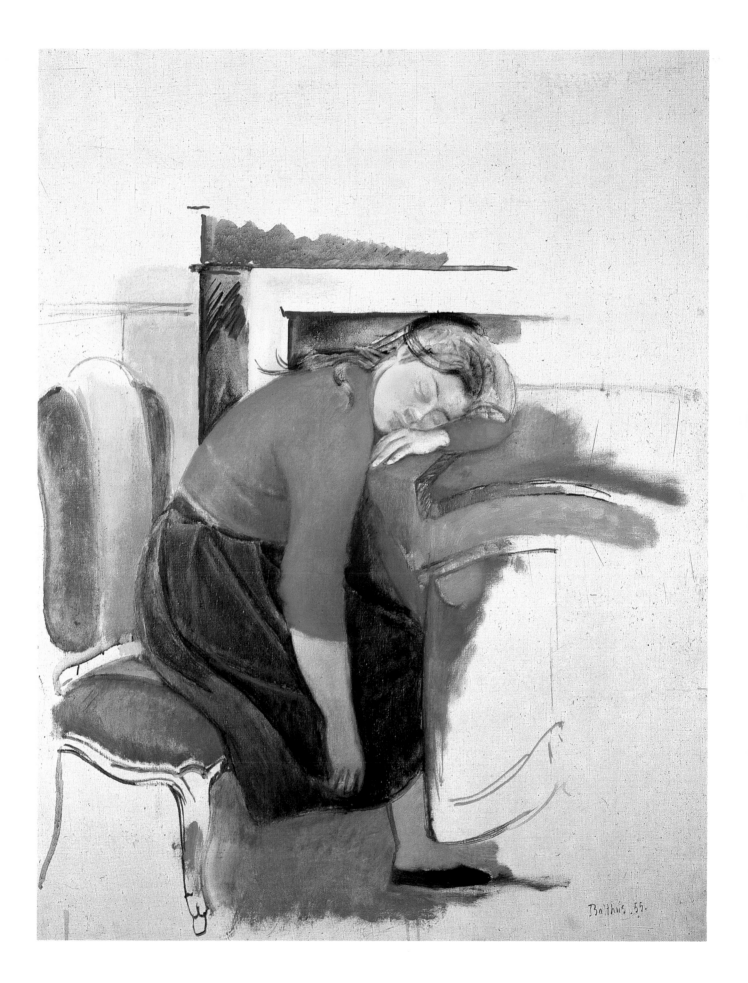

107. *Jeune fille à la fenêtre*, 1955
[Girl at a Window]

oil on canvas
196 × 126 cm
signed and dated lower right:
"Balthus 1955"
private collection

provenance: Claude Hersent
(Hersaint), Meudon, purchased
from the artist; Hélène Anavi;
sale Sotheby's, 27 March 1984,
n. 33
exhibitions: New York 1956,
n. 31
bibliography: Leymarie 1978,
pl. 24 and 2nd ed. 1990, pl. 25;
Leymarie 1982, pl. p. 78
and p. 135 and 2nd ed. 1990,
pl. p. 70 and p. 138; Klossowski
1983, pl. 47; catalog
MNAM.CNACGP, Paris 1983,
pl. p. 185, p. 296 and p. 364
n. 148; Kisaragi, Takashina,
Motoe 1994, pl. 34; Xing 1995,
pl. 36; Roy 1996, p. 168;
Klossowski 1996, n. 60;
Clair, Monnier 1999, n. P 253;
Vircondelet 2000, p. 45

Sabine Rewald has related the Nordic, Romantic filiation to which the *Jeune fille à la fenêtre* of 1955[1] belongs. The drawing of the Danish artist Christopher Eckersberg in which one of the two children rests her knee on a stool, as Balthus's young girl rests hers on a chair, but especially the famous *Woman at the Window* by Caspar David Friedrich (fig. 1) to which the present painting is related by its layout and the melancholy impression it produces.
The composition rests on the two dark stripes outlining the window frame. The young girl is seen from the back, her elbows resting on the outer window ledge, her head and torso leaning out. A great amount of space—one-third of the painted surface—is devoted to the landscape; it is accurately represented and in every detail, between the open left- and right-hand windows, whereas in Friedrich all that is suggested is merely the silhouette of a building and the masts of a ship outlined against the sky.
In Balthus, the sunny landscape, where we recognize the farmyard rooftops and big fir, forms a contrast with the bare room. It is that combination that gives rise to the enigmatic sense of melancholy emanating from the painting. Whereas Friedrich's *Woman* was content with just looking out the window, Balthus's *Jeune fille* looks like she is waiting for something or someone, and we wonder what is keeping her from going down to the farmyard.
Entirely different is the impression given by a second *Jeune fille à la fenêtre*, painted two years later (fig. 2). The window of the Chassy drawing-room, on the ground floor, is wide open onto the two successive courtyards. A springlike sun bathes them, playing in the new foliage of the tree. The young girl rests both hands on the window sill, standing slightly away from it. Rather than going out, she looks like she wants to absorb the sun that is turning her hair golden, to invite spring and it light scents to come into the drawing room.

[1] S. Rewald, in *Balthus, un atelier dans le Morvan*, exhibition catalog, Dijon 1999, pp. 22–24.

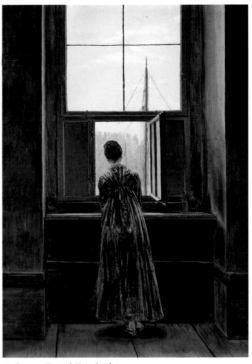

1. Caspar David Friedrich,
Woman at the Window, 1822,
oil on canvas, 44 × 37 cm.
Berlin, Nationalgalerie

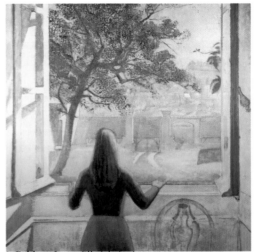

2. Balthus, *Jeune fille à la fenêtre*
[Young Girl at the Window], 1957,
oil on canvas, 160 × 162 cm.
Private collection

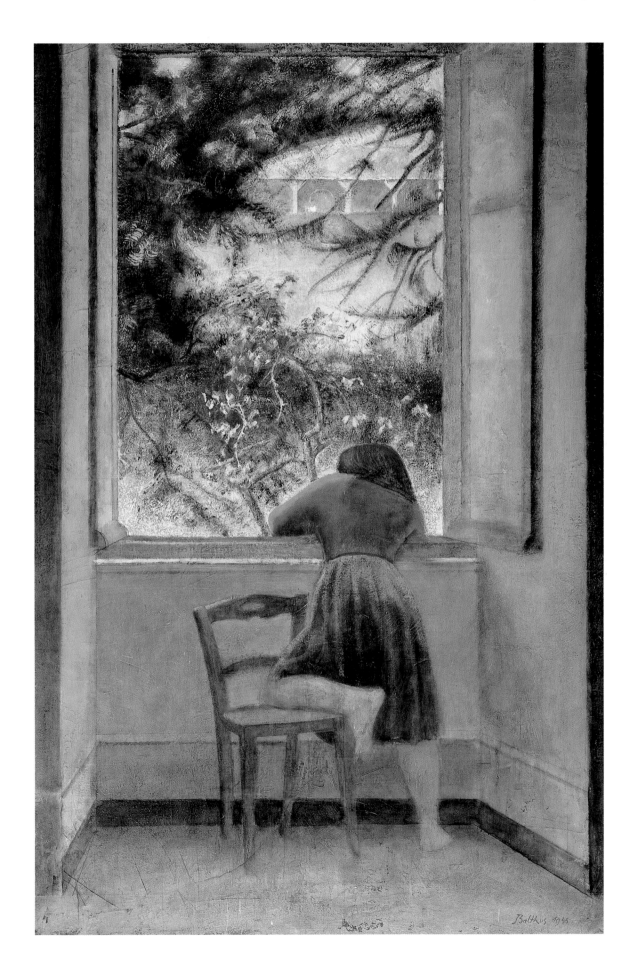

108. *La Coiffure*, 1955
[Hairdressing]

oil on canvas
130.2 × 96.5 cm
private collection

provenance: Pierre Matisse
Gallery, New York;
Mrs Nancy Olson Lerner
exhibitions: Paris 1956;
New York 1956, n. 29;
New York 1962, n. 8
bibliography: catalog
MNAM.CNACGP, Paris 1983,
p. 366 n. 159; Leymarie 1990,
p. 136; Clair, Monnier 1999,
n. P 241

This painting is an exception in Balthus's work,
there are none others like it either in the subject
or the manner in which it is rendered.
It depicts two young girls in the intimacy
of their toilet. They are seen from close-up
and half-length. The one on the left, whose
morphology reminds us of Georgette (cat. 83),
appears overflowing with life and full of energy;
she shamelessly reveals her bare thigh amidst the
folds of her peignoir. The other one, more
reserved, has the slightly old-fashioned profile
and slender neck of nineteenth-century women;
she is burying her face in the draped collar of her
dressing-gown and letting her hair be combed.
The theme is apparently harmless: two girls are
playing "grown-up," one is smirking, the other
laughing, probably parodying the gestures
and futile talk of her mother's hairdresser.
It appears in light eighteenth- and nineteenth-
century etchings.
But here the scene is laden with a special
eroticism, of which it seemed interesting
to analyze the components. It arises from
the combination of three distinct factors.
The first consisted of putting the spectator
in the situation of a voyeur, by introducing him
into the intimacy of the little girls, shown
in close-up. A second device was to give them
childish faces while making them have an adult
activity, thus provoking also an ambiguity
regarding the feigned innocence of their game.
Last, by individualizing their physical types,
contrasting the one's daring with the other's
shyness, the artist suggested a dynamic
and a hierarchy between them: the one
hairdressing dominates the one whose hair
is being dressed.
Consequently, in the spectator's mind,
the insignificant back of the chair might have
a special meaning, that of the fragile barrier
drawing the borderline between children's games
and "forbidden" games.

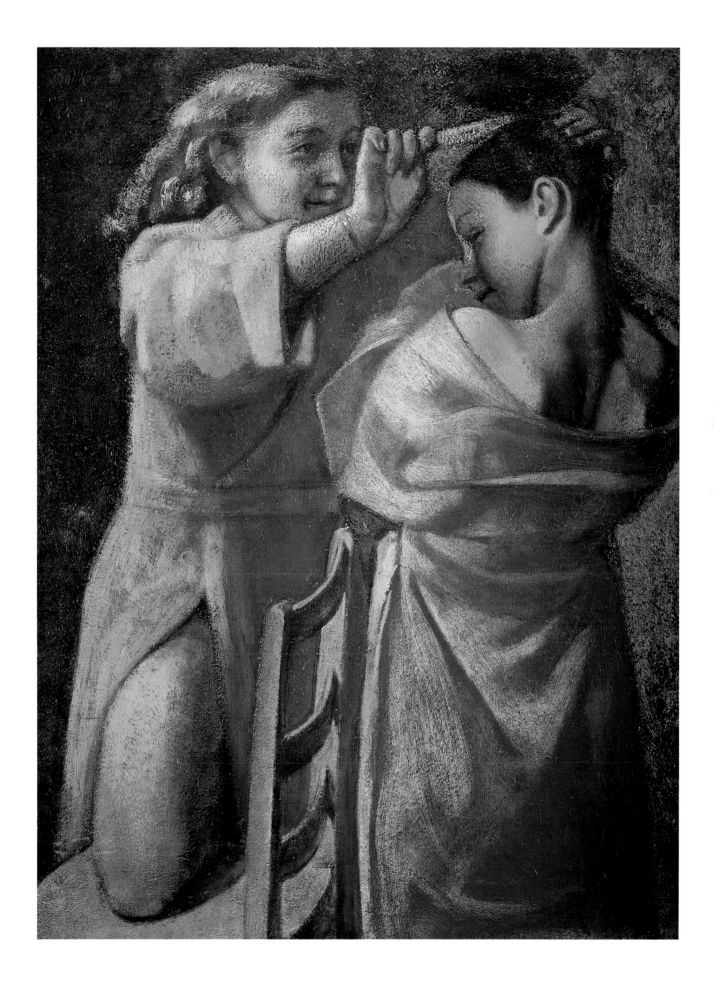

109. *Etude pour "Le Rêve II," 1956*
[Study for "The Dream II"]

pencil on paper
53 × 42 cm
Upperville, Mrs Paul Mellon
collection

exhibitions: New York 1963,
n. 46; Paris 1971, n. 66;
Marseilles 1973, n. 56,
New York, MoMA *et alia*
1966–67, n. 28; New York
1977, n. 18
bibliography: Clair, Monnier
1999, n. D 868

Le Rêve II (fig. 1) goes back to the theme
of the *Rêve I* (cat. 96, fig. 3), emphasizing the
realism of the décor in which the scene takes
place. Now the whole room is shown; the details
of the Persian carpet, of the kilim over the table,
of the fabric covering the couch, the chess board,
the coffee tray and the rumpled napkin leave
no doubt as to the very real nature of the place.
The vision, that still has its extra-natural character,
its straight profile and inexpressive face,
is lit by the light from the window; it now slips
between the table and the couch just like
a human being.
The realistic character is also heightened
in the portrayal of the sleeper, whose head rests
on the arm of the couch. She was given several
separate studies, one of which is shown here.
We have the impression she fell sound asleep
out of the blue, which explains the suddenness
of the apparition. The drawing perfectly renders
the depth of the sleep, the serenity with which
the sleeper yields to it, and we can imagine
the happiness her dream is bringing her.
In *Le Fruit d'or* (fig. 2), the third picture
of the series, Balthus would give her a puppet's
body, a rather artificial posture, like that of a child
pretending to sleep so as to watch for the instant
when the strange creature would appear, its gray
mask-like face contrasting with the magic fruit
it is holding.

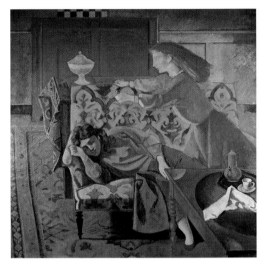

1. Balthus, *Le Rêve II*
[The Dream II], 1956–57,
oil on canvas, 198 × 198 cm.
Private collection

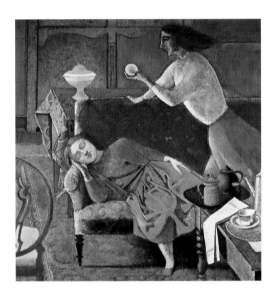

2. Balthus, *Le Fruit d'or*
[The Golden Fruit], 1956,
oil on canvas, 159 × 160.5 cm.
Private collection

110. *Grand paysage aux arbres* (le champ triangulaire), 1955
[Large Landscape with Trees (The Triangular Field)]

oil on canvas
114 × 162 cm
signed and dated lower right:
"Balthus 1955"
private collection

provenance: Galerie Henriette
Gomès, Paris, purchased
from the artist; André Gomès
exhibitions: Paris 1956; New
York 1957, n. 15; Rome 1958,
n. 7; Turin 1958; Paris,
Arts décoratifs 1966, n. 25;
Knokke-le-Zoute 1966, n. 25;
London, Tate Gallery 1968,
n. 41; Marseilles 1973, n. 28;
Paris 1977; Venice 1980;
Paris, MNAM.CNAGP 1983–84,
n. 43; New York 1984, n. 38;
Kyoto 1984, n. 16; Rome 1990,
p. 117; Ornans 1992, n. 35;
Lausanne 1993; Tokyo
1993–94, n. 17; Hong Kong
1995, n. 12; Beijing 1995,
n. 12; Taipei 1995, n. 12
bibliography: Leymarie 1978,
pl. 20 and 2nd ed. 1990, pl. 21;
Leymarie 1982 pl. pp. 68–69
and p. 148 and 2nd ed. 1990,
pl. p. 61 and p. 153; Klossowski
1983, pl. 46; catalog
MNAM.CNAGP, Paris 1983,
pl. p. 181 and p. 364 n. 147;
Kisaragi, Takashina, Motoe
1994, pl. 38; Xing 1995, pl. 32;
Roy 1996, p. 163; Klossowski
1996, n. 61; Clair, Monnier
1999, n. P 250

This view is the one you have from the north
tower of the castle of Chassy; it appears
in three other paintings.
The composition is arranged around a large
triangular field, with a an eye-shaped hollow
at the tip. It is a winter landscape, bathed in pale
sunlight and crossed with long shadows that
emphasize or multiply the lines of the hedges.
The entire foreground is dark, either backlit or
drowned in the late afternoon growing shadow.
You can barely discern, at center, the blue
silhouette of a man seen from the back, walking
with his right arm raised. He appears to be hailing
the horse grazing yonder, amidst the old apple
trees. Beyond the road lined with wooden posts,
two other four-legged animals, minute,
are pasturing in a field of fodder grasses.
The only signs of life, in a melancholy, yet serene,
landscape, typical of that Morvan where Balthus
had decided to withdraw.
Three years later, Balthus made a bright version
of this painting, one of the few springtime
landscapes of his we know (fig. 1). On the edge
of the sown fields, the hedges' new leaves are
shining in the sunlight, the fruit trees are
flowering, greens and pinkish ochres alternate
from the foreground all the way to the mauve line
of the distant mountains. A bouquet of roses,
placed on the window-sill, give the composition
an intimist, cheerful note, utterly exceptional
in Balthus.

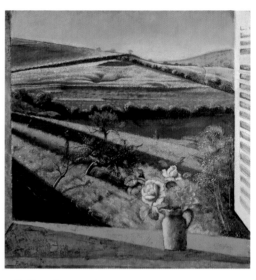

1. Balthus, *Bouquet de roses
sur la fenêtre* [Bunch of Roses
on the Window], 1958,
oil on canvas, 134 × 131 cm.
Indianapolis Museum of Art,
gift of Joseph Cantor

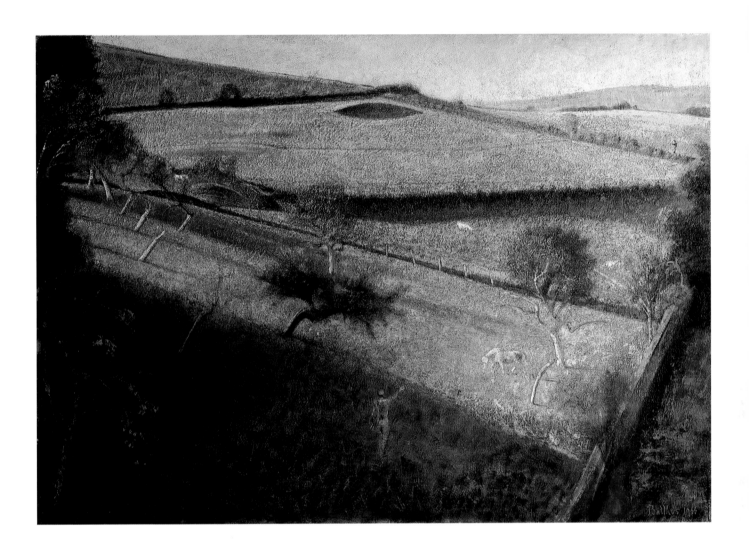

111. *Fruits sur le rebord d'une fenêtre*, 1956
[Fruit on a Windowsill]

oil on canvas
66.5 × 86.5 cm
signed and dated lower left:
"Balthus 1956"
private collection

provenance: William Inge;
Pierre Matisse Gallery,
New York; Richard Feigen
Gallery, Chicago; Jerome Stern;
John Herring; James Kirkman,
London
bibliography: Leymarie 1978,
pl. 26 and 2nd ed., 1990, pl. 27;
Leymarie 1982, pl. p. 76
and p. 135 and 2nd ed, 1990,
pl. p. 69 and p. 141; catalog
MNAM.CNACGP, Paris 1983,
p. 368 n. 173; Xing 1995, pl. 42;
Roy 1996, p. 258; catalog Dijon
1999, p. 102; Clair,
Monnier 1999, n. P 270

By putting four pieces of fruit and a spray
of ivy on a window-sill of one of the studio
windows, Balthus joins near and far, interior
and exterior. In the golden flush of a late fall
afternoon, the fruit—a quince, a pear and two
apples—that recalls Courbet's still lifes, is haloed
by the silvery light rising from the pond,
on the edge of which grow or in which are
reflected a few thin trees.
There are two studies for this painting, that has
never been shown before. The first (fig. 1) relates
directly to the left side of the canvas, while
the two clumsy apples of the second (fig. 2)
reappear in the right part of the painting.[1]
These two studies are bathed in a light that
Giovanni Carandente called Cézannian.[2]
They have its transparency and weightlessness
but, whereas in the Aix master color is applied
rather freely onto the drawn form, here it
rigorously follows the outlines.
We observe that the color shades of the skins
of the fruit and their shadows cast on the stone,
produced by the wash and penciled hatching
in the studies, accurately reappear in the painting.
Balthus is certainly not interested in botanical
precision, but in rendering the light, the balance
of color values that create an interplay between
the large fruit in the foreground and the landscape
in the background. The eye constantly shifts
from one to the other; that motion introduces
into this utterly tranquil picture, the epitomy
of the *still life*, painted with a limited color
palette, a subtle dynamism to which it owes
its perfection.

[1] A third study of fruit, very similar, is reproduced
in Clair, Monnier 1999, n. D 863.
[2] G. Carandente, in *Balthus, disegni e acquarelli*,
exhibition catalog, Spoleto 1982, p. 67.

1. Balthus, *Nature morte
(coing et poire)* [Still Life
(Quince and Pear)], 1956,
water color and pencil
on paper, 35 × 51 cm.
Private collection

2. Balthus, *Nature morte
(pommes et coing)* [Still Life
(Apples and Quince)], 1956,
water color and pencil
on paper, 35 × 51 cm.
Private collection

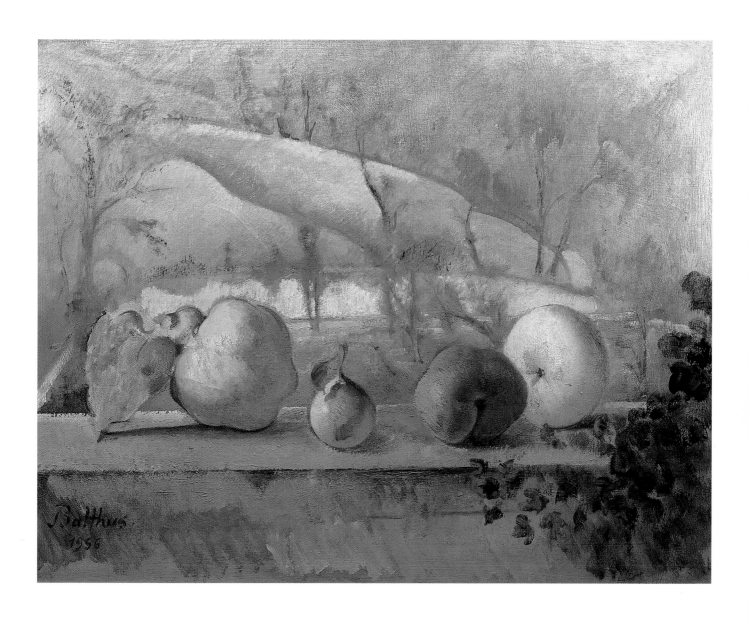

112. *Etude pour "Paysage à la tour,"* 1956 [Study for "Landscape with a Tower"]
113. *Paysage à la tour*, 1956 [Landscape with a Tower]
114. *L'Etang de Chassy*, 1957 [The Pond at Chassy]

112.
pencil on paper
32 × 44 cm
monogrammed lower left: "Bs"
Geneva, private collection

provenance: Galerie Alice Pauli,
Lausanne
exhibitions: Lausanne 1993
bibliography: Faye 1998, p. 89;
Clair, Monnier 1999, n. D 855

113.
oil on canvas
65 × 81 cm
signed and dated lower left:
"Balthus 56"
private collection

provenance: baroness Cécile
de Rothschild, purchased from
the artist; Galleria Condotti 75,
Rome; Lee Ault Gallery,
New York; sale Sotheby's,
New York, 17 May 1978, n. 87;
Pierre Matisse Gallery,
New York; private collection;
Galerie Beyeler, Basel;
private collection; Pierre Matisse
Gallery, New York; Galerie
Claude Bernard, Paris; private
collection; sale Sotheby's,
New York, 10 May 1995 n. 323;
sale Loudmer, Paris,
15 October 1995, n. 98
exhibitions: Rome 1996–97,
p. 95; Karuizawa 1997, p. 73
bibliography: Leymarie 1982,
p.148 and 2nd ed. 1990, p.152;
catalog MNAM.CNACGP, Paris
1983, p. 368 n. 174; catalog
Dijon 1999, p. 52; Clair,
Monnier 1999, n. P 268

114.
oil on panel
78 × 95 cm
monogrammed and dated
lower left: "Bs 57"
private collection

provenance: Galerie Henriette
Gomès, Paris
exhibitions: Lausanne 1993
(not reproduced in the catalog);
Tokyo 1993–94 n. 20;
Dijon 1999, n. 15
bibliography: Leymarie 1982,
p. 148 and 2nd ed. 1990, p. 152;
catalog MNAM.CNACGP, Paris
1983, p. 369 n. 177; Roy 1996,
p. 118; Clair, Monnier 1999,
n. P 275

The *Paysage à la tour* depicts the field we saw
in the *Grand paysage aux arbres* of 1955
(cat. 110), seen from the castle but here from
a lower floor and a slightly different angle.
That is why the tree on the left is replaced by
a tower, and the one on the right, formerly partly
hidden by the gable of a wall, is now entirely
visible in the draughted *Etude* (cat. 112).
Thus the perspective on the field is symmetrically
framed, probably too much so for Balthus,
since the half-dozen preparatory studies
for the painting reflect his hesitations: now
the tower is gone, now it is the tree's turn
to disappear.[1]
Hesitations detectable even in the canvas
(cat. 113) since, as we already pointed out,[2]
the tree figured in the first state of the painting:
we can still discern the trunk in the lower right
corner and glimpse the foliage, beneath
the light clouds overcasting the sky.
On suppressing the tree, Balthus introduced
a different equilibrium in the composition. Now
the tower has a pointed roof; the foreground,
light in the *Etude*, is dark green in the painting,
whereas the low wall, with dark hatching in the
drawing, becomes a pale gray in the canvas.
The round bush, ghostlike, as if erased, in the
Etude, is set ablaze by the rays of the setting sun.
The appeased balance of the drawing is followed
by a sense of diffuse anxiety before the immensity
of the vacant landscape, open onto infinity.
The picture, like Oriental paintings, becomes
the subject of a meditation and the painter, as a
philosopher or a poet, ponders in contemplating
the sumptuous spectacle of the day's culmination.
The human figure is absent from the canvas;

alone an empty garden chair, placed in front
of the low wall, proves it exists.
The *Etang de Chassy* he painted the following
year (cat. 114) can be considered as forming
a pair with the *Paysage à la tour*. It features
the same round tower and the terrace bordered
by the low wall. The isometric projection unfolds
from one hill to the next all the way to the
blueish mountains of the massif of the Morvan,
whose ridges are outlined on a blue and white
speckled sky. Again a summer landscape, but
executed with a light brush that lets the white
preparation coating the support (here wood)
show through, on the left along the tower, below,
on the right and even at center. This technique,
that would be used again in the landscapes of the
years 1959–60, helps imbue the painted surface
with a circulation, a sense of breathing, associated
with the notion of a vacuum, one of the
fundamental features of Chinese painting
and calligraphy. Although the *Etang de Chassy* is
not a prelude for any other more finished version,
it was prepared by a series of pencil studies in
which we can see the composition work Balthus
devoted himself to (fig. 1). A group of rectilinear
obliques contrasted by the gentle meshing of hills
and hedges, joined, at center, by the half-circle
formed by the trees with their ball-shaped foliage.
The layout of the colors, from greenish yellow
to dark green, reproduces the composition
of the painting, and the pond that gives it its title
is barely perceptible in the background.

[1] Clair, Monnier 1999, nn. D 852–857.
[2] *Balthus, un atelier dans le Morvan, 1953-1961*,
exhibition catalog, Dijon 1999, p. 52.

1. Balthus, *Etude pour
"L'Etang de Chassy"*
[Study for "The Pond at Chassy"],
1957, pencil on paper,
42.5 × 52.5 cm.
Location unknown

112

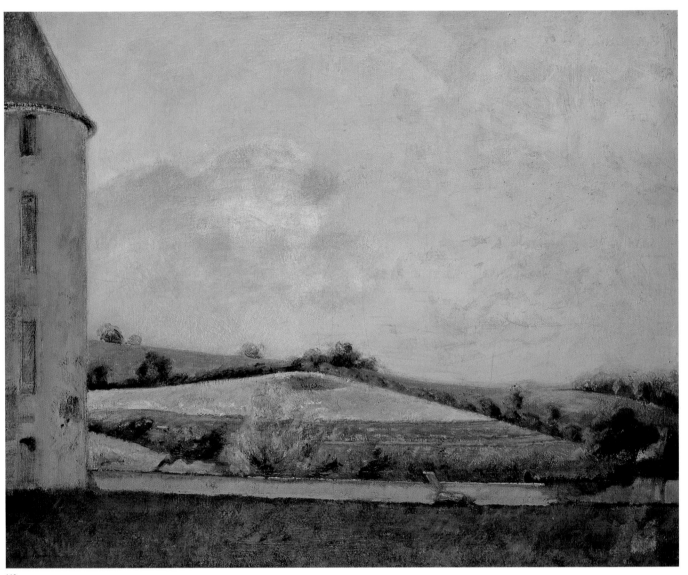

113

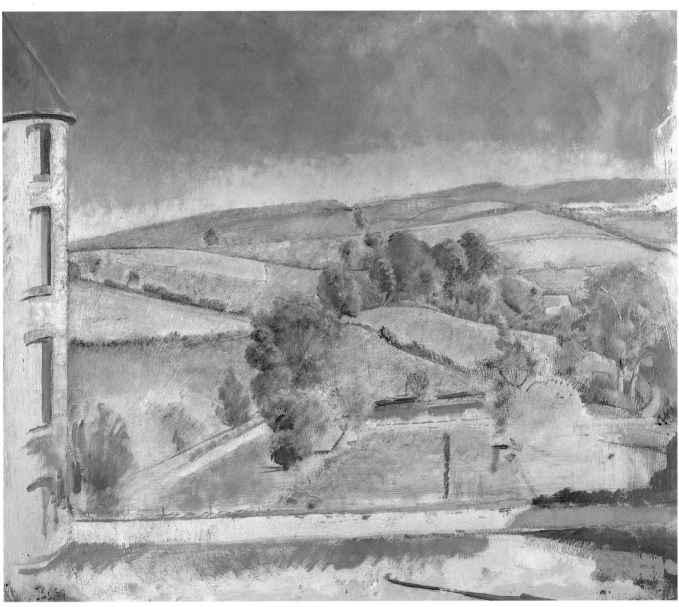

114

115. *La Vallée de l'Yonne*, 1957
[The Yonne Valley]

oil on canvas
58 × 90 cm
signed and dated lower left:
"Balthus 1957"
Antibes, Musée Picasso

provenance: Galerie Henriette
Gomès, Paris
exhibitions: Paris, Gomès 1966;
Paris, Arts décoratifs 1966,
n. 30; Knokke-le-Zoute 1966,
n. 30; London, Tate Gallery
1968, n. 46; Marseilles 1973,
n. 33; Paris 1977; Paris, Gomès
1983–84; Hong Kong 1995,
n. 13; Beijing 1995, n. 13;
Taipei 1995, n. 13; Madrid 1996;
Karuizawa 1997, p. 71;
Dijon 1999, n. 12
bibliography: Leymarie 1982
p. 148; catalog MNAM.CNACGP,
Paris 1983, p. 369 n. 176;
Clair, Monnier 1999, n. P 276

The landscape is the last of a set of three.
We get a glimpse, between two rows of trees,
of the Yonne that flows on the property boundary,
looking south, then the hamlet of Chassy
and, further on, the hills. The subdued tones
are still wintery, and like the two preceding ones,
this painting is inscribed in a horizontal structure,
layered in successive levels.
Its dimensions are the same as the first version
(fig. 1), a classical "seascape" format, traditionally
used for panoramas—and smaller than the second
(fig. 2). If we compare them, we observe that the
painter gradually focuses his gaze on the center
of the landscape he has before him, as though
using a magnifying glass.
The *Paysage d'hiver* (fig. 1) is framed by a black
mask. Sophie Lévy remarked that it had been
added *a posteriori* on the finished painting,
as if to display it through a scuttle, to isolate it
from its surroundings.[1] That device is abandoned
in the second version, the most luminous
of the three, where four cows, going down
the path, create a semblance of movement.
The third version, the one shown here, is the most
austere, the most concentrated. The close-up
view Balthus gives of the hamlet excludes
the representation of the sky, giving the painting
a density the two others lack. The green dominant
is lit up by the mat gray of the sheet metal roofs,
the only spots of light in a landscape bathed
in a diffused radiance.

[1] S. Lévy, *Balthus, un atelier dans le Morvan, 1953-1961*,
exhibition catalog, Dijon 1999, p. 40.

1. Balthus, *Paysage d'hiver*
[Winter Landscape], 1954,
oil on hardboard, 59 × 92 cm.
Private collection

2. Balthus, *La Vallée de l'Yonne*,
1955, oil on canvas, 90 × 162 cm.
Troyes, Musée d'art moderne,
bequest Pierre and Denise Lévy.

116. *La Toilette*, 1957
[The Toilette]

oil on canvas
162 × 130.8 cm
private collection

provenance: Pierre Matisse
Gallery, New York; Billy Wilder,
Los Angeles; sale Christie's,
New York, 13 November 1989,
n. 71; Galerie Krugier, Geneva
exhibitions: New York 1962,
n. 11; Paris, Arts décoratifs
1966, n. 33; Knokke-le-Zoute
1966, n. 33; Marseilles 1973,
n. 32; Lausanne 1993; Madrid 1996
bibliography: Leymarie 1978,
pl. 29 and 2nd ed. 1990, pl. 30;
Leymarie 1982, pl. p. 80
and p. 141 and 2nd ed. 1990,
pl. p. 73 and p. 148; catalog
MNAM.CNACGP, Paris 1983,
p. 370 n. 183; Xing 1995, pl. 45;
Roy 1996, p. 192; Clair,
Monnier 1999, n. P 282

La Toilette and its pendant *Nu à la chaise* (fig. 1)
were painted in 1957 at Chassy, as a replay
of *La Chambre* executed ten years earlier in Paris
(cat. 74). The same subject, the same frontal
representation of the figure that takes up the
entire height of the canvas, and as in *La Chambre*,
as in *Le Lever* (cat. 104) or *Le Drap bleu*
that follows (cat. 118), the same centering
of the composition on the young girl's pubes.
The *Nu à la chaise* (fig. 1) is painted in cold tones
in harmony with the bareness of the room and the
plainness of the furniture. The young girl, slightly
leaning her weight on one hip, is, if not
provocative, at least proud of her beauty.
Her high schoolgirl socks, the bed, tucked
in like in boarding school, give the painting
an ambiguous flavor.
La Toilette is less so. Maybe because the young

girl has her eyes cast down, maybe because
her nudity is better suited to the elegant décor
in which she is represented. The *Louis-Seize* bed,
placed in an alcove shut by a curtain, is covered
with a counterpane whose white, red and orangey
motifs draw the eye and connect with the towels
hanging on the dressing-table as well as with the
young girl's socks and slippers. Here the red of
the latter item, that resounds in the *Nu à la chaise*,
is complementary to the greens and subtly echoed
in the light reflections playing over the paving,
the model's face, torso and arms.
The squaring of the canvas, that Balthus
intentionally left showing on the curtain
and the dressing table, puts a distance between
the viewer and the subject, as though the nude
were seen through the screen of a *camera lucida*
or some other optical instrument.

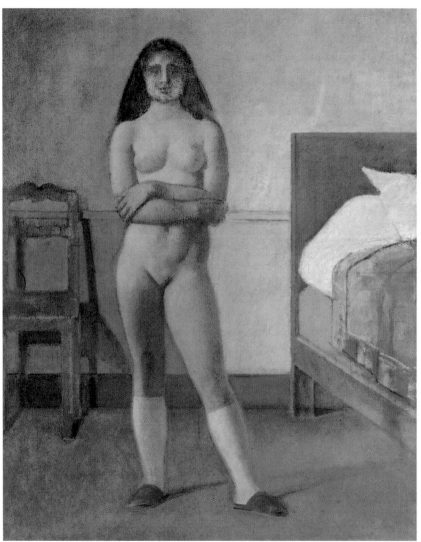

1. Balthus, *Nu à la chaise*
[Nude with a Chair], 1957,
oil on canvas, 162 × 130 cm.
Private collection

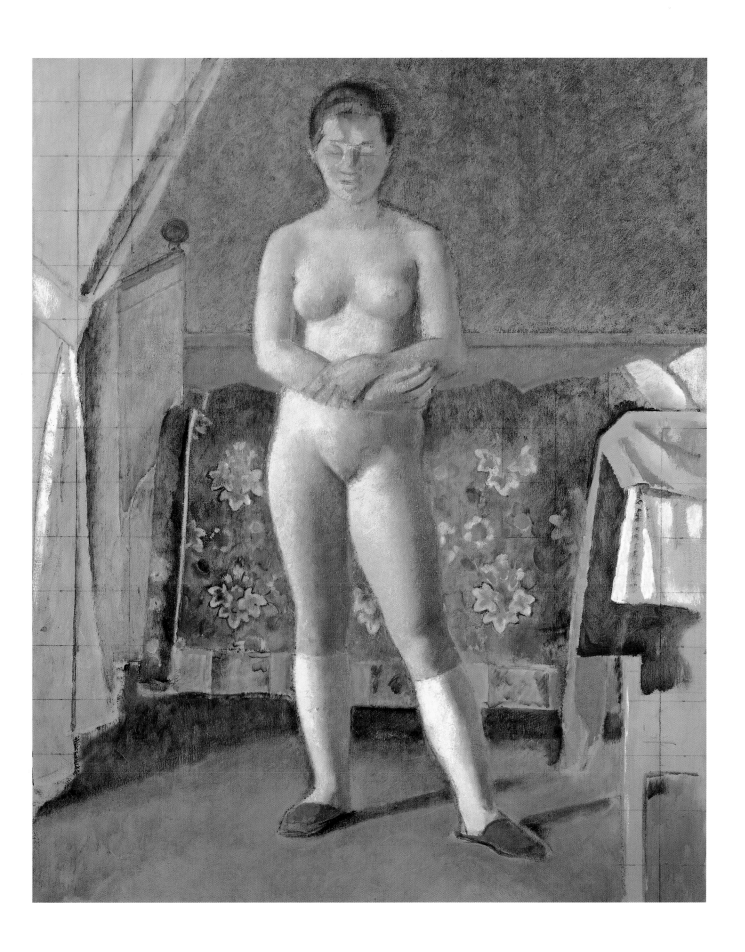

117. *La Toilette (Nu au tabouret)*, 1958
[The Toilette (Nude with a Stool)]

oil on canvas
73 × 60 cm
monogrammed and signed
upper left: "Bs 58"
private collection

provenance: Pierre Matisse
Gallery, New York; private
collection; Thomas Ammann
Fine Art A.G., Zurich; Galerie
Beyeler, Basel; private collection;
Elkon Gallery Inc., New York
exhibitions: Zurich 1982, n. 1
bibliography: Leymarie 1982
p. 143 and 2nd ed. 1990, p. 148;
catalog MNAM.CNACGP,
Paris 1983, p. 371 n. 186;
Clair, Monnier 1999, n. P 284

This picture is a variant of *La Sortie du bain* (fig. 1), painted a year before and whose décor was the bathroom at Chassy.
The model's posture is drawn from it and, like it, breaks as much with the traditional bodily canon as with the staticity usually associated with such a subject.
The *Nu au tabouret* is seen in a wide open room. The composition is framed by a pair of curtains; the left one partly masks a light surface that might be a large mirror in which the young girl is looking at herself. She has just thrown on the chair the peignoir she was wearing[1] and is gathering the bulk of her hair on the top of her head. She rests her foot on the stool, as she did on the edge of the tub in *La Sortie du bain*; but in the latter, the motion of her arms followed that of her legs; here, they unexpectedly contradict each other, since were she to move forward, the young girl would bump into the mirror she is looking into to knot her hair.
Comparing the *Nu au tabouret* with the *Nu devant la cheminée* (cat. 98, fig. 1), we realize that the tension that makes the painting so singular springs from that very ambiguity.

[1] There is a sketched study of it; cf. Clair, Monnier 1999, n. D 905.

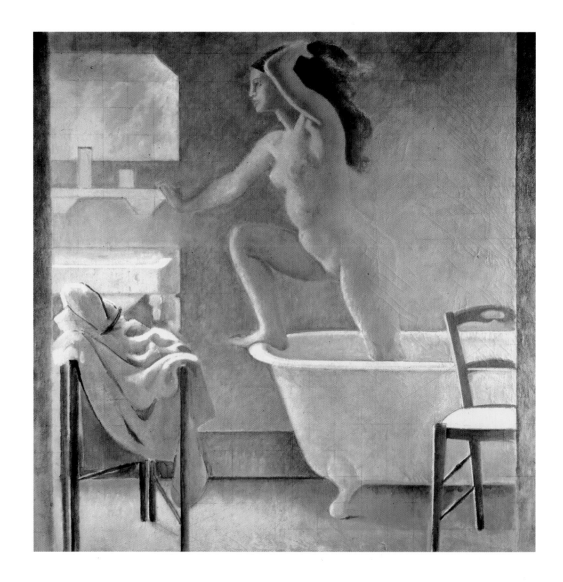

1. Balthus, *La Sortie du bain*
[The Bathwrap], 1957,
oil on canvas, 200 × 200 cm.
Private collection

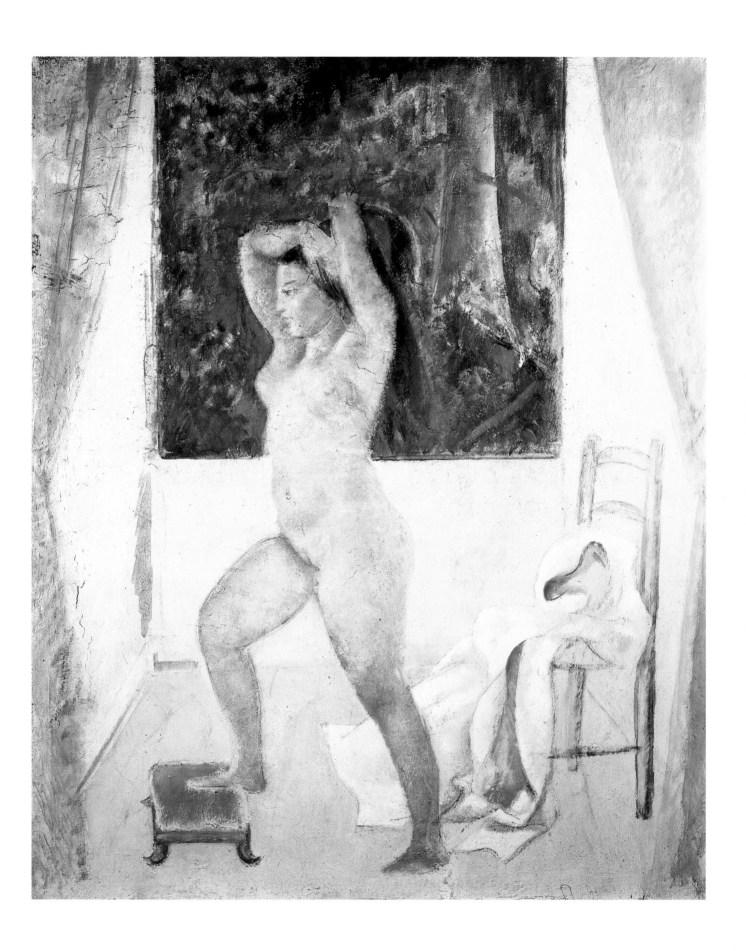

118. *Le Drap bleu*, 1958
[The Blue Towel]

oil on canvas
162 × 97 cm
signed lower right: "Balthus"
possibly signed and dated
on the reverse as well
private collection

provenance: purchased
from the artist
exhibitions: Paris, Arts
décoratifs 1966, n. 37;
Knokke-le-Zoute 1966,
n. 37; Kyoto 1984, n. 22;
Lausanne 1993; Madrid 1996
(not exhibited, and erroneously
illustrated on P. 250)
bibliography: Leymarie 1982,
p. 143 and 2nd ed. 1990, p. 148;
Klossowski, Paris 1983, pl. 58;
catalog MNAM.CNACGP 1983,
p. 371 n. 185; Roy 1996, p. 194;
Klossowski 1996, n. 72;
Clair, Monnier 1999, n. P 285

This painting combines the frontality
of *La Toilette* (cat. 116) with the décor of *La Sortie
du bain* (Clair, Monnier 1999, n. P 283), although
the room is seen from another angle.
However it differs from them both, and from their
respective variants, by its composition, its possible
interpretation, and its colors. The plaette here
is pastel, with a pink and blue dominant, subtly
shaded in mauve and light green. The only pure,
and complementary colors, are the red of the bath
mat stripes and the green of the young girl's
slippers.
Our attention is directed first of all on the large
naked body, rising in front of the edge of the wall
that works as an axis, and moreover placed so
that the pubes is right on the horizontal median
of the painting. Her arms crossed above her head,
the young girl is removing a full blue garment that
frames the curve of the face while entirely hiding
the hair. That makes the shadowed triangle
of the crotch all the more suggestive. Likewise,
the breasts are not depicted; when the viewer's
gaze moves from the face, it slides from the
hollow of the neck, along a shadowed line,
to the navel and thence, unavoidably, to the
genitals.
The painting can also be read from the bottom
up. The stripes of the mat and the edge of the
enamelled bathtub guide the eye to the upper left
quarter of the canvas that in itself forms a
separate, humorous little composition.
Beneath the window, the bottles of salts and jars
for cotton or talcum, alternately pink and blue,
are arranged in neat rows, like in a Morandi still
life. But in their midst, recognizable by its shape
and characteristic label, there is a bottle
of Synthol, that lotion famed in the France
of the fifties for its multiple therapeutic qualities.[1]
That part of the painting can also be seen as
a whimsical reference to the Bonnard of the same
period, insofar as Balthus plays at making the
space waver between successive planes: in the
right half, the window panes reflect, in purple,
the lower branch of the fir outlined, in the left
half, against the sky; on the same side,
the corbelled construction of the rain pipe,
like a shadowgraph, acts as a foil to the foliage
but responds, in reverse, to the tree in the back;
the dressing gown hanging on the wall on the left
forms a screen but also a link with the full
bathtub, that Bonnard was so fond of...
Thus the *Drap bleu*, behind its apparent naiveté,
is a complex painting, thought out at length
and very different from the other *toilette* scenes
painted at Chassy.

[1] Synthol cured insect bites, sore throats, bruises,
sprains, light burns, etc.

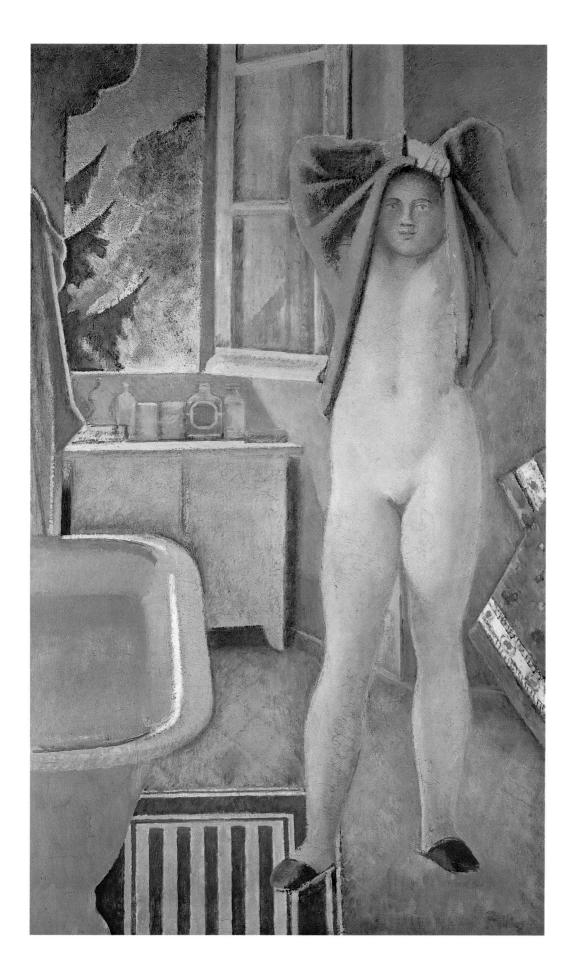

119. *La Phalène*, 1959
[The Moth]

casein tempera on canvas
162 × 130 cm
Paris, Musée national d'art
moderne, Centre Georges
Pompidou

provenance: Galerie Henriette
Gomès, Paris, purchased
from the artist
exhibitions: Paris, Arts
décoratifs 1966, n. 38;
Knokke-le-Zoute 1966, n. 38;
London, Tate Gallery 1968,
n. 50; Marseilles 1973,
n. 35; Venice 1980; Paris,
MNAM.CNACGP 1983–84, n. 53;
New York 1984, n. 42; Kyoto
1984, n. 28; Ornans 1992, n. 44;
Lausanne 1993; Hong Kong
1995, n. 19; Beijing 1995, n. 19;
Taipei 1995, n. 19
bibliography: Leymarie 1978,
pl. 31 and 2nd ed. 1990, pl. 32;
Leymarie 1982, pl. p. 89
and p. 144 and 2nd ed. 1990,
pl. p. 81 and p. 148; Klossowski
1983, pl. 61; catalog
MNAM.CNACGP, Paris 1983,
pl. p. 197 and p. 376 n. 209;
Clair 1984, p. 84 fig. 63;
Kisaragi, Takashina, Motoe
1994, pl. 47; Xing 1995, pl. 50;
Roy 1996, p. 175; Klossowski
1996, n. 74; Fox Weber 1999,
p. 479; Clair, Monnier 1999,
n. P 301; Vircondelet 2000, p. 32

La Phalène returns to the theme of the dream,
the dreamlike vision Balthus had treated
in the years 1954–56 (cf. cats. 96, 97 fig. 3).
The open bed, the lit lamp suggest the idea
of sleep but the sleeper is not shown.
The apparition, seen as if through a veil, the huge
nocturnal butterfly, fascinated by the light, seems
to issue from the depths of the canvas. The effect
is owed in part to the pictorial material used,
that *casearti* Balthus will use once again in Rome,
that gives it together its mat quality and an
impression of density even though the layer
of paint is very thin. Owed also to the golden
colors Balthus utilizes to render the particular
light produced by the petrol lamp, a very bright
luminosity but having a weak radiance.
That is the reason why we can barely see
the chair in the foreground, and why the wall
in the background remains dark.
The moth's wings are so delicate that we wonder
if it is real and, consequently, what its relationship
with the apparition is. Is *La Phalène* a dream
or the recollection of a dream? A question
of the greatest importance in the world through
the looking glass Balthus is referring to.
We should recall the story of Chuang-tzu,
whose work Balthus discovered when he was
twelve years old, then illustrating for Rilke several
episodes of his more or less legendary life.[1]
The Taoist sage, on awakening from a dream
in which he was turned into a butterfly, wondered
whether he had dreamed he was a butterfly
or whether the butterfly had dreamed it was
Chuang-tzu ("was he awake as Chuang-tzu
or was he merely a creature dreamed
by a butterfly?"[2]).

[1] C. Roy, *Balthus*, Gallimard, Paris 1996, p. 26.
[2] F. Cheng, *L'écriture poétique chinoise*, Seuil, Paris 1977,
p. 92, with regard to a poem by Li-Shang-yin (812–58).

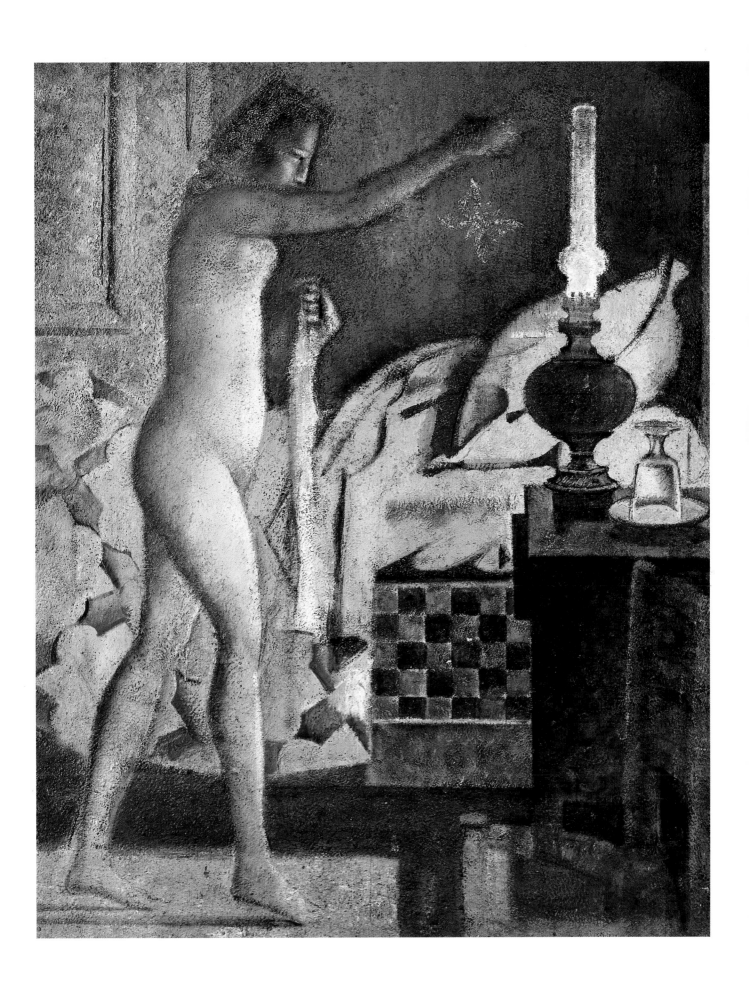

120. *Portrait de James Lord*, 1959
[Portrait of James Lord]

pencil on paper
38 × 29 cm
monogrammed and dated
lower right: "B 59"
New York, Charlotte
and Duncan McGuigan

provenance: James Lord;
private collection
exhibitions: New York 1963,
n. 47; New York, MoMA *et alia*
1966–67, n. 29; Spoleto 1982,
n. 70; Paris, MNAM.CNACGP
1983–84, n. 92; Andros 1990,
n. 60; Rome 1990, p. 125
bibliography: Clair,
Monnier 1999, n. D 952

James Lord arrived in France with the American
GI's in 1944, settling in Paris where he became
friends with Picasso and Giacometti.
He wrote on his recollections of those two artists,
their entourage and the collectors gravitating
around them in several books: *A Giacometti
Portrait* (1965), *Where the pictures were* (1973);
Five remarquable Women (1994) and *Giacometti*
(1997).

121. *Grand Paysage avec vache*, 1959–60
[Large Landscape with a Cow]

oil on canvas
162 × 130 cm
monogrammed and dated
lower left: "Bs1959–1960"
private collection

provenance: Pierre Matisse
Gallery, New York, purchased
from the artist; private
collection
exhibitions: New York 1962,
n. 15; Cambridge 1964, n. 23;
Chicago 1964, n. 23; Paris,
Arts décoratifs 1966, n. 39;
Knokke-le-Zoute 1966, n. 39;
London, Tate Gallery 1968,
n. 51; Detroit 1969, n. 13;
Marseilles 1973, n. 37;
New York 1977, n. 10; Venice
1980; Paris, MNAM.CNACGP
1983–84, n. 54; New York 1984,
n. 43; Lausanne 1993;
Madrid 1996
bibliography: Leymarie 1978,
pl. 33 and 2nd ed. 1990, pl. 34;
Leymarie 1982, pl. p. 73 and
p. 149 and 2nd ed. 1990, pl. p.
66 and p. 154; Klossowski 1983,
pl. 59; catalog MNAM.CNACGP,
Paris 1983, pl. p. 198, p. 294
and p. 374 n. 201;
Kisaragi,Takashina, Motoe 1994,
pl. 48; Xing 1995, pl. 53; Roy
1996, p. 119; Klossowski 1996,
n. 73; catalog Dijon 1999,
p. 60; Fox Weber 1999, p. 485;
Clair, Monnier 1999, n. P 306

This *Paysage* can be compared to two others, very
alike, that were painted at the same time toward
the end of Balthus's stay at Chassy. All three show
the same field, seen from a window of his studio
facing west. The rhythm of the *Grand Paysage
avec vache* is given by three trees—the one
in the middle is smaller, farther from us than
the others. The second one (fig. 1) is as though
scarred by the capricious obliques of the branches
of the two trees framing it; the central tree only
stands out by its white trunk. The third combines
the approaches of the two others (fig. 2).
The *Grand paysage avec vache* is clearly vertical,
the other two are nearly square, executed
on the same sized canvases presented
one in height, the other in width.
A cow is crossing the field in the foreground,
followed by the farmer, in boots, dressed in blue,
and raising his arm as if hailing us in a friendly
gesture. Beyond, separated from the first by a
thick hedge of black brambles, lies a second field
that seems to reflect the blue of a winter sky, then
a farm whose buildings bar the horizon. In a way,
what is shown to us is a closed world, divided in
two parts, like the *Cour de ferme* of the same year
(cat. 122). And like the *Cour de ferme*, it opposes
a "full" space to an "empty" one, a space where
time flows—at the ruminant's slow pace—to a
space where time is suspended.
That contrast does not appear in the two
other versions. The *Grand paysage* (fig. 2),
in an astonishing chromatic harmony, opposes
to the cold earth and sky tones a foliage that gives
the impression of being "solarised" by a warm
ochre that, depending on the distance from which
you look at the picture, either masks or else
emphasizes the perspective and the farm buildings.

1. Balthus, *Paysage* [Landscape],
1959–60, oil on canvas,
156 × 140 cm.
Private collection

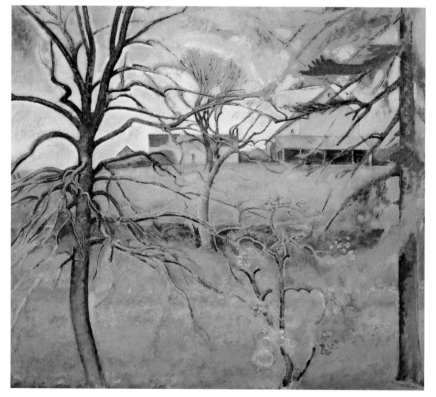

2. Balthus, *Grand paysage*
[Large Landscape], 1960,
oil on paper mounted on canvas,
140 × 156 cm.
Private collection

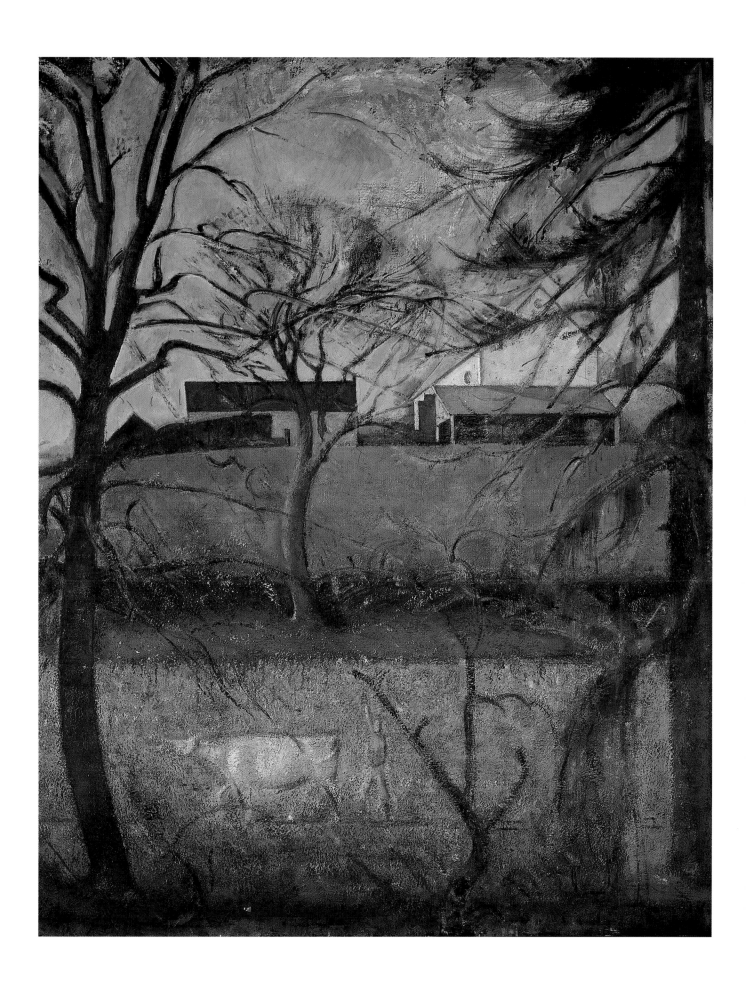

122. *Cour de ferme à Chassy* (Grand paysage), 1960
[The Courtyard of the Farm at Chassy (Large Landscape)]

oil on canvas
130 × 162 cm
Paris, Musée national d'art
moderne, Centre Georges
Pompidou

provenance: Paris, Galerie
Henriette Gomès, purchased
from the artist
exhibitions: Paris, Arts
décoratifs 1966, n. 44;
Knokke-le-Zoute 1966, n. 44;
London, Tate Gallery 1968,
n. 54; Marseilles 1973, n. 41;
Paris 1977; Venice 1980;
Paris, MNAM.CNACGP 1983–84,
n. 56; New York 1984, n. 45;
Kyoto 1984, n. 27; Tokyo
1993–94, n. 26; Hong Kong
1995, n. 21; Beijing 1995, n. 21;
Taipei 1995, n. 21; Madrid 1996;
Dijon 1999, n. 20
bibliography: Leymarie 1978,
pl. 36 and 2nd ed. 1990, pl. 37;
Leymarie 1982, pl. pp. 70–71
and p. 149 and 2nd ed. 1990,
pl. p. 63 and p. 154; Klossowski
1983, pl. 60; catalog
MNAM.CNACGP, Paris 1983,
pl. p. 203 and p. 375 n. 204;
Kisaragi, Takashina, Motoe
1994, pl. 49; Xing 1995, pl. 57;
Roy 1996, p. 167;
Klossowski 1996, n. 77;
Clair, Monnier 1999, n. P 314

This landscape is the last view Balthus gave
of Chassy, before leaving for Rome. Prepared
by two studies (fig. 1 and Clair, Monnier 1999,
n. P 313), he goes back to the point of view,
widening it, of his 1954 *Cour de ferme* (cat. 100).
But even though again painted in winter, it is,
unlike the work in the former Gomès collection,
dazzling with light.
It is one of the rare Balthus's sunlit landscapes.
The work keeps the two-part division of the 1954
canvas; only now the contrast is created between
the shadowed area, the two courtyards, and the lit
area, the fields. The merging of the two is again
produced by the graphic device of the tree
branches, but also by the stripes of sunlight
mottling the courtyard. In front of the acid-yellow
one on the left, we discern a stiff silhouette
moving away with its back turned to us. It nearly
blends with the elements. Is it the painter,
as he already represented himself in the *Passage du
Commerce* (cat. 92)? Is it the farmer we glimpsed
in the *Grand Paysage aux arbres* (cat. 110)?
To tell the truth it hardly matters, since here, as
there, the landscape appears just as uninhabited.
The geometrization of the forms, those of the
fields, the little farmhouses, or the courtyard
whose triangle shape is enhanced by the play
of shadows, gives the painting an abstract
appearance, heightened by the lack of perspective
depth. Certain forms are even hard to make out:
thus a small white surface that has the polyhedric
form of rock crystal, right behind the masonry
porch. Consequently, the eye lingers on others:
the cubic, windowless farmhouses articulating
the landscape, this or that chimney pot.
We practically need blink to be able
to recompose the landscape.
Here again, Balthus interprets anew his "oriental"
vision of landscape, giving all the elements the
same values. As in front of a Chinese painting,
we must contemplate it at length, sharpen our
vision, let ourselves be gradually permeated
by the colors, to be able to read the picture,
recreating its perspective and subtleties.

1. Balthus, *Etude pour
"Cour de ferme à Chassy"*
[Study for "The Courtyard
of the Farm at Chassy"] (1960),
oil on canvas, 89 × 96 cm.
Formerly André Gomès collection

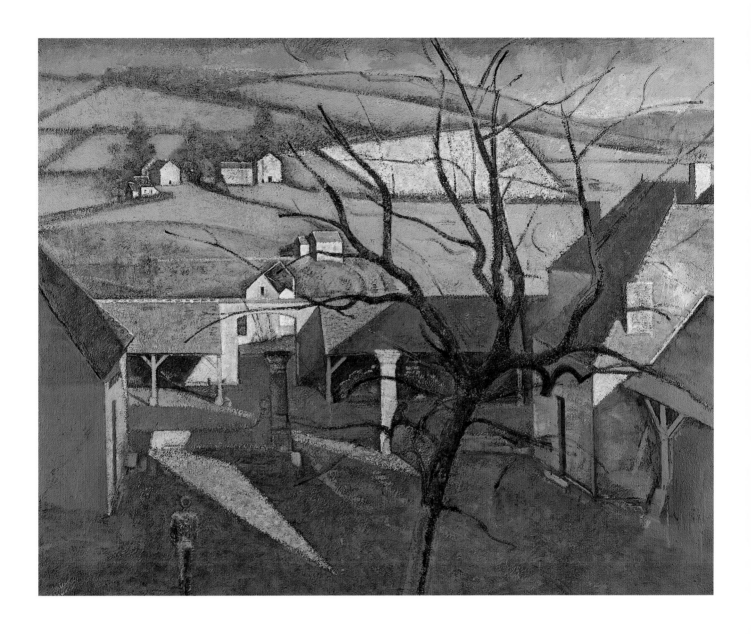

Rome (1961–77)

When, in 1961, Balthus was appointed Director of the Académie de France in Rome (Villa Medici), the task of renovating the building left him little time to paint. That is why his Roman years are represented here above all by drawings. Balthus's first model was his young Japanese wife, Setsuko Ideta, who posed for many drawings and preparatory studies for three large paintings, *La Chambre turque*, *Japonaise à la table rouge* and *Japonaise au miroir noir*.

Beginning in 1969, two sisters succeeded one another in his studio: Katia and Michelina. They are shown in nearly a dozen drawings, allowing us to grasp the manner whereby Balthus achieved a form of expression that was new to him. Henceforth he considered his drawings autonomous works rather than mere preparatory studies for his paintings.

123. *Nu*, 1961
[Nude]

pencil and water color wash
on paper
28 × 21 cm
signed and dated lower toward
center: "Balthus 1961"
Switzerland, private collection

provenance: from the artist
exhibitions: Lausanne 1993;
Rome 1996–97, p. 139;
Karuizawa 1997, p. 84;
Wroclaw 1998, n. 1
bibliography: Faye 1998, p. 22;
Clair, Monnier 1999, n. D 979

Drawings heightened by water color
are relatively rare in Balthus's work.
This one, intimist in character, is appealing
by its simplicity and gracefulness.

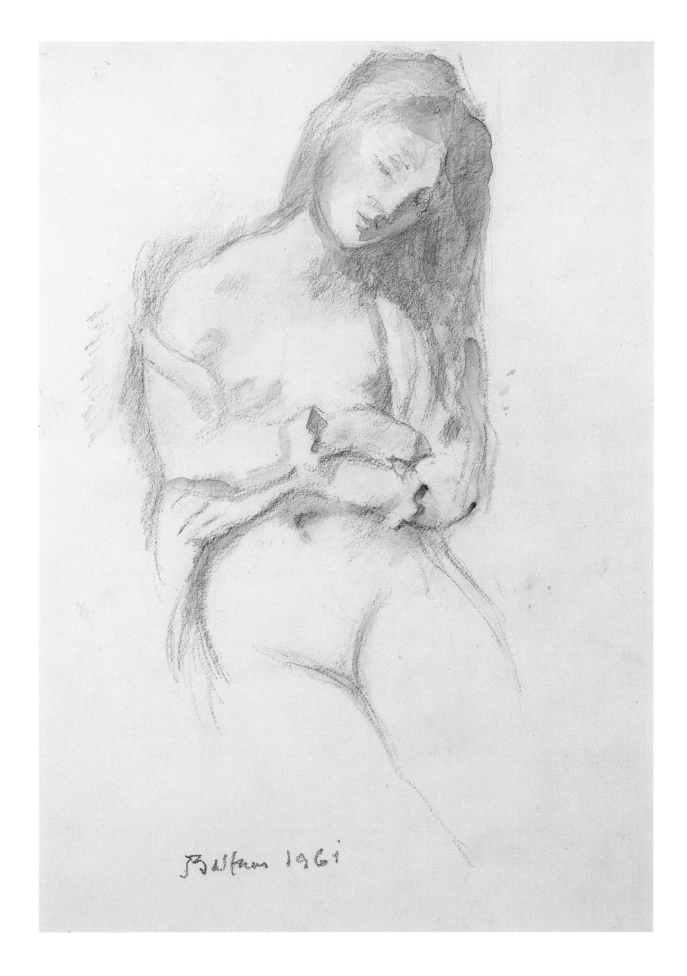

Balthus 1961

124. *Jeune fille en buste*, 1963 [Bust of a Girl]
125. *Jeune fille en buste*, 1963 [Bust of a Girl]

124.
pencil on paper
57 × 43 cm
monogrammed and dated
lower right: "B 1963"
private collection

provenance: Galerie Henriette
Gomès, Paris
exhibitions: Spoleto 1982, n. 74;
Paris, MNAM.CNACGP 1983–84,
n. 94; Kyoto 1984, n. 50
bibliography: catalog New York
1984, p. 152, pl. 129; Xing 1995;
Faye 1999, p. 83; Clair,
Monnier 1999, n. D 1002

125.
pencil on paper
53.5 × 40 cm
signed and dated lower right:
"Balthus 63"
private collection

provenance: Frédérique Tison;
New York, Pierre Matisse
Gallery
exhibitions: New York 1967,
n. 25; New York 1977, n. 21;
Spoleto 1982, n. 80; Andros
1990, n. 66; Rome 1990, p. 134;
Bern 1994, n. 50
bibliography: Roy 1996, p. 151
(mistakenly quoted as a lost
work); Clair, Monnier 1999,
n. D 1003

In 1962, André Malraux assigned to Balthus
a cultural mission in Japan. It was there
that he met a young, twenty year-old student,
Setsuko Ideta, who was to become his wife
in 1967. Setsuko joined Balthus in Rome
the following year and soon began posing
for him. She was the model for three large
paintings executed at the Villa Medici,
La Chambre turque (cf. cat. 127, fig. 1),
Japonaise à la table rouge (cf. cat. 133, fig. 1)
and *Japonaise au miroir noir* (cf. Clair, Monnier
1999, n. D 1085).
The two drawings belong to the very first Balthus
did of her. She is represented seated, her torso
bared by the open folds of her garment.
Seen three-quarters and with her hair loose
in the first, she is portrayed frontally, her hair held
by a headband in the second. The two drawings
insist on the perfect oval of her face
and the regularity of her features. In the first,
treated with a soft pencil, Balthus strove
to render the volumes, the curve of the cheek,
the hollow of the neck or the shadow
of the breast. The second, more incisive,
looks like a working drawing. It is rather severe,
less worked, but remarkably vivid.

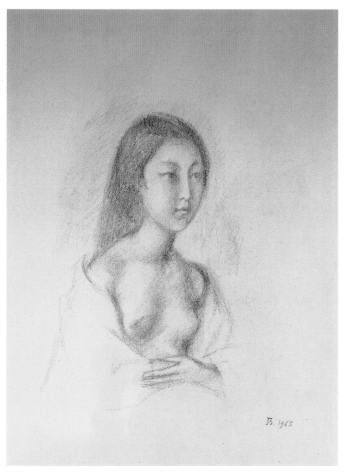

124

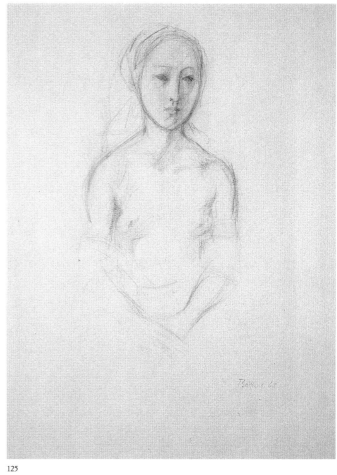

125

126. *Sans titre* (1963)
[Untitled]

pencil on paper
40 × 30 cm
Switzerland, private collection

provenance: the artist
bibliography: Clair,
Monnier 1999, n. D 1006

By Balthus we know but very few erotic works,
in the strict sense of the term: a small series
after some etchings by the Japanese master
Sukenobu executed in 1964[1] and a few others
representing a women's couple asleep in 1967.[2]
This one recalls the famous painting by Courbet
titled *The Origin of the World* (fig. 1). A legendary
work, painted in 1866 for the Ottoman
ambassador Khalil Bey, but that Balthus must
have seen since it belonged to Jacques Lacan,[3]
who kept it concealed behind a landscape
by André Masson that served as a shield.
This drawing is not a copy of Courbet's painting;
if the angle of vision is identical, you do not see
the model's belly, masked by her hands,
the position of the right leg is different
and the genitalia are hairless. Yet is is inspired by
it; indeed it reproduces an anatomical inaccuracy
that in Courbet had caused outrage: the cleft
of the vulva, as thin as a line, goes all the way
to the crease of the anus, ignoring the anatomical
particularities of the female body.
The drawing is vertical, whereas Courbet's
painting (a 10 points: 46 × 55 cm)) is in width.
The layout is fluidly arranged around the
diagonal, the line drawn by the right knee being
followed up by that of the hands and the left hip
of the model.

[1] Cf. Clair, Monnier 1999, nn. D 1050–D 1052.
[2] *Ibidem,* nn. D 1094–D 1098.
[3] Cf. cat. 86, note 1.

1. Gustave Courbet,
The Origin of the World, 1866,
oil on canvas, 46 × 55 cm.
Paris, Musée d'Orsay

127. *Etude pour "La Chambre turque,"* 1963 [Study for "The Turkish Room"]
128. *Etude pour "La Chambre turque,"* 1963 [Study for "The Turkish Room"]

127.
pencil on paper
28.9 × 39 cm
New York, The Elkon
Gallery Inc.

exhibitions: New York 1998,
n. 17
bibliography: Roy 1996, p. 153;
Clair, Monnier 1999, n. D 1018

128.
pencil and water color on paper
50 × 68 cm
dedicated and monogrammed
lower right: "Pour Pierre
et Patricia Bs"
New York, The Museum
of Modern Art, gift
in memoriam Patricia
Kane Matisse

provenance: Pierre Matisse
exhibitions: Detroit 1969, n. 39;
Paris 1971, n. 30; Marseilles
1973, n. 60; New York 1977,
n. 20; Bern 1994, n. 53; Madrid
1996 (not reproduced)
bibliography: Xing 1995;
Clair, Monnier 1999, n. D 1023

La Chambre turque (fig. 1) is the first large
painting Balthus began working on at the Villa
Medici. He is starting up a new period, breaking
with the preceding one: a new aesthetic, inspired
as much by Italy as by his encounter with Setsuko
Ideta (cf. cat. 124), coincides with a new
technique. If the support of the paintings is
still canvas, the medium changes. Balthus seeks
to achieve a mat surface, emulating frescoes.
To do so, he uses a mixture of casein, *gesso*
and oil colors, adding various binders. The result
matches his intent, but makes several paintings
so fragile that they can no longer be removed.
That is why *La Chambre turque* is not included
in this exhibition.
The "Turkish room" really exists. It is a small,
Oriental-style room that had been furnished
in the attics of the Villa Medici by Horace Vernet
when he was director of the Académie de France
in Rome (1828–35).
The floor is paved in polychrome marble, the
walls and ceiling faced with glazed terracotta tiles,
endlessly repeating a stylized plant motif. The
room is lit by a twin window with a Moorish arch.
This décor is faithfully reproduced in the painting
and was not given advanced preparatory studies.
On the other hand, the young woman's pose was
thought out at length in order to be inscribed
in a pattern associating the rigor of a squaring
(achieved by the division of the height in five
equal segments and of the width in six) with
the fluidity of two parallel arcs framing her body.
The first of the two drawings presented here

could be seen entirely apart from *La Chambre
turque*, it being so alive and free of the
intellectualization evidenced in the painting.
Yet it is, nonetheless, linked up with it since we
can already find in it the formal elements allowing
the composition to swivel around, to literally furl
itself around an axis: the foreshortening of the left
leg and the long curve drawn by the right thigh,
the back, the shoulder and the head. That curve,
still slightly clumsy, gradually becomes more
accurate in the studies, while the sleeves
of the peignoir swell and the left arm is raised.
The Museum of Modern Art of New York
drawing (cat. 128) is close to the final
composition. Like the painting, it belonged
to Pierre Matisse; for the reasons we already
mentioned, we have not been able to unite
the two works here. It is unfortunate, because
it would have permitted to seize *de visu* the final
stage of the creative process. The placing of the
body, more precisely of the trunk and the legs,
is already defined in the study and will not vary.
On the other hand, the arabesque its outer line
traces will be hollowed by the garment drawn up
over the shoulder and the bent arm, thus using
again the study of figure 1. Of the latter, Balthus
will also keep the line of the neck, all the while
retaining the frontal face of the Museum
of Modern Art drawing. Last, we should notice
how the left arm will be slightly extended,
so that the edge of the mirror, at the base of the
knee, designs with the odalisque's left shinbone
the third arc underlying the composition.

1. Balthus, *La Chambre turque*
[The Turkish Room], 1963–66,
casein tempera on canvas,
180 × 210 cm.
Paris, Musée national
d'art moderne, Centre
Georges Pompidou

127

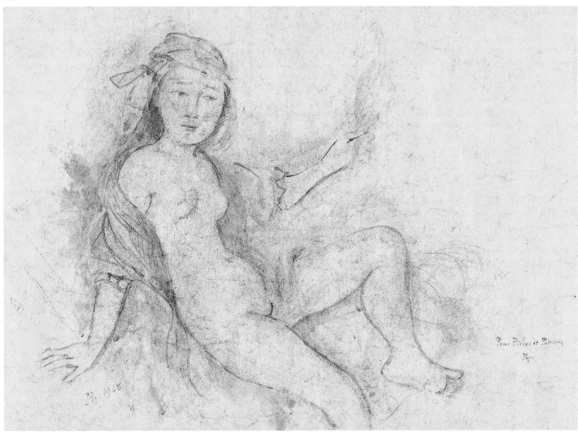

128

129. *La Grotte*, 1963 [The Grotto]
130. *Etude de paysage*, 1963 [Study for a Landscape]
131. *Etude de paysage, Monte Calvello*, 1970 [Study for a Landscape, Monte Calvello]

129.
water color and pencil
on beige paper
30 × 42 cm
monogrammed and dated
lower right: "Bs 63"

exhibitions: Marseilles 1973,
n. 63; Spoleto 1982, n. 79
bibliography: Xing 1995;
Clair, Monnier 1999, n. D 1036

130.
water color, ink and pencil
on beige paper
37.5 × 45 cm
dedicated and signed
lower right: "Setsuko no
tamani Balthus"
private collection

provenance: the artist
exhibitions: Rome 1996–97,
p. 158
bibliography: Clair,
Monnier 1999, n. D 1037

131.
water color on elephant
skin paper
34.5 × 50 cm
Switzerland, private collection

provenance: the artist
exhibitions: Spoleto 1982,
n. 115, Rome 1989, n. 13;
Bern 1994, n. 65
bibliography: Clair,
Monnier 1999, n. D 1184

The first of these water colors is dated, the second is not, but the likeness of the layout has induced us to connect them. Both drawings represent a large rock, covered with greenery, with a stream flowing at its base.

The sparseness of means used to depict *La Grotte* recalls Chinese paintings on paper. A water color wash in amethyst tones, a few dabs of ink diluted in water, three pencil lines are all that is needed to suggest the rocky mass, the plays of shadow and light on the bushes hanging from it.

The painter has an overall view and his depiction of the landscape is comprehensive. The spectator mentally recreates the perspective, and with his imagination can, as he likes, replace the large rock in a landscape or else have it loom out of a diffuse mist.

L'Etude de paysage that we present with it is more elaborate but expresses the same endeavor to render an overall view of the landscape.

As in *La Grotte*, the economy of means is outstanding. The color of the paper is used as a dominant, showing through the water colored areas; it is highlighted in yellow to render the radiance of the sunlight, or darkened with burnt Siena to suggest the shadows. Thanks to that device, the modulations of the relief seem to spring from inside the very drawing.

Both ink and pencil are used. The first, in dark black hatching, to give the landscape its density, the second to outline a tortured tree with silvery reflections that gives the composition its stability.

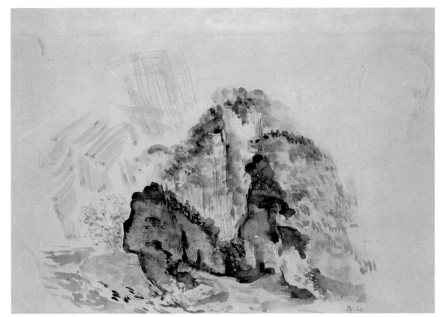

129

130

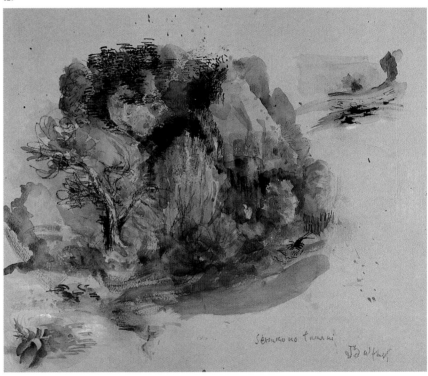

138

131

393

132. *Corbeille de fruits*, 1964
[Basket of Fruit]

water color and pencil on paper
40 × 53 cm
signed and dated lower left:
"Balthus 64"
J.-M. Folon

bibliography: Clair,
Monnier 1999, n. D 1048

In a wicker basket whose weaving is meticulously
drawn, Balthus put some autumn fruit: a quince,
a pear, a large apple, some peaches and plums,
perhaps a grapefruit on the bottom, probably
chosen for their round form emphasized
by a penciled line. Water color is used to model
the volumes: three or four shades of yellow,
more or less acid, a few touches of carmine
placed rather arbitrarily, a bit of bistre to give
the ensemble some relief.
A slightly smaller variant of this water color
was shown at Spoleto in 1982.[1]

[1] *Balthus, disegni e acquarelli*, exhibition catalog, Spoleto
1982, n. 78; repr. in Clair, Monnier 1999, n. D 1049.

133. *Etude pour "Japonaise à la table rouge,"* 1964
[Study for "Japanese Girl with a Red Table"]

pencil on paper
49 × 69 cm
monogrammed and dated
lower left: "Bs 64"
inscribed in Japanese
ideograms upper right
New York, The Elkon
Gallery Inc.

provenance: Detroit, Donald
Morris Gallery; Minneapolis,
Howard B. Marks
exhibitions: Detroit 1969, n. 43;
Spoleto 1982, n. 91; New York
1998, n. 19
bibliography: Faye 1998, p. 19;
Clair, Monnier 1999, n. D 1070

Setsuko Ideta, who was Balthus's inspiration for
La Chambre turque, also posed for two paintings
that were executed simultaneously between 1967
and 1976 and that form pendants, *Japonaise au
miroir noir* and *Japonaise à la table rouge* (fig. 1)
of which the finest study is shown here.
Dated 1964, it was drawn three years before
the starting up of the canvas it seems to prepare.
A sketchbook corroborates the assumption that
Balthus thought out these paintings at great length
before undertaking them.[1] Even if owing to its
beauty and the balance of the composition, this
drawing can be considered a work on its own,
we can see it is very close to the canvas, despite
the different framing.
It is obvious that Japanese art inspired its
convolutions, expressed in the young woman's
sophisticated pose. An art from which Balthus
also borrows refined details that he uses in his

own way: the ribbon on the brow to hold back
the luxuriant hair usually arranged in artful loops,
the kimono attached at the waist, its large bow
enhancing the line of the back, and whose folds,
thrown back, disclose the young woman's nudity,
that in the Far East would have only been
glimpsed. Thus a drawing of today, but in the
Japanese tradition, to which the ideograms
calligraphed on the right explicitly refer.
Ukiyoé means "the floating world" and that
is the expression used to designate etchings
of the Edo period (eighteenth and nineteenth
centuries), wootcuts depicting a light, libertine
atmosphere, featuring a refined eroticism.

[1] Cf. Clair, Monnier 1999, n. CC 1496/12 and ff. 14
of the 19 sheets this sketchbook contains feature
sketches that appear to have been done at different
periods, between 1963 and 1974, which is unusual.

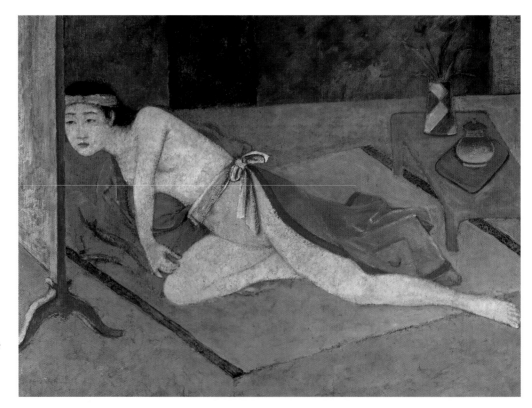

1. Balthus, *Japonaise à la table rouge*
[Japanese Girl with a Red Table],
1967–76, casein tempera
on canvas, 145 × 192 cm.
Private collection

浮世絵

134. *Portrait d'une jeune japonaise*, 1963
[Portrait of a Japanese Girl]

pencil on paper
41 × 32 cm
Switzerland, private collection

provenance: the artist

This drawing was executed during
one of Balthus's stays in Japan. It is shown
here for the first time. The sitter, Toyo,
is a friend of Setsuko's, Balthus's wife.

134. *Portrait d'une jeune japonaise*, 1963
[Portrait of a Japanese Girl]

135. *Katia endormie*, 1969–70 [Katia Asleep]
136. *Katia endormie*, 1969–70 [Katia Asleep]
137. *Katia endormie*, 1969–70 [Katia Asleep]

135.
pencil on paper
monogrammed lower right:
"Bs"
New York, The Elkon
Gallery Inc.

bibliography: Clair,
Monnier 1999, n. D 1135

136.
pencil on paper
35.5 × 38 cm
monogrammed lower right:
"Bs"
Lausanne, Alice Pauli collection

exhibitions: Andros 1990, n. 78;
Rome 1990, p. 146; Ornans
1992, n. 54; Lausanne 1993;
Tokyo 1993–94, n. 40
bibliography: Roy 1996, p. 140;
Faye 1999, p. 81; Clair,
Monnier 1999, n. D 1136

137.
pencil on paper
26.5 × 29.5 cm
inscribed lower left: "Katia"
monogrammed lower right:
"Bs"
private collection

bibliography: Clair,
Monnier 1999, n. D 1137

Katia, the daughter of an employee at the Villa
Medici, started to pose for Balthus toward 1967,
after he had finished *La Chambre turque*, on which
he had worked for three years. A first series
of portraits shows her asleep, a second reading,
as in the large painting *Katia lisant* and the group
of studies on paper connected with it; those two
attitudes allowed the child she was to hold the
pose without too much constraint; that explains
why she was so often thus portrayed.
At the time Balthus was very busy with the
restoration work inside the Villa Medici and
in the gardens. He painted slowly and had little
time to do so. André Malraux wanted him to play
the part of cultural ambassador of France as well
and entertain accordingly. Since the budget
allotted to the director of the Villa did not cover
those expenses, Balthus made a great number
of drawings that he sold for that purpose.
These two combined reasons led him to
reconsider his approach to that technique.
Up to then, he only regarded his drawings
as studies, preparatory to his paintings.
Henceforth he viewed them as independent
works, elaborate and meant to be seen
for themselves.
That is the case for the three drawings presented
here. They belong to a group of a dozen variations
where Katia is seen either half-reclining in a big
armchair (fig. 1), or half-length, her head turned
to the left, her arms limply crossed over her
dressing gown whose neckline shows her bosom.
None of them are colored, just the indication of
the shadows models the very young girl's full face,
rather wide nose, small fleshy mouth and plump
shoulders. The pencil in some places is blurred,
in others accurately outlines the neckline of the
garment, in others again suggests, in sweeping
hatchings, the young girl's hair, that looks
unwieldy to the comb.
These three drawings are thus a magnificent
example of the mastery with which Balthus
exploits the resources of a technique he had
for a long time considered secondary.

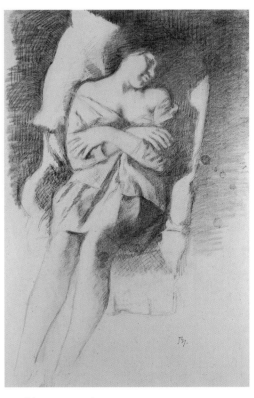

1. Balthus, *Katia endormie*, 1969–70,
pencil and charcoal on paper,
70 × 50 cm.
Geneva, Galerie Jan Krugier,
Ditesheim & Cie

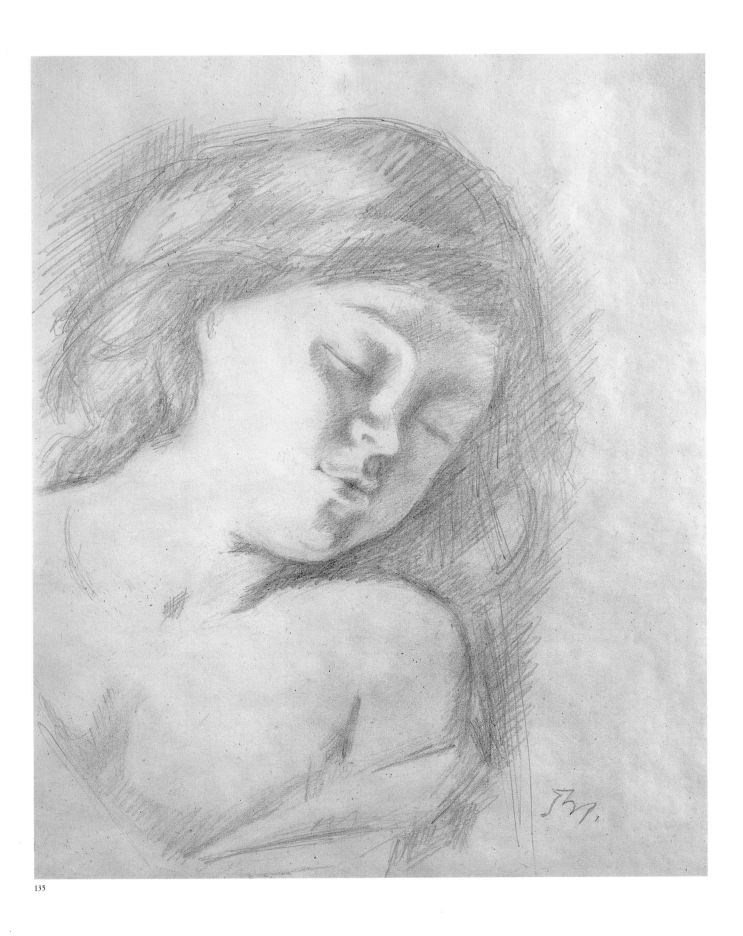

135

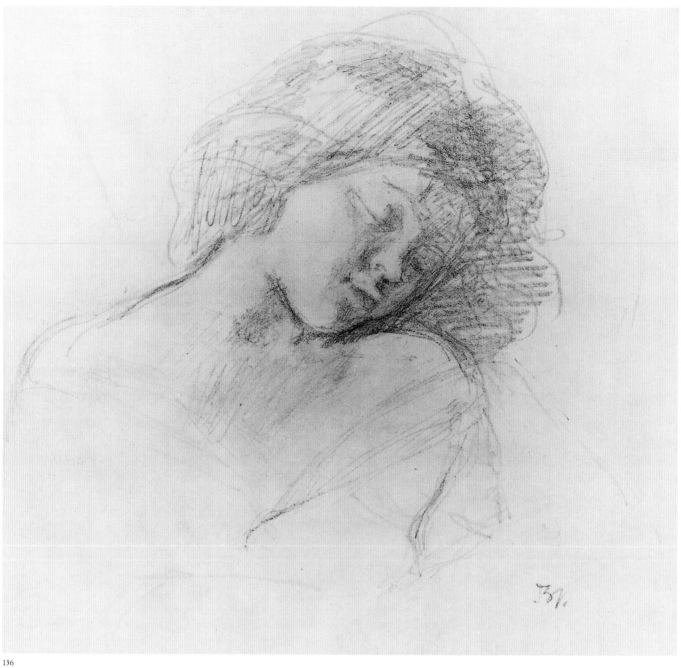

136

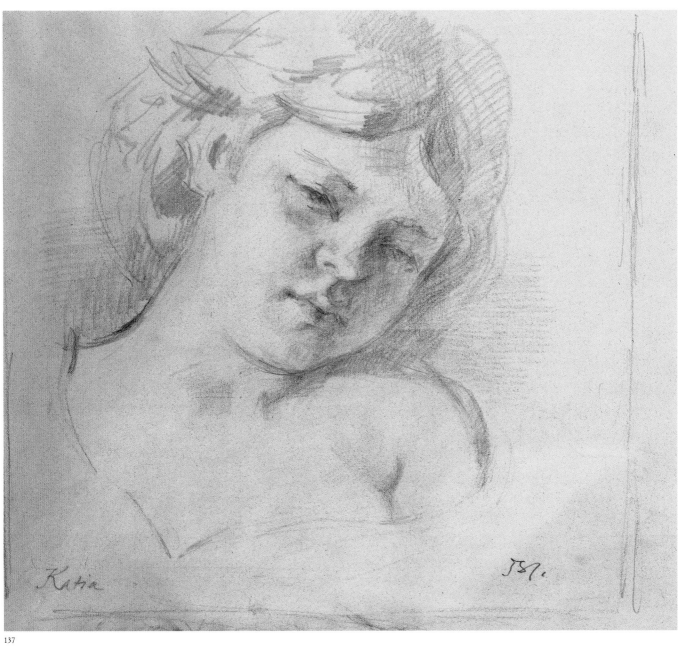

137

138. *Etude pour "Nu assoupi"* (1969) [Study for "Sleeping Nude"]
139. *Deux études pour "Nu assoupi"* (1969) [Two Studies for "Sleeping Nude"]

138.
pencil on paper
72 × 50 cm
signed lower right: "Balthus"
private collection

provenance: Dr. Hubert de Watteville; sale Gabus, hôtel des Bergues, Geneva, 26 October–4 November 1984; Vivian Horan Gallery, New York
exhibitions: Spoleto 1982, n. 95
bibliography: Faye 1998, p. 29; Clair, Monnier 1999, n. D 1143

139.
pencil on paper
54.5 × 42 cm
signed and dated lower right: "Balthus Rome 1964"
Switzerland, private collection

exhibitions: Ornans 1992, n. 52; Lausanne 1993; Rome 1996–97, p. 140; Karuizawa 1997, p. 110; Venice 2000, p. 42
bibliography: Faye 1998, p. 30; Clair, Monnier 1999, n. D 1144

Despite the 1964 datation, figuring at the bottom of the *Deux études pour "Nu assoupi"*, this sheet is definitely posterior. Indeed we recognize Katia's face, and we know she did not begin posing for Balthus until around 1967. So there is good reason to suppose it was signed and dated later, and mistakenly so. The second drawing shown here is close to the first. It was dated toward 1969 by Giovanni Carandente on indications by Balthus;[1] so that is the date we have retained for both works.
We already pointed out in the preceding notice the circumstances that led Balthus to execute drawings not connected with his painted work. Yet, the case of the *Nu* is paradoxical: it serves, indeed, as a work in its own right, finished, of which the double study would have been the first insight. But at the same time it is at the origin of a painting executed ten years later (fig. 1) that, with a slightly different layout, borrows its main characteristics. The young girl is dozing in the corner of a bench-seat, her head leaning against the window-frame. One leg is bent, the other outstretched, her arms are crossed at her waist. She is naked, but wearing a béret and high white socks. One of the studies of cat. 139 is very similar to this drawing, the other slightly different, since Katia is dressed and shown sitting in a chair, with her right arm raised.
The technique of the drawing recalls the different versions of *Katia endormie*, while the colors of the painting are inspired by Italy, shades of lavender blue and orangey reds geometrically arranged on the tiling and a pillow featuring a Roman mosaic pattern.

[1] G. Carandente, *Balthus, disegni e acquarelli*, exhibition catalog, Spoleto 1982, n. 95.

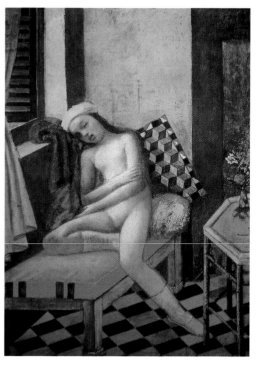

1. Balthus, *Nu assoupi* [Sleeping Nude], 1980, casein tempera on canvas, 200 × 150 cm. Private collection

138

139

140. *Buste de jeune fille*, 1972 [Bust of a Girl]
141. *Buste de jeune fille* [Bust of a Girl]

140.
pencil on elephant skin paper
48 × 32 cm
dedicated and monogrammed
lower right: "per Umberto
suo amico Bs"
Municipality of Gualtieri

provenance: Umberto Tirelli,
gift of the artist
exhibitions: Spoleto 1982,
n. 106; Bern 1994, n. 68
bibliography: Clair,
Monnier 1999, n. D 1264

141.
pencil on paper
Setsuko Klossowska de Rola

This portrait is one of the first of Michelina,
Katia's younger sister (cf. cat. 135 and ff.),
who was to pose for Balthus for six years.
Also one of the first drawings made on a paper
that is tinted and veined in the pulp, called
"elephant skin," whose texture Balthus uses
like a fresco painter plays with the coating
he is working on.
Michelina is viewed frontally, seated, her torso
bare, her hands joined on her thighs. On her
head, turned slightly to the left, she is wearing
a small round bonnet; her overall attitude recalls
the very first portraits of Setsuko made about
ten years before (cats. 24, 125).
However, it cannot be compared to them;
for, because of the nature of the paper
and the way Balthus sketches the effigy, the figure
seems to arise from the support itself, to have
been inscribed since time immemorial in the sheet
from which the pencil merely detached it.
A recollection of the restoration work on the
murals of the Villa Medici? Of the unexpected
discovery of the frescoes in Ferdinand's *studiolo*?[1]
We might imagine that experience suggested to
Balthus the particular treatment of this drawing,
with its extremely singular mood.

[1] The *studiolo* of Ferdinand de Medici is one of the
stanze sopra le mura where he liked to retire. The fresco,
by Iacopo Zucchi, is dedicated to Aurora and represents
an aviary filled with all kinds of birds. See *La Villa
Médicis*, edited by André Chastel, Ecole française
de Rome, Roma 1989 and C. Roy, *Balthus*, Gallimard,
Paris 1996, p. 226.

140

141

142. *Nu de profil*, 1973–77
[Nude in Profile]

oil on canvas
225 × 200 cm
private collection

provenance: Pierre Matisse
Gallery, New York, purchased
from the artist; private
collection, New York
exhibitions: New York 1977,
n. 15; Venice 1980
bibliography: Leymarie 1978,
pl. 46 and 2nd ed. 1990, pl. 47;
Leymarie 1982, pl. p. 113
and p. 145 and 2nd ed. 1990,
pl. p. 101 and p. 149;
Klossowski 1983, pl. 70;
catalog MNAM.CNACGP, Paris
1983, p. 270 and p. 379 n. 226;
catalog New York 1984, p. 53
pl. 90; Clair 1984, p. 45 pl. 30;
Xing 1995, pl. 67; Roy 1996,
p. 202; Clair 1996, p. 54;
Klossowski 1996, n. 85;
Clair, Monnier 1999, n. P 334

The studies for the *Nu de profil* were drawn
at the same time as Michelina's preceding portrait,
some being executed, as it was, on elephant
paper.[1] In the loveliest one of them (fig. 1),
the young girl's body, drafted in an accurate,
nearly continuous line, stands out against the veins
of the sheet, that suggest the unevenness
of a trowel-smoothed wall.
Those same elements are found in the painting.
Michelina is standing, nude, in a bathroom set up
in a tower. In front of the window, a wrought iron
table, covered with a cloth, and a gres basin.
The young girl's face, her torso and the yellow
towel she is holding in her hands are brightly lit.
The bare wall is very elaborate. And although
the medium is oil and not *casearti*,[2] Balthus
was able to render the uneven, worn appearance
of traditional plastering.
It is against that rustic background that
the smooth body of the girl stands out.
Her skin seems to reflect the light, an effect that,
paradoxically, is obtained by the use of a dry, very
fine-grained pictorial material. We should point
out, by the way, the treatment of the hair, hastily
gathered in a chignon at the nape of the neck,
that combines the two techniques.
Her legs tensed with one foot forward, her back
arched, shoulders thrown back, head very erect,
the young girl holds herself like a ballerina.
We shall find her again, nearly the same, in two
paintings begun in 1981, the *Nu au foulard* (fig. 2)
and the *Nu au miroir* (fig. 3). But the comparison
between the three pictures shows that the gradual
stretching of the body, the lengthening of the legs
have given rise to a new aesthetic canon, a sort
of archetype of the young girl, to which Balthus's
name is associated.

[1] Cf. Clair, Monnier 1999, nn. D 1257–D 1263.
[2] Cf. *supra*, cat. 127.

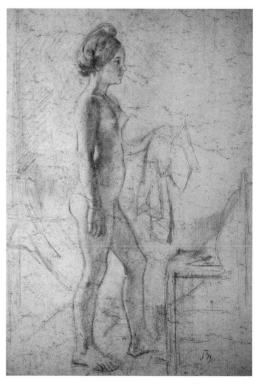

1. Balthus, *Etude pour "Nu de profil"*
[Study for "Nude in Profile"],
1972, pencil on elephant skin paper,
100 × 70 cm.
Private collection

2. Balthus, *Nu au foulard*
[Nude with a Scarf], 1981–82,
oil on canvas, 163 × 130 cm.
Private collection

3. Balthus, *Nu au miroir*
[Nude with a a Mirror], 1981–83,
oil on canvas, 163 × 130 cm.
Private collection

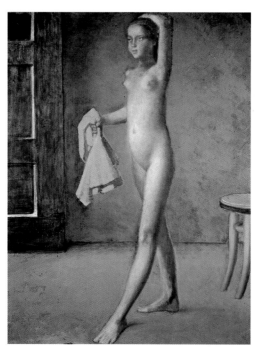

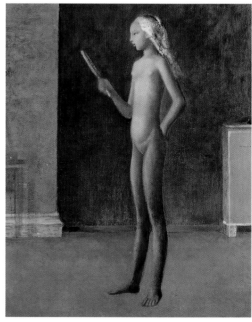

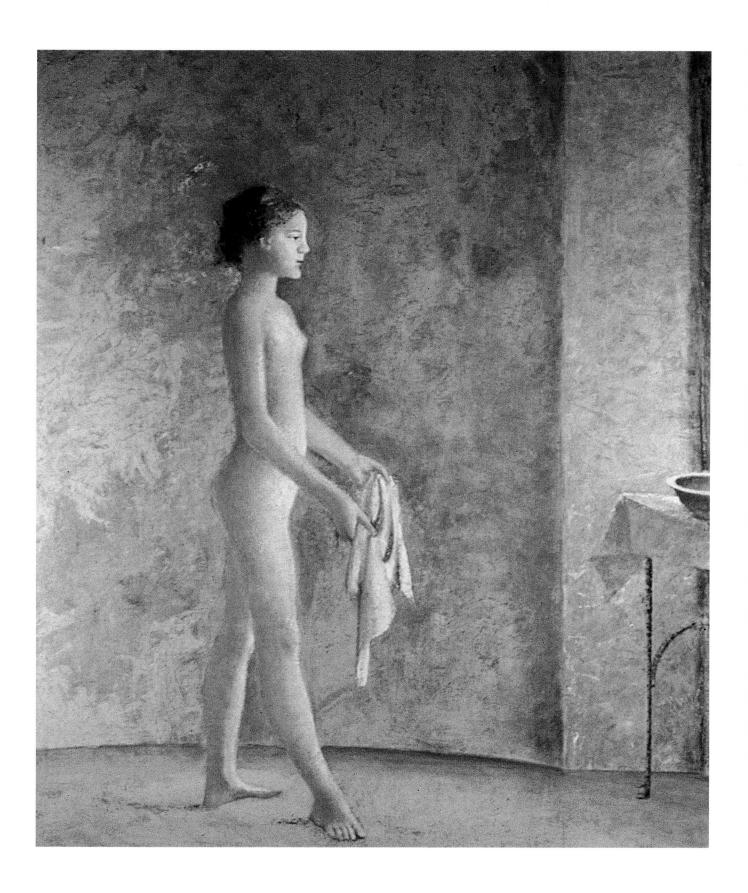

143. *Etude pour "Nu au repos,"* 1972
[Study for "Nude at Rest"]

pencil on paper
100 × 70 cm
dedicated and monogrammed
lower left: "Pour Pierre Matisse
son ami Bs"
private collection

provenance: Pierre Matisse
exhibitions: New York 1978,
n. 23; Spoleto 1982, n. 98;
Kyoto 1984, n. 61; Andros 1990,
n. 90; Rome 1990, p. 157;
Lausanne 1993; Bern 1994,
n. 67; Madrid 1996
(reproduced p. 31)
bibliography: Clair,
Monnier 1999, n. D 1280

In 1972, Balthus made a series of drawings
showing a partly nude young girl sitting
in an armchair, with her right leg bent.
None of them are dated, but they are stylistically
very close to one another and were certainly
executed during the same period.
The date of 1972 that is commonly accepted
is corroborated by the fact that one of them
was shown at Marseilles the following year.
That means that they were done five years before
the large picture titled *Nu au repos* that Balthus
painted the last year of his stay in Rome (fig. 1).
Should we therefore consider them as preparatory
studies of the painting *stricto sensu*, or as a series
of variations on a theme he would come back
to in 1977? A certain number of them, in any
event, act as independent drawings.
The one exhibited here is dedicated to Pierre
Matisse, who also was the owner of the painting.
The two are very alike. The composition is laid out
around the diagonal that descends from the upper
left corner to the lower right corner; around it
unfold the curves of the body and of the garment,
symmetrically or complementarily reversed:
the mass of the right shoulder matching the curve
of the left hip, that of the skull the rounded form
of the bent knee. Likewise, in one of the studies
(fig. 2), the right arm was raised to match the left
leg. That symmetry also appears in the shadows,
in the hollow of the neck and of the breast
on one side, in the crease of the garment
and that of the knee on the other.
Comparing the painting with the drawing,
we notice the young girl's body has slipped
to the left, altering the angle the head forms
with the shoulders. A minute variation yet
that has its importance, since it allows the painter
to place the young girl's genitalia, now veiled
by light panties, exactly at the geometric center
of the composition.

1. Balthus, *Nu au repos*
[Nude at Rest], 1977,
oil on canvas, 200 × 150 cm.
Dolores Kohl collection

2. Balthus, *Etude pour
"Nu au repos,"* 1972,
pencil on elephant skin paper,
100 × 70 cm.
Private collection

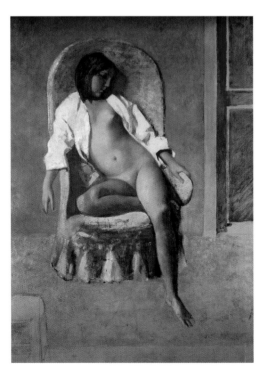

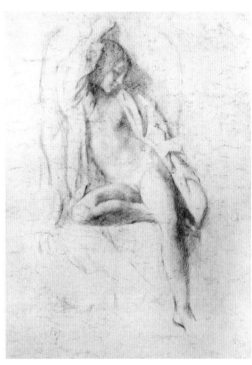

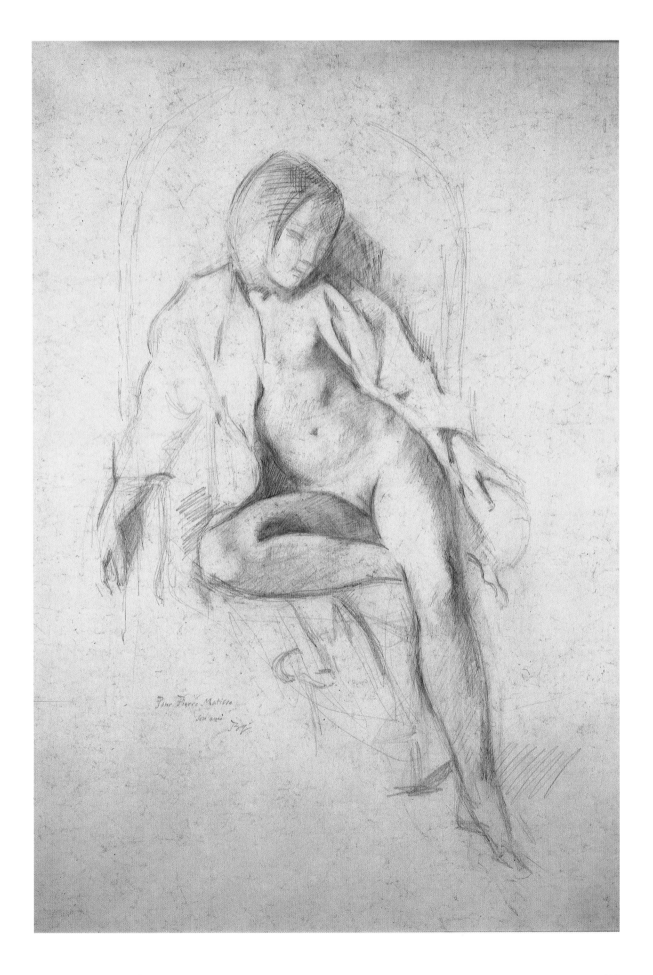

144. *Etude pour "Le Lever,"* 1974
[Study for "The Waking up"]

pencil on elephant skin paper
100 × 70 cm
monogrammed upper left: "Bs"
London, Thomas Gibson
Fine Art Ltd

provenance: Galerie Claude
Bernard, Paris; Roger
Vanthournout, Belgium
bibliography: Clair,
Monnier 1999, n. D 1327

There are two paintings titled *Le Lever*; the first,
presently at the Edinburgh Museum (cat. 104),
was painted at Chassy and the second (fig. 1),
which this drawing refers to, in Rome.
In a painting that would become famous,
Jean-Baptiste Greuze linked up the theme
of the bird with that of the young girl, giving
the subject an ambiguous meaning that the
eighteenth-century libertine public did not fail
to see.[1] We are also familiar with the symbolism
of the cat in the vocabulary of eroticism,
when depicted next to a nude.[2]
Balthus deliberately associated those themes here,
but giving them a twist, with his biting irony
and the naiveté he masterfully feigned.
In *Le Lever*, there is indeed a nude, a bird
and a cat. However, the young girl does not
appear in the least desolate, the bird is a wooden
toy beating its mechanical wings and the cat
coming out of its box like a tiger out of a circus
cage has eyes but for the decoy. Just a perfectly
ordinary scene, after all? Let us not be fooled
by it, and indeed remember Manet's response to
the hail of insults he had provoked by exhibiting
the portrait of a prostitute at the *Salon* of 1865:
"I render as simply as possible the things I see.
Like the Olympia, what could be more naive?".[3]
There are a dozen studies for *Le Lever* (figs. 2 and
3).[4] They all have to do with the young girl, most
of the time wearing a light dressing gown arranged
so as to reveal rather than conceal her nudity.
She is resting her elbow on a pillow, neither
the bird nor the cat are depicted. But the delicacy
with which she is portrayed and the innocence
of her face just enhance the erotic atmosphere
permeating the composition.

[1] *Girl Weeping for Her Dead Bird*, 1765, Edinburgh,
National Gallery.
[2] Need we mention Baudelaire's famous "Is it actually
a cat?" on the subject of Manet's *Olympia*?
[3] Quoted by F. Cachin, *Manet*, exhibition catalog, Paris,
Grand Palais, 1983, p. 182.
[4] Cf. Clair, Monnier 1999, nn D 1314–D 1328 and CC
1503/6–7.

1. Balthus, *Le Lever*
[The Waking up], 1975–78,
oil on canvas, 169 × 159.5 cm.
Private collection

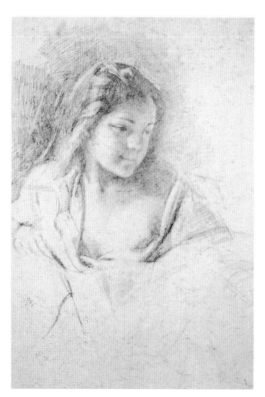

2. Balthus, *Etude pour "Le Lever,"*
1974, pencil on paper,
36.5 × 48.5 cm.
Private collection

3. Balthus, *Etude pour "Le Lever,"*
1974, pencil on elephant skin
paper, 100 × 70 cm.
Private collection

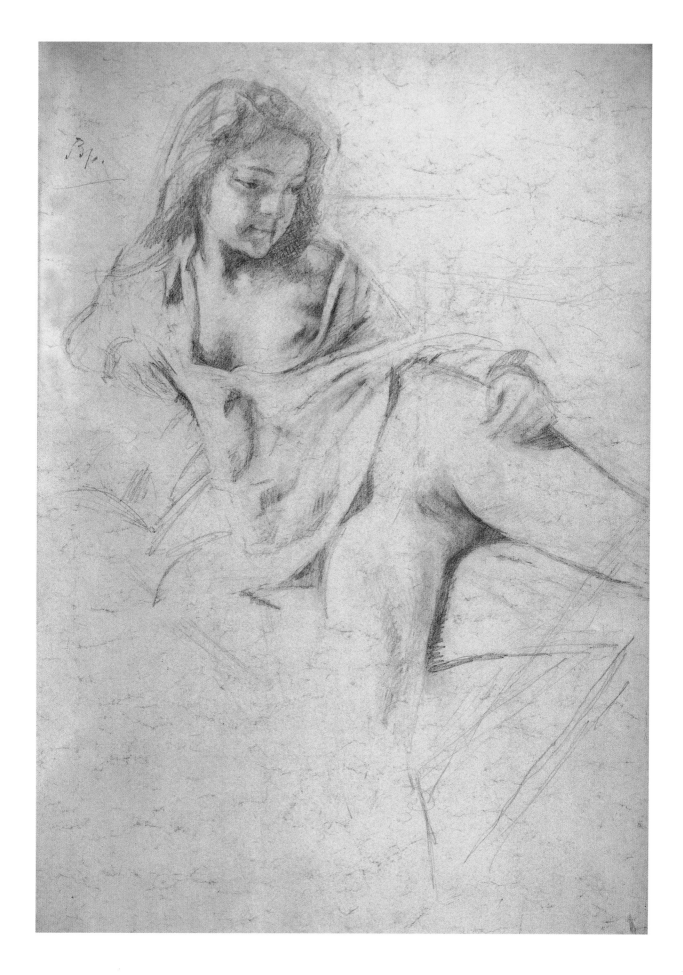

145. *Michelina endormie* (1975)
[Michelina Asleep]

pencil and charcoal
on elephant skin paper
70 × 100 cm
monogrammed lower left: "Bs"
Paola Ghiringhelli

exhibitions: Spoleto 1982,
n. 131; Bern 1994, n. 76;
Madrid 1996; Rome 1996–97,
p. 137
bibliography: Roy 1996,
p. 142–43; Faye 1998, p. 73;
Clair, Monnier 1999, n. D 1329

Like the preceding one, this large drawing belongs
to a classicizing manner that for a short time
marked Balthus's work in the mid-seventies.
Michelina, the model, is Katia's sister (cats. 135
and ff.) but hardly resembles her. Her fine
features, very Italian, lend themselves to
idealization. In her smooth face, as though blurred
by the sleep she is immersed in, Balthus
underlines the arch of the eyebrows parallel with
the line of the eyelashes, the hollow of the eyelid,
the jaw bone, the full lips and small snub nose.
The balanced composition plays with interwoven,
matching undulations; little does Balthus care
if the curve of the shoulder is exaggerated, the
armpit anatomically inaccurate and the humerus
too long. The globe of the breasts matches
the curve of the jaw and that of the forehead,
the round forms of the shoulder, the wrists
or the fingers match the creases of the pillow
the young girl is drawing toward her head.
We can compare this portrait with another,
just slightly posterior one, under which
Balthus wrote a few verses by Lewis Carroll:

> And, though the shadow of a sigh
> May tremble through the story,
> For 'happy summer days' gone by,
> And vanished summer glory -
> It shall not touch with breath of bale
> The pleasance of our fairy-tale.[1]

[1] L. Carroll, *Through the Looking-Glass.*
Last stanza of the poem ending the preface.

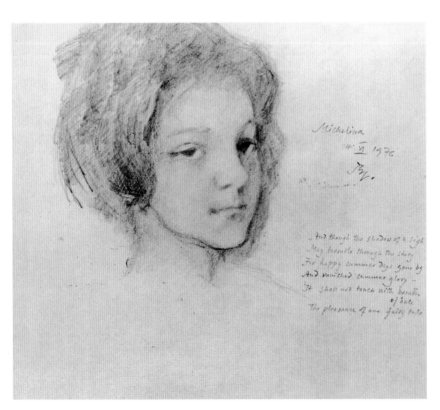

1. Balthus, *Portrait de Michelina*
[Portrait of Michelina], 1976,
pencil on paper, 34 × 38 cm.
Private collection

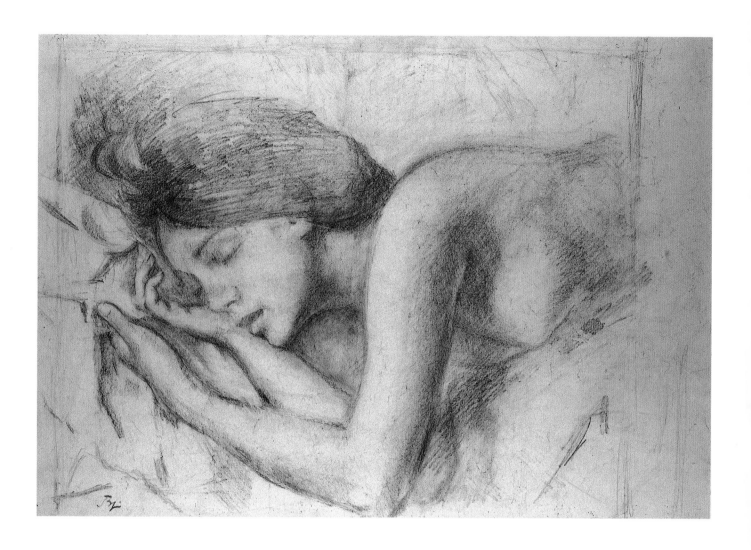

146. *Portrait de Renato Guttuso*, 1975
[Portrait of Renato Guttuso]

pencil on paper
41 × 36 cm
inscribed, dedicated and
monogrammed lower center:
"il nostro Renato un tentativo
per Sandro Bs"
New York, private collection

provenance: the artist
exhibitions: Rome 1989, n. 25;
Andros 1990, n. 97; Rome 1990,
p. 168
bibliography: Roy 1996, p. 252;
Clair, Monnier 1999, n. 1337

Balthus and Renato Guttuso (1912–87) met
in Rome. In his youth, the Italian painter
had been very active fighting Fascism; his interest
in politics, his militancy,[1] as his painting
were quite removed from Balthus's world.
Notwithstanding, they both admired Picasso;
on the occasion of his frequent stays in Paris,
Guttuso had spent a great deal of time with
Picasso, whose *Guernica* had been essential
to the development of his style. That is confirmed
by a second portrait of Guttuso (fig. 1), done
at the same time as this one, bearing the
inscription: "In memoriam Pablo Picasso."

[1] In 1972 Guttuso had published an essay on art
and society titled *Mestiere di pittore: scritti sull'arte
e la società*.

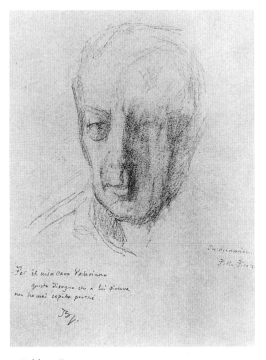

1. Balthus, *Portrait
de Renato Guttuso*
[Portrait of Renato Guttuso],
1975, pencil on paper,
41 × 33 cm.
Private collection

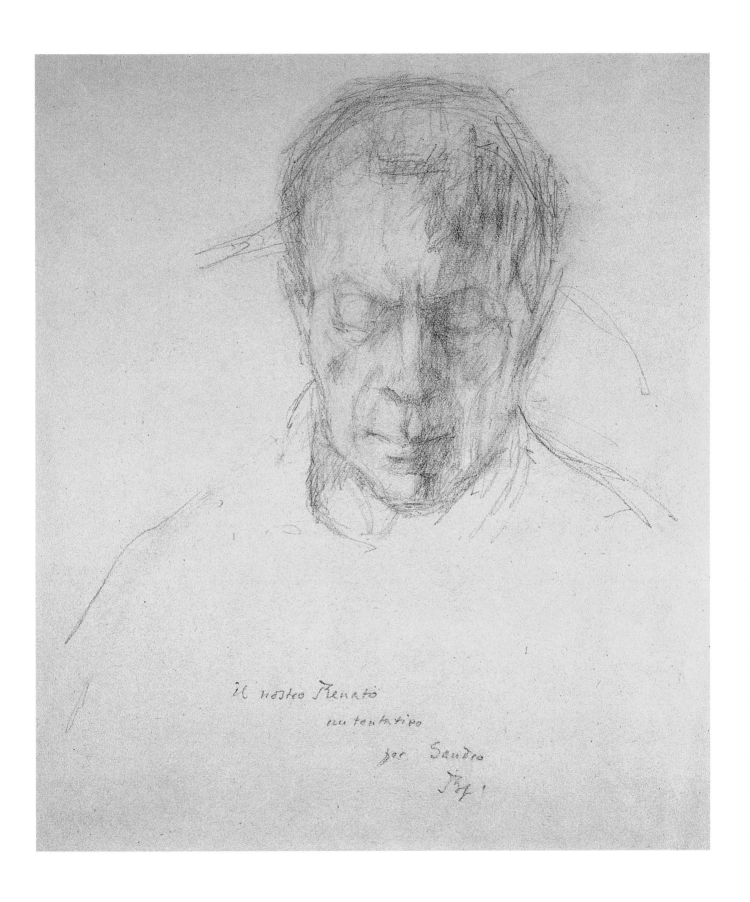

il nostro Renato

un tentativo

per Sandro

147. *Paysage de Monte Calvello* (1975)
[Monte Calvello Landscape]

pencil and water color
on elephant skin paper
66.3 × 70 cm
Stanislas Klossowski de Rola

provenance: the artist
exhibitions: Madrid 1996;
Rome 1996–97, p. 154;
Karuizawa 1997, p. 92;
New York 2000, n. 22
bibliography: Clair,
Monnier 1999, n. D 1340

Balthus bought the castle of Monte Calvello,
near Viterbo, in the early seventies. He set up
a studio on the top floor and, like at Chassy,
drew the series of *Paysages de Monte Calvello*
from one of its windows. We know around twenty
versions. Several were executed as early as 1970,
two others, including this one, in 1975
and the last in 1978 (cf. cats. 154, 155).
Balthus never represented the castle, but always
a tall watch-tower, built on a steep spur separated
from the castle by a small wooded valley.
By playing with the texture of the paper, tinted
and veined, he was able to render the powdery
light of the Latium, the vibration in which, at
certain hours of the day, the landscape dissolves.
A light pencil just barely highlighted with a wash
suggests the tower, the bushes hemming it in.
The whiteness of the cliffs and the dense shadow
revealing the hollow of the valley are the only
areas actually featuring color, in an intense range
that draws the eye and implies the perspective.

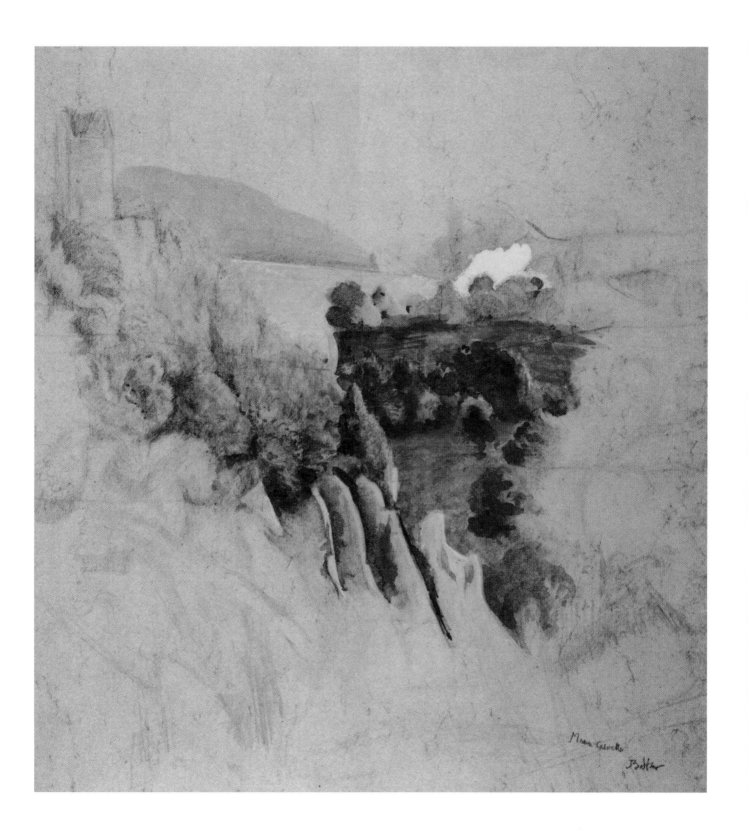

Rossinière (1977–2001)

In 1977, Balthus withdrew to the Grand Chalet of Rossinière in Switzerland. Production of this last period of his life is the least prolific. It features reminiscences of Italy, like the *Paysage de Monte Calvello*, and the last cycle he painted, on the theme of the *Chat au miroir*.

The *Jeune fille à la mandoline* is his last work, unfinished.

148. *Etude pour "Le Peintre et son modèle"* (1977)
[Study for "The Painter and His Model"]

pencil on paper
65.1 × 94 cm
monogrammed lower right:
"Bs"
private collection

provenance: Galerie Alice Pauli,
Lausanne; Thomas Ammann
Gallery Inc., Zurich; Odyssia
Gallery, New York; B.C.
Holland, Chicago; James
Corcoran, Santa Monica;
Thomas Ammann Gallery Inc.,
Zurich; Nowinski collection,
Seattle; Stephen Mazoh & Co.
Inc., New York; Max Kohler,
Art Focus, Zurich
exhibitions: Spoleto 1982,
n. 113; London 1996, n. 16
bibliography: Faye 1998, p. 32;
Clair, Monnier 1999, n. D 1374

When Balthus portrayed André Derain, in 1936,
he showed him in his studio (although he actually
posed at the Cour de Rohan) and a painter's
traditional context: behind him we perceive a
model and, to his right, a few stretchers turned
against the wall. At the time he associated two
themes, that of the portrait and that of the
"painter's studio" or the "painter and his model."
When, nearly forty years later, he returns to that
theme, he immediately breaks with its traditional
iconography. If we examine the picture (fig. 1)
for which this drawing is a study, we cannot
imagine we are in a studio: no easel, no drapes, no
brushes or jars of paint, no other canvas, nothing
allowing us to suppose we are seeing someone
posing. The artist portrays himself from the back,
pulling the curtain of a high window. A little girl,
kneeling on the floor, is reading a magazine placed
on a chair on which she rests her elbow. On the
right, a stool and a metal can, on the left a second
chair, toward the back a table with a basket of

fruit and a box of biscuits where Balthus
concealed his monogramme and the date.
Contrary to what we might expect, the
protagonists appear entirely indifferent to each
other. The girl is absorbed in an activity that must
be familiar to her, in a posture equally so,
and that vaguely recalls *Les Enfants Hubert
et Thérèse Blanchard* (cat. 53). The study, like
another one very akin to it,[1] is mainly intent
on placing her in the décor since it is on her,
after all, that Balthus wants to focus our attention.
We should also notice that, in the study, the little
girl's face still seems to be a portrait; on the other
hand, in the painting she has lost any kind of
individuality; the small face, framed in a crown
of curls, is smooth and expressionless, the dress
has become a simple tunic; as in certain Italian
paintings of the Trecento, what we now are shown
is an εικων.

[1] Cf. Clair, Monnier 1999, n. D 1373.

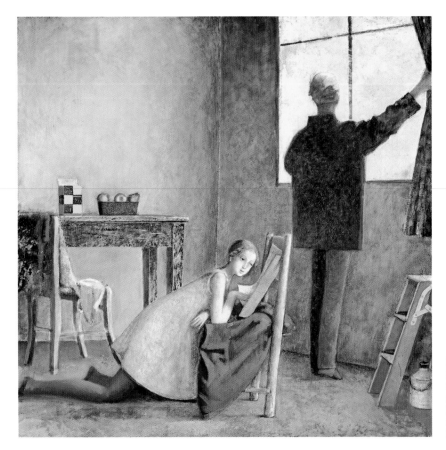

1. Balthus, *Le Peintre et son modèle*
[The Painter and His Model],
1980–81, casein tempera
on canvas, 226.5 × 230.5 cm.
Paris, Musée national
d'art moderne,
Centre Georges Pompidou

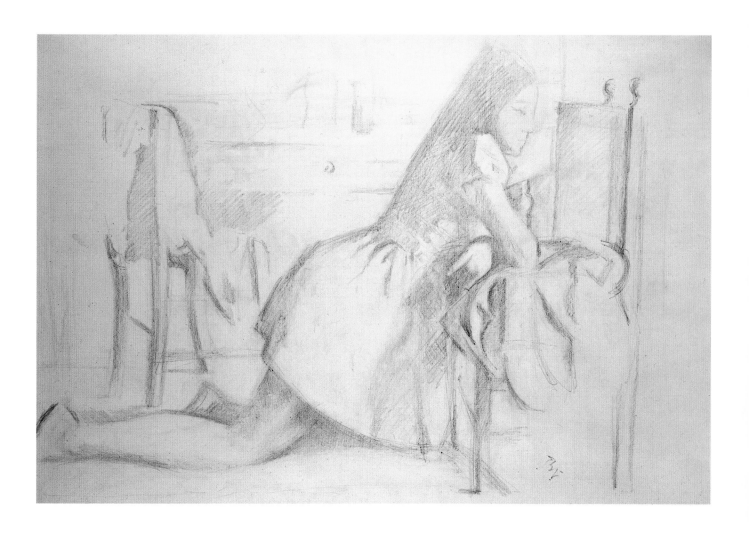

149. *Etude pour "Nu couché,"* 1976–77 [Study for "Reclining Nude"]
150. *Etude pour "Nu couché,"* 1977–78 [Study for "Reclining Nude"]
151. *Etude pour "Nu couché,"* 1977–78 [Study for "Reclining Nude"]

149.
pencil on elephant skin paper
70 × 100 cm.
signed lower right: "Balthus"
private collection

provenance: Galerie
Claude Bernard, Paris
bibliography: Clair,
Monnier 1999, n. D 1390

150.
pencil on paper
70 × 100 cm
signed lower left: "Balthus"
private collection

provenance: Valerio Zurlini;
private collection;
Galerie Cazeau-Béraudière
exhibitions: Spoleto 1982,
n. 124; Andros 1990, n. 106;
Rome 1990, p. 181; Bern 1994,
n. 81; Rome 1996–97, p. 136
bibliography: Roy 1996,
pp. 144–45; Faye 1998, p. 64;
Clair, Monnier 1999, n. D 1392

151.
pencil on paper
66 × 96 cm
monogrammed lower left: "Bs"
private collection
provenance: Vivian Horan
Gallery, New York,
purchased from the artist
bibliography: Faye 1998, p. 64;
Clair, Monnier 1999, n. D 1393

Her arms forming an arch over her head, a young girl is asleep, resting on a pile of pillows. Her morphology, still that of a child, forms a contrast with her adolescent countenance. Michelina, the model, recently told how the sittings went and about the intensity with which Balthus sought to express that particular moment in a young girl's life, the transition from childhood to adolescence. She also explained that she had been perfectly aware of the sensuality emanating from these drawings and been flattered by the way the painter had rendered her vague feelings regarding the transformations taking place in her body.[1] Balthus studied the pose at length; this led to a series of studies (fig. 1 and Clair, Monnier 1999, nn. D 1380–D 1390), that he would remember a few years later when he was to paint the *Nu couché*, cat. 157 in this exhibition. The body has the form of a large arc, circumscribing, in counterpoint, the angle of the bent left arm and that of the thighs. The various studies concentrate on the relationship between those two geometric figures.
Cat. 151 is hatched in black throughout the upper area. We shall again find that dark background in the picture Balthus was to paint after these two drawings several years later (cat. 157).

[1] M. Terreri, "Michelina," *L'Infini*, 73, Spring 2001, pp. 75–81.

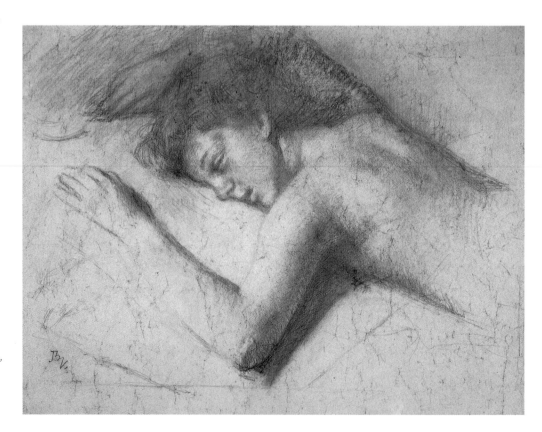

1. Balthus, *Etude pour "Nu couché,"* 1976–77, pencil on elephant skin paper, 70 × 93 cm. Dr. Kasriel Tausk, on loan to the Art Institute of Chicago

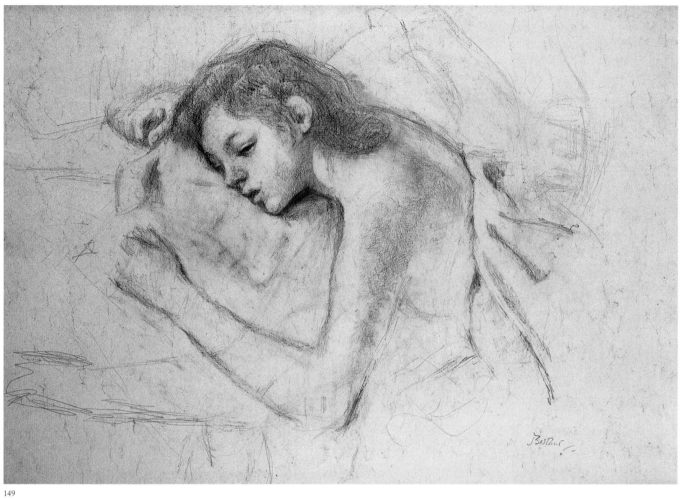

149

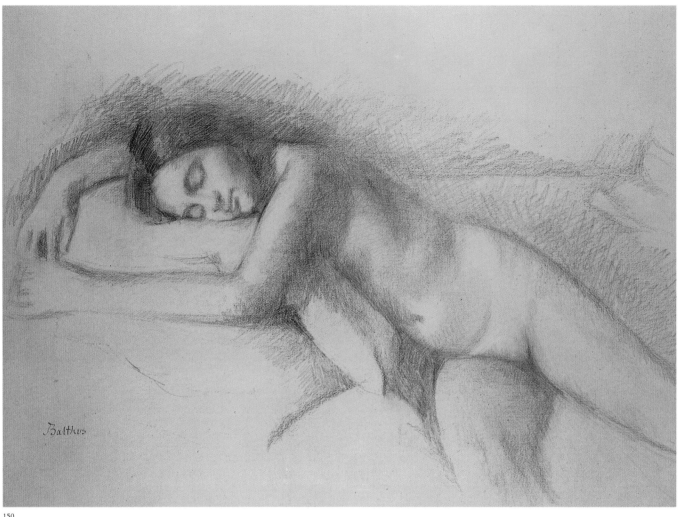

150

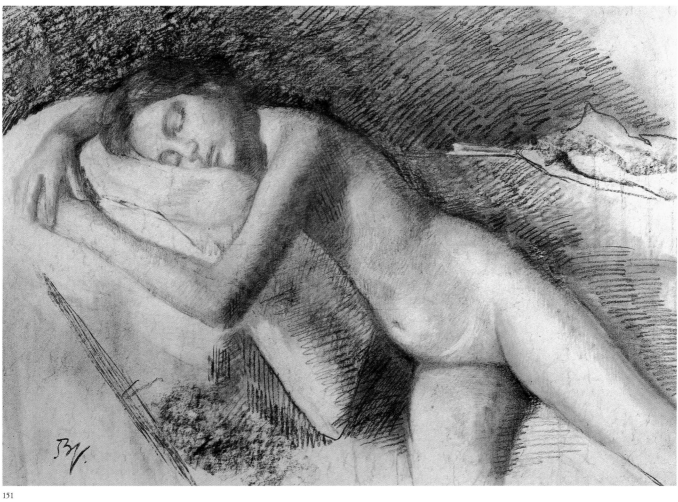

151

152. *Jeune fille assoupie*, 1978 [Dozing Girl]
153. *Jeune fille endormie*, 1978 [Sleeping Girl]

152.
pencil on paper
100 × 70 cm.
signed lower left: "Balthus"
Rome, private collection

exhibitions: Spoleto 1982,
n. 126; Andros 1990, n. 99;
Rome 1990, p. 169
bibliography: Xing 1995;
Clair, Monnier 1999, n. D 1410

153.
pencil on paper
70 × 100 cm
dedicated and monogrammed
lower: "Per il mio caro
Sandro suo amico Bs"
New York, private collection

provenance: the artist
exhibitions: Spoleto 1982,
n. 129; Andros 1990, n. 105;
Rome 1990, p. 182; Bern 1994,
n. 82; Madrid 1996
bibliography: Xing 1995;
Roy 1996, pp. 156–57;
Clair, Monnier 1999, n. D 1412
signed lower left: "Balthus"
private collection
exhibitions: Spoleto 1982, n. 123
bibliography: Clair,
Monnier 1999, n. D 1062

These drawings, as well as two others that are
very close to them (figs. 1 and 2), were executed
at Monte Calvello. The model is Michelina
(cf. cat. 145), whose long slender silhouette
and face with its snub-nose and far-set eyes
are familiar to us.
It would seem this is the last time she posed
for independent drawings. The ones here form
a group. We see her, either half-dressed or naked,
sitting in a large armchair, or with her back resting
on a cushion. The ingenuousness of her face
contrasts with the immodesty of her pose,
but her being portrayed with her eyes closed,
as though withdrawn into sleep, creates between
her and the spectator a remoteness that somehow
transcends the eroticism of the subject.
Balthus, for these drawings, used a soft-lead
pencil and a fine-grain paper so as to render
all the young body's softness and tenderness.
Here again he wanted to glorify beauty
and femininity. Michelina is one of those budding
young girls, whose depiction is associated
with Balthus's name and whom, to shield
himself from the rather equivocal reputation
he was sometimes given, he called "angels."

1. Balthus, *Jeune fille assoupie*, 1978,
pencil on paper, 100 × 70 cm.
Location unknown

2. Balthus, *Jeune fille assise*
[Girl Seated], 1978,
pencil on gray paper, 100 × 70 cm.
Private collection

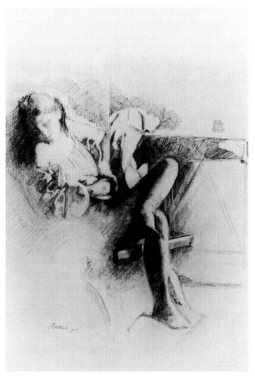

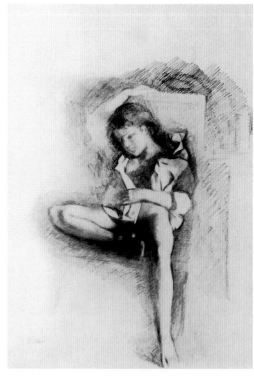

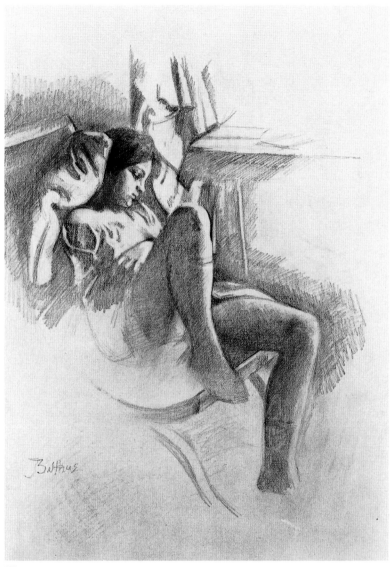

152

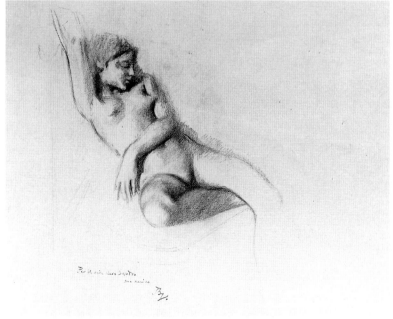

153

154. *Etude pour "Paysage de Monte Calvello,"* 1978 [Study for "Monte Calvello Landscape"]
155. *Paysage de Monte Calvello*, 1979 [Monte Calvello Landscape]

154.
color pencils and watercolor
on elephant skin paper
48 × 60 cm
dedicated and monogrammed
lower right: "Pour Tadeusz
et Louise Noël 1982 Bs"
private collection

provenance: the artist
bibliography: Clair,
Monnier 1999, n. D 1409

155.
casein tempera on canvas
130 × 162 cm
private collection

provenance: Pierre Matisse
Gallery, New York, purchased
from the artist
exhibitions: Venice 1980; Paris,
MNAM.CNACGP 1983–84, n. 61;
New York 1984, n. 50; Andros
1990, n. 103; Rome 1990, p.
179; Lausanne 1993; Madrid
1996; Rome 1996–97, p. 113;
Zurich 1999, n. 15
bibliography: Leymarie 1982,
pl. pp. 120–121 and p. 149
and 2nd ed. 1990, pl. p. 107
and p. 154; Klossowski 1983,
pl. 73; catalog MNAM.CNACGP,
Paris 1983, pl. p. 212 and
p. 380 n. 229; Leymarie 1990
(hardback ed.), pl. 50; Kisaragi,
Takashina, Motoe 1994, pl. 56;
Xing 1995, pl. 70; Roy 1996,
p. 137; Klossowski 1996, n. 89;
Fox Weber 1999, pl. 15;
Clair, Monnier 1999, n. P 337

This landscape, painted 35 years after the
Gottéron (cat. 100, fig. 1), might be seen as
a "light" version of it. It has the same overall
view of a landscape, done nearly flat on the
canvas, carefully avoiding emphasizing any single
detail. As is often the case with Balthus, the
composition is laid out around the diagonal that
goes from the upper left corner down to the
lower right corner. This determines here a "full"
space, the steep hillock on which the tower is
raised, and an "empty" space, behind the first, as
clearly shown in a preparatory drawing (fig. 1).
In the painting, the "empty" area will become
a landscape of hills with fields, crossed by
a zigzagging road, a structural complement
to the "full" area.
The binary conception reflects the influence
of Chinese landscape painters we already
brought up in reference to the *Gottéron*.
In the same spirit, we should point out the light
mists veiling and unveiling the foot of the hillock,
altering the view from one to another, but also
separating two spaces, corresponding to the
sacred and the profane in Taoist philosophy.
The two tiny figures, bathed in light, that are

gazing at the tower from the castle terrace,
would be seeking, according to the same
tradition, what lies beyond the visible.
Balthus wishes his vision to be all-embracing.
We have already seen how, in the paintings
of his youth (cat. 17), he combined, in a same
work, diverse points of view. That device
appears again in the *Paysage de Monte Calvello*,
so subtly mastered that it is barely perceptible.
The comparison between the watercolor
and the painting perfectly illustrates it.
They are very close, and represent the same
panorama but seen from two different places,
higher up for the drawing, lower for the painting.
That is why the tower is more soaring, the chalk
cliffs steeper. The painter appears in the
composition; his presence, like a subtle nudge,
suggests yet a third viewpoint, whence a painting
still to come could be executed.
In so doing, he mentally reconstitutes
the three levelled perspectives of Song dynasty
painters and, in his own way and his own period,
succeeds in expressing their aim, which was to
confer on a specific landscape a universal,
timeless connotation.

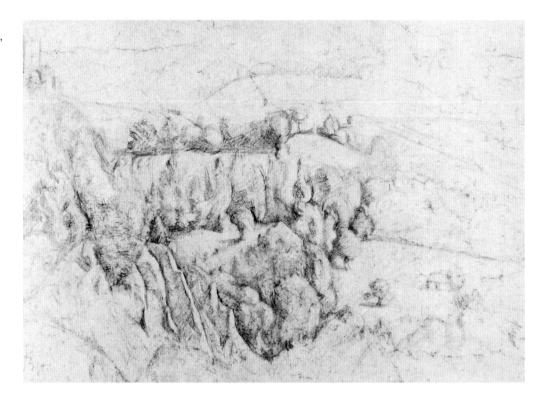

1. Balthus, *Etude pour
"Paysage de Monte Calvello,"* 1975,
pencil and water color
on paper, 70 × 100 cm.
Private collection

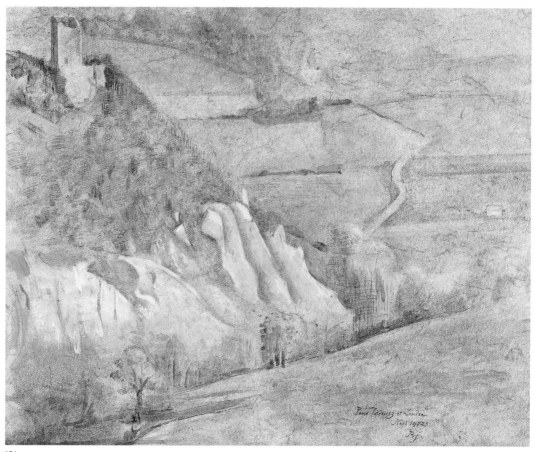

154

155

156. *Le Chat au miroir* I, 1977–80
[The Cat with a Mirror I]

casein tempera on canvas
180 × 170 cm
monogrammed and dated
lower right: "B 77–80"
private collection

provenance: Pierre Matisse
Gallery, New York,
purchased from the artist
exhibitions: Venice 1980;
Rome 1996–97, p. 111
bibliography: Leymarie 1982,
pl. p. 116 and p. 145 and 2nd
ed. 1990, pl. p. 115 and p. 150;
Klossowski 1983, pl. 74-75;
catalog MNAM.CNACGP,
Paris 1983, pl. p. 210, p. 272
and p. 380 n. 230; Clair 1984,
p. 51 pl. 37; Leymarie 1990
(hardback ed.), pl. 54; Kisaragi,
Takashina, Motoe 1994, pl. 61;
catalog London 1994, p. 7;
Xing 1995, pl. 71; Roy 1996,
p. 261; Clair 1996, p. 58;
Klossowski 1996, nn. 87–88;
Fox Weber 1999, p. 556;
Clair, Monnier 1999, n. P 338;
Vircondelet 2000, p. 87

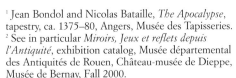

1. Anonymous French, *Sight*,
tapestry of the *Lady with the
Unicorn* series, late fifteenth century.
Paris, Musée des Thermes
et de l'Hôtel de Cluny

Between 1977 and 1994, Balthus was to develop three versions of a subject depicting a young girl holding out a mirror to a cat (cf. cats. 158 and 159). It is significant that the title he chose does not mention the young girl, although she plays the leading role in each of those compositions. In the first, she is naked on a bed, one foot resting on a stool, the other still hidden under the thrown-back blankets. The position of her legs recalls *Le Lever* of 1955 (cat. 104), whereas the upper part of her body vaguely resembles *La Chambre turque* (cat. 127, fig. 1). In her right hand, that comes out of her dressing-gown sleeve, she is holding a folded letter, and in her left a mirror on a handle. Her arm outstretched, she is not looking at herself in it, as was the case in *La Chambre turque*, but is presenting it to a cat perched on the back of a chair at the foot of the bed.

The theme of the woman with a mirror is recurrent in European painting since the Middle Ages. Balthus himself treated it as early as 1944 (*Les Beaux jours*, cats. 71 and 72) and on several occasions (*Les Trois sœurs*, cat. 101, *La Chambre turque*, cat. 127, fig. 1), thus joining the long tradition of painters fascinated by the theme and its many allegorical meanings. One of the very oldest of its representations is probably that of "The Great Prostitute" of Saint John's Apocalypse,[1] where the mirror appears as the symbol of lust, vanity and falsehood, as opposed the mirrors of wisdom and knowledge of which the late Middle Ages were also fond.[2]

Beginning with the Renaissance, the mirror reflects the beauty of nature and communicates neo-Platonic ideals. But in becoming secular, Jean Clair wrote,[3] the theme "was to assume an uncanny gravity," the painter seeing in it "the exaltation of a glorious flesh, melancholy in its awareness of being vulnerable" and thus "the very image of his art, the fleeting reflection of the immutable, pure world of beauty." The nineteenth century would see mirrors as laden with a broader, more diffuse symbolism, comprising narcissism and inconstancy, as well as prudence, illusion and so on.

But to go back to the *Chat au miroir* I. We should mention that in Western painting there are but very few representations in which the mirror does not reflect the woman herself but the pet that is there with her. The most well-known one is *Sight*, the first of the six tapestries of the *Lady with the Unicorn* of the Musée des Thermes et de l'Hôtel de Cluny of Paris (fig. 1). We shall not linger on the complicated symbolism the late fifteenth century attributed to the fabled animal[4] nor question why the unicorn rather than the woman is complacently looking at itself in the "mirror of vanities." We shall merely point out the way she is looking—disapprovingly?— at the animal, yet whose neck she is caressing. Likewise, in *Le Chat au miroir* I, there is a closeness between the young girl and the cat, mediated by the mirror she is holding out to it. But in the painting there is a lightness, a hedonism, that are obviously lacking in the tapestry. The young girl seems to want to play, to tease the cat, perhaps so as to be able to read in peace the letter she is holding, perhaps because the content of the letter suggested to her a secret game, whose rules are not revealed to us, a game of delight and love to which the symbolism connected with cats also refers.

[1] Jean Bondol and Nicolas Bataille, *The Apocalypse*, tapestry, ca. 1375–80, Angers, Musée des Tapisseries.
[2] See in particular *Miroirs, Jeux et reflets depuis l'Antiquité*, exhibition catalog, Musée départemental des Antiquités de Rouen, Château-musée de Dieppe, Musée de Bernay, Fall 2000.
[3] "Les métamorphoses d'Eros," in *Balthus*, exhibition catalog, Paris, 1983, pp. 256–79; 2nd ed. Réunion des musées nationaux, Paris 1996.
[4] See in particular C. Sterling, *La Peinture médiévale à Paris*, t. II, pp. 333 ff., Bibliothèque des Arts, Paris 1990.

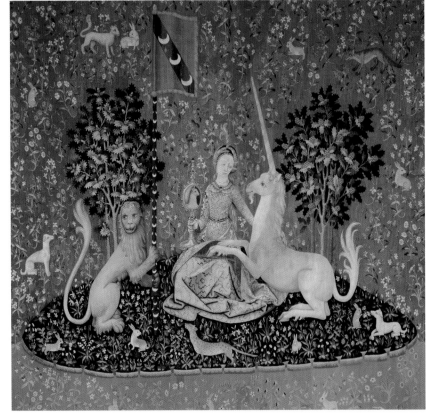

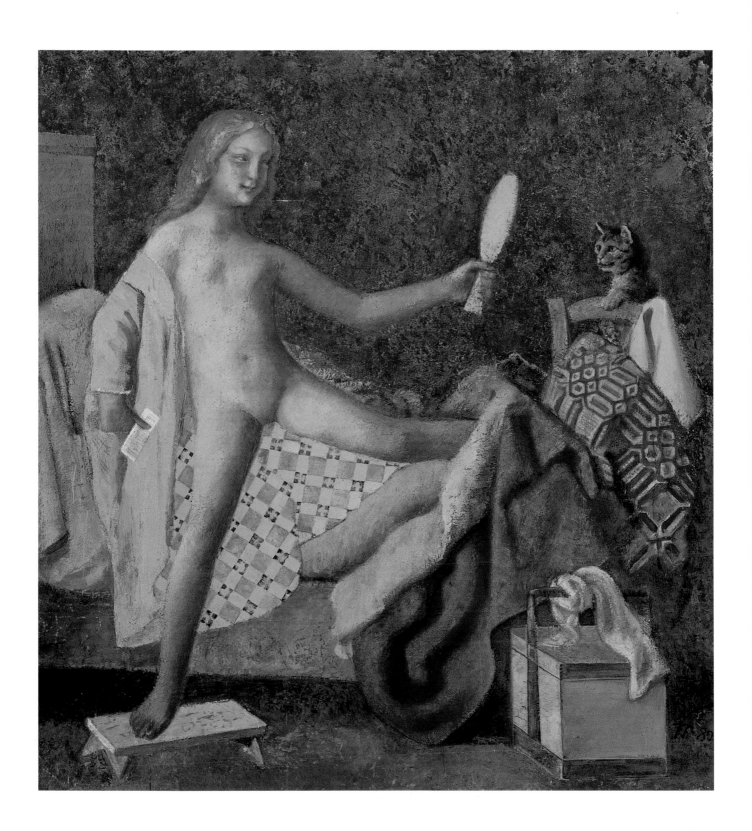

157. *Nu couché*, 1983–86
[Reclining Nude]

oil on canvas
93 × 118 cm
monogrammed and dated
lower left: "Bs 83–86"
private collection

provenance: purchased
from the artist
exhibitions: Lausanne 1993;
Tokyo 1993–94, n. 30;
Hong Kong 1995, n. 23;
Beijing 1995, n. 23; Taipei 1995,
n. 23; Madrid 1996;
Karuizawa 1997, p. 85
bibliography: Roy 1996, p. 249;
Klossowski 1996, n. 99;
Clair, Monnier 1999, n. P 346

The *Nu couché* is, excepting the very recent *Songe d'une nuit d'été*,[1] [Mid-Summer Night's Dream] the only painting of Balthus's entire work that we could call 'nocturnal. It is inspired from a series of studies made at the end of his stay in Rome (cf. cats. 150 and 151), in the last one of which appeared the dark background with the nude body standing out against it. Yet the atmosphere here is different; the gentle sensuousness of the drawing is replaced by a sort of distance, a coldness giving the picture a singular intensity. The reddened cheeks, the greenish hues of the body stand out on the dull linen. The creases of the pillows or of the sheet are stiff, brittle, mineral. Some forms we cannot even decipher: thus, is the one placed against the sleeping girl's abdomen a pillow, a stone or a huge skull, whose big eye sockets look like a sinister counterpart of those in the child's smooth face?

[1] It is a free interpretation of the *Sleeping Nymphe Surprised by Satyr*s by Nicolas Poussin (London, National Gallery), executed in 1998–2000 for the exhibition "Encounters, New Art from old," London, The National Gallery, 14 June–17 September 2000.

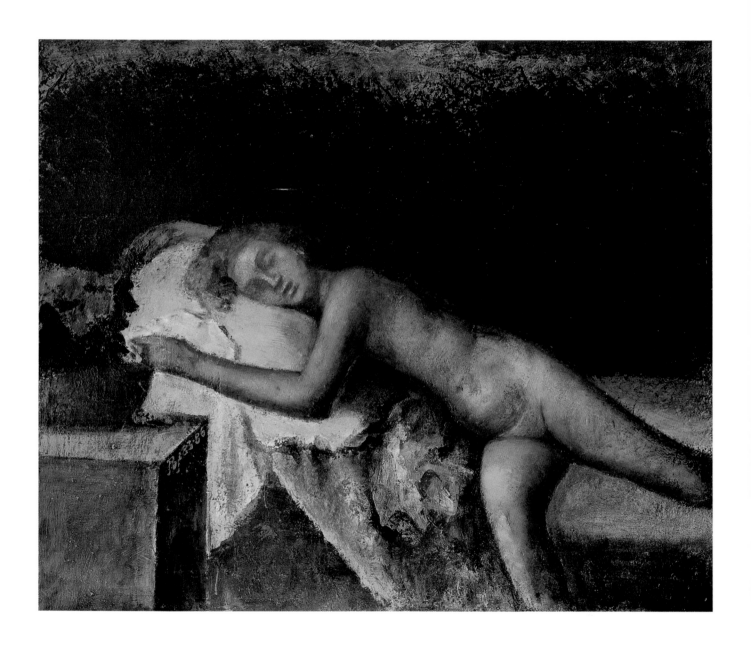

158. *Le Chat au miroir* II, 1986–89 [The Cat with a Mirror II]
159. *Le Chat au miroir* III, 1989–94 [The Cat with a Mirror III]

158.
oil on canvas
200 × 170 cm
monogrammed lower left: "B"
signed on reverse
private collection

provenance: Thomas Ammann
Fine Art A.G., Zurich,
purchased from the artist
exhibitions: Andros 1990,
n. 121; Rome 1990, p. 199;
Rome 1996–97, p. 125
bibliography: Leymarie 1990,
pl. p. 116, and hardback
ed. 1990, pl. 55; catalog London
1994, p. 9; Kisaragi, Takashina,
Motoe 1994, pl. 62; Xing 1995,
pl. 76; Roy 1996, p. 263;
Klossowski 1996, nn. 101,
102, 105; Clair, Monnier 1999,
n. P 347; Vircondelet 2000,
p. 86

159.
oil on canvas
220 × 195 cm
signed and dated lower right:
"Balthus 1989/94"
private collection

provenance: the artist,
represented by The Lefevre
Gallery, London
exhibitions: Lausanne 1993;
Tokyo 1993–94, n. 31;
London 1994; Madrid 1996;
Rome 1996–97, p. 127;
Karuizawa 1997, p. 87
bibliography: Kisaragi,
Takashina, Motoe 1994, cover
and pl. 63; Xing 1995, pl. 77;
Roy 1996, p. 263; Klossowski
1996, nn. 103, 104, 106, 107;
Costantini 1996; Fox Weber
1999, pl. 16; Clair, Monnier
1999, n. P 348; Vircondelet
2000, p. 87

In the late eghties, Balthus's eyesight began
to dim, so he gave up making drawings
for his large pictures. That is why there are
no preparatory studies for the second and third
versions of the *Chat au miroir*. To arrange the
composition of these two paintings, he thought
of using a polaroid camera, that would allow him
to "jot down" with the greatest accuracy
and speed the basic elements he could
then use to work directly on the canvas.
The iconography of the *Chat au miroir* II and III
is quite similar to the first version (cat. 156),
except that the young girl is dressed and seated
on a couch instead of a bed. So the erotic
connotation the first version might have had yields
to the play between the young girl and the cat.
In the *Chat au miroir* II, she is wearing a close-
fitting jersey and holding a book the cat seems to
have interrupted her reading, since she is holding
it part-open with her forefinger slipped between
the pages. In the third version, she is younger than
in the preceding ones, and wearing a school-girl's
smock over an emerald green sweater. Neither
standing nor seated, she rests on a pile of cushions
and it is hard to discern the articulation of her legs
with her torso. Several lines of undecipherable
handwriting are inscribed in turquoise in the
middle of the couch. The composition is more
concentrated and we cannot make out whether
she or the cat is reflected in the mirror.
The background is very elaborately worked, which
reproduction fails to render. It looks like it is
sinking into a sort of slow swirl of which the
epicenter, a "black hole," is located somewhere
between the girl and the mirror. Thus she appears,
with the golden-eyed cat, to be the custodian
of an unknown world, a beyond, of which
the mirror, half-light half-dark, would be
the *open Sesame*. This interpretation that
may be considered personal is partly based
on a conversation with Balthus, in front
of the painting that was not quite finished;
a conversation in which he insisted on the need
to read beyond appearances, to enter into
the depth of the canvas, and was anxious
whether or not he would be able to create
the means to do so.[1]

[1] Rossinière, 4 May 1993.

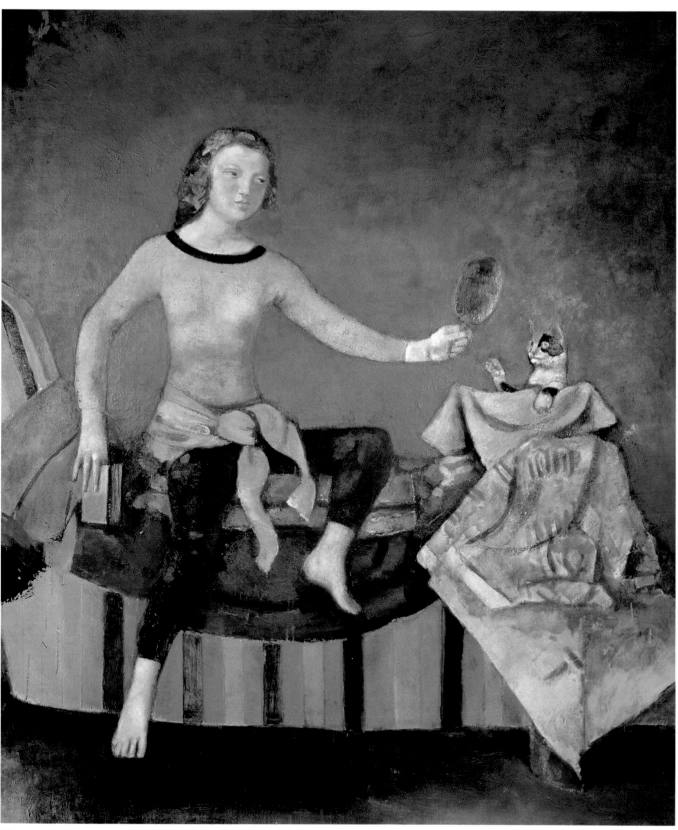

158

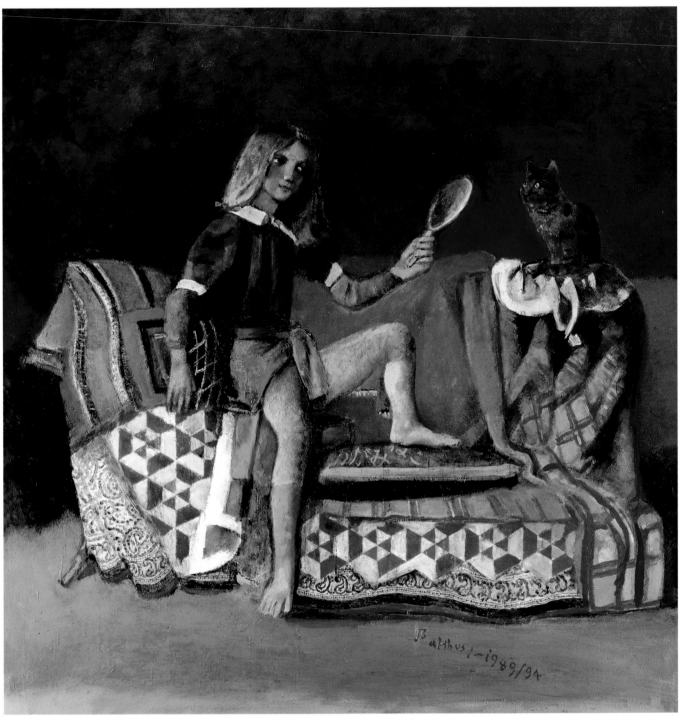

159

160. *Jeune fille à la mandoline*, 2000–01
[Girl with a Mandolin]

oil on canvas
190 × 249.5 cm
Switzerland, private collection

This painting, that is not finished, is the one
Balthus was working on up to his death.
It is shown here for the first time.

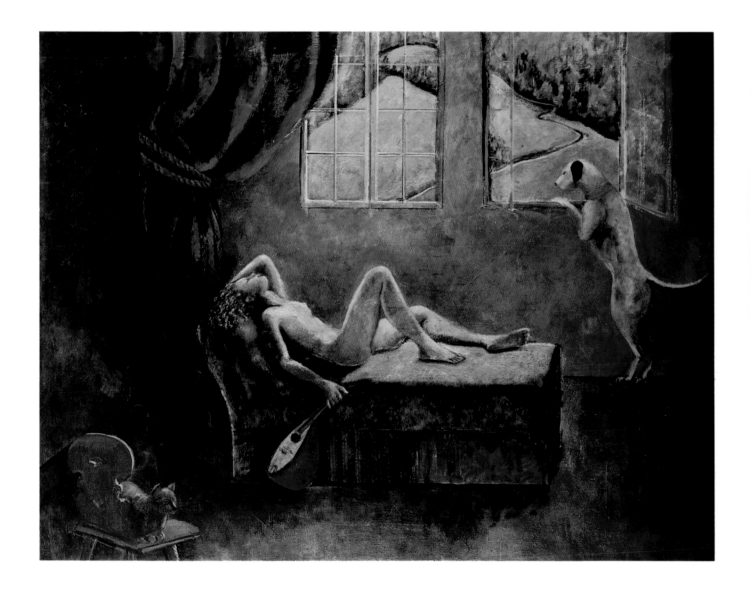

Balthus and the Theater

Balthus' activity as a theater decorator spans over twenty-five years (1934 to 1960), during which, through seven productions, he dealt with the main genres: comedy, tragedy, ballet, opera.

He collaborated with leading directors and authors, in a reciprocal influence allowing his name to be written alongside those of the men who renewed twentieth-century dramatic expression.

Victor Barnowski first of all, who had been, in Berlin, the director of the Kleinestheater (1905), of the Lessingtheater (1913 to 1924), of the Konigsprätzerstrasse and the Komœdienhaus (1925 to 1933), and had contributed to the fame of Wedekind, Shaw, Ibsen and Strindberg. At his request Balthus painted the sets for Shakespeare's comedy *As You Like It* in 1934.

The following year, Antonin Artaud called upon him for *Les Cenci*, an illustration of his theory of the *Theater of Cruelty*. An entirely novel performance, in which sets, costumes, lights, music/sounds and direction had equal parts in the whole, breaking with the nineteenth-century illusionist tradition.

Then came, in 1948, *L'Etat de siège* by Albert Camus, directed by Jean-Louis Barrault on music by Arthur Honegger, a spectacle for which Balthus adopted the idea of built, not painted, sets. The next year, there was *Le Peintre et son modèle*, a ballet by Boris Kochno, Diaghilev's former secretary, on a choreography by Léonide Massine, that with its sparse sets made of a few used props, distanced itself from the tradition of the Ballets Russes.

In 1950 Cassandre called him for Mozart's *Così fan tutte* for the newly-created Aix-en-Provence festival. He created gorgeous sets, painted in acid colors, blending the spirit of the Renaissance with that of the eighteenth century.

For Ugo Betti's *L'Ile des chèvres*, in 1953, he returned to a more austere conception than even the author had imagined, and used, as a backdrop, the bare wall of the stage, soiled with glue and tattered, torn posters. The furniture was reduced to a well and a door.

Last, for Shakespeare's *Julius Caesar*, directed by Jean-Louis Barrult in 1960, he had an architectural set made, inspired by Palladio's Teatro Olimpico of Vicenza, and for the fourth act, by a Piero della Francesca fresco.

We have chosen here to show two entirely different aspects of that activity; on the one hand, a group of studies for the sets and especially for the extremely innovatory costumes of *Les Cenci*; on the other, a series of preparatory gouaches for the sets and costumes of *Così fan tutte*.

These studies, most of which have never been shown, are unique testimonies of the performances for which they were made. Indeed, the set for *Les Cenci* was taken apart in 1934; as for those of *Così*, that form the most important group of painted decors by Balthus, and were used again in Aix in 1956, then in Paris, at the Opéra Comique and the Théâtre Gabriel, they were destroyed in a fire.

Les Cenci
adaptation by Antonin Artaud, after Shelley and Stendhal

Tragedy in 4 acts and 10 scenes
performed at the Folies-Wagram
in Paris from 7 to 21 May 1935
Direction: Antonin Artaud
Music: Roger Desormière
Sets and costumes: Balthus
Leading roles: Antonin Artaud
(F. Cenci), Iya Abdy (Béatrice),
Cécile Bressant (Lucretia),
Pierre Asso (Orsino),
Jean Mamy (Camillo),
Julien Bertheau (Giacomo),
Carlo Naal (Andrea),
Yves Forget (Bernardo)

Artaud drew his tragedy *Les Cenci* from two
nineteenth-century texts: a drama by Shelley
(1819), based on a sixteenth-century manuscript
written at the time of Beatrice Cenci's torture,
and found in the archives of Palazzo Cenci
in Rome, and the translation of that same
manuscript by Stendhal, appearing in 1837
in the *Revue des Deux Mondes* and later included
in his *Italian Chroniques*.

Artaud took several liberties with these sources,
but kept to the gist of them. Francesco Cenci, a
notorious non-believer, sodomite and condemned
as such more than once, had from a first marriage
seven children whom he loathed. To some degree
guilty of the death of two of his sons, he had
furthermore raped his youngest daughter,
Beatrice, when she was sixteen. His second wife,
Lucrezia, whom he held in contempt, was unable
to check the spiral of violence devastating the
family. Cenci died murdered by two of his
vassals, with the help of his daughter Beatrice,
who was sentenced to the wheel.

Artaud makes Beatrice the mind behind the
crime, adding parricide to incest and revenge,
thus converging with the great Greek myths.

"It is because Les Cenci is a Myth that this
subject, transposed to the theater, has become
a tragedy.

I am saying tragedy and not drama; for here
men are more than men, if they are not yet gods.
Neither innocent nor guilty, they submit
to the same fundamental amorality as those gods
of the ancient Mysteries whence all tragedy
arose."[1]

"I accept the crime, but deny the guilt," Beatrice
claims, refusing to sign the statement presented
to her.[2]

Antonin Artaud placed the action of his tragedy
in various parts of palazzo Cenci in Rome:
in "a deep, winding gallery" (act I, scene 1);
in the garden, bordered on the right by the
gallery (act I, scene 2); in a hall that "more or less
recalls the Noces de Cana ("by Veronese"

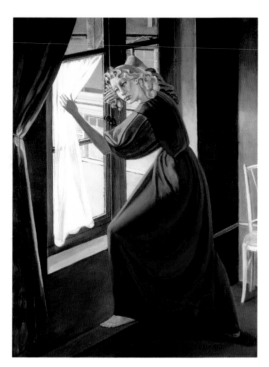

1. Balthus, *Lady Abdy*, 1935,
oil on canvas, 186 × 140 cm.
Private collection

the manuscript specifies[3]), but far more barbaric"
(act I, scene 3); in a room with a large bed
(act II, scene 1); in "an unspecified place.
Heath, hallway, staircase, or whatever you like"
(act II, scene 2 and following).

For the final scene, he writes: "On the ceiling
of the theater, a wheel goes round, as though
on an axis passing through its diameter. Beatrice,
hanging by her hair and pushed by a guard
pulling her arms backward, walks along the axis
of the wheel. At every two or three steps she
takes, a scream rises, with the sound of a winch,
a wheel being turned or beams being torn apart."
Balthus imagined a set "built like a huge ruin,
with its scaffoldings and their draped canvas
sheets replacing friezes;" "a set as though
for ghosts, grandiose like a ruin in a dream
or like an outsized ladder"[4]. He represented
a hall of the Cenci palace framed by matching
pillars, columns and architectural elements.
On the right side of the stage there was an arch
of triumph topped by a gigantic helmet, drawn
from Piranese. Behind the palace, you could
glimpse a Roman temple with its pediment,
with a scaffolding made of beams bound
with ropes looming over it (fig. 2).

For the final scene, the set was partly masked
by an enormous painted canvas figuring a wall
with blind windows in front of which was placed
the torture wheel to which Beatrice Cenci
was bound (fig. 3).

The direction, the rhythm, now accelerated,
now suspended, the actors' movements drawing
symbolic circles in space, the lights, the sound
illustration, inspired by the Tibetan *Book*

2. *Les Cenci*, act I, scene 3

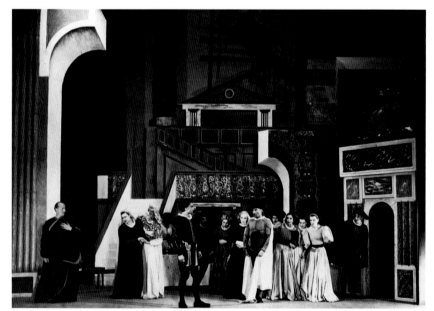

3. *Les Cenci*, act IV, scene 3

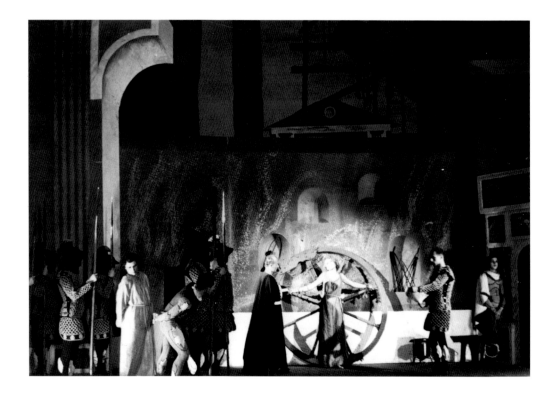

of the Dead, were all essential to the performance[5]. The colors were no less relevant: "[…] And the young painter Balthus, one of the strongest personalities of his generation, who admirably knows the symbolism of forms like those of colors, green the color of death, yellow the color of violent death, used that symbolism for the choice of costumes and to design magnificent sets…"[6]. Thus, Iya Abdy, who had commissioned the play and played the part of Beatrice Cenci, was dressed either in red, as in the large portrait Balthus painted of her in the same period (fig. 1), or in black as in the scene where she sends the murderers to kill her father (cat. 165). The men's costumes were even more innovatory. Drawing his inspiration from sculptures of *écorchés*, Balthus asked Mme. Karenska to embroider on the leotards lines suggesting the pectoral muscles, the abdomen, and even, for count Cenci's, a sort of red trachea suggesting breath and the vital flow (cat. 169).

Giacomo's had patches on the legs that looked like torn bits of skin (cat. 167).
Financially the play was a failure, and only fourteen performances were held.
Nonetheless, it had a significant impact on theater professionals, especially Jean-Louis Barrault who, fourteen years later, called upon Balthus to design the set for Albert Camus's *L'Etat de siège*, a set that somewhat recalls the one for *Les Cenci*.

[1] A. Artaud, "Ce que sera la tragédie Les Cenci aux Folies-Wagram," *Le Figaro*, Paris, 5 May 1935.
[2] Act IV, scene 3.
[3] A. Artaud, *Œuvres Complètes*, Gallimard, Paris 1978, p. 340, note 1.
[4] Quoted by F. de Mèredieu, "Peinture et mise en scene, Artaud Balthus," *Cahiers du Musée National d'art moderne, 12,* 1983, pp. 216–23.
[5] See S. Colle-Lorant, "Balthus décorateur de théâtre," in *Balthus*, exhibition catalog, Paris 1983, pp. 314–27.
[6] A. Artaud, "Les Cenci," *Comœdia,* Paris, 6 May 1935.

161. *Etude pour l'acte I, scène 3 ("Maintenant, dehors tout le monde,*
je veux rester seul avec celle-ci")
[Study for Act I, Scene 3 ("Now, everybody out, I want to be left alone with her")]

India ink on paper
30.5 × 31.8 cm
signed and inscribed lower left:
"Balthus les Cenci"
private collection

provenance: Pierre Matisse,
New York
exhibitions: Spoleto 1982, n. 30;
Paris, MNAM.CNACGP 1983–84,
n. 72; Kyoto 1984, n. 36;
Andros 1990, n. 25; Rome 1990,
p. 78; Bern 1994, n. 21
bibliography: catalog New York
1984, p. 35 fig. 49; catalog
Madrid 1996, p. 29; Clair,
Monnier 1999, n. T 1609

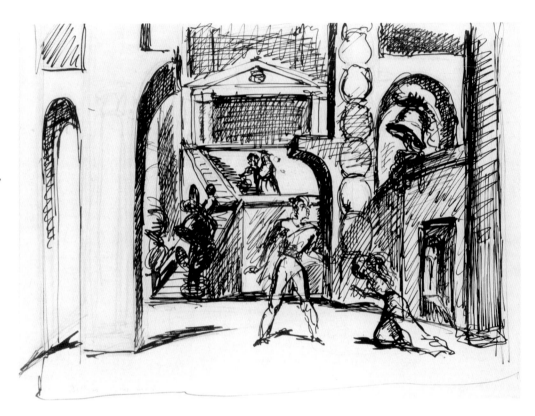

162. *Etude pour le costume de Beatrice Cenci* [Study for the Costume of Béatrice Cenci]
163. *Etude pour le costume de Beatrice Cenci* [Study for the Costume of Béatrice Cenci]
164. *Etude pour le costume de Beatrice Cenci* [Study for the Costume of Béatrice Cenci]
165. *Etude pour le costume de Beatrice Cenci* [Study for the Costume of Béatrice Cenci]

162.
India ink, water color
and wash on paper
29.5 × 19.3 cm
private collection

provenance: Iya Abdy
bibliography: Clair,
Monnier 1999, n. T 1615

163.
India ink, water color
and wash on paper
29.8 × 18.7 cm
private collection

provenance: Iya Abdy
bibliography: Clair,
Monnier 1999, n. T 1616

164.
India ink, water color
and wash on paper
30.5 × 19 cm
private collection

provenance: Iya Abdy
bibliography: Clair,
Monnier 1999, n. T 1617

165.
India ink, water color
and wash on paper
30.5 × 18.7 cm
private collection

provenance: Iya Abdy
bibliography: Clair,
Monnier 1999, n. T 1618

162

163

164

165

166. *Etude pour le costume de Lucretia Cenci* [Study for the Costume of Lucretia Cenci]
167. *Etude pour le costume de Giacomo Cenci* [Study for the Costume of Giacomo Cenci]
168. *Etude pour le costume de Bernardo Cenci* [Study for the Costume of Bernardo Cenci]
169. *Etude de costume masculin (comte Cenci)* [Study for Male Costume (Count Cenci)]

166.
India ink and wash on paper
20 × 16.5 cm
private collection

provenance: Iya Abdy
bibliography: Clair,
Monnier 1999, n. T 1619

167.
India ink, water color
and wash on paper
30.5 × 18.5 cm
inscribed lower center:
"Giacomo Cenci"
private collection

provenance: Iya Abdy
bibliography: Clair,
Monnier 1999, n. T 1620

168.
India ink, water color
and wash on paper
30.5 × 18.7cm
inscribed lower center:
"Bernardo Cenci"
private collection

provenance: Iya Abdy
bibliography: Clair,
Monnier 1999, n. T 1621

169.
India ink, water color
and wash on paper
29.8 × 18.7 cm
private collection

provenance: Iya Abdy
bibliography: Clair,
Monnier 1999, n. T 1622

166

167

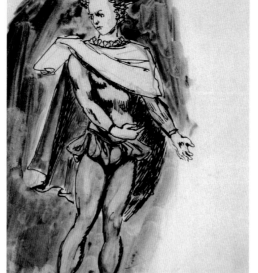

168

169

170. *Etude de costume masculin* [Study for Male Costume]
171. *Trois études de costume masculin* [Three Studies for Male Costumes]

170.
India ink and wash on paper
29.2 × 18.5 cm
private collection

provenance: Iya Abdy
bibliography: Clair,
Monnier 1999, n. T 1623

171.
India ink, wash and pencil
on paper
29.5 × 18.7 cm
private collection

provenance: Iya Abdy
bibliography: Clair,
Monnier 1999, n. T 1624

170

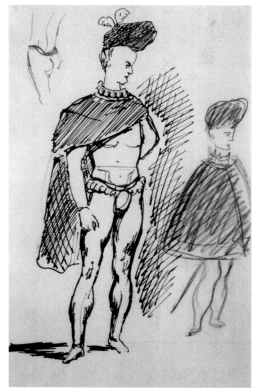

171

Così fan tutte

Wolfgang-Amadeus Mozart
Libretto: Lorenzo da Ponte
Comic opera in two acts
presented at the 3rd Festival
of Aix-en-Provence in July 1950
Director: Jean Meyer
Music director: Hans Rosbaud
Sets and costumes: Balthus
Leading roles: Suzanne Danco
(Fiordiligi), Eugenia Zareska
(Dorabella), Emmy Loose
(Despina), Leopold Simoneau
(Ferrando), Renato Capecchi
(Gugliemo), Marcello Cortis
(Don Alfonso)

We are familiar with the very flimsy plot Mozart's
opera is built around. Ferrando and Guglielmo,
urged by the cynical don Alfonso, decide to put
their beloveds, Fiordiligi and Dorabella,
to the test. They pretend to go away to war,
disguise themselves as Albanian noblemen
and return to each woo the other's intended.
Of course, the two sisters surrender, a mock-
wedding is signed in front of the chamber-maid
disguised as a notary, just before the two youths
remove their disguise to confound them.
So, it was on letting himself be carried away
by the music, that he tirelessly listened to
for months, that Balthus imagined his sets.
"It is the set of the mood of Così fan tutte"
Jouve would write.[1] A dreamlike mood where
the masquerade blends with the improbabilities
of the libretto. "Pale blue, antique green, silver
or old gold braid" are the indications Balthus
wrote on the costume designs. Costumes attuned
to the sparkling colors of the sets, that accompany
the music: slightly acid and merry, in harmonies
of pink and orange and dark purple for the
interiors, blue and dark green for the gardens.
The specific nature of the Aix outdoor theater,
shallow, very wide and rather high, imposed
constraints that Cassandre, who had designed
it the year before for Don Giovanni, for which
he created the sets and costumes, had defined
"omission of built volumes or partly designed
in trompe-l'œil, swiftly converging linear
perspective, monumentality matching
that of the archbishopric courtyard."[2]
Balthus, Jouve says, "closely followed A.M.
Cassandre's monumental décor for Don Giovanni,
in a totally opposite figuration." In fact he chose
to emphasize the illusionist aspect of the comic
opera by playing with perspective, but also by
making up props: painted figures, mirrors, statues,
even the fantastic sphinx of act II scene 2,
contributed to the magic, to the variations
on the theme of the doubling of the protagonists,
of the delusion of love and death, of pretense
(masquerades, mock suicides, etc.) Balthus
painted four backdrops and four sets
that, combined one with another, allowed
to suggest the eight different spaces in which
the action takes place. They also allowed to play
on the inside/outside opposition and alternation:
thus in the first scene you had a glimpse
of the Bay of Naples through the arches
of the café, the bay in front of which, unlike
in the libretto indications, the scene
of the mock-wedding took place.

[1] Così fan tutte ou le changement des objets, program of
the 3rd International music Festival of Aix-en-Provence,
1950, reprinted under the title "Ironie de Così fan
tutte," En miroir, Paris, Mercure de France, 1952,
pp. 192–200 and Balthus, exhibition catalog, Paris 1983,
pp. 60–62.
[2] Le théâtre en plein air au Festival international de
musique d'Aix-en-Provence, René Kister, Genève 1957.

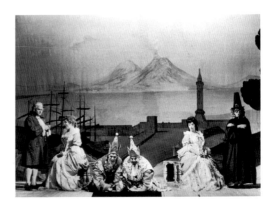

3. Così fan tutte, "The Nuptials,"
act II, scene 4

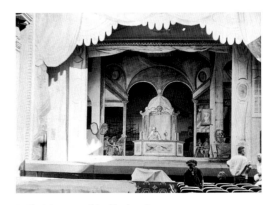

2. Così fan tutte, "An Enchanting
Little Garden," act I, scene 4

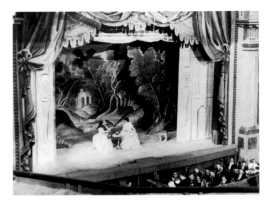

1. Così fan tutte, "A Café
in Naples," act I, scene 1

172. *Etude pour le décor de l'acte I, scène 1 (Un café à Naples)*
[Study for the Set of Act I, Scene 1(A Café in Naples)]

gouache
36 × 64 cm
private collection

provenance: the artist
bibliography: catalog
MNAM.CNACGP, Paris 1983,
p. 322; Clair, Monnier 1999,
n. T 1647

The tavern owner and the customers seated
at the tables were painted on the canvas.
Notice, on the left, a standing figure, leaning
on the column, who seems to be gazing
at the landscape of the bay that appeared
on the backdrop. Sylvia Colle-Lorant compared
the round face, haloed and winged, topping
the pavilion, to the drawing of the table
 in Hogarth's *A Reception at Sir Richard
and Lady Child's*.[1]

[1] *Balthus décorateur de théâtre*, exhibition catalog,
Paris 1983, pp. 314-327.

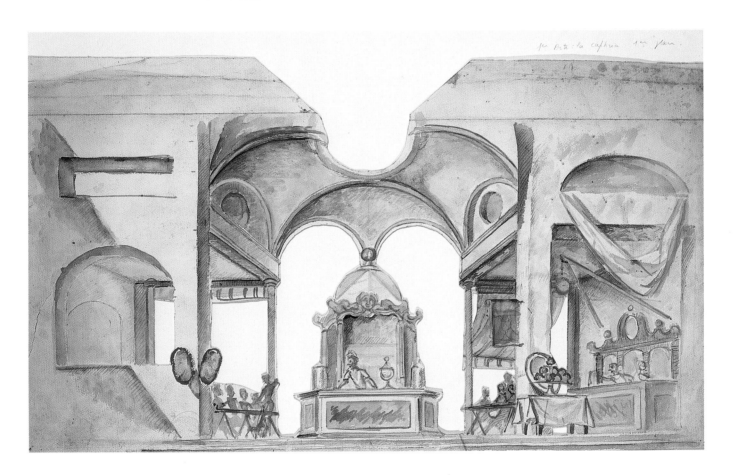

173. *Etude pour la toile de fond des acte I, scène 1 et acte II, scène 4 (La baie de Naples)*
[Study for the Backdrop of Act I, Scene 1 and Act II, Scene 4 (The Bay of Naples)]
174. *Etude pour la toile de fond des acte I, scène 1 et acte II, scène 4 (La baie de Naples)*
[Study for the Backdrop of Act I, Scene 1 and Act II, Scene 4 (The Bay of Naples)]

173.
gouache and pencil on paper
49 × 64 cm
private collection

provenance: the artist
bibliography: catalog
MNAM.CNACGP, Paris 1983,
p. 321; Clair, Monnier 1999,
n. 1681

174.
gouache and pencil on paper
18 × 54 cm
private collection

provenance: the artist
bibliography: catalog
MNAM.CNACGP, Paris 1983,
p. 321; Clair, Monnier 1999,
n. 1682

The landscape that we glimpsed
in the first scene, in the
background, was entirely
revealed in the final scene
of the opera.

173

174

175. *Projet pour le décor de l'acte I, scène 2 (Un jardin près d'une plage)*
[Design for the Set of Act I, Scene 2 (A Garden by the Seashore)]

water color
36 × 54 cm
monogrammed lower right:
"Bs"
Sandro Manzo, New York

provenance: sale Kandterer,
Munich, 26 November 1979,
n. 72
exhibitions: Spoleto 1982, n. 46;
Andros 1990, n. 46;
Rome 1990, p. 96
bibliography: Clair,
Monnier 1999, n. 1657

This design, of which there are four versions,
led to the backdrop that was drawn for Ferrando
and Gugliemo's departure scene. As the military
march rang out, you could see, between the
garden and the sea, two groups of pasteboard
infantrymen passing by, preceded by their colonel
on horseback.

176.
water color and pencil on paper
32.5 × 54 cm
private collection

provenance: the artist
bibliography: Roy 1996, p. 216;
Clair, Monnier 1999, n. 1660

177.
gouache on paper
34.5 × 53 cm
private collection

provenance: the artist
bibliography: catalog
MNAM.CNACGP, Paris 1983,
p. 322; Clair, Monnier 1999,
n. T 1663

176. *Etude pour le décor des acte* I,
scène 3 et acte II, *scènes 1 et 3*
[Study for the Set of Act I, Scene 3
and Act II, scenes 1 and 3]

This set, that we recognize in the two following
water colors, was in the foreground of two
different backdrops, respectively representing
the two sisters' boudoir and bedroom. The large
curved arch, resting on the carved double pillars,
the balusters, the sculptures, are drawn
from Renaissance palaces.

177. *Etude pour la toile de fond de l'acte* I,
scène 3 (Le boudoir des deux sœurs)
[Study for the Backdrop of Act I, Scene 3
(The Two Sisters' Boudoir)]

There are two studies conserved for this
backdrop, of which this one is the final version.
Although it shows the two sisters' private
apartment, notice that the room appears
to be open onto the sky, like an inner courtyard.

176

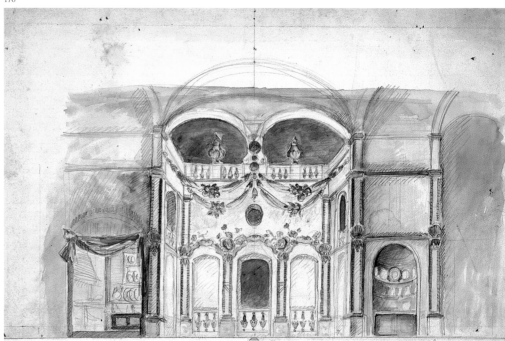

177

178. *Etude pour le décor et la toile de fond de l'acte II, scènes 1 et 3 (La chambre des deux sœurs)* [Study for the Set and Backdrop of Act II, Scenes 1 and 3 (The Two Sisters' Bedroom)]

This study, that is the final version for two scenes of the second act, combines a Renaissance architecture with eighteenth-century furnishings. The symmetrical arrangement of the consoles, the mirrors and the doors, is meant to suggest the hesitations, the comings and goings of the two sisters before their Albanian suitors whose cause Despina, the chambermaid, defends.

179. *Etude pour la toile de fond des acte I, scène 4 et acte II, scène 2 (Un jardin)* [Study for the Backdrop of act I, Scene 4 and Act II, Scene 2 (A Garden)]

The vale that is painted here looks more like English eighteenth-century parks than Renaissance ones; the small pavilion you can glimpse among the pines, the ruin standing out against the sky recall Watteau's landscapes. It was in the midst of this recreated nature that would appear, like an invitation to a dream, the large boat adorned with a monumental sphinx, carrying the "Albanian noblemen."

178.
gouache and pencil on paper
32.5 × 53.5 cm
private collection

provenance: the artist
bibliography: catalog
MNAM.CNACGP, Paris 1983,
p. 322; Clair, Monnier 1999,
n. T 1665

179.
gouache on paper
36.5 × 52.5 cm
monogrammed and dated
upper right: "Bs 1949–50"
Roland Dumas
inscribed left: "commencer au droit du trait" and, not autograph: "trait"

provenance: the artist
bibliography: Clair,
Monnier 1999, n. T 1672

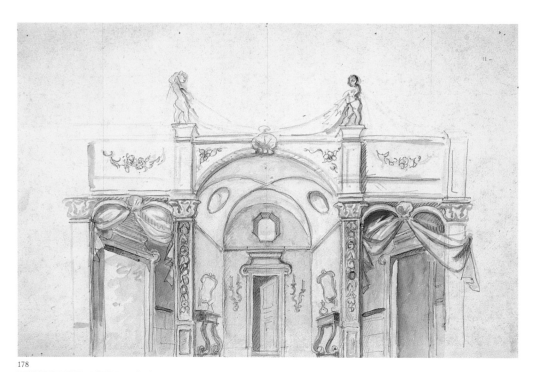

178

179

180. *Etude de costume masculin, un soldat*
[Study for a Male Costume, a Soldier]

181. *Etude de costume masculin,
seigneur albanais*
[Study for a Male Costume,
Albanian Nobleman]

180.
gouache and pencil on paper
27 × 18.5 cm
inscribed upper right: "soldat"
and lower right:
"Capecchi/Simoneau"
private collection

provenance: the artist
bibliography: Clair,
Monnier 1999, n. T 1693

181.
water color and pencil on paper
27.3 × 22.7 cm
inscribed lower right:
"Déguisement Ferrando;"
upper right, not autograph:
"passementerie or cordon
et gland;" slightly lower:
"passementerie argent"
private collection

provenance: the artist
bibliography: Clair, Monnier
1999, n. T 1697

It is in the studies for costumes that we can best grasp all the imagination and the sense of humor Balthus wanted to communicate. Thus in this caricature of a soldier, "champion of Mars and Venus," as don Alfonso sings, strutting forward, his shoulders thrown back, his muscles tensed, strapped in his dazzling uniform.
The names written at the bottom of the page are those of the singers who played the parts of Gugliemo and Ferrando.

The unlikely headdress and the huge moustache of Ferrando masquerading as an Albanian nobleman remind us of the eighteenth-century fondness for *turqueries*. "I wonder what they are—Wallachians or Turks," Despina sings on seeing Ferrando and Gugliemo in disguise.

180

181

182. *Quatre études de costumes*
[Four Studies for Costumes]

gouache and water color
on paper
26.5 × 18 cm
inscriptions (not autograph),
above: "rose et bleu. jaune et
mauve. passementerie orange"
below: "1, 2 5,6"
private collection

provenance: the artist
bibliography: Clair,
Monnier 1999, n. T 1699

This fantasy relates to the final scene of the opera,
in which the notary Beccavivi (Despina in
disguise) presents the wedding contract
to the two young girls "with the usual notarial
dignity,"under don Alfonso's impassive gaze.

183. *Etude pour le costume de don Alfonso*
[Study for the Costume of Don Alfonso]

184. *Etudes pour le costume de don Alfonso*
[Studies for the Costume of Don Alfonso]

183.
water color on paper
23 × 37cm
recto of cat. 184
private collection

provenance: the artist
bibliography: Roy 1996, p. 215;
Clair, Monnier 1999, n. T 1700

184.
gouache and pencil on paper
verso of cat. 183
inscribed upper right:
"Don Alfonso (Cortis)"
and not autograph upper left:
"tricorne classique petit.
veste violet gris. gilet vieux
rouge. culotte vieux rouge
violacé ou même violet que
la veste. perruque.
Compter 2 en plus. Chemise"

bibliography: Clair, Monnier
1999, n. T 1701

A cynical old gentleman, Don Alfonso is shown
here as a podgy, potbellied little old man,
with legs deformed by the gout, a ridiculous wig,
a caricature of Don Juan or Casanova
that Lorenzo Da Ponte, Mozart's librettist
had known in Venice.

183

184

185. *Etude de costume de valet*
[Study for a Servant's Costume]

gouache and water color
on paper
26 × 19.5 cm
inscribed lower right:
"4 valets"
private collection

provenance: the artist
bibliography: Roy 1996, p. 215;
Clair, Monnier 1999, n. T 1703

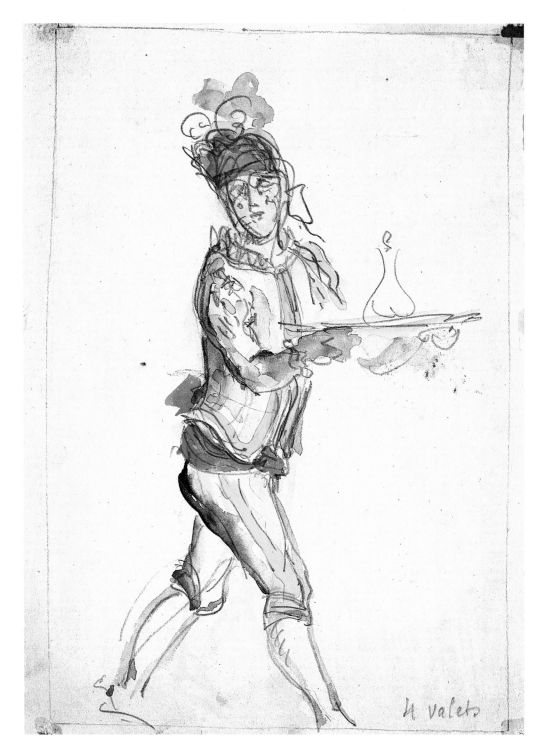

Croquetons

The drawings assembled in this section were discovered in the course of our inquiries addressed to collectors or in auction catalogues, but of course there are many others. Snatches of conversations, jokes, meals shared with other artists, they illustrate a minor aspect of Balthus's work, yet an unfamiliar one reflecting a sense of humour and informality.

186. *L'Avaleur de cigarettes*, 1928
[The Man who Swallows Cigarettes]

India ink on fine paper
monogrammed and dated
lower right: "Bs 1928"
22.5 × 18.5 cm
private collection

This drawing, recently unearthed, had given
several lithographic editions, one of which was
published in its place and time in the *Catalogue
raisonné de l'œuvre complet*.[1] With Balthus's
agreement, it had been dated to the years
1936–37. The discovery of the original drawing
allows to date it to about ten years earlier.
The subject remains enigmatic; it might be
a fair tumbler's act, rather rarely performed
but popular between the two wars.

[1] Under the title *Le Nain* [The Dwarf], Clair, Monnier
1999, n. Cr 1721. Two lithographic editions are
mentioned in it. Two other ones, smaller and more
recent (*Guilde de la Gravure*, 57 × 38 cm, and
38.1 × 23.5 cm, toward 1960) recently appeared
on the market (Christies, New York, 31 October 2000,
n. 312 and London, 1st December 2000, n. 7).

187. *Le Chat botté* [Puss-in-boots]
188. Projet pour *"Le Chat botté,"* 1975–76 [Sketch for "Puss-in-boots"]

187.
pencil on paper
30 × 22 cm
monogrammed lower right:
"Bs"
Edmonde Charles-Roux
Defferre

provenance: from the artist
bibliography: Clair,
Monnier 1999, n. T 1712

188.
pencil on blue writing-paper
21 × 22.7 cm
monogrammed and dated
lower right: "Bs 1970?"
Switzerland, private collection

exhibitions: Rome 1996–97,
p. 172; Karuizawa 1997, p. 102;
Zurich 1999, n. 37
bibliography: Faye 1998, p. 110;
Clair, Monnier 1999, n. T 1713;
Vircondelet 2000, p. 98

This drawing was made for the cover
of the program of the ballet *Le Chat botté*
(inspired by Charles Perrault's fairy tale) staged
by the Compagnie Roland Petit, its première
being held at Marseilles on 21 November 1981.
The Marseilles soap firm Le Chat had financially
backed the Compagnie, which explains
the iconography of the sketch.
The sketch (cat. 188) was drawn on the back
of a draft of a letter to the owner of the final
drawing, and dated September 1975. So it would
appear it took several years to succeed in putting
on the ballet. A span of time Balthus used
to revise the image he had been asked for. The cat
that at first was seen three-quarters right, is now
nearly frontal. He is wearing an open-neck shirt
and has a human hand. He is holding between
his thumb and forefinger the tube with the soap
bubble hanging on the end, resting the tip on his
three other closed fingers. The dish of soapy water
is turned into a bowl decorated with a rim
on the upper part. All these elements are inspired
by a painting by Manet, titled *Soap Bubbles*,
of which, not having seen it, Balthus at least could
have had on hand a reproduction.[1]

[1] Since 1934 the painting has been in the Calouste
Gulbenkian collection, at Lisbon, but it was published
in 1975 by D. Rouart and D. Wildenstein, *Edouard
Manet. Catalogue raisonné*, n. 129.

187

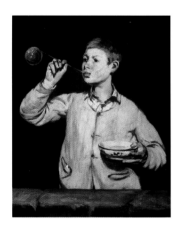

1. Edouard Manet, *Soap Bubbles*,
Lisbon, Calouste Collection,
Gulbenkian Foundation

188

189. *Portrait présumé de Georges Hugnet*, 1948–49 [Presumed Portrait of Georges Hugnet]
190. *Portrait de Dora Maar*, 1948–49 [Portrait of Dora Maar]
191. *Portrait-charge de Léonor Fini*, 1948–49 [Caricature of Léonor Fini]

189.
pencil on a piece of paper
tablecloth of the restaurant
Le Catalan
12 × 11 cm
René and Rodney Chichignoud

provenance: Dora Maar;
sale PIASA, Paris, 26 May 1999,
n. 27
bibliography: Clair,
Monnier 1999, n. 1759

190.
pencil on a piece of paper
tablecloth of the restaurant
Le Catalan
21 × 25 cm
René and Rodney Chichignoud

provenance: Dora Maar;
sale PIASA, Paris, 26 May 1999,
n. 27
bibliography: Clair,
Monnier 1999, n. 1763

191.
pencil on a piece of paper
tablecloth of the restaurant
Le Catalan
24 × 17.5 cm
inscription (not autograph)
lower right: "Léonor Fini
par Balthus"
René and Rodney Chichignoud

provenance: Dora Maar;
sale PIASA, Paris, 26 May 1999,
n. 27
bibliography: Clair,
Monnier 1999, n. 1754

Up until we were married in April 1950, every time I spent the evening with him—before going home to my parents—my future husband, Georges Hugnet,[1] would take me to dinner at the Catalan, a restaurant in the Rue des Grands-Augustins where he dined nearly every evening. We were rarely by ourselves, his friends knowing they could find him there would join us at our table, including Balthus, who came over from the nearby Cour de Rohan where he had his studio, and Dora Maar who was a neighbor, from the Rue de Savoie where she lived. Balthus would arrive late, tall, slim, already nearly old—to the very young girl I was—, a long overcoat, a cane, tired, rubbing his eyes with a weary gesture, and coming to join us at our table with an "Ah! My poor children." And there was no one more elegant, more aristocratic than he. At the time, the end of 1949, he was working on the sets of Così fan tutte for the Festival of Aix. Dora would arrive even later, lively, dark, carrying a long cigarette-holder, and before sitting down, advising the maître d'hôtel: "Pierre, coffee, I've already dined."
Quite often the four of us would have dinner together. And while we were talking, between courses, pencils and pens were brought out nearly automatically, and the attraction of the paper tablecloth was such that drawings, portraits, often caricatures, and poems would naturally come and be inscribed there, between the plates, the glasses that had to be pushed aside, moved, to leave room for a line to take off. The magic of the paper tablecloth.
Everyone succombed to it. Most of the time Balthus used a very hard lead pencil, sometimes a kind of charcoal, or else a fountain pen.
He seemed very much alone. I cannot remember hearing him mention his sons. Occasionally he would come with a very young girl—18 years old, I think, my age—who posed for him. She was Laurence Bataille.
Balthus often expressed the desire for me to pose with her, but it never happened, my future husband having turned a deaf ear to the suggestion. He probably was afraid I might be shocked. Today I immensely regret it. I would have known his studio, the way he worked. And I am sure that that painter of immodesty was the most modest man in the world. I can add to the recollection I have of him an impression of great reserve. But my future husband probably had his reasons.

It was just a couple of months before our marriage, planned for April 1950.
Preparations were in full sway, even moreso since Marie-Laure de Noailles had decided to hold a great reception in her hôtel of the Place des Etats-Unis in honor of the union between the Poet and the Maiden.
Much to my distress, a member of the family—whom I was told would not attend the wedding—refused to be witness. Spontaneously Balthus said to me: "I shall be witness." So our witnesses were Marie-Laure, Jean Cocteau, Paul Eluard and Balthazar Michel count Klossowski de Rola called Balthus. For the record I should say that Paul Eluard did not act as witness. Called to Prague for I do not know what honors, he chose to follow Party orders rather than staying to honor a friend. My husband never forgave him. As for me I shall never forget the gift Balthus gave me that day. Then came the portrait of Claude Hersant—later become Hersaint—. The sitting lasted over two years. It was a very handsome portrait, without flattery, of which we were invited to the "opening" on the occasion of a reception at the Tour de Villebon, a splendid estate belonging to the Hugo family, where Claude Hersant and his first wife Hélène lived.
Then there was Villa Medici, Balthus's last residence in my husband's address book.
Later on, it became more and more difficult to get in touch with him. Probably at his own request, you had to go through Henriette Gomès, his faithful dealer, who passed on to him his mail and messages.
My husband never saw him again. Nor did I.

Myrtille Hugnet
March 2001

[1] Georges Hugnet (1906–74) met, in the early twenties, Max Jacob who was the first illustrator of his poems and introduced him to Cocteau, Picasso, Desnos, Duchamp, Salmon, Man Ray, Tzara, Zadkine, Sauguet, Miró, Max Ernst, Calder... He began to draw in 1926, founding, three years later, the Editions de La Montagne that published, in particular, Gertrude Stein. While he was working on an important study on the Dada movement, he was introduced to André Breton and joined, in 1932, the Surrealist group. It was heading a delegation of that group that he went to Balthus's studio at the end of 1933, on the eve of an exhibition organized by the Galerie Pierre. Balthus' painting disappointed them because it was "figurative." Hugnet left the Surrealist group in 1939.

189

190

191

192. *Pierre Jean Jouve et* L'Enjambement, *1948–49*
193. *Illustration caricaturale de* L'Enjambement *de Pierre Jean Jouve, 1948–49*
194. *Illustration caricaturale de* L'Enjambement *de Pierre Jean Jouve, 1948–49*

192.
pencil on a piece of paper
tablecloth of the restaurant
Le Catalan
21.5 × 17 cm
Barrie and Emmanuel Ramon

provenance: Dora Maar;
sale PIASA, Paris, 26 May 1999,
n. 28
bibliography: Clair,
Monnier 1999, n. 1770

193.
ink on a piece of paper
tablecloth of the restaurant
Le Catalan
17 × 16 cm
Barrie and Emmanuel Ramon

provenance: Dora Maar;
sale PIASA, Paris, 26 May 1999,
n. 28
bibliography: Clair,
Monnier 1999, n. 1771

194.
pencil on a piece of paper
tablecloth of the restaurant
Le Catalan
7 × 9 cm
Barrie and Emmanuel Ramon

provenance: Dora Maar;
sale PIASA, Paris, 26 May 1999,
n. 28
bibliography: Clair,
Monnier 1999, n. 1772

The drawing owes its name to the note found
with it in Dora Maar's papers and that bears
an inscription in her handwriting: "P.J. Jouve.
et l'Enjambement/Dessin de Balthus./Diners
du Catalan." The bald man with the oval skull
and the cane caricatured here is Jouve himself.
L'enjambement does not refer to any of his works.
It could be the echo of a conversation held
at the Catalan. We have linked up the drawing
with the two following caricatures that have
the same theme.

192

193

194

195. *Portrait-charge d'un homme âgé,*
1948–49
[Caricature of an Old Man]

196. *Portrait-charge d'homme*
en costume de nain, 1948–49
[Caricature of a Man in a Dwarf Costume]

195.
pencil on a piece of paper
tablecloth of the restaurant
Le Catalan
14.5 × 8.5 cm
René and Rodney Chichignoud

provenance: Dora Maar;
sale PIASA, Paris, 26 May 1999,
n. 27
bibliography: Clair,
Monnier 1999, n. 1756

196.
pencil on a piece of paper
tablecloth of the restaurant
Le Catalan
12.5 × 10 cm
René and Rodney Chichignoud

provenance: Dora Maar;
sale PIASA, Paris, 26 May 1999,
n. 27
bibliography: Clair,
Monnier 1999, n. 1757

195

196

197. *Portrait-charge d'un homme le torse nu,*
1948–49
[Caricature of a Bare-chested Man]

198. *Etude de chat*, 1949
[Study of a Cat]

197.
pencil on a piece of paper
tablecloth of the restaurant
Le Catalan
10 × 18 cm
René and Rodney Chichignoud

provenance: Dora Maar;
sale PIASA, Paris, 26 May 1999,
n. 27
bibliography: Clair,
Monnier 1999, n. 1758

198.
pencil on a piece of paper
tablecloth of the restaurant
Le Catalan
9 × 18.2 cm
René and Rodney Chichignoud

provenance: Dora Maar;
sale PIASA, Paris, 26 May 1999,
n. 27
bibliography: Clair,
Monnier 1999, n. 1768

197

198

199. *Neuf dessins "pour amuser Harumi,"*
1976–77
[Nine Drawings "To Entertain Harumi"]

200. *Lapin chasseur*
[Hunter Rabbit]

199.
pencil, felt-tip pens
and colored pencils on paper
the series: 45 × 56 cm
Switzerland, private collection

provenance: the artist
bibliography: Clair, Monnier
1999, n. Cr 1810; Vircondelet
2000, p. 99

200.
Ink on squared paper
20 × 31 cm
dedicated and monogrammed
upper right: "Harumi chian
no tameni Bs"
[for Harumi darling]
Switzerland, private collection

provenance: the artist
exhibitions: Rome 1996–97,
p. 172; Karuizawa 1997, p. 102
bibliography: Faye 1998, p. 126;
Clair, Monnier 1999, n. Cr 1811

Balthus made these drawings for his daughter,
born in 1973. We can recognize, lower center,
Humpty Dumpty, the character imagined by
Lewis Carroll in *Through the Looking-Glass*.

This drawing depicts one of the episodes of the
"Story of the Wild Hunter" in *Der Strüwwelpeter*
by Heinrich Hoffmann (cf. cat. 21).

199

1. Heinrich Hoffmann,
"Story of the Wild Hunter,"
Der Strüwwelpeter, 1851

200

Balthus and His Circle

This section features Balthus by means of the works of other artists who were in contact with him in different circumstances. Different forms of art—painting, literature, photography—draw a private portrait of Balthus, perceived by those who knew and loved him.

201. Baladine Klossowska
Balthus and His Cat, 1916

202. Baladine Klossowska
Portrait of Balthus, 1922

201.
gouache and water color
on paper
32 × 24.5 cm
Paris, private collection

202.
water color on paper
33.3 × 27.5 cm
private collection

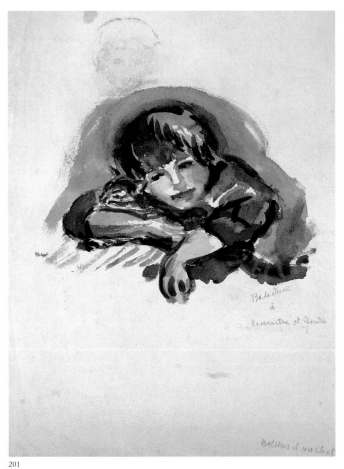

201

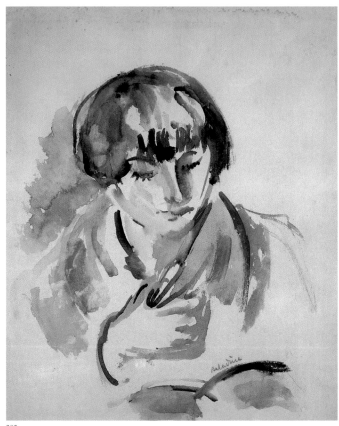

202

203. Heinrich Hoffmann
Der Strüwwelpeter [Shock-headed Peter]

204. Pierre Jean Jouve
Langue

203.
original edition:
*Der Strüwwelpeter oder lustige
Geschichten und drollige
Bilder für Kinder von 3 bis
6 Jahren*, Loewes Verlag
Ferdinand Carl, Frankfurt 1844
Paris, Laura Bossi collection

204.
poem illustrated with three
lithographs by Balthus,
André Masson and Joseph Sima,
L'Arche, 1952
32.5 × 24.7 cm
Barrie and Emmanuel Roman

Heinrich Hoffmann (1809–94), a German
psychiatrist, wrote this book of children's tales
for his son Carl, giving it to him as a Christmas
present in 1844. The work was followed, in 1851,
by *König Nussknacker und der arme Reinhold*
(cf. cat. 43, fig. 4). *Shock-headed Peter* made
a deep impression on the imagination of several
generations of children, and traces of it
can be discerned in several paintings, drawings
and sketches throughout Balthus's life
(cf. cats. 21, 43, 83, 200).

203

204

205. Antonin Artaud
Faits remontant à 1934

school notebook
with grey cover
19 sheets of squared
and lined paper
22 × 77 cm
private collection

La misère peintre

Balthus a commencé par la misère crasse,
la misère noire et crasse,
non celle du vêtement mais celle dirai je du sentiment.
On se sent pauvre, dehors et dedans
c'était l'époque où on allait <u>découvrir</u> un peintre, on allait de nouveau découvrir un nouveau grand peintre
un peintre ni comme par derrière ni comme par devant
ni
comme
<u>jamais</u>
disait on
c'était du moins l'atmosphère.
cette atmosphère qu'on ne retrouve plus et à laquelle maintenant je ne crois plus qui se dégageait d'autour du
berceau vide et qui attend son nouveau né,
qui se dégageait donc autour du pauvre Balthus pas encore échu.

Balthus menait sans fin une bataille et discrète et secrète une bataille
convulsive
<u>concrète</u> contre la misère et contre la faim
une bataille hérissée d'armures et de guerriers
pleines de coquilles craquelantes, givrées
ou c'était toi
ou c'était moi qui aurait le dernier mot
à la fin
dans cette bataille entre la faim et la misère et la misère de la fin;
Il habitait rue de Furstenberg un atelier au sommet d'une espèce d'appentis d'échafaudage comme de charpente
pour l'éternité charpentié,
qu'il semblait qu'il n'en finirait plus
et de descendre et de monter,
ou plutôt de rester au faîte de cette espèce de charpente
ou je ne sais quoi d'éternel ou de sempiternel était charpenté
car
rue de Furstenberg il y a un bordel
et il y a en même temps une chapelle où des espèces de sales francs maçons viennent prier dans un gros bréviaire
armorié,
il paraît qu'il y a là les descendants et comme les apparentés d'une secte
de vieux rose-croix
de vieux initiés
<u>habillés</u>
et
deshabillés
mais qui ne sont habillés et déshabillés
qu'en entrant et sortant
l'angle [?]
de la rue de Furstenberg
car pour le reste du dedans
ils sont purement et proprement
c'est à dire
très

co MALHEUR A QUI
chon parait ici dedans
 une ombre de pornographie
 malheur et malédiction
non il y a donc
dans cette maison
le ventre d'un canon
un canon avec un ventre armé.
on entre. Et à main droite en entrant se trouve
un porte manteau avec 14 crocs
ou plutôt 13 moins un: c'est à plus un;
mais il y a le balancier
d'une horloge qui ne se décide
jamais
à apporter
le dernier battant d'une barre
qui pourrait former <u>trinité</u>
 et quadrilatère.

C'est là que ceux qui croyaient ne pas avoir d'âme venaient hurler dans un coin que vraiment il
<u>VRAIMENT</u>
ils
n'en avaient pas

n'en auraient jamais,
que rien de ce que peut être âme, toucher à l'âme, ou qui touche à l'âme ne viendront jamais frayer avec eux, voisiner
avec eux, caqueter ou coqueter avec eux.
Et tout cela avait lieu autour de ce porte manteau susdit à 14 crocs
ou plutôt 13 crocs
plus un
ou plutôt
quattorze crocs moins un
ou plutôt
non

[13 lignes, à raison d'un mot par ligne, dans une langue étrangère]

Balthus disait descendre d'une race de barons baltes des bords de la Baltique
 dont ils prétendent
avoir
 co
 m
 mencé
 LA MER
En tout cas le voisinage de ce petit cercle d'initiés (qu'ils disaient) et de l'atelier de Balthus le peintre
avait quelque chose
de bien
singulier,
car il y avait
d'un côté
la vie de
Balthus
qui avait à vivre
a assurer son coucher son sommeil les 3 repas journaliers,
le local de son travail,
c'est à dire l'endroit où travailler
et puis
le travail
lui-même
sa valeur
son efficacité.
Je dois dire que cet article est est écrit en ce moment même
comme à la loupe au microscope, de loin,
comme du haut d'une espèce
non pas du haut
du fond
de l'arrière
trèsfonds et de haut fond du corps de toute la masse d'un canon de haute portée qui peut ... bien voir
je dis voir
et donc voir
que bombarder.
On sait ce que c'est que le ressac!
ce coup de ressort que la mer elle même donne sur ses propres reins
et bien cet article est comme un coup de ressort que je me donne à moi même sur moi même pour me regarder du
fond de mon propre passé,
et me regardant
regarder
Balthus
BALTHUS
le même Balthus
Balthus
Balthus qui rêve au fond de son propre passé
Le même Balthus tout seul et qui voulut se suicider un soir, et que je trouvai tout seul au fond de son lit avec à sa
gauche sur une chaise une petite fiole de 15 grammes de laudanum de Sydenham
et a coté de la fiole une photographie
Je regardai la fiole, la photographie et Balthus respirant à peine
 et il me parut que l'allusion était trop forte,
trop grossièrement forte pour que je puisse l'accepter
c'était trop,
 beaucoup trop
le suicide au laudanum banal,
et suicide à cause d'une femme,
suicide par désespoir d'amour
pour qu'il me parut acceptable
et recevable.
J'étais entré dans la chambre pour voir Balthus comme je venais le voir tous les soirs vers les 6 hre 1/2 7 heures
La porte n'était pas plus fermée que tous les soirs. Balthus était étendu sur son lit comme cela lui arrivait quelques
fois mais comme enfoncé dans son propre sommeil, plus qu'enfoncé on peut le dire:

enseveli
véritablement ENSEVELI
il ne respirait plus,
il était mort, pas mort comme quelqu'un déjà enterré dans sa bière, mais mort comme presque
debout
Il faudrait dire enfin ce qui me frôle les lèvres et la langue depuis plus de vingt ans
parce que
ce que tout le monde dira sera exactement le contraire de ce que je dus dire
et que tout le monde
et ce tout le monde sera personne
quelques personnes
ou presque [?]
[...]
prendra le contrepied
c'est que Balthus aura été un précurseur
le précurseur
à notre époque
d'Holbein
d'Ingres
de Corot
de Courbet
et du Poussin
il faut pour juger Balthus penser à ce coup de ressac de la mer aux équinoxes
ou toute la nature d'elle même
[...] même se prend aux reins
et se regarde dans son train
aussi bien avant d'arrière;
elle prend toute sa matière et la sonde;
et moi j'ai l'impression d'avoir connu et rencontré Balthus
le même
Balthus
que maintenant
à une heure qui fut et était
de haut et de loin l'heure
du dernier jugement, ce
fameux dernier jugement
dont parles Charles Baudelaire dans sa « Charogne » et il me montrait dans l'ombre de son poignet droit
je dis bien, vous entendez: l'ombre,
je dis: l'ombre, et
je dis: le poignet
et je dis
l'ombre du poignet
je dis
l'ombre du poignet droit,
il me montrait dis je
dans l'ombre
dure
de son poignet
droit
des paysages particuliers
qui défilaient l'un après l'autre dans des lumière exactement caractérisées,
très exactement caractérisées,
un fond de forêt vu comme
au spectroscope et du fin bout d'une haute lentille stellaire
où
chaque moindre
détail
se dégageait
non pas dans une lumière
de peintre
mais une lumière
de vitrier, de plombier, de zingueur
et plus, bref,
toutes les lumières
supposables du petit artisan et
qu'on contemplait
quand on était garçonnet et nonpas homme fait
qui s'imagine faire
de la haute mystique ent
enlevant 1 à 14 pour faire
13 et en
[.... ...]
[... ...]
hauts sites

d'esprit de
d'Epidaure
d'Hermès
ou de Solon
trismégiste
lesquels ne furent
 à tout prendre
que de HAUTS CONS.
non, Balthus a isolé la petite lumière
il a su isoler la petite lumière exacte des petits matins de tous les petits matins où l'on regarda la vie qui s'éveille
et cette petite lumière exacte et sans pareille
il a su l'appliquer
à un fond de sous bois
l'après midi
à un dessus de table,
quant à Poussin
qui a <u>pensé</u> au
Poussin
avant Balthus
Je dis avant
ce terrible
et [...]
alignement;
de maisons banches et comme mortes,
de toits blafards à force d'être teints à la chaux.
C'est Balthus qui a fait Poussin
et non Poussin qui a fait Balthus,
[...] avec ses nus
Et c'est là que m'apparait ce terrible
mort-noir
noir et empoisonné
que je confonds avec
un jeune homme couché mort et intoxiqué
sur un certain lit de la rue de Furstenberg,
dans une maison proche d'un bordel
et qui du fond
du premier
jugement
fulminait
et l'une après l'autre dégageait
ce qu'il n'aurait jamais fallu faire
et qui fit le
premier péché de peindre
dans l'astral
<u>ancré</u>
et qui apparaissent
comme faites
quand il faut cent milliards d'éternités
et d'applications l'une à l'autre surajoutées pour parvenir à faire sortir
ce que Balthus
justement mieux
que le Poussin
Corot ou Courbet a fait sortir
une main calleuse de vie
d'un enlemineur *(incertain)*
illuminé
et qui n'est pas
cinématographie
mais [...]
de leur auteur
 1947

Balthus and his cat at Rossinière,
1999, photographed
by Martine Franck

Balthus in his home,
1990, photographed
by Henri Cartier-Bresson

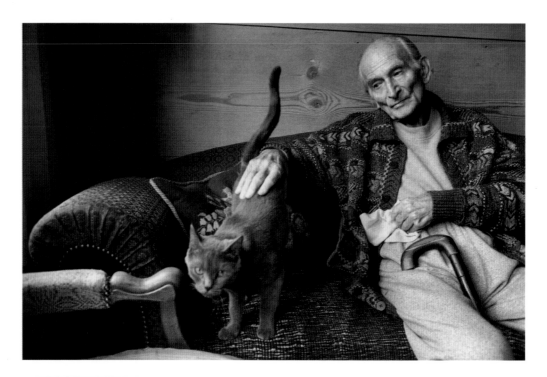

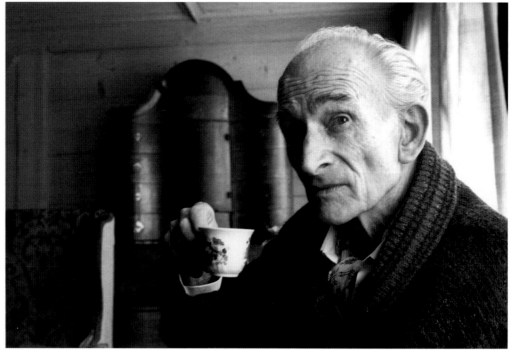

opposite page
Balthus in his home, 1990,
photographed
by Henri Cartier-Bresson

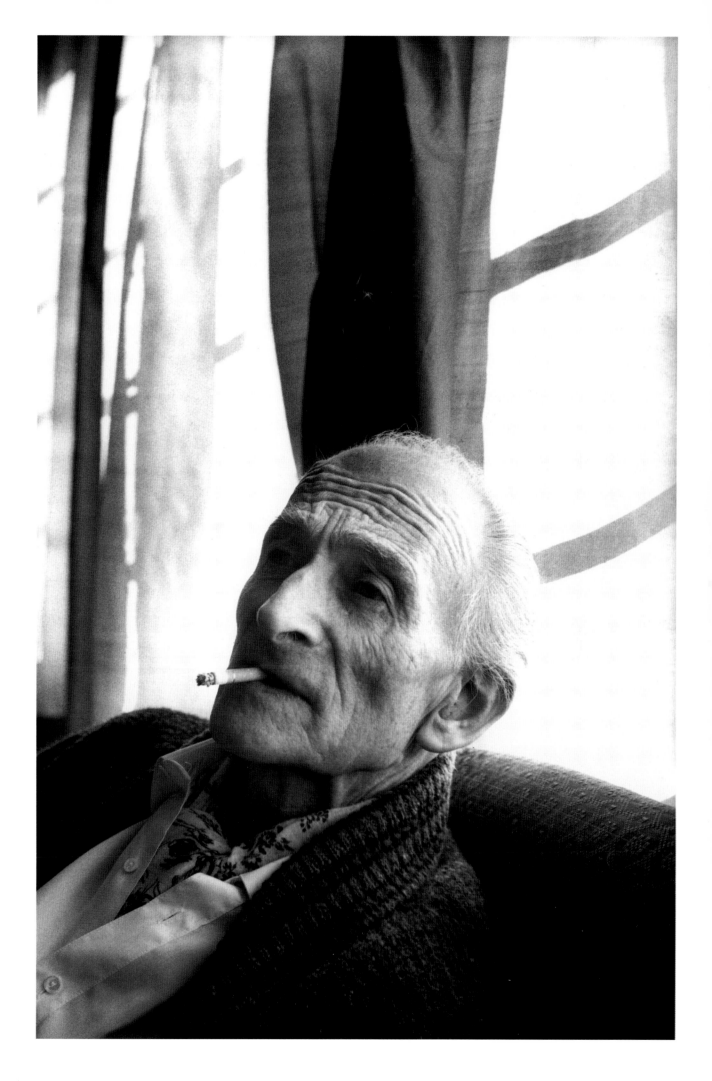

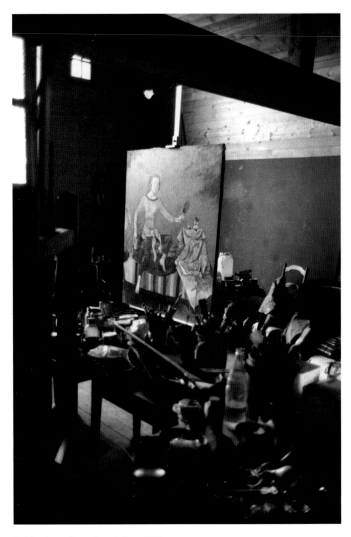

Balthus's studio at Rossinière, 1990,
photographed by Martine Franck

Balthus in his studio at Rossinière,
1990, photographed
by Henri Cartier-Bresson

Balthus's studio at Rossinière, 1990,
photographed by Martine Franck

Balthus and his wife Setsuko
at Rossinière, 1996,
photographed by Martine Franck

Balthus and his daughter Harumi,
1990, photographed
by Henri Cartier-Bresson

Balthus, Setsuko and Harumi
at Rossinière, 1990, photographed
by Henri Cartier-Bresson

Balthus at Rossinière,
1990, photographed
by Henri Cartier-Bresson

Appendix

1908
29 February: birth in Paris of Balthasar Klossowski, second son of Erich Klossowski (1875–1946) and Elisabeth Dorothea Spiro (1886–1969). Erich Klossowski was a painter and art historian, author of a monograph on Henri Daumier that is still relevant. His wife as well was a painter, known as Baladine. Their elder son, born in 1905, is the writer and painter Pierre Klossowski. Erich Klossowski was of Polish birth, of a family that had taken refuge in Eastern Prussia since the mid-nineteenth century. Baladine was born at Breslau (Wroclaw), in Silesia, a region under Prussian rule at the time. The couple had been living in Paris since 1903, in the district of Montparnasse, and belonged to Pierre Bonnard's circle. They also kept company with some artists and writers who had left Breslau as they had. Among them the painter Eugen Spiro, Baladine's brother, the art historians Julius Meier-Grafe and Wilhelm Uhde.

1914
When the war broke out, the Klossowskis, being German citizens, had to leave France. Their possessions were seized and sold; a small part was kept safe by Pierre Bonnard. Their financial situation was extremely critical. After staying in Zurich as Professor Jean Strohl's guests, they settled in Berlin.

1916
Erich Klossowski designed for Victor Barnowski, who was also from Breslau, and director of the Lessingtheater since 1913, sets and costumes that met with great success.

1917
The Klossowski couple separated. Baladine and her two sons spent a few months in Bern. Contrary to what has been claimed, the boys did not attend school, but it was at that time that Balthus would have met Robert and Hubert de Watteville, brothers of his future wife Antoinette. In November, Baladine, Pierre and Balthus left Bern for Geneva.

1919
Rainer Maria Rilke, travelling through Geneva, visited Baladine whom he had met in Paris before the war. Several months later a romance blossomed between the poet, whom she called René and Baladine, become Merline. Balthus was enrolled in the Lycée Calvin. An episode of his childhood—the adoption and then the loss of a kitten—was the origin of the 40 drawings of *Mitsou*. About at that time Baladine began spending the summer months at Beatenberg, a small but cosmopolitan resort on the shores of the Lake of Thun, with Balthus; there

he met Margrit Bay, a woman painter and sculptor surrounded by a group involved in anthroposophy, and would become her assistant in 1922.

1920
Beginning of the correspondence between Rilke and Baladine.
Balthus discovered, through a book, Chinese culture, becoming fascinated by it. He illustrated for Rilke several episodes from the life of the Taoist sage Chuang-tzu, then inventing a "Chinese novel." Rilke was enthusiastic over the drawings of *Mitsou* and tried to have them published.

1921
Publication of *Mitsou, quarante images par Baltusz*, with a preface by Rilke. During the spring, Baladine and her sons settled in Berlin again where Eugen Spiro took them in.
In the summer, Baladine arranged the castle of Muzot, near Sierre, for Rilke. In November, she returned to Berlin with her sons. Their studies were broken off, because of a lack of means.

1922
Balthus executed some maquettes of settings for a Chinese play he proposed to the Staatstheater in Munich. The offer came to nothing since the play was not staged. At Beatenberg, Balthus painted his playmates, the young local peasants, worked with Margrit Bay and took part in the theatrical activities of her entourage. He spent the fall at Muzot, Rilke being away at the time.
The Klossowski family was back in Berlin for the winter. Balthus failed to be admitted to the Academy of Applied Arts.

1923
In May, Baladine and Balthus left Berlin permanently for Beatenberg. There Balthus painted, for Margrit Bay, a large panel representing the *Madonna and Child* surrounded by Saint John the Baptist and Saint Luke. He had a mural project, that he would have to give up.
For Christmas, Rilke sent him a copy of Dante and a work by the art historian W. Worringer and received from him a painting.
Pierre Klossowski moved to Paris, where, at Rilke's request, he stayed at André Gide's.

1924
In the spring, Baladine and Balthus joined Pierre in Paris.
During the summer, at Beatenberg, Balthus met Antoinette de Watteville, who was then twelve years old.
After returning to Paris in the fall, he sat in on classes at the Academy of La Grande

Chaumière. During the same period, he showed his drawings and paintings to Pierre Bonnard and Maurice Denis who encouraged him to copy Poussin's paintings in the Louvre.

1925
In the spring, Balthus and his mother were guests in Toulon of the Vulliez couple, whom Baladine had met through Rilke. There Balthus painted the *Paysage Provençal*.
Rilke was in Paris (9 January–18 August), then left for Muzot with Baladine. She came back in the late fall.
In the Louvre, Balthus copied Poussin's *Narcissus* that he sent to Rilke, and painted several views of the Luxembourg garden.

1926
Thanks to a group of sponsors, the most important one being Professor Jean Strohl, Balthus spent part of the summer in Italy. He copied several frescoes of the cycle of the *Legend of the True Cross* by Piero della Francesca at Arezzo and the *Resurrection* at Borgo San Sepolcro, as well as frescoes by Masaccio and Masolino in Florence.
In the fall, he was back in Beatenberg. He may have gone with his mother to Toulon for Christmas.
Rilke died on 29 December.

1927
January: Balthus attended Rilke's funeral. During the spring, in the Protestant temple of Beatenberg, where Margrit Bay's father had been minister, he painted frescoes depicting *The Good Shepherd* and the *Four Evangelists*. He had the project of a big painting on the theme of the story of Tobia; that work would never be done. During the fall, he began in Paris a series of paintings and drawings with street scenes and views of the Luxembourg garden. Erich Klossowski moved to Sanary-sur-mer, in the South of France, where he lived with Hilde Stieler, a German journalist.

1928
Balthus stayed in Zurich from February to September. He was a guest of the Müller and Thomann families, and portrayed several of their members.

1929
In April, Balthus was invited to Berlin to stay with the publisher Martin Hürlimann whose portrait he painted. In September–October, the Forter gallery of Zurich organized an exhibition that showed about ten paintings by Balthus, works by Toni Ciolino and lithographs by Gregor Rabinovitch. It was Balthus's first exhibition.
Back in Paris, he sought, unsuccessfully,

funds to rent a studio. He is believed
to have destroyed, at the time, a certain
number of paintings.

1930

During the summer, Balthus spent several
weeks with his friends the Wattevilles.
He fell in love with Antoinette, and painted
her portrait.
In October, he was called up to perform
his military service in the French army.
He was drafted in the 4e régiment
de tirailleurs marocains (Moroccan
artillery), at Kenitra, on the Atlantic coast
of Morocco. Several sketches and a water
color allude to the barrack-room at Kenitra.

1931

February: he had an eight-day leave
that he spent in Gibraltar.
August: he was transferred to Headquarters
in Fez where he was to stay until the end
of his service, in December. A couple
of sheets of sketches of Gibraltar
and a group of drawings executed
in the barracks yard in Fez are
all that remain of that period. Later on
three paintings would be executed.

1932

Spring: after staying in Zurich, where
Professor Jean Strohl tried in vain to find
him a job, Balthus went to Beatenberg
and then to Bern. He was there from May
to October, as a guest of the Watteville
family, and executed a series of copies
after the cycle of *Swiss Peasants*
by Joseph Reinhardt.
Antoinette fell in love with a Belgian
diplomat.
Back in Paris in the fall, Balthus shared
an apartment with Pierre Leyris (who had
been his brother Pierre's school-mate
at the Lycée Janson-de-Sailly in 1923)
and his young wife Betty. He resumed
the illustrations for *Wuthering Heights* by
Emily Brontë, begun early that same year.
Pierre and Betty Leyris posed for him on
several occasions.

1933

March: he rented the studio of the Swiss
architect Jeanneret, Le Corbusier's cousin,
at 4, Rue de Furstenberg.
He became friends with Pierre Jean Jouve,
whom he had met during Rilke's stay
in Paris in 1925, and frequently went
to see André Derain, who gave him
technical advice.
Painted *La Rue* that Jean Cassou put
forward for the Grand Prix de la peinture
organized by the Bernheims. The painting
was rejected because of its size. He then
painted *La Caserne*, in memory of Fez,
Alice, whose model was Betty Leyris,
and *La Fenêtre*. He spent the first half
of August at Muzot, and then in September

went to see his father at Sanary.
In November, collaborated in the sets for
Johann Strauss's Junior *La Chauve-souris*,
staged by Max Reinhardt at the Théâtre
Pigalle. It was his first personal engagement
in the theater world.
December: finished *La Toilette de Cathy*.
Julien Green came to see him twice
and Wilhelm Uhde visited him bringing
Pierre Loeb, the young owner
of the Galerie Pierre that championed
Surrealist painting. Loeb claimed he was
very impressed by *La Rue*. An exhibition
was considered.
In the following weeks, André Breton
visited him along with Paul Eluard,
Georges Hugnet and Alberto Giacometti.
The Surrealists were highly disappointed
to discover he was a resolutely figurative
painter, but that would be the beginning
of the friendship between Balthus
and Giacometti (himself soon a dissident
of the Surrealist movement) that was
to last for thirty years.

1934

March: Pierre Loeb sought to make Balthus
known: the Minister of the Interior
Albert Sarraut and Picasso came to see him
April: one-man show at the Galerie Pierre.
Balthus presented *La Rue, La Toilette
de Cathy, La Fenêtre, Alice* and *La Leçon
de guitare*, that caused a scandal, as well
as two portraits, including one
of Antoinette (probably the *Jeune fille
en costume d'amazone*).
The exhibition, that Balthus had meant
to be provocative, did create a little social
"scandal" but not a single painting sold.
Notwithstanding, it drew the attention
of several personalities, among whom
the famous vicomtesse de Noailles,
and especially Antonin Artaud, who praised
it in a review in the *N.R.F.*
May: exhibition in Brussels around
the review *Minotaure*. *La Toilette de Cathy*
was shown.
June: a stay in Beatenberg. His nerves
shattered by the letdown of his exhibition
and Antoinette's sentimental vacillations,
Balthus alternated between states
of exaltation and despair.
July: attempted suicide.
During the summer, Pierre Matisse,
Henri Matisse's son, who owned a gallery
in New York, discovered Balthus's painting
at the Galerie Pierre.
August: the famous Berlin stage director
Victor Barnowski, for whom Erich
Klossowski had worked during
the First World War, and who had sought
refuge in Paris after Hitler's election, asked
Balthus to create the costumes and sets
for Shakespeare's comedy *Comme il vous
plaira* [As You Like It], that he wished
to stage. The play was presented
at the Théâtre des Champs Elysées

in October but was thwarted
by the performance held at the same time
by Jacques Copeau at the Théâtre
de l'Atelier, as well as by the latent
antisemitism surrounding Barnowski.
Balthus continued working on his
illustrations for *Wuthering Heights*.
Spent Christmas at Bern at the Watteville's.

1935

February: Antonin Artaud called upon
Balthus to design the sets and costumes for
The Cenci. That tragedy, an interpretation
of Shelley's play, was supposed to illustrate
Artaud's innovatory conceptions, published
in 1932 by the *N.R.F.* under the title
"Théâtre de la Cruauté."
The play was sponsored by Iya Abdy, who
played the leading role, and whose portrait
Balthus painted at the time. Varia Karinska,
who made the costumes, introduced him to
the poster artist A.M. Mouron-Cassandre,
from whom he immediately received a
commission to do a portrait of his family.
March: Antoinette broke off
her engagement.
May: Publication of eight of the illustrations
for *Wuthering Heights* in Albert Skira's
Le Minotaure.
Brief stay in London at Herman Shrijver's.
Two portraits, including that of *Lelia
Caetani* were shown.
September: stay in Engadine at Pierre Jean
Jouve's.
October: Balthus moved into the studio
in the Cour de Rohan. Pierre Colle
commissioned him to paint the *Portrait
d'André Derain* and Loeb advanced
him funds so he could begin *La Montagne*.
Finished the final version of the illustrations
for *Wuthering Heights*.
Attempted to publish a study, the manuscript
of which is lost, on nineteenth-century
illustrated children's books.
That year was also the date of the first
painted self-portrait, titled *Le Roi des chats*,
the first study for *La Montagne* and a series
of social portraits that would support
him for two years.

1936

January: began *La Montagne*.
March: exhibited in London his illustrations
for *Wuthering Heights*, without succeeding
in having them published. A short stay
at Hyères at the vicomtesse de Noailles's
who commissioned her portrait.
April: second stay in London.
Painted the portraits of *La vicomtesse
de Noailles* and *André Derain* as well as
Roger et son fils.
August: Balthus traveled with Pierre Jean
Jouve to Soglio, in Engadine.
Fall: third stay in London to portray
Lady Schuster and her daughter. He began
a series of drawings and paintings
whose models were the Blanchard children.

The first portrait of *Thérèse* was bought
by Jouve.
Executed an illustration for Jouve's poem,
Urne (GLM, Paris 1926).

1937
2 April: married Antoinette de Watteville.
Painted *Les Enfants Blanchard, La Jupe
blanche*, completed *La Montagne*.
La Rue entered the collection of the
American collector James Thrall Soby.
Pierre Loeb commissioned him to paint
the portrait of *Joan Miró et sa fille Dolorès*,
for Miró's fiftieth birthday.

1938
March–April: first exhibition at the
Pierre Matisse Gallery in New York.
Stay at Champrovent, in Savoie, with
Pierre and Betty Leyris. There he painted
La Falaise and the two versions of *Sous bois*.
That was the year of the *Portrait
de Joan Miró et de sa fille Dolorès*,
the *Portrait de Pierre Matisse,
Thérèse rêvant*. The portrait of Miró
was received at the Museum
of Modern Art of New York.

1939
Painted the view of *Larchant*, a village
near Fontainebleau where he had probably
been taken by Jouve, who devoted three
poems to the church of Saint-Mathurin.
In September, Balthus was drafted and sent
to Alsace. Wounded or ill, he returned
to Paris in December.

1940
In January–February, spent several weeks
of convalescence with Antoinette
at Sittgriswil, near Beatenberg, then went
through Bern where he left Antoinette.
At the end of February, was back
in Paris where he was demobilized.
June: settled with Antoinette
at Champrovent where Betty Leyris had
sought refuge since the month of April.
He thought of having Jouve come
and stay in a nearby property at Chemillieu.
Painted an *Autoportrait, Le Cerisier,
L'Enfant gourmand* and *Le Goûter*.

1941
Balthus and Antoinette spent the month of
March and April in Bern at the Watteville's.
May: return to Champrovent without
Antoinette. He began the *Paysage
de Champrovent*, the different versions
of the *Salon*.
October: Picasso purchased *Les Enfants
Blanchard* from Pierre Colle.

1942
When the Germans entered the South zone,
Balthus left Champrovent, and settled
with Antoinette at Bern and then Fribourg.
Birth of their son Stanislas.

1943
Fribourg. Several commissions of portraits.
He painted *La Patience* and *Le Gottéron*.
November: gallery Moos of Geneva
organized an exhibition of his works.

1944
February: birth of his son Thadée.
November: stay in Paris, visited Picasso.

1945
Moved into Villa Diodati at Cologny
near Geneva, where he became friends
with the publisher Albert Skira,
was introduced to André Malraux,
and met up again with Giacometti,
Jean Starobinski, etc.
Completed *Les Beaux Jours*.
Prepared, in collaboration with the French
Embassy, an exhibition titled "Ecole
de Paris" that would be shown at the
Kunsthalle of Bern in the spring of 1946
and where he showed *Les Beaux Jours*.
Stay in Paris. Met up again with the artists
exiled by the war at the restaurant
Le Catalan, where he would spend a great
deal of time during the years 1948–50.
Publication in the review *Fontaine*
of the letters Rilke had written him
between 1920 and 1926.

1946
Balthus separated permanently
from Antoinette and moved back to Paris.
November–December: exhibition at the
gallery Beaux-Arts organized by Henriette
Gomès. Twenty-seven paintings were
shown, including *La Victime*, begun in 1939
and finished that year, various portraits
and landscapes, *Les Beaux Jours*
and two versions of the *Salon*.

1947
Summer: trip with André Masson
in the south of France. On the Côte d'Azur
met up again with Lacan, Sylvia Bataille,
Picasso, Françoise Gillot. On that occasion
he met Laurence Bataille of whom he made
several portraits.
Balthus became friends with Albert Camus
and Paul Eluard.
Painted *La Chambre* and the *Portrait
de Jacqueline Matisse*.

1948
Albert Camus asked him to design the sets
and costumes for *L'Etat de Siège* directed
by Jean-Louis Barrault.
Painted a series of *Nus* and began
La Partie de cartes.

1949
Balthus designed the sets and costumes
for Boris Kochno's ballet, *Le peintre
et son modèle*.
Exhibition at the Pierre Matisse Gallery in
New York, with a preface by Albert Camus.

Painted *La Semaine des quatre jeudis*,
a half-dozen *Nus*, the *Portrait de Rosabianca
Skira* and *Le Chat de la Méditerranée*.
Death of Erich Klossowski, at Sanary.

1950
With Marie-Laure de Noailles
and Jean Cocteau, Balthus was witness
to the marriage of Georges and Myrtille
Hugnet.
Designed the sets and costumes
for Mozart's *Così fan tutte* for the Festival
of Aix-en-Provence, commissioned
by Cassandre.
Painted the first *Etude pour le passage
du Commerce-Saint-André*.

1951
During the summer, stayed in Italy,
invited by the Caetanis. Went to Rome
and to Sermoneta where he painted
the *Paysage d'Italie*.

1952
Began the *Passage du Commerce
Saint-André* and *La Chambre*.
Gave an illustration for *Langue*
by Pierre Jean Jouve (L'Arche,
Paris 1952).

1953
Balthus left Paris and, thanks
to the support of a group of collectors
and dealers, settled at the château
de Chassy in the Morvan.
Designed the sets and costumes
of *L'Ile des chèvres* by Ugo Betti.

1954
Painted a series of views of Chassy,
the two portraits of *Colette* and the three
paintings portraying *Léna Leclerc*.
Completed *La Chambre* and the *Passage
du Commerce Saint-André*. Painted
the first studies for *Les Trois sœurs*.
Frédérique Tison, his brother Pierre's
stepdaughter, joined him at Chassy.
She would live with him until
around 1962. First studies for *Le Rêve I*.
Publication of the Rilke-Baladine
correspondence (Max Niehans, Zürich).

1955
Painted the first two versions
of the *Trois Sœurs*, the *Jeune fille
à la fenêtre*, *Le Rêve I*, *Jeune fille
à la chemise blanche*, *Nu devant
la cheminée*.
In December, spent three months in Paris.

1956
29 February: opening of his exhibition
at the gallery Gomès.
Exhibition at the Museum of Modern Art
in New York.
Painted *La Tireuse de cartes*, *Le Rêve II*,
Le Fruit d'or.

1957
Exhibition at the Pierre Matisse Gallery
in New York.
Painted *Golden Afternoon, La Toilette,
La Sortie du bain*.

1958
First exhibitions in Italy, in Turin
and Rome.
Le Drap bleu, several still lifes
and landscapes.

1959–60
Le Phalène, several landscapes.
Designed the sets for Shakespeare's
Jules César directed by Jean-Louis Barrault.

1961
André Malraux, Minister of Culture,
appointed Balthus director of the Academy
of France in Rome, Villa Medici,
despite the opposition of the Institut
of which Balthus was not a member.
His mission was to undertake
the restoration of the Villa and update the
statutes of the Prix de Rome, so as to open
it to researchers, restorers or young authors.

1962
Balthus was sent by Malraux on a mission
to Japan; there he met Setsuko Ideta.
In Rome, became friends with Renato
Guttuso, Federico Fellini, Valerio Zurlini,
several actors and writers.

1963
Resumed *La Chambre turque*, its model
being Setsuko Ideta.

1964
Began the series of the *Trois sœurs*,
giving two new versions.

1966
May–June, major retrospective of his work
at the Musée des Arts Décoratifs in Paris,
then taken to Knokke-le-Zoute in Belgium.
Several exhibitions of his drawings
in the United States.

1967
Balthus and Setsuko Ideta were married
in Japan.
La Chambre turque and *Les Trois sœurs*
were shown at the Pierre Matisse Gallery
in New York. *La Chambre turque*
was purchased by the French state.
Balthus began *Japonaise au miroir noir*
and *Japonaise à la table rouge*.
The restoration of the buildings
of Villa Medici being completed,
he began that of the gardens.

1968
Birth of Fumio, son of Balthus and Setsuko,
who would live but two years.
October–November: retrospective

at the Tate Gallery in London, curated
by John Russel.
Began *Katia lisant*.

1969
Death, in Paris, of Baladine Klossowska.

1970
First drawings of Monte Calvello,
the medieval castle he bought near Viterbo.

1971
October–November: major exhibition
at the gallery Claude Bernard in Paris
of drawings executed in Rome,
with a preface by Jean Leymarie.

1973
Birth of his daughter Harumi.
Exhibition at the Musée Cantini
of Marseilles.

1973–77
Balthus completed *Japonaise au miroir noir,
Japonaise à la table rouge, Katia lisant*.
Painted *Nu de profil* and *Nu au repos*.

1977
Federico Fellini wrote a preface for a major
exhibition gathering works from 1934
to 1977 at the Pierre Matisse Gallery
in New York.
La Toilette de Cathy was purchased
by the Musée national d'art moderne
of Paris.
Jean Leymarie replaced Balthus as director
of the Villa Medici. Balthus moved
to Rossinière, in Switzerland, with his wife
and their daughter.

1977–80
*Paysage de Monte Calvello, Chat au miroir I,
Nu assoupi*.

1979
La Rue was bequeathed by James Thrall
Soby to the Museum of Modern Art
of New York.

1980
Twenty-six paintings were shown
in the context of the Venice Biennale.

1981
Balthus was appointed member
of the Royal Academy of London.
Completed *Le Peintre et son modèle*
that was received in the collection of the
Musée national d'art moderne of Paris.

1982
First retrospective of works on paper at
Spoleto, curated by Giovanni Carandente.
Publication of *Balthus* by Jean Leymarie,
first exhaustive catalog of the paintings
(Skira, Genève).
La Montagne was received in the collection

of the Metropolitan Museum
of Art of New York.

1983
Nu au miroir, Nu au foulard.

1983–84
Retrospective at the Musée d'art
moderne of Paris, curated by Jean Clair;
at the Metropolitan Museum of New York
by Sabine Rewald and at the City Museum
of Kyoto.

1983–86
*Nu à la guitare, Nu couché, Composition
au corbeau*.

1987–90
Chat au miroir II.

1989–94
Chat au miroir III.

1993
Retrospective at the Musée cantonal
des Beaux Arts of Lausanne.

1994
Retrospective of drawings
at the Kunstmuseum of Bern.

1995
Traveling exhibition in Hong Kong
(Museum of Art), Beijing (Palace of Fine
Arts) and Taipei (Fine Art Museum).

1996
Retrospective at the Centro de Arte Reina
Sofia in Madrid.

1996–97
Exhibition at the Accademia Valentino
in Rome.

1998
Balthus went to Poland for the first time.
He was made *doctor honoris causa*
of the University of Wroclaw.
Painted the *Paysage de Monte Calvello II*.

1999
Exhibition at the Musée des Beaux Arts of
Dijon, gathering works painted at Chassy.
Publication of the *Catalogue raisonné
de l'œuvre complet* (Virginie Monnier,
under the scientific supervision
of Jean Clair, Gallimard, Paris).

2000
A Mid-Summer Night's Dream, a tribute
to Poussin, painted for the exhibition
"Encounters, New Art from Old," curated
by the National Gallery of London.

2001
18 February: death of Balthus at Rossinière,
Switzerland.

Monographs
edited by Virginie Monnier

For essays, articles, interviews, illustrations for books and texts, and filmography, see: Virginie Monnier, Jean Clair, edited by, Balthus. Catalogue raisonné de l'œuvre complet, *Gallimard, Paris 1999, pp. 570–72. English edition* Balthus. Catalog Raisonné of the Complete Works, *Harry N Abrams, New York 2000.*

Carrillo de Albornoz 2000
Christina Carrillo de Albornoz, *Balthus*, Assouline, Paris

Clair, Monnier 1999
Virginie Monnier, Jean Clair, edited by, *Balthus. Catalogue raisonné de l'œuvre complet*, Gallimard, Paris

Biggs 1979
Lewis Harold Biggs, *The Early Works of Balthus*, The University of London, London

Clair 1984
Jean Clair, *Metamorphosen des Eros, Essay über Balthus*, Schirmer/Mosel, München

Clair 1996
Jean Clair, *Balthus. Les métamorphoses d'Eros*, Paris, Réunion des musées nationaux (also published under the title of "Les métamorphoses d'Eros," in *Balthus*, exhibition catalog, Paris, MNAM.CNACGP, Paris 1983)

Colle, Lorant, Saalburg 2000
Marie-Pierre Colle, Sylvia Lorant, Béatrice Saalburg, *Balthus, Las tres hermanas*, preface by Jean Leymarie, D.R. Landucci Editores S.A. de C.V., Mexico

Costantini 1996
Costanzo Costantini, *L'enigma Balthus. Conversazioni con il pittore più affascinante del nostro tempo*, Gremese Editore, Roma

Davenport 1989
Guy Davenport, *A Balthus Notebook*, The Ecco Press, New York

Faye 1998
Jean-Pierre Faye, *Balthus, Les dessins*, Adam Biro/Archimbaud, Paris

Fellini, Federico, *see* **Leymarie**, Jean

Fox Weber 1999
Nicholas Fox Weber, *Balthus, a Biography*, Alfred A. Knopf, New York

Jaunin 1999
Françoise Jaunin, *Balthus, Les méditations d'un promeneur solitaire de la peinture*, La Bibliotèque des Arts, Lausanne

Kisaragi, Takashina, Motoe 1994
Koharu Kisaragi, Shûji Takashina, Kunio Motoe, *Balthus*, Kodansha Ltd, Tokyo

Klossowski 1983
Stanislas Klossowski de Rola, *Balthus: Paintings*, Thames & Hudson, London, Harper & Row, New York; *Balthus: Gemälde*, Schirmer-Mosel, München; *Balthus: Peintures*, Hermann, Paris (with a different text); *Balthus: Pitture*, Electa, Milano

Klossowski 1996
Stanislas Klossowski de Rola, *Balthus*, Thames & Hudson, London; *Balthus*, La Martinière, Paris (with a different text)

Leymarie 1978
Jean Leymarie, *Balthus*, Skira, Genève (new edition, revised and integrated 1990); Rizzoli International Publications Inc., New York 1979

Leymarie 1982
Jean Leymarie, *Balthus*, Skira, Genève (new edition 1990); Skira-Rizzoli

International Publications Inc., New York

Leymarie, Fellini 1981
Jean Leymarie, Federico Fellini, *Balthus à la biennale de Venise 1980*, Herscher, Paris

Lorant, Sylvia, *see* **Colle**, Marie-Pierre

Marc 2000
Olivier Marc, *Balthus et les artisans du réel*, Séguier, Paris

Motoe, Kunio, *see* **Koharu**, Kisaragi

Rilke 1945
Rainer Maria Rilke, *Lettres à un jeune peintre, Balthus*, Archimbaud, Paris undated (1994), reprint undated (1995) and 1998. Taken from "Lettres à un jeune peintre," *Fontaine*, 44, Paris

Roy 1996
Claude Roy, *Balthus*, Gallimard, Paris; Bulfinch Press Book, Little & Brown & Co, Boston; Schirmer-Mosel, München 1996; Kawade Shobo Shinsha, Tokyo 1997

Saalburg, Béatrice, *see* **Colle**, Marie-Pierre

Takashina, Shûji, *see* **Kisaragi**, Koharu

Vircondelet 2000
Alain Vircondelet, *Les chats de Balthus*, Flammarion, Paris

Xing 1995
Xiaosheng Xing, *Balthus*, Éd. des Beaux-Arts du Peuple de Shangaï, Shangaï

Zeki 1995
Semir Zeki, *Balthus ou la quête de l'essentiel*, Les Belles Lettres-Archimbaud Paris

One-Man Exhibitions
edited by Virginie Monnier

The list of one-man exhibitions presented here, arranged in chronological order, differs from previous one in several respects. The first exhibition of paintings and compositions by Balthusz at the Galerie Druet in October 1924 is not mentioned, in agreement with the artist, who claimed it had been a mere "presentation" of his works to Maurice Denis and Albert Marquet, made by Pierre Bonnard within a retrospective the gallery was holding for him. That presentation is documented in Clair-Monnier, 1999, P 19. However, Antoine Terrasse was unable to find evidence of it in Bonnard's notebooks.

Three so-called group shows appear here ("Alberto Giacometti and Balthus," Albert Loeb & Krugier Gallery, New York, 1966, "Balthus - Twombly," Thomas Ammann Fine Art, Zurich, 1982 and "Balthus, Giacometti, Bonnard," Galerie Alice Pauli, Lausanne, 1984) since they were, as evidenced by the hanging and the catalogue, separate presentations shown at the same time.

Two other like exhibitions had been hitherto neglected. One was held at the Forter gallery in Zurich in 1929 (with Tonio Ciolino and Gregor Rabinovitch). That first public exhibition of paintings by Balthus did not have a catalog. It is documented by the reviews that appeared in the Zurich Kunstkronik of September 13 and 27, 1929, the artist's comments and corrections on these articles, two of his letters conserved in a private collection and the recollections of collectors whose families loaned or purchased works on that occasion (see Clair-Monnier 1999, P 36, P 43, P 45, P 47, P 49, P 54 and P 56).

Furthermore, the illustrations for Wuthering Heights were shown in London at the beginning of 1936 at the Lund Humphries publishing firm, along with bindings by Mary Reynolds. Last, an exhibition held at the MoMA of New York in 1966 and that travelled in the United States for two years is mentioned here for the first time. When two exhibitions were held at the same time in the same city, they are identified by the name of the museum and the gallery.

Zurich 1929
Galerie Forter, 12 September–13 October, with Tonio Ciolino and Gregor Rabinovitch
Paris 1934
Galerie Pierre, 13–28 April
Balthus
London 1936
Éditions Lund Humphries, 27 February–10 March, with bindings by Mary Reynolds
Illustrations to "Wuthering Heights"
New York 1938
Pierre Matisse Gallery, 21 March–16 April
Balthus Paintings, introduction by James Thrall Soby
New York 1939
Pierre Matisse Gallery 17, March–8 April
Balthus: Paintings and Drawings (Illustrations for "Wutherings Heights")
Geneva 1943
Galerie Georges Moos, November
Balthus, introduction by Pierre Courthion
Paris 1946
Galerie Beaux-Arts, 25 November–10 December
Balthus. Peintures de 1936 à 1946
Paris 1948
Galerie Renou-Colle, 2–13 July
Balthus
New York 1949
Pierre Matisse Gallery
Balthus, introduction by Albert Camus
Paris 1956
Gazette des Beaux-Arts, 29 February–17 March
Balthus
New York 1956
The Museum of Modern Art, December
Balthus, introduction by James Thrall Soby
New York 1957
Pierre Matisse Gallery, January
Balthus
Turin 1958
Galleria Galatea, 10–30 April
Balthus, introduction by Luigi Carluccio
Rome 1958
Galleria l'Obelisco, 12–18 May
Balthus, see **Turin 1958**
New York 1962
Pierre Matisse Gallery, March
Balthus Paintings 1929–1961, introduction by Jacques Lassaigne
New York 1963
E.V. Thaw & Co, 26 November–21 December
Drawings by Balthus, introduction by John Rewald
Cambridge 1964
The New Hayden Gallery, The Massachusetts Institute of Technology, 10 February–2 March
Balthus
Chicago 1964
Arts Club of Chicago, 21 September–28 October

Balthus, introduction by John Rewald
Paris, Arts décoratifs 1966
Musée des Arts décoratifs, 12 May–27 June
Balthus, introduction by Gaétan Picon
Paris, Gomès 1966
Galerie Henriette Gomès, June
Balthus
Paris, Hao 1966
Galerie Jeanine Hao
Knokke-le-Zoute 1966
City Casino, July–September
Balthus, introduction by Gaétan Picon
Chicago 1966
Holland Gallery, 23 September–18 October
Exhibition of Balthus drawings, introduction by H. Bouras
New York 1966
Albert Loeb & Krugier Gallery, December
Alberto Giacometti and Balthus Drawings, introduction by James Lord
New York et alia, 1966–67
The Museum of Modern Art, 1966; Akron Art Institute, 18 December 1966–18 January 1967; University of Minnesota Art Gallery, 2–23 February 1967; University of Iowa, 9–30 March 1967; La Jolla Museum of Art, 16 April–13 May 1967; Davison Art Center, Wesleyan Art University, Middletown, Ct., 22 September–25 October 1967; University of Manitoba, Winnipeg, 1–22 November 1967
Balthus, 1966, introduction by James Thrall Soby
New York 1967
Pierre Matisse Gallery, 28 March–22 April
Balthus: La Chambre turque, Les Trois Sœurs, Drawings and Watercolours (1933–1966), introduction by Patrick Waldberg
London, Tate Gallery 1968
Tate Gallery, 4 October–10 November
Balthus, introduction by John Russell
London, Annely Juda 1968
Annely Juda Fine Art, 19 October
Balthus Drawings
Detroit 1969
Donald Morris Gallery, 24 November–20 December
Balthus, introduction by Charles Lucet
Paris 1971
Galerie Claude Bernard, 21 October–November
Balthus: dessins et aquarelles, introduction by Jean Leymarie
Marseilles 1973
Musée Cantini, July–September
Balthus, introduction by Jean Leymarie
Bevaix 1975
Galerie Arts Anciens, 1 November–11 December
Balthus, peintures, aquarelles, dessins,

introduction by Pierre-Yves Gabus

New York 1977
Pierre Matisse Gallery
Balthus, Paintings and Drawings, 1934–1977, introduction by Federico Fellini

Paris 1977
Galerie Henriette Gomès, 2 June–8 July
Paysages et natures mortes de Balthus

Paris 1978–79
Galerie Claude Bernard, 5 December–27 January
Balthus: dessins, 1978, introduction by Jean Leymarie

Chicago 1980
The Museum of Contemporary Art
Balthus in Chicago

New York 1980
Gertrude Stein Gallery, 1 May–30 June
Balthus Drawings, introduction by George Szabo

Venice 1980
Biennale di Venezia
Balthus, introductions by Jean Leymarie and Federico Fellini

Berkeley 1980
University Art Museum, November–December
Balthus, Matrix/Berkeley 38

Hartford 1981
Wadsworth Atheneum, February–March
Balthus, Matrix/65

Spoleto 1982
Festival dei due Mondi, Palazzo Racani Aroni, 22 June–31 July
Balthus, disegni e acquarelli, introduction by Giovanni Carandente

Zurich 1982
Thomas Ammann Fine Art
Balthus-Twombly

Paris, MNAM-CNACGP 1983–84
Musée national d'art moderne, Centre Georges Pompidou, 5 November–23 January
Balthus, 1983, introduction by Dominique Bozo, essays by Piero Bigongiari, Jean Clair, Sylvia Colle-Lorant, Marc Le Bot, Octavio Paz, John Russell; antology and recollections
(see Monographs)

Paris, Gomès, 1983–84
Galerie Henriette Gomès, November–January
Balthus

New York 1984
The Metropolitan Museum of Art, spring
Balthus, introduction by Philippe de Montebello

Lausanne 1984
Galerie Alice Pauli, 17 May–14 July
Balthus, Giacometti, Bonnard, introduction by Alexandre Bruggmann, catalog edited by Sabine Rewald

Kyoto 1984

Museum of the City of Kyoto, 17 June–22 July
Balthus, texts by Jean Clair, Shûji Takashina

Rome 1989
Centre culturel français de Rome, *Balthus*, introduction by Paul Bedarida, texts by Federico Fellini, Jean Leymarie, Anne Marie Sauzeau

Andros 1990
Museum of modern art, Basil and Elise Goulandris Foundation, 30 June–17 September
Balthus, drawings, water colors, oils, texts by Jean Clair, Federico Fellini, Basil Goulandris, Kyriakos Koutsomallis, Jean Leymarie

Rome 1990
Villa Medici, 8 October–18 November
Balthus a Villa Medici, texts by Jean Clair, Jean-Marie Drot, Federico Fellini, Basil Goulandris, KyriaLos Kousomallis, Jean Leymarie

Ornans 1992
Musée Maison natale Gustave Courbet, summer
Balthus dans la maison de Courbet, texts by Yoshio Abé, Jean-Jacques Fernier, Jean Leymarie and Xing Xiaozhou

Lausanne 1993
Musée Cantonal des Beaux-Arts, 29 May–29 August
Balthus, texts by Jean Leymarie, Jean Rodolphe de Salis, Jean Starobinski, Jorg Zutter

Tokyo 1993–94
Tokyo Station Gallery, 3 November 1993–30 January
Balthus, 1993, introduction by Jean Leymarie, essays by Yoshio Abé

Bern 1994
Kunstmuseum, 18 June–4 September
Balthus, Zeichnungen, introduction by Jean Leymarie

London 1994
The Lefevre Gallery, 23 June–15 July
Le Chat au Miroir III by Balthus, forward by Jean Leymarie

Hong Kong 1995
Hong Kong Museum of Art, 5 May–4 June
Balthus, texts by Isabelle Monod-Fontaine, Scarlett and Philippe Reliquet, Xing Xiaosheng

Beijing 1995
Palais des Beaux-Arts, 24 June–28 July
Balthus, texts by Isabelle Monod-Fontaine, Scarlett and Philippe Reliquet,

Taipei 1995
Taipei Fine Art Museum, 12 August–1 October
Balthus, texts by Isabelle Monod-Fontaine, Scarlett and Philippe Reliquet, Xing Xiaosheng

Madrid 1996
Museo Nacional Centro de Arte Reina Sofia, January–March

Balthus, texts by Francisco Calvo Serraller, Cristina Carrillo de Albornoz, Jean Leymarie, Antoni Tápies

Viterbo 1996
Palazzo dei Papi, autumn
Dessins de Balthus

London 1996
The Lefevre Gallery, 2–20 December
Works on paper by Balthus

Rome 1996–97
Accademia Valentino, 24 October–31 January
Omaggio a Balthus, texts by Solange Auzias de Turenne, Costanzo Costantini, Jean Leymarie, Jean-Marie Tasset

Karuizawa 1997
Musée d'art Mercian
Balthus et Giacometti, introduction by Aomi Okabe, texts by Germain Viatte, H.-U. Obrist, Isabelle Monod-Fontaine, Yves Bonnefoy, Albert Camus, Antonin Artaud, Claude Roy, Stanislas Klossowski de Rola

New York 1988
The Elkon gallery Inc., May–June
Matisse and Balthus. Works on paper, introduction by Frrançoise Gilot

Wroclaw 1998
Wratislavia Cantans, 17–23 September
Balthus

Zurich 1999
Sotheby's, 5–19 May
Kingdom of the Cats

Dijon 1999
Museé des Beaux-Arts, 12 June–27 September
Balthus, un atélier dans le Morvan, 1953–61, introduction by Emmanuel Starcky,
texts by Jean Clair, Sabine Rewald, Sophie Lévy, references by Sophie Lévy and Virginie Monnier

New York 1999
Beadleston Gallery, New York, 20 October–13 November
Balthus

Venice 2000
Museo Correr
Balthus, Alberto e Diego Giacometti, Henri Cartier-Bresson, Jean Leymarie, Martine Franck, texts by Jean Leymarie

London 2000
The Tate Gallery
Balthus, Alberto e Diego Giacometti, Henri Cartier-Bresson, Jean Leymarie, Martine Franck, texts by Jean Leymarie

New York 2000
Dickinson Roundell Inc., 2–22 November
Balthus. Drawings from the collection of Stanislas Klossowski de Rola, texts by Stanislas Klossowski de Rola, John Richardson and Rachel Mauro

New York 2001
The Metropolitan Museum of Art, 27 March–27 May
Balthus remembered

Index of Names